1,500
STRETCHES

Black Dog & Leventhal Publishers

Hachette Book Group
1290 Avenue of the Americas
New York, NY 10104
www.hachettebookgroup.com
www.blackdogandleventhal.com

First edition: October 2017

Black Dog & Leventhal Publishers is an imprint of Hachette Books, a division of Hachette Book Group.
The Black Dog & Leventhal Publishers name and logo are trademarks of Hachette Book Group, Inc.

The publisher is not responsible for websites (or their content) that are not owned by the publisher.

The Hachette Speakers Bureau provides a wide range of authors for speaking events. To find out more, go to www.HachetteSpeakersBureau.com or call (866) 376-6591.

Interior design by Moseley Road, Inc.

LCCN: 2017940502
ISBNs: 978-0-316-44035-6 (hardcover); 978-0-316-47368-2 (ebook)

Printed in China

1010

10 9 8 7 6 5 4 3 2 1

1,500
STRETCHES

The Complete Guide to Flexibility and Movement

Hollis Liebman

BLACK DOG
& LEVENTHAL
PUBLISHERS

Contents

Stretching: The Natural Healer

We all do it—we stretch in the morning to get our blood flowing, we stretch our legs after a long drive, and we stretch our shoulders after sitting at our desks for hours. Stretching is an intuitive movement, not only for humans but animals as well. (Try doing some yoga on your living room floor without your dog or cat coming by to stretch alongside you!) We stretch because it is a simple and effective way to loosen our muscles and invigorate our bodies.

Stretching Back in Time

The history of stretching extends as far back as 3000 B.C., when yoga was first mentioned in sacred Indian texts. For thousands of years, yoga practitioners have recognized the value of performing complex stretching postures along with deep breathing. Yoga is said to improve the flow of "prana," or life energy, through the body, restoring physical and mental well-being.

Likewise, in Ancient Greece and Rome, athletes and military personnel incorporated stretching routines into their training regimens. Hippocrates and Galen, the father of sports therapy and physician to gladiators, believed that regular stretching was beneficial for healing aggravated muscles and maintaining general health.

Everyone Benefits from Stretching

Stretching is not only for athletes and yogis. Anyone who wants to improve their flexibility and range of motion should consider performing a few stretches every day.

People with sedentary lifestyles, in particular, should stretch daily to help improve their mobility. Sedentary individuals are generally more prone to injuries because their tight muscles aren't acclimated to sudden or jerky movements. Muscle strains may then be a further hindrance to exercise, perpetuating the cycle of inactivity and leading to an even greater decline in mobility.

As we get older, our muscle mass naturally decreases and our activity levels decline. Inevitably, muscles grow weaker and joints stiffen up. Stretching can help reverse that aging process. Whether you are young or old, athletic or sedentary, stretching is a great way to improve your fitness and agility.

1,500 Stretches

A detailed and comprehensive book, *1,500 Stretches* shows you, in simple step-by-step instructions, how to perform a variety of stretches—from basic beginner's poses to more challenging postures. Within these pages, you'll find just the right stretches for you. Remember, as with any new workout, begin slowly: You don't want to overstretch.

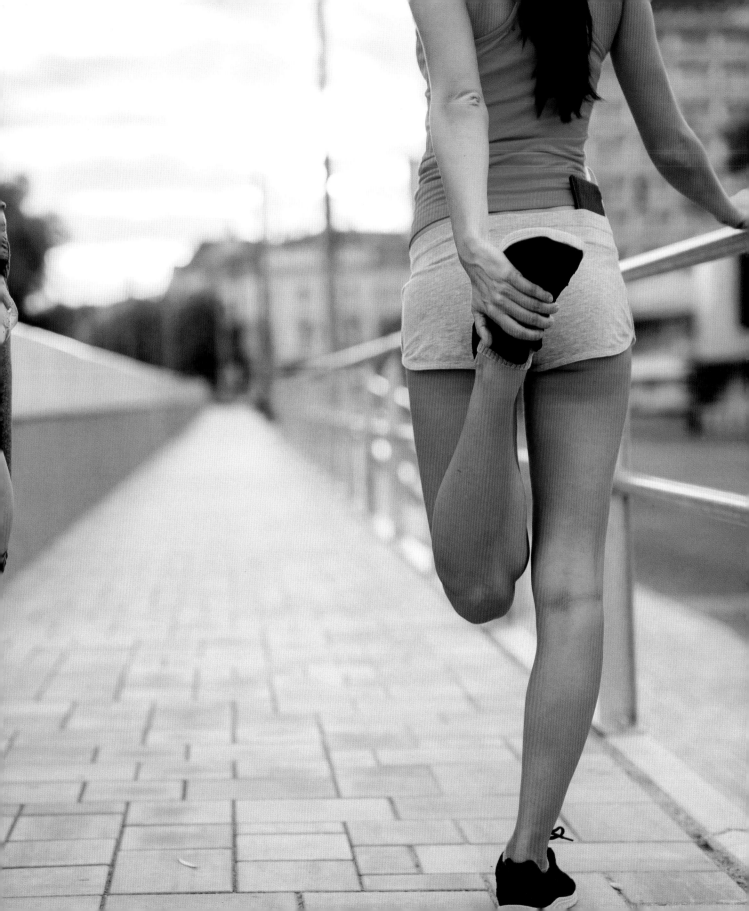

Stretch for Health

Roll out an exercise mat and start stretching! The numerous health benefits are worth it: Stretching enhances agility, relieves stress, alleviates back pain, and improves posture. Yet recently, stretching has taken a backseat to other types of exercise, perhaps because a few sports-related studies have shown conflicting results about the benefits of stretching. But don't let that deter you—most of those reports simply address the relative advantages of stretching before or after a workout. Stretching remains an excellent form of exercise for overall health.

Flex Your Muscles

The most obvious payoff of regular stretching is greater flexibility and a healthier range of motion in your joints. Stretching not only helps improve your athletic agility but also helps you perform everyday tasks, such as bending down to pick something up from the floor. When an agile person can more easily perform such basic movements, the body requires less energy, resulting in better stamina and less fatigue.

Improve Your Workouts

Before you begin a strenuous workout, performing a dynamic stretch (such as jogging in place) is an excellent way for you to warm up your muscles and prime your body for vigorous activity. Following a workout, static stretches (stationary poses, such as a lunge) allow your body to cool down gradually and may help to minimize muscle soreness by lengthening muscles that have contracted during your workout. Static stretches also help keep your blood flowing, allowing more nutrients to flush through the tired muscles and promote cell growth and repair.

Reduce the Risk of Injury

Tight muscles can be hazardous to your health. If your muscles tend to be stiff, you are more likely to pull a muscle or sprain a ligament when you perform a new exercise or you suddenly increase the amount of activity that you do. The more accustomed your body is to elongating your muscles, the less likely you are to suffer an injury by overextending yourself.

Stretch Away the Stress

The pressures of daily life often have a negative impact on your body. When you are continuously in fight-or-flight mode, the chronic tension can lead to knotted-up muscles in the neck, shoulders, lower back, and hips. These classic zones of stress are susceptible to aches and pains. By focusing on stretching out those areas where you tend to keep your tension, you can alleviate the pain.

Boost Your Mood

Stretching can elevate your mood by releasing the feel-good chemicals called endorphins through your body. All forms of exercise trigger these mood-enhancing chemicals, and stretching is no exception.

Additionally, when you perform stretches in a calm, thoughtful manner, you teach your body to slow down and relax. Particularly with static stretches, your breathing rate naturally decreases as you try to loosen and extend your muscles. Slow and deep breathing also increases your oxygen uptake, enhancing the sense of relaxation.

Realign Your Spine

Good posture goes a long way toward reducing back pain. A lot of back pain is due to stress or tight hamstrings, so stretching the muscles along your spine and your legs will improve your posture and make you feel more balanced.

Commit to a Long-Term Plan

You will enjoy the best results from stretching if you perform the exercises on a daily basis. Alternate parts of the body from day to day, and keep this order of stretches in mind: Start out by stretching your back and obliques; next stretch your calves and glutes before your hamstrings; and stretch your arms before your chest.

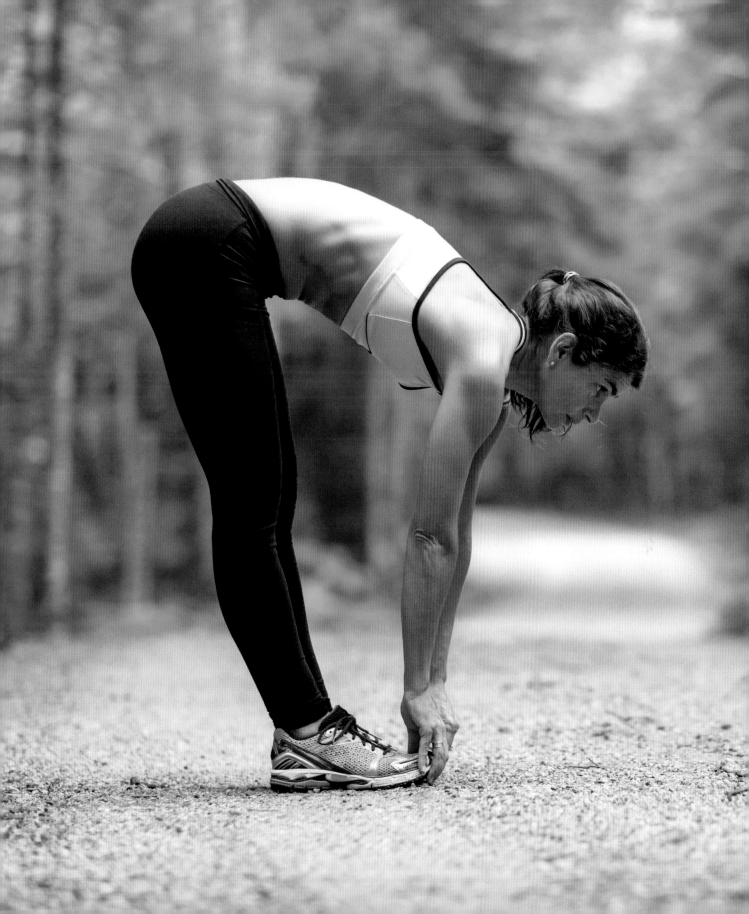

Stretching Techniques

Don't be confused by the variety of stretching methods out there! Basically all stretches are either static or dynamic, and either active or passive. Most other stretching techniques are simply variations of these basic groups.

Static vs. Dynamic Stretching

When we think of stretching, many of us may imagine a simple stretch like bending forward to touch our toes—that's a static (stationary) stretch. Static stretching refers to maintaining a position that elongates a muscle, or a muscle group, for a period of time, generally 30 seconds. (No bouncing, please! That's ballistic stretching, which has largely been discredited.)

For a static stretch to be effective, you should maintain the pose long enough for your body to overcome the "stretch reflex," which is your body's protective mechanism against overextending your muscles. After about 20 seconds in a stretch, you should feel your muscles relax into a slightly deeper stretch. Gradually, your body acclimates to the new lengthening of your muscles and your flexibility increases.

On the opposite end of the spectrum is dynamic stretching, which combines movement along with the stretch. So rather than bending forward to touch your toes for 30 seconds, you might jog in place for 30 seconds to prepare for a brisk run, or you might swing your arms in circles to loosen your shoulders before a game of tennis.

Active vs. Passive Stretching

Another way of thinking about stretches is whether they are active (unassisted) or passive (assisted). An active stretch is one that you perform without the help of any equipment or a training partner: for instance, extending an arm overhead and holding that pose unassisted.

Passive stretching, on the other hand, takes the stretch a step further and includes a force that exerts pressure on the muscle to attain a deeper stretch. So, if you clasp your hands and extend your arms overhead, you are using the additional force of both arms working together. Many stretches in this book are static-passive stretches, whether that additional force comes from your own body or from a resistance band or a training partner.

Other methods such as isometric and PNF are variations of static-passive stretching that incorporate contraction-relaxation techniques.

In this definitive collection of *1,500 Stretches,* we simplify the categories into specific parts of the body. So from head to toe, you can find the stretches you need to work out every muscle in your body.

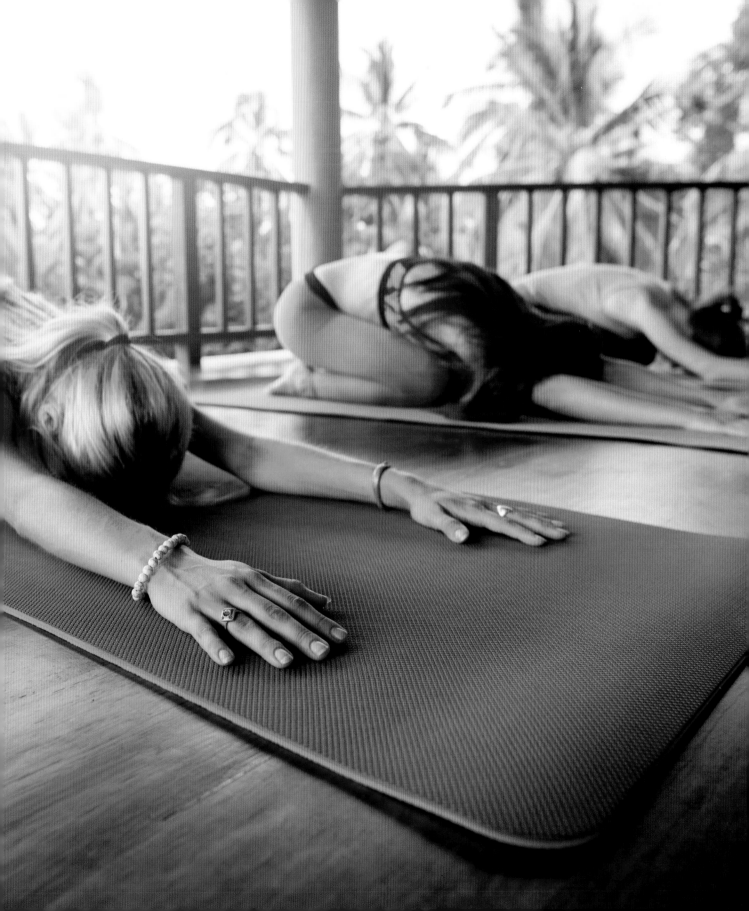

ANATOMY FRONT

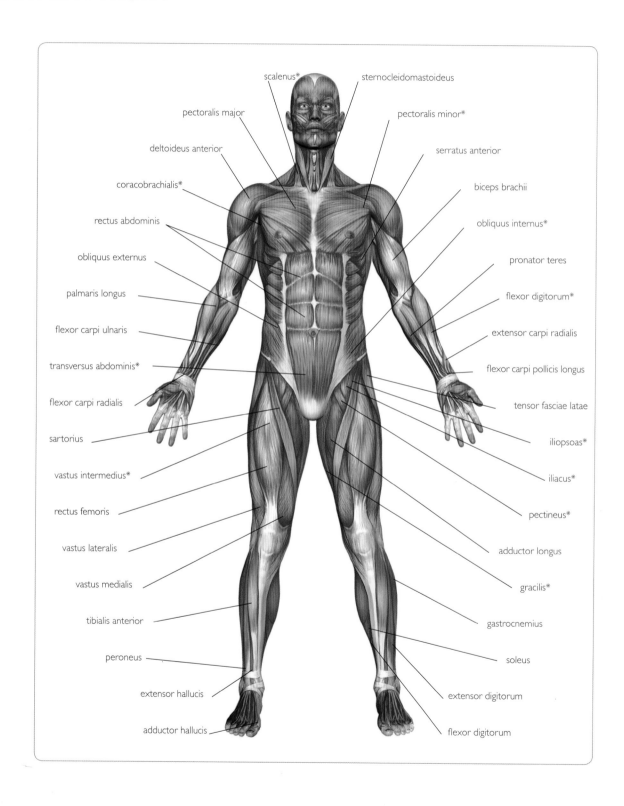

scalenus*

sternocleidomastoideus

pectoralis major

pectoralis minor*

deltoideus anterior

serratus anterior

coracobrachialis*

biceps brachii

rectus abdominis

obliquus internus*

obliquus externus

pronator teres

palmaris longus

flexor digitorum*

flexor carpi ulnaris

extensor carpi radialis

transversus abdominis*

flexor carpi pollicis longus

flexor carpi radialis

tensor fasciae latae

sartorius

iliopsoas*

vastus intermedius*

iliacus*

rectus femoris

pectineus*

vastus lateralis

adductor longus

vastus medialis

gracilis*

tibialis anterior

gastrocnemius

peroneus

soleus

extensor hallucis

extensor digitorum

adductor hallucis

flexor digitorum

ANATOMY BACK

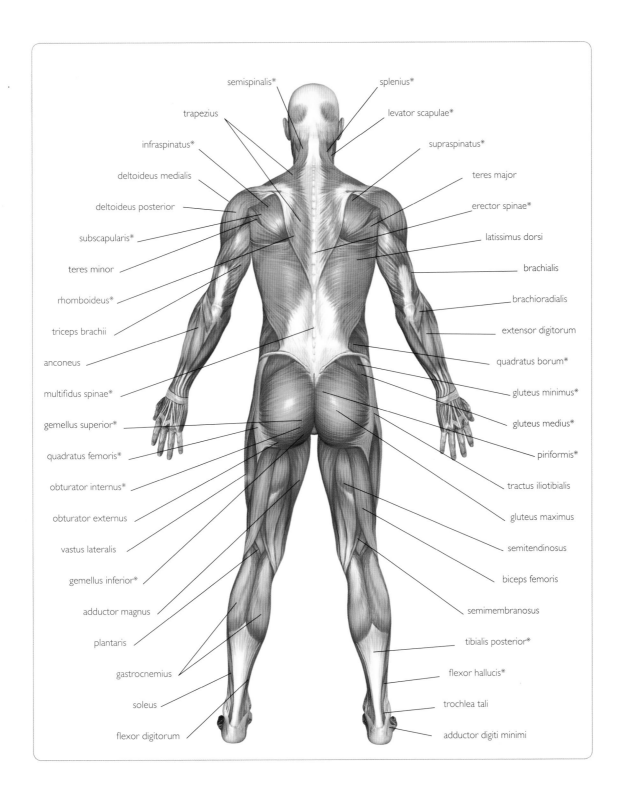

semispinalis*

splenius*

trapezius

levator scapulae*

infraspinatus*

supraspinatus*

deltoideus medialis

teres major

deltoideus posterior

erector spinae*

subscapularis*

latissimus dorsi

teres minor

brachialis

rhomboideus*

brachioradialis

triceps brachii

extensor digitorum

anconeus

quadratus borum*

multifidus spinae*

gluteus minimus*

gemellus superior*

gluteus medius*

quadratus femoris*

piriformis*

obturator internus*

tractus iliotibialis

obturator externus

gluteus maximus

vastus lateralis

semitendinosus

gemellus inferior*

biceps femoris

adductor magnus

semimembranosus

plantaris

tibialis posterior*

gastrocnemius

flexor hallucis*

soleus

trochlea tali

flexor digitorum

adductor digiti minimi

Targeted Stretches

Head and Neck Stretches

Shoulder Stretches

Arm Stretches

Back Stretches

Chest Stretches

Core Stretches

Upper-Leg Stretches

Lower-Leg Stretches

Head and Neck Stretches

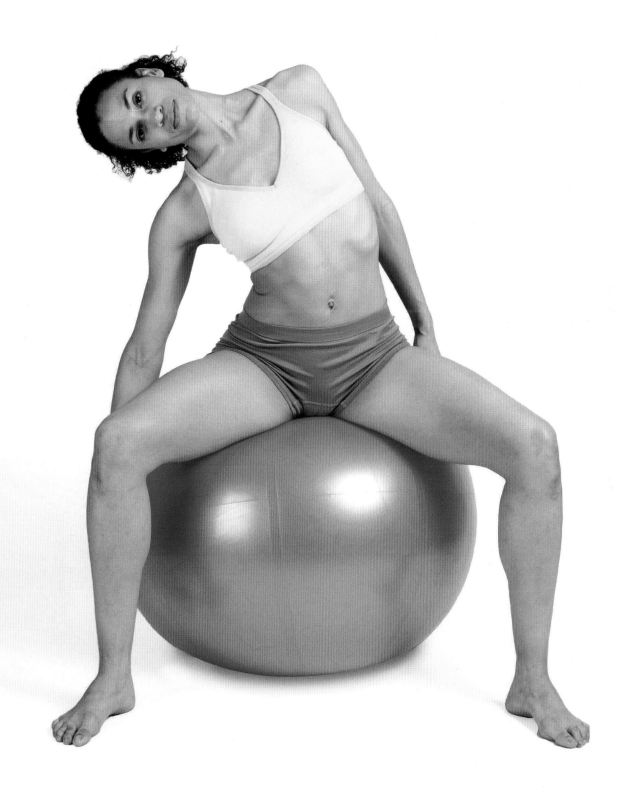

Eye Box Stretch

Target: Face.

Benefits: Improves strength and reflexes in the muscles surrounding the eyes.

Steps: 1. Look as far as you can to the upper left. Look directly to the left. Then look to the lower left. **2.** Switch direction and look as far as you can to the upper right. Look to the right. Then look to the lower right.

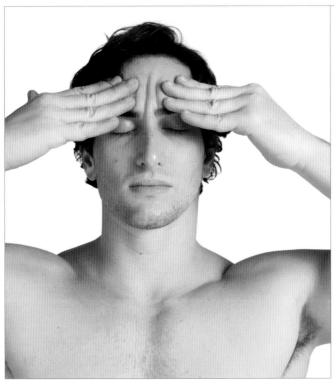

Frown Buster

Target: Face.

Benefits: Relieves tension and tightness in the muscles of the forehead.

Steps: 1. Use your fingers to scrunch the skin of the forehead in and out. **2.** Rub clockwise and then counterclockwise.

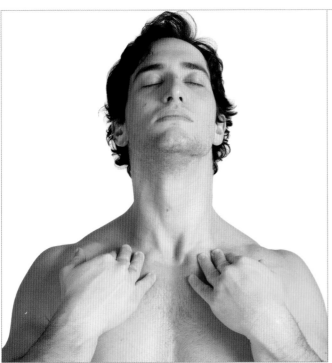

Giraffe-Neck Stretch

Target: Face.

Benefits: Relieves tension and tightness in the muscles of the neck.

Steps: 1. Use your fingers to pull down against the collarbone. **2.** Extend your chin upward to increase the stretch.

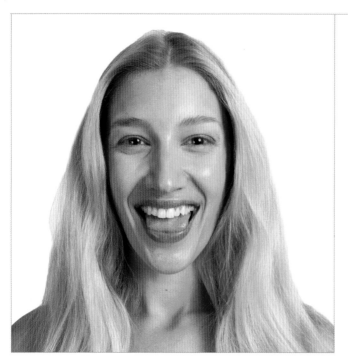
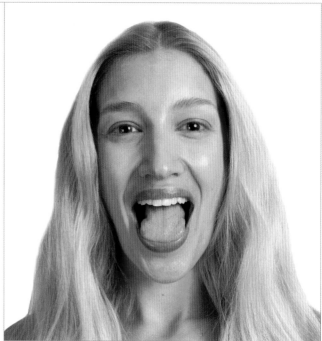

Lion Face Stretch

Target: Face.

Benefits: Stretches and relieves tension in the facial muscles around the cheekbones.

Steps: 1. Smile broadly with your mouth open to form an O. **2.** Stick out your tongue as far as possible, and hold for five seconds. **3.** Close your mouth and relax your facial muscles. **4.** Repeat twenty times.

Scalp Stretch

Target: Head.

Benefits: Relieves tension and tightness in the scalp.

Steps: 1. Grab hold of the hair from the upper edges of your scalp. **2.** Pull your hair up and away from your face.

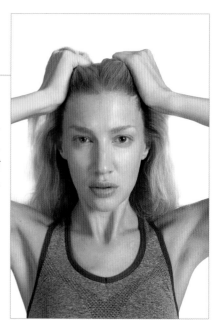

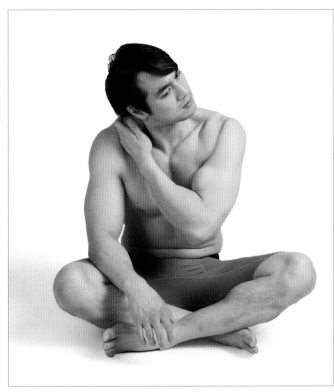

Anterior Neck Mobilization

Target: Neck.

Benefits: Reduces stiffness and tension in the neck.

Steps: 1. Hold a yoga or tennis ball against your neck.
2. Press the ball into your neck, circling any troubled areas.
3. Work the ball into the muscles surrounding your neck for thirty seconds.

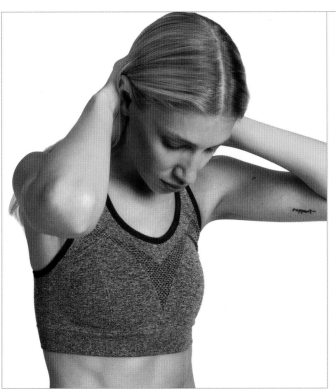

Back and Neck Stretch

Target: Neck.

Benefits: Releases any stiffness or cricks along the back of the neck.

Steps: 1. Place both hands on the back of your neck with your thumbs resting under your ears. **2.** Pull your head upward and away from your shoulders.

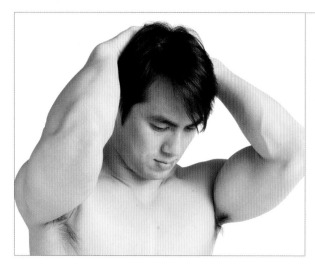

Back-of-Neck Stretch

Target: Neck.

Benefits: Lengthens the muscles in the upper back and neck.

Steps: 1. Tuck your head down to your chest and place both hands on the back of your head. **2.** Pull down on the top of your head and shoulders.

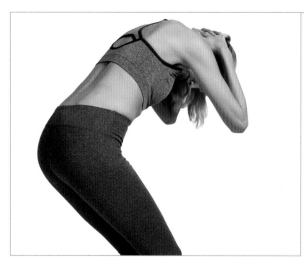

Back and Neck Stretch, Crouching

Target: Neck.

Benefits: Lengthens the muscles along the spine and the neck.

Steps: 1. Bend your knees into a crouching position. Tuck your head down to your chest and place both hands on the back of your head. **2.** Pull down on the top of your head and shoulders.

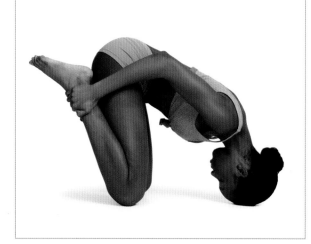

Both Hands-on-Legs Cow Pose on Head

Target: Neck.

Benefits: Lengthens the neck and upper back.

Steps: 1. Begin on all fours. Lower your head, so the top of your head is resting on the floor. **2.** Lift your feet up to rest on the back of your hips. Balancing on your head, reach both hands around you to hold your ankles to your thighs. **3.** Hold this position for twenty seconds.

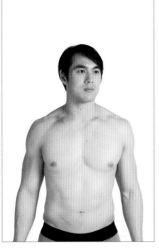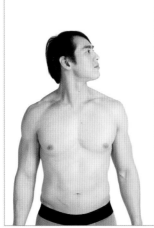

Complete Head Rotation

Target: Neck.

Benefits: Provides a wide range of motion in the neck muscles, reducing stiffness from poor posture or lack of mobility.

Steps: 1. Start in a standing or sitting position with straight posture. **2.** Tilt your head forward and try to touch your chin to your chest. **3.** Rotate your head clockwise, tilting your head as far as you can. Keep rotating your head, looking as far behind you as you can. **4.** Finish by tilting your head to the left with as much range of motion as possible. **5.** Repeat these steps multiple times. Then rotate counterclockwise.

Head and Shoulder Stretch

Target: Neck.

Benefits: Reduces stiffness and tension in the neck and upper back.

Steps: 1. Stand straight with your hands clasped behind your back. **2.** Curl your head and shoulders forward, touching your chin to your chest. Stay in this pose for fifteen seconds. **3.** Pull your head and shoulders back, pointing your chin to the ceiling. Hold this pose for fifteen seconds. **4.** Repeat these positions five times.

Eastern Intense-Stretch Pose, Seated

Target: Neck.

Benefits: Stretches the front of the neck and opens the chest.

Steps: 1. Sit with your knees bent and your palms flat on the floor behind you. Point your fingers toward your back. **2.** Tilt your head and shoulders back to face the ceiling. **3.** Hold this pose for thirty seconds.

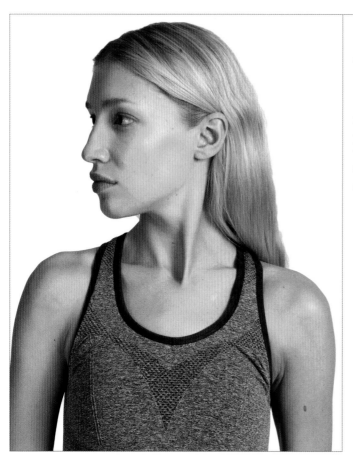

Neck and Head Turn

Target: Neck.

Benefits: Increases mobility and reduces muscle imbalance in the neck.

Steps: 1. Sit or stand with good upright posture. **2.** Turn your head as far to the right as you are able. Hold for fifteen seconds. **3.** Turn your head as far to the left as you are able. Hold for fifteen seconds. **4.** Return to the left and repeat this exercise ten times.

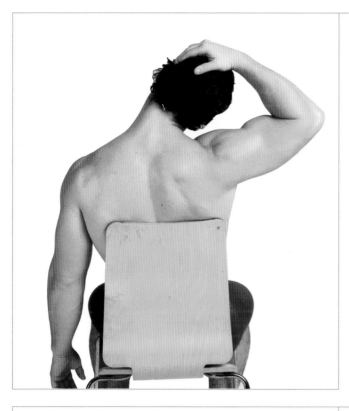

Neck Flexor and Rotational Stretch

Target: Neck.

Benefits: Relieved tightness or tension in the neck muscles.

Steps: 1. Sit or stand with good upright posture. **2.** Place your right hand on the upper left side of your head. Gently pull your head toward the right. **3.** Hold this position for twenty seconds before alternating sides.

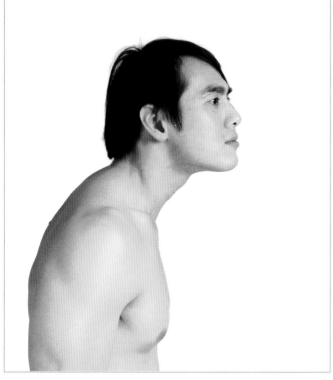

Neck Hyperextension

Target: Neck.

Benefits: Lengthens and strengthens the muscles along the neck.

Steps: 1. Sit or stand with good back and shoulder posture. **2.** Without using your hands, push your chin out in front of you. **3.** Hold this position for thirty seconds before releasing.

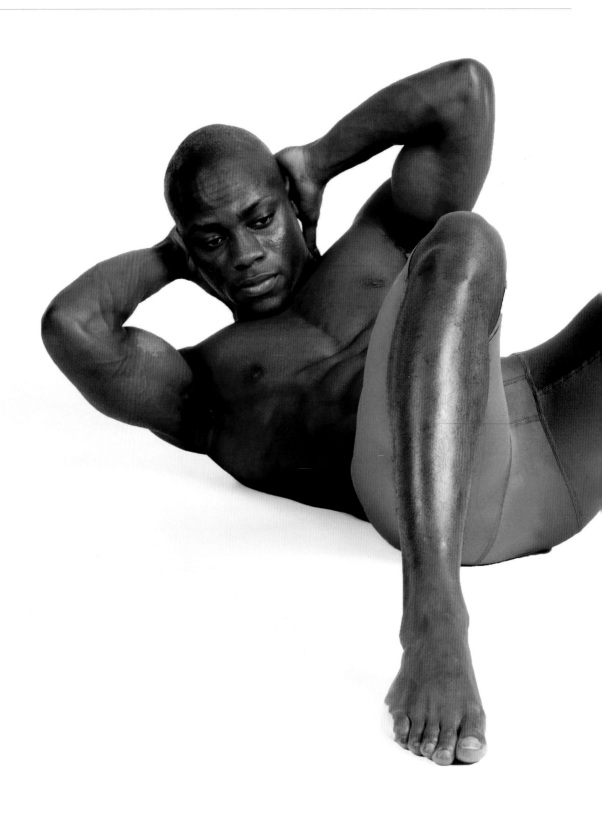

Neck Stretch Across

Target: Neck.

Benefits: Increases mobility and reduces tightness in the neck and upper back while strengthening the abdomen.

Steps: 1. Lie on your back with your knees bent and your hands resting under your head. **2.** Raise your shoulders from the floor and twist your torso to the right. Pull your neck gently with your hands. **3.** Return to the floor and raise your shoulders, this time twisting to the left. Gently pull your neck in the other direction. **4.** Return to the floor and repeat the exercise ten times, alternating sides.

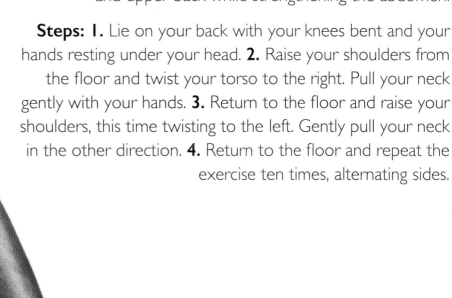

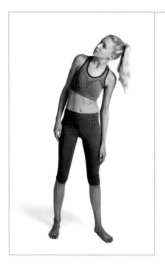 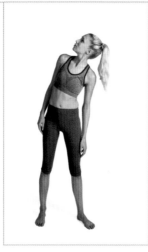

Neck Stretch, Diagonal

Target: Neck.

Benefits: Releases tightness and helps eliminate neck pain.

Steps: 1. Stand up straight with good back posture. **2.** Twist your shoulders back and to the left. Slowly, drop your head back, raising your gaze up and to the right. **3.** Hold this position for fifteen seconds and then repeat to the other side.

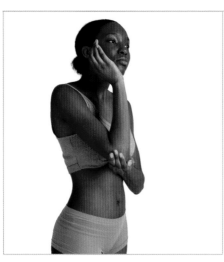

Neck Stretch from Chin

Target: Neck.

Benefits: Extends the muscles along your neck.

Steps: 1. Sit or stand with good upright posture. **2.** Place the palm of your right hand on the right side of your jaw. **3.** Gently press your chin upward and to the right. Hold for fifteen seconds. **4.** Release and repeat on the left side with your left hand.

Neck Stretch with Arm Pull

Target: Neck.

Benefits: Lengthens the muscles along the side of your neck and upper back.

Steps: 1. Grab your right forearm with your left hand. Tilt your head to the left. **2.** Pull down on your right arm while stretching your head as far toward your left shoulder as you are able. **3.** Hold this pose for thirty seconds before switching sides.

Neck Tilt, Downward

Target: Neck.

Benefits: Improves posture and relieves neck pain.

Steps: 1. Sit or stand with good back and shoulder posture. **2.** Drop your chin down toward your right shoulder. Pull as deeply to the right as you are able. **3.** Hold this pose for thirty seconds before repeating to the left.

Neck Tilt, Downward Assisted

Target: Neck.

Benefits: Improves posture and relieves neck pain.

Steps: 1. Sit or stand with good back and shoulder posture. Place your right hand on the top left side of your head. **2.** Drop your chin down toward your right shoulder. Gently pull your head toward the right. **3.** Hold this pose for thirty seconds before repeating.

Neck Tilt, Side

Target: Neck.

Benefits: Improves posture and relieves neck pain.

Steps: 1. Sit or stand with good back and shoulder posture. **2.** Drop the side of your head down toward your right shoulder. Pull as deeply to the right as you are able. **3.** Hold this pose for thirty seconds before repeating to the left.

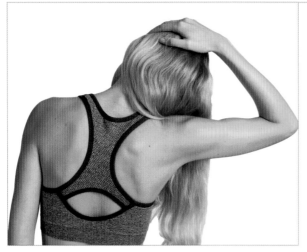

Neck Tilt, Side Assisted

Target: Neck.

Benefits: Improves posture and relieves neck pain.

Steps: 1. Sit or stand with good back and shoulder posture. Place your left hand on the top right of your head. **2.** Drop the side of your head down toward your right shoulder. Gently pull your head to the right. **3.** Hold this pose for thirty seconds before repeating to the left.

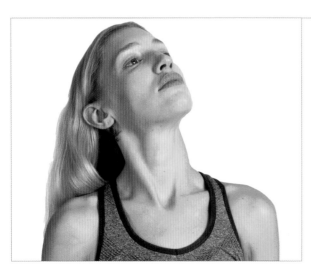

Neck Tilt, Upward

Target: Neck.

Benefits: Improves posture and relieves neck pain.

Steps: 1. Sit or stand with good back and shoulder posture. **2.** Raise your chin up above your right shoulder. Drop your head down to the left and raise your chin as far up to the right as you are able. **3.** Hold this pose for thirty seconds before repeating to the left.

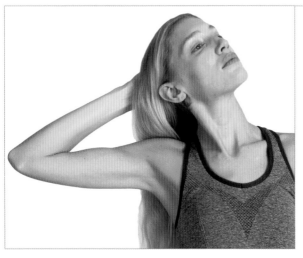

Neck Tilt, Upward Assisted

Target: Neck.

Benefits: Improves posture and relieves neck pain.

Steps: 1. Sit or stand with good back and shoulder posture. Place your right hand on the top right side of your head. **2.** Raise your chin up above your right shoulder. Drop your head down to the left and raise your chin as far up to the right as you are able. Press slightly against your head with your hand. **3.** Hold this pose for thirty seconds before repeating to the left.

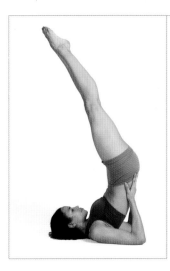

Shoulder Stand

Target: Neck.

Benefits: Lengthens the muscles in the neck and upper back while strengthening the legs and core.

Steps: 1. Lie faceup on the floor with knees bent, feet on the floor, and arms on either side. **2.** Raise your legs up from the floor and extend your feet straight into the air above your hips. **3.** Place your fingers on your lower back for support, as you attempt to push your hips and lower back up into a shoulder stand. **4.** Try to keep your legs and hips straight. Hold this pose for twenty seconds.

Caution: Draw your chin away from your chest to take any pressure off your throat during this stretch.

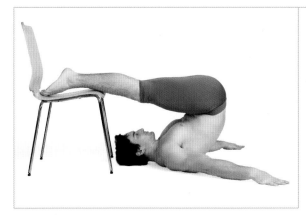

Shoulder Stand, Overhead Easier

Target: Neck.

Benefits: Lengthens the muscles in the neck and upper back while strengthening the legs and core.

Steps: 1. Lie faceup by a sturdy chair, with knees bent, feet on the floor, and arms on either side. **2.** Raise your legs and extend your feet up above your hips. **3.** Bend from the hip, lowering your toes above your head and onto the seat of the chair. Try to keep your legs and back straight so you get a nice right angle. Attempt to lift your thighs and tail bone upward. **5.** Hold this pose for twenty seconds.

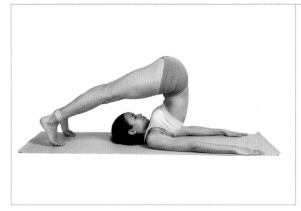

Shoulder Stand, Overhead with Band

Target: Neck.

Benefits: Lengthens the muscles in the neck and upper back and strengthens the core and the leg muscles, with emphasis on the abductors.

Steps: 1. Wrap a resistance band around both ankles. Lie faceup on the floor, with knees bent, feet on the floor, and arms at your sides. **2.** Raise your legs, extending your feet above your hips. **3.** Place your hands on your lower back for support and push your hips and lower back up into a shoulder stand. **4.** Exhale and bend from the hip, lowering your toes toward the floor. Keep your legs and back straight, while lifting your tail bone upward. **5.** Hold for twenty seconds, keeping the band taut throughout.

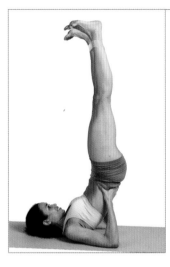

Shoulder Stand with Band

Target: Neck.

Benefits: Lengthens the muscles in the neck and upper back, and strengthens the core and the leg muscles, with emphasis on the abductors.

Steps: 1. Attach a resistance band around your ankles. Lie faceup on the floor, with knees bent, feet on the floor, and arms at your sides. 2. Raise your feet up and above your hips. 3. Place your hands on your lower back for support, as your attempt to push your hips and lower back up into the air into a shoulder stand. Keep the band taut between your ankles. 4. Hold this pose for twenty seconds, making sure to keep the band taut throughout.

Side-Twist Curved Spine

Target: Neck.

Benefits: Lengthens the back of the neck and upper spine while engaging the core.

Steps: 1. Begin seated on an exercise ball with your legs spread wide apart. Place your hands on the back of your head with your elbows out to your sides. 2. Drop your head and shoulders down to one side. Press gently against your head with both hands. 3. Hold this pose for thirty seconds before rising back up and repeating down to the other side.

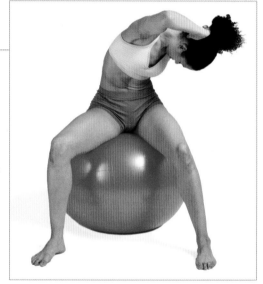

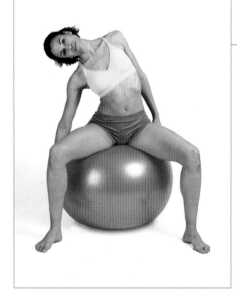

Spine and Neck Stretch on Ball

Target: Neck.

Benefits: Lengthens the muscles across the side of the neck and upper back while engaging the core.

Steps: 1. Begin seated on an exercise ball with your legs spread wide apart. Straighten your arms down to your sides behind you. 2. Drop your head and your shoulders down to your right. Lower your right arm down toward the floor. 3. Hold for thirty seconds before rising back up and repeating on the other side.

Up-and-Down Neck Stretch

Target: Neck.

Benefits: Lengthens and stretches the neck muscles.

Steps: 1. Begin seated or standing with good back and shoulder posture. **2.** Drop your chin down to your chest, pulling your head down as deeply as is comfortable. Hold this position for thirty seconds. **3.** Raise your chin up toward the ceiling as far as you are able. Hold this position for thirty seconds.

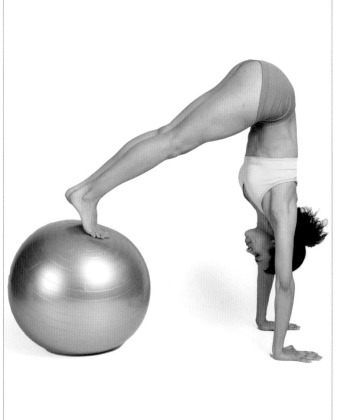

Handstand Prep on Ball

Target: Headstand and handstand.

Benefits: Increases stability in the shoulders and upper arms, while engaging the core and improving balance.

Steps: 1. Begin in a plank, with your feet resting on an exercise ball and your hands flat on the floor beneath your shoulders. **2.** Push your hips up toward the ceiling in a downward dog position. Walk your hands in toward the ball, so your shoulders are directly below your hips. **3.** Hold this position for thirty seconds before walking your hands back out, lowering your hips and stepping your feet off the ball.

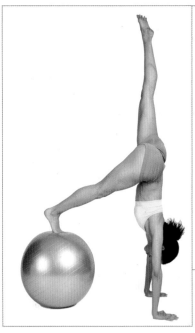

Handstand Prep on Ball, One Leg Raised

Target: Headstand and handstand.

Benefits: Increases stability in the shoulders and upper arms while engaging the core and improving balance.

Steps: 1. Begin in a plank, with your feet resting on an exercise ball and your hands flat on the floor beneath your shoulders. **2.** Push your hips up toward the ceiling, in a downward dog position. Walk your hands in toward the ball, so your shoulders are directly below your hips. **3.** Raise one leg from the ball, directly up above you. **4.** Find your balance and hold this position for thirty seconds.

Handstand Prep

Target: Headstand and handstand.

Benefits: Prepares the neck, arms, shoulders, and upper back to hold the weight in a handstand position.

Steps: 1. Begin on all fours, with your toes raised and your feet against the wall. **2.** Brace your hands and shoulders to hold your weight, and push your hips up into the air in a downward dog pose. **3.** Step one foot at a time up the wall, until both legs are straight and both feet are level. **4.** Hold this pose for thirty seconds before stepping one foot at a time back down to the floor.

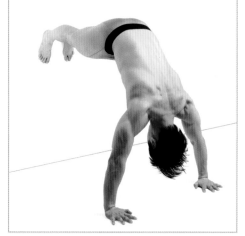

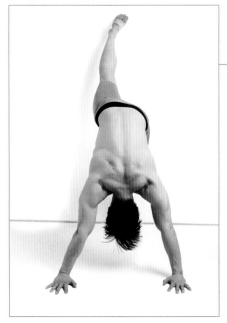

Handstand, Wall Assisted

Target: Headstand and handstand.

Benefits: Prepares the neck, arms, shoulders, and upper back to hold the weight in a handstand position.

Steps: 1. Begin on all fours, with your toes raised and your feet against the wall. **2.** Brace your hands and shoulders to hold your weight, and push your hips up into the air in a downward dog pose. **3.** Step one foot at a time up the wall, until both legs are straight and both feet are level. **4.** Raise one leg from the wall up into the air above you. **5.** Hold this pose for thirty seconds before stepping one foot at a time back down to the floor.

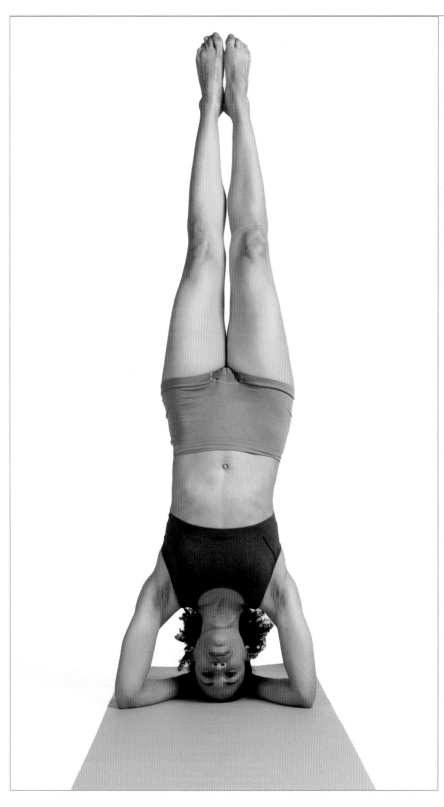

Headstand

Target: Headstand and handstand.

Benefits: Strengthens the arms, legs, and spine while toning the abdominal muscles.

Steps: 1. Kneel on the floor. Lace your fingers together and set your forearms on the floor, elbows at shoulder width apart. Set the crown of your head on the floor. **2.** Inhale and lift your knees up off the floor. Carefully walk your feet closer to your elbows, heels elevated. Try to keep your torso as straight as possible. **3.** Exhale and lift your feet off the floor, taking both feet up at the same time, even if it means bending your knees and hopping lightly off the floor. As your legs (or thighs, if your knees are bent) rise to perpendicular to the floor, firm the tail bone against the back of the pelvis. **4.** Turn the upper thighs in slightly, and actively press the heels toward the ceiling (straightening the knees if you bent them to come up). Your toes should be directly above your hips and in line with your shoulders. **5.** Hold for ten or more seconds before safely returning to the floor.

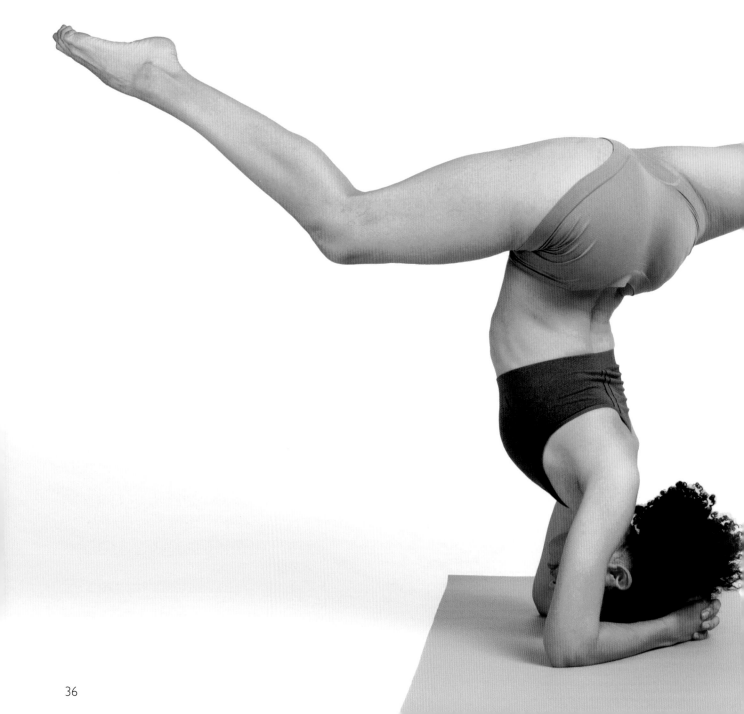

Headstand Advanced Modification I

Target: Headstand and handstand.

Benefits: Strengthens the arms, legs, and spine while toning the abdominal muscles and strengthening the adductors and abductors.

Steps: 1. Kneel on the floor. Lace your fingers together and set your forearms on the floor, elbows at shoulder width apart. Place the crown of your head on the floor. **2.** Inhale and lift your knees off the floor. Carefully walk your feet closer to your elbows, heels elevated so your legs form an upside-down V. Try to keep your torso as straight as possible. **3.** Exhale and lift your feet off the floor, taking both feet up at the same time, even if it means bending your knees and hopping lightly off the floor. As the legs (or thighs, if your knees are bent) rise to perpendicular to the floor, firm the tail bone against the back of the pelvis. **4.** Turn the upper thighs in slightly, and actively press the heels toward the ceiling (straightening the knees if you bent them to come up). **5.** Once you are balanced in this position, lower your legs away from each other, bending both knees in the process, into a wide split. **6.** Hold this position for ten or more seconds before safely returning to the floor.

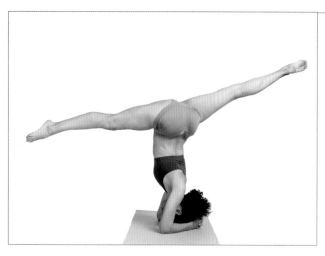

Headstand, Advanced Modification 2

Target: Headstand and handstand.

Benefits: Strengthens the arms, legs, and spine while toning the abdominals, adductors, and abductors.

Steps: *Perform Steps 1 through 4 of Headstand Advanced Modification 1 (on previous page).* **5.** Once you are balanced in this position, lower your legs away from each other into a wide split, straightening your knees and pointing your toes. **6.** Hold this position for ten or more seconds before safely returning to the floor.

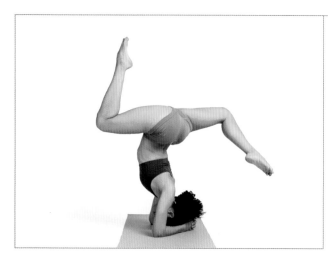

Headstand, Advanced Modification 3

Target: Headstand and handstand.

Benefits: Strengthens the arms, legs and spine while toning the abdominal muscles and strengthening the adductors and abductors.

Steps: *Perform Steps 1 through 4 of Headstand Advanced Modification 1 (on previous page).* **5.** Once you are balanced in this position, lower your legs away from each other, bending both knees into a split. **6.** Once your legs are fully extended, continue to bend your knees so both form 90-degree angles. **7.** Hold this position for ten or more seconds.

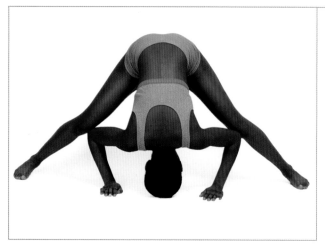

Headstand Prep

Target: Headstand and handstand.

Benefits: Prepares the neck and head to hold the pressure of a headstand.

Steps: 1. Kneel on the floor. Place your palms on the floor ahead of your knees. Set the crown of your head on the floor. **2.** Inhale and lift your knees off the floor. Carefully walk your feet closer to your elbows, heels elevated so your legs form an upside-down V. **3.** Hold this position for ten or more seconds.

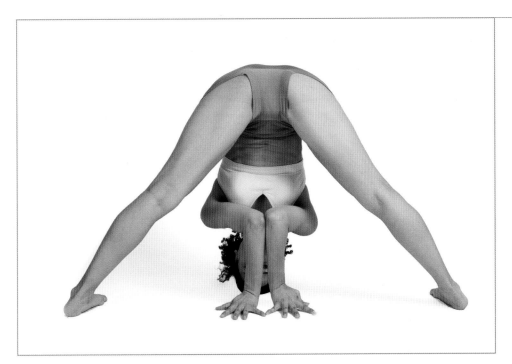

Headstand Prep, Intense Wrist

Target: Headstand and handstand.

Benefits: Prepares the neck and head to hold the pressure of a headstand.

Steps: 1. Kneel on the floor. Place your palms on the floor ahead of your knees, with your fingers pointed toward your knees. Set the crown of your head on the floor. **2.** Inhale and lift your knees off the floor. Carefully walk your feet closer to your elbows, heels elevated so your legs form an upside-down V. **3.** Hold this position for ten or more seconds.

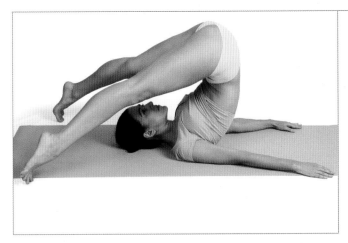

Shoulder Stand, Overhead Modification

Target: Headstand and handstand.

Benefits: Lengthens the muscles in the neck and upper back.

Steps: 1. Lie faceup on the floor, with knees bent, feet on the floor, and arms at your sides. **2.** Raise your legs, extending your feet above your hips. **3.** Push your hips and lower back up into a shoulder stand. **4.** Exhale and bend from the hip, lowering your toes onto the floor and lifting your tail bone upward. Keep your legs and back straight. **5.** Hold this pose for twenty seconds.

Shoulder Stretches

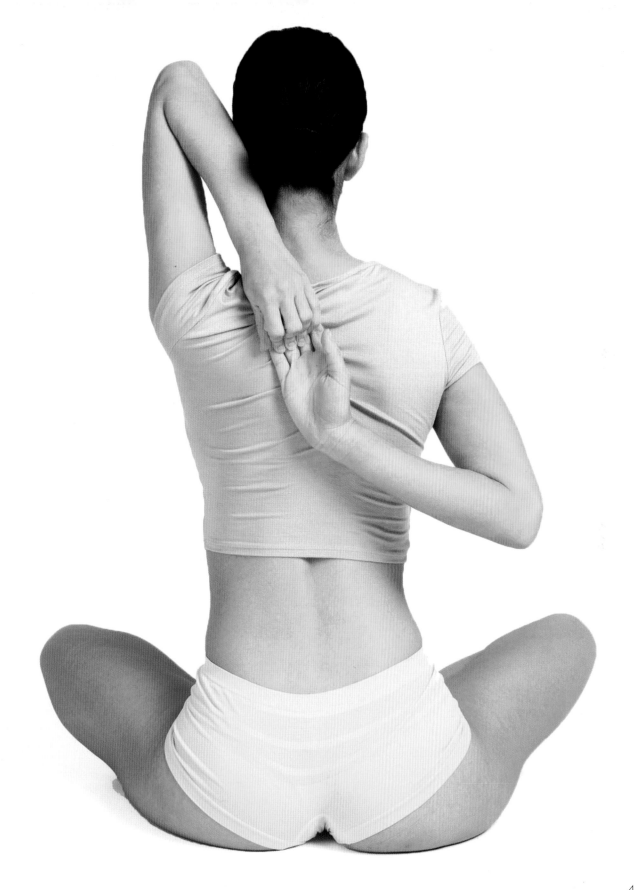

Arm Adduction, Across Back

Target: Shoulders.

Benefits: Improves postural imbalance and mobility in the shoulders.

Steps: 1. Stand straight with good back and shoulder posture. **2.** Reach your right arm behind and across your back, bending at the elbow. **3.** Grab your right wrist with your left hand and gently pull your wrist. **4.** Continue this stretch for thirty seconds before switching arms.

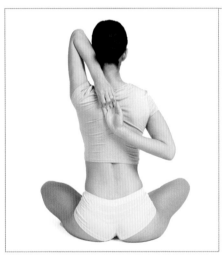

Angle Pose, Bound 1

Target: Shoulders.

Benefits: Helps reduce tension built up in the back and shoulders.

Steps: 1. Sit cross-legged on the floor. **2.** Reach your right hand behind you and up your spine, while reaching your left hand over your shoulder and down your spine. **3.** Clasp your hands together behind you and pull your hands gently apart. **4.** Continue this exercise for thirty seconds, before alternating your arms.

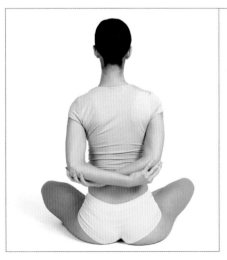

Angle Pose, Bound 2

Target: Shoulders.

Benefits: Helps reduce tension built up in the back and shoulders.

Steps: 1. Sit cross-legged on the floor. **2.** Reach your right hand behind and across your back. Reach your left hand behind and across your back. **3.** Clasp each hand around the opposite elbow. Pull your elbows down toward the floor and open your chest. **4.** Hold for thirty seconds.

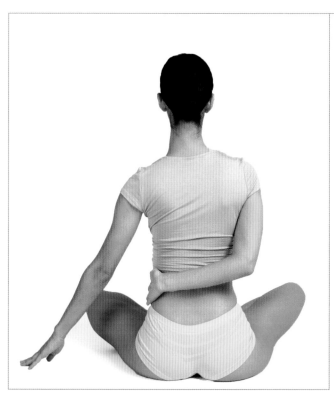

Angle Pose

Target: Shoulders.

Benefits: Helps reduce tension built up in the back and shoulders.

Steps: 1. Sit cross-legged on the floor. **2.** Reach your right arm behind and across your back, and grab hold of your waist on the opposite side. Rest the fingertips of your left hand on the floor out to your side. **3.** Twist your right elbow behind you to increase pressure on the shoulder.

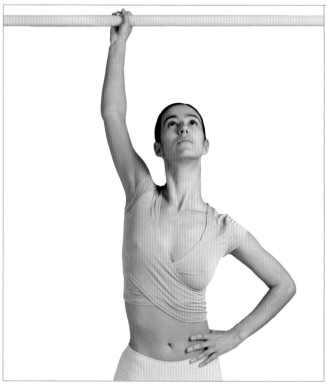

Anterior-Shoulder Stretch

Target: Shoulders.

Benefits: Opens the shoulders, alleviating tightness and increasing mobility.

Steps: 1. Stand up straight, in a doorway or under an overhead bar. **2.** Reach your right arm up and grab hold of the door casing or the bar. **3.** Without moving your feet, gently push your shoulder forward. **4.** Maintain this stretch for thirty seconds before alternating arms.

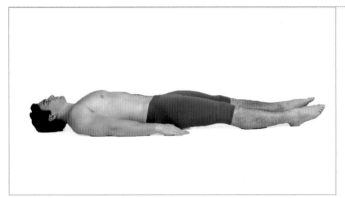

Arm Stretch, Lying Down

Target: Shoulders.

Benefits: Opens the chest and shoulders, to correct poor posture or lack of flexibility.

Steps: 1. Lie on your back with your legs straight. 2. Raise your arms over your head and place them flat on the floor. 3. Point your toes and pull along the length of your body. 4. Continue this stretch for thirty seconds before releasing.

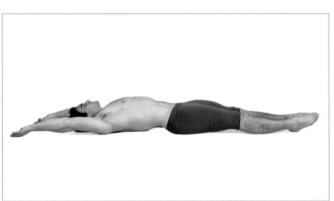

Arm Extension

Target: Shoulders.

Benefits: Engages the muscles in the shoulders and upper arms, increasing strength and range of motion.

Steps: 1. Kneel on the floor, resting your hips on your heels. 2. Drop your left hand down to the floor and raise your right arm straight up to your right. 3. Pull your right shoulder away from your chest. 4. Maintain this pose for thirty seconds before switching sides.

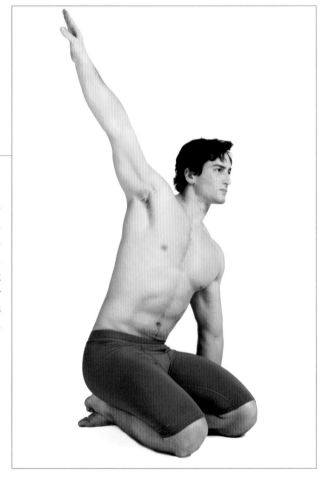

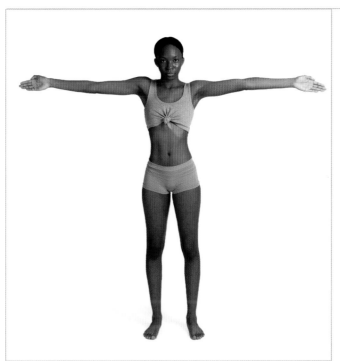

Arm Circles

Target: Shoulders.

Benefits: Helps to alleviate stiffness and tension in the shoulders.

Steps: 1. Stand with your arms extended out to your sides. **2.** Swing your arms in circles, moving clockwise. Try to keep your shoulders down. **3.** Repeat the movement in a counterclockwise direction.

Arm Extension to Side with Band

Target: Shoulders.

Benefits: Strengthens the muscles in the shoulders and upper arms.

Steps: 1. Stand upright, with a resistance band beneath both feet. Hold the ends of the band with either hand. **2.** Straighten your arms out to your sides and pull them upward against the resistance of the band. **3.** Return your arms down to your sides. Perform this rep fifteen times.

Arm Hyperextension with Support

Target: Shoulders.

Benefits: Lengthens the muscles along the shoulders and upper arms.

Steps: 1. Kneel upright on the floor behind a chair. Raise one knee so your foot is flat on the floor ahead of you. **2.** Reach both arms behind you and grab hold of the sides of a chair. **3.** Maintaining hold of the chair, lower your hips further toward the floor, in order to deepen the effect of the stretch.

Arm Rotation Y's

Target: Shoulders.

Benefits: Improves posture and tightness in the shoulders and upper back.

Steps: 1. Stand straight with your arms at your sides. **2.** Raise your arms up to form a Y angle to your body. **3.** Lower your arms so they are pointed down and out from your sides. **4.** Raise your arms back above and continue repeating this motion for thirty seconds.

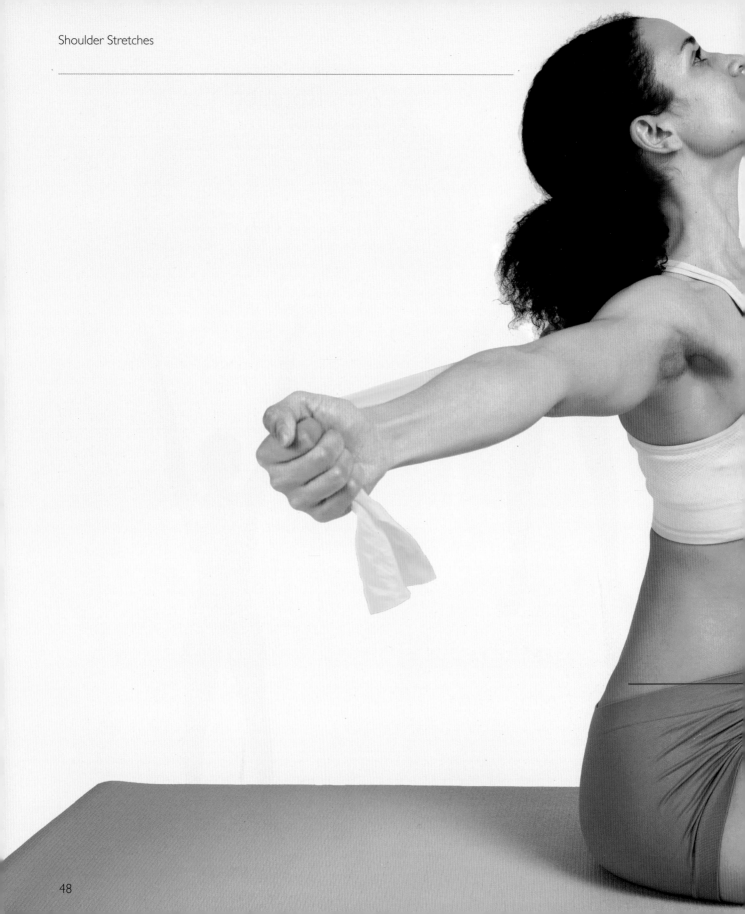

Arm Stretch Behind Chest Opener with Band

Target: Shoulders.

Benefits: Increases strength and mobility in the shoulders and upper back.

Steps: 1. Sitting or standing with good posture, hold a resistance band with both hands behind your back. **2.** Raise the band to shoulder height and pull your head and shoulders back to open your chest. **3.** Pull your hands away from each other against the resistance of the band. **4.** Hold this pose for thirty seconds.

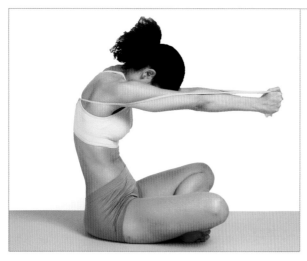

Arm Stretch, Behind Spine Curve with Band

Target: Shoulders.

Benefits: Increases strength and mobility in the shoulders and upper back.

Steps: 1. Sitting or standing with good posture, hold a resistance band with both hands behind your back. **2.** Raise the band to shoulder height. **3.** Bend your arms into your sides and then extend them straight out in front of you. **4.** Slowly return your arms to your sides. **5.** Continue the motion of bending and straightening your arms for thirty seconds.

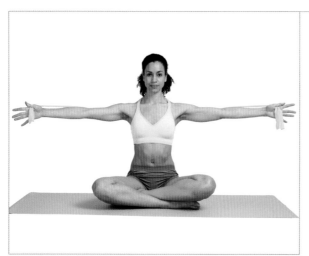

Arm Stretch, Behind with Band

Target: Shoulders.

Benefits: Increases strength and mobility in the shoulders and upper back.

Steps: 1. Sitting or standing with good posture, hold a resistance band with both hands behind your back. **2.** Raise the band to shoulder height. **3.** Straighten your arms out to your sides against the resistance of the band. **4.** Hold this pose for thirty seconds.

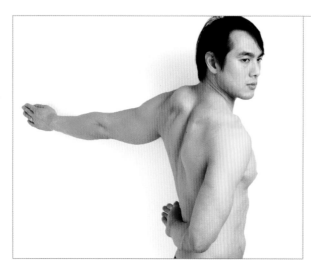

Arm Twist, Supported

Target: Shoulders.

Benefits: Opens the shoulders and chest, targeting chronically tight and hard-to-reach muscles.

Steps: 1. Stand near a wall or doorway. Reach your right arm behind your back. **2.** Raise your left arm up to the wall, so it is at shoulder height and your palm is flat against the wall. **3.** Twist your torso to the right, pressing gently against your left palm. **4.** Maintain this pose for thirty seconds before alternating sides.

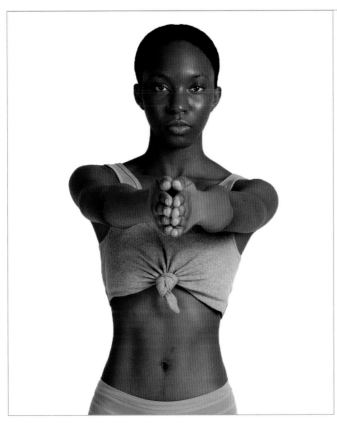

Arms Together, Rotational Shoulder Stretch

Target: Shoulders.

Benefits: Twists the spine and extends the muscles in the upper arms and shoulders.

Steps: 1. Stand upright, with your arms raised to shoulder height and your palms together in front of you. **2.** Swing your hands up to one side, then back down to the center and up to the opposite side. **3.** Return to the starting position and repeat these motions for thirty seconds.

Bent-Arm Fly

Target: Shoulders.

Benefits: Increases mobility and strength in the shoulders.

Steps: 1. Stand with your elbows bent and raised out to your sides, perpendicular to your shoulders. **2.** Bring your elbows in toward each other, ahead of you. **3.** Return your elbows back to the starting position and repeat this motion, making sure to keep your elbows at shoulder height.

Note: To increase the difficulty of this stretch, hold a dumbbell in either hand while performing this stretch.

Bound-Arm Stretch

Target: Shoulders.

Benefits: Engages the muscles in the shoulders and upper arms, increasing strength and range of motion.

Steps: 1. Sit cross-legged with your arms outstretched. **2.** Cross your right wrist over your left. Rotate your palms in toward each other and clasp your hands. **3.** Keeping your arms straight, twist your clasped hands one way and then the other. **4.** Release and repeat with your left wrist raised.

Bound-Arm Stretch, Behind

Target: Shoulders.

Benefits: Relieves tightness and tension in the muscles of the upper arms and shoulders.

Steps: 1. Sit cross-legged with your hands clasped behind your back. **2.** Straighten your arms and pull them up and away from your body. **3.** Maintain this stretch for thirty seconds.

Chair Squat, Intense-Wrist Stretch, Revolved Half-Bound

Target: Shoulders.

Benefits: Targets the muscles in the shoulders, chest, and arms.

Steps: 1. Begin by standing up straight. Reach your right arm across your back and hold your opposite hip in a half bound position.
2. Bend both knees into a 90-degree angle in a chair squat. **3.** Twist your torso to the right and drop your left hand to the floor, with your fingers pointed behind you. **4.** Turn your gaze and shoulders upward.
5. Hold this pose for thirty seconds before alternating sides.

Corner Stretch

Target: Shoulders.

Benefits: Opens the chest and shoulders, increasing strength and flexibility.

Steps: 1. Stand facing the corner of a room. **2.** With your palms facing the walls and elbows slightly below shoulder height, place your hands and forearms on the walls. **3.** Slowly lean inward and bring your head and trunk toward the corner until you feel a mild stretch in your chest. **4.** Hold this pose for thirty seconds.

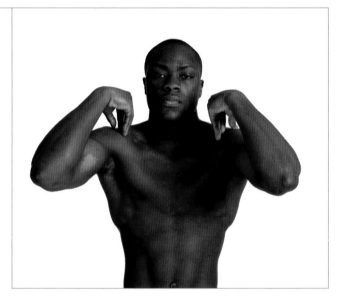

Elbow Circles

Target: Shoulders.

Benefits: Increases strength and mobility in the upper arms and shoulders.

Steps: 1. Standing straight, place your fingers on your shoulders. Raise your elbows out to the sides at shoulder height. **2.** Circle your elbows clockwise then counterclockwise around your shoulders.

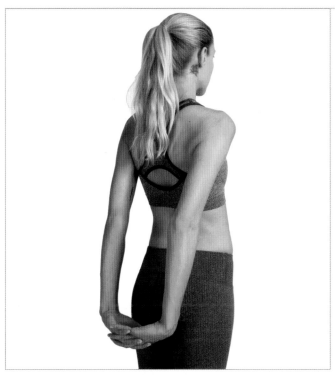

Elbow Supination

Target: Shoulders.

Benefits: Relieves tightness and tension in the muscles of the forearms and elbows.

Steps: 1. Standing straight, clasp your fingers together behind your back, palms facing upward. **2.** Keeping hands clasped, move arms from side to side.

Note: For an advanced modification, try this stretch with palms facing down to increase pressure on the forearms.

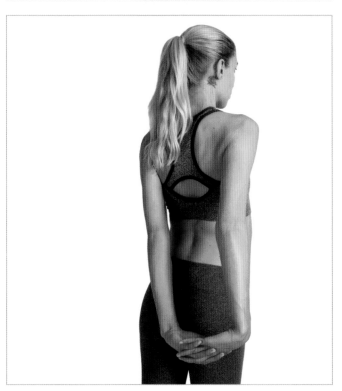

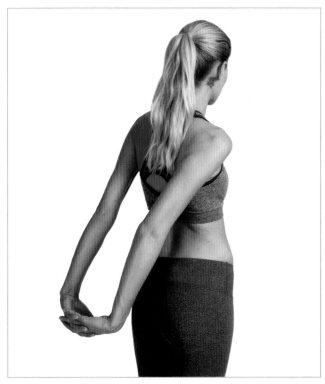

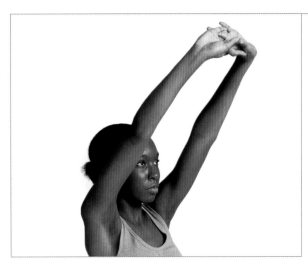

Finger Press, Ahead

Target: Shoulders.

Benefits: Extends the muscles in the shoulders, wrists, and forearms.

Steps: 1. Begin by standing or sitting upright. With your arms outstretched in front of you, lace your fingers together, palms facing outward. **2.** Raise your arms up above eye level. **3.** Maintain this position for thirty seconds before releasing.

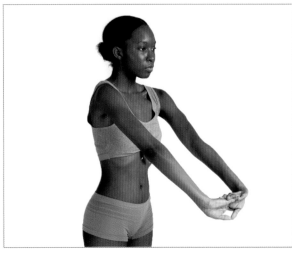

Finger Press, Downward

Target: Shoulders.

Benefits: Extends the muscles in the shoulders, wrists, and forearms.

Steps: 1. Begin by standing or sitting upright. With your arms outstretched in front of you, lace your fingers together, palms facing outward. **2.** Lower your arms down to hip level. **3.** Maintain this position for thirty seconds before releasing.

Finger Press, Overhead

Target: Shoulders.

Benefits: Extends the muscles in the shoulders, wrists, and forearms.

Steps: 1. Begin by standing or sitting upright. With your arms outstretched in front of you, lace your fingers together, palms facing outward. **2.** Raise your arms above your head, so your palms are facing the ceiling. **3.** Maintain this position for thirty seconds before releasing.

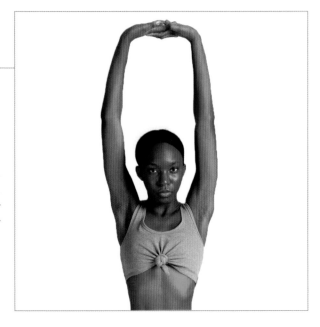

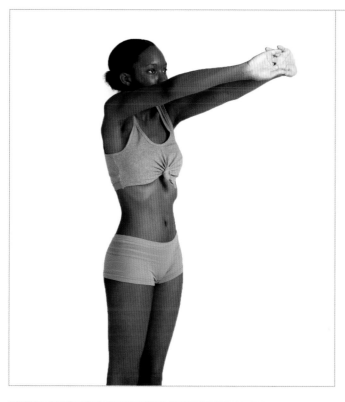

Finger Press, Shoulder Height

Target: Shoulders.

Benefits: Extends the muscles in the shoulders, wrists, and forearms.

Steps: 1. Begin by standing or sitting upright. With your arms outstretched in front of you, lace your fingers together, palms facing outward. **2.** Raise your arms out just above shoulder height. **3.** Maintain this position for thirty seconds before releasing.

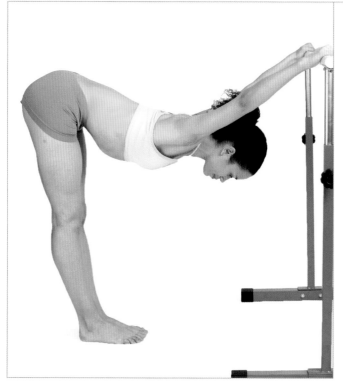

Forward Bend at Ballet Bar

Target: Shoulders.

Benefits: Deeply opens the chest and shoulders, improving muscle imbalance and poor posture.

Steps: 1. Stand facing the ballet bar, at an arms distance away. **2.** Place both hands on the bar and lean your torso forward at the waist. Drop your head down below your shoulders. **3.** Maintain this position for thirty seconds.

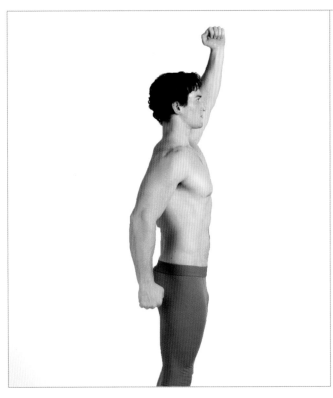

Half-Windmill

Target: Shoulders.

Benefits: Increases mobility and strength in the shoulders and triceps.

Steps: 1. Begin standing upright. **2.** Raise your left fist up above your shoulder and lower your right fist to your hip, slightly bending both elbows. **3.** Alternate your arm positions, raising your right fist and lowering your left. **4.** Continue alternating your arms for thirty seconds.

Half-Windmill, Modification

Target: Shoulders.

Benefits: Increases mobility and strength in the shoulders and triceps, while opening the hips.

Steps: 1. Step your left foot about foot two feet forward. **2.** Raise your left fist up above your shoulder and lower your right fist to your hip, slightly bending both elbows. **3.** Alternate your arm and leg positions, raising your right fist and lowering your left fist, while stepping forward with your right foot. **4.** Continue alternating your arms and legs for thirty seconds.

Hand Crossover

Target: Shoulders.

Benefits: Increases mobility and strength in the shoulders and upper arms.

Steps: 1. Stand straight with your right arm extended down at your side and your left arm raised up above your shoulder, so that your arms form a diagonal line across your chest. **2.** Swing your right arm up above your left shoulder, while swinging your left arm down below your right shoulder. **3.** Bring your arms back to the starting position. **4.** Repeat this exercise for thirty seconds, moving quickly.

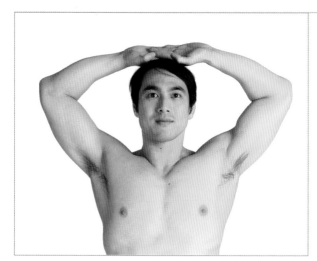

Overhead Stretch

Target: Shoulders.

Benefits: Opens the chest and shoulders, improving posture and reducing muscle imbalance.

Steps: 1. Stand or sit with good upright posture. Lace your fingers together ahead of you. **2.** Keeping your fingers laced, raise your hands to rest on the top of your head with your palms facing up and elbows extended to your sides. **3.** Press your shoulders up from your chest. Hold this stretch for thirty seconds.

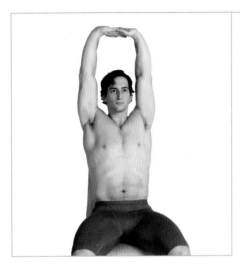

Overhead Stretch, Sitting

Target: Shoulders.

Benefits: Opens the chest and shoulders, improving posture and reducing muscle imbalance.

Steps: 1. Sit up with good upright posture. Lace your fingers together ahead of you. **2.** Keeping your fingers laced, raise your arms straight above you and turn your palms to face upward. **3.** Press your hands and shoulders up from your chest. **4.** Maintain this stretch for thirty seconds.

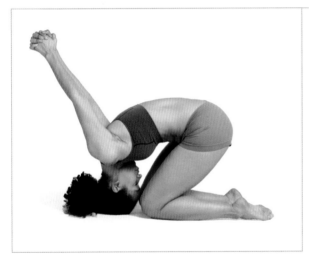

Rabbit Pose Shoulder Stretch

Target: Shoulders.

Benefits: Opens and strengthens your shoulders, improving alignment across the entire shoulder girdle.

Steps: 1. Start on all fours. Lower your head to the floor, toward your knees. **2.** Raise your hands and clasp your hands behind your back. Try to balance yourself on the crown of your head. **3.** Raise your clasped hands as far up your back as you are able. **4.** Hold this position for twenty seconds before releasing.

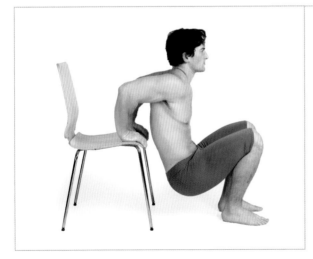

Reverse Shoulder Stretch

Target: Shoulders.

Benefits: Strengthens the muscles in the triceps and shoulders, providing increased agility and range of motion.

Steps: 1. Sit in a chair and place your hands at the edge of the chair, keeping them shoulder-width apart. Lift your hips from the chair and extend your legs in front of you. **2.** Bend your elbows and lower your body toward the floor until your elbows are at a 90-degree angle. Straighten your elbows to lift your body up to the initial position. **3.** Repeat this exercise fifteen times.

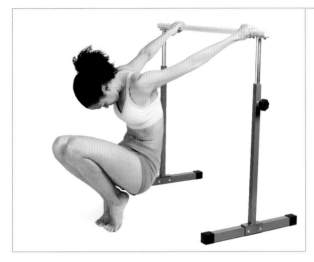

Reverse Shoulder Stretch and Curl on Tiptoe at Ballet Bar

Target: Shoulders.

Benefits: Stretches the muscles along the shoulders and arms, reducing tightness and increasing flexibility.

Steps: 1. Stand on tiptoes facing away from a ballet bar. Reach both hands behind you and hold onto the bar. **2.** Lower your torso down toward the floor, remaining on tiptoes so your hips are resting just above the floor. Curl your head and shoulders down toward your knees. **3.** Keep hold of the ballet bar with both hands and remain in this position for thirty seconds.

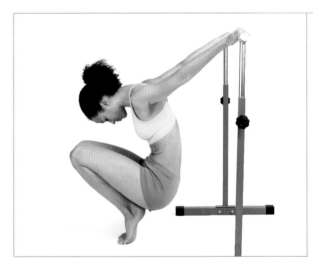

Reverse Shoulder Stretch at Ballet Bar

Target: Shoulders.

Benefits: Stretches the muscles along the shoulders and arms, reducing tightness and increasing flexibility.

Steps: 1. Stand facing away from a ballet bar. Reach both hands behind you and hold onto the bar. **2.** Lower your torso down toward the floor, remaining on tiptoes so your hips are resting just above the floor. Curl your head and shoulders down toward your knees. **3.** Keep hold of the ballet bar with both hands and remain in this position for thirty seconds.

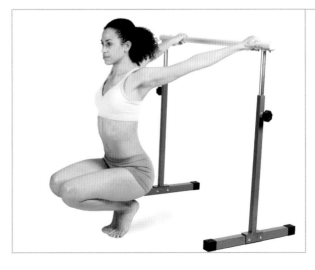

Reverse Shoulder Stretch at Ballet Bar on Tiptoe 1

Target: Shoulders.

Benefits: Stretches the muscles along the shoulders and arms, reducing tightness and increasing flexibility.

Steps: 1. Stand facing away from a ballet bar. Reach both hands behind you and hold onto the bar. **2.** Lower your torso down toward the floor, remaining on tiptoes so your hips are resting just above the floor. **3.** Keep hold of the ballet bar with both hands and remain in this position for thirty seconds.

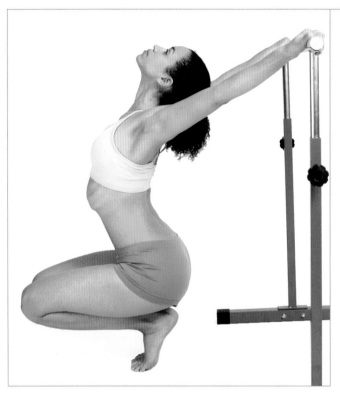

Reverse Shoulder Stretch, Chest Opener at Ballet Bar on Tiptoe

Target: Shoulders.

Benefits: Stretches the muscles along the shoulders and arms, reducing tightness and increasing flexibility.

Steps: 1. Stand facing away from a ballet bar. Reach both hands behind you and hold onto the bar. **2.** Lower your torso down toward the floor, remaining on tiptoes so your hips are resting just above the floor. Pull your head and shoulders back toward the bar to open your chest. **3.** Keep hold of the ballet bar with both hands and remain in this position for thirty seconds.

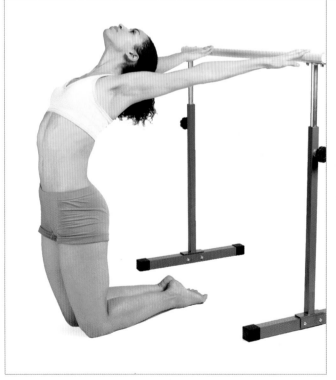

Reverse Shoulder Stretch, Kneeling at Ballet Bar

Target: Shoulders.

Benefits: Stretches the muscles along the shoulders and arms, reducing tightness and increasing flexibility.

Steps: 1. Stand facing away from a ballet bar. Reach both hands behind you and hold onto the bar. **2.** Lower your torso down toward the ground, lowering one leg at a time so you are on your knees. Pull your head and chest back toward the bar to open your chest. **3.** Keep hold of the ballet bar with both hands and remain in this position for thirty seconds.

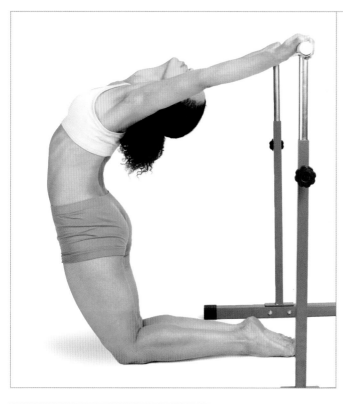

Reverse Shoulder Stretch, Kneeling Intense

Target: Shoulders.

Benefits: Stretches the muscles along the shoulders and arms, reducing tightness and increasing flexibility.

Steps: 1. Stand facing away from the ballet bar. Reach both hands behind you and hold onto the bar. **2.** Lower your torso down to the floor, lowering one leg at a time so you are on your knees. Pull your head and chest back toward the bar to open your chest. Lean forward with your hips for a deep stretch. **3.** Keep hold of the ballet bar with both hands and remain in this position for thirty seconds.

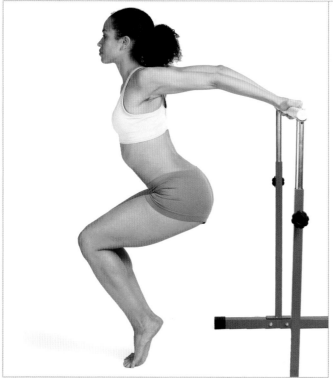

Reverse Shoulder Stretch at Ballet Bar on Tiptoe 2

Target: Shoulders.

Benefits: Stretches the muscles along the shoulders and arms, reducing tightness and increasing flexibility.

Steps: 1. Stand facing away from the ballet bar. Reach both hands behind you and hold onto the bar. **2.** Keeping hold of the bar, rise up onto your tiptoes and bend your knees into an elevated squat. **3.** Keep hold of the ballet bar with both hands and remain in this position for thirty seconds.

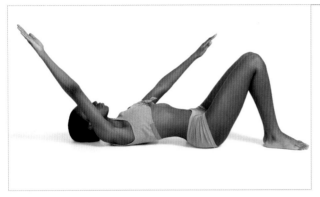

Scissor Arms, Lying

Target: Shoulders.

Benefits: Stimulates and strengthens the muscles in the shoulders and upper arms.

Steps: 1. Lie on your back, with both knees bent. **2.** Extend your right arm overhead to the floor and place your left arm straight down at your side. Raise both arms and alternate positions, so your left arm is above your head and your right arm is at your side. Keep both arms straight throughout. **3.** Raise both arms and swing them back to the original position. Repeat this motion for thirty seconds.

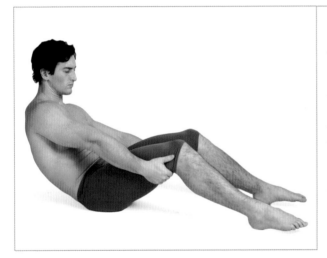

Scoop Rhomboids

Target: Shoulders.

Benefits: Improves mobility in the shoulders and upper back, alleviating tension from poor posture and prolonged hunching.

Steps: 1. Sit up straight on the floor, with your knees bent and your feet flat on the floor in front of you. **2.** Grab the backs of your thighs with both hands and begin to round your upper back. **3.** Keeping hold of your thighs, lean back and rock onto your hip bones. Keep your chin tucked to your chest. **4.** Hold this position for twenty seconds before rocking back to a seated position.

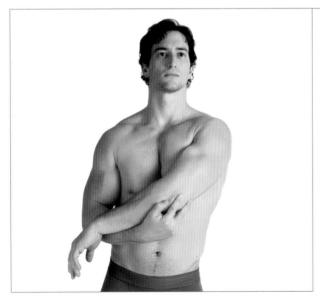

Shoulder Abductor, Protractor, and Elevator

Target: Shoulders.

Benefits: Increases flexibility in the shoulders, reducing the risk of injury or overexertion.

Steps: 1. Reach your left arm across your chest. **2.** With your right hand, gently press against your left elbow, into your chest. **3.** Maintain this position for thirty seconds before switching arms.

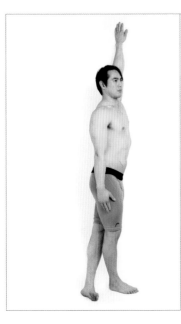

Shoulder Abductor to Wall

Target: Shoulders.

Benefits: Opens the shoulders and lengthens the associated muscles.

Steps: 1. Stand beside the wall, about a foot away. Step one foot behind the other so they are in line. **2.** Raise your arm closest to the wall, and place your palm on the wall above you. **3.** Lean your torso into the wall, to fully open your shoulder. **4.** Remain in this pose for twenty seconds before alternating arms.

Shoulder Adductor and Extensor Stretch, Overhead

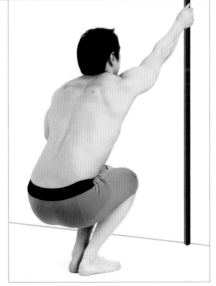

Target: Shoulders.

Benefits: Increases flexibility in the shoulders and augments range of motion in the surrounding muscles.

Steps: 1. Stand facing a door frame or a similarly sturdy vertical surface. Crouch down low to the floor, so your hips are resting on your heels. **2.** Reach one arm out and grab hold of the door frame above eye level. Lean back against your supporting hand. **3.** Maintain this stretch for twenty seconds before repeating with the opposite arm.

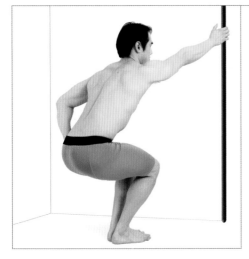

Shoulder Adductor and Extensor Stretch, Supported

Target: Shoulders.

Benefits: Increases flexibility in the shoulders and augments range of motion in the surrounding muscles, while also strengthening the calves and quadriceps.

Steps: 1. Stand facing a door frame or a similarly sturdy vertical surface. Bend both knees to a 90-degree angle. **2.** Reach one arm out and grab hold of the door frame at eye level. Lean back against your supporting hand. **3.** Maintain this stretch for twenty seconds before repeating with the opposite arm.

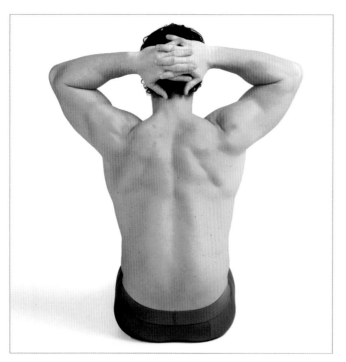
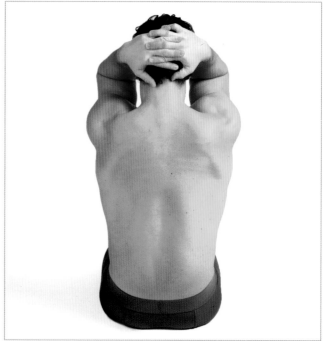

Shoulder Blade, In-and-Out

Target: Shoulders.

Benefits: Stimulates the muscles in the shoulders and upper back, improving blood flow and reducing the risk of injury.

Steps: 1. Begin by sitting or standing straight. Raise both palms to rest on the back of your head with your elbows extended out to the sides. **2.** Tightly pinch your shoulder blades together and hold for ten seconds. **3.** Release your shoulder blades and swing your elbows in toward your face. **4.** Swing your elbows back to the starting position. **5.** Repeat the exercise ten times.

Shoulder Extensor, Abductor, and Retractor

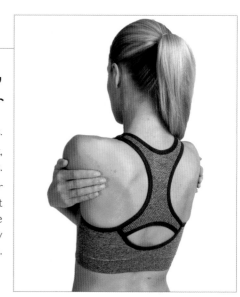

Target: Shoulders.

Benefits: Extends the muscles in your shoulders and upper back, releasing built-up tension and tightness.

Steps: 1. Stand or sit with good back and shoulder posture. **2.** Reach your right arm across your chest, and place your right hand on your back just below your left shoulder. Reach your left arm across your chest, and place your left hand on your right shoulder. **3.** Squeeze both arms tightly for thirty seconds. **4.** Release and repeat, alternating arm sequence.

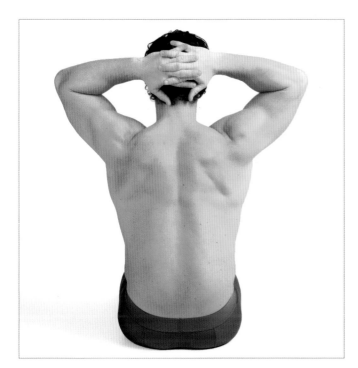 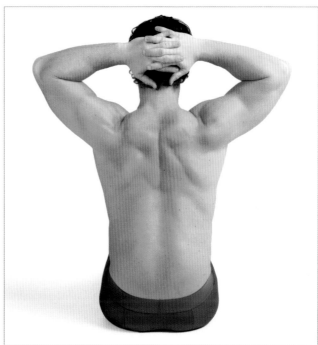

Shoulder Blade Pinch

Target: Shoulders.

Benefits: Contracts the muscles in the shoulders and upper back, relieving tension and improving posture.

Steps: 1. Begin by sitting or standing straight. Raise both palms to rest on the back of your head with your elbows extended.
2. Tightly pinch your shoulder blades together and hold for ten seconds. **3.** Release your shoulder blades and hold for five seconds before repeating the exercise.

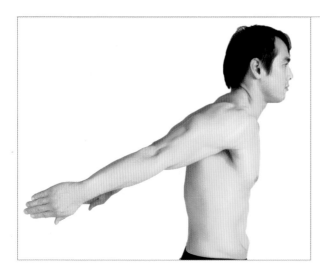

Shoulder Flexor

Target: Shoulders.

Benefits: Reduces stress manifested from tightness and hyperactivity in the shoulder muscles.

Steps: 1. Stand straight with good upright posture. **2.** Reach both arms straight out behind you and up your back. **3.** Pull your arms in toward each other to flex the muscles in your shoulders.
4. Maintain this position for thirty seconds before releasing.

Shoulder Flexor and Depressor Stretch Supported

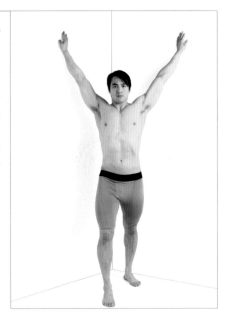

Target: Shoulders.

Benefits: Opens and strengthens your shoulders, improving alignment across the shoulder girdle and upper back.

Steps: 1. Stand in the corner of a room, facing out. **2.** Raise both arms above your head and place your palms against the walls. **3.** Keeping your palms to the wall, push your chest out. Hold this position for thirty seconds before releasing.

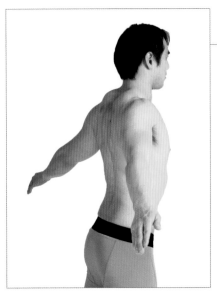

Shoulder Girdle

Target: Shoulders.

Benefits: Opens and strengthens your shoulders, improving alignment across the shoulder girdle and upper back.

Steps: 1. Stand straight with good upright posture. **2.** Extend both arms out to your sides and behind you. **3.** Pull your arms in toward each other to flex the muscles in the shoulders. **4.** Maintain this position for thirty seconds before releasing.

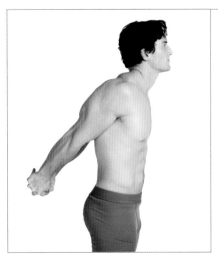

Shoulder Hyperextension 1

Target: Shoulders.

Benefits: Relieves tightness and tension in the muscles of the upper arms and shoulders.

Steps: 1. Stand straight with your hands clasped behind your back. **2.** Straighten your arms, holding them away from your body, and attempt to lift up your hands. **3.** Maintain this stretch for thirty seconds.

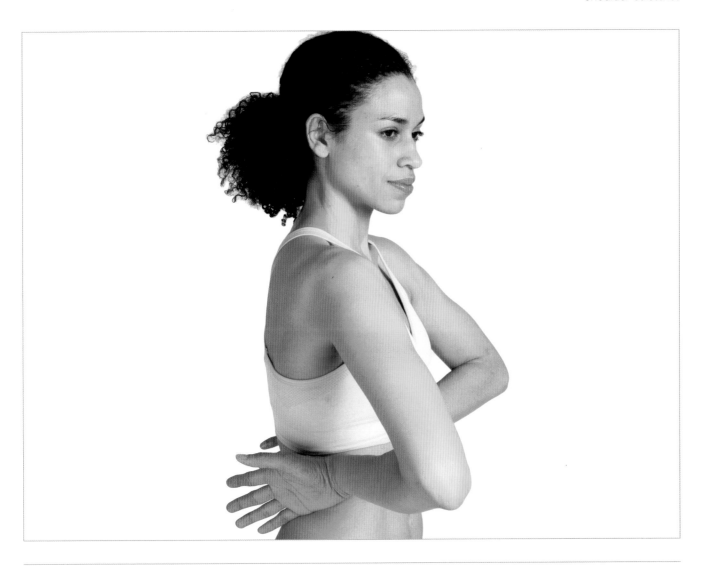

Shoulder Hyperextension 2

Target: Shoulders.

Benefits: Targets hard-to-reach muscles in the shoulders and along the upper arms.

Steps: 1. Stand or sit with good upright posture. Press the backs of your wrists into your waist, so your elbows are bent. **2.** Pull your elbows forward and toward each other. **3.** Continue this stretch for thirty seconds before releasing.

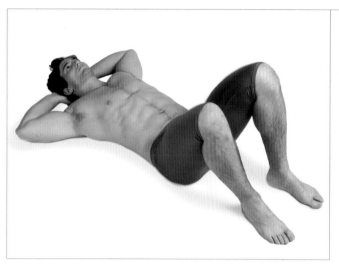
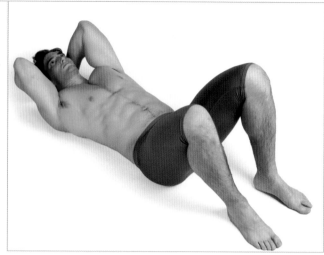

Shoulder Press

Target: Shoulders.

Benefits: Increases circulation and flexibility in the shoulders and upper back.

Steps: 1. Lie on your back with both knees bent. Place your palms beneath your head, and rest your elbows on the floor. **2.** Pull your elbows up toward the sides of your head. Release and lower your elbows back down to the floor. **3.** Repeat this motion for thirty seconds.

Shoulder Reverse Stretch with Body Bar

Target: Shoulders.

Benefits: Maintains strength and range of motion in the triceps and biceps.

Steps: 1. Hold the body bar vertically at your right side, reaching with your left hand across your waist to grip the bottom of the bar and reaching your right hand overhead to hold the top of the bar. **2.** Attempt to slowly raise and lower the bar. **3.** Perform this exercise for thirty seconds.

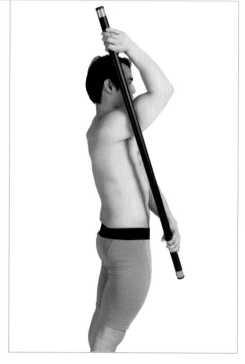

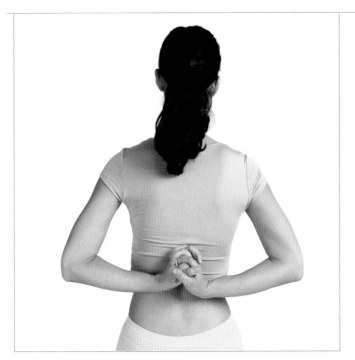 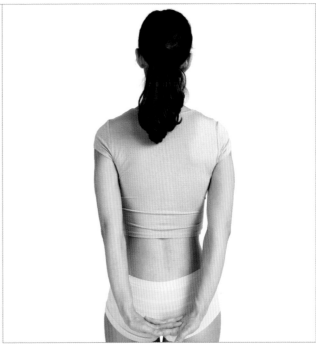

Shoulder Reach Behind Back

Target: Shoulders.

Benefits: Lengthens the muscles in the shoulders and the forearms.

Steps: 1. Stand straight with your fingers clasped behind your back and raised to the center of your spine. **2.** Extend your arms downward, keeping your fingers laced so your palms are facing down toward the floor. Pull your shoulders back and hold this pose for ten seconds before returning your hands to the starting position. **3.** Repeat this exercise ten times.

Shoulder Stretch, Body Bar Twist

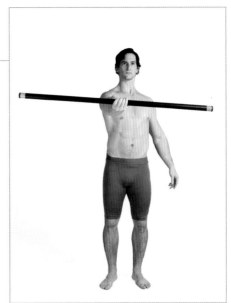

Target: Shoulders.

Benefits: Increases strength and mobility in the shoulders.

Steps: 1. Stand holding the middle of a body bar with one hand. Straighten your arm in front of you, holding the bar vertically. **2.** Rotate your hand so the bar is parallel to the ground. **3.** Rotate the bar back to the starting position and repeat this exercise for thirty seconds on each arm.

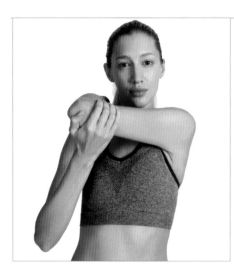

Shoulder Stretch 1

Target: Shoulders.

Benefits: Increases flexibility in the shoulders, reducing the risk of injury or overexertion.

Steps: 1. Reach your left arm toward your right shoulder and extend your left hand behind you. **2.** With your right hand, gently press your left elbow toward your chest. **3.** Maintain this position for thirty seconds before switching arms.

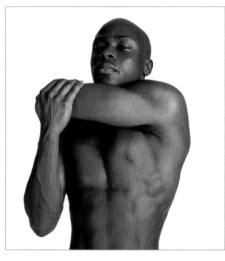

Shoulder Stretch 2

Target: Shoulders.

Benefits: Increases flexibility in the shoulders, reducing the risk of injury or overexertion.

Steps: 1. Reach your left arm toward your right shoulder and extend your left hand behind you. **2.** With your right hand, gently press your right elbow toward your chest. **3.** Maintain this position for thirty seconds before switching arms.

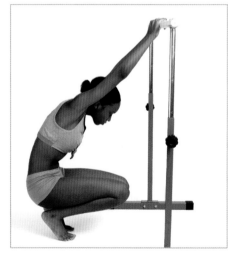

Shoulder Stretch and Reach at Ballet Bar

Target: Shoulders.

Benefits: Extends and contracts the muscles in the shoulders and upper back.

Steps: 1. Stand facing a ballet bar, and hold the bar with both hands shoulder width apart. **2.** Crouch down to the floor on your toes, so your hips are resting on your heels. **3.** Press your shoulders in to open your chest. Hold this pose for fifteen seconds. **4.** Release and curl your shoulders down, raising your upper back. Hold this pose for fifteen seconds.

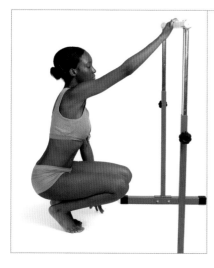

Shoulder Stretch at Ballet Bar

Target: Shoulders.

Benefits: Opens and strengthens your shoulders, improving alignment across the shoulder girdle and upper back.

Steps: 1. Stand facing a ballet bar and place one hand on the bar. **2.** Crouch down to the floor on your toes, so your hips are resting on your heels. **3.** Press your shoulders in to open your chest. Hold this pose for fifteen seconds. **4.** Release and curl your shoulders down, raising your upper back. Hold this pose for fifteen seconds. **5.** Switch arms and repeat.

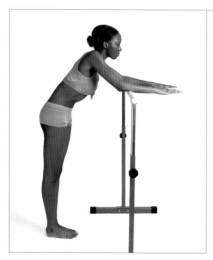

Shoulder Stretch at Ballet Bar, Forward Lean

Target: Shoulders.

Benefits: Opens the chest and shoulders, improving posture and reducing muscle imbalance.

Steps: 1. Stand facing a ballet bar. Place both forearms on the bar, just below your elbows. **2.** Leaning your torso down against the bar, pull your shoulders back and open your chest. **3.** Hold this position for thirty seconds.

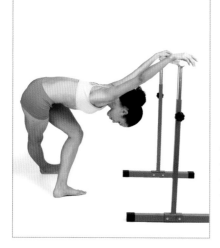

Shoulder Stretch, Cross-Legged at Ballet Bar

Target: Shoulders.

Benefits: Extends the muscles in the hips and shoulders, while lengthening the spine.

Steps: 1. Stand facing the bar. Step your right foot behind your left foot as far to the left as you can. **2.** Lean forward and place both wrists on the bar. Begin to bend forward at the waist into a forward bend. **3.** Let your head and shoulders drop toward the floor. Hold this position for thirty seconds. **4.** Switch the position of your legs and repeat.

Shoulder Stretch, Cross-Over

Target: Shoulders.

Benefits: Extends and contracts the muscles in the shoulders and across the upper back.

Steps: 1. Place your hands on the opposite knees, crouching down toward the floor. **2.** Keeping your hands on your knees, curl your head and shoulders down toward the floor. Hold for thirty seconds. **3.** Pull your shoulders back and raise your gaze upward. **4.** Hold for thirty seconds.

Shoulder Stretch, Crouching

Target: Shoulders.

Benefits: Opens the shoulders and chest, targeting chronically tight and hard-to-reach muscles.

Steps: 1. Stand with your hands clasped behind your back. **2.** Bend your knees and lean your torso down, so it is resting alongside your upper legs. **3.** Attempt to raise your clasped hands up your back and straight out from your shoulders. **4.** Hold this position for thirty seconds.

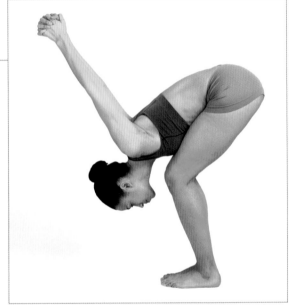

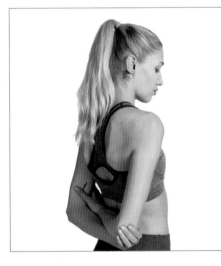

Shoulder Stretch, Hands to Elbows

Target: Shoulders.

Benefits: Helps reduce tension built up in the back and shoulders.

Steps: 1. Sit cross-legged on the floor. **2.** Reach your right hand behind and across your back, then reach your left hand behind and across your back. **3.** Clasp each hand around the opposite elbow. Pull your elbows down toward the floor and open your chest. **4.** Maintain this pose for thirty seconds.

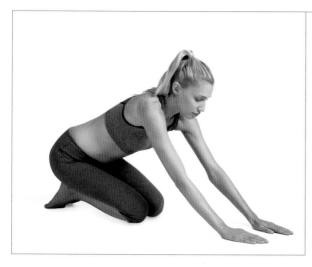

Shoulder Stretch, Kneeling, Arms Extended

Target: Shoulders.

Benefits: Lengthens and realigns the muscles in the shoulders and upper back.

Steps: 1. Kneel on all fours, with your palms flat on the floor in front of you. **2.** Step both hands forward by one to two feet. **3.** Lean your hips back onto your heels. Gently pull back against your shoulders and hands. **4.** Hold this position for thirty seconds.

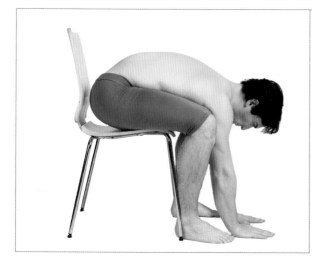

Shoulder Stretch, Overhead Reach to Floor, Seated

Target: Shoulders.

Benefits: Lengthens the spine and shoulders, increasing flexibility and range of motion.

Steps: 1. Begin seated on a chair. **2.** Bend forward at the waist, dropping your torso to your thighs and placing your hands on the floor between your feet. **3.** Hold this position for thirty seconds.

Shoulder Stretch, Reverse Supported

Target: Shoulders.

Benefits: Stretches the muscles along the shoulders and arms, reducing tightness and increasing flexibility.

Steps: 1. Stand facing away from a sturdy chair. Reach both hands behind you and grab hold of the top of the chair. **2.** Bend both knees, lowering your torso into a squat, until your arms are straight and parallel to the floor. **3.** Keep hold with both hands and remain in this position for fifteen seconds.

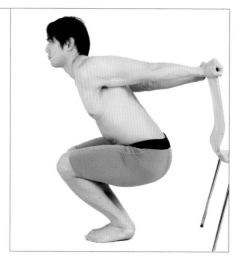

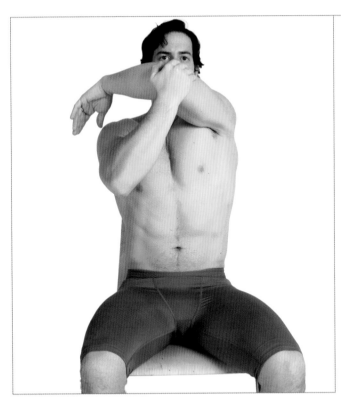

Shoulder Stretch, Seated

Target: Shoulders.

Benefits: Increases flexibility in the shoulders, reducing the risk of injury or overexertion.

Steps: 1. Begin seated with good upright posture. **2.** Raise your left arm and reach across your upper body. **3.** With your right hand, gently press against your left elbow, into your body. **4.** Maintain this position for thirty seconds before switching arms.

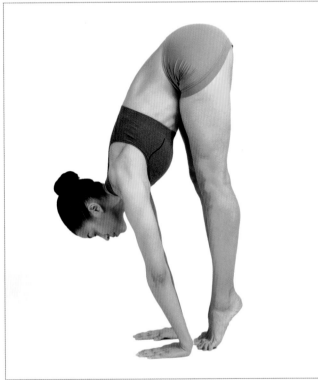

Tiptoe Half-Intense Stretch Pose, Hands Flat

Target: Shoulders.

Benefits: Strengthens the muscles in the shoulders, upper arms, and legs.

Steps: 1. Stand with your feet shoulder-width apart. **2.** Bend forward at the waist, into a forward bend. Place your palms flat on the floor in front of your feet. **3.** Lift your feet up onto your toes. **4.** Hold this position for twenty seconds or longer.

Shoulder Traction 1

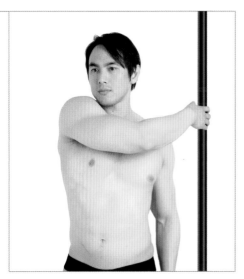

Target: Shoulders.

Benefits: Lengthens the muscles in the shoulders and upper arms, targeting hard-to-reach and often neglected muscles.

Steps: 1. Stand with your left side perpendicular to a door frame or similar vertical structure. **2.** Reach your right arm across your chest and grab hold of the door frame. **3.** Gently pull against your right arm, increasing pressure on the shoulder. **4.** Continue this stretch for thirty seconds before repeating on the other side.

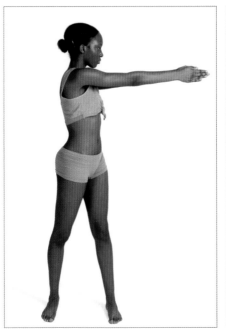

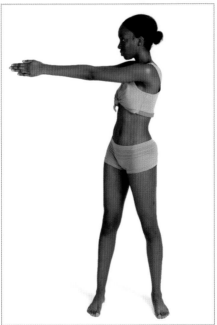

Shoulder Traction 2

Target: Shoulders.

Benefits: Twists the spine and extends the muscles in the upper arms and shoulders.

Steps: 1. Stand upright, with your arms raised to shoulder height and your palms together. **2.** Swing your arms to your left side, then back to the center. **3.** Swing your arms to your right side and return to the starting position. **4.** Continue to run through these motions for thirty seconds.

Arm Stretches

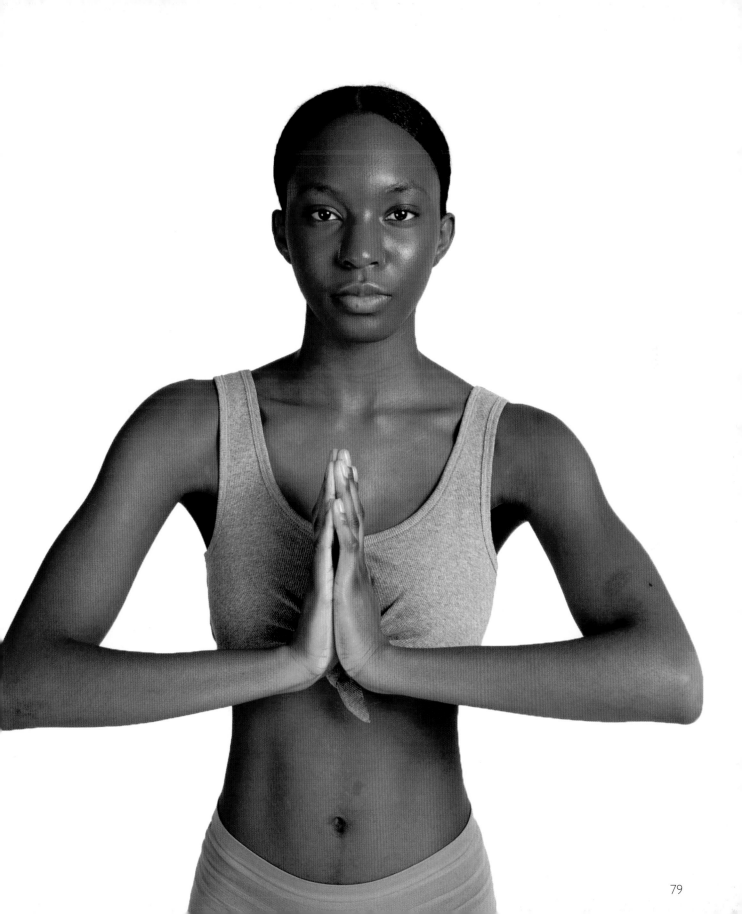

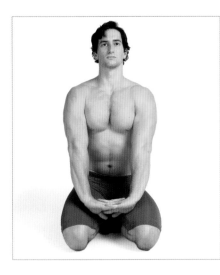

Forearm Stretch, Fingers Laced

Target: Forearms.

Benefits: Lengthens the muscles in the wrists and forearms.

Steps: 1. Begin in a kneeling position, toes pointed behind you.
2. Lace your fingers, stretching your palms down toward your lap.
3. Hold for thirty seconds.

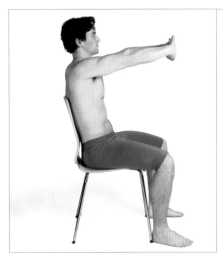

Forearm Stretch, Fingers Laced and Raised

Target: Forearms.

Benefits: Lengthens the muscles in the wrists and forearms, while strengthening the shoulders.

Steps: 1. Begin seated or standing with good upright posture.
2. Raise your arms to shoulder height, lace your fingers, and stretch your palms out and away from you. **3.** Hold for thirty seconds.

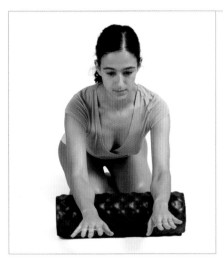

Forearm Stretch on Roller

Target: Forearms.

Benefits: Relieves tight and fatigued forearm muscles.

Steps: 1. Begin in a kneeling position, feet tucked beneath your hips.
2. Place the foam roller beneath your forearms. **3.** Lift your hips, rolling your forearms forward and backward to target troubled muscles. **4.** Continue rolling for thirty seconds.

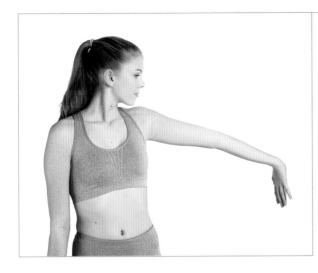

Forearm Stretch, Palm to Wall

Target: Forearms.

Benefits: Relieves tightness and tension in the forearms and elbows.

Steps: 1. Stand with your left side perpendicular to a wall. **2.** Outstretch your left arm, placing your palm against the wall, fingers pointed downward. **3.** Press into the wall to increase the effect of the stretch. **4.** Hold for thirty seconds.

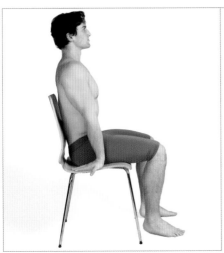

Forearm Stretch, Seated

Target: Forearms.

Benefits: Lengthens the muscles in the forearms and triceps.

Steps: 1. Begin seated on a chair, arms at your sides. **2.** Raise your arms and place your palms flat on the seat of the chair, fingers pointed behind you. **3.** Hold for thirty seconds.

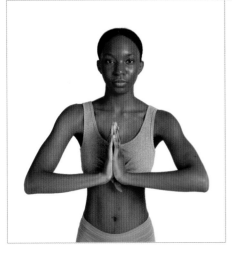

Prayer Hands

Target: Forearms.

Benefits: Helps to reduce stress and find balance.

Steps: 1. Gently press your palms together at your chest, fingers pointing upward. **2.** Hold for thirty seconds.

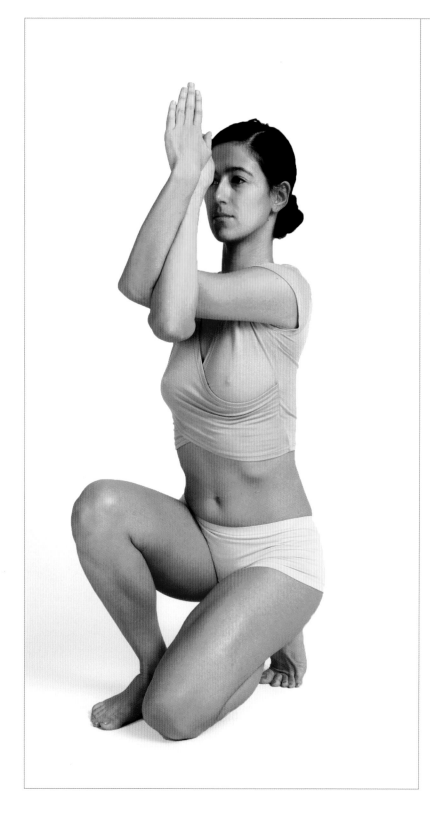

Prayer Hands, Double-Twined

Target: Forearms.

Benefits: Lengthens the muscles in the arms and wrists.

Steps: 1. Bend your elbows in front of you and intertwine your forearms so that your fingers and palms are touching. If flexibility allows, attempt to extend the stretch so both palms are touching. **2.** Maintain the position for thirty seconds.

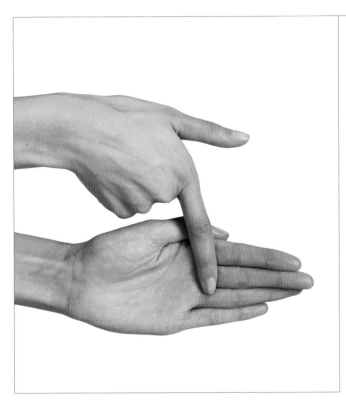

Finger Pull, Downward

Target: Hands.

Benefits: Lengthens and strengthens the muscles in the finger.

Steps: 1. Extend both hands in front of you, palms together. **2.** Raise your right hand above your left, so your palms are facing opposite directions. **3.** With your right hand, extend one finger at a time downward and press it against your outstretched left palm. **4.** Hold the stretch for ten seconds per finger, before alternating hands.

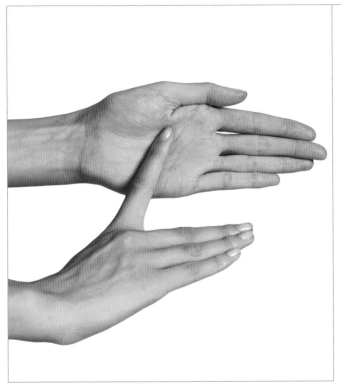

Finger Pull, Upward

Target: Hands.

Benefits: Lengthens and strengthens the muscles in the finger.

Steps: 1. Extend both hands in front of you, palms together. **2.** Raise your left hand above your right, so your palms are facing opposite directions. **3.** Extend one finger at a time upward from your right hand and press it against your outstretched left palm. **4.** Hold the stretch for ten seconds per finger, before alternating hands.

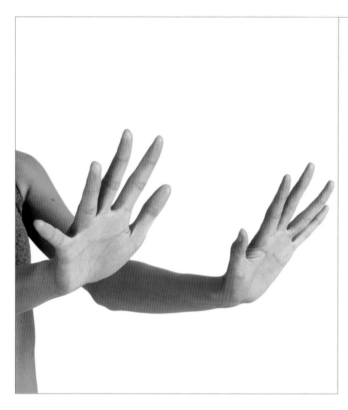

Finger Spread

Target: Hands.

Benefits: Stimulates the muscles in the fingers and hands.

Steps: 1. Raise both hands in front of your, palms facing forward. **2.** Stretch the fingers and thumbs of each hand as wide apart as possible. **3.** Hold for thirty seconds.

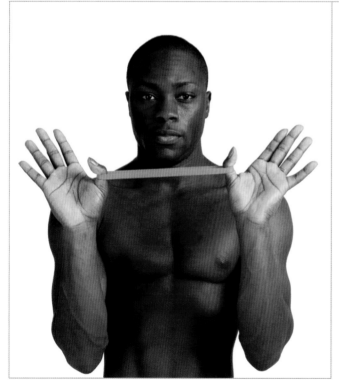

Thumb Stretch

Target: Hands.

Benefits: Strengthens the muscles in the thumbs.

Steps: 1. Raise both hands in front of your, palms facing forward. **2.** Place a rubber band around both thumbs.
3. Pull your thumbs away from one another, against the resistance of the band. **4.** Hold for thirty seconds.

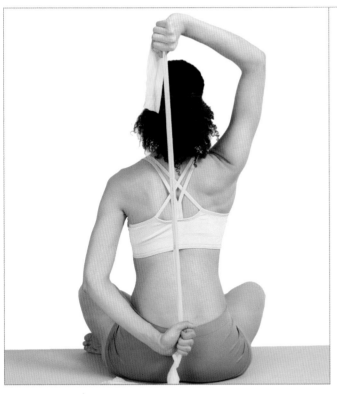

Arm Lengthener, Behind Back with Band

Target: Biceps/Triceps.

Benefits: Engages the muscles in the shoulders while strengthening the biceps and triceps.

Steps: 1. Begin seated on the floor. Holding the band with your right hand, raise it above your head so it hangs behind your back. **2.** Grab the lower end of the band with your left hand, so you are holding the band along the length of your spine with your thumbs pointed toward each other. **3.** Keep your left hand in place, holding the band just above the floor, while your right hand pulls the band upward. **4.** Hold for thirty seconds before lowering back toward the floor. Repeat on the other side.

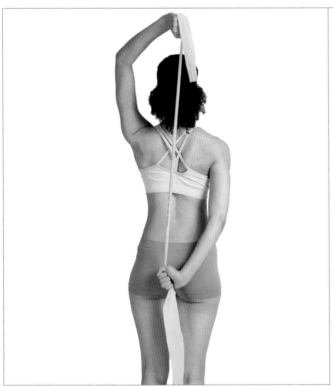

Arm Lengthener, Behind Back with Band, Standing

Target: Biceps/Triceps.

Benefits: Engages the muscles deep in the shoulders while strengthening the biceps and triceps.

Steps: 1. Holding the band with your left hand, raise it above your head so it hangs behind your back. **2.** Grab the lower end of the band with your right hand, so you are holding it along the length of your spine with your thumbs pointed toward each other. **3.** Pull both hands away from each other, against the resistance of the band. **4.** Hold for thirty seconds before bringing your hands back together. Repeat on the other side.

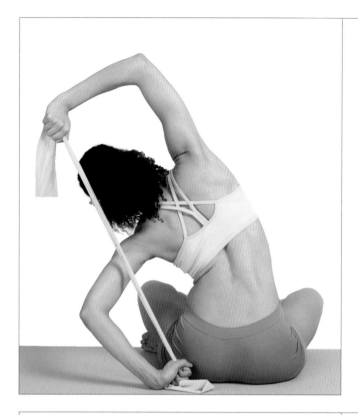

Arm Lengthener to Side with Band

Target: Triceps and biceps.

Benefits: Provides increased pressure on the targeted shoulders and triceps.

Steps: 1. Holding the band with your right hand, raise it above your so it hangs behind your back. **2.** Grab the lower end of the band with your left hand, so you are holding it along the length of your spine with your thumbs pointed toward each other. **3.** Lean your body to the left side, so your left hand is touching the floor. **4.** Pull the band upward with your right hand, holding for thirty seconds before lowering back toward the floor. Repeat on the other side.

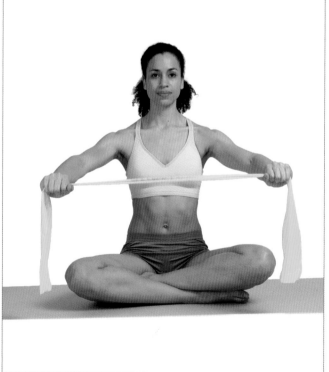

Arm Stretch Front, Seated with Band

Target: Triceps and biceps.

Benefits: Increases strength and mobility in the shoulders and triceps.

Steps: 1. Begin seated, holding the band with both hands about a foot apart. **2.** Raise your hands to shoulder height and pull them away from each other against the resistance of the band. **3.** Hold this position for thirty seconds before bringing your hands back toward each other.

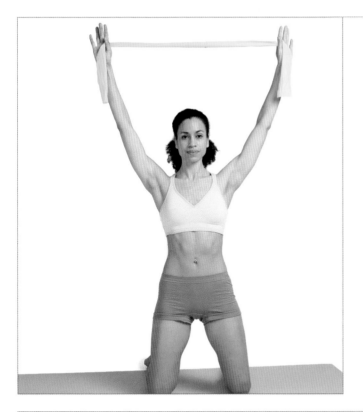

Arm Stretch Overhead, Kneeling with Band

Target: Triceps and biceps.

Benefits: Strengthens the muscles in the upper arms while engaging the core.

Steps: 1. Begin by kneeling, holding a band with both hands about a foot apart. **2.** Raise your hands above your head and pull them away from each other against the resistance of the band. **3.** Hold this position for thirty seconds or more before bringing your hands back together.

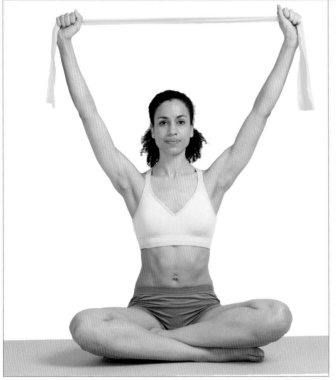

Arm Stretch Overhead, Seated with Band

Target: Triceps and biceps.

Benefits: Strengthens the muscles in the upper arms and shoulders.

Steps: 1. Begin seated holding the band with both hands about a foot apart. **2.** Raise your hands to shoulder height, before pulling them away from each other against the resistance of the band. **3.** Hold this position for thirty seconds before bringing your hands back together.

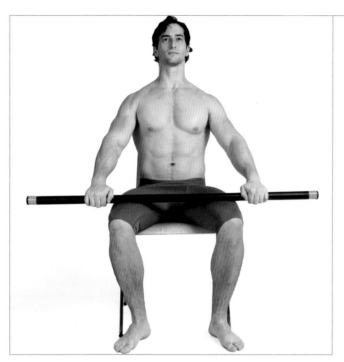
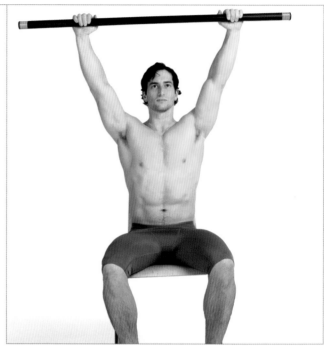

Bar Lift, Seated

Target: Triceps and biceps.

Benefits: Increases strength in the shoulders and upper arms.

Steps: 1. Begin seated on a chair, holding an exercise bar with both hands at shoulder-width apart. **2.** Slowly raise the bar above your head and hold for five seconds before returning it back to your lap. **3.** Repeat this motion ten or more times.

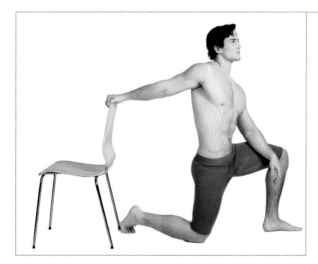

Bicep Self-Stretch

Target: Triceps and biceps.

Benefits: Lengthens the muscles along the biceps.

Steps: 1. Begin by kneeling on the floor, with the back of a chair or an object of similar height at arm's length behind you. **2.** Reach your right arm behind you and grab the top of the chair. **3.** Holding onto the top of the chair, pull your body away to stretch the targeted muscles.

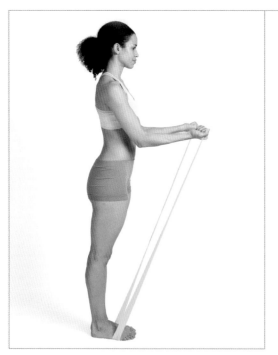 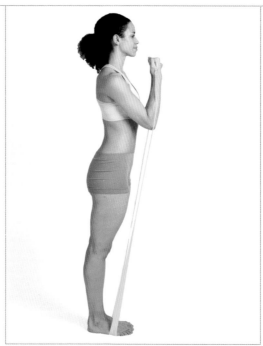

Bicep-Curl Arm Extension with Band

Target: Triceps and biceps.

Benefits: Strengthens the muscles in the biceps.

Steps: 1. Stand with both feet on a resistance band, holding the ends of the band in either hand and your palms facing upward. **2.** Slowly curl your hands up to your shoulders, keeping your elbows in at your sides. **3.** Slowly release your arms back down to the starting position. **4.** Repeat this motion ten or more times.

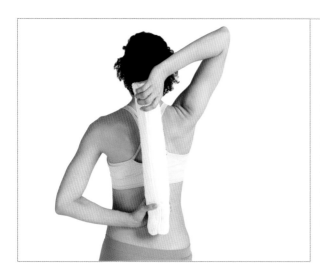

Double-Arm Pull with Towel

Target: Triceps and biceps.

Benefits: Using a towel for this stretch provides greater resistance and a shorter range of motion.

Steps: 1. Hold one end of a towel with your right hand and raise it above your head so it hangs behind your back. **2.** Grab the lower end of the towel with your left hand, so you are holding it along the length of your spine with your thumbs pointed toward each other. **3.** While holding the towel steady with your left hand, pull it upward with your right hand. **4.** Maintain the stretch for thirty seconds before alternating sides.

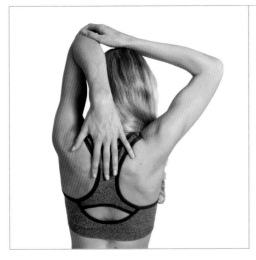

Overhead Bicep Stretch

Target: Triceps and biceps.

Benefits: Extends the muscles along the biceps.

Steps: 1. Bend your left elbow so it is tucked against the top of your head and your left palm is resting on your back. **2.** Use your right hand to press down on your raised elbow, pushing your left hand farther down your back.

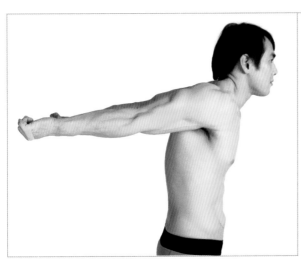

Rear Arm Stretch with Band

Target: Triceps and biceps.

Benefits: Targets the muscles in the shoulders and biceps.

Steps: 1. Hold a resistance band behind your back, with both palms facing upward. **2.** Straighten your elbows, pulling your hands away from each other against the resistance of the band. **3.** Hold this position for ten seconds before returning to the starting position.

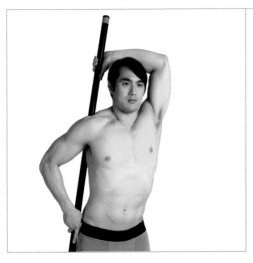

Rotator Stretch, Arm Down

Target: Triceps and biceps.

Benefits: Lengthens and strengthens the muscles in the upper arms.

Steps: 1. Hold the body bar vertically with your right hand at your side. Reach your left hand over your head and hold the top of the bar. **2.** Attempt to raise the bar upward with your left hand. **3.** Hold this position for five or more seconds before lowering the bar. Repeat on the other side.

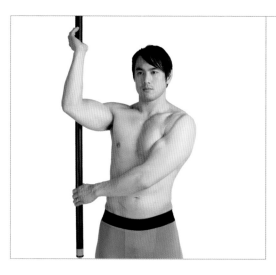

Rotator Stretch, Arm Up

Target: Triceps and biceps.

Benefits: Lengthens and strengthens the muscles in the upper arms.

Steps: 1. With your left hand, hold the body bar vertically on the right side of your body at hip level. **2.** Grab the top of the bar with your right hand, keeping your elbow in front of the bar. **3.** Raise and lower the bar with both hands. **4.** Continue the movement for thirty seconds.

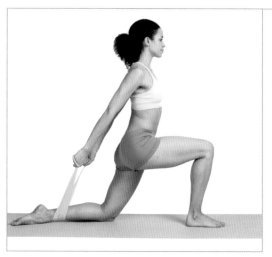

Shoulder and Hip Stretch, Kneeling with Band

Target: Triceps and biceps.

Benefits: Elongates the muscles in the shoulders and biceps.

Steps: 1. Kneeling on the floor, place a resistance band under your left leg and bend your right leg in front of you. **2.** Straighten your arms behind you, holding each end of the band. **3.** Attempt to raise your hands upward, making sure to keep your arms straight. **4.** Hold this position for ten seconds or more. **5.** Lower your arms and repeat this motion.

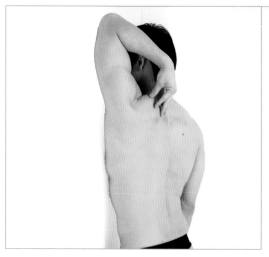

Shoulder Stretch, Against the Wall

Target: Triceps and biceps.

Benefits: Lengthens the muscles in your triceps and shoulders.

Steps: 1. Stand directly against the wall with your left elbow bent above your head and your hand on your upper back. **2.** Press your raised elbow against the wall to amplify the stretch. **3.** Hold for thirty seconds, and repeat on the opposite arm.

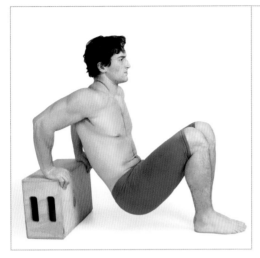

Tricep Dip, Low

Target: Triceps and biceps.

Benefits: Strengthens the triceps and upper body.

Steps: 1. Sit directly in front of a sturdy block or low raised surface, and place your hands on the surface behind you, using your arms to lift your butt from the floor. **2.** Start with your arms straight and your legs bent at a 90-degree angle. **3.** Slowly bend your elbows and lower your butt almost to the floor, then straighten your arms and raise your body back up. **4.** Repeat this motion five or more times.

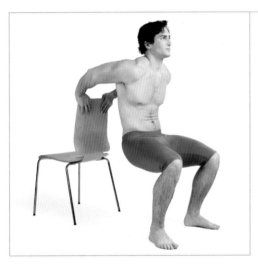

Tricep Dips, High

Target: Triceps and biceps.

Benefits: Strengthens the muscles in the triceps and quadriceps.

Steps: 1. Stand directly behind a sturdy chair. Reach behind you and hold the back of the chair. **2.** Start with your arms straight and your legs bent at a 90-degree angle. **3.** Slowly bend your elbows until they are also at a 90-degree angle, before raising yourself back to the starting position. **4.** Repeat this motion five or more times.

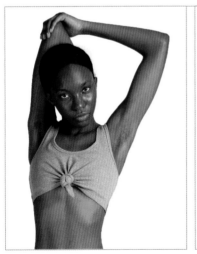
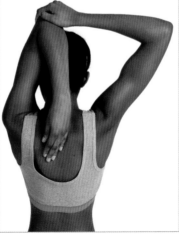

Tricep Self-Stretch 1

Target: Triceps and biceps.

Benefits: Releases tension and stress in the triceps and shoulders.

Steps: 1. Begin by standing tall with your back and neck straight. **2.** Bend your right elbow above your head, and rest your right palm on your upper back. **3.** Use your left hand to gently press down on your right elbow, pushing your right hand lower down your back. **4.** Hold for thirty seconds, and repeat on the opposite arm.

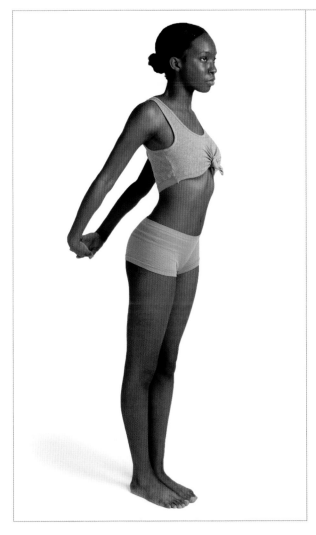

Tricep Stretch

Target: Triceps and biceps.

Benefits: Opens the chest and lengthens the muscles along the arms.

Steps: 1. Standing up straight, grasp your hands together behind your back. **2.** Straighten your arms and lift your clasped hands toward the ceiling.

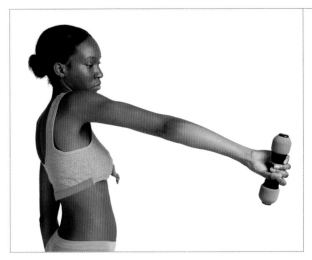

Tricep Stretch, Dumbbell Raise, Palm Out

Target: Triceps and biceps.

Benefits: Strengthens the muscles in the triceps and shoulders.

Steps: 1. Hold a dumbbell weighing four or more pounds in your right hand. **2.** Straighten your arm, and twist it so your palm faces outward. **3.** Keeping your palm in this position, lower and raise the dumbbell for thirty-second intervals. **4.** Repeat on your other arm.

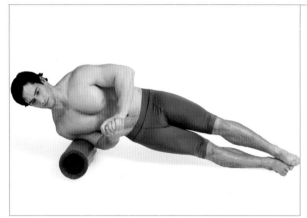

Tricep Stretch on Roller

Target: Triceps and biceps.

Benefits: Relieves tightness and tension in the triceps.

Steps: 1. Lie on your right side and place your right shoulder on a foam roller, with your elbows bent. **2.** Roll along the length of your upper arm, targeting any troubled muscles. **3.** Repeat on the opposite side.

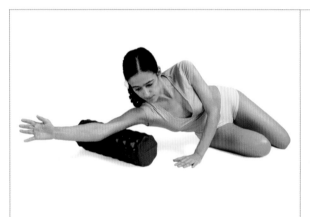

Tricep Stretch on Roller with Extended Arm

Target: Triceps and biceps.

Benefits: Reduces the risk of strain or injury to the triceps muscles.

Steps: 1. Lie on your side with your lower arm extended overhead. **2.** Place the foam roller under your extended triceps. **3.** Roll up and down the triceps, targeting any troubled muscles. **4.** Repeat on the other side.

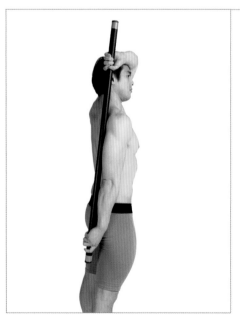

Tricep Stretch with Body Bar

Target: Triceps and biceps.

Benefits: Maintains strength and range of motion in the triceps and biceps.

Steps: 1. With your right hand, hold a body bar vertically at your right side. **2.** With your left hand, reach over your head and grip the top end of the bar. **3.** Attempt to slowly raise and lower the bar. **4.** Continue the motion for thirty seconds, and alternate sides.

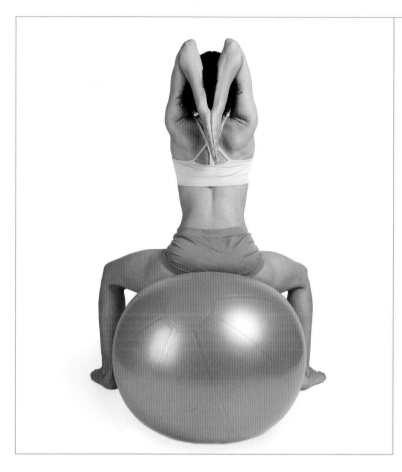

Upper-Arm Stretch, Reverse Prayer on Ball

Target: Triceps and biceps.

Benefits: Extends the muscles in the triceps and upper arms while engaging the core.

Steps: 1. Sit flat on an exercise ball, with your legs wide apart. **2.** Join your palms together above your head into prayer position. **3.** Keeping your palms together, lower your hands behind your back with your fingers pointed downward. **4.** Maintain the stretch for thirty seconds.

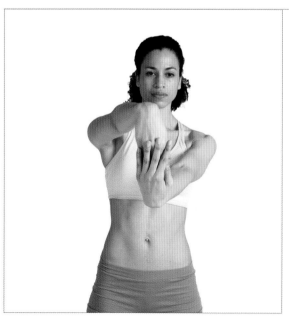

Tennis Elbow Stretch

Target: Wrists.

Benefits: Relieves tightness and elongates the muscles in the wrists and forearms.

Steps: 1. Begin by standing straight with both arms extended in front of you. **2.** Raise your right hand above the left, and with your left hand, grab the fingers of your right hand from below. **3.** Pull back on the fingers to increase pressure on the wrist and forearm. **4.** Repeat on the opposite hand.

Note: For an advanced modification, try this stretch with the palm of the upper hand facing outward to increase pressure on the wrist and forearm.

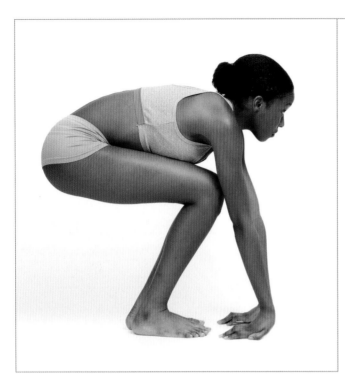

Fierce Pose, Intense Wrist

Target: Wrists.

Benefits: Increases circulation and flexibility in the wrists.

Steps: 1. Crouch low to the floor placing your palms flat on the floor in front of you so your fingers are pointed directly toward you. **2.** Hold this position for fifteen seconds or more before releasing.

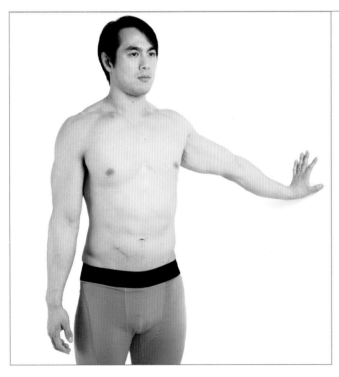

Finger Stretch, Supported

Target: Wrists.

Benefits: Prevents weakness and stiffness in the arms and fingers.

Steps: 1. Stand at arm's length from a wall at your left side. **2.** Raise your left arm and place your palm flat on the wall with your fingers spread wide. **3.** Lean into the wall to amplify the stretch. **4.** Hold for thirty seconds, and alternate sides.

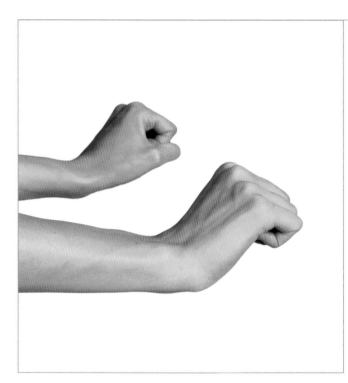

Fist Rotations

Target: Wrists.

Benefits: Increases flexibility and mobility in the wrists.

Steps: 1. Ball both hands into fists. **2.** Rotate your fists clockwise then counterclockwise, for thirty seconds in each direction.

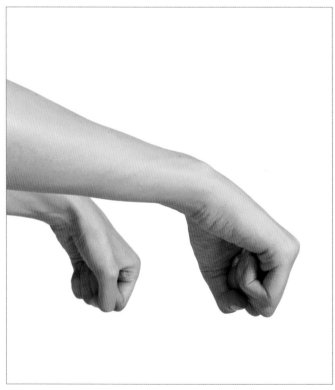

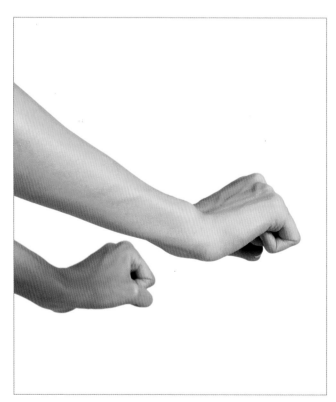

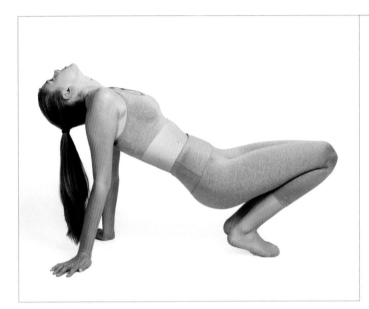

Half Eastern Intense-Stretch Pose, Easy

Target: Wrists.

Benefits: Targets the muscles in the wrists while engaging the abdomen.

Steps: 1. Begin seated, with your palms a few inches behind your torso pointed directly behind you.
2. Supporting yourself with your hands and feet, lift your hips from the floor so your torso creates a straight line between your knees and shoulders. **3.** Hold the position for thirty seconds, then draw your shoulders down and release your head and neck.

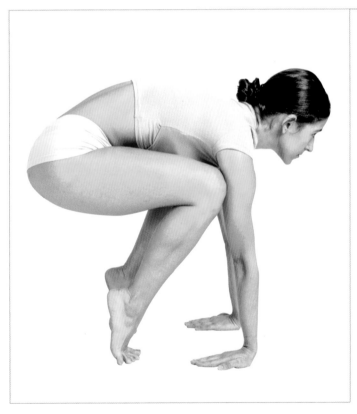

Intense-Wrist Crane Pose

Target: Wrists.

Benefits: Prevents tightness in the wrists while strengthening the calves and ankles.

Steps: 1. Crouch low to the floor and place your palms flat on the floor in front of you with your fingers pointed directly toward you. **2.** Rise up onto your tiptoes, lifting your hips. **3.** Hold this position for fifteen seconds or more before releasing.

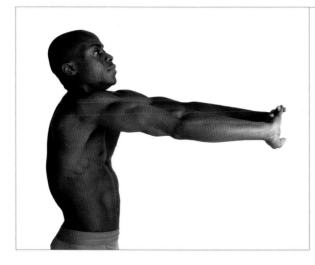

Interlaced-Finger Stretch

Target: Wrists.

Benefits: Lengthens the muscles in the fingers and wrists.

Steps: 1. Interlace your fingers and outstretch your arms with your palms facing away from you. **2.** Raise your arms until they are in line with your shoulders. **3.** Hold this position for thirty seconds or longer.

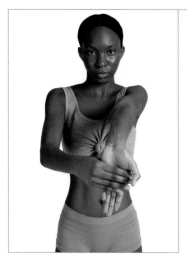

Palm-Down, Arm-Straight Wrist Stretch

Target: Wrists.

Benefits: Lengthens the muscles in the wrists and forearms, relieving tightness and tension.

Steps: 1. Raise your left arm straight ahead of you, palm facing out and fingers pointed down. **2.** Use your right hand to pull your outstretched left fingers down and toward you. **3.** Hold for fifteen seconds, and repeat on the other arm.

Palm-Down Wrist Stretch

Target: Wrists.

Benefits: Increases flexibility and range of motion in the wrists.

Steps: 1. Bring your right wrist toward your chest, with your palm facing out. **2.** Use your left hand to press down on your outstretched right fingers to stretch your right wrist. **3.** Hold for fifteen seconds, and repeat on the other arm.

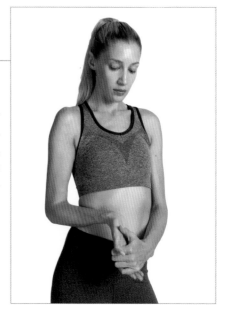

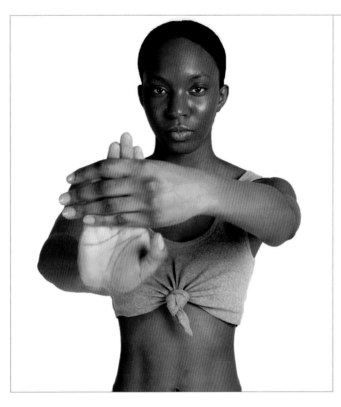

Palm-Upward Wrist Stretch

Target: Wrists.

Benefits: Lengthens the muscles in the wrists and forearms, relieving tightness and tension.

Steps: 1. Raise your right arm straight ahead of you, palm facing out and fingers pointed upward. **2.** Use your left hand to pull your outstretched fingers toward you. **3.** Hold for fifteen seconds before repeating on the other side.

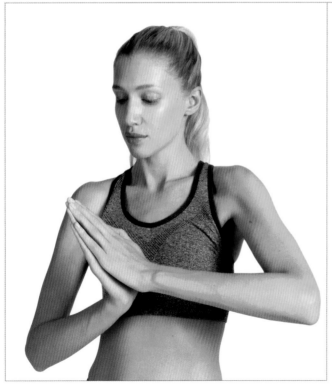

Prayer-Hands Wrist Rotation

Target: Wrists.

Benefits: Extends the muscles in your wrists and forearms.

Steps: 1. Place your palms together in front of your chest. **2.** Keeping your palms joined, point your fingers from side to side, up and down. **3.** Continue the movements for thirty seconds.

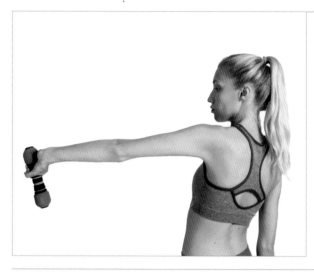

Wrist Ulnar with Dumbbell

Target: Wrists.

Benefits: Increases strength and mobility in the arms, wrists, and shoulders.

Steps: 1. Hold the dumbbell in your left hand and extend your arm straight in front of you with your wrist facing out to the left and your thumb pointing toward the floor. **2.** From this position, raise and lower the dumbbell for thirty-second intervals. **3.** Repeat on the opposite arm.

Wrist Bend

Target: Wrists.

Benefits: Lengthens the muscles in the wrists and forearms.

Steps: 1. Raise your hands in front of you with your palms facing each other and thumbs pointing toward the ceiling.
2. Keeping your hands in this position, bend your wrists so your fingers point toward the ground.
3. Hold this position for fifteen seconds before releasing.

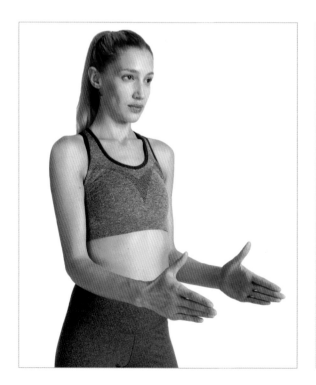

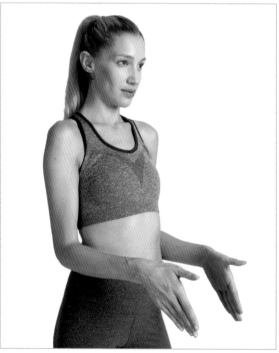

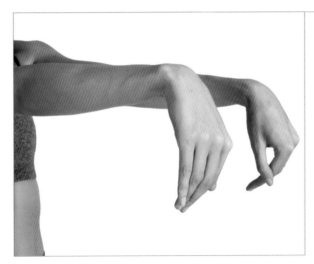

Wrist Extensor

Target: Wrists.

Benefits: Reduces pain and stiffness below the elbows.

Steps: 1. Raise your hands straight out in front of you. **2.** Keeping your elbows straight, flex your wrists so your palms are facing toward you. **3.** Curl your wrists inward, bringing your palms as far inward as you are able. **4.** Hold for fifteen seconds.

Wrist Extensor, Assisted

Target: Wrists.

Benefits: Reduces pain and stiffness below the elbows.

Steps: 1. Raise your right hand out in front of you, with your elbow bent. **2.** Flex your wrist so your palm is facing down and toward you. **3.** Use your left hand to pull your fingers as far inward as you can. **4.** Hold for fifteen seconds.

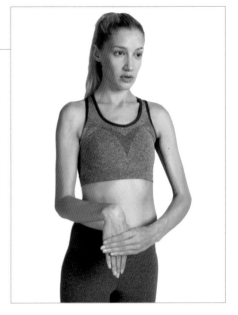

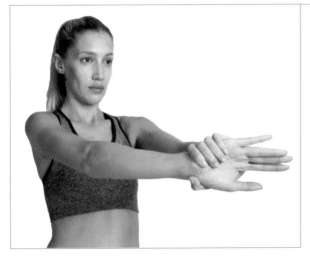

Wrist Flex, Side

Target: Wrists.

Benefits: Targets the muscles in the wrists and up to the elbows.

Steps: 1. Raise your right hand straight out in front of your chest, with your palm facing out and thumb pointing down. **2.** With your left hand, pull the top of your raised palm in toward you. **3.** Hold for fifteen seconds and repeat on the opposite arm.

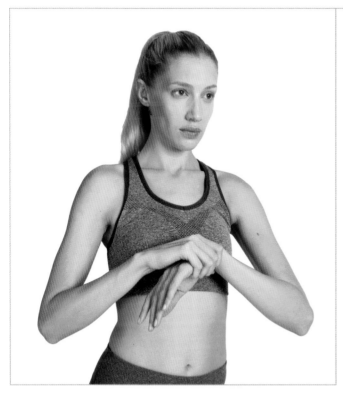

Wrist Flexion

Target: Wrists.

Benefits: Increases circulation and flexibility in the wrists.

Steps: 1. Raise your left hand to your chest and bend your wrist downward. **2.** Use your right hand to push down on your bent hand. **3.** Hold for fifteen seconds.

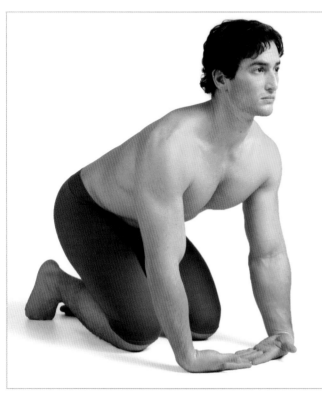

Wrist Radial Deviation and Extensor Stretch

Target: Wrists.

Benefits: Extends the muscles in the wrists.

Steps: 1. Kneel on the floor on all fours. **2.** Roll your hands outward, one hand at a time, so you are resting on the backs of the hands rather than your palms. **3.** Gently push into the floor and hold for fifteen seconds.

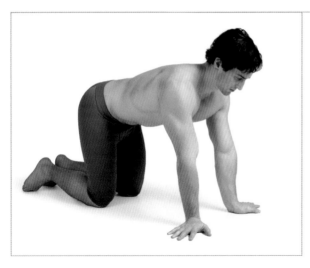

Wrist Radial Deviation and Flexor Stretch

Target: Wrists.

Benefits: Extends the muscles in the wrists.

Steps: 1. Kneel on the floor on all fours, fingers pointing straight ahead of you. **2.** Rotate your hands outward so your fingers are pointed to either side, in opposite directions. **3.** Gently push into the floor and hold for fifteen seconds.

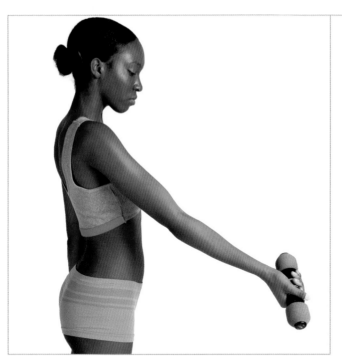

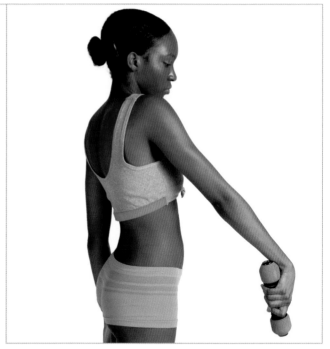

Wrist Radial Stretch with Dumbbell

Target: Wrists.

Benefits: Increases strength and mobility in the wrists and shoulders.

Steps: 1. Hold the dumbbell in your right hand and extend your arm straight in front of you.

2. Keeping your arm straight, rotate your arm so your wrist faces in and then faces out.

3. Repeat this motion for thirty seconds or more.

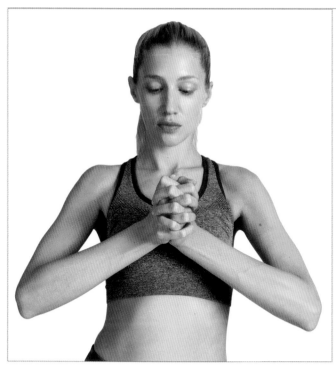

Wrist Rotation

Target: Wrists.

Benefits: Increases circulation and flexibility in the wrists and fingers.

Steps: 1. Bring your palms together in front of your chest, with your fingers clasped. **2.** Keeping your palms together, rotate your wrists clockwise, then counterclockwise. **3.** Continue the movement for thirty seconds.

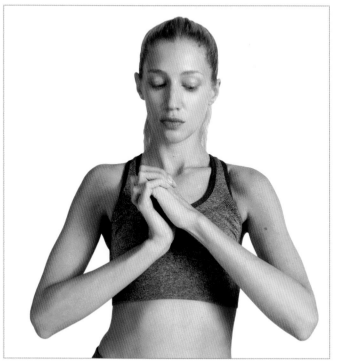

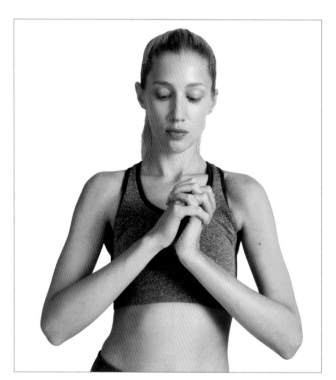

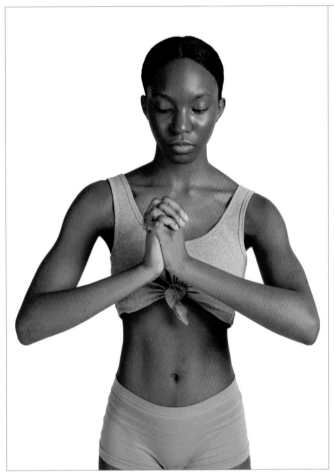

Wrist Rotations, Up-Down

Target: Wrists.

Benefits: Increases circulation and flexibility in the wrists and fingers.

Steps: 1. Bring your palms together in front of your chest, with your fingers clasped. **2.** Keeping your palms together, rotate your fingers in toward your chest and then out toward the floor. **3.** Continue the movement for thirty seconds.

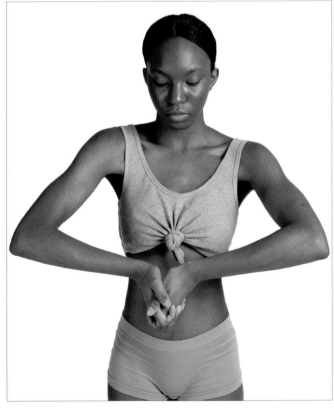

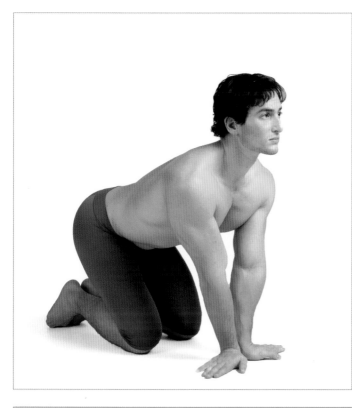

Wrist Ulnar Deviation and Extensor Stretch

Target: Wrists.

Benefits: Increases circulation and flexibility in the wrists and fingers while lengthening the spine.

Steps: 1. Crouch on the floor on all fours, with your palms flat to the floor. **2.** Bring your hands in together, so they are touching at the wrist and your fingers are pointed out in opposite directions. **3.** Gently press down in the floor for fifteen seconds.

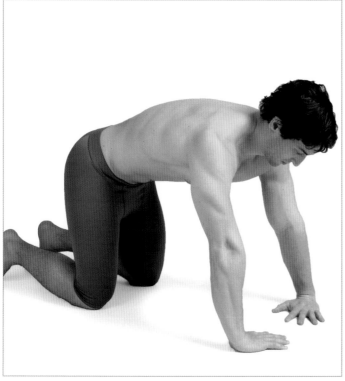

Wrist Ulnar Deviation and Flexor Stretch

Target: Wrists.

Benefits: Increases circulation and flexibility in the wrists and fingers while lengthening the spine.

Steps: 1. Crouch on the floor on all fours, with your palms flat and your fingers pointing forward. **2.** Turn your hands so your fingers are pointed in toward each other. **3.** Arch your back up and drop your shoulders. **4.** Hold for fifteen seconds.

Back Stretches

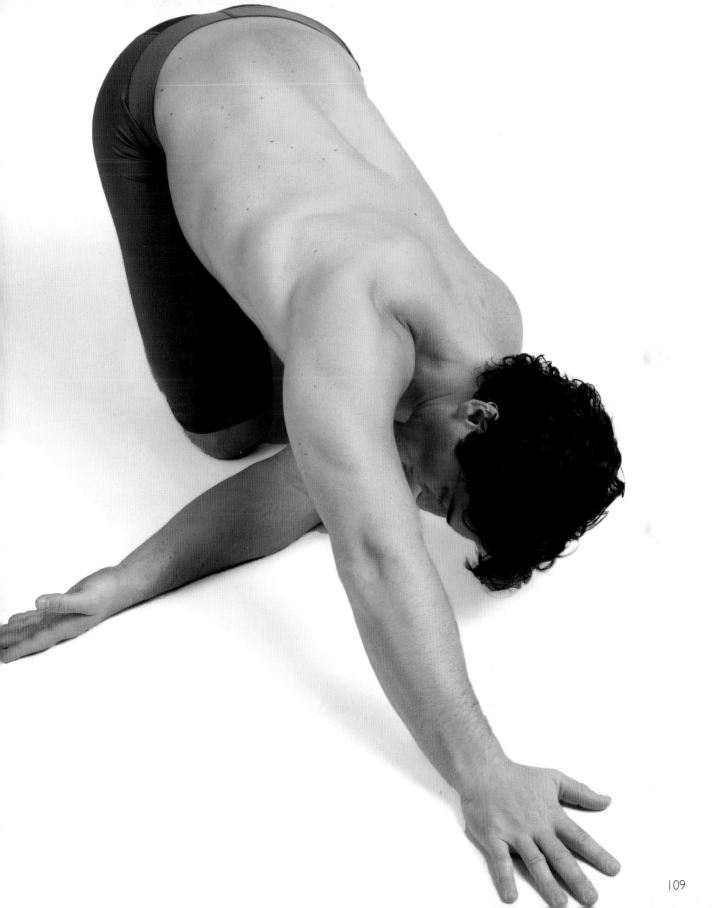

Bound Revolved, Half-Intense Back-Stretch Pose

Target: Latissimus dorsi.

Benefits: Opens the chest and extends the lat muscles.

Steps: 1. Stand straight with feet hip-width apart. **2.** Bend forward at your waist and reach with your left hand through your knees and up toward your left hip. **3.** Reach your right hand across your back to join your hands together. **4.** Hold for twenty seconds and alternate sides.

Arm Extension with Bent Knees

Target: Latissimus dorsi.

Benefits: Engages the lats and core while extending both arms.

Steps: 1. Crouch low to the floor, keeping your back parallel to the floor and extending both arms straight at your sides. **2.** Twist your torso to the right so your arms and chest are facing to the right, then twist to the left side. **3.** Repeat this motion for thirty seconds.

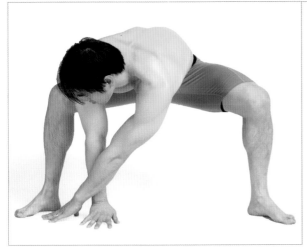

Forward-Lunge Lat Stretch

Target: Latissimus dorsi.

Benefits: Lengthens the lats while strengthening the quads and glutes and opening the hips.

Steps: 1. Spread your feet wide apart, lowering your torso into a wide squat, with your palms flat on the floor in front of your hips. **2.** Lift your left hand over the right so it is resting beside your right foot, twisting your torso toward the right. **3.** Hold the position for thirty seconds.

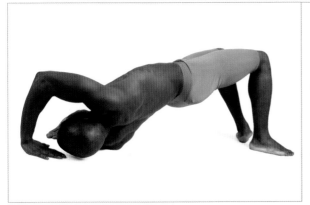

Hip-Raise Twist

Target: Latissimus dorsi.

Benefits: Targets the muscles in the latissimus dorsi while engaging the core.

Steps: 1. Lie flat on your back with your knees raised and bent. **2.** Place your right hand flat on the floor to the left of your head, with your elbow in the air. **3.** Use this hand for support while you twist your torso in the opposite direction. **4.** Hold this position for fifteen seconds before releasing.

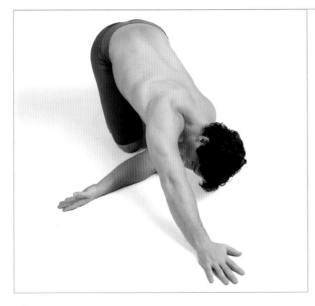

Lat and Upper-Back Stretch in Child's Pose

Target: Latissimus dorsi.

Benefits: Strengthens and realigns the muscles in the lats and upper back.

Steps: 1. Kneel on the floor and extend your right arm in front of you. **2.** Drop your left shoulder to the floor, and rotate your torso to the right, bringing your left arm out to the right side. **3.** Hold this position for fifteen seconds before alternating sides.

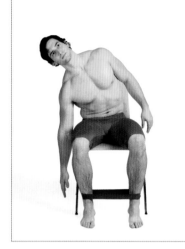

Lat Side Stretch, Sitting

Target: Latissimus dorsi.

Benefits: Extends the muscles in the lats and obliques while engaging the abductors.

Steps: 1. Sitting on a chair, wrap a resistance band around your lower calves. **2.** Keeping the band taut and your shoulders straight, lean down to your right side so your fingers extend toward the floor. **3.** Hold this position for fifteen seconds before repeating this stretch on the opposite side.

Lat Stretch, Cross-Legged at Ballet Bar

Target: Latissimus dorsi.

Benefits: Lengthens the muscles in the lats, obliques, and abductors.

Steps: 1. Stand to the right of a ballet bar, resting your left forearm on the bar. **2.** Cross your right leg behind the left, so your right foot approaches the bar. **3.** Resting on your left forearm, raise your right arm over your head toward the left to stretch the right side of your body.

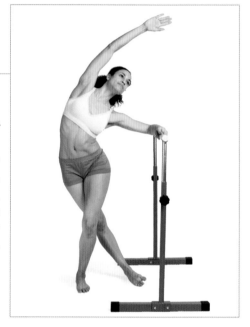

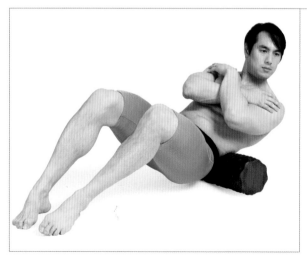

Lat Stretch on Roller

Target: Latissimus dorsi.

Benefits: Relieves tight and fatigued muscles in the latissimus dorsi.

Steps: 1. Lie on your back, with the foam roller beneath your shoulder blades and your arms folded across your chest. **2.** Twist your torso so that you target one side at a time. **3.** Roll your torso up and down the foam roller, so the roller massages your lats and shoulder blade region.

Lat Stretch on Roller, Side-Lying 1

Target: Latissimus dorsi.

Benefits: Relieves tight and fatigued muscles in the latissimus dorsi.

Steps: 1. Lie on your right side, with your right arm extended above your head. **2.** Place the foam roller beneath your upper torso.
3. Roll up and down your lats to target troubled muscles. **4.** Repeat on the opposite side.

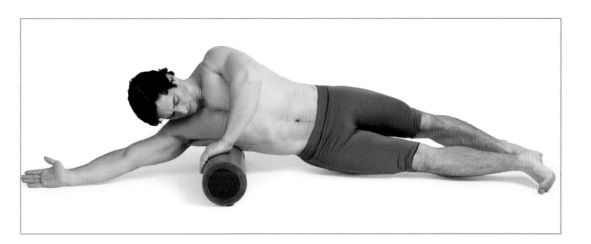

Lat Stretch on Roller, Side-Lying 2

Target: Latissimus dorsi.

Benefits: Relieves tight and fatigued muscles in the latissimus dorsi.

Steps: 1. Lie on your right side, with your right arm extended above your head. **2.** Place the foam roller beneath your upper torso.
3. Bend your right knee up toward the roller, and roll up and down your lats to target troubled muscles. **4.** Repeat on the other side.

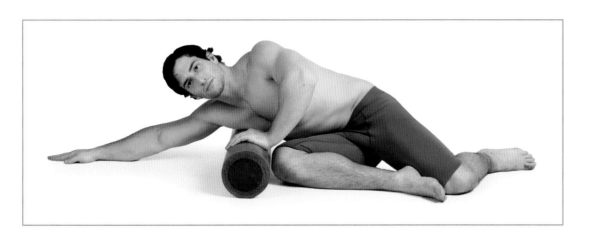

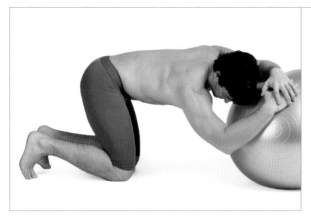

Lat Stretch with Trunk Rotation

Target: Latissimus dorsi.

Benefits: Increases flexibility and range of motion in the lats and trunk rotators.

Steps: 1. Kneeling on the floor, place your forearms across the front of an exercise ball and rest your head on your hands. **2.** Roll the ball to your right side, gently twisting at the middle of your back. **3.** Hold for fifteen seconds, before alternating sides.

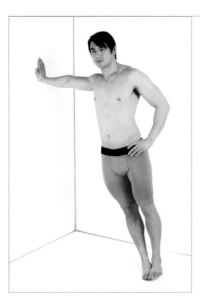

Lower-Trunk Lateral Flexor, Supported

Target: Latissimus dorsi.

Benefits: Flexes the muscles in the latissimus dorsi.

Steps: 1. Lean your right hand against a wall. **2.** Step your feet farther out to the left so your upper body is angled toward the wall. **3.** Use your left hand to press in against your hips to magnify the stretch. **4.** Hold for thirty seconds and alternate sides.

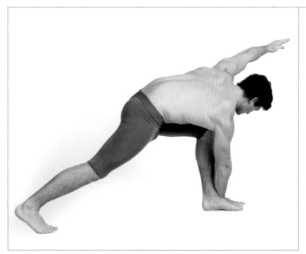

Lunging-Forward Twist I

Target: Latissimus dorsi.

Benefits: Lengthens the lats while extending the calves and Achilles tendons.

Steps: 1. Step your left foot as far forward as you are able, bending into a deep lunge. **2.** From this position, twist your torso to the left and place your right hand flat on the floor to the outside of your left ankle. **3.** Extend your left arm straight in front of you. **4.** Hold for thirty seconds and alternate sides.

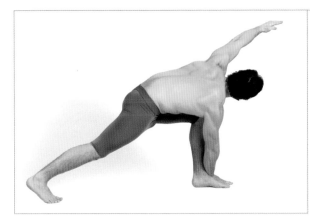

Lunging-Forward Twist 2

Target: Latissimus dorsi.

Benefits: Lengthens the lats while extending the calves and Achilles tendons.

Steps: 1. Step your left foot as far forward as you are able, bending into a deep lunge. **2.** From this position, twist your torso to the left and place your right hand flat on the floor to the outside of your left ankle. **3.** Extend your left arm straight in front of you and try to turn your head upward to your left. **4.** Hold for thirty seconds and alternate sides.

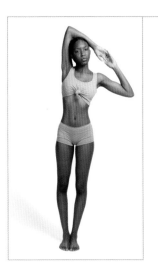
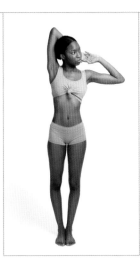

Mountain Pose with Shoulder Opener

Target: Latissimus dorsi.

Benefits: Opens the chest and shoulders while stretching the lats.

Steps: 1. Standing straight, bend your right elbow and reach your right arm behind your head. **2.** Use your left hand to pull the right arm toward your left shoulder. **3.** To increase the stretch, bend your spine slightly to the left. **4.** Hold for thirty seconds and alternate sides.

Noose Pose, Half-Bound

Target: Latissimus dorsi.

Benefits: Opens the chest and extends the lats while increasing balance.

Steps: 1. Squat low to the floor with your legs and feet together. **2.** Twist your torso to the right and extend your left hand to the floor at your right side. **3.** Twist your right arm behind you, binding it around your back. **4.** Hold this position for fifteen seconds before alternating sides.

Notes: If you are unable to keep your heels on the floor for this stretch, try placing a towel beneath your feet to aid balance.

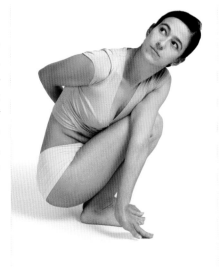

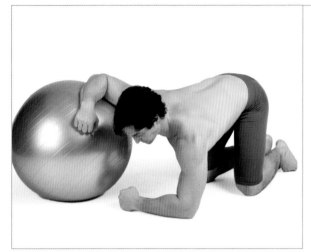

Pectoral Stretch on Ball

Target: Latissimus dorsi.

Benefits: Opens the chest and engages the lats.

Steps: 1. Kneel on your knees and elbows, with an exercise ball beside your right shoulder. **2.** Raise your right arm onto the ball, keeping it bent at the elbow. **3.** Roll the ball side to side, engaging the muscles below your shoulder. **4.** Hold for thirty seconds and repeat on the opposite side.

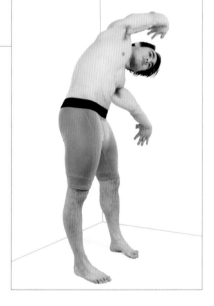

Reaching Lat Stretch

Target: Latissimus dorsi.

Benefits: Reduces tightness in the lats and shoulders.

Steps: 1. Begin by standing straight and leaning your left hand against a wall, fingers pointing down. **2.** Reach your right arm over your head until both hands are resting on the wall in line with each other. **3.** Extend your hips out to the right in order to intensify the stretch. **4.** Hold for thirty seconds and repeat on the opposite side.

Caution: Make sure to keep your hips and spine in line during this stretch so as to avoid throwing off the alignment in your body.

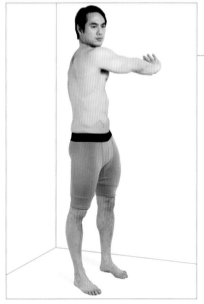

Shoulder Extensor, Abductor, and Retractor, Body Turned

Target: Latissimus dorsi.

Benefits: Lengthens and realigns the muscles in the lats and spine.

Steps: 1. Stand about a foot away from a wall with your left side perpendicular to the wall. **2.** Reach your right hand across your chest and place it on the wall. **3.** Push your hips away from the wall in order to amplify the stretch. **4.** Hold for thirty seconds and alternate sides.

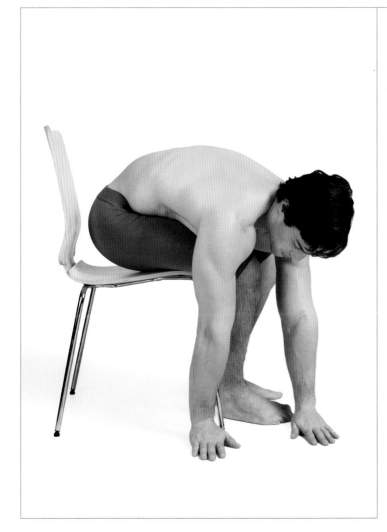

Shoulder Stretch Overhead, Side Reach to Floor, Seated

Target: Latissimus dorsi.

Benefits: Lengthens and realigns the muscles in the lats and shoulders.

Steps: 1. Sit on a chair with your feet on the floor. **2.** Twist your torso to your right side and bend forward until your hands are flat on the ground to your right. **3.** Hold this position for fifteen seconds before alternating sides.

Side Stretch on Ball, Arm Extended

Target: Latissimus dorsi.

Benefits: Reduces stiffness and pain in the back and lats, improving posture.

Steps: 1. Kneel on the ground in front of an exercise ball, with your right hand on the ball and your left hand on the floor. **2.** Straighten your raised arm, reaching forward along the ball. **3.** Hold this position for thirty seconds before alternating sides.

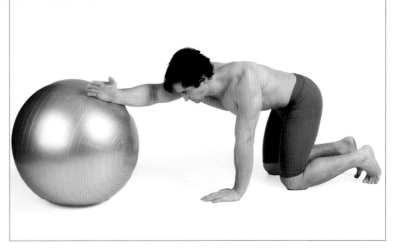

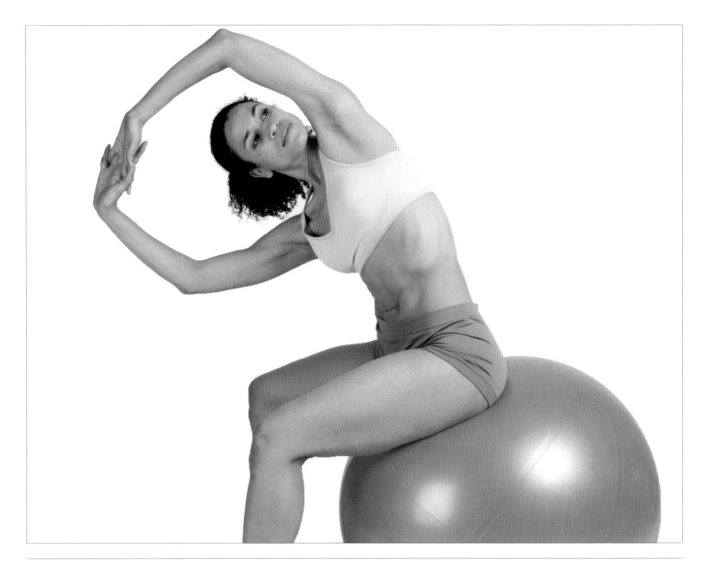

Side Twist with Clasped Hand on Ball

Target: Latissimus dorsi.

Benefits: Lengthens the muscles in the back and spine while engaging the core and opening the chest.

Steps: 1. Begin seated on an exercise ball, with your fingers clasped and raised above your head. **2.** Keeping your fingers clasped, twist your torso up toward your left side. **3.** Hold this position for fifteen seconds before switching sides.

Standing Crescent Pose

Target: Latissimus dorsi.

Benefits: Increases flexibility and range of motion in the latissimus dorsi and oblique muscles.

Steps: 1. Begin by standing straight with your fingers clasped and raised overhead. **2.** Keeping your back and shoulders aligned, bend toward your left side. **3.** Hold this position for fifteen seconds before switching sides.

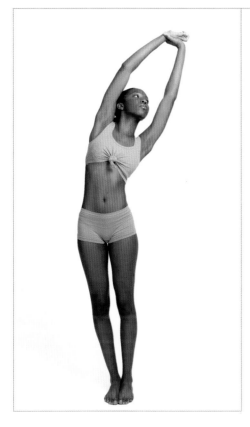

Traction Lateral

Target: Latissimus dorsi.

Benefits: Reduces tightness and increases flexibility in the lats and spinal muscles.

Steps: 1. Begin by standing straight, at an arm's distance from a door frame. **2.** Place your right hand on the door frame and reach your left arm over your head until both hands can grab onto the edge of the door frame. **3.** Extend your hips toward the left in order to intensify the stretch.

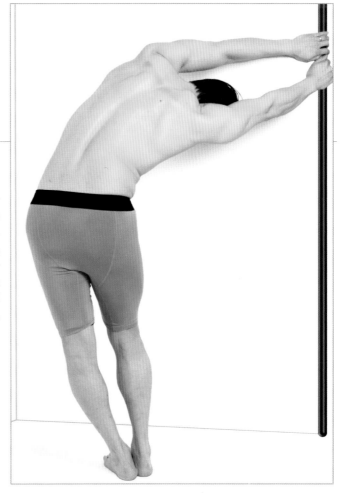

Anterior and Lateral Lower-Leg Forward Bend

Target: Lower back.

Benefits: Lengthens the lower back and spine while stretching the hamstrings.

Steps: 1. Sit on the floor, with your legs out straight and feet spread wide apart. **2.** Lean your head forward toward the floor, grabbing your feet with either hand. **3.** Keeping hold of your feet, pull your torso down as low to the floor as you are able. **4.** Hold this position for thirty seconds before releasing.

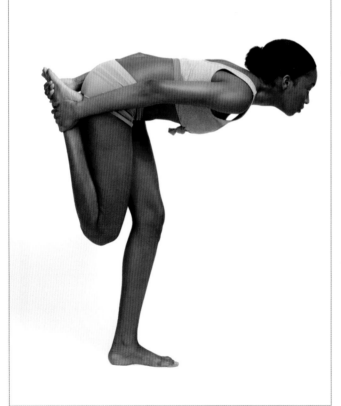

Both Hands to Foot, Half-Standing, Wind-Relieving, Intense-Stretch Pose

Target: Lower back.

Benefits: Reduces tightness in the lower back while increasing balance.

Steps: 1. Standing straight, bend your right leg back so your foot touches your hip. **2.** Grab hold of your raised foot with both hands, and find your balance before beginning to lean your head down into a forward bend. **3.** Hold this position for fifteen seconds before alternating legs.

Double-Leg Side Extension

Target: Lower back.

Benefits: Increases mobility and flexibility in the lower back.

Steps: 1. Lie flat on the floor, with your arms outstretched at your sides. **2.** Bring your legs into your chest, and extend them both straight out to your right. **3.** Hold this position for thirty seconds before switching sides.

Note: Attempt to keep both shoulders on the floor when performing this stretch, to target your lower back.

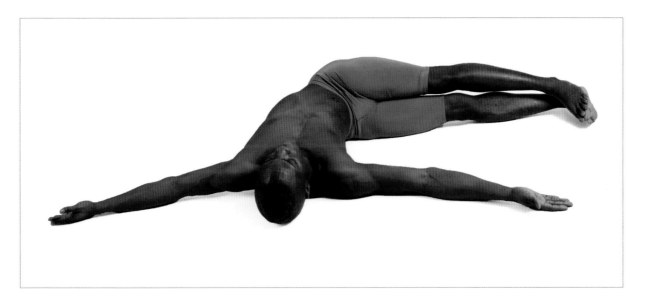

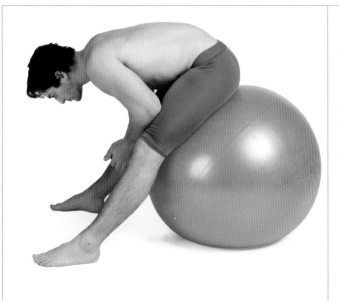

Forward Lean on Ball

Target: Lower back.

Benefits: Lengthens the spine and realigns the muscles in the lower back.

Steps: 1. Begin seated on an exercise ball with your feet spread wide apart. **2.** Placing your elbows on your knees for support, lean your head down toward the floor. **3.** Hold for thirty seconds.

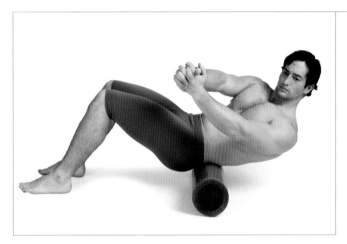
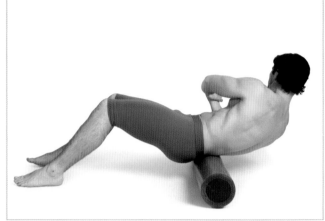

Lower-Back Stretch on Roller

Target: Lower back.

Benefits: Relieves pain and improves mobility in the lower back and spine.

Steps: 1. In a seated position, place a foam roller under your lower back. Cross your arms in front of you and protract your shoulders. **2.** Raise your hips off the floor and lean back, keeping your weight on your lower back. **3.** Shift your weight slightly to the left, keeping your weight off the spine. **4.** Hold for twenty seconds and alternate sides.

Half-Bound, Unsupported Bound, One-Legged Intense-Stretch Pose Prep

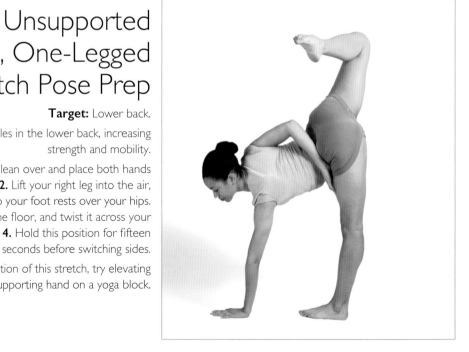

Target: Lower back.

Benefits: Flexes the muscles in the lower back, increasing strength and mobility.

Steps: 1. Standing straight, lean over and place both hands on the floor in front of you. **2.** Lift your right leg into the air, pulling toward your body so your foot rests over your hips. **3.** Lift your right hand from the floor, and twist it across your back into a half-bound position. **4.** Hold this position for fifteen seconds before switching sides.

Notes: For an easier modification of this stretch, try elevating your supporting hand on a yoga block.

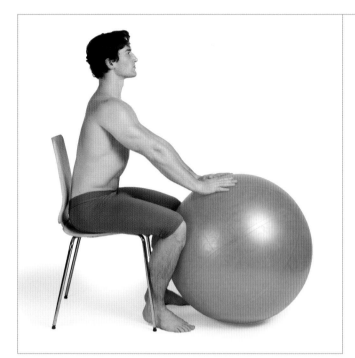
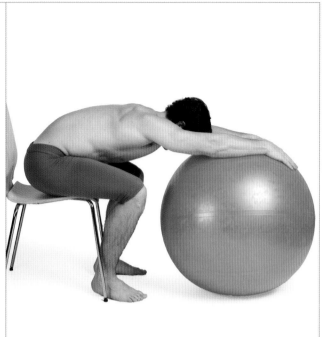

Lumbar Stretch, Sitting with Ball

Target: Lower back.

Benefits: Relieves tightness and increases mobility in the lower back and spine.

Steps: 1. Begin by sitting on a chair and placing your hands on an exercise ball directly in front of you. **2.** Roll forward across the ball, until your elbows rest on the ball. **3.** Hold this position for fifteen seconds.

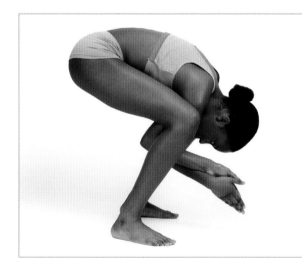

Half Intense-Stretch Pose with Hand Position in the Pose Dedicated to Garuda

Target: Lower back.

Benefits: Lengthens the muscles in the lower back and spine.

Steps: 1. Crouch low to the floor, bringing your elbows between your knees. **2.** Cross one elbow behind the other and attempt to join your palms in an intertwined prayer-hands position. **3.** Drop your head and shoulders down toward the floor.

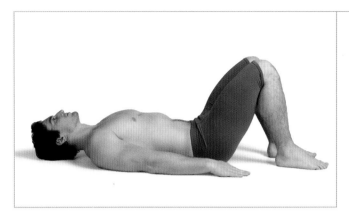 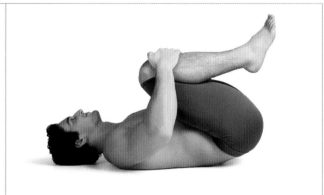

Supine Lumbar Flexion

Target: Lower back.

Benefits: For relieving pain and stiffness in the lower back.

Steps: 1. Lie with your back on the floor and both knees bent. **2.** Use your hands to pull your knees into your chest. **3.** Hold this position for thirty seconds before releasing.

Knee to Chest

Target: Lower back.

Benefits: Helps relax and relieve pain in your lower back and glutes.

Steps: 1. Lying flat on your back, bring your left knee in toward your chest.
2. Use your hands to pull the knee in closer your chest, in order the magnify the stretch.

Note: For an advanced version of this stretch, place a yoga block directly beneath your hips.

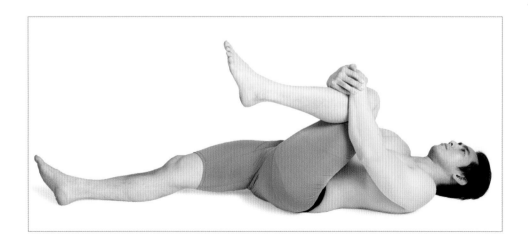

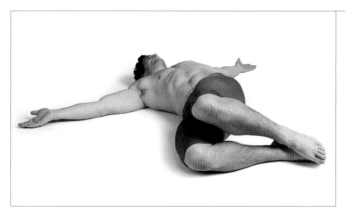
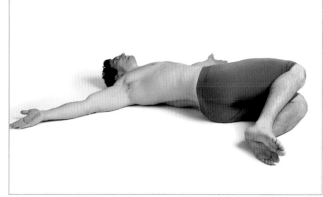

Supine Lumbar Rotation

Target: Lower back.

Benefits: Increases flexibility and range of motion in the lower back.

Steps: 1. Lie on your back with both knees bent and your arms stretched to either side. **2.** Lower both knees to one side, keeping your shoulders and arms on the floor. **3.** Hold this position for fifteen seconds before alternating sides.

Lower-Back Standing

Target: Lower back.

Benefits: Relieves pain and tightness in the lower back resulting from prolonged sitting or poor posture.

Steps: 1. Stand with your back and shoulders straight. **2.** Place your palms flat to your lower back, pushing your hips and stomach forward. **3.** Hold for thirty seconds.

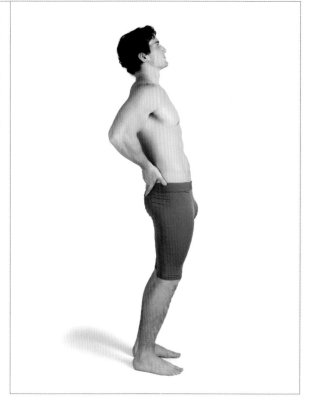

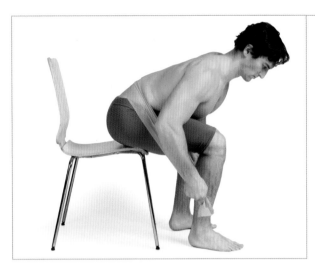

Back Extensor Self-Stretch

Target: Upper back.

Benefits: Strengthens the spinal cord and engages the muscles in the chest and upper back.

Steps: 1. Sit upright in a chair and place a resistance band around your lower back. **2.** With elbows bent, grip the ends of the band in either hand and bend forward. **3.** Straighten your arms and extend them downward to feel the resistance in your upper back. **4.** Hold for thirty seconds.

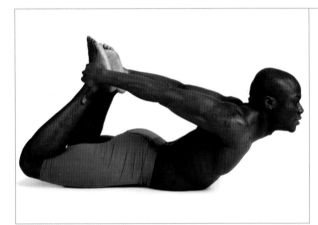

Arch Stretch on Stomach

Target: Upper back.

Benefits: Lengthens the spinal cord and engages the muscles in the chest and upper back.

Steps: 1. Lie on your stomach with your knees bent and feet tucked into your butt. **2.** Reach around with both hands, grabbing hold of your feet. **3.** Keeping your hands and feet bound, pull your shoulders, chest and knees up from the floor so your back is arched and your arms are straight. **4.** Hold this pose for ten seconds or longer.

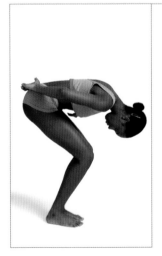

Back and Chest Lift

Target: Upper back.

Benefits: Lengthens the spinal cord and engages the muscles in the chest and upper back.

Steps: 1. Start in a standing position and place your hands on your lower back. **2.** With your knees slightly bent, lower your torso so your back is parallel with the floor. **3.** Place your hands on your upper thighs and roll your head upward. **4.** Hold for thirty seconds.

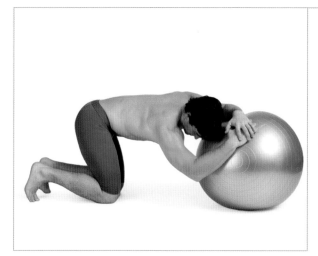

Back Extension Prone

Target: Upper back.

Benefits: Opens the chest and engages the upper back while lengthening the spine.

Steps: 1. Kneel in front of a fitness ball. **2.** Clasp your hands over your head and place them on top of the ball. **3.** Tilt your torso to the right and hold for thirty seconds.

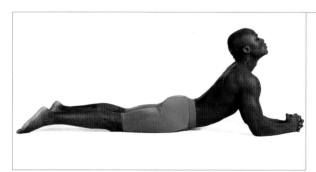

Back Extensions

Target: Upper back.

Benefits: Engages the muscles in the upper back while opening the spine.

Steps: 1. Lie flat on your stomach, with your forearms on the floor at your sides. **2.** Using your forearms for support, lift your chest from the floor and tilt your head to face the ceiling. **3.** Hold this position for thirty seconds before releasing.

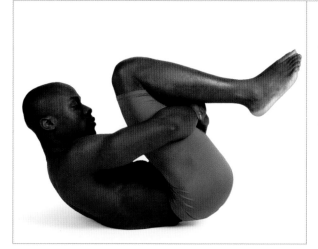

Back Roll 1

Target: Upper back.

Benefits: Limbers up the spine and upper back.

Steps: 1. Lie on your back and bring your knees into your chest. **2.** Wrap your hands underneath your legs, keeping them close to your body and bring your forehead toward your knees. **3.** Hold this position for thirty seconds before releasing.

Caution: Be sure to avoid rocking too far up your back and putting pressure on your neck. Lie on a yoga mat or soft surface if this exercise hurts your back.

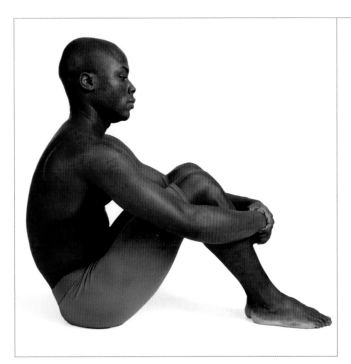

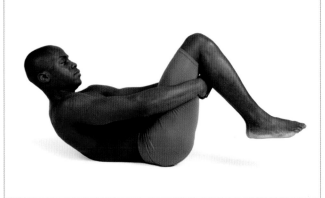

Back Roll 2

Target: Upper back.

Benefits: Limbers up the spine and upper back.

Steps: 1. Lie on your back and bring your knees into your chest. **2.** Wrap your hands underneath your legs, keeping them close to your body, and bring your forehead toward your knees. **3.** Rock slowly up and down the length of your back for thirty seconds.

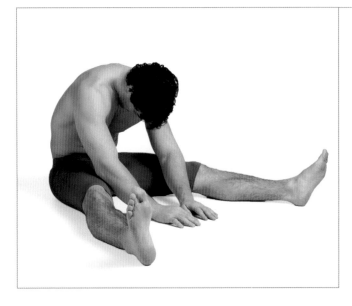

Back Stretch, Bent over Sitting, Legs Spread

Target: Upper Back.

Benefits: Reduces tightness and increases flexibility in the upper back.

Steps: 1. Sit with your legs wide apart and your hands on the floor in front of you. **2.** Extend your hands forward until they are resting between your knees. **3.** Drop your head to your chest and roll your shoulders forward. **4.** Hold for thirty seconds.

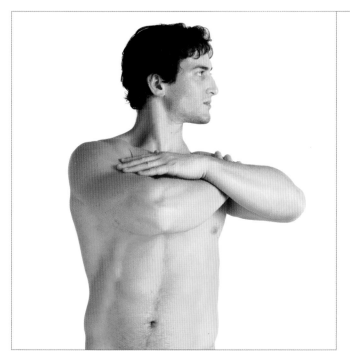
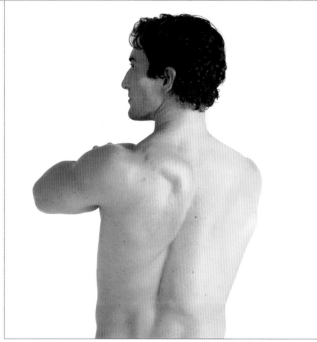

Back Rotation, Standing

Target: Upper back.

Benefits: Twists open the spine and increases flexibility in the upper back.

Steps: 1. Stand with your arms crossed and hands resting on opposite shoulders.
2. Twist your torso from one side to the other for thirty seconds.

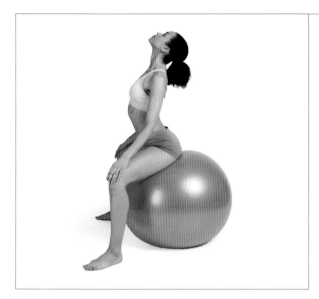

Back Stretch, High Arch on Ball

Target: Upper back.

Benefits: Opens the chest and releases tension in the upper back.

Steps: 1. Seated on the exercise ball, spread your legs wide apart, resting your hands on your knees for support. **2.** Drop your head and shoulders behind you, so you are facing the ceiling and your chest is extended. **3.** Hold for thirty seconds.

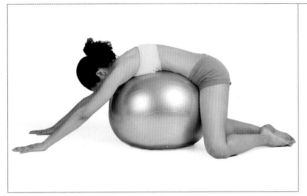

Back Stretch on Ball 1

Target: Upper back.

Benefits: Lengthens and relaxes the muscles in the upper back and spine.

Steps: 1. Lie on your stomach across the top of an exercise ball, with your knees apart and feet together. **2.** Keeping your hands and knees on the floor, let your head and shoulders drop so your spine is fully relaxed. **3.** Stay in this position for thirty seconds before releasing.

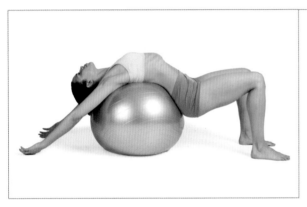

Back Stretch on Ball 2

Target: Upper back.

Benefits: Opens the chest and releases tightness in the upper back, improving posture.

Steps: 1. Sit on an exercise ball and lean back slightly. **2.** Walk your feet away from the ball so that it is directly beneath your spine, while keeping your knees bent and your feet hip-distance apart for stability. **3.** Extend your arms above your head and let them drop to the floor, releasing your neck and shoulder muscles. **4.** Stay in this position for thirty seconds before sitting up.

Back Stretch on Roller

Target: Upper back.

Benefits: Relieves pain and improves mobility in the upper back and spine.

Steps: 1. Sit on the floor with the foam roller directly behind your hips. **2.** Lean back and raise your hips from the floor, so your lower back is resting on the roller. **3.** Slowly roll up the length of your spine, focusing on any troubled muscles.

Note: To deepen the stretch, extend your arms above your head as you are using the roller.

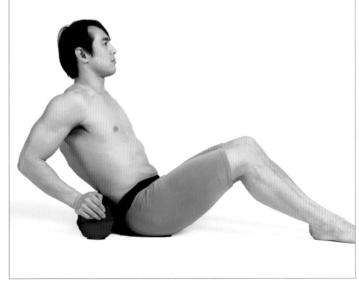

Back Stretch, Reaching

Target: Upper back.

Benefits: Extends the muscles in the upper back and shoulders.

Steps: 1. Stand straight, with your arms extended above your head. **2.** Cross your arms at the wrists and attempt to pull your arms as far toward the ceiling as you are able. **3.** Hold for thirty seconds.

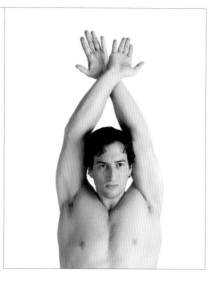

Back Stretch, Sitting Bent

Target: Upper back.

Benefits: Stretches the vertebrae in your upper back and neck.

Steps: 1. Sit with your legs straight ahead of you. **2.** Tuck your hands beneath your thighs and pull your head and shoulders down toward the floor. **3.** Hold for thirty seconds.

Back Stretch with Arms Reaching

Target: Upper back.

Benefits: Improves posture and relieves back pain.

Steps: 1. Kneeling on the floor, reach your arms forward and place your hands on the floor in front of you. **2.** Lower your hips onto your heels. **3.** Drop your head to the floor and hold for fifteen seconds.

Back Twist, Upward

Target: Upper back.

Benefits: Twists the spine and extends the upper back and chest.

Steps: 1. Crouch low to the floor and rest your left knee on the floor. **2.** Twist your torso to the left and place your right hand on your left hip, while reaching your left arm behind your back. **3.** Turn your head upward to open your chest. **4.** Hold this pose for fifteen seconds before switching sides.

Bilateral Seated Forward Bend

Target: Upper back.

Benefits: Improves posture and relieves upper back and neck pain.

Steps: 1. Sit on the floor with your legs pointed straight ahead and your hands resting on your knees. **2.** Drop your head and shoulders, pulling them down toward your knees. **3.** Hold this position for ten seconds before relaxing.

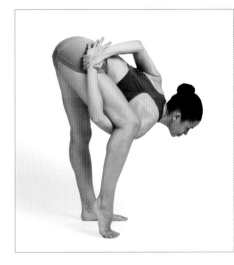

Bound Uneven-Legs, Half Intense-Stretch Pose

Target: Upper back.

Benefits: Stretches the muscles across the upper back and shoulders.

Steps: 1. Start in a forward bend. **2.** Prop your right foot onto tiptoes, and slightly bend your right knee. **3.** Drop your right shoulder, reaching your right arm beneath your bent knee and around your back. **4.** Twist your left arm around your back, and grab hold of your right hand so your arms are bound behind the back and around your right leg. **5.** Twist your torso to the left to maximize the stretch. **6.** Hold this position for ten seconds before alternating sides.

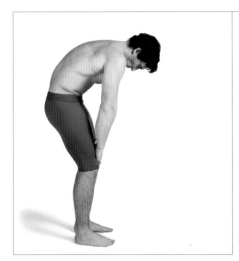

Cat Stretch, Standing

Target: Upper back.

Benefits: Relieves pain and tightness resulting from prolonged sitting or poor posture.

Steps: 1. Stand with your feet shoulder-width apart and your hands on your knees. **2.** Slowly arch your back as high toward the ceiling as you are able. **3.** Hold this position for five seconds before returning to the starting position.

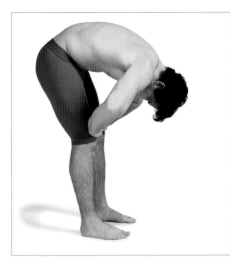

Cat Stretch, Standing, Extended Forward Bend

Target: Upper back.

Benefits: Relieves pain and tightness resulting from prolonged sitting or poor posture.

Steps: 1. Stand with your feet shoulder-width apart and your hands resting on your knees. **2.** Lean forward so your back is parallel to the floor and your elbows are bent. **3.** Slowly arch your back up toward the ceiling, keeping your knees slightly bent. **4.** Hold this position for five seconds before returning to the starting position.

Backbend, Feet Under Hips

Target: Upper back.

Benefits: Lengthens the spine and compresses the neck and upper back.

Steps: 1. Kneel on the floor and lower your hips so they are resting on your heels. **2.** Lean back, dropping your head behind your shoulders, so that the top of your head is touching the floor. **3.** Hold this position for ten seconds before sitting up.

Notes: For an easier version of the stretch, use a yoga block to elevate your head from the floor.

Hands-to-Wall Upper-Back Stretch

Target: Upper back.

Benefits: Lengthens the upper spine and shoulders.

Steps: 1. Place both hands on the wall at shoulder height. **2.** Take one step away from the wall, and let your head and shoulders drop toward the floor. **3.** Hold for thirty seconds.

Cobra Pose Back Stretch

Target: Upper back.

Benefits: Increases mobility and reduces muscle imbalance in the upper back.

Steps: 1. Begin by lying on your stomach, with your hands flat on the floor by your shoulders. **2.** Using your hands for support, raise your chest from the floor straightening your arms. **3.** Pull back your shoulders and raise your gaze upward. **4.** Maintain this position for fifteen seconds before releasing.

Cobra Pose, Easy Modification

Target: Upper back.

Benefits: Increases mobility and reduces muscle imbalance in the upper back.

Steps: 1. Begin by lying on your stomach, with your hands flat on the floor by your shoulders. **2.** Raise your chest from the floor, keeping your elbows at your sides. **3.** Maintain this position for fifteen seconds before releasing.

Easy Upper-Back Stretch

Target: Upper back.

Benefits: Lengthens the muscles along the spine and neck.

Steps: 1. Begin by standing with your feet apart and your arms at your sides. **2.** Lean your torso forward, bending at the waist. **3.** Pull your shoulders down toward your hips while extending your neck forward. **4.** Hold for ten seconds before releasing.

Advanced Four-Limbs Staff Pose

Target: Upper back.

Benefits: Lengthens the spine and hamstrings with aligning the muscles in the upper back.

Steps: 1. Standing with your feet wide apart, bend over placing your hands on the floor for support. **2.** Once you are in a full forward bend, lift your hands from the floor and extend your arms out behind your knees. **3.** Attempt to straighten your legs and raise your hips as high as possible. **4.** Maintain this position for twenty seconds.

Hand-to-Foot Reverse-Plank Stretch

Target: Upper back.

Benefits: Extends the muscles across the upper back while lengthening the hamstrings and strengthening the abdomen.

Steps: 1. Begin in a reverse plank position on your elbows, with your knees bent and your shoulders and hips aligned. **2.** Raise your left leg from the floor, extending it straight above you. **3.** Raise your right arm, reaching to grab hold of your raised ankle. **4.** Hold this position for ten seconds before releasing and alternating sides.

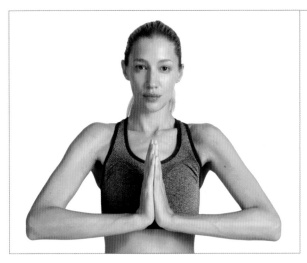

Prayer-Hand Shoulder Press

Target: Upper back.

Benefits: Flexes the muscles in the upper back and shoulders.

Steps: 1. Place your palms together in front of your chest.
2. Push your palms against each other, engaging your shoulders and upper back. **3.** Hold for thirty seconds.

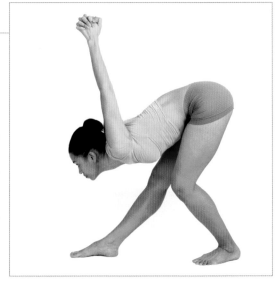

Feet-Spread Forward Bend, Hands Clasped Above

Target: Upper back.

Benefits: Targets the shoulders and upper back muscles while lengthening the calves and hamstrings.

Steps: 1. Step your right foot forward and lower your torso toward the floor. Bend your left knee while keeping your right leg straight. **2.** Clasp your hands behind your back and bend your shoulders down toward your extended knee. **3.** Maintain this position and attempt to raise your clasped hands toward the ceiling above your back.

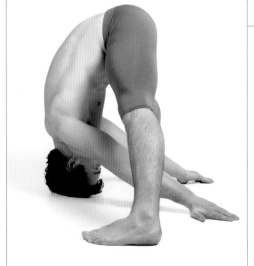

Feet-Spread-Out, Intense-Stretch Pose 1

Target: Upper back.

Benefits: Lengthens the spine and hamstrings while aligning the muscles in the upper back.

Steps: 1. Stand with your feet wide apart and bend forward. **2.** Place your hands on the floor between your legs for support and continue into a forward bend until the top of your head is touching the floor. **3.** Straighten your arms, so your palms are resting on the floor behind you.

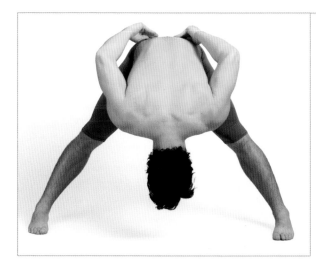

Feet-Spread-Out, Intense-Stretch Pose 2

Target: Upper back.

Benefits: Lengthens the spinal cord and hamstrings while improving flexibility in the upper back.

Steps: 1. Stand with your feet wide apart and your hands resting on your lower back. **2.** Bend forward at the hips into a forward bend. **3.** Let your head and shoulders drop toward the floor to target the upper back. **4.** Hold for twenty seconds.

Feet-Spread-Out, Intense-Stretch Pose 3

Target: Upper back.

Benefits: Lengthens the spinal cord and hamstrings while improving flexibility in the upper back.

Steps: 1. Stand with your feet wide apart and your hands clasped above your head. **2.** Bend forward at the waist, until your clasped hands are touching the floor in front of you. **3.** Hold for twenty seconds.

Feet-Spread-Out, Intense-Stretch Pose 4

Target: Upper back.

Benefits: Lengthens the spinal cord and hamstrings while stretching the muscles across the upper back.

Steps: 1. Stand with your feet wide apart and bend forward, placing your hands on the floor in front of either foot. **2.** Continue into a forward bend, bending at the elbows and bringing the top of your head as close to the floor as you are able. **3.** Attempt to straighten your legs and raise your hips as high as possible. **4.** Hold for twenty seconds.

Feet-Spread-Out, Intense-Stretch Pose 5

Target: Upper back.

Benefits: Lengthens the spinal cord and hamstrings while improving flexibility and range of motion in the upper back and shoulders.

Steps: 1. Stand with your feet wide apart and your hands in reverse-prayer position behind your spine. **2.** Bend forward at the waist, bringing the top of your head toward the floor. **3.** Maintaining this position, bring your joined palms as far up your back as you can. **4.** Hold for twenty seconds.

Feet-Spread-Out, Intense-Stretch Pose 6

Target: Upper back.

Benefits: Lengthens the spine and hamstrings while aligning the muscles in the upper back and shoulders.

Steps: 1. Stand with your feet wide apart and bend forward, placing your hands on the floor between your legs for support. **2.** Continue into a forward bend until the top of your head is touching the floor. **3.** Lift your hands from the floor and extend your arms up at a 45-degree angle. **4.** Hold for twenty seconds.

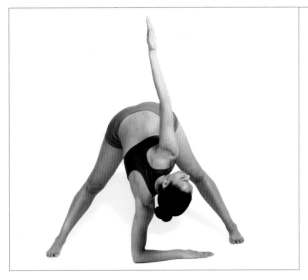

Feet-Spread-Out, Intense-Stretch Pose, Elbow to Ground

Target: Upper back.

Benefits: Lengthens the spine and hamstrings while twisting open the upper back and chest.

Steps: 1. Stand with your feet wide apart and bend forward at the hips, placing your hands on the floor between your legs for support. **2.** Lower yourself onto your right elbow and place your forearm flat on the floor. **3.** Lift your left arm straight into the air toward the ceiling, twisting your torso open and head upward. **4.** Maintain this position for twenty seconds.

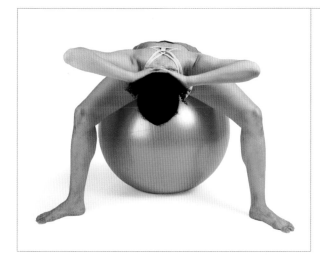

Forward Bend, Flat-Back on Ball

Target: Upper back.

Benefits: Lengthens the muscles in the upper back and neck while engaging the abdomen.

Steps: 1. Begin seated on an exercise ball with your legs spread wide apart. **2.** Clasp your fingers together and place your hands on the back of your head. **3.** Slowly fold forward at the waist, pressing down lightly on the back of your head. **4.** Hold for thirty seconds.

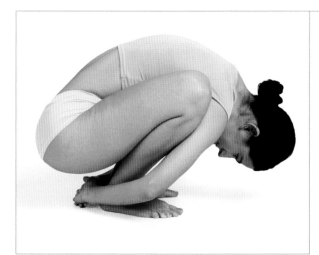

Garland Pose

Target: Upper back.

Benefits: Lengthens the spine and broadens the upper back while increasing mobility in the hips, calves, and ankles.

Steps: 1. Squat low to the floor so your knees are together and your hips are resting on your heels. **2.** Placing your hands on the floor for support, spread your knees apart and lower your chest so it is parallel to the floor. **3.** Let your shoulders and neck drop toward the floor, arching the full length of your spine. **4.** Lift your hands from the floor, and reach behind you, clasping your hands behind your feet. **5.** Attempt to remain in this pose for fifteen seconds before releasing.

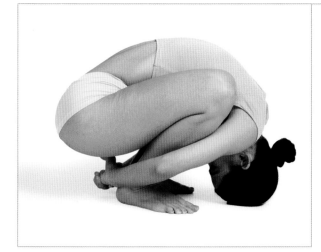

Garland Pose, Advanced Variation 1

Target: Upper back.

Benefits: Lengthens the spine and broadens the upper back while increasing mobility in the hips, calves, and ankles.

Steps: 1. Squat low to the floor so your knees are together and your hips are resting on your heels. **2.** Placing your hands on the floor for support, spread your knees apart and lower your chest so it is parallel to the floor. **3.** Arch your back and let your shoulders and neck drop so the top of your head is resting on the floor. **4.** Lift your hands from the floor and reach behind you, clasping your hands behind your feet. **5.** Attempt to remain in this pose for fifteen seconds before releasing.

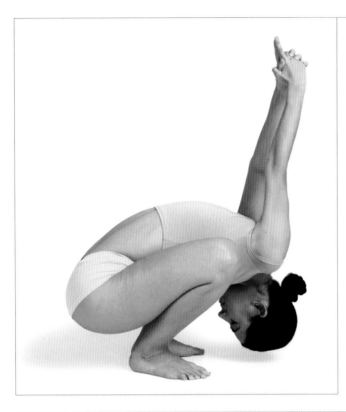

Garland Pose, Advanced Variation 2

Target: Upper back.

Benefits: Lengthens the spine and broadens the upper back while increasing mobility in the hips, calves, ankles, and shoulders.

Steps: 1. Squat low to the floor so your knees are together and your hips are resting on your heels. **2.** Placing your hands on the floor for support, spread your knees apart and lower your chest so it is parallel to the floor. **3.** Let your shoulders and neck drop toward the floor, arching the full length of your spine. **4.** Lift your hands from the floor, and clasp them behind your back. **5.** Reach your hands upward and attempt to remain in this pose for fifteen seconds before releasing.

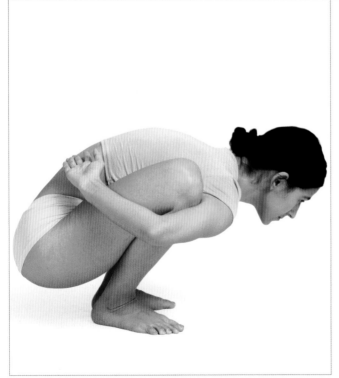

Garland Pose, Advanced Variation 3

Target: Upper back.

Benefits: Lengthens the spine and broadens the upper back while increasing mobility in the hips, calves, ankles, and shoulders.

Steps: 1. Squat low to the floor so your knees are together and your hips are resting on your heels. **2.** Placing your hands on the floor for support, spread your knees apart and lower your chest so it is parallel to the floor. **3.** Let your shoulders and neck drop toward the floor, arching the full length of your spine. **4.** Lift your hands onto your back with your palms facing the ceiling. **5.** Attempt to remain in this pose for fifteen seconds before releasing.

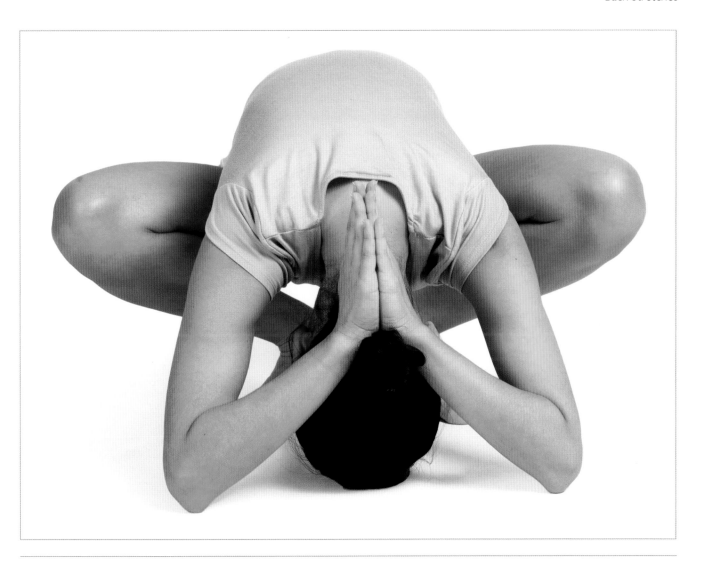

Garland Pose, Advanced Variation 4

Target: Upper back.

Benefits: Lengthens the spine and broadens the upper back while increasing mobility in the hips, calves, ankles, and shoulders.

Steps: 1. Squat low to the ground so your knees are together and your hips are resting on your heels. **2.** Placing your hands on the ground for support, spread your knees apart and lower your chest so it is parallel to the floor. **3.** Let your shoulders and neck drop so the top of your head is resting on the ground. **4.** Lift your hands from the ground, so you are resting on your elbows. **5.** Place your palms together behind your head, with your fingers pointed toward the ceiling. **6.** Attempt to remain in this pose for fifteen seconds before releasing.

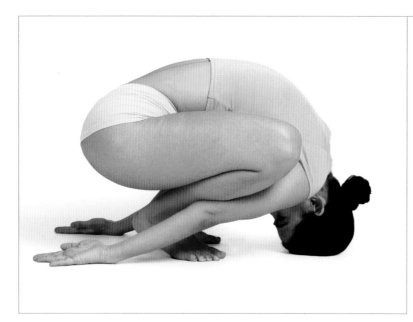

Garland Pose, Advanced Variation 5

Target: Upper back.

Benefits: Lengthens the spine and broadens the upper back while increasing mobility in the hips, calves, ankles, and shoulders.

Steps: 1. Squat low to the floor so your knees are together and your hips are resting on your heels. **2.** Placing your hands on the floor for support, spread your knees apart and lower your chest so it is parallel to the floor. **3.** Arching your back, drop your shoulders and neck downward and rest the top of your head on the floor. **4.** Extend your hands behind you, with your palms facing the ceiling. **5.** Remain in this pose for fifteen seconds.

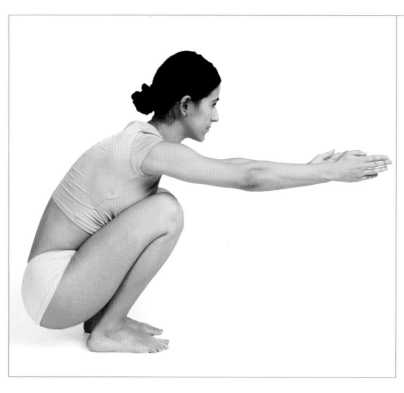

Garland Pose, Balance Prep

Target: Upper back.

Benefits: Stretches your upper back, Achilles tendons, and leg muscles, while engaging the core.

Steps: 1. Squat low to the ground so your knees are together and your hips are resting on your heels. **2.** Once you have found your balance, raise your arms straight in front of your chest with your palms together. **3.** Hold this position for twenty seconds.

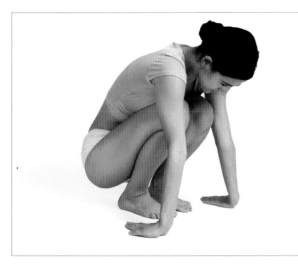

Garland Pose, Intense Wrist Stretch

Target: Upper back.

Benefits: Lengthens your wrists and Achilles tendons while extending your upper back.

Steps: 1. Squat low to the floor with your knees together and your hips resting on your heels. **2.** Place your hands in front of you with your palms flat on the floor and your fingers pointed behind you in an intense wrist position. **3.** Hold for twenty seconds.

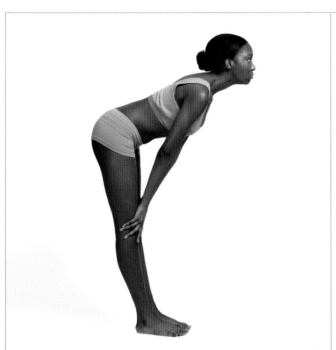

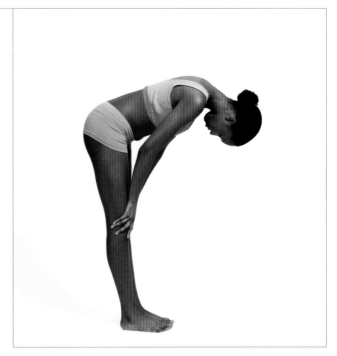

Head-Tilted Forward Bend

Target: Upper back.

Benefits: Extends and contracts the muscles in the chest and upper back.

Steps: 1. Stand with your feet slightly apart and bend your torso forward at the hips, placing your hands just above your knees. **2.** Pull your shoulders back, opening your chest and raising your head while looking straight ahead. **3.** Drop your head and curl your shoulders down toward the floor. **4.** Repeat the movement for thirty seconds.

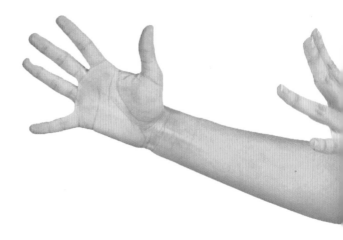

Garland Pose, Half-Lotus, One-Legged

Target: Upper back.

Benefits: Stretches your upper back, groin, and leg muscles while engaging the core.

Steps: 1. Squat down, resting your hips on your heels. **2.** Balancing yourself on the tips of your right fingers, grab your left foot with your left hand and bring your foot onto your right thigh so that you are in half lotus, balancing on your right foot. **3.** Once you have found your balance, straighten your spine and raise your arms straight above you. **4.** Maintain this position for fifteen seconds.

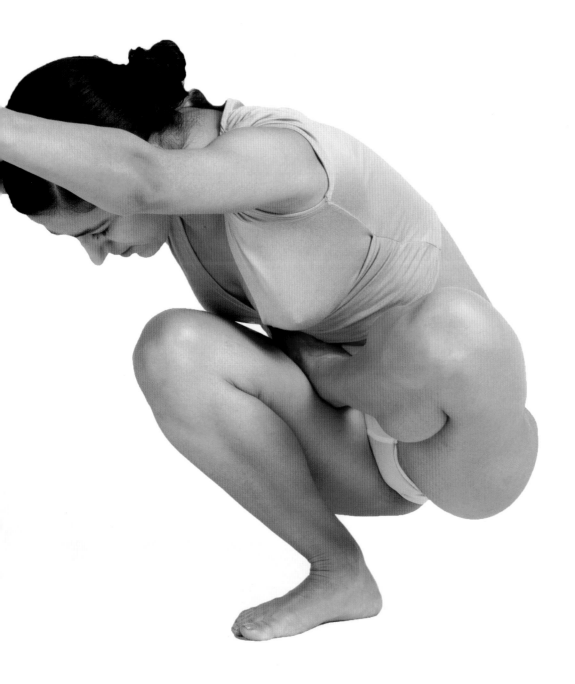

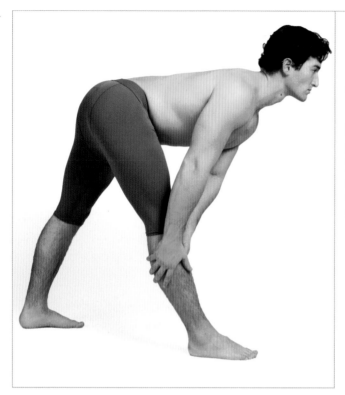

Intense Side-Stretch Pose Prep, Modification

Target: Upper back.

Benefits: Lengthens the muscles in the calves and hamstrings while engaging the spine and upper back.

Steps: 1. Step your right foot forward and make sure to keep both your legs straight throughout. **2.** Bend your torso so it is parallel to the floor and slide your hands down your right leg for support. **3.** Keep your gaze forward and hold for thirty seconds.

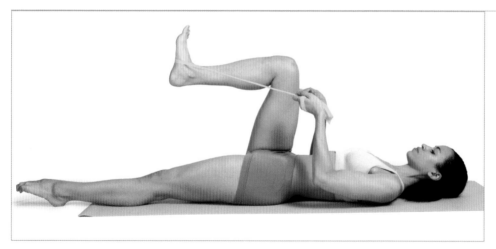

Kick Back with Band

Target: Upper back.

Benefits: Strengthens the glutes while lengthening the spine.

Steps: 1. Lie flat on your back, with your right knee bent into your chest and your left leg straight. **2.** Loop a resistance band around your right foot. **3.** Kick your right foot away from your torso, so it extends straight up. **4.** Bring your foot back into your chest and repeat this motion for thirty seconds.

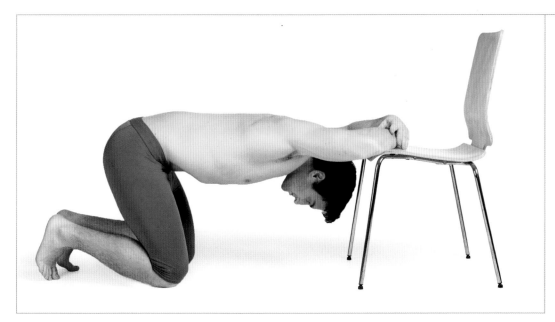

Kneeling Reach

Target: Upper back.

Benefits: Relieves pain and tension in the upper back, improving posture and coordination.

Steps: 1. Kneel at arm's length from the seat of a chair. **2.** Place both forearms on the chair and fold forward at the waist until your back is parallel to the floor. **3.** Let your head and shoulders drop toward the floor to maximize the stretch. **4.** Hold for thirty seconds.

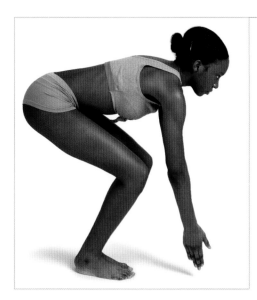

Knees-Bent Shoulder and Back Adductor

Target: Upper back.

Benefits: Lengthens the muscles across the back and shoulders.

Steps: 1. Keeping your knees together, bend your knees and lower your torso into a squat. **2.** Extend your arms down toward the floor, with your palms together. **3.** Keep your back parallel to the floor while you pull your arms away from your shoulders to increase the effect of the stretch on your upper back. **4.** Hold for twenty seconds.

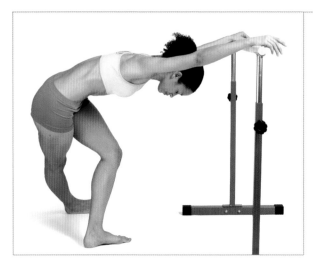

Lat Stretch, Cross-Legged at Ballet Bar

Target: Upper back.

Benefits: Lengthens the spine and upper back while stretching the abductors.

Steps: 1. Stand several paces from a ballet bar. Cross your right leg behind the other and bend your left knee slightly. **2.** Lean forward, bending at the waist, until you are able to reach both wrists across the bar. **3.** Let your head and shoulders drop toward the floor in order to amplify the stretch. **4.** Hold for thirty seconds.

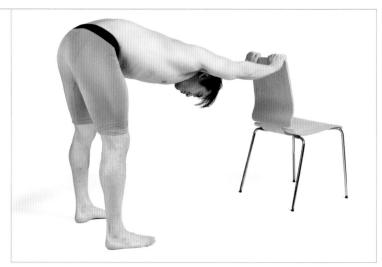

Leg-Hinge Double

Target: Upper back.

Benefits: Relieves tight muscles in the upper back and hamstrings.

Steps: 1. Stand several paces from the back of a sturdy chair. **2.** Lean forward, bending at the waist, and grab hold of the chair with both hands. **3.** Let your head and shoulders drop toward the floor. **4.** Hold for thirty seconds.

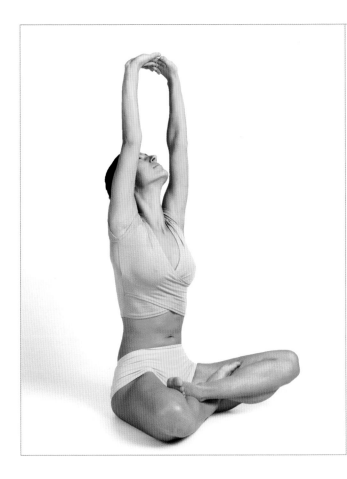

Lotus Pose, Arms Extended

Target: Upper back.

Benefits: Relieves tightness in the spine and upper back while stretching the knees, groin, and ankles.

Steps: 1. Sit on the floor, with your legs extended, spine straight, and arms resting at your sides. **2.** Bring your right ankle to rest in the crease of your left hip, with the sole of your foot facing upward. **3.** Bend your left knee and cross your left ankle over the top of your right shin toward your right hip. The sole of your left foot should also face upward. **4.** Lengthen your spine and lace your fingers, raising them up above your head so your arms are straight and your palms are facing upward. **5.** Gaze toward the ceiling and hold for thirty seconds.

Lotus Pose, Reaching Back

Target: Upper back.

Benefits: Opens the chest and extends the upper back while stretching the knees, groin, and ankles.

Steps: 1. Sit on the floor with your legs extended, spine straight, and arms resting at your sides. **2.** Bring your right ankle to rest in the crease of your left hip with the sole of your foot facing upward. **3.** Bend your left knee and cross your left ankle over the top of your right shin and into your right hip. The sole of your left foot should also face upward. **4.** Place your palms flat on the floor behind you with your fingers pointed forward. **5.** Drop your shoulders back and extend your chest so you are looking upward, and hold for thirty seconds.

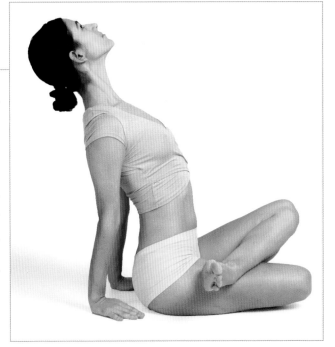

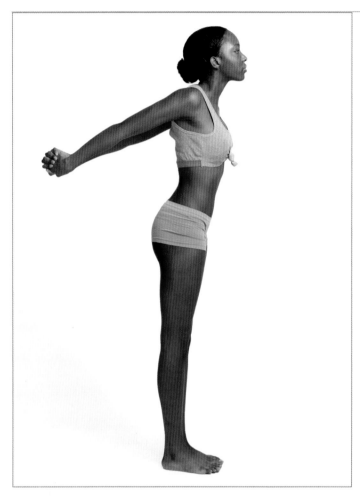

Mountain Pose with Bound Hands

Target: Upper back.

Benefits: Flexes the muscles in the upper back and shoulders, increasing mobility and strength.

Steps: 1. Stand with your back and shoulders straight and clasp your hands together behind your back. **2.** Raise your clasped hands as high up as you are able. **3.** Maintain this position for fifteen seconds before releasing.

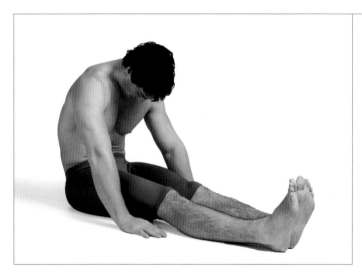

Shoulder and Back Curl, Seated

Target: Upper back.

Benefits: Relieves stiffness in the upper-back muscles.

Steps: 1. Sit with your legs straight in front of you and hands flat on the floor beside your knees. **2.** Drop your head to your chest and curl your shoulders forward. **3.** Hold for twenty seconds.

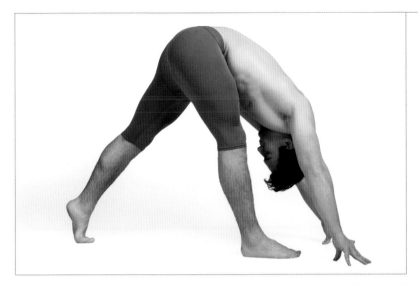

Uneven-Legs Tiptoe, Intense Side-Stretch Pose, Variation

Target: Upper back.

Benefits: Lengthens the spine and broadens the upper back while stretching the hamstrings.

Steps: 1. Step your right foot forward and bend your torso forward at the hips. **2.** Raise your left foot onto tiptoes and continue to bend forward until you are able to place your hands on the floor. **3.** Let your head and shoulders drop down in order to complete the stretch.

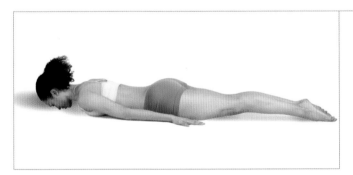
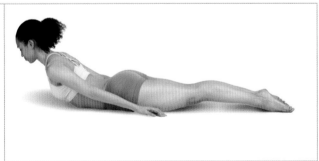

Upper-Back Extension

Target: Upper back.

Benefits: Counteracts poor posture and hunched shoulders, by strengthening the upper-back and neck muscles.

Steps: 1. Lie face down on your stomach, with your hands and arms raised slightly from the floor. **2.** Using only the muscles in your upper body and abdomen, attempt to lift your chest from the floor. **3.** Hold this position for ten seconds at a time before releasing and repeating.

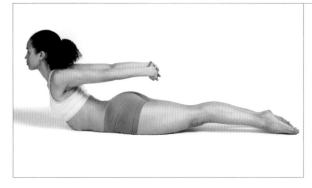

Upper-Back Extension with Clenched Fingers

Target: Upper back.

Benefits: Counteracts poor posture and hunched shoulders by strengthening the upper back, neck, and shoulder muscles.

Steps: 1. Lie facedown on your stomach with your hands clasped together behind your back. **2.** Pulling your shoulders and chest from the floor, attempt to raise your hands so they are in line with your shoulders. **3.** Hold this position for ten seconds at a time before releasing and repeating.

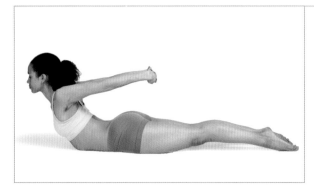

Upper-Back Extension with Clenched Fingers, Advanced

Target: Upper back.

Benefits: Counteracts poor posture and hunched shoulders by strengthening the upper back, neck, and shoulder muscles.

Steps: 1. Lie facedown on your stomach with your hands clasped together behind your back. **2.** Pulling your shoulders and chest from the floor, attempt to raise your clasped hands above your shoulders. **3.** Hold for twenty seconds at a time before releasing and repeating.

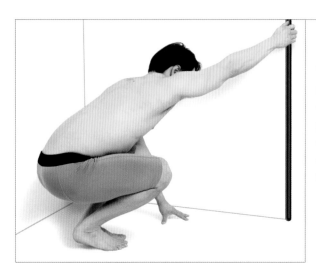

Upper-Back Reaching

Target: Upper back.

Benefits: Lengthens the muscles in the shoulders and across the lower back.

Steps: 1. Crouch low to the floor, beside a door frame or other vertical structure. **2.** Reach and grab hold of the door frame with your right hand. **3.** Pull your lower back away from your outstretched arm. **4.** Hold for twenty seconds.

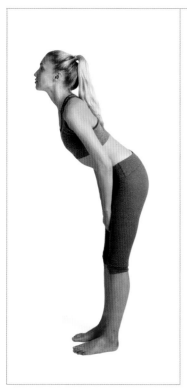
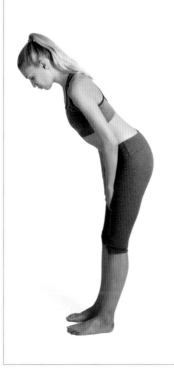

Upper-Back Shoulder Stretch

Target: Upper back.

Benefits: Opens your chest and contracts the muscles in your upper back and shoulders.

Steps: 1. Stand with your feet hip-width apart and your hands resting on top of your thighs. **2.** Bend your torso forward at the hips, so it is at a 45-degree angle to the floor, and keep your back straight. **3.** Pull your shoulders back and extend your chest while raising your head and looking straight ahead. **4.** Hold for ten seconds and relax your neck before repeating.

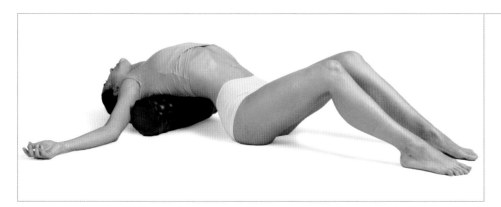

Upper-Back Stretch on Roller

Target: Upper back.

Benefits: Reduces pain and stiffness in the upper back.

Steps: 1. With your knees bent and feet on the floor, lower your upper back onto a foam roller.
2. Roll slowly from your upper back to the base of your ribcage, targeting any troubled muscles.

Note: For an advanced modification of this stretch, cross your arms over your chest.

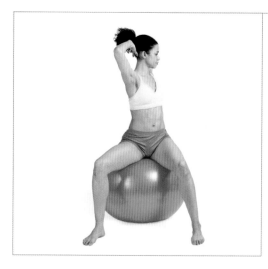

Upper-Back Twist, Arms Extended on Ball

Target: Upper back.

Benefits: Twists the spine and extends the upper back and chest while engaging the abdomen.

Steps: 1. Sit on an exercise ball with your legs apart and your hands resting on the back of your head. **2.** Twist your torso as far to the left as possible. **3.** Hold this position for fifteen seconds and alternate sides.

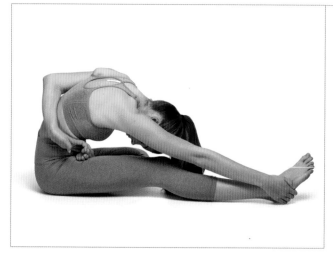

Western Intense Half-Bound Lotus Stretch

Target: Upper back.

Benefits: Increases flexibility in the upper back and hips.

Steps: 1. Begin by sitting on the mat with your legs straight out in front of you. **2.** Bend your left knee and pull your heel into half-lotus, resting it on your right hip. **3.** Reach your left arm across your back and clasp your left big toe. **4.** Lean forward and grab hold of your right foot with your right hand as you attempt to touch your forehead to your extended leg to lengthen the spine. **5.** Hold this position for ten seconds before alternating sides.

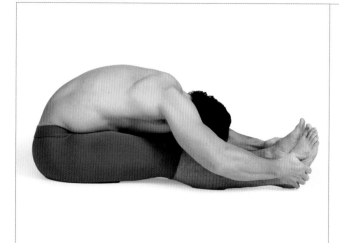

Western Intense Stretch

Target: Upper back.

Benefits: Extends the muscles across the upper back and spine while lengthening the hamstrings.

Steps: 1. Sit with your legs straight out in front of you. **2.** Lean forward, bending at the waist, dropping your shoulders and lowering your forehead to your shins. **3.** Reach your hands around the outsides of your heels, pulling the length of your spine. **4.** Hold for fifteen seconds.

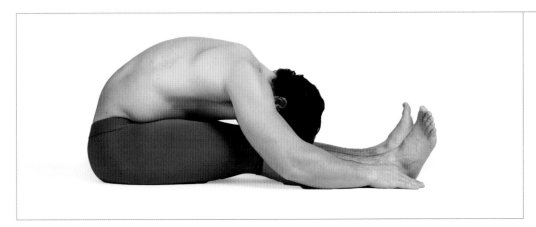

Western Intense Stretch, Advanced

Target: Upper back.

Benefits: Extends the muscles across the upper back and spine while lengthening the hamstrings.

Steps: 1. Sit with your legs straight out in front of you. **2.** Lean forward, bending at the waist, until you are able to place your forearms flat on the floor beside your legs. **3.** Continue to fold forward, dropping your shoulders and lowering your forehead to your legs. **4.** Hold for fifteen seconds.

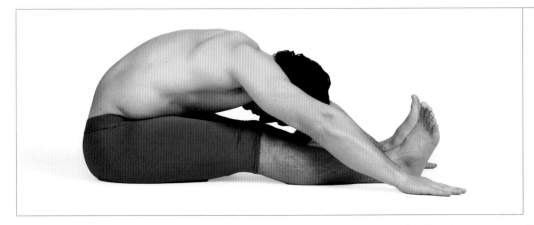

Western Intense Stretch, Advanced, Palms to Floor

Target: Upper back.

Benefits: Extends the muscles across the upper back and spine while lengthening the hamstrings.

Steps: 1. Sit with your legs straight out in front of you. **2.** Lean forward, bending at the waist, until your forehead is resting on your legs. **3.** Straighten your arms and rest your palms flat on the floor in front of your feet, lengthening the spine. **4.** Hold for twenty seconds.

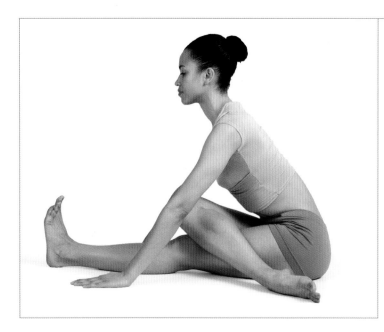

Western Intense Stretch, Half Cow Face Prep

Target: Upper back.

Benefits: Extends the muscles across the upper back and spine while lengthening the hamstrings and opening the hips.

Steps: 1. Sit with your legs straight out in front of you. **2.** Cross your right foot over the left leg and rest it on the floor beside your left hip. **3.** Lean forward, bending at the waist, and place your hands on the floor on either side of your extended leg. **4.** Hold for twenty seconds.

Western Intense Stretch, Half Cow Face

Target: Upper back.

Benefits: Extends the muscles across the upper back and spine, while lengthening the hamstrings and opening the hips.

Steps: 1. Sit with your legs straight out in front of you. **2.** Cross your left foot over your right thigh and rest it on the floor beside your right hip. **3.** Lean forward, bending at the waist, and place your hands on the floor on either side of your extended foot. **4.** Drop your head and shoulders, continuing to pull along the length of your spine. **5.** Hold this position for fifteen seconds before switching legs.

Western Intense Stretch, Half Cow Face Variation

Target: Upper back.

Benefits: Extends the muscles across the upper back and spine while lengthening the hamstrings and opening the hips.

Steps: 1. Sit with your legs straight out in front of you. **2.** Cross your left foot over your right leg and rest it on the floor beside your right hip. **3.** Lean forward, bending at the waist, until you are able to grab hold of your extended foot. **4.** Drop your head and shoulders, continuing to pull along the length of your spine. **5.** Hold this position for fifteen seconds before switching legs.

Western Intense Stretch, Hands to Toes

Target: Upper back.

Benefits: Lengthens the muscles in the upper back, shoulders, and spine while extending the hamstrings.

Steps: 1. Sit with your legs straight out in front of you. **2.** Lean forward, bending at the waist, and drop your shoulders as you attempt to lower your forehead to your legs. **3.** Reach your arms forward and grab hold of your toes, lengthening your spine. **4.** Maintain this position for twenty seconds.

Western Intense-Stretch Pose, Upward Side Infinity Revolved

Target: Upper back.

Benefits: Extends the muscles across the upper back while twisting open the spine, lengthening the hamstrings, and opening the hips.

Steps: 1. Sit with your legs straight out in front of you. **2.** Cross your left foot over your right thigh and rest it on the floor beside your right hip. **3.** Twist to the right, bending at the waist, and rest your right forearm on the floor. **4.** Increase the stretch by placing your left elbow on the floor near your right foot. **5.** Maintain this position for fifteen seconds before releasing and alternating sides.

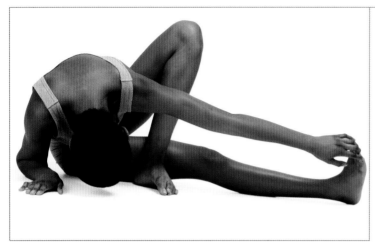

Western Intense-Stretch Pose, Hand-to-Foot Infinity Revolved, Head to Floor

Target: Upper back.

Benefits: Extends the muscles across the upper back while opening the spine and hips and lengthening the hamstrings.

Steps: 1. Sit with your legs straight in front of you. **2.** Cross your left foot over your right leg and rest it on the floor. **3.** With your left hand, grab your right foot and twist open your torso. **4.** Place your right forearm flat on the floor and try to reach your forehead to the floor. **5.** Maintain this position for fifteen seconds and alternate sides.

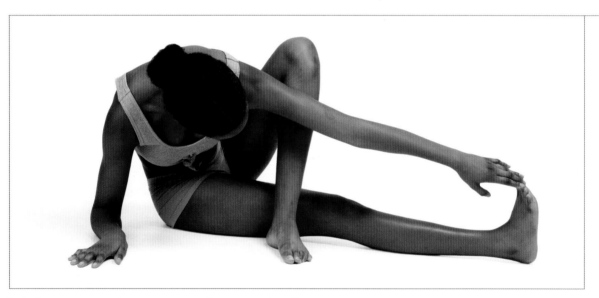

Western Intense-Stretch Pose, Hand-to-Foot Infinity Revolved

Target: Upper back.

Benefits: Extends the muscles across the upper back while twisting open the spine, lengthening the hamstrings, and opening the hips.

Steps: 1. Sit with your legs straight out in front of you. **2.** Cross your left foot over your right thigh, and rest it on the floor beside your right hip. **3.** Extend your left arm and grab your right foot while resting your right forearm flat on the floor. **4.** Maintain this position for fifteen seconds before releasing and alternating sides.

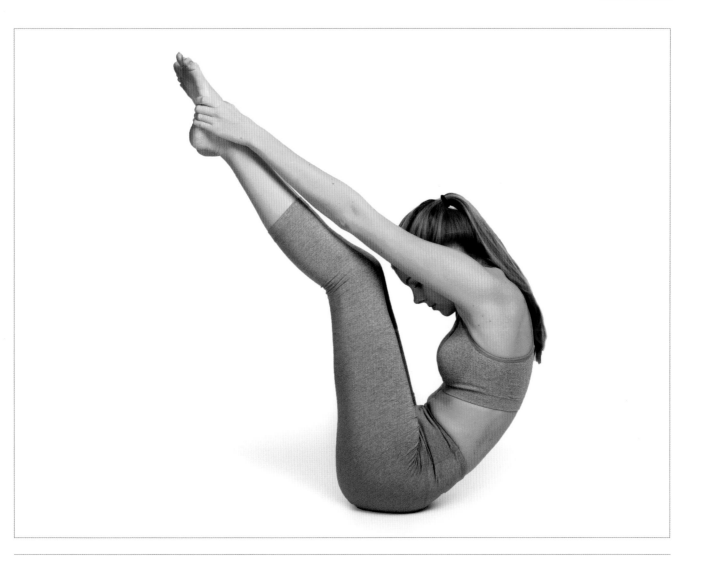

Western Intense Stretch, Upward Half Dog

Target: Upper back.

Benefits: Lengthens the spine while strengthening the abdominals, hip flexors, and upper back.

Steps: 1. Sit on the floor, with your knees bent, and grab your feet with either hand. **2.** Without letting go of your feet, extend your legs upward, balancing on your pelvic bones. **3.** Keeping your back straight, rest your forearms on your shins and try to bring your legs as close to your body as you can. **4.** Hold this position for fifteen seconds before releasing.

Chest Stretches

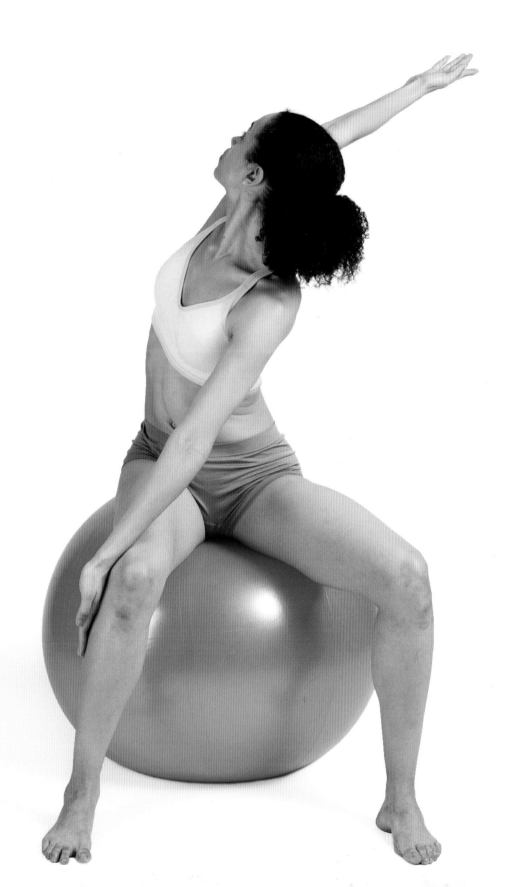

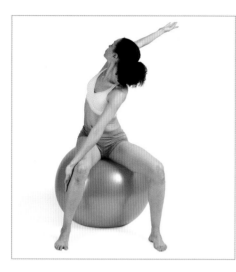

Chest Stretch, Spinal Twist on Ball

Target: Chest opener.

Benefits: Twists the spine and opens the chest.

Steps: 1. Sit on a fitness ball with your back straight and your legs about two feet apart. **2.** Twist your torso to the right and grab the outside of your right knee with your left hand. **3.** Extend your right hand up and behind you while gazing upward. **4.** Hold for fifteen seconds before switching sides.

Backbend, Arms Clasped Behind

Target: Chest opener.

Benefits: Opens the chest, improving posture and enabling range of motion.

Steps: 1. Stand up straight, with your hands clasped behind your back. **2.** Open your chest and drop your head back to face behind you. **3.** Attempt to pull your arms down toward the floor, arching your chest upward. **4.** Hold for fifteen seconds.

Benu Bird Pose 1

Target: Chest opener.

Benefits: Extends the chest and shoulders while opening the groin.

Steps: 1. Kneel on the floor and extend your right leg straight out to the side. **2.** Lean forward, bending at the hips, until your torso is parallel to the floor. **3.** Straighten your arms out to your sides. **4.** Hold for twenty seconds.

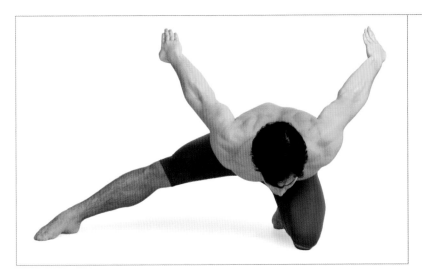

Benu Bird Pose, Advanced

Target: Chest opener.

Benefits: Extends the chest and shoulders while opening the groin.

Steps: 1. Kneel on the floor and extend your right leg straight out to the side. **2.** Lean forward, bending at the hips, until your torso is parallel to the floor. **3.** Straighten your arms out to your sides and attempt to lift your arms above and behind you. **4.** Hold for twenty seconds.

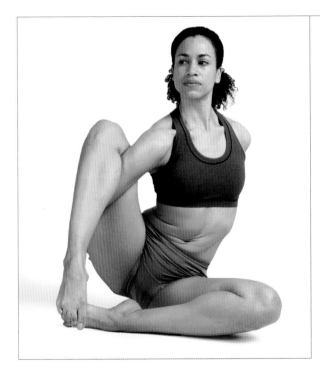

Binding and Twist

Target: Chest opener.

Benefits: Twists the spine and opens the chest while extending the adductor muscles.

Steps: 1. Sit with your feet together. **2.** Raise your right knee up to your chest and lower your left knee to the floor. **3.** Reach your right hand beneath your right knee and your right arm behind you, until you are able to clasp your hands behind your back in a bound position. **4.** Continue to twist your torso to the left to extend the stretch. **5.** Hold this position for ten seconds before alternating sides.

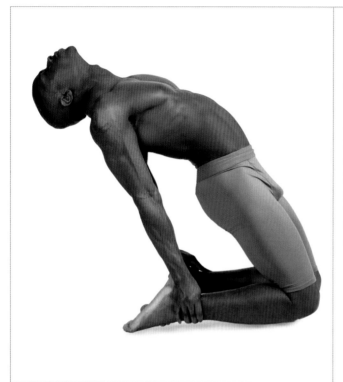

Bound-Ankle Chest Opener

Target: Chest opener.

Benefits: Fully extends the chest and stomach, relieving pain and tightness resulting from prolonged sitting or poor posture.

Steps: 1. Begin by kneeling upright with your knees hip-distance apart and your shins and the tops of your feet flat on the floor. **2.** Place your hands on your lower back, with your fingers pointing to the floor. Lengthen your tail bone down toward the floor and widen the back of your pelvis. **3.** Lean your head and shoulders back, reaching down to grab hold of either ankle. **4.** Hold for thirty seconds before releasing.

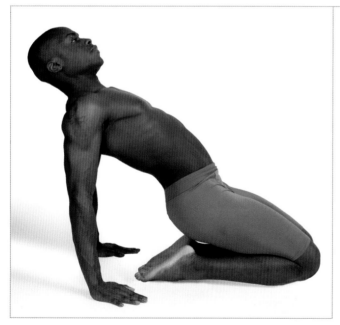

Bound-Ankle Chest Opener, Intense Wrist

Target: Chest opener.

Benefits: Fully extends the chest and stomach, relieving pain and tightness resulting from prolonged sitting or poor posture.

Steps: 1. Begin by kneeling upright with your knees hip-distance apart and your shins and the tops of your feet flat on the floor. **2.** Place your hands on your lower back, with your fingers pointing to the floor. Lengthen your tail bone down toward the floor and widen the back of your pelvis. **3.** Lean your shoulders back, while resting your palms down on the floor with your fingers pointing forward. **4.** Hold for thirty seconds before releasing.

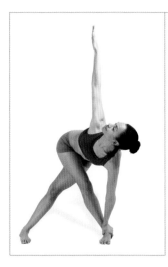

Revolved Triangle

Target: Chest opener.

Benefits: Opens the chest and spine while lengthening the muscles in the hip abductors.

Steps: 1. Standing straight, step your left leg behind your right so your feet are crossed and about two feet apart. **2.** Bend at the hips and twist your torso to the right, dropping your left hand down to your right foot. **3.** Continue the twist, raising your right arm straight up toward the ceiling and turning your gaze upward. **4.** Hold this position for fifteen seconds before alternating sides.

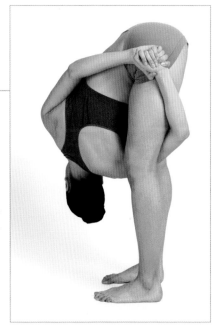

Bound Revolved, Half Intense-Chest Stretch Pose

Target: Chest opener.

Benefits: Opens the chest and extends the lats.

Steps: 1. Begin in a forward bend. **2.** Reach your left hand between your legs and up to toward your left hip. **3.** Extend your right arm across your back and clasp your hands together. **4.** Hold for twenty seconds.

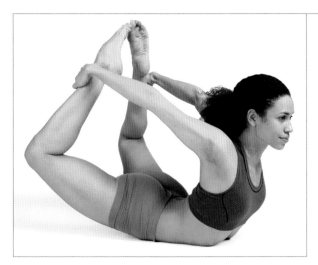

Bow Pose, Underhand Grip

Target: Chest opener.

Benefits: Deeply extends the chest and stomach while flexing the muscles in the back, shoulders, and glutes.

Steps: 1. Begin by lying flat on your stomach with your chin on the floor and your hands resting at your sides. **2.** Bend your knees, bringing your heels in toward your back. **3.** Reach around with both hands and grab hold of your ankles. **4.** Drawing your shoulder blades together, raise your shoulders and thighs off the floor. **5.** Hold for ten seconds before releasing.

Bow Pose, Upward

Target: Chest opener.

Benefits: Stretches open your chest while strengthening your arms, legs, and glutes.

Steps: 1. Lie flat on your back. **2.** Bend your elbows and place your palms flat on the ground beside your head. **3.** Pushing against your hands and feet, lift your torso, head, and hips from the ground. **4.** Relax your neck, letting your head hang. **5.** Hold this position for ten seconds.

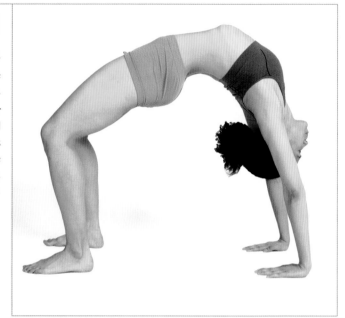

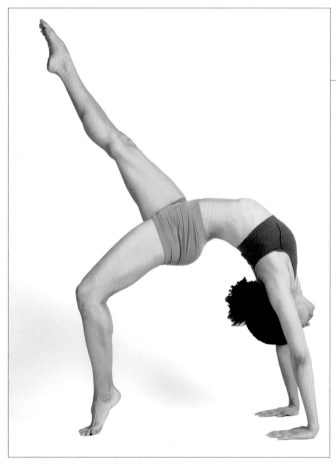

Bow Pose Upward, Advanced

Target: Chest opener.

Benefits: Opens your chest while strengthening the glutes and shoulders.

Steps: 1. Lie flat on your back. **2.** Bend your elbows and place your palms flat on the ground beside your head. **3.** Pushing against your hands and feet, lift your torso, head, and hips from the ground. **4.** From this position, extend your right leg straight into the air and raise your left foot onto tiptoes. **5.** Relax your neck, letting your head hang. **6.** Hold this position for ten seconds.

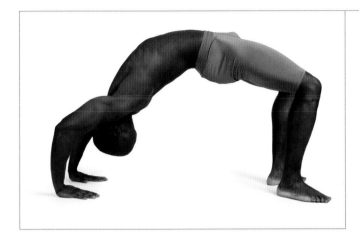

Bridge

Target: Chest opener.

Benefits: Extends the spine and hips while strengthening the glutes and quadriceps.

Steps: 1. Lie flat on your back with your knees bent. **2.** Reach your hands over your head and place your palms flat on the floor beside your head, with your fingers pointing toward your shoulders. **3.** Using your arms and legs, lift your body off the floor and round your back so your bellybutton is your highest point. **4.** Let your head and shoulders drop. **5.** Hold this pose for as long as you feel confident.

Bridge Tiptoe

Target: Chest opener.

Benefits: Extends the spine and hips while strengthening the glutes and quadriceps.

Steps: 1. Lie flat on your back with your knees bent. **2.** Reach your hands over your head and place your palms flat on the floor beside your head, with your fingers pointing toward your shoulders. **3.** Using your arms and legs, lift your body off the floor and round your back so your bellybutton is your highest point. **4.** Rise up onto your tiptoes and let your head and shoulders drop. **5.** Hold this pose for as long as you feel confident.

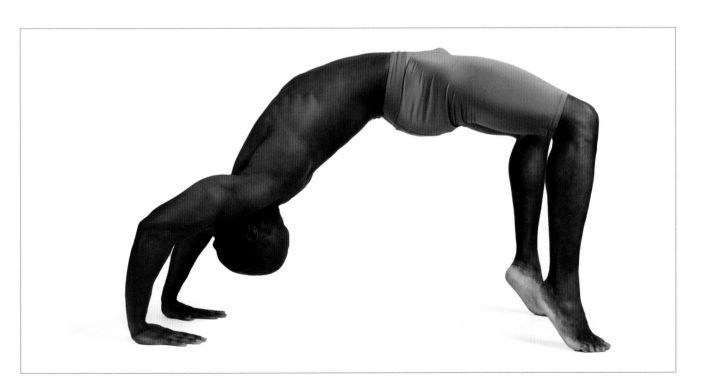

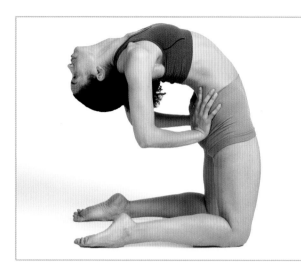

Camel Pose Prep

Target: Chest opener.

Benefits: Fully extends the chest and stomach, relieving pain and tightness resulting from prolonged sitting or poor posture.

Steps: 1. Begin by kneeling upright with your knees hip-distance apart and your shins and the tops of your feet flat on the floor. **2.** Place your hands on your lower back, with your fingers pointing up. **3.** Slowly lean backward so you are facing behind you. **4.** Press into your hips to widen the back of your pelvis. **5.** Hold for fifteen seconds.

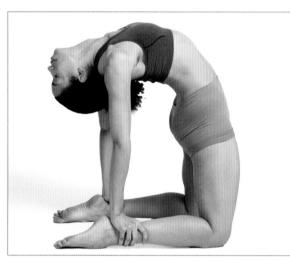

Camel Pose

Target: Chest opener.

Benefits: Fully extends the chest and stomach, relieving pain and tightness resulting from prolonged sitting or poor posture.

Steps: 1. Begin kneeling upright with your knees hip-distance apart and your shins and the tops of your feet flat on the floor. **2.** Place your hands on your lower back, with your fingers pointing up. **3.** Lengthen your tail bone down toward the floor and widen the back of your pelvis. **4.** Lean your head and shoulders back, reaching down to grab hold of either ankle. **5.** Hold for thirty seconds before releasing.

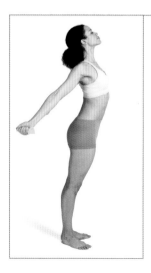 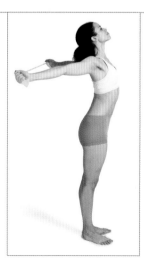

Chest Extension with Band

Target: Chest opener.

Benefits: Opens the chest and lengthens the muscles of the shoulders and triceps.

Steps: 1. Begin by standing straight, holding a resistance band in either hand behind your back. **2.** With both hands, raise the band up toward the ceiling. **3.** Hold for fifteen seconds.

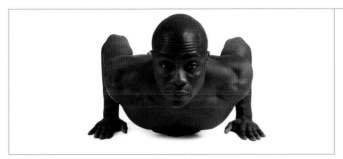

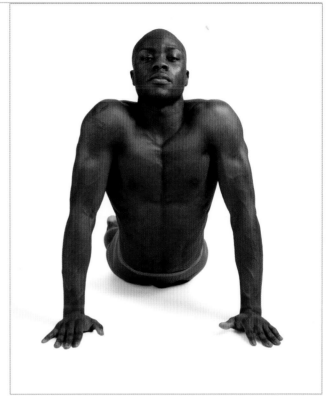

Chest Lift

Target: Chest opener.

Benefits: Extends the chest and lengthens the upper spine.

Steps: 1. Lie on your stomach, palms flat on the floor at chest level.
2. Using your arms for support, raise your chest up from the floor.
3. Hold for twenty seconds before lowering yourself down.

Chest Lift and Twist

Target: Chest opener.

Benefits: Strengthens the arms and lats while extending the chest and upper spine.

Steps: 1. Lie on your stomach, palms flat on the floor at chest level. **2.** Keeping one arm bent, straighten the other, and raise your chest to face one side. **3.** Hold this position for twenty seconds before alternating sides.

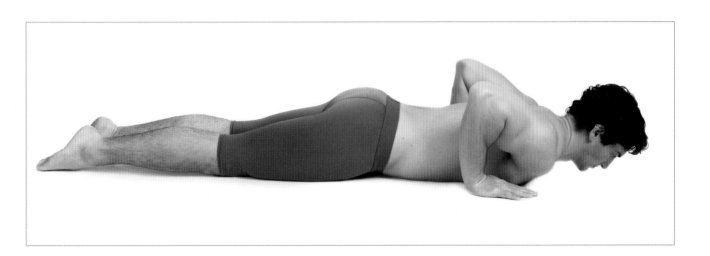

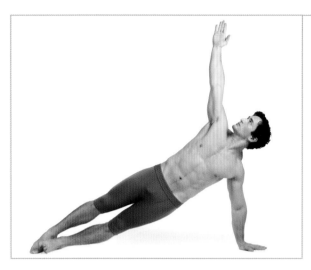

Chest Lift, Twist, and Raise

Target: Chest opener.

Benefits: Strengthens the arms and lats while extending the chest.

Steps: 1. Lie on your stomach, palms flat on the floor at chest level. **2.** Keeping your left arm bent, straighten your right arm and raise your chest, twisting it to face right. **3.** Using your left arm and foot for support, raise your right arm and hips from the floor into a side plank. **4.** Outstretch your right arm to the ceiling to fully open the chest. **5.** Hold for fifteen seconds before alternating sides.

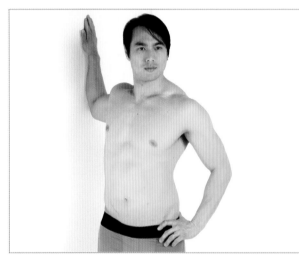

Chest Opener, Against the Wall

Target: Chest opener.

Benefits: Lengthens the muscles in the chest, triceps, and biceps.

Steps: 1. Stand with your right side perpendicular to a wall. **2.** Raise your right arm and press your forearm against the wall. **3.** Extend your chest toward your left. **4.** Hold for twenty seconds and repeat on the opposite side.

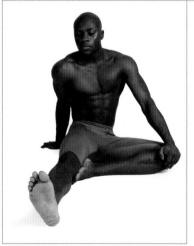

Chest Opener in Half-Lotus

Target: Chest opener.

Benefits: Opens the chest and the groin while extending the spine.

Steps: 1. Begin seated with your legs extended straight ahead of you. **2.** Bend your left knee outward and place your left hand on your bent knee. **3.** Plant your right hand on the floor behind your back and twist your upper torso to the right. **4.** Hold for twenty seconds and alternate sides.

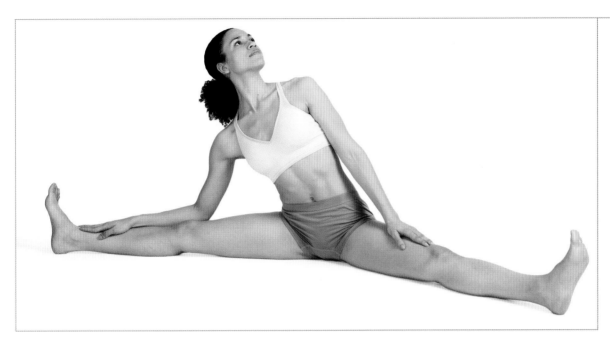

Chest Opener, Legs Wide Apart

Target: Chest opener.

Benefits: Releases tension and stress in the chest while lengthening the muscles in the groin.

Steps: 1. Begin seated with your legs spread wide apart and feet flexed. **2.** From this position, lower your right forearm to your right leg and twist your chest upward. **3.** Gaze upward and hold for twenty seconds.

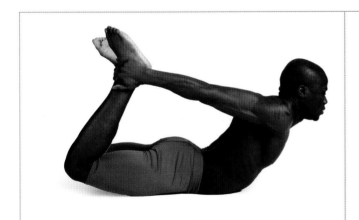

Chest Opener on Stomach

Target: Chest opener.

Benefits: Extends the chest, neck, and shoulders.

Steps: 1. Lie on your stomach with your knees bent and feet resting on your hips. **2.** Reach behind you and grab your ankles with either hand. **3.** Keeping hold of either ankle, raise your shoulders off the floor. **4.** Hold for twenty seconds.

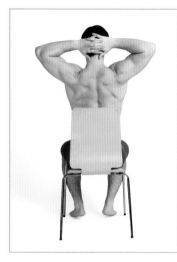

Chest Opener, Seated

Target: Chest opener.

Benefits: Flexes the muscles in the chest and shoulders.

Steps: 1. Seated on a chair, rest your hands behind your head, fingers clasped. **2.** Using your head for support, press your elbows backward. **3.** Hold for fifteen seconds.

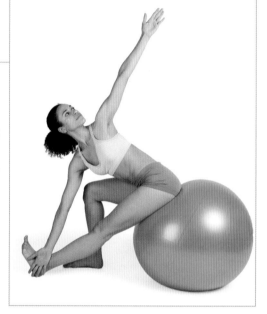

Chest Opener, Side Twist on Ball

Target: Chest opener.

Benefits: Opens the chests and shoulders while improving balance and engaging the core.

Steps: 1. Sit on an exercise ball and extend your left leg so it is resting on its heel. **2.** Twist your torso to the left and reach your right hand to the outside of your left ankle. **3.** Extend your left arm up toward the ceiling to open the chest. **4.** Hold for fifteen seconds and alternate sides.

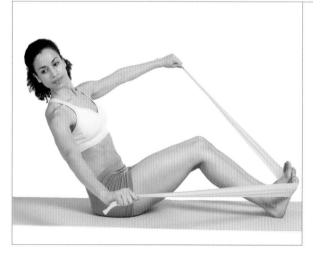

Chest Opener with Band Around Both Feet

Target: Chest opener.

Benefits: Opens the chest and strengthens the muscles of the shoulders and triceps.

Steps: 1. Sit with legs slightly bent and wrap a resistance band under both feet. **2.** Hold the ends of the band with either hand and spread your arms open and away from your torso against the resistance of the band. **3.** Hold for twenty seconds.

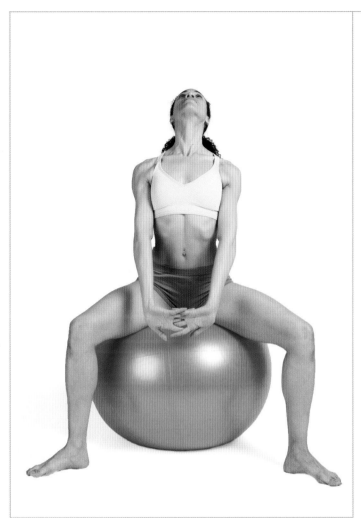

Chest Opener with Clasped Hands on Ball

Target: Chest opener.

Benefits: Opens the chest and extends the upper spine.

Steps: 1. Sit on an exercise ball with your legs spread wide apart. **2.** Clasp your hands, palms outstretched in front of you. **3.** Keeping your hands clasped, bend your neck backward, chin pointing toward the ceiling. **4.** Hold for fifteen seconds.

Chest Rotation, Seated

Target: Chest opener.

Benefits: Opens the chest and extends the upper spine.

Steps: 1. Begin seated on the floor, legs extended ahead. **2.** Bend your right leg and cross it over your left leg. **3.** Press your left forearm against your right knee for support and plant your right hand on the floor directly behind you. **4.** Twist open your torso and hold for twenty seconds before alternating sides.

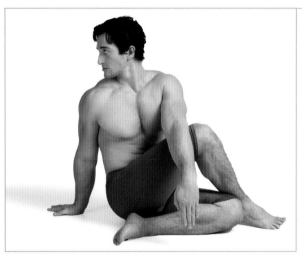

Chest Rotation, Seated Variation

Target: Chest opener.

Benefits: Opens the chest and extends the upper spine and hip abductors.

Steps: 1. Begin seated with knees bent. **2.** Drop your left knee to the floor and tuck your left foot under your right hip. **3.** Cross your right foot over your left thigh and plant it beside your left knee. **4.** Press your left arm against your right thigh for support and place your right hand on the floor directly behind you, twisting open your torso. **5.** Hold for twenty seconds before alternating sides.

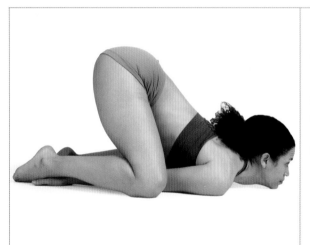

Chest to Ground

Target: Chest opener.

Benefits: Opens the chest and extends the upper spine.

Steps: 1. Begin in a kneeling position. **2.** Extend your arms downward, between your knees, and rest your palms on the floor beneath your feet. **3.** Place your chin on the floor and press your shoulders in to the floor. **4.** Hold for twenty seconds.

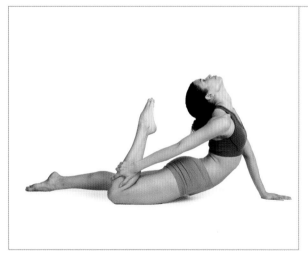

Cobra Pose, Advanced Modification

Target: Chest opener.

Benefits: Opens the chest and increases mobility in the back and spine.

Steps: 1. Begin by lying on your stomach, with your hands flat on the floor by your shoulders. **2.** Using your hands for support, raise your chest from the floor and straighten your arms. **3.** Bend your right leg, bringing your foot to rest on your butt. **4.** Reach back with your right hand and grab hold of your right shin. **5.** Pull back your shoulders and raise your gaze upward. **6.** Hold this position for fifteen seconds before switching to the other side.

Cobra Stretch Prep

Target: Chest opener.

Benefits: Opens the chest and increases mobility in the back and spine.

Steps: 1. Lie on your stomach, with your hands flat on the floor by your shoulders and your toes pointed.
2. Slowly raise your head from the floor, keeping your chin down, and hold for twenty seconds.

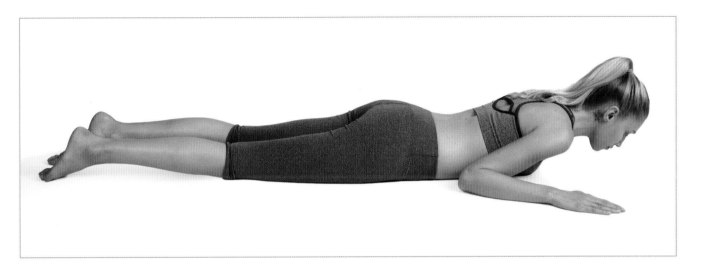

Cobra Stretch

Target: Chest opener.

Benefits: Opens the chest and increases mobility in the back and spine.

Steps: 1. Begin by lying on your stomach, with your hands flat on the floor by your shoulders. **2.** Using your hands for support, raise your chest from the floor and straighten your arms. **3.** Pull back your shoulders and raise your gaze upward. **4.** Hold this position for fifteen seconds before releasing.

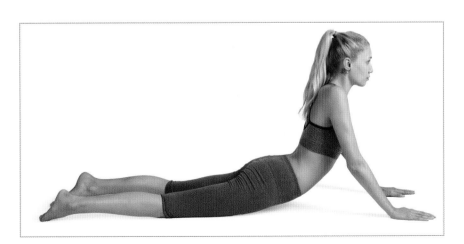

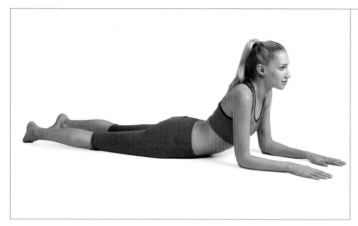

Cobra Stretch, Easy Modification

Target: Chest opener.

Benefits: Opens the chest and increases mobility in the back and spine.

Steps: 1. Begin by lying on your stomach, with your arms bent at your sides. **2.** Using your forearms for support, raise your chest from the floor. **3.** Pull back your shoulders and raise your gaze upward. **4.** Hold this position for fifteen seconds before releasing.

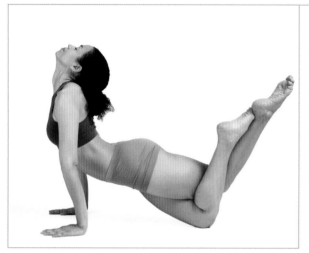

Cobra Twined-Legs Backbend

Target: Chest opener.

Benefits: Opens the chest and increases mobility in the back and spine while lengthening the hamstrings.

Steps: 1. Lie on your stomach, with your hands flat on the floor by your shoulders. **2.** Bend your legs and cross your left leg to rest on the other. **3.** Using your hands for support, lift your chest and hips off the floor. **4.** Pull back your shoulders and raise your gaze upward. **5.** Hold this position for fifteen seconds before releasing.

Cow Face Pose and Garuda

Target: Chest opener.

Benefits: Extends the chest and shoulders, improving mobility and posture.

Steps: 1. Kneel on the floor and cross your left leg over the other so your knees are bent and in line with each other. **2.** Join your palms in prayer position in front of your forehead. **3.** Lean your head and shoulders back, extending your hands over your head and down toward the floor behind you. **4.** Hold this position for fifteen seconds.

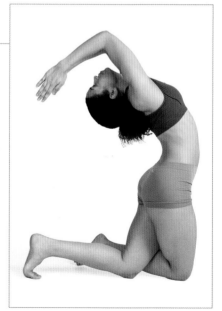

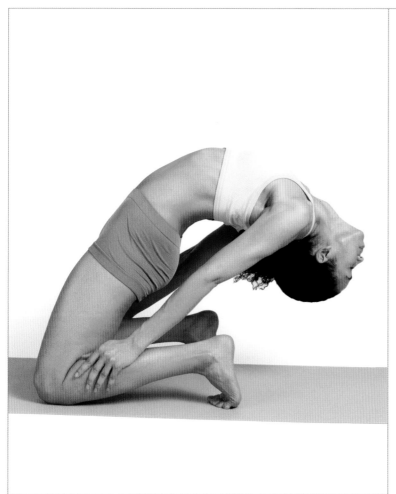

Crane Pose Tiptoe

Target: Chest opener.

Benefits: Opens the chest, neck, and shoulders, improving mobility and posture.

Steps: 1. Kneel on the floor, with your knees apart and arms at your sides. **2.** Lean your head and shoulders backward, sliding your hands down your legs to rest on your calves. **3.** Continue to pull your head as far down as possible. **4.** Hold this pose for ten seconds before releasing.

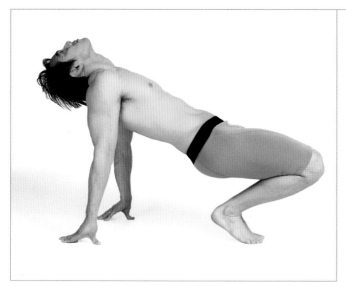

Eastern Intense Stretch

Target: Chest opener.

Benefits: Opens the chest and stomach while strengthening the arms, legs, and abdomen.

Steps: 1. Begin seated on the floor, with your palms flat on the floor a few inches behind your torso. **2.** Supporting yourself with your hands and feet, lift your hips from the floor so your torso creates a straight line between your knees and shoulders. **3.** Draw your shoulders down and release your head and neck. **4.** Hold for fifteen seconds.

Easy Spinal Twist

Target: Chest opener.

Benefits: Twists the spine and opens the chest.

Steps: 1. Stand with your feet shoulder-width apart. Cross your left arm over your abdomen, holding your right side. **2.** Turn your head toward your right shoulder, and begin to twist your torso to the right. **3.** Extend your right arm straight behind you to increase the effect of the stretch. **4.** Hold this pose for fifteen seconds before alternating sides.

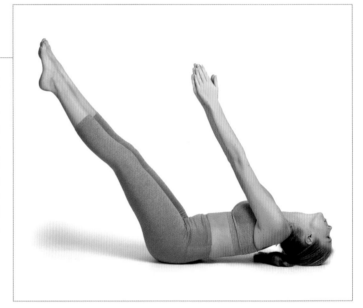

Extended Fish Pose

Target: Chest opener.

Benefits: Opens the neck and chest, while compressing the upper back and strengthening the abdomen.

Steps: 1. Lie on your back and rest the crown of your head on the floor so your neck is elongated. **2.** Raise your legs straight into the air at a 45-degree angle and extend your arms upward with your fingers pointing toward the ceiling. **3.** Hold for fifteen seconds.

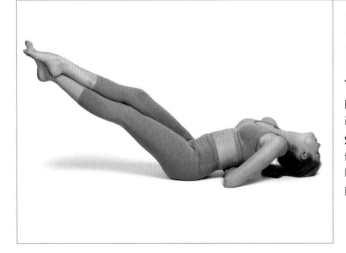

Extended Fish Pose with Prayer Hands

Target: Chest opener.

Benefits: Opens the neck and chest while lengthening the muscles in the shoulders and upper arms.

Steps: 1. Lie on your back and rest the crown of your head on the floor so your neck is elongated. **2.** Cross your ankles and raise your legs into the air at a 45-degree angle. **3.** Join your hands together in prayer pose beneath your arched spine.

Extended Four-Limbs Staff Pose

Target: Chest opener.

Benefits: Strengthens the muscles in the arms, hands, legs, and abdomen.

Steps: 1. Begin on all fours, with your palms placed beneath your shoulders. **2.** Lift both feet onto your toes and step your feet away from your torso. **3.** Using your hands and forearms, lift your hips from the floor. Make sure to create a straight line from your heels to your shoulders. **4.** Hold this pose for twenty seconds or longer.

Extended Four-Limbs Staff Pose, Arms Crossed

Target: Chest opener.

Benefits: Strengthens the muscles in the arms, hands, legs, and abdomen.

Steps: 1. Begin by lying on your stomach with your arms crossed and your palms placed beneath opposite shoulders. **2.** Lift both feet onto your toes and step your feet apart from one another. **3.** Using your hands and forearms, lift your body from the floor. Make sure to create a straight line from your heels to your shoulders. **4.** Hold this pose for twenty seconds or longer.

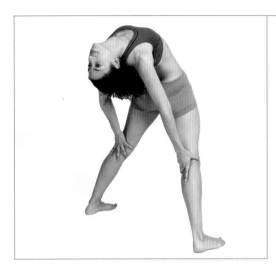

Feet-Spread Backbend

Target: Chest opener.

Benefits: Opens the chest while deeply bending the back and spine.

Steps: 1. Stand with your legs wide apart and your palms resting on your lower back. **2.** Pull back your head and shoulders, sliding your hands down your legs as you bend farther backward. **3.** Hold this position for fifteen seconds before returning upright.

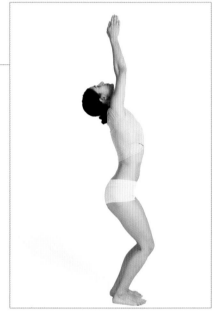

Fierce Pose 1

Target: Chest opener.

Benefits: Lengthens the spine and extends the chest upward.

Steps: 1. Stand with your feet at shoulder-width apart and your knees slightly bent. **2.** Extend your arms straight above you, pressing your palms together. **3.** Shift your gaze upward and lengthen your spine. **4.** Hold for fifteen seconds.

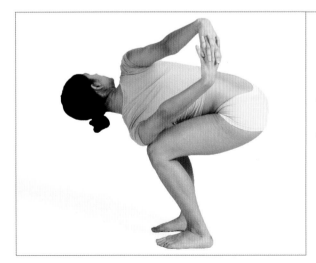

Fierce Pose 2, Revolved Bound

Target: Chest opener.

Benefits: Increases the flexibility of the spine and back and stretches the shoulders and chest.

Steps: 1. With your feet shoulder-width apart, crouch down toward the floor. **2.** Clasp your hands behind your back in a bound position. **3.** Twist your torso to the right and lift your ribcage, turning your gaze upward. **4.** Hold this position for fifteen seconds before releasing and switching sides.

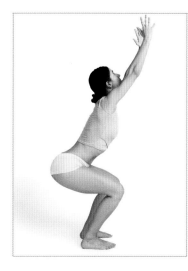

Fierce Pose, Extended

Target: Chest opener.

Benefits: Lengthens the spine and extends the chest upward.

Steps: 1. Stand with your feet at shoulder-width apart and your knees slightly bent. **2.** Crouch down toward the floor, and extend your arms straight above you with your fingers flared. **3.** Shift your gaze upward and lengthen your spine. **4.** Hold this position for fifteen seconds.

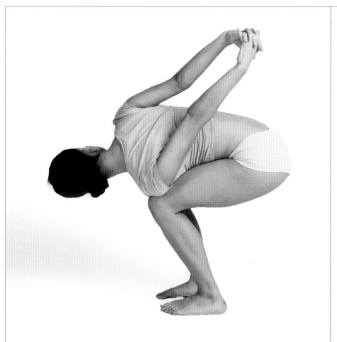

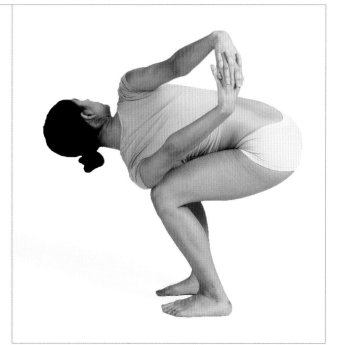

Fierce Pose Revolved, Hands Clasped

Target: Chest opener.

Benefits: Increases the flexibility of the spine and back and stretches the shoulders and chest.

Steps: 1. Stand with your feet shoulder-width apart and your knees slightly bent. **2.** Crouch down and lace your fingers behind your back. **3.** Straighten your arms behind you and twist your torso to your right. **4.** Attempt to raise your clasped hands as far up as you are able. **5.** Hold this position for fifteen seconds before alternating sides.

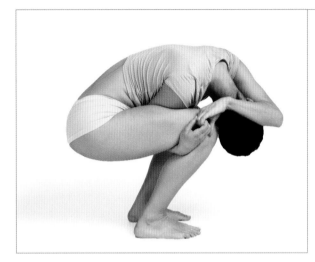

Fierce Pose Revolved, One Leg Bound

Target: Chest opener.

Benefits: Increases the flexibility of the spine and back while lengthening the spine and upper back.

Steps: 1. Stand with your feet shoulder-width apart and your knees slightly bent. Crouch down toward the floor. **2.** Weave your right arm under your right knee while wrapping your left arm behind your neck, and attempt to clasp your hands together in a bound position. **3.** Draw your shoulders upward and lengthen your spine. **4.** Hold this pose for twenty seconds before alternating sides.

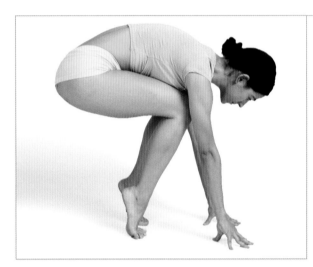

Fierce Pose, Tip-Forward Bend

Target: Chest opener.

Benefits: Lengthens the spine and shoulders while strengthening the calves and hamstrings.

Steps: 1. Stand with your feet shoulder-width apart and your knees slightly bent. **2.** Rise up onto your tiptoes, keeping your knees bent. **3.** Bend your torso forward at the waist, dropping your shoulders until you are able to touch the floor with your fingertips. **4.** Arch your back and attempt to pull the center of your spine up from the floor.

Fierce Pose, Tiptoe

Target: Chest opener.

Benefits: Lengthens the spine and extends the chest upward while strengthening the calves and hamstrings.

Steps: 1. Stand with your feet shoulder-width apart and your knees slightly bent. **2.** Rise up onto your tiptoes, keeping your knees bent. **3.** Raise your arms above your head, pointing toward the ceiling, lengthening your spine. **4.** Hold for twenty seconds.

Four-Limbs Staff Pose, One-Legged

Target: Chest opener.

Benefits: Strengthens the muscles in the arms, hands, legs, and abdomen.

Steps: 1. Begin on all fours with your palms flat on the floor below your shoulders. **2.** Lift both feet onto your toes and step them away from your torso. **3.** Using your hands and forearms, lift your hips from the floor, making sure to create a straight line from your heels to your shoulders. **4.** Lift your left foot from the floor, resting in on your right ankle. **5.** Hold this pose for twenty seconds or longer.

Garuda Legs

Target: Chest opener.

Benefits: Opens the chest and spine, engaging the muscles in the core.

Steps: 1. Begin by lying on your back, propped up on both elbows and with your knees bent. **2.** Cross your left leg over the other and tuck your left foot under your right ankle. **3.** Raise your right foot onto tiptoes. **4.** Keeping your right forearm on the floor, extend your left arm straight above you. Shift your gaze upward, opening your chest. **5.** Hold this position for thirty seconds before switching sides.

Gate Pose

Target: Chest opener.

Benefits: Lengthens the abdominal muscles along the sides while extending the neck, shoulders, and hamstrings.

Steps: 1. Begin by kneeling upright. **2.** Raise your left knee from the floor and extend your leg straight to your side, with your toes pointed out. **3.** Place your left hand flat on the floor in front of your outstretched thigh and extend your right arm overhead, with your palm pointing left. **4.** Resting your biceps against the side of your face, stretch your right arm upward and to the left. **5.** Turn your gaze up to the ceiling and hold this position for fifteen seconds before alternating sides.

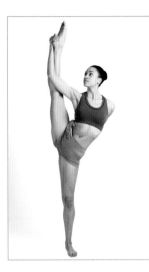

Half-Bound Leg-Extension Pose

Target: Chest opener.

Benefits: Twists open the chest and shoulders while deeply extending the groin and increasing balance.

Steps: 1. Stand straight and raise your right knee to your chest. **2.** Using your right hand, extend your leg straight up to your side in a standing split. **3.** Once you are balanced, wrap your left arm behind your back, holding on to your right hip in a half-bound position. **4.** Extend your gaze upward to complete the stretch. **5.** Hold this pose for ten seconds before switching sides.

Half-Bound Lotus Forward Bend

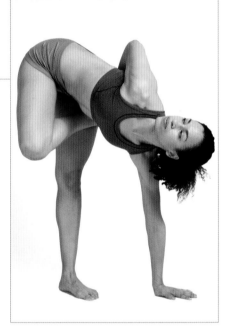

Target: Chest opener.

Benefits: Opens the chest and shoulders while lengthening the hip abductors and quads and improving balance.

Steps: 1. Begin by standing straight. Bending your right knee, grab your right foot with both hands and bring it in to your left hip. **2.** Holding your foot in position with your left hand, wrap your right hand around your back and grab your foot from behind in a bound position. **3.** Let go with your left hand and begin to bend forward at the waist. Place your left palm flat on the floor. **4.** Twist your torso further to the right, shifting your gaze to the ceiling. **5.** Hold this position for fifteen seconds before releasing and switching sides.

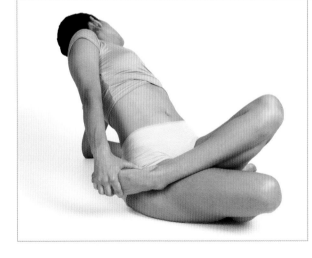

Half-Bound Sideways, Easy Leg Position of Cow Face Pose 2

Target: Chest opener.

Benefits: Opens the chest and groin while extending the muscles across the upper back.

Steps: 1. Begin by sitting on the floor with your legs crossed. Lift your left foot from the floor and tuck it into your right hip. **2.** Hold your foot with your right hand and begin to lean back. **3.** Place your left forearm on the floor behind you for support. **4.** Twist your head and shoulders farther to the left to maximize the stretch. **5.** Hold this position for fifteen seconds before alternating sides.

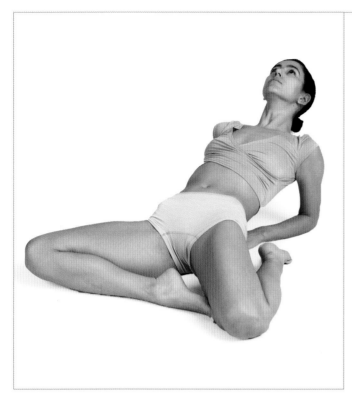

Half-Hero Bound, Half-Bound, Angle Variation

Target: Chest opener.

Benefits: Opens the chest and groin while extending the neck and shoulders.

Steps: 1. Sit on the floor with your left foot bent behind you and your right foot bent into your groin. **2.** Lean your shoulders back, resting both elbows on the floor for support. **3.** Drop your head and shoulders back to complete the stretch. **4.** Hold for twenty seconds before alternating sides.

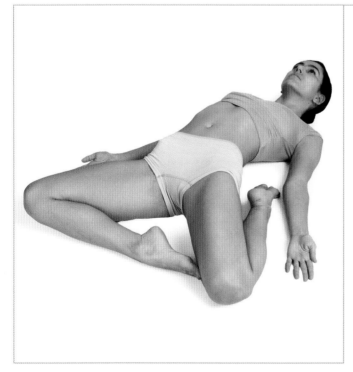

Half-Hero Bound, Half-Bound, Angle Variation

Target: Chest opener.

Benefits: Opens the chest and groin while extending the neck and shoulders.

Steps: 1. Sit on the floor with one foot bent behind you and your right foot bent into your groin. **2.** Lean your shoulders back, resting both elbows on the floor for support. **3.** Continue to lean back until your head and shoulders are resting flat on the floor. **4.** Extend your arms at your sides and hold for twenty seconds before alternating sides.

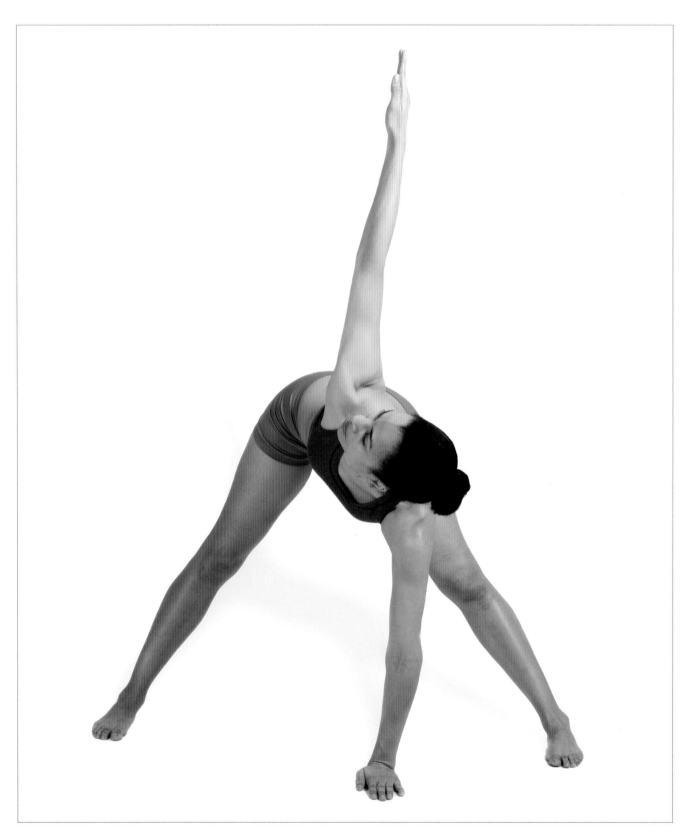

Half Feet-Spread-Out, Intense Stretch Revolved

Target: Chest opener.

Benefits: Extends the arms and chest while stretching the muscles in the groin.

Steps: 1. Stand with your legs wide apart and arms straight out to your sides. **2.** Begin to drop your torso down in a forward bend, while twisting to your right side. Continue bending until you are able to place your left palm flat on the floor. **3.** Extend your right arm overhead and shift your gaze up toward your raised hand, pulling your hand as high toward the ceiling as you are able. **4.** Hold this position for thirty seconds before alternating sides.

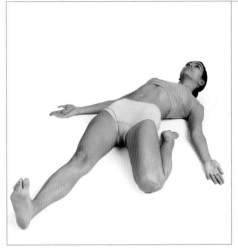

Half-Hero Bound, Half-Bound Angle, Variation 2

Target: Chest opener.

Benefits: Opens the chest and groin while extending the neck and shoulders.

Steps: 1. Sit on the floor with your left foot bent behind you and the other bent into your groin. **2.** Lean your shoulders back and rest your elbows on the floor for support. **3.** Continue to lean back, dropping your head and shoulders flat on the floor. **4.** Extend your arms at your sides and straighten your right leg.

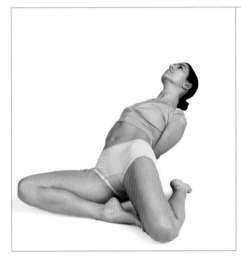

Half-Hero, Half-Bound Angle Stretch

Target: Chest opener.

Benefits: Opens the chest and groin while extending the neck and shoulders.

Steps: 1. Sit on the floor with your left foot bent behind you and the other bent into your groin. **2.** Lean your shoulders back, resting both elbows on the floor for support. **3.** Cross your left arm behind your back and touch your hand to your right hip. **4.** Hold for fifteen seconds before alternating sides.

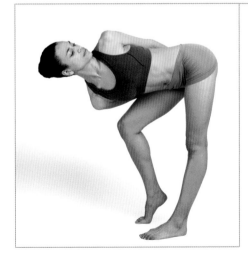

Half Intense-Stretch Pose, Hands-Bound Uneven Legs

Target: Chest opener.

Benefits: Opens the chest, neck, and shoulders while lengthening the calves, hamstrings, and hip abductors.

Steps: 1. Stand with your feet shoulder-width apart and your hands clasped behind your back. **2.** Prop your right leg up on tiptoes, bending slightly at the knee. **3.** Begin to lower your torso forward, bending at the waist and twisting to your left. **4.** Continue to bend until your back is parallel to the floor. **5.** Raise your gaze upward and hold this position for fifteen seconds before switching sides.

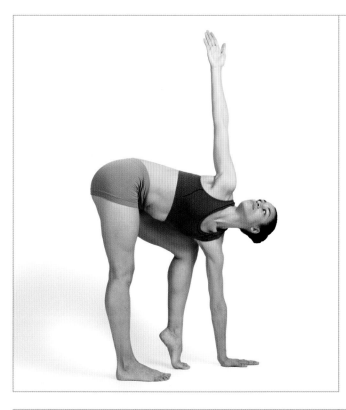

Half Intense-Stretch Pose, Revolved Uneven Legs

Target: Chest opener.

Benefits: Opens the chest, neck, and shoulders while lengthening the calves, hamstrings, and hip abductors.

Steps: 1. Stand with your feet shoulder-width apart and your arms straight out at your sides. **2.** Prop one leg up on tiptoes, bending slightly at the knee. **3.** Begin to lower your torso forward, bending at the waist and twisting in the opposite direction of your propped foot. **4.** Continue to bend until you are able to place your lower palm flat on the ground. **5.** Raise your gaze upward and hold this position for fifteen seconds before switching sides.

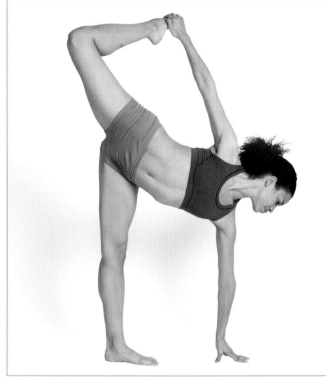

Half-Moon Bent Hand to Foot

Target: Chest opener.

Benefits: Opens the chest, groin, and hamstrings while improving strength and balance.

Steps: 1. Stand straight with your arms out at your sides. **2.** Shifting all your weight onto your left foot, begin to bend your torso forward and raise your right leg behind you. **3.** Continue bending until your back is parallel to the ground and your right leg is straight out behind you. **4.** Twist your torso to the right while placing your left palm flat on the floor and extending your right arm straight above you. **5.** Bend your right leg and reach around with your right hand to grab hold of your foot. **6.** Push your right hand and foot toward the ceiling and shift your gaze upward to fully open your shoulders and chest. **7.** Hold for fifteen seconds before alternating sides.

Half-Moon on Ball 2

Target: Chest opener.

Benefits: Opens the chest, groin, and hamstrings while improving balance and engaging the core.

Steps: 1. Standing straight in front of an exercise ball, step your right foot backward and extend your arms out to your sides. **2.** Shifting your weight onto your left foot, begin to bend your torso forward and raise your right leg. Continue bending until you are able to rest your left palm on the ball. **3.** Twist your torso to the right and extend your right arm straight behind you. **4.** Shift your gaze up to the ceiling to fully open your chest and shoulders. **5.** Hold for fifteen seconds and alternate sides.

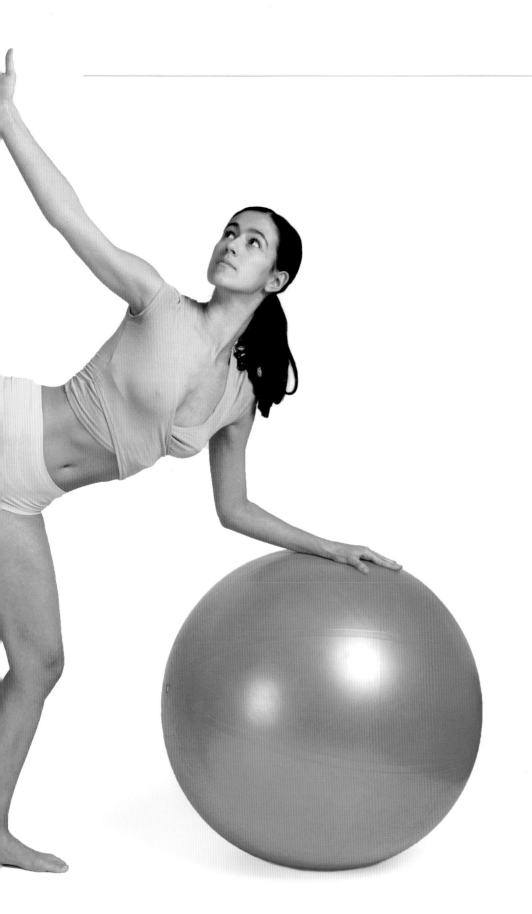

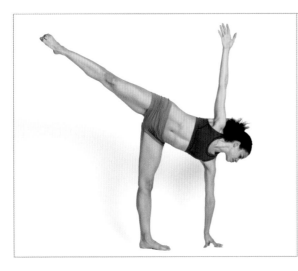

Half-Moon Pose

Target: Chest opener.

Benefits: Opens the chest, groin, and hamstrings while improving strength and balance.

Steps: 1. Standing straight, step your left foot forward and extend your arms straight out to your sides. **2.** Shift all your weight onto your left foot and begin to bend your torso forward while raising your right leg. Continue bending until your back is parallel to the floor and your right leg is straight out behind you. **3.** Twist your torso to the right, placing your left palm flat on the floor and extending your right arm straight above you. **4.** Hold for fifteen seconds and repeat on the opposite side.

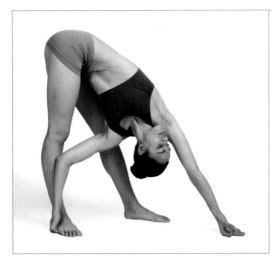

Intense-Stretch Pose with Chest Opener

Target: Chest opener.

Benefits: Opens the chest and shoulders while lengthening the hamstrings and spine.

Steps: 1. Stand with your legs apart and your arms at your sides. **2.** Bend your torso forward from the hips and reach your left hand to your right foot. **3.** Keeping hold of your foot, extend your right hand to the floor and twist your torso outward and to the right. **4.** Hold this position for fifteen seconds before alternating sides.

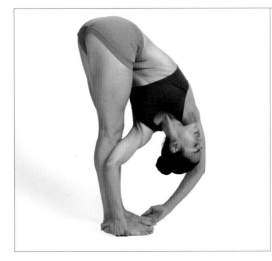

Intense-Stretch Pose with Chest Opener Bound

Target: Chest opener.

Benefits: Deeply opens the chest and shoulders, twists the spine, and lengthens the hamstrings.

Steps: 1. Stand with your legs hip-width apart and your arms at your sides. **2.** Bend your torso forward from the hips and reach your left hand to your right foot. **3.** Keeping hold of your foot, twist your torso outward and rest your right hand beside your left foot. **4.** Hold this position for fifteen seconds before alternating sides.

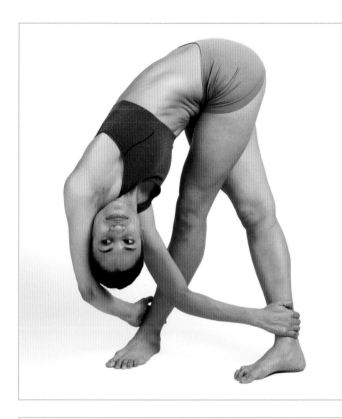

Intense Stretch Pose with Chest Opener, Bound and Twisted

Target: Chest opener.

Benefits: Twists the spine and opens the chest and shoulders, while lengthening the hamstrings and hip abductors.

Steps: 1. Standing straight, cross your left leg in front of your right. **2.** Bend your torso forward from the hips and place your left hand on your left ankle. **3.** Keeping hold of your ankle, twist your torso to your left and grab hold of your right ankle with your right hand. **4.** Hold this position for fifteen seconds before alternating sides.

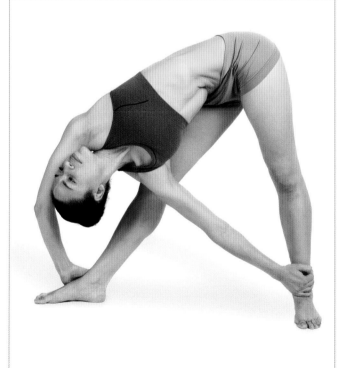

Intense Triangle Pose, Revolved Forward Bend

Target: Chest opener.

Benefits: Twists the spine and opens the chest and shoulders, increasing flexibility and mobility in the back and shoulders.

Steps: 1. Stand with your legs about two feet apart, your left foot pointing forward and your right foot pointing out to the side. **2.** Bend your torso forward from the hips, dropping your left hand to your right ankle. **3.** Keeping hold of your ankle, twist your torso to your left and reach your right hand to the outside of your left ankle. **4.** Raise your gaze up to the ceiling to fully open your chest and shoulders. **5.** Hold this position for fifteen seconds before alternating sides.

Chest Stretches

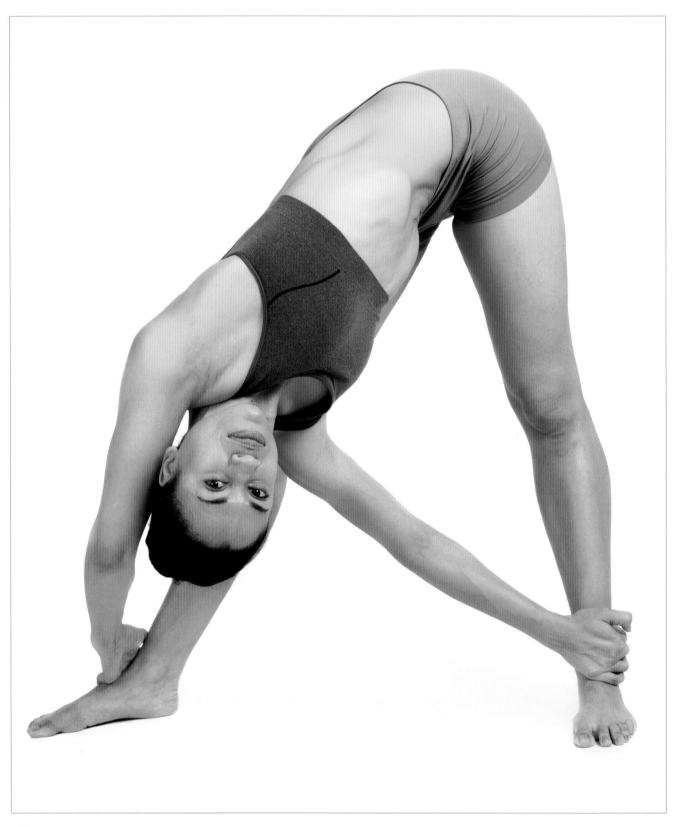

198

Intense Triangle Pose, Revolved Forward Bend Prep

Target: Chest opener.

Benefits: Twists the spine and opens the chest and shoulders, increasing flexibility and mobility in the back and shoulders.

Steps: 1. Stand with your legs apart, with your left foot pointing forward and your right foot pointing out to the side. **2.** Bend your torso forward from the hips, dropping your left hand to your right ankle. **3.** Keeping hold of your ankle, twist your torso to your left and reach your right hand to the outside of your left ankle. **4.** Hold this position for ten seconds before alternating sides.

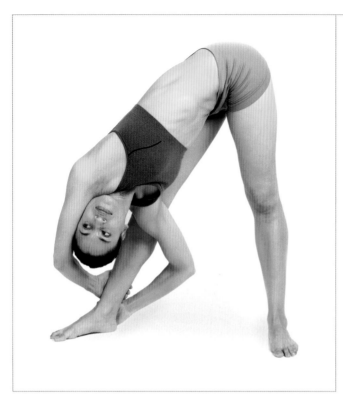

Intense Triangle Pose, Revolved to One Side

Target: Chest opener.

Benefits: Twists the spine and opens the chest and shoulders, increasing flexibility and mobility in the back and shoulders.

Steps: 1. Stand with your legs about two feet apart, your left foot pointing forward and your right foot pointing out to the side. **2.** Bend your torso forward from the hips, dropping your left hand to your right ankle. **3.** Twist your torso to the left and reach your right hand behind your right foot to meet your left hand. **4.** Hold this position for fifteen seconds before alternating sides.

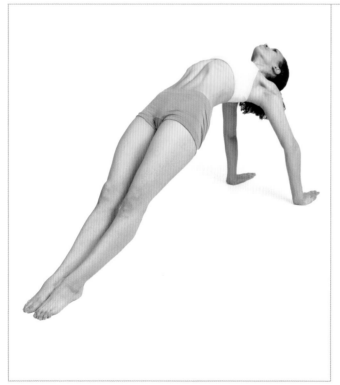

Inverse-Plank Chest Opener

Target: Chest opener.

Benefits: Opens the chest while engaging the arms and core for support.

Steps: 1. Sit on the floor, with legs straight ahead and hands flat on the ground pointed behind the body. **2.** Using your hands for support, lift your hips from the ground, straightening your legs. **3.** Hold this pose for ten seconds to strengthen the core and open the chest.

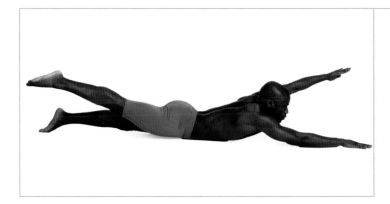

Leg Raise Rear Superman

Target: Chest opener.

Benefits: Strengthens the glutes and chest.

Steps: 1. Begin by lying flat your stomach, toes pointed and arms straight ahead. **2.** Raise your left arm and right leg simultaneously. **3.** Hold this position five or more seconds, keeping arms and legs straight, and then alternate sides.

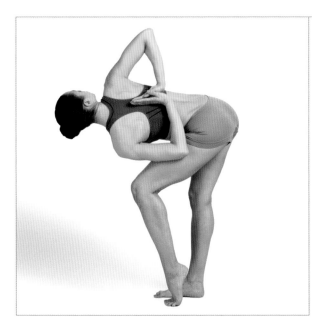

Reverse Prayer, Revolved Uneven-Legs, Half-Intense Stretch

Target: Chest opener.

Benefits: Twists the spine and opens the chest and shoulders while lengthening the spine and hamstrings.

Steps: 1. Stand with your feet shoulder-width apart and your palms pressed together in reverse prayer pose behind your back. **2.** Prop your left leg up on tiptoes, bending slightly at the knee. **3.** Begin to bend your torso forward while twisting to the right. **4.** Continue bending until your back is parallel to the floor. **5.** Raise your gaze upward and hold this position for fifteen seconds before switching sides.

Lower-Trunk Flexor, Standing

Target: Chest opener.

Benefits: Opens the chest and neck, improving posture and range of motion in the back and shoulders.

Steps: 1. Stand with your feet shoulder-width apart and your knees slightly bent. **2.** Drop your head to your shoulders, opening your neck and chest. **3.** Pull your shoulders back, leaning into a backbend, so your chin is pointed toward the ceiling. **4.** Hold this position for thirty seconds before releasing.

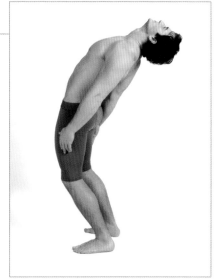

Revolved Feet-Spread-Out Intense Stretch

Target: Chest opener.

Benefits: Opens the chest and twists the spine, extending the muscles in the groin.

Steps: 1. Stand with your legs wide apart, and your torso bent parallel to the floor. **2.** Reach your right arm down to your left ankle. **3.** Continue to twist your torso to the left, reaching your left arm behind your back to your right thigh. **4.** Extend your gaze upward and hold this position for fifteen seconds before switching directions.

Revolved Plank

Target: Chest opener.

Benefits: Opens the neck and chest while strengthening the arms, legs, and core.

Steps: 1. Sit on the floor with your knees bent and your palms on the floor behind you, fingers pointed forward. **2.** Lift your hips from the floor, keeping your knees bent and your thighs and torso parallel to the floor. **3.** One at a time, step your legs out straight, keeping your hips and shoulders raised. **4.** Let your head drop behind you, fully extending your chest and neck. **5.** Hold this position for fifteen seconds or more.

Revolved Staff Pose, Upward, One Arm Extended, Hand to Foot

Target: Chest opener.

Benefits: Opens the outer hips and chest, lengthening the body.

Steps: 1. Sit on the floor with your legs straight in front of you. **2.** Twist your torso to the right and bring your left hand to your right foot. **3.** Extend your right arm behind you, creating a straight line with both arms. **4.** Shift your gaze upward toward your raised hand to fully open the chest and shoulders and hold for twenty seconds before alternating sides.

Revolved Angle Pose, Advanced

Target: Chest opener.

Benefits: Openers the chest and hips.

Steps: 1. Step your left leg far forward, bending at the knee and raising your right foot onto tiptoes to lower into a deep lunge. Place both palms flat on the floor beside your front foot for support. **2.** Raise your left foot onto tiptoes and lift your hands onto their fingertips. **3.** Extend your left arm straight above you. **4.** Hold for fifteen seconds and alternate sides.

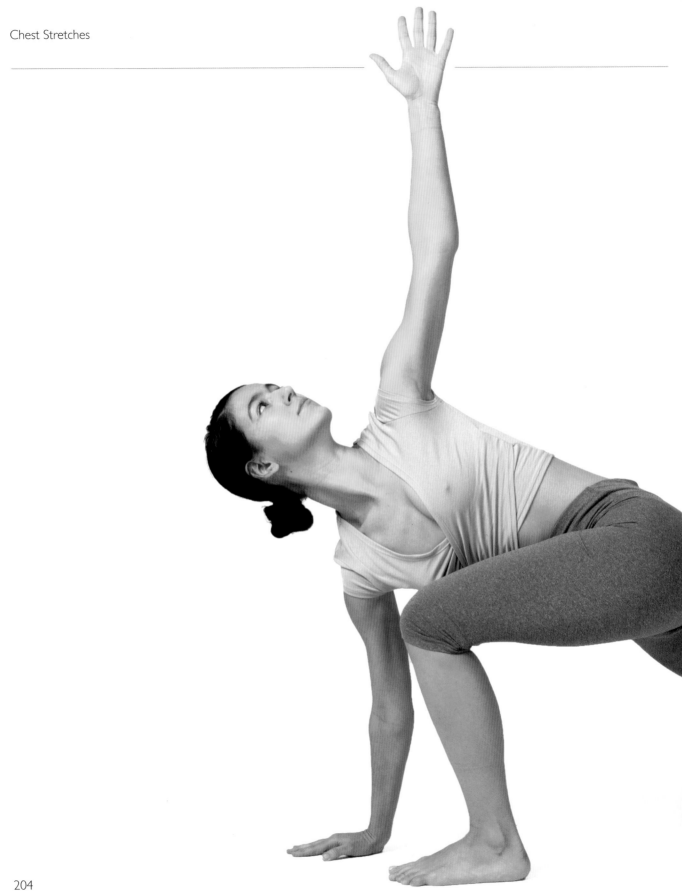

Revolved Angle Pose

Target: Chest opener.

Benefits: Opens the chest and shoulders, while increasing strength and flexibility in the legs and hips.

Steps: 1. Step your left leg far forward, bending at the knee and raising your right foot onto tiptoes to lower into a deep lunge. Place both palms flat on the floor beside your left foot for support. **2.** Lift your left hand from the ground, and extend your arm straight above you. Shift your gaze up toward your hands to fully open your chest. **3.** Hold this pose for fifteen or more seconds before switching sides.

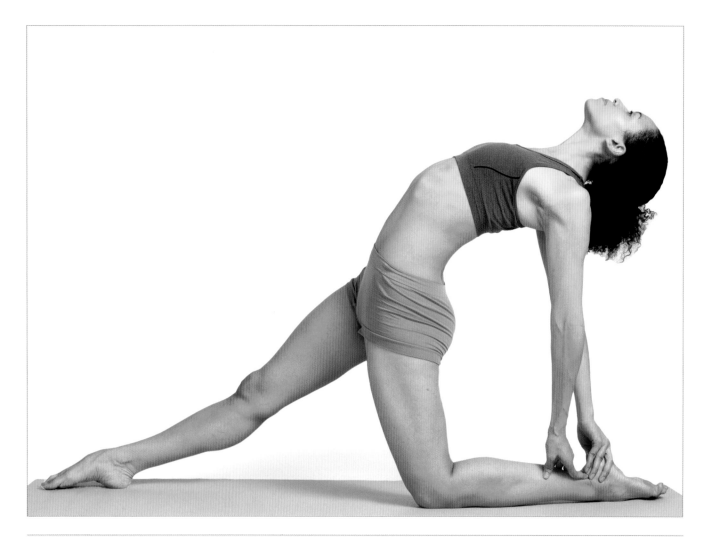

Son of Anjani, Both Hands to Foot, Front Leg Straight

Target: Chest opener.

Benefits: Opens the chest and shoulders while lengthening the muscles in the groin and legs.

Steps: 1. Start with your hands and feet on the floor and your hips pointed upward, in a downward dog position. **2.** Step your right foot forward in between your palms and lower your left knee to the ground, lifting your foot to rest on its top. **3.** Lift your palms from the floor and press your hips lower to the ground. **4.** Drop your head and pull your shoulders back into a backbend. Continue to arch your chest, reaching hold of your left ankle with both hands. **5.** Hold this position for ten seconds or longer.

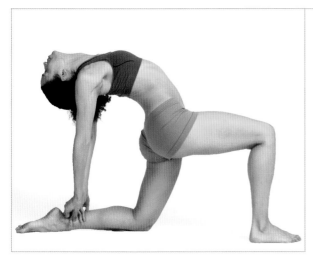

Son of Anjani Lunge, Both Hands to Foot

Target: Chest opener.

Benefits: Opens the chest and shoulders while lengthening the muscles in the groin and legs.

Steps: 1. Start with your hands and feet on the floor in a downward dog position. **2.** Step your right foot forward in between your palms and lower your left knee to the ground, lifting your foot to rest on its top. **3.** Lift your palms from the floor and lean into a backbend, dropping your head and pulling your shoulders back. **4.** Reach for your left ankle with both hands. **5.** Hold for ten seconds and alternate sides.

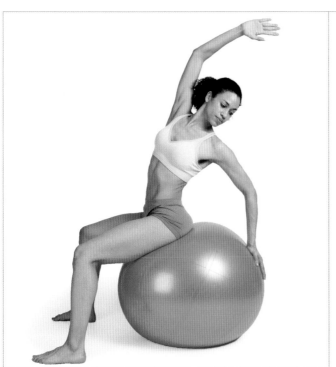
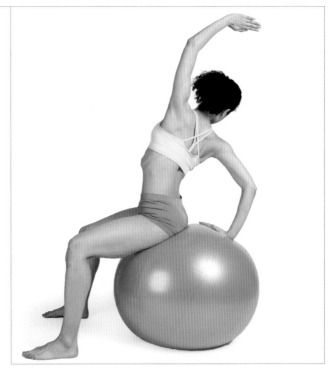

Spinal Twist on Ball

Target: Chest opener.

Benefits: Twists the spine and extends the chest and shoulders, while engaging the core.

Steps: 1. Sit on an exercise ball with your knees apart. **2.** Place your left palm flat on the back of the ball. **3.** Extend your right arm overhead and stretch it down toward the floor behind you. **4.** Turn your gaze to the ground and hold this position for ten seconds before alternating sides.

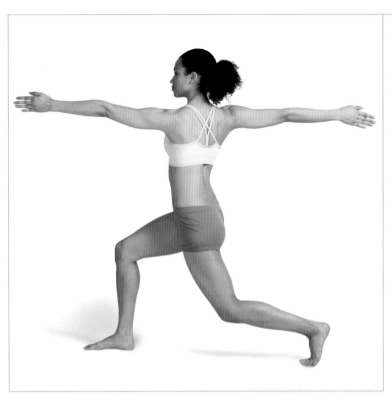

Thigh-Quad Anterior Stretch

Target: Chest opener.

Benefits: Opens the chest and spine while strengthening the legs.

Steps: 1. Stand with your arms straight out to your sides. **2.** Step your right foot forward, and bend both knees into a lunge position. **3.** Twist your torso to the right side and hold for ten seconds, then twist to the left and hold for ten more seconds. **4.** Alternate legs and repeat.

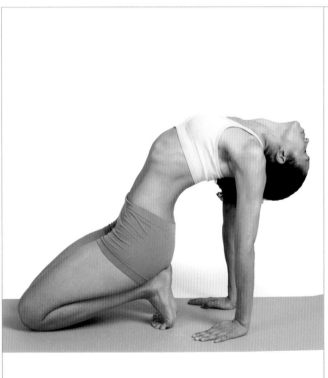

Thunderbolt Pose Tiptoe

Target: Chest opener.

Benefits: Lengthens the spine, toes, and shoulders while opening the chest.

Steps: 1. Begin by kneeling with your legs and feet together. Lift both feet onto tiptoes and lower your hips onto your heels. **2.** Lean back and place your palms flat on the floor behind you with your fingers pointed forward. **3.** Drop your head and shoulders behind you to fully extend your chest. **4.** Hold for twenty seconds.

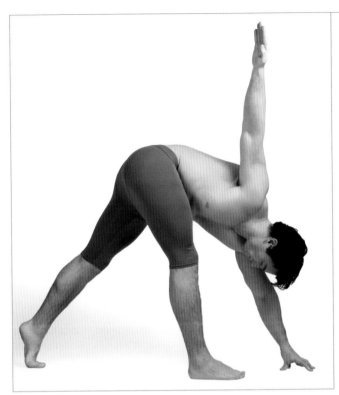

Uneven-Legs Tiptoe, Intense Side-Stretch Pose

Target: Chest opener.

Benefits: Opens the chest and shoulders while lengthening the calf and hamstrings.

Steps: 1. Stand with your arms straight out to your sides. Step your right foot forward, propping your left foot up on to tiptoes. **2.** Fold your torso forward, simultaneously twisting to the right. **3.** Place your left hand on the floor and extend your right hand above you. **4.** Hold for thirty seconds and alternate sides.

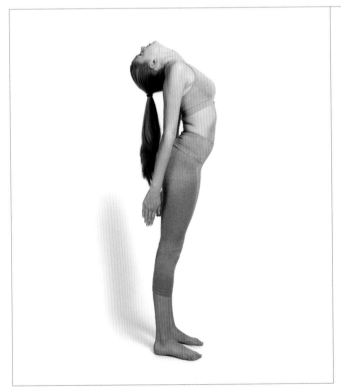

Upward-Facing Dog Back and Neck Stretch

Target: Chest opener.

Benefits: Stretches open the front of the body, improving posture and strengthening the muscles in the back and shoulders.

Steps: 1. Begin by standing straight, with your feet shoulder-width apart and your arms straight at your sides. **2.** Pull your shoulders back, extending your chest upward. **3.** Let your head drop to your shoulders, to fully open the chest. **4.** Hold for twenty seconds.

Core Stretches

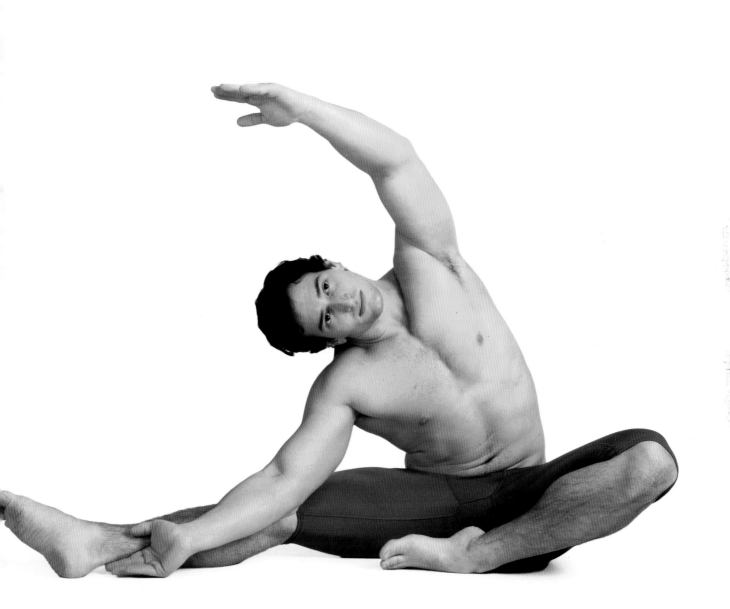

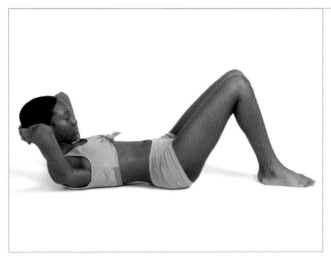

Abdominal Crunch Basic

Target: Abdominals.

Benefits: Engages and strengthens the muscles in the abdominals.

Steps: 1. Lie flat on the floor with both knees bent. **2.** Raise your head and shoulders slightly from the ground. Place both palms under the back of your head with your elbows extended out to the sides. **3.** Raise your back up from the ground toward your knees. **4.** Lower your torso back down, keeping your head and shoulders raised. **5.** Repeat this motion fifteen or more times.

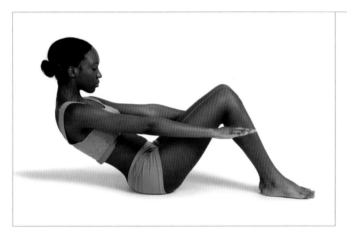

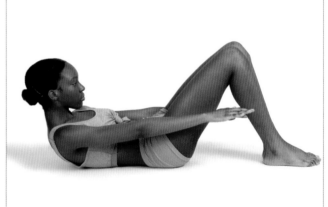

Ab Upper Slide

Target: Abdominals.

Benefits: Engages and strengthens the muscles in the abdominals.

Steps: 1. Lie flat on the floor with both knees bent. **2.** Raise your head and shoulders slightly from the floor, while extending your arms forward and keeping them parallel to the floor. **3.** With your arms straight, curl your back up from the floor until your hands extend beyond your shins. **4.** Lower your torso back down, keeping your arms and shoulders raised. **5.** Repeat this motion fifteen or more times.

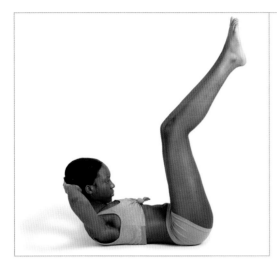

Abdominal Crunch, Legs Extended

Target: Abdominals.

Benefits: Engages and strengthens the muscles in the abdominals, glutes, and hamstrings.

Steps: 1. Lie with your back on the ground and both legs raised in the air. **2.** Raise your head and shoulders slightly from the ground. Place both palms under the back of your head with your elbows extended out to the sides. **3.** Raise your upper back up from the ground toward your knees. **4.** Lower back down, keeping your head and shoulders raised. Repeat this motion fifteen or more times.

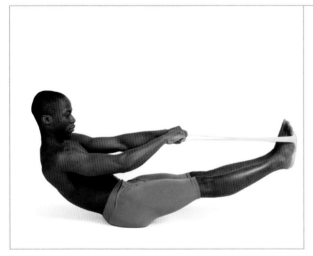

Double-Leg Extension with Band

Target: Abdominals.

Benefits: Strengthens the muscles in the upper arms and abdominals while lengthening the hamstrings.

Steps: 1. Begin by sitting upright, with your legs straight out ahead of you. Wrap a resistance band behind both feet. **2.** Keeping your legs straight, pull the ends of the band into your chest. Lean your body back so you are balancing on your pelvic bones. **3.** Hold this position for fifteen seconds or more.

Eastern Intense-Stretch Pose

Target: Abdominals.

Benefits: Lengthens the muscles in the neck and chest while engaging the abdomen and upper arms.

Steps: 1. Begin seated on the floor, with your palms a few inches behind your torso and pointed toward your hips. **2.** Supporting yourself with your hands and feet, lift your hips from the ground. Step both feet away so your torso creates a straight line between your knees and shoulders. **3.** Draw your shoulders down and drop your head to extend your neck and chest fully. **4.** Hold this position for fifteen seconds.

Eastern Intense-Stretch Pose, Elbows

Target: Abdominals.

Benefits: Lengthens the muscles in the wrists and neck while engaging the abdomen.

Steps: 1. Begin seated on the floor, with your legs straight ahead of you. Lean your torso back, resting both forearms flat on the floor. **2.** Supporting yourself with your arms and feet, lift your hips from the ground. Step both feet away so your torso creates a straight line between your knees and shoulders. **3.** Draw your shoulders back and drop your head to extend your neck and chest fully. **4.** Hold this position for fifteen seconds.

Eastern Intense-Stretch Pose, Flex

Target: Abdominals.

Benefits: Lengthens the muscles in the wrists and neck while engaging the abdomen.

Steps: 1. Begin seated on the floor, with your legs straight ahead of you. Lean your torso back, resting your forearms flat on the floor. **2.** Supporting yourself with your hands and feet, lift your hips and arms from the floor. **3.** Step both feet away, resting on your heels and flexing your toes. **4.** Draw your shoulders back and drop your head to extend your neck and chest fully. **5.** Hold this position for fifteen seconds.

Half Eastern Intense-Stretch Pose

Target: Abdominals.

Benefits: Targets the muscles in the wrist while engaging the abdomen.

Steps: 1. Begin seated, with your palms flat on the floor behind your hips and your fingers pointed directly behind you. **2.** Bend your knees so your feet are flat on the floor shoulder-width apart. **3.** Supporting yourself with your hands and feet, lift up your hips so your torso is parallel to the floor. **4.** Draw your shoulders back and drop your head to open the neck and chest fully. **5.** Hold this position for twenty seconds.

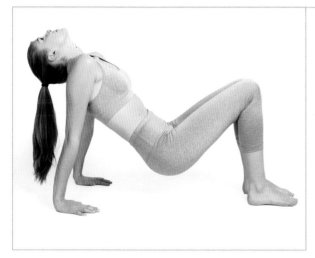

Half Eastern Intense-Stretch Pose, Easy Modification

Target: Abdominals.

Benefits: Strengthens the uppers arms and abdominal muscles while extending the neck and chest.

Steps: 1. Begin seated, with your palms flat on the floor behind your hips and your fingers pointed toward you. **2.** Bend your knees so your feet are flat on the floor and shoulder-width apart. **3.** Pressing against your hands and feet, lift your hips off the ground. **4.** Draw your shoulders back and drop your head to open the neck and chest fully. **5.** Hold this position for fifteen seconds

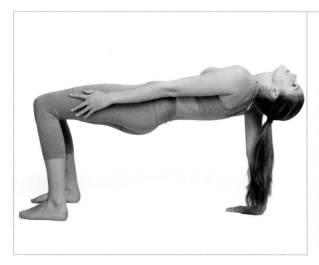

Half Eastern Intense-Stretch Pose, One Arm

Target: Abdominals.

Benefits: Strengthens the uppers arms and abdominal muscles while extending the neck and chest.

Steps: 1. Begin seated, with your knees bent and your palms flat on the floor behind you, fingers pointing toward your hips. **2.** Supporting yourself with your hands and feet, lift up your hips so your torso is parallel to the floor. **3.** Raise your left hand off the floor and place your arm straight at your left side. **4.** Draw your shoulders back and drop your head to open the neck and chest fully. **5.** Hold this position for fifteen seconds before alternating arms.

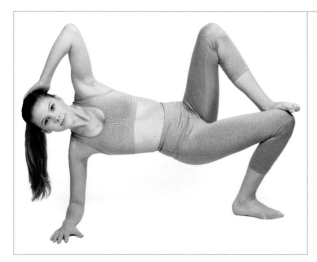

Half Eastern Intense-Stretch Pose, One Arm, One Leg

Target: Abdominals.

Benefits: Deeply strengthens the abdominal muscles and upper arms while extending the neck and chest.

Steps: 1. Begin seated, with your legs straight. Lean your torso back, resting your forearms on the floor. **2.** Supporting yourself with your arms and feet, lift up your hips. Step your feet away so your torso is parallel to the floor. **3.** Raise your left foot and place it on your right knee. **4.** Lift your left arm and place your palm on the back of your head, pointing your elbow upward. **5.** Find your balance and hold for fifteen seconds before alternating sides.

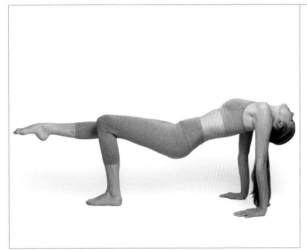

Half Eastern Intense-Stretch Pose, One Leg

Target: Abdominals.

Benefits: Strengthens the glutes, abdominals, and uppers arms while extending the neck and chest.

Steps: 1. Begin seated, with your knees bent and your palms flat on the floor behind your hips, fingers pointing toward you. **2.** Supporting yourself with your hands and feet, lift up your hips so your torso is parallel to the floor. **3.** Raise your right leg and extend it straight out from your hips. **4.** Draw your shoulders back and drop your head to open the neck and chest fully. **5.** Hold this position for fifteen seconds before releasing and alternating legs.

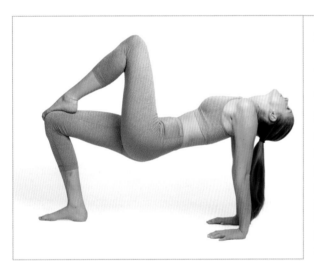

Half Eastern Intense-Stretch Pose, Knee Up

Target: Abdominals.

Benefits: Strengthens the uppers arms and abdominal muscles while extending the neck and chest.

Steps: 1. Begin seated, with your knees bent and your palms flat on the floor behind your hips, fingers pointing toward you. **2.** Supporting yourself with your hands and feet, lift up your hips so your torso is parallel to the floor. **3.** Raise your left foot and place it on your right knee. **4.** Draw your shoulders back and drop your head to open the neck and chest fully. **5.** Hold this position for twenty seconds before releasing and alternating legs.

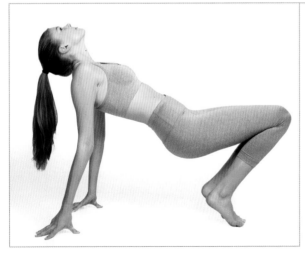

Half Eastern Intense-Stretch Pose, Tiptoe

Target: Abdominals.

Benefits: Targets the muscles in the wrists while engaging the abdomen.

Steps: 1. Begin seated, with your knees bent and your palms flat on the floor behind your hips, fingers pointing backward. **2.** Raising your feet onto tiptoes and your hands onto your fingertips, lift your hips off the floor. **3.** Draw your shoulders back and drop your head to open the neck and chest fully. **4.** Hold this position for twenty seconds.

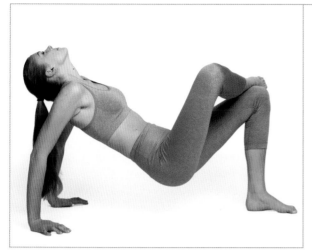

Half Eastern Intense-Stretch Pose with Legs Crossed

Target: Abdominals.

Benefits: Strengthens the uppers arms and abdominal muscles while extending the neck and chest.

Steps: 1. Begin seated, with your knees bent and your palms flat on the floor behind your hips, fingers pointing toward you. **2.** Supporting yourself with your hands and feet, lift your hips up off the floor. **3.** Raise your right leg and place your ankle on your left knee. **4.** Draw your shoulders back and drop your head to open the neck and chest fully. **5.** Hold this position for twenty seconds before alternating legs.

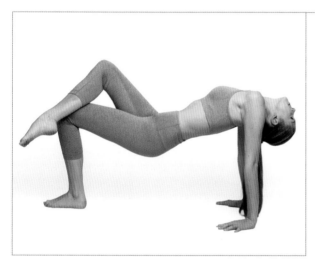

Half Eastern Intense-Stretch Pose, Legs-Crossed Advanced

Target: Abdominals.

Benefits: Strengthens the uppers arms and abdominal muscles while extending the neck and chest.

Steps: 1. Begin seated, with your knees bent and your palms flat on the floor behind your hips, fingers pointing toward you. **2.** Supporting yourself with your hands and feet, lift your hips so your torso is parallel to the floor. **3.** Raise your right foot and place your ankle on your left knee. **4.** Draw your shoulders back and drop your head to open the neck and chest fully. **5.** Hold this position for twenty seconds before releasing and alternating legs.

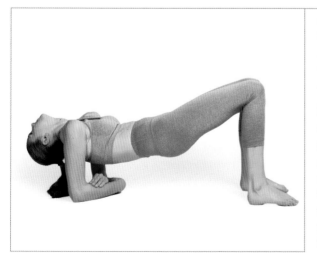

Hands-Bound, Half Eastern Intense-Stretch Pose

Target: Abdominals.

Benefits: Lengthens the muscles in the wrists, and neck while engaging the abdomen.

Steps: 1. Begin seated, with knees bent. **2.** Lean your torso back, resting both elbows on the floor, and reach your hands in to grab hold of the opposite forearm. **3.** Supporting yourself with your arms and feet, lift up your hips and step your feet away so your torso is in line with your shoulders and knees. **4.** Draw your shoulders back and drop your head to extend your neck and chest fully. **5.** Hold this position for fifteen seconds.

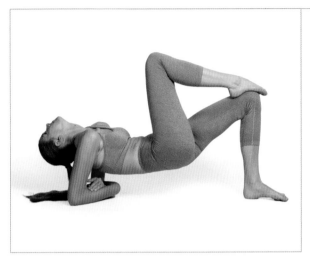

Hands-Bound, One-Legged Half Eastern Intense-Stretch Pose

Target: Abdominals.

Benefits: Lengthens the muscles in the wrists and neck while engaging the abdomen.

Steps: 1. Begin seated, with knees bent. **2.** Lean your torso back, resting both elbows on the floor, and reach your hands in to grab hold of the opposite forearm. **3.** Supporting yourself with your arms and feet, lift up your hips and step your feet away so your torso is in line with your shoulders and knees. **4.** Lift your right foot and place it on your left knee. **5.** Draw your shoulders back and drop your head to extend your neck and chest. **6.** Hold for fifteen seconds before alternating legs.

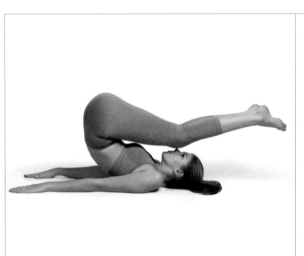

Hip Raise

Target: Abdominals.

Benefits: Builds strength in the abdomen.

Steps: 1. Lie flat on your back and bend your knees slightly. **2.** Raise your legs up so they are pointing toward the ceiling. **3.** Use your upper back and abdominal muscles to push your hips off the floor and extend your legs straight overhead so they are parallel to the floor. **4.** Hold this position for thirty or more seconds before lowering your hips to the floor.

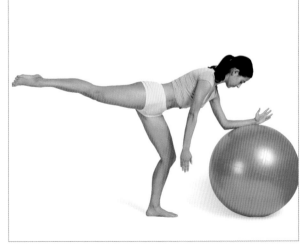

Leg Rotation, Leaning on Ball

Target: Abdominals.

Benefits: Provides strength in the abdominals, glutes, and triceps, using the exercise ball for an increased challenge.

Steps: 1. Stand several paces from an exercise ball, and lean forward until you are able to rest your left forearm on the ball. **2.** Bend your left knee slightly and raise your right leg straight out behind you. Point your right arm downward. **3.** Hold this position for fifteen seconds or longer and alternate sides.

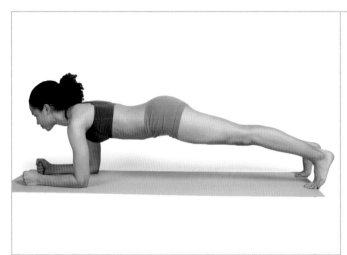

Plank Forearm

Target: Abdominals.

Benefits: Strengthens the upper arms, glutes, and abdominals.

Steps: 1. Begin on all fours, with your palms placed beneath your shoulders. Lower one arm at a time onto your forearms, bending at the elbows. **2.** Lift both feet onto your toes and step your feet away from you. **3.** Lift your hips from the floor, making sure to create a straight line from your heels to your shoulders. **4.** Hold this pose for twenty seconds or longer.

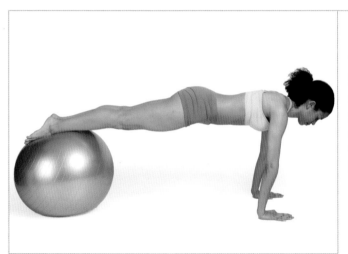

Plank on Ball

Target: Abdominals.

Benefits: Improves strength and endurance in the abdomen and upper arms.

Steps: 1. Begin on all fours, with your palms placed beneath your shoulders and an exercise ball behind you. **2.** Lift your feet one at a time to rest on top of the ball. **3.** Extend your body into a full plank position. **4.** Hold this pose for fifteen seconds or more.

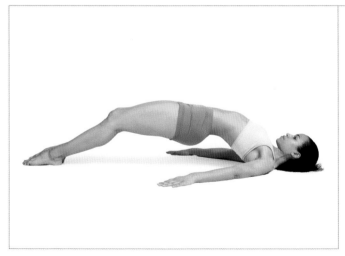

Shoulder Bridge

Target: Abdominals.

Benefits: Engages and strengthens the abdominals, hips, and quadriceps.

Steps: 1. Lie flat on your back, with your arms at your sides. **2.** Step both feet in so your knees are bent and your feet are flat on the floor. **3.** Keeping your arms and shoulders lowered, push your hips up off the ground. **4.** Hold this position for thirty seconds before releasing.

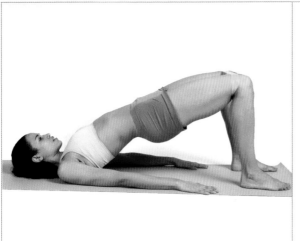

Shoulder Bridge, Pelvic Press with Band

Target: Abdominals.

Benefits: Engages and strengthens the muscles in the abdominals, hips, and quadriceps.

Steps: 1. Lie flat on your back, with your arms at your sides. Attach a resistance band around both legs above the knees. **2.** Step both feet in so your knees are bent and your feet are flat on the ground. **3.** Keeping your arms on the floor and the band taut, raise your hips up off the ground. **4.** Hold this position for thirty seconds before releasing.

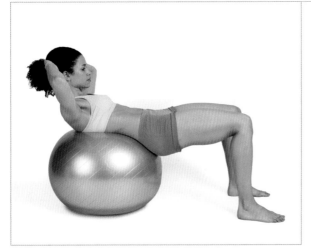

Sit-Up on Ball

Target: Abdominals.

Benefits: Increases strength in the abdominals and quadriceps.

Steps: 1. Rest your lower back on an exercise ball, with your knees at a 90-degree angle. **2.** Place your hands under your head for support and raise your shoulders from the ball in an abdominal crunch position. **3.** Hold for thirty seconds.

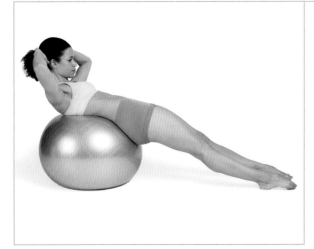

Sit-Up on Ball, Leg Extended

Target: Abdominals.

Benefits: Increases strength in the abdominals and quads and lengthens the lower back.

Steps: 1. Rest your lower back on an exercise ball, with your legs straight ahead. **2.** Place your hands under your head for support and raise your shoulders from the ball in an abdominal crunch position. **3.** Hold for thirty seconds.

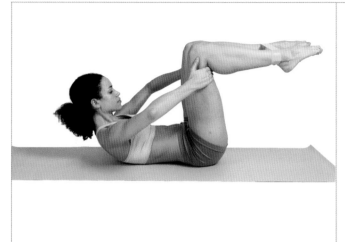

Sit-Ups with Band

Target: Abdominals.

Benefits: Increases strength in the abdominals, quads, and abductors.

Steps: 1. Lie flat on your back and attach a resistance band around your ankles. **2.** Raise your legs so your knees are bent directly above your hips. **3.** Making sure to keep the band taut around your ankles, lift your shoulders from the ground in an abdominal crunch. **4.** Return your shoulders to the ground, and repeat this motion.

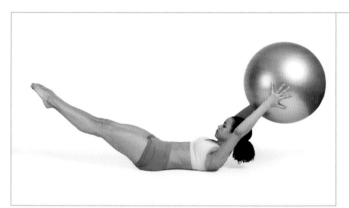

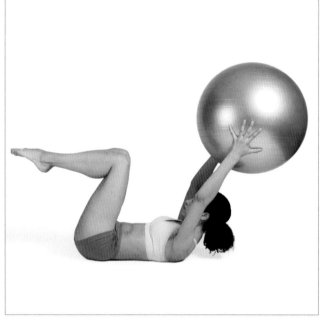

Abdominal Crunch with Ball

Target: Abdominals.

Benefits: Strengthens and elongates the abdominal muscles.

Steps: 1. Begin by lying flat on your back, holding an exercise ball above your head and extending your legs straight off the ground at a 45-degree angle. **2.** On exhale, bend your knees and bring them in over your hips while raising the exercise ball over your head. **3.** Return to the starting position and repeat this motion.

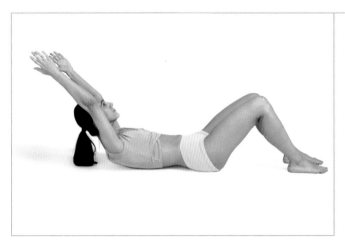 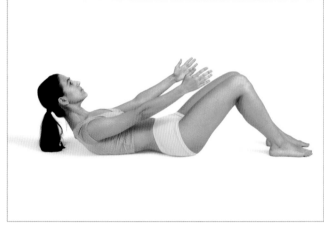

Abdominal Lift, Arms Extended

Target: Abdominals.

Benefits: Targets the abdominal muscles while strengthening the upper back and triceps.

Steps: 1. Begin by lying flat on your back, with knees bent and arms raised above your head. **2.** Raise your shoulders from the ground and bring your arms toward your knees. **3.** Return your arms toward your head, keeping shoulders raised. **4.** Repeat this motion.

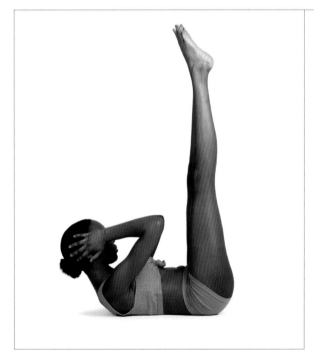

Abdominal Lift, Legs Up

Target: Abdominals.

Benefits: Strengthens the abdominals and glutes.

Steps: 1. Lie flat on your back, with both legs extended straight upward and hands beneath your head. **2.** Raise your head and shoulders off ground into an abdominal crunch, keeping your legs straight. **3.** Hold this position for five or more seconds before lowering shoulders back to the floor.

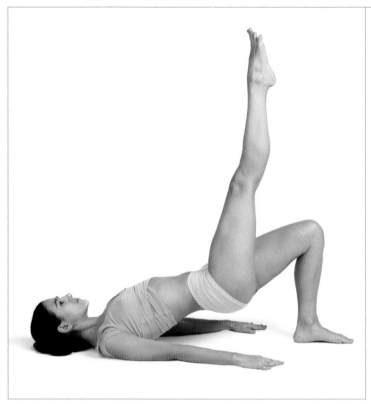

Abdominal-Lift Pelvis Stabilizer, Leg Extended

Target: Abdominals.

Benefits: Improves strength and mobility in the abdominals and quadriceps.

Steps: 1. Lie flat on your back, with knees bent and arms at your sides. **2.** Extend your right leg straight upward. **3.** Raise your pelvis off the ground, making sure to keep the extended leg straight. **4.** Hold this position for five or more seconds before lowering back to the floor and alternating sides.

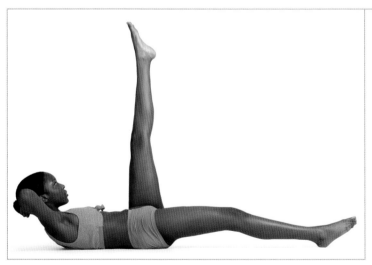

Abdominal-Lift Pose 1

Target: Abdominals.

Benefits: Improves strength and mobility in the abdominals and quadriceps.

Steps: 1. Begin by lying flat on your back, with your hands behind your head. **2.** Extend your left leg straight upward, and keep your right leg on the floor with toes pointed. **3.** Lift your arms and shoulders off the ground. **4.** Hold this position for thirty seconds or more before lowering to the floor and alternating sides.

Abdominal-Lift Shoulder Raise, Knees Bent

Target Abdominals.

Benefits: Increases strength and range of motion in the abdominals.

Steps: 1. Begin by lying flat on your back, with your knees bent and arms at your sides. **2.** Lift your shoulders off the ground.
3. Hold this position five or more seconds. **4.** Slowly lower your shoulders back to the floor.

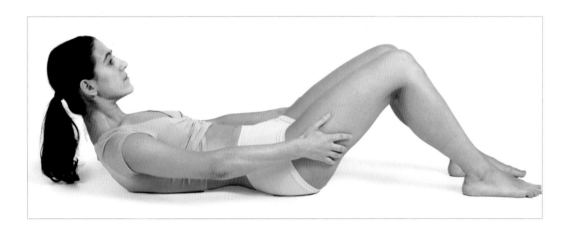

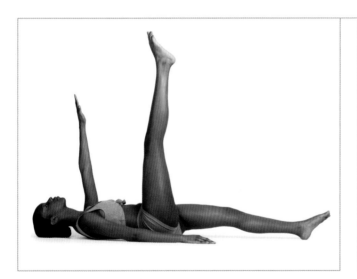
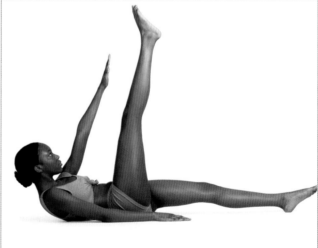

Abdominal-Lift Pose 2

Target: Abdominals.

Benefits: Increases strength and stamina in the abdominals and glutes.

Steps: 1. Lie flat on your back and extend your right leg straight up, keeping your knees straight.
2. Raise your left arm straight up so it is parallel with your right leg. **3.** On exhale, raise your shoulders
from the floor into an abdominal crunch. **4.** Keeping your arm and leg raised, lower your shoulders back to
the floor. **5.** Alternate sides and repeat.

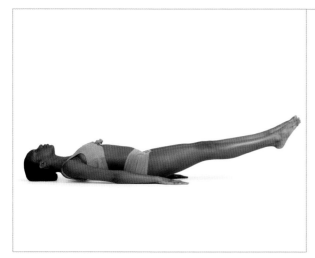

Abdominal-Lift Shoulder Raise, Toes Pointed

Target: Abdominals.

Benefits: Strengthens the muscles in the abdominals and glutes.

Steps: 1. Start by lying flat on the floor, your toes pointed and arms at your sides. **2.** Raise both legs from the floor, making sure they are straight, and lift your shoulders from the floor. **3.** Hold for ten seconds and slowly lower your shoulders.

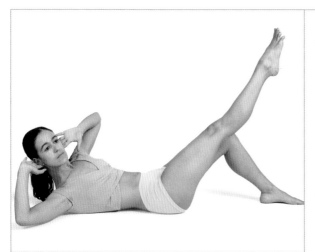

Abdominal-Lift Twist, Elbows Extended

Target: Abdominals.

Benefits: Provides strength in the abdominals and glutes, while increasing mobility in the spine.

Steps: 1. Begin by lying flat on your back, with your knees bent and your hands behind your head. **2.** Extend your right leg straight out at a 45-degree angle. **3.** Raise your arms and shoulders off the floor and twist to the right. **4.** Lower your torso down and repeat, alternating sides.

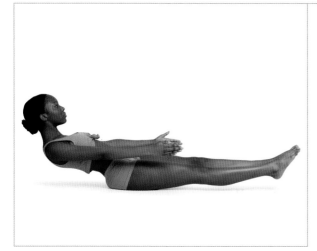

Abdominal Lift, Two Legs Extended 1

Target: Abdominals.

Benefits: Increases strength and stamina in the abdominals and glutes.

Steps: 1. Begin by lying flat on your back, with your arms at your sides and toes pointed. **2.** Slowly lift your legs and torso off the floor, keeping the legs and back straight. **3.** Hold this position for fifteen seconds. **4.** Slowly lower to the floor and repeat.

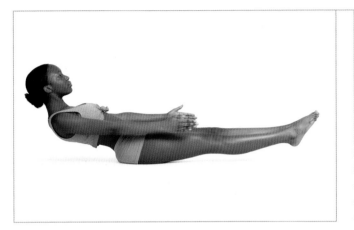

Abdominal Lift, Two Legs Extended 2

Target: Abdominals.

Benefits: Increases strength in the abdomen and glutes.

Steps: 1. Begin by lying flat on your back with your arms at your sides and toes pointed. **2.** Slowly lift your legs and torso off the floor, being sure to keep the legs and back straight. **3.** Hold this position for ten seconds. **4.** Slowly return to the ground and repeat.

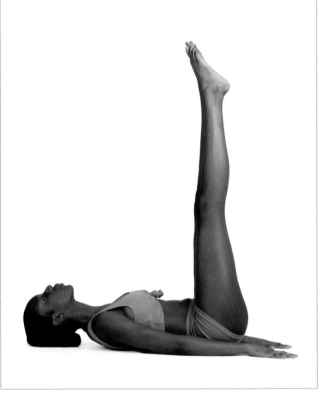

Abdominal Lift with Twist and Leg Stretch

Target: Abdominals.

Benefits: Increases endurance and strength in the abdominals and glutes while improving mobility in the spine.

Steps: 1. Lie on your back, with knees bent, and extend your arms above your shoulders, hands clasped together. **2.** Extend your right leg up while raising your shoulders off the floor, twisting your torso to the right. **3.** Hold for ten seconds and lower your shoulders and leg. Repeat, alternating sides.

Abdominal Lift with Twist Hands Clasped

Target: Abdominals.

Benefits: Increases strength and endurance in the abdominals while improving mobility in the spine.

Steps: 1. Lie on your back, with knees bent, and extend your arms above your shoulders, hands clasped together. **2.** Raise your shoulders off the floor, twisting your torso to the right. **3.** Lower your shoulders and repeat, alternating sides.

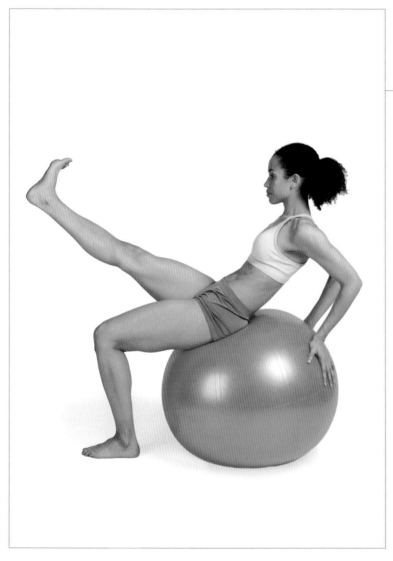

Leg Extension on Ball

Target: Abdominals.

Benefits: Increases strength and endurance in the abdominals while improving mobility in the spine.

Steps: 1. Begin in a seated position on an exercise ball. **2.** Leaning back on the ball, raise your right leg straight from the ground until it is above hip level. **3.** Hold this position for fifteen seconds or longer before alternating sides.

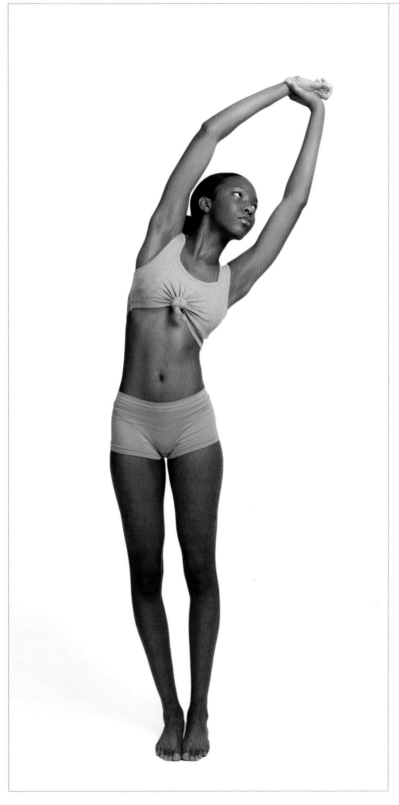

Crescent Pose, Standing

Target: Obliques.

Benefits: Lengthens the sides of the body, stretching the intercostal and abdominal muscles.

Steps: 1. Stand up straight, with your hands clasped and raised overhead.
2. Lean your arms and torso to the left, lengthening the left side of your body.
3. Hold for fifteen seconds before repeating this stretch on the other side.

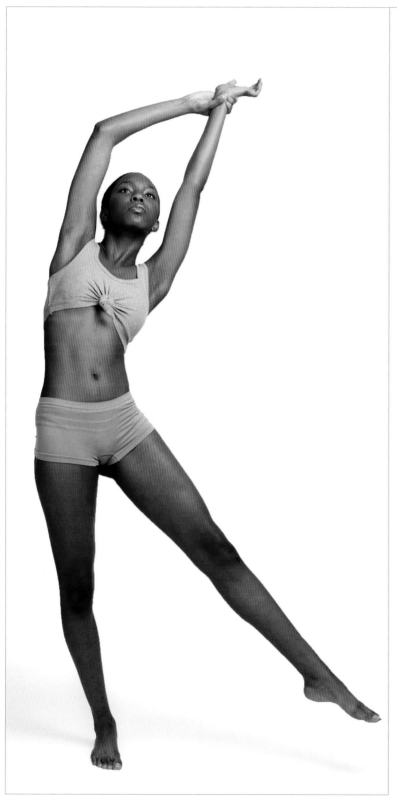

Crescent Pose, One-Legged

Target: Obliques.

Benefits: Lengthens the sides of the body, stretching the intercostal and abdominal muscles while increasing balance.

Steps: 1. Stand up straight with your arms raised overhead and palms together. **2.** Lift your left leg from the floor and extend it out to your left side, keeping your foot just above the floor. **3.** Lean your arms and torso to the left, lengthening the right side of your body. Hold for fifteen seconds before alternating sides.

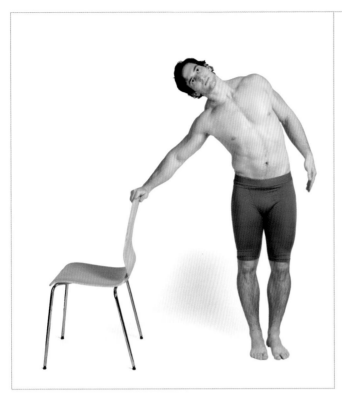

Abductor Stretch, Hip Out

Target: Obliques.

Benefits: Lengthens your external and internal obliques, increasing flexibility and range of motion in the spine.

Steps: 1. Stand up straight, with the back of a sturdy chair about two feet to your right. **2.** Lean your head and torso toward the chair, reaching hold of it with your right hand. **3.** Continue to bend toward the chair, making sure not to curl your spine and shoulders forward. **4.** Hold for twenty seconds and alternate sides.

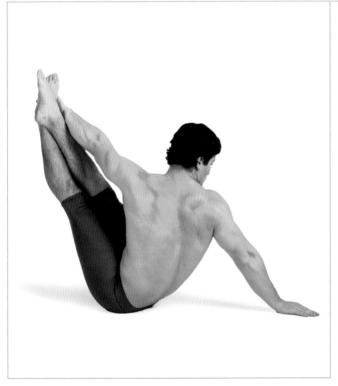

Boat Pose, Revolved Supported

Target: Obliques.

Benefits: Extends the muscles along the external and internal obliques while strengthening the core and hamstrings.

Steps: 1. Starting from a seated position with your hands on the floor, cross the right foot over the left and extend both legs up. **2.** Grab the inside of your left foot with your left hand as you start to twist to the right. **3.** Find your balance. Extend your spine and try to reach your right hand farther behind you. **4.** Hold this position for fifteen seconds before switching sides.

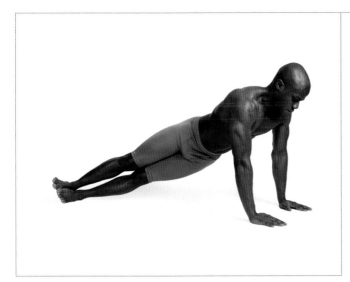

Extended Four-Limbs Staff Pose, Revolved

Target: Obliques.

Benefits: Extends the muscles along the external and internal obliques while strengthening the arms and core.

Steps: 1. Begin on all fours with your palms placed beneath your shoulders. **2.** Lift both feet onto your toes and step your feet back into a plank position. **3.** Turn your left foot onto its side and lift your right foot to rest on your left foot. **4.** Hold this pose for twenty seconds before alternating legs.

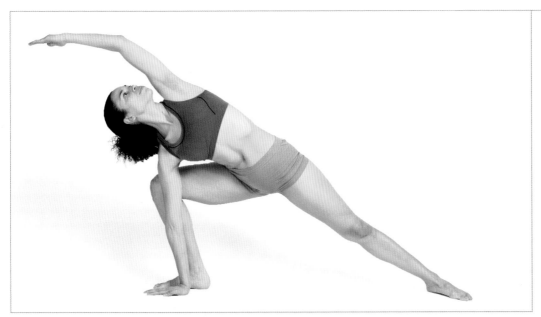

Extended Side-Angle Stretch

Target: Obliques.

Benefits: Lengthens the muscles along the side of the body while stretching the groin.

Steps: 1. Stand with your feet shoulder-width apart. Extend your left leg straight out to the side, and lower your body into a deep side squat. **2.** Lower your right hand flat on the ground in front of your right foot. **3.** Extend your left arm over your head, leaning your torso deeply to the right. **4.** Raise your gaze up to the ceiling and hold this position for fifteen seconds before alternating sides.

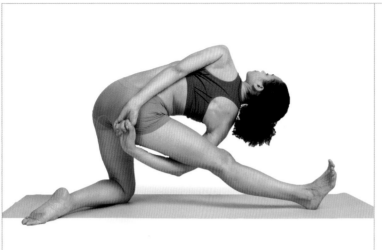

Gate Pose, Revolved Bound

Target: Obliques.

Benefits: Lengthens the obliques, shoulders, and hamstring

Steps: 1. Begin by kneeling upright. Raise your right knee and extend your leg straight to your side, with your foot flexed. **2.** Lower your torso toward your right knee. **3.** Weave your right hand under and behind your right thigh while your left arm reaches across your back to clasp hands in a bound position. **4.** Turn your gaze up to the ceiling to open your shoulders and chest. **5.** Hold this position for fifteen seconds before switching sides.

Half Intense-Stretch Pose, Sideways

Target: Obliques.

Benefits: Lengthens the external oblique muscles while strengthening the core.

Steps: 1. Stand with your feet together, your arms straight up in the air, and hands clasped together. **2.** Bend forward at the hips and touch your hands to the floor just to the outside of your right foot. **3.** Hold this position for thirty seconds and alternate sides.

Half-Lotus Pose, Dedicated to Sage Vasistha

Target: Obliques.

Benefits: Lengthens the obliques, neck, shoulders, and hamstrings.

Steps: 1. Begin by kneeling upright, hands at your sides. Raise your left knee and extend your leg straight to the side, with your toes pointed out. **2.** Tuck your right foot up to your left hip into a half lotus pose. **3.** Lower your right hand to the floor beside your right knee. **4.** Extend your left arm over your head, leaning your torso deeply to the side. **5.** Raise your gaze up to the ceiling and hold this position for fifteen seconds before alternating sides.

Head to Knee, Sideways

Target: Obliques.

Benefits: Lengthens the obliques, neck, shoulders, and hamstrings.

Steps: 1. Begin by sitting on the floor. Extend your right leg straight out to the side, and bring your left foot into your pelvis. **2.** Raise your arms over your head, with your palms facing each other. **3.** Lean your torso to the right, dropping your right hand to the ground. **4.** Hold this position for fifteen seconds before switching sides.

Intense Side Stretch

Target: Obliques.

Benefits: Lengthens the obliques, neck, shoulders, and hamstrings.

Steps: 1. Begin by sitting on the floor. Extend your right leg straight out to the side and bring your left foot into your pelvis. **2.** Place your hands against the back of your head and twist your torso down to the right, dropping your right elbow to the ground. **3.** Hold this pose for fifteen seconds before alternating sides.

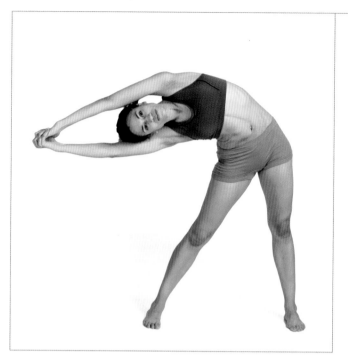
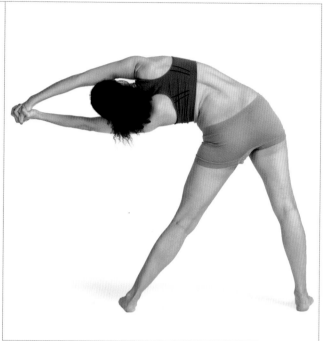

Intense Side Stretch, Hands Clasped Overhead

Target: Obliques.

Benefits: Lengthens the obliques while deeply extending the hamstrings and hips.

Steps: 1. Begin by standing with your legs about two feet apart and your hands clasped straight overhead.
2. Lean your torso to the right, until your shoulders are perpendicular to the floor. **3.** Hold this position for twenty seconds before standing back up and leaning to the other side.

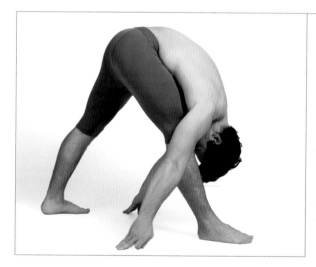

Intense Side-Stretch Pose

Target: Obliques.

Benefits: Lengthens the obliques while deeply extending the hamstrings and hips.

Steps: 1. Step your left foot several feet back and turn it slightly outward. **2.** Bend your torso forward at the waist, twisting toward your right leg, and drop your hands to the floor on either side of your right foot. **3.** If you can, bend your torso down completely along the front of your right leg and straighten your arms to deepen the stretch. **4.** Hold for fifteen seconds and alternate sides.

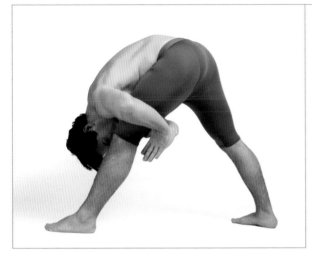

Intense Side-Stretch Pose with Prayer Hands

Target: Obliques.

Benefits: Lengthens the obliques while deeply extending the hamstrings and hips.

Steps: 1. Step your right foot several feet back, turning it slightly outward. **2.** Bend your torso forward at the waist, twisting toward your left leg, and drop your hands to the ground on either side of your left foot. **3.** Bend your torso farther down, so it is resting along the front of your left leg. **4.** Lift your hands into prayer position behind your front leg. **5.** Hold this position for thirty seconds and alternate sides.

Intense Side-Stretch Pose Prep

Target: Obliques.

Benefits: Lengthens the obliques while deeply extending the hamstrings and hips.

Steps: 1. Stand with your arms straight overhead and your palms together. **2.** Step your right foot several feet back, turning it slightly outward. **3.** Bend your torso forward at the waist over your left leg until your torso is parallel to the floor. **4.** Hold this position for thirty seconds and alternate legs.

Intense Side Triangle Pose

Target: Obliques.

Benefits: Lengthens the obliques while deeply extending the hamstrings and hips.

Steps: 1. Stand with your arms straight overhead and step your right foot several feet back, turning it slightly outward. **2.** Bend your torso forward at the waist over your left leg until your torso is parallel to the floor. **3.** Drop your left hand to the floor, directly behind your left foot. **4.** Hold this position for thirty seconds before switching sides.

IT Side Stretch

Target: Obliques.

Benefits: Lengthens the obliques and shoulders, reducing tightness and increasing flexibility.

Steps: 1. Lie on your left side, with your hands behind your head for support. **2.** Bend your right leg, bringing your foot behind your hips, and grab hold of your foot with your right hand. **3.** Extend your shoulder and pull your right foot away from your body. **4.** Hold for twenty seconds and repeat on the opposite side.

Kneeling Reach Around

Target: Obliques.

Benefits: Twists the spine and stretches the obliques.

Steps: 1. Begin on all fours, with your palms flat on the floor. **2.** Reach your right hand to your right ankle. **3.** Hold for fifteen seconds before repeating on the opposite side.

Lunge to Side

Target: Obliques.

Benefits: Lengthens the obliques while opening the groin.

Steps: 1. Stand with your legs about three feet apart, toes pointing out, and your arms at your sides. **2.** Bend your right knee into a side lunge and drop your right elbow to rest on your knee. **3.** Raise your left arm up and over your head, bending deeply to the right. **4.** Hold this position for fifteen seconds before alternating sides.

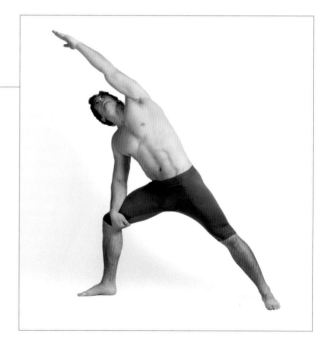

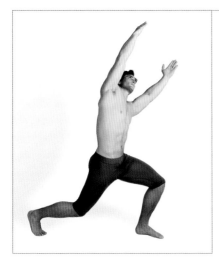

Lunge with Side Bend

Target: Obliques.

Benefits: Strengthens the leg muscles while lengthening the spine and obliques.

Steps: 1. Stand with your arms arched up above your head. **2.** Step your left foot forward, bending at the knee, and prop your right foot up onto tiptoes in a lunge pose. **3.** Lean your torso to the left side and hold for fifteen seconds before alternating sides.

Lunge with Side Stretch

Target: Obliques.

Benefits: Stretches the obliques and shoulders, reducing tightness and increasing flexibility.

Steps: 1. Step your right leg far forward, bending at the knee, and raise your left foot onto tiptoes to lower into a lunge. **2.** Drop your right hand down to your side, and raise your left arm straight up beside your head, with your palm facing in. **3.** Bend your torso to the right and hold for fifteen seconds before alternating sides.

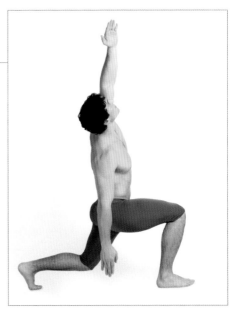

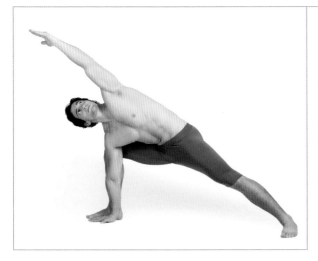

Lunging Side Stretch, Modification

Target: Obliques.

Benefits: Lengthens the obliques while deeply opening the groin.

Steps: 1. Step your feet wide apart, with your toes pointing out. **2.** Bend your right knee into a deep side lunge and drop your right hand to the floor beside your foot. **3.** Extend your left arm up and over your head, bending deeply to the right. **4.** Hold for fifteen seconds before alternating sides.

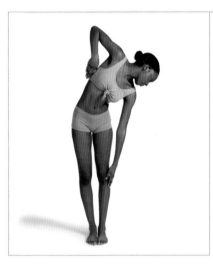

Side Bend

Target: Obliques.

Benefits: Stretches the muscles in the inner and outer obliques, stabilizing the core and maintaining good posture.

Steps: 1. Stand with your feet together and your arms at your sides. **2.** Bend your right elbow and raise it above your shoulder, resting your right hand on your side. **3.** Lean your torso to the left, bending only at the waist, and reach your left hand down the side of your leg to the outside of your knee. **4.** Perform fifteen or more reps on each side.

Mermaid Pose 1

Target: Obliques.

Benefits: Lengthens the obliques and stretches the intercostal and abdominal muscles.

Steps: 1. Sit on the floor, with your knees bent and feet tucked to the right. **2.** Hold your ankles with your right hand and raise your left arm straight up above you. **3.** Raise your left shoulder upward, pulling along the length of your left side. **4.** Perform this stretch for twenty seconds on either side.

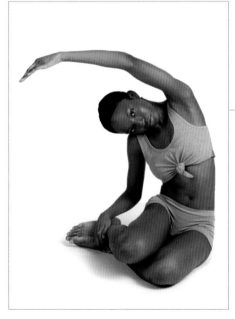

Mermaid Pose 2

Target: Obliques.

Benefits: Lengthens the obliques and stretches the intercostal and abdominal muscles.

Steps: 1. Sit on the floor, with your knees bent and feet tucked to the right. **2.** Hold your ankles with your right hand and raise your left arm straight up above you. **3.** Stretch your left arm over your head to the right, pulling along the length of your left side. **4.** Perform this stretch for twenty seconds on either side.

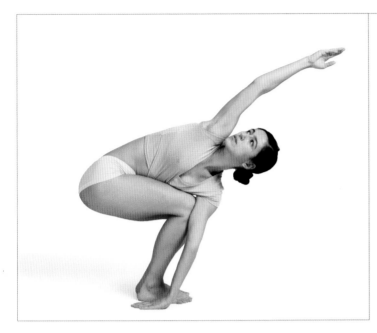

Noose Pose

Target: Obliques.

Benefits: Stretches the obliques and shoulders while twisting the lower spine.

Steps: 1. Begin by standing with your feet together. **2.** Bend your legs and lower your hips so they are in line with your knees. Place your fingertips on the floor for balance. **3.** Twist your torso to the right and extend your left hand to the floor beside your right foot, hooking your left elbow to the outside of your right knee. **4.** Extend your right arm up and over your head, expanding the chest and lengthening the side. **5.** Stay in this position for ten seconds before switching sides.

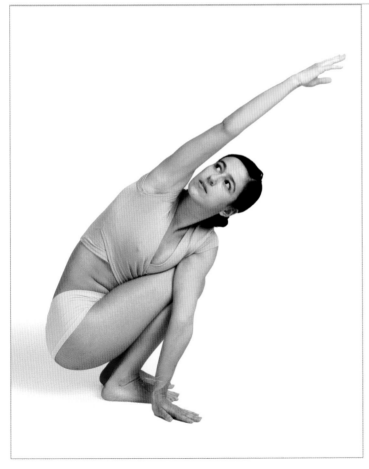

Noose Pose, Deep Squat

Target: Obliques.

Benefits: Stretches the obliques and shoulders while twisting the lower spine.

Steps: 1. With your feet together, squat low to the ground. Place your fingertips on the floor for balance. **2.** Twist your torso to the right and extend your left hand to the floor, hooking your left elbow to the outside of your right knee. **3.** Extend your right arm up and over your head, expanding the chest and lengthening the side. **4.** Stay in this position for ten seconds before switching sides.

One-Hand Side Stretch

Target: Obliques.

Benefits: Stretches the spine and obliques, promoting better posture.

Steps: 1. Sit on the floor with your right knee bent and your left leg outstretched to the side. **2.** Reach your arms straight up overhead. **3.** Lower your left hand down to your left foot and lengthen your right arm over your head, bending your torso to the left. Turn your gaze up toward the ceiling. **4.** Hold for twenty seconds and return your arms overhead before repeating on the opposite side.

Overhead Reach on Ball

Target: Obliques.

Benefits: Lengthens the external and internal obliques and engages the abdominals.

Steps: 1. Begin seated on an exercise ball with your legs spread wide apart. **2.** Raise your left arm up and over your head, and rest your right hand on your hip for support. **3.** Lean your torso over to the right, stretching along your left side. **4.** Hold this position for fifteen seconds before alternating arms.

Overhead Reach with Band

Target: Obliques.

Benefits: Lengthens the external and internal obliques while strengthening the arms and shoulders.

Steps: 1. Begin by kneeling upright with your knees shoulder-width apart. **2.** Hold a resistance band with both hands and stretch your arms straight overhead. **3.** Pull your arms apart against the resistance of the band and lean your torso to your right. **4.** Hold this position for fifteen seconds before returning to the center and leaning to the other side.

Simple Side Stretch

Target: Obliques.

Benefits: Stretches the external and internal obliques, improving posture and reducing back pain.

Steps: 1. Stand straight with your arms at your sides and feet together. **2.** Without bending forward, lean your torso to the right, extending your fingers down the side of your leg as low as you are able. **3.** Hold for fifteen seconds before repeating on the opposite side.

Forward Bend, Cross Legged

Target: Obliques.

Benefits: Loosens the external obliques and IT Band.

Steps: 1. Stand with your arms at your sides and cross your right foot in front of the left, keeping both legs straight. **2.** Gradually bend forward, folding at the waist, until you are able to touch your hands to the floor. **3.** Hold this position for twenty seconds before standing back up and switching feet positions.

Side Bend, Double Arm Band Stretch

Target: Obliques.

Benefits: Extends the obliques and expands the ribcage, providing for increased elasticity and range of motion in the spine and shoulders.

Steps: 1. Stand with your feet spread wide apart. **2.** Holding a resistance band in both hands, extend your arms straight above you. **3.** Pull your arms away from each other, against the resistance of the band, and lean your torso to the right side, bending only at the waist. **4.** Hold for thirty seconds before performing this stretch on the other side.

Side Bend, Double Arm Band Stretch, Squatting

Target: Obliques.

Benefits: Extends the obliques and expands the ribcage, providing for increased elasticity and range of motion in the spine and shoulders.

Steps: 1. Stand with your feet spread wide apart and bend both legs, lowering your torso into a wide squat. **2.** Holding a resistance band in both hands, extend your arms straight above you. **3.** Pull your arms away from each other, against the resistance of the band, and lean your torso to the right side, bending only at the waist. **4.** Hold for thirty seconds before performing this stretch on the other side.

Side Bend on Ball

Target: Obliques.

Benefits: Lengthens and relaxes the muscles in the obliques and shoulders, while opening the hips.

Steps: 1. Start by sitting on an exercise ball, with your legs wide apart. **2.** Raise your right arm up and over your head and lean your torso over to the left, pulling across the length of the right side of your body. **3.** Hold this position for thirty seconds before alternating sides.

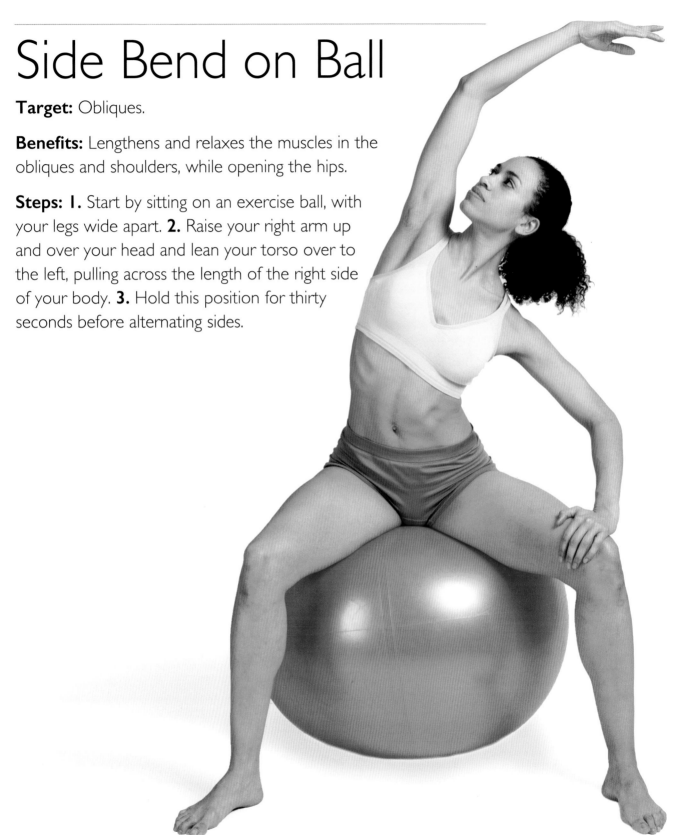

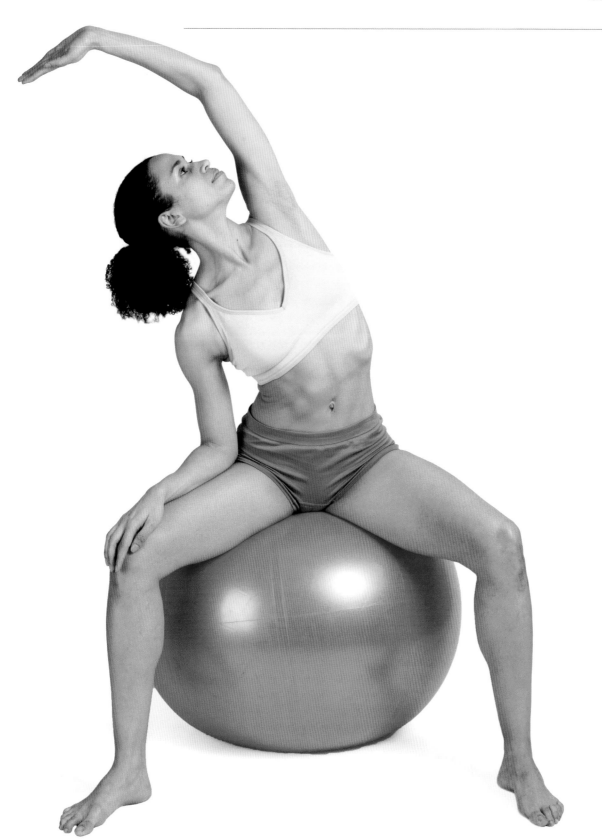

Side Bend, Double-Arm Stretch and Calf Stretch

Target: Obliques.

Benefits: Extends the obliques and expands the ribcage, providing increased elasticity and range of motion in the spine and shoulders.

Steps: 1. Standing straight, extend your left leg out to the side resting on the heel. **2.** Hold a resistance band in both hands, and extend your arms straight above you. **3.** Pull your arms away from each other, against the resistance of the band, and lean your torso to the right, bending only at the waist. **4.** Hold for thirty seconds before performing this stretch on the other side.

Side Bend on Ball, Leg Extended

Target: Obliques.

Benefits: Extends the obliques, expands the ribcage, and lengthens the calves and hamstrings.

Steps: 1. Start by sitting on an exercise ball, with your legs wide apart, and stretch your right leg out straight so it is resting on its heel. **2.** Raise your right arm up and over your head, and lean your torso to the left, pulling across the length of the right side of your body. **3.** Hold this position for thirty seconds before alternating sides.

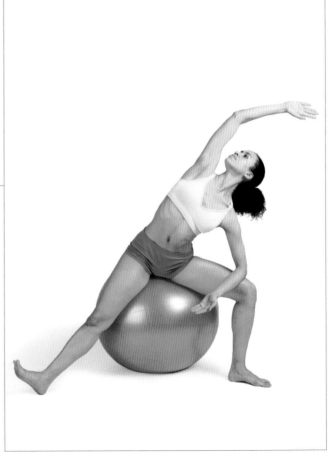

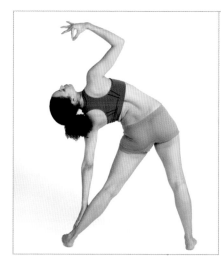

Side Bend, Overhead Reach

Target: Obliques.

Benefits: Extends the obliques and expands the ribcage, providing for increased elasticity and range of motion in the spine.

Steps: 1. Stand with your legs about feet three feet apart and extend your arms straight out to your sides. **2.** Bend your torso toward the left and extend your left hand down to your left ankle. **3.** Turn your head up to the ceiling and hold this position for thirty seconds before switching sides.

Side Bend, Seated

Target: Obliques.

Benefits: Extends the spinal column and obliques while opening the shoulders.

Steps: 1. Begin seated with your feet apart and your fingers laced above your head. Turn your hands so your palms face the ceiling. **2.** Bend your torso to the right side, making sure not to curl your shoulders forward. **3.** Hold this stretch for thirty seconds before alternating sides.

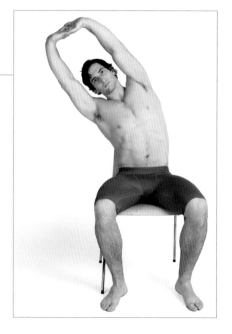

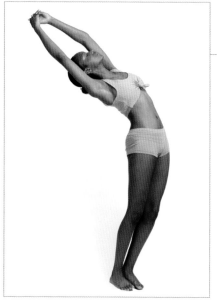

Side-Bending Mountain Pose

Target: Obliques.

Benefits: Opens the sides and expands the ribcage, engaging muscles in the core and increasing blood flow.

Steps: 1. Stand straight with your feet together and your hands clasped above your head. **2.** Bend your arms and torso backward and to your left side, opening your chest to the ceiling and lengthening the muscles along your obliques. **3.** Hold this position for thirty seconds and repeat on the opposite side.

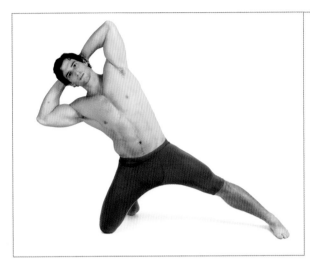

Side Lift, Kneeling

Target: Obliques.

Benefits: Extends the obliques and expands the ribcage while opening the groin.

Steps: 1. Begin by kneeling upright, with your hands resting on the back of your head. Extend your left leg straight out to your side. **2.** Lean your torso over to the right side. **3.** Hold this position for thirty seconds before alternating sides.

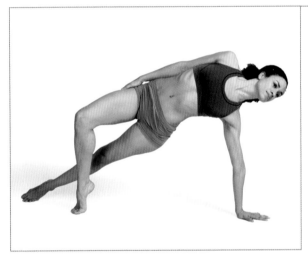

Side Plank

Target: Obliques.

Benefits: Strengthens the muscles in the arms and obliques.

Steps: 1. Begin by lying on your left side. **2.** Step your right toes on the floor in front of your left knee and place your right hand on the floor by your left shoulder. **3.** Using your hands and feet for support, lift your hips and torso from the floor. Straighten your left arm, so you are resting on the length of your left foot. **4.** Lift your right hand from the floor and, if possible, bring your right foot to rest on your left. **5.** Hold this position for thirty seconds, before attempting on the other side.

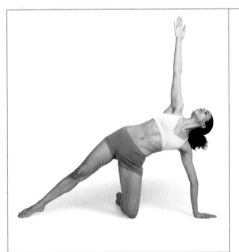

Side Plank, Easier Modification

Target: Obliques.

Benefits: Strengthens the muscles in the arms and obliques.

Steps: 1. Begin by lying on your left side. Bend your left knee so your foot points out behind you. **2.** Lift your hips and torso from the floor and straighten your left arm, so you are resting on your left hand and knee. **3.** Raise your right hand up into the air. **4.** Hold this position for thirty seconds, before repeating on the other side.

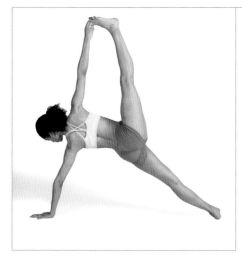

Side Plank, Extended Split

Target: Obliques.

Benefits: Strengthens the arms and obliques while opening the groin.

Steps: 1. Begin by lying on your left side. **2.** Step your right toes on the floor in front of your left knee, and place your right hand on the floor by your left shoulder. **3.** Using your hands and feet for support, lift your hips and torso from the floor. Straighten your left arm so you are resting on the length of your left foot. **4.** Raise your right hand and right foot from the floor and extend your right leg straight above you. **5.** Attempt to grab hold of your extended right foot with your right hand, pulling it into a wider split. **6.** Hold this position for thirty seconds, before switching to the other side.

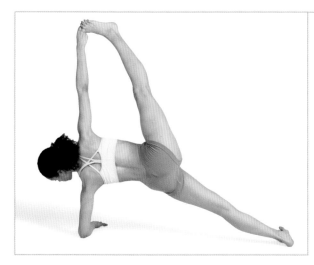

Side Plank, Extended Split on Elbow

Target: Obliques.

Benefits: Strengthens the arms and obliques while opening the groin.

Steps: 1. Begin by lying on your left side. **2.** Step your right toes on the floor in front of your left knee, and place your right hand on the floor by your left shoulder. **3.** Lift your hips and torso from the floor, resting on your left elbow and the length of your left foot. **4.** Raise your right hand and right foot from the floor and extend your right leg straight above you. **5.** Attempt to grab hold of your extended right foot with your right hand, pulling it into a wider split. **6.** Hold this position for thirty seconds, before switching to the other side.

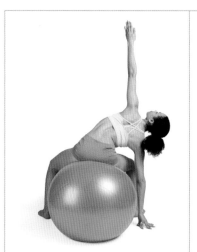

Side Stretch, Arm Extended on Ball

Target: Obliques.

Benefits: Strengthens the arms and obliques while engaging the core.

Steps: 1. Start seated on an exercise ball, with your legs wide apart, and extend your arms out at your sides. **2.** Lean your torso to the right side, bending only at the waist, until you can touch the floor with your right hand. **3.** Extend your left hand toward the ceiling and turn your gaze upward. **4.** Hold this pose for thirty seconds before performing on the opposite side.

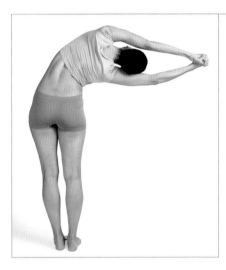

Side Stretch, Arms Clasped Overhead

Target: Obliques.

Benefits: Extends the spinal column and obliques, relieving pain and tightness resulting from prolonged sitting or poor posture.

Steps: 1. Stand with your feet together and your hands clasped above your head. **2.** Lean your torso to the right side, keeping both heels on the floor. **3.** Hold this stretch for thirty seconds and repeat on the opposite side.

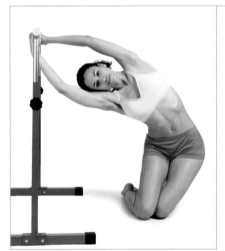

Side Stretch at Ballet Bar, Kneeling

Target: Obliques.

Benefits: Stretches the internal and external obliques while opening the shoulders.

Steps: 1. Set the ballet bar low, at hip height. **2.** Kneel upright with the bar at your right, slightly more than an arm's length away. Raise both arms above your head. **3.** Lean your torso toward the bar, until you are able to reach hold of it with both hands. **4.** Pull your hips to the left, away from the bar, to increase the stretch. **5.** Hold for twenty seconds before switching to the other side of the bar.

Side Stretch, Elbows Bent Overhead

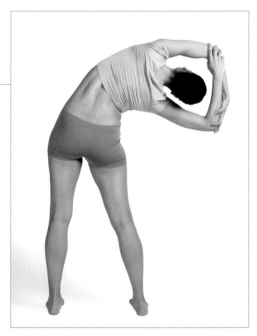

Target: Obliques.

Benefits: Extends the spinal column and obliques while opening the shoulders.

Steps: 1. Stand with your feet about shoulder-width apart. **2.** Raise your arms over your head and grasp opposite elbows with either hand. **3.** Lean your torso to the right side, keeping both heels on the ground. **4.** Hold this stretch for thirty seconds and repeat on the opposite side.

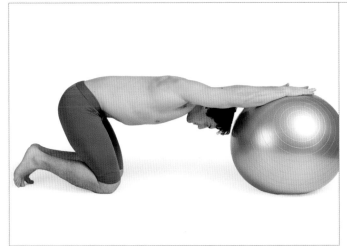

Side Stretch, Both Arms on Ball

Target: Obliques.

Benefits: Opens the chest and extends the internal obliques.

Steps: 1. Begin by kneeling upright, with an exercise ball several feet ahead of you. **2.** Bend forward at the waist, resting your forearms across the top of the ball. **3.** Pull your head and shoulders down toward the ground to increase the pressure on your sides and shoulders. **4.** Hold for twenty seconds.

Side Stretch, Hip on Ball

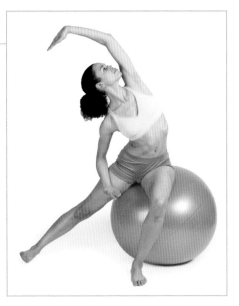

Target: Obliques.

Benefits: Extends the obliques and shoulders while opening the hips.

Steps: 1. Begin seated on an exercise ball. **2.** Roll onto the right side of the ball and extend your right leg out to the side. **3.** Raise your left arm up and over your head as you bend your torso to the right toward your outstretched leg. **4.** Continue to pull along the length of your side for twenty seconds before switching sides.

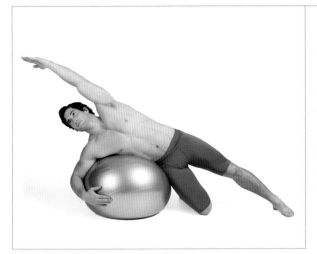

Side Stretch on Ball

Target: Obliques.

Benefits: Lengthens the external obliques and hip abductors while opening the shoulder.

Steps: 1. Kneel upright with an exercise ball at your right side. **2.** Lower yourself onto the ball, so it is resting under your side and you are supporting yourself on your right knee. **3.** Straighten your left leg and raise your left arm up over your head to feel the pull along the left side of your body. **4.** Hold this position for thirty seconds before switching sides.

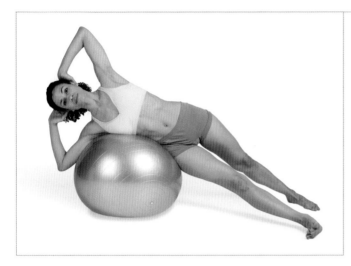

Side Stretch on Ball, Legs Extended

Target: Obliques.

Benefits: Lengthens the muscles in the outer obliques and hip abductors while opening the shoulder.

Steps: 1. Kneel upright with an exercise ball at your right side. **2.** Lower yourself onto the ball so it is resting under your side. **3.** Straighten your legs with your right leg slightly in front of the other and rest your hands on the back of your head. **4.** Maintain this position for thirty seconds before switching sides.

Side Stretch, Side-Lying

Target: Obliques.

Benefits: Lengthens the obliques while strengthening the arms and abdomen.

Steps: 1. Lie on your left side and place both palms flat on the floor by your chest. **2.** Push your shoulders and torso up from the floor, straightening your arms for support. **3.** Hold this position for thirty seconds before switching sides.

Side Stretch, Side-Lying Easy Modification

Target: Obliques.

Benefits: Lengthens the obliques while strengthening the arms and abdomen.

Steps: 1. Lie on your left side and place both palms flat on the floor by your chest. **2.** Bend your right leg and place your foot on the floor in front of your left thigh. **3.** Push your shoulders and torso up from the floor to rest on your left forearm and right foot. **4.** Hold this position for thirty seconds before switching sides.

Side Stretch, Sitting Up Extended

Target: Obliques.

Benefits: Lengthens the obliques while strengthening the arms and abdomen.

Steps: 1. Lie on your left side and place both palms flat on the floor by your chest. **2.** Bend your right leg and place your foot on the floor in front of your left thigh. **3.** Push your shoulders and torso up from the floor, straightening your arms for support. **4.** Hold this position for thirty seconds before switching sides.

Side Stretch, Star Pose

Target: Obliques.

Benefits: Lengthens the obliques and hamstrings and opening the chest.

Steps: 1. Stand with your legs wide apart, pointing your toes out to the sides. **2.** Bend your torso down to the left, dropping your left hand to your toes. **3.** Raise your right arm up toward the ceiling and shift your gaze upward to extend the chest more fully. **4.** Hold this position for twenty seconds and repeat on the opposite side.

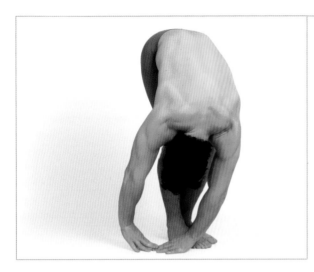

Sideways Intense-Stretch Pose 2

Target: Obliques.

Benefits: Lengthens the spinal cord and hamstrings while targeting the obliques.

Steps: 1. Stand straight with your feet together. **2.** Bend forward at the waist, twisting to your right side. **3.** Drop your palms to the floor beside your right foot. **4.** Hold this position for twenty seconds before alternating sides.

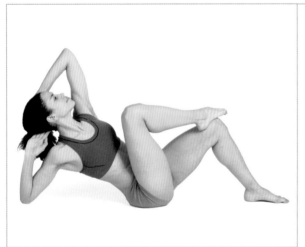

Six Triangle Pose

Target: Obliques.

Benefits: Extends the spinal column and obliques while strengthening the abdominals.

Steps: 1. Sit on the floor, with your knees bent and lean back on your right forearm. **2.** Bring your right knee into your chest and rest your foot on your left knee. **3.** Place your hands on the back of your head and twist your torso to the right. **4.** Turn your gaze up to the ceiling to complete the stretch. **5.** Hold this pose for thirty seconds before alternating sides.

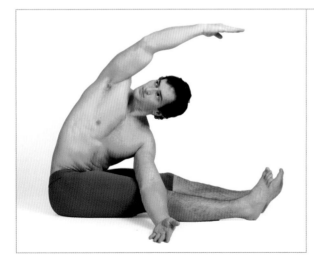

Western Intense Stretch, One-Hand Revolved

Target: Obliques.

Benefits: Increases flexibility and range of motion in the obliques and upper back.

Steps: 1. Sit with your legs straight out ahead. **2.** Fold forward, twisting to your right, and place your left elbow onto your right thigh. **3.** Extend your right arm over your head and shift your gaze up to the ceiling to fully engage your obliques. **4.** Hold this pose for thirty seconds before alternating arms.

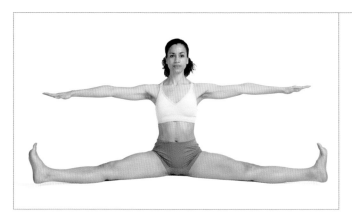 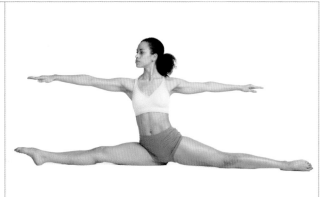

Split with Side Reach

Target: Obliques.

Benefits: Deeply opens the groin and chest while lengthening the obliques.

Steps: 1. Sit on the floor, with your legs spread wide in a horizontal split, and extend both arms straight out to your sides. **2.** Point your toes and turn your torso and gaze toward your right. **3.** Hold this position for twenty seconds and repeat on the opposite side.

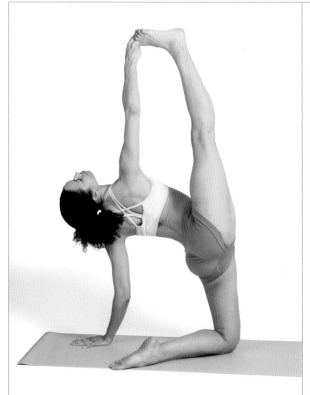

Advanced Split, Kneeling Backbend

Target: Spine.

Benefits: Deeply opens the groin while extending the spine and hamstrings.

Steps: 1. Kneel upright and lean your left hand onto the floor beside you. **2.** Raise your right knee into your chest and grab your right foot with your right hand. **3.** Extend your leg up into a kneeling half-split position and let your head and shoulders drop backward to extend the spine. **4.** Hold this position for twenty second before switching to the other side.

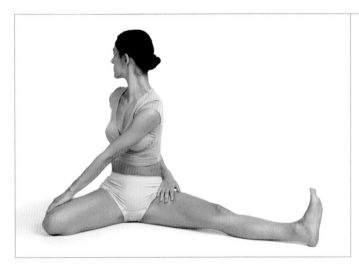

Angle Pose, One Leg Extended Spinal Twist

Target: Spine.

Benefits: Opens the chest and spine.

Steps: 1. Sit on the ground, with legs outstretched, and tuck your right knee under your hip. **2.** Twisting your torso to your right, place your left hand on your right knee and reach your right hand behind your back to touch your left thigh. **3.** Hold this position for thirty seconds before switching sides.

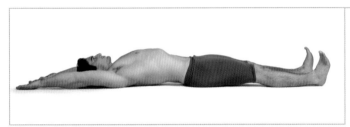

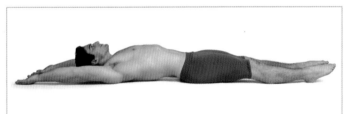

Arms-Above-Head Toe Flex

Target: Spine.

Benefits: Lengthens the spinal cord, relieving tightness and immobility.

Steps: 1. Lie flat on your back with your legs and arms extended. **2.** Point your toes and attempt to pull along your arms and feet away from one another to lengthen the body. **3.** Perform this stretch for thirty seconds before releasing.

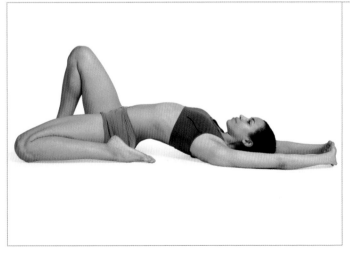

Backbend, Knee Bent, Shoulders Extended

Target: Spine.

Benefits: Lengthens the spine and shoulders.

Steps: 1. Begin by lying on your back, with your right knee bent and your left foot tucked in by your hip. **2.** Clasp your hands and raise them over your head with your palms facing outward. **3.** Arch your back as high as possible, and hold this position for thirty seconds.

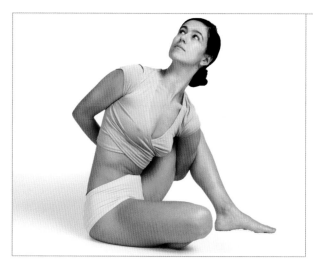

Bound and Twisted Spinal Twist

Target: Spine.

Benefits: Deeply extends the spine and hips, improving mobility and posture.

Steps: 1. Begin by sitting on the floor cross-legged and raise your left knee up to your chest. 2. Weave your left arm under your left knee and behind you. Reach your right arm around your back to grab your left hand in a bound position around your left leg. 3. Twist your torso to the right and shift your gaze upward to complete the stretch. 4. Hold for twenty seconds before switching sides.

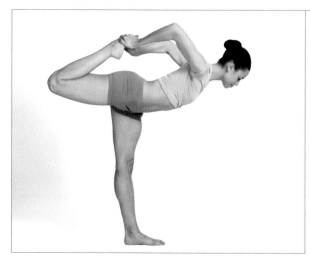

Bowing with Respect Lord of Dance

Target: Spine.

Benefits: Extends the spine and chest while lengthening the muscles in the quads and shoulders.

Steps: 1. Balance on one foot, lifting the other foot behind you. 2. Grab hold of your raised foot with both hands. 3. Lean your head forward toward the floor, while extending your bound foot away from you.

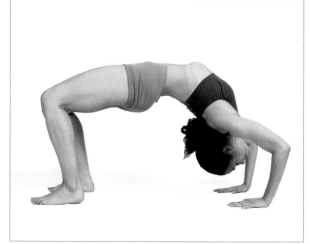

Bridge

Target: Spine.

Benefits: Extends the spine and hips while strengthening the glutes and quadriceps.

Steps: 1. Lie flat on your back with your knees bent. 2. Bend your elbows and place your palms flat on the floor beside your head, with your fingers pointed toward you. 3. Using your arms and legs, lift your body off the floor and round your back so your belly button is your highest point. 4. Let your head and shoulders drop. 5. Hold this pose for as long as you feel confident.

Caution: Make sure you are confident doing a shoulder bridge before attempting this stretch. Perform on a yoga mat or cushioned surface.

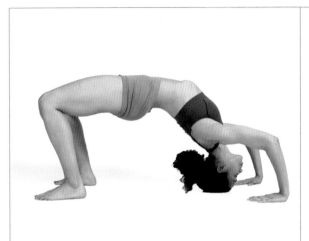

Bridge on Forehead

Target: Spine.

Benefits: Extends the spine and hips while strengthening the glutes and quadriceps.

Steps: 1. Lie flat on your back with your knees bent. **2.** Bend your elbows and place your palms flat on the floor beside your head, with your fingers pointed toward you. **3.** Using your arms and legs, lift your body off the floor, keeping your elbows bent so the top of your head is resting on the floor. **4.** Hold this pose for as long as you feel confident.

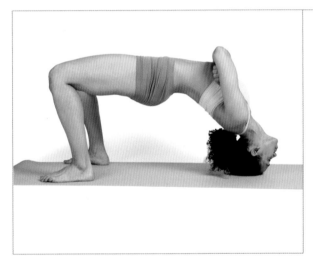

Bridge on Forehead, Modification

Target: Spine.

Benefits: Extends the spine and hips while strengthening the glutes and quadriceps.

Steps: 1. Lie flat on your back with your knees bent. **2.** Bend your elbows and place your palms flat on the floor beside your head, with your fingers pointed toward you. **3.** Using your arms and legs, lift your body off the floor, keeping your elbows bent so the top of your head is resting on the floor. **4.** Raise your hands off the floor and rest them across your chest. **5.** Hold this pose for as long as you feel confident.

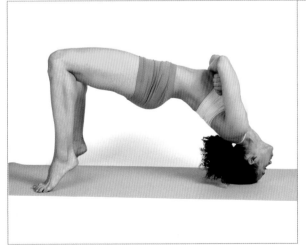

Bridge on Forehead, Advanced Modification

Target: Spine.

Benefits: Extends the spine and hips while strengthening the glutes and quadriceps.

Steps: 1. Lie flat on your back with your knees bent. **2.** Bend your elbows and place your palms flat on the floor beside your head, with your fingers pointed toward you. **3.** Using your arms and legs, lift your body off the floor, keeping your elbows bent so the top of your head is resting on the floor. **4.** Raise your hands off the ground and rest them across your chest. **5.** Lift your feet onto your tiptoes and hold this pose for as long as you feel confident.

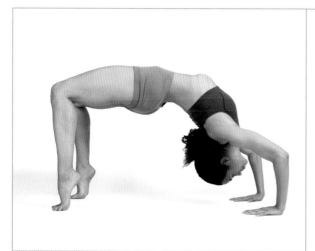

Bridge on Raised Toes

Target: Spine.

Benefits: Extends the spine and hips while strengthening the glutes and quadriceps.

Steps: 1. Lie flat on your back with your knees bent. **2.** Bend your elbows and place your palms flat on the floor beside your head, with your fingers pointed toward you. **3.** Using your arms and legs, lift your body off the floor and round your back so your belly button is your highest point. **4.** Lift your feet onto your tiptoes and let your head and shoulders drop. **5.** Hold this pose for as long as you feel confident.

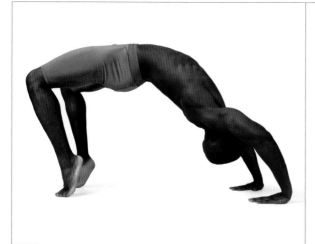

Bridge Tiptoe, Arms Extended

Target: Spine.

Benefits: Extends the spine and hips while strengthening the glutes and quadriceps.

Steps: 1. Lie flat on your back with your knees bent. **2.** Bend your elbows and place your palms flat on the floor beside your head, with your fingers pointed toward you. **3.** Using your arms and legs, lift your body off the floor and step your arms away from you to extend the stretch. **4.** Lift your feet onto your tiptoes and let your head and shoulders drop. **5.** Hold this pose for as long as you feel confident.

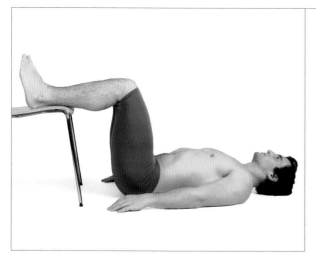

Chair Stretch Twist

Target: Spine.

Benefits: Twists the lower back and spine, relieving tightness and immobility.

Steps: 1. Lie on your back and place your feet on the seat of the chair. **2.** Raise your right foot over the other, crossing your ankles. **3.** Twist your knees to the right, keeping both shoulders on the floor. **4.** Hold for fifteen seconds before switching sides.

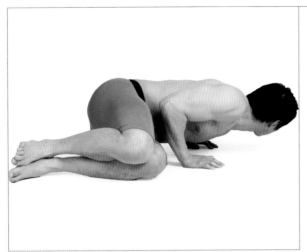

Chest-to-Floor Twist

Target: Spine.

Benefits: Provides greater strength and flexibility in spine and shoulders.

Steps: 1. Begin by lying on your stomach. **2.** Bend both legs to the right, so one knee is stacked on the other. **3.** Bend your elbows and bring your palms flat on the floor beneath your shoulders. **4.** Pull your right shoulder up from the floor to increase the stretch. **5.** Maintain this position for twenty seconds before alternating sides.

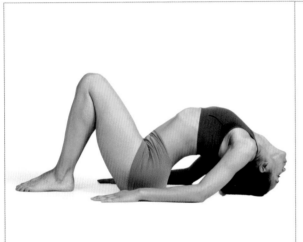

Fish Pose Backbend

Target: Spine.

Benefits: Opens the neck and chest while elongating the spinal column.

Steps: 1. Start by lying on your back, with both knees bent and your feet and palms flat on the floor. **2.** Arch your back up from the floor, raising your chest and shoulders. **3.** Let your head drop so the top of your head is resting on the floor. **4.** Hold this position for twenty seconds.

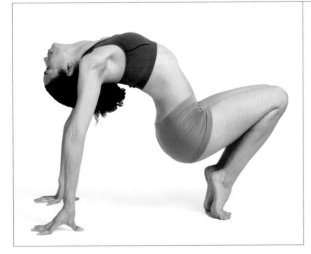

Fish Pose Backbend, Extended

Target: Spine.

Benefits: Opens the neck and chest while elongating the spinal column.

Steps: 1. Start by lying on your back with both knees bent and your feet flat on the floor. **2.** Arch your back up from the floor, raising your chest and hips. **3.** Bend your elbows and place your palms on the floor by your shoulders, with your fingers pointed behind you. **4.** Pressing against your palms, lift your head and shoulders from the floor. **5.** Straighten your arms and let your head drop to complete the stretch. **6.** Hold this position for twenty seconds.

Foot-to-Back Twist

Target: Spine.

Benefits: Twists the spine and extends the upper back and shoulders.

Steps: 1. Begin on your knees with your hips resting on your heels.
2. Bring your left knee to your chest and place your foot flat on the floor.
3. Place your right elbow on the outside of your left knee and reach your left hand across your back to your opposite hip. **4.** Twist your torso to the left while turning your gaze to the right. **5.** Hold this pose for twenty seconds before switching sides.

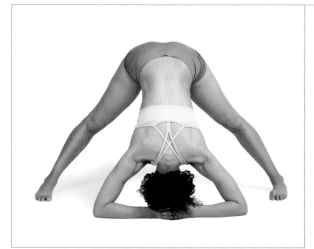

Forward Bend, Advanced

Target: Spine.

Benefits: Stretches the length of your spinal column and hamstrings.

Steps: 1. Stand with your legs wide apart and your fingers clasped ahead of you. **2.** Fold your torso forward at the hips until you are able to rest your palms on the floor between your legs. **3.** Continue to bend until the top of your head rests on your hands and your forearms are flat on the floor. **4.** Hold this position for ten seconds.

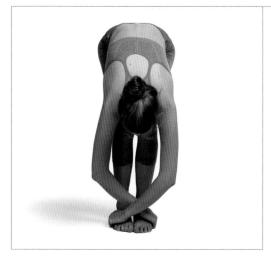

Forward Bend, Arms Crossed

Target: Spine.

Benefits: Lengthens the spine and hamstrings.

Steps: 1. Stand with your feet together and arms crossed at the elbows. **2.** Lean your head toward the floor, folding at the hips, until you are able to touch the floor. **3.** Keeping your knees straight, deepen the stretch by grabbing the bottom of either foot with the opposite hand and bending your elbows. **4.** Maintain this position for twenty seconds or longer.

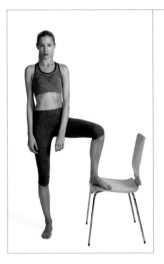
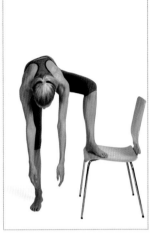

Front Bend, Chair Assisted

Target: Spine.

Benefits: Lengthens the spine and hamstrings while targeting the muscles across the lower back.

Steps: 1. Stand straight with your right foot on the floor and your left foot raised onto the seat of a chair beside you. **2.** Slowly bend at the hips, reaching toward the floor. **3.** Reach as low as you can and hold this position for fifteen seconds before alternating legs.

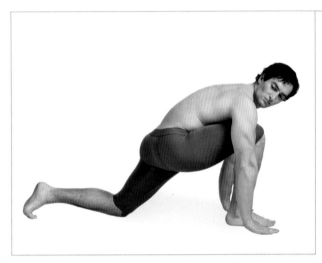

Hip Twist

Target: Spine.

Benefits: Opens the hips while extending the spine and lower back.

Steps: 1. Step your right foot forward, bending both knees into deep lunge. **2.** Place your hands flat on the floor on either side of your right foot, and push your right shoulder up from the floor to increase pressure on the spine. **3.** Maintain this pose for twenty seconds before alternating sides.

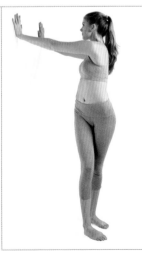

Lateral Wall Stretch

Target: Spine.

Benefits: Twists the spine and lengthens the lats.

Steps: 1. Begin by standing straight, with your legs apart, facing away from a wall at arm's length away. **2.** Twist your torso around to your right and extend both palms to the wall. **3.** Hold this position for fifteen seconds on either side.

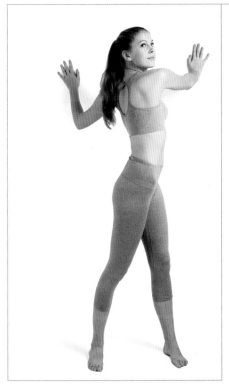

Lateral Wall Stretch, Variation

Target: Spine.

Benefits: Twists the spine and lengthens the lats.

Steps: 1. Begin by standing straight, with your legs apart, facing away from a wall at arm's length away. **2.** Twist your torso around to the left, extending both palms to the wall. **3.** Turn your gaze to your right to increase the stretch. **4.** Hold this position for fifteen seconds on either side.

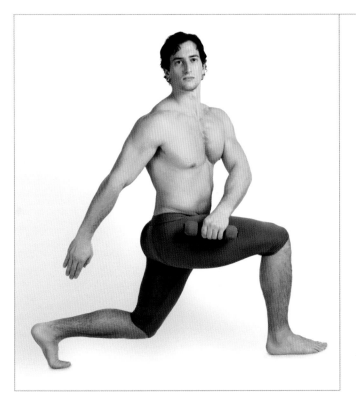

Lunge with Diagonal Reach

Target: Spine.

Benefits: Strengthens the calves and quads while extending the lower back and spine.

Steps: 1. Step your right foot forward and lower yourself into a lunge position. **2.** Twist your torso to the right and place your left hand on your right thigh. **3.** Hold this position for ten seconds before alternating sides.

Note: For an advanced modification, attempt to hold a weight in your front hand.

One-Leg Bound, Standing Balance

Target: Spine.

Benefits: Extends the muscles along the spine and lower back while opening the hips.

Steps: 1. From a standing position, bend your right knee up to your chest. **2.** Maintaining your balance, twist your torso to the right and wrap your left arm under your right knee from the outside. **3.** Extend your right arm across your back, and bind your hands together around your right leg. **4.** Turn your shoulders and head fully to the right to complete the stretch. **5.** Hold for twenty seconds before switching sides.

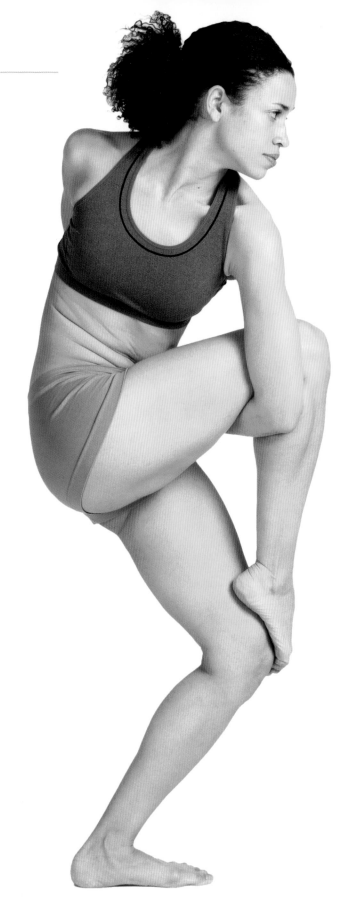

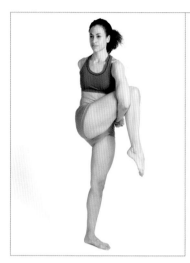

One-Leg Bound, Standing Balance Variation

Target: Spine.

Benefits: Extends the muscles along the spine and lower back while opening the hips.

Steps: 1. From a standing position, bend your right knee up to your chest. **2.** Maintaining your balance, twist your torso to the right and wrap your left arm under your right knee from the outside. **3.** Extend your right arm across your back and bind your hands together around your right leg. **4.** Slowly bend your left leg and place your right foot on your left knee. **5.** Hold for twenty seconds before switching sides.

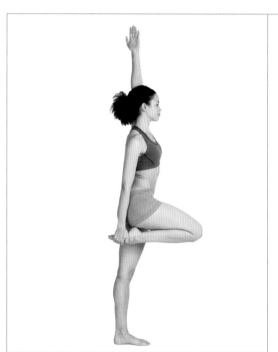

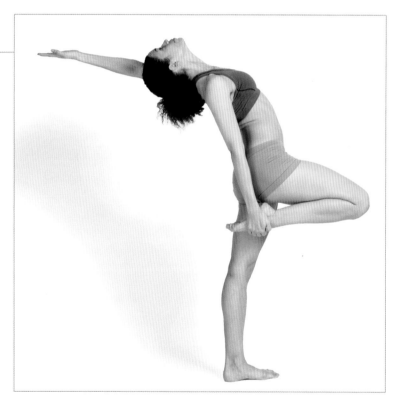

One-Leg Standing Balance, Intense Backbend

Target: Spine.

Benefits: Increases flexibility and range of motion along the spine while practicing balance.

Steps: 1. From a standing position, bend your right leg up to your hips and grab your raised foot with your right hand. **2.** Extend your left hand straight above you. **3.** Keeping your right hand and foot bound, slowly bend your upper body backward at the waist, leaning as far back as you can before alternating sides.

Caution: Try this stretch with a partner before attempting alone.

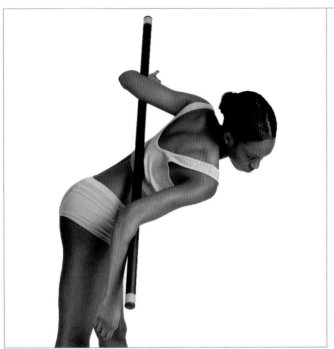 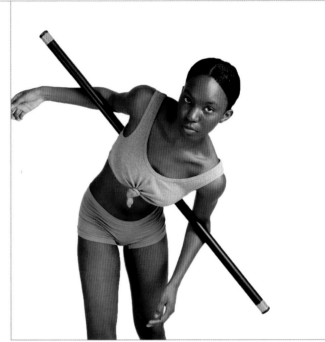

Paraspinal Stretch with Body Bar

Target: Spine.

Benefits: Extends the spine and engages the abdomen.

Steps: 1. Stand straight with a body bar tucked under your elbows behind your back.
2. Bend your shoulders forward and slowly twist your torso from one side to the other.

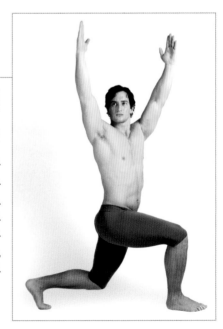

Reverse Lunge with Twist and Overhead Reach

Target: Spine.

Benefits: Strengthens the calves and quads while lengthening the neck and spine.

Steps: 1. Step your right foot forward and lower yourself into a lunge position.
2. Twist your torso to the right and extend your arms above your head.
3. Hold this position for ten seconds before alternating sides.

Note: For an arm-strengthening modification of this stretch, attempt holding weights in either hand.

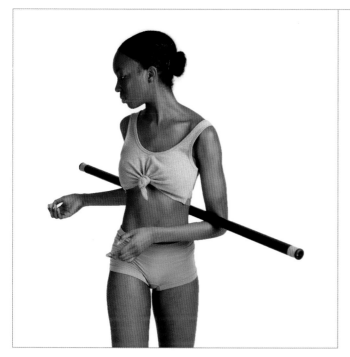

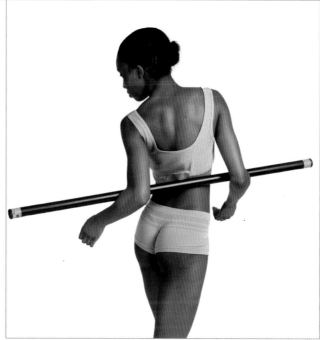

Paraspinal Twist with Body Bar

Target: Spine.

Benefits: Extends the spine and engages the abdomen.

Steps: 1. Stand with the body bar tucked under both elbows behind your back.
2. Keeping your back upright, twist your torso from one side to the other.

Seated Spinal Stretch

Target: Spine.

Benefits: Engages the spinal cord while stretching the shoulders, hips, and neck.

Steps: 1. Begin by sitting on the floor cross-legged. **2.** Twist your spine to the right, bringing your left hand to your right knee and reaching your right hand to the floor behind you. **3.** Shift your gaze behind you to extend the spine fully. **4.** Hold this position for fifteen seconds on each side.

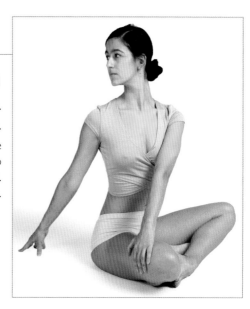

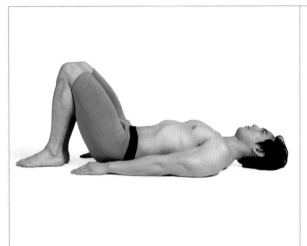

Shoulder Bridge Prep

Target: Spine.

Benefits: Engages and strengthens the abdominals, hips, and quadriceps.

Steps: 1. Lie flat on your back, with your arms at your sides.
2. Bend your knees and step both feet in toward your hips while keeping your feet flat on the floor.

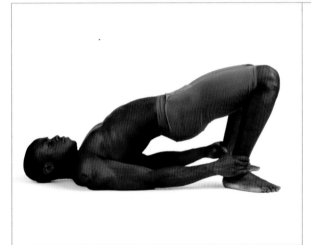

Shoulder Bridge Bound

Target: Spine.

Benefits: Engages and strengthens the abdominals, hips, and quads while lengthening the spine.

Steps: 1. Lie flat on your back, with your arms at your sides.
2. Step both feet in, so your knees are bent and your feet are flat on the floor. **3.** Keeping your arms and shoulders down, push your hips up off the ground and reach your hands to your ankles.
4. Maintaining hold of your ankles, push your hips as high from the floor as you are able. **5.** Hold this position for thirty seconds before releasing.

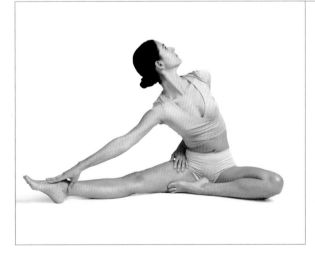

Sideways Spinal Stretch, Toe Touch

Target: Spine.

Benefits: Engages the spine and lengthens the obliques and hamstrings.

Steps: 1. Sitting on the floor, point your right leg straight out to your side and bend the other foot into your groin in a half-split pose.
2. Drop your torso down toward your right leg and reach for your ankle with your right hand. **3.** Reach your left arm behind your back to hold your right thigh. **4.** Shift your gaze up to the left and hold this position for thirty seconds before switching sides.

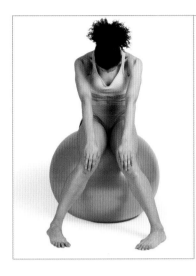

Spinal Curve with Feet on Ball

Target: Spine.

Benefits: Lengthens the spine and neck while engaging the core.

Steps: 1. Begin seated on an exercise ball, with your legs apart. **2.** Keeping your feet planted, bring your knees together and place your hands on your knees. **3.** Drop your head and shoulders down toward your knees, deeply arching your back. **4.** Hold this position for thirty seconds.

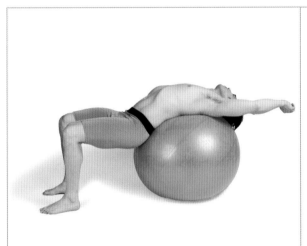

Spinal Stretch on Ball

Target: Spine.

Benefits: Opens the chest and extends the length of the spine, relieving stiffness and back pain.

Steps: 1. Lie on your back across the top of an exercise ball, keeping your knees bent at a 90-degree angle for support. **2.** Extend your arms overhead behind you. **3.** Remain in this position for thirty seconds.

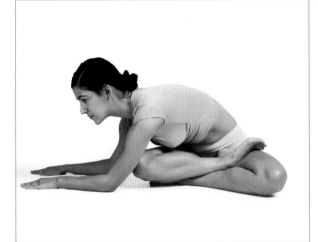

Spinal Twist, Deep Seated

Target: Spine.

Benefits: Engages the spinal cord while stretching the shoulders, hips, and neck.

Steps: 1. Begin by sitting on the floor cross-legged. **2.** Twist your torso to the right and lower your torso over your right thigh. **3.** Place your forearms on the floor by your right knee and gaze upward. **4.** Hold this position for fifteen seconds before switching sides.

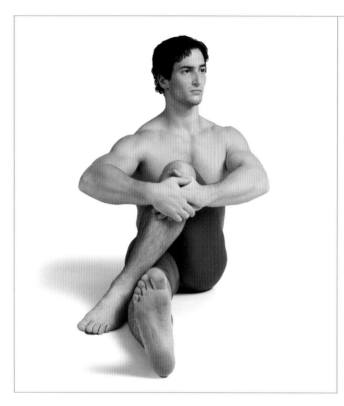

Spinal Twist, Modification

Target: Spine.

Benefits: Lengthens the spine and hamstrings.

Steps: 1. Begin seated with your legs straight ahead. **2.** Bend your left leg over your right, so your left foot is on the floor to the outside of your right thigh and your knee is tucked close to your chest. **3.** Hold your knee with both hands and twist your torso from one side to the other. **4.** Repeat with the other leg.

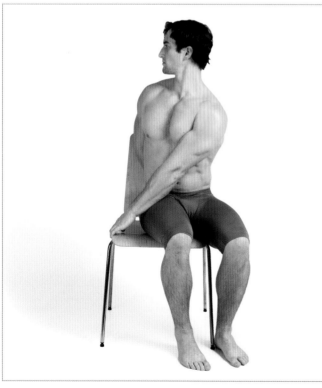

Spinal Twist, Seated

Target: Spine.

Benefits: Improves mobility and posture along the spine.

Steps: 1. Begin seated on a chair with your knees slightly apart. **2.** Twist your torso to the right and place your left hand on the right side of the chair seat. Reach your right hand behind you to grab the left side of the chair's back. **3.** Turn your gaze to the right and pull your back into a deeper twist. **4.** Release and perform on the opposite side.

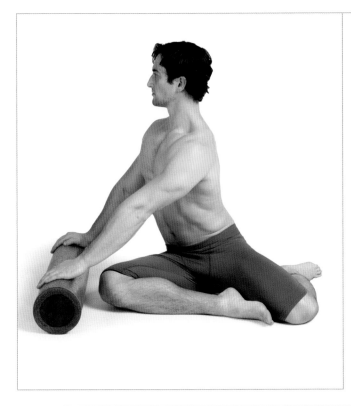

Spinal Twist with Roller

Target: Spine.

Benefits: Twists the spine and opens the groin.

Steps: 1. Begin seated with a foam roller on the floor at your right side. **2.** Bend both knees, so your left foot points behind you and your right foot is tucked into your groin. **3.** Twist your torso to the right, placing both hands on the roller. **4.** Hold this position for thirty seconds before switching to the opposite side.

Spine and Shoulder Twist, Advanced

Target: Spine.

Benefits: Deeply extends the spine and hips, improving mobility and posture.

Steps: 1. Begin by lying on your stomach, with your arms straight out at your sides. **2.** Lift your head, so you are resting on your chin. **3.** Lift your right leg from the floor and extend it over your left leg, placing your toes on the floor near your left hand. **4.** Hold this pose for twenty seconds before switching sides.

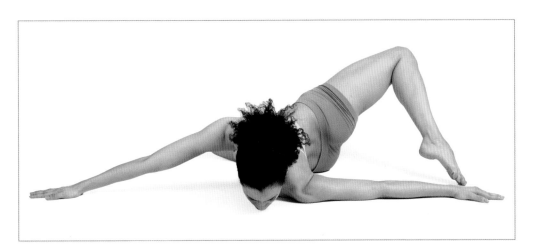

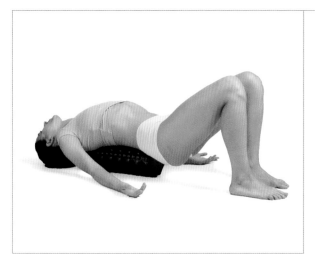

Spine Length on Roller

Target: Spine.

Benefits: Relieves tightness and muscle strain along the spine.

Steps: 1. Lay your back along the length of a foam roller, with your knees bent. **2.** Let your shoulders, head, and arms drop down to the floor. **3.** Roll side to side, targeting any troubles areas along your spine.

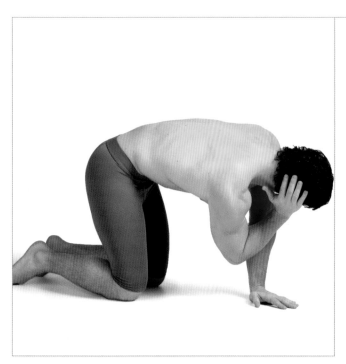

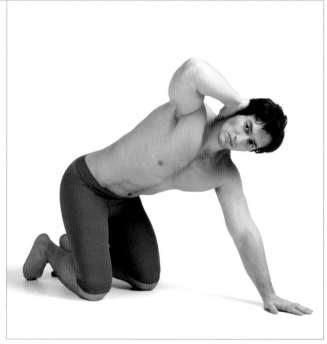

Thoracic Rotation

Target: Spine.

Benefits: Strengthens the muscles in the upper back and chest while elongating the spine.

Steps: 1. Begin by kneeling on all fours. **2.** Place your right hand on the back of your head and raise your right elbow just above shoulder height. **3.** Lower your elbow and perform twenty repetitions with each arm.

Supine Trunk Rotation

Target: Spine.

Benefits: Twists the lower back and spine, relieving tightness and muscle pain.

Steps: 1. Begin by lying on your back, holding an exercise ball above your head with both hands. **2.** Bend your knees into your chest and drop them over to your left side. **3.** Hold this position for twenty seconds before raising your knees and lowering them to the other side.

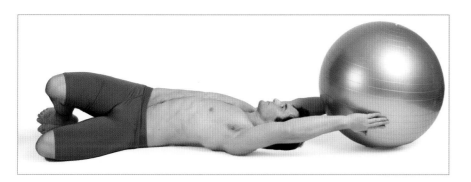

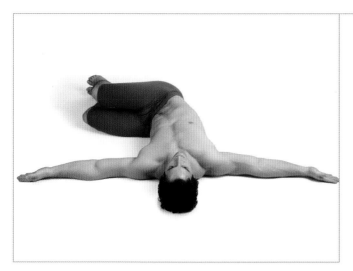
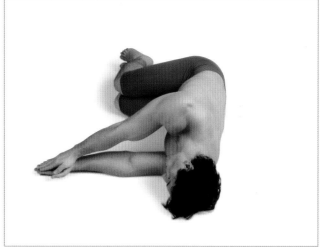

Thoracic Rotation, Side-Lying

Target: Spine.

Benefits: Strengthens the muscles in the upper back and chest while twisting the spine.

Steps: 1. Begin by lying on your back, with your arms straight out at your sides. **2.** Bring your knees into your chest and drop them down to your left side. **3.** Turn your torso to the left. Bring your right hand over your body and place it on your left palm. **4.** Lift your arm back over your body to the starting position. **5.** Repeat thirty times before alternating sides.

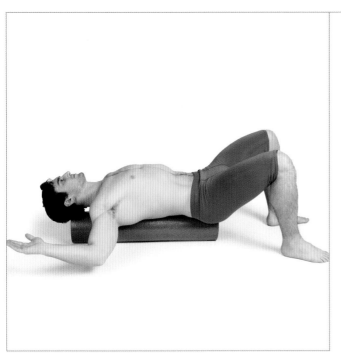
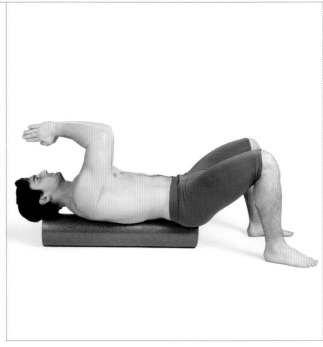

Thoracic Spine

Target: Spine.

Benefits: Relieves tightness and muscle strain along the spine while strengthening the upper back and chest.

Steps: 1. Lay your back along the length of a foam roller, with your knees bent, and bring your hands together in prayer position above your head. **2.** Keeping your elbows bent, slowly extend your arms away from each other, until they are parallel to the floor. **3.** Bring your hands back up to prayer position and repeat thirty times.

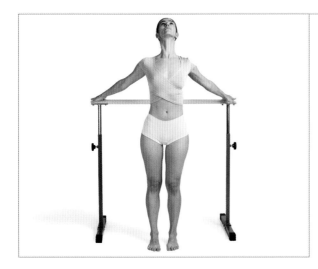

Traction Stretch at Ballet Bar

Target: Spine.

Benefits: Opens the chest and shoulders while lengthening the spine.

Steps: 1. Stand facing away from the ballet bar. **2.** Reach behind you and hold the ballet bar with both hands. **3.** Keeping hold of the bar, straighten your arms and pull your body away from the bar. **4.** Lift your gaze to the ceiling and hold for twenty seconds.

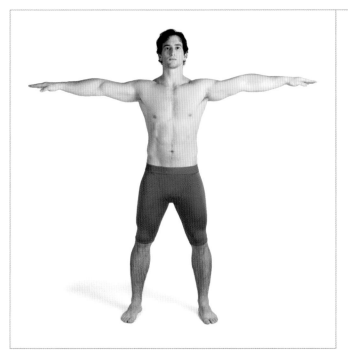

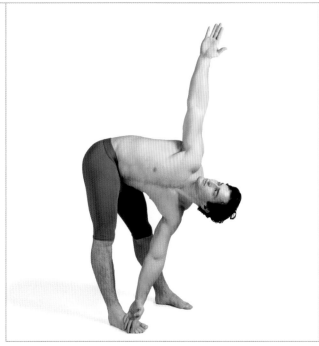

Torso Twist

Target: Spine.

Benefits: Lengthens the spine and hamstrings, improving strength and posture.

Steps: 1. Stand with your legs apart and your arms straight out to your sides. **2.** Bend your torso forward at the waist and twist to your right. **3.** Touch your right foot with your left hand and raise your torso back up to the starting position. **4.** Bend your torso to the left, and touch your left foot with your right hand. **5.** Repeat this movement twenty times.

Trunk Rotator

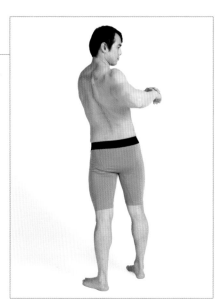

Target: Spine.

Benefits: Twists the spine and lower back, improving flexibility and mobility.

Steps: 1. Stand upright with your feet slightly apart. **2.** Bend your elbows up to your sides and hold your fists in front of your chest. **3.** Twist your torso from one side to the other and perform twenty repetitions per side.

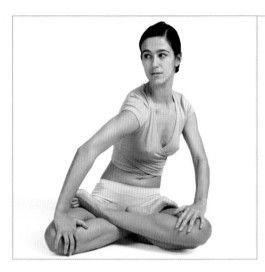

Twisted Lotus

Target: Spine.

Benefits: Opens the hips and groin while extending the spine and shoulders.

Steps: 1. Sit on the floor with your legs extended, spine straight, and arms resting at your sides. **2.** Bring your right foot to rest in the crease of your left hip, with the sole of your foot facing upward. **3.** Bend your left knee, and cross your left foot over your right shin and into your right hip. The sole of your left foot should also face upward. **4.** Place your hands on your knees and twist your shoulders to the left while gazing to your right. **5.** Hold for twenty seconds and repeat in the opposite direction.

Twisted-Lotus Variation

Target: Spine.

Benefits: Opens the hips and groin while extending the spine and shoulders.

Steps: 1. Sit on the floor with your legs extended, spine straight, and arms resting at your sides. **2.** Bring your right foot to rest in the crease of your left hip, with the sole of your foot facing upward. **3.** Bend your left knee, and cross your left foot over your right shin and into your right hip. The sole of your left foot should also face upward. **4.** Drop your left shoulder down to your right knee and extend your right arm straight up, shifting your gaze to the ceiling. **5.** Hold this position for twenty seconds before alternating your arms.

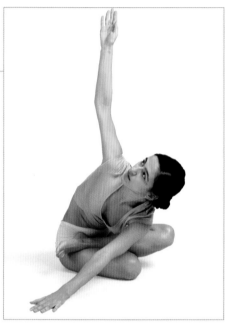

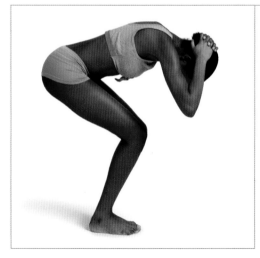

Upper-Back Spine Stretch, Crouching

Target: Spine.

Benefits: Relieves tightness and elongates the muscles in the spine and upper back.

Steps: 1. Begin by standing with your feet together and your arms at your sides. **2.** Bend your knees slightly into a crouching position and bring both hands to the back of your head. **3.** Pull your head down to the floor, while pushing the center of your back upward. **4.** Hold this position for twenty seconds.

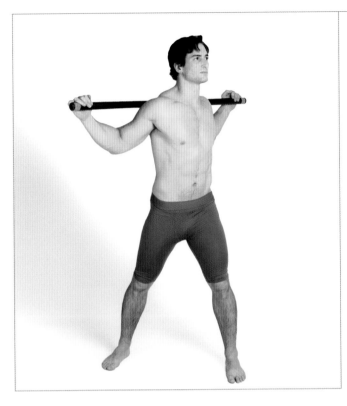

Upper-Back Stretch with Body Bar

Target: Spine.

Benefits: Lengthens the spine and upper back, improving flexibility and mobility.

Steps: 1. Stand up straight with your legs about two feet apart. **2.** Place a body bar behind your shoulders, holding it with both hands. **3.** Press the bar forward against your upper back while pushing against it with your head and shoulders. **4.** Hold for fifteen seconds.

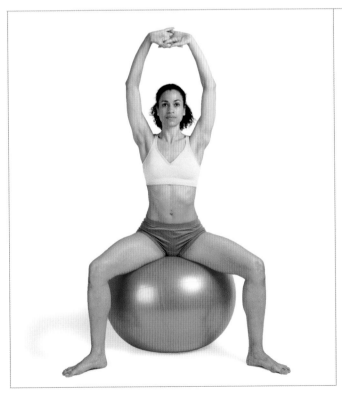

Upper-Body Stretch with Clasped Hands on Ball

Target: Spine.

Benefits: Lengthens the spine and opens the chest and shoulders.

Steps: 1. Sit on an exercise ball with your legs apart. **2.** Clasp your hands above your head, with your palms facing upward. **3.** Pull your hands up to the ceiling, lengthening your spine, and hold for twenty seconds.

Upper-Leg
Stretches

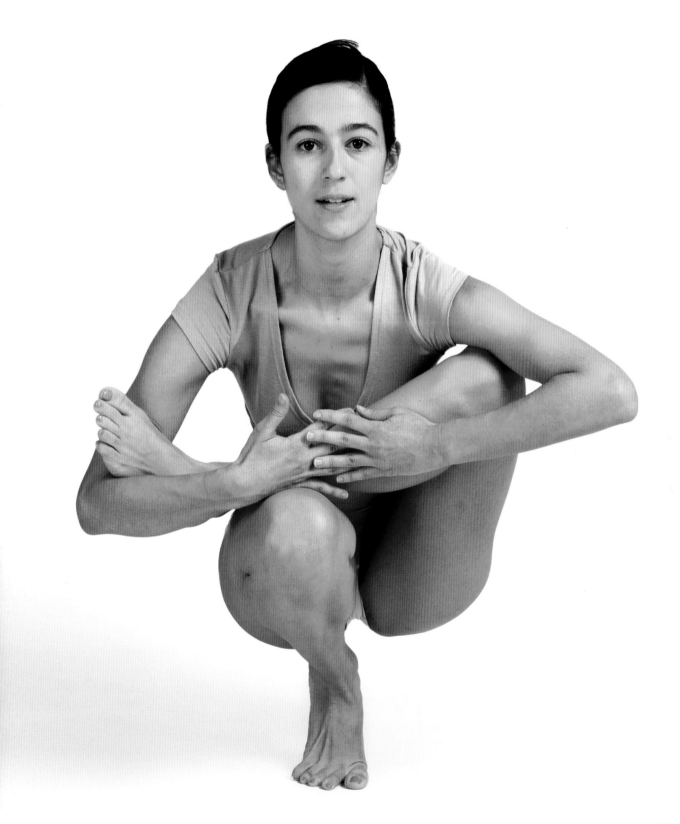

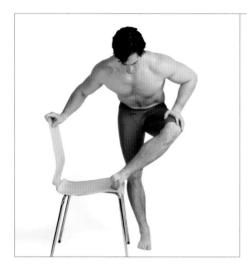

Abduction Stretch, Foot Raised

Target: Abductors.

Benefits: Increases the range of motion in the hip abductors.

Steps: 1. Start by standing straight, with a sturdy chair at your right side. **2.** Holding the back of the chair, place your left foot on the seat of the chair. **3.** Lean forward and, with your left hand, push against your left knee. **4.** Hold for thirty seconds before alternating sides.

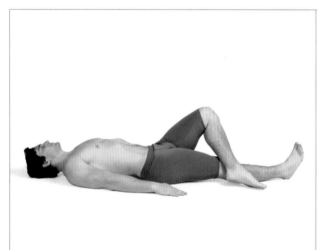

Abduction Stretch, Leg Crossed Over

Target: Abductors.

Benefits: Elongates the abductors.

Steps: 1. Begin by lying on your back, with your left knee bent. **2.** Cross your left leg over the right and place your left foot on the outside of your right knee. **3.** Hold for twenty seconds before alternating sides.

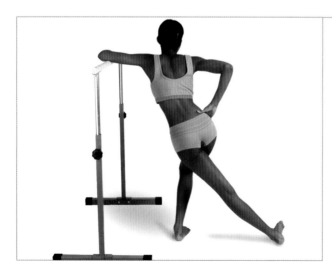

Abduction Stretch, Leg Crossed Under at Ballet Bar

Target: Abductors.

Benefits: Aids flexibility in the abductor and tensor fasciae latae muscles.

Steps: 1. Begin by standing straight, with a ballet bar to your left. **2.** Rest your left elbow on the bar and cross your left leg behind the other, placing the outside of your foot on the floor. **3.** Lower your torso to increase the stretch and hold for twenty seconds before repeating on the other side.

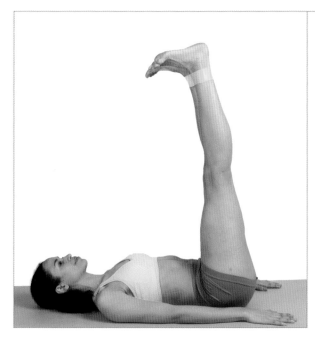

Abductor Stretch, Ankles Bound

Target: Abductors.

Benefits: Stretches adductors on either side of the pelvis.

Steps: 1. Attach a short resistance band around your ankles. **2.** Lie flat on your back and raise both legs straight above your hips, keeping the band taut. **3.** With your feet flexed and legs straight, pull your ankles apart against the resistance of the band. **4.** Hold for fifteen seconds.

Abductor Stretch, Ankles Bound Modification

Target: Abductors.

Benefits: Turning toes outward intensifies the calf stretch.

Steps: 1. Attach a short resistance band around your ankles. **2.** Lie flat on your back and raise both legs straight above your hips, keeping the band taut. **3.** With your feet flexed and legs straight, turn your toes outward and pull your ankles apart against the resistance of the band. **4.** Hold for fifteen seconds.

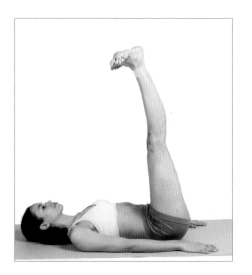

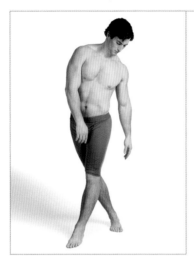

Abductor Stretch, Leg Crossed Under

Target: Abductors.

Benefits: Lengthens the hip abductors.

Steps: 1. Begin by standing straight, with your arms at your sides. **2.** Cross your right leg behind the other, pointing both feet straight ahead. **3.** Stretch your torso down toward your left side to heighten the pressure on the abductors. **4.** Hold for twenty seconds and alternate sides.

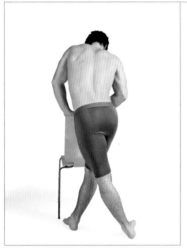

Abductor Stretch, Leg Crossed Under with Chair

Target: Abductors.

Benefits: Lengthens the hip abductors.

Steps: 1. Begin by standing straight, facing the back of a chair. **2.** Hold onto the back of the chair and cross your left leg behind the other, keeping both feet straight ahead. **3.** Stretch your torso toward your right to heighten the pressure on the abductors. **4.** Hold for twenty seconds and alternate sides.

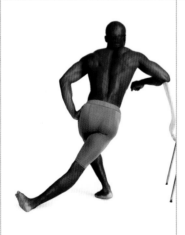

Abductor Stretch, Leg Crossed Under with Chair, Advanced

Target: Abductors.

Benefits: Lengthens the hip abductors.

Steps: 1. Start by standing straight, with a sturdy chair at your right side. **2.** Leaning your right elbow on the back of the chair, cross your right leg behind the other. **3.** Lower your torso to maximize this stretch. **4.** Hold for twenty seconds and alternate sides.

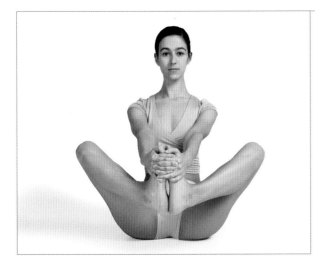

Angle Pose, Equilibrium Bound

Target: Abductors.

Benefits: Strengthens the hips and lower back, while improving core strength and balance.

Steps: 1. Sit on the floor, with your knees bent at your sides and the soles of your feet pressed together. **2.** Reach forward and grab hold of your feet and toes with both hands. **3.** Raise your feet off the floor and hold for twenty seconds.

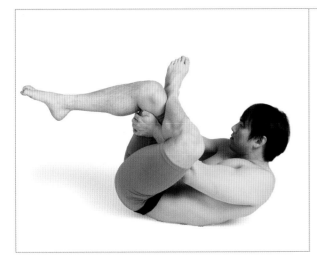
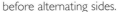

Ankle-on-Knee Stretch

Target: Abductors.

Benefits: Relieves tension and tightness in the muscles of the outer hip.

Steps: 1. Begin by lying on your back, knees tucked into your chest. **2.** Place your left ankle on your right knee. **3.** From this position, pull your right knee in toward your chest. Lengthen your spine and balance on your hip bones. **4.** Hold for ten seconds before alternating sides.

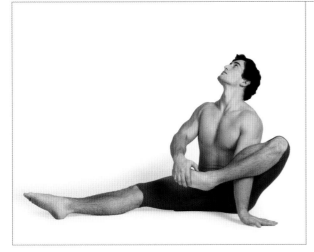

Archer's Pose Prep

Target: Abductors.

Benefits: Opens the groin while lengthening the hip abductors.

Steps: 1. Begin seated on the floor with your legs extended out to your sides. **2.** Place your left hand flat on the floor in front of your left knee and bend your left knee. **3.** Hold your left foot with your right hand and lift your left leg from the floor. **4.** Hold for twenty seconds before releasing and repeating on the opposite leg.

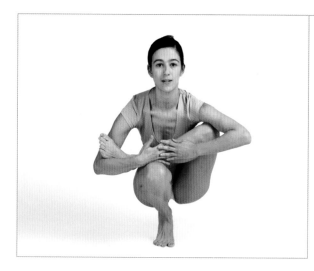

Baby Cradle Pose in One-Legged Tiptoe

Target: Abductors.

Benefits: Extends the muscles in the hips while improving core balance and strength.

Steps: 1. Begin by crouching low to the ground on tiptoes. **2.** Raise your left foot from the floor and place it across your right thigh. **3.** Maintaining your balance, use your hands to pull your left leg further into your chest to increase the stretch on the hip abductors. **4.** Hold this pose for as long as you are able. **5.** Release and repeat, switching feet.

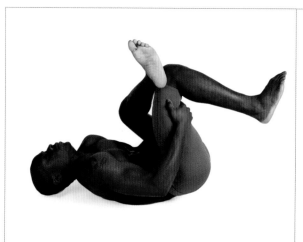

Cross-Knee Pull

Target: Abductors.

Benefits: Targets tightness or tension in the abductors.

Steps: 1. Lie flat on the floor, with both knees bent. **2.** Raise your left foot from the floor and rest your left ankle on the opposite knee. **3.** Grab the back of your right thigh with both hands and pull your knees toward your body. **4.** Hold for twenty seconds and alternate sides.

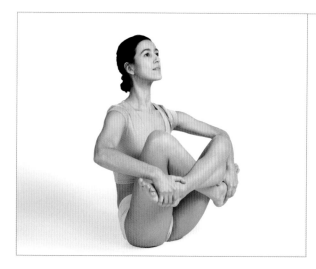

Easy Pose Embryo in Womb

Target: Abductors.

Benefits: Lengthens the abductors while improving core balance and hip alignment.

Steps: 1. Sit cross-legged and reach your hands down to grab the opposite foot. **2.** Lean your torso back and lift your feet from the floor, balancing on your hip bones. **3.** Hold this pose for twenty seconds.

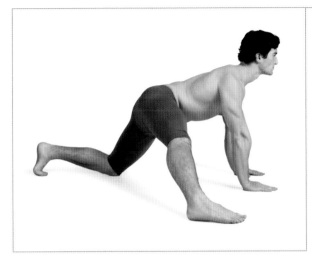

Extended Four-Limbs Staff Pose, Leg to Side 1

Target: Abductors.

Benefits: Opens the hips and stretches the outer length of the legs and hips.

Steps: 1. Begin on all fours, with your palms flat on the floor and your toes raised behind you. **2.** Extend your right leg straight out to the side, resting your right foot flat on the floor. **3.** Press your hips down toward the floor to increase the stretch. **4.** Hold this pose for thirty seconds before releasing and performing with the other leg.

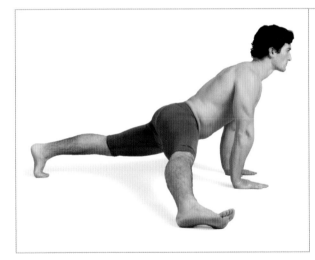

Extended Four-Limbs Staff Pose, Leg to Side 2

Target: Abductors.

Benefits: Opens the hips and stretches the outer length of the legs and hips.

Steps: 1. Begin on all fours, with your palms flat on the floor and your toes raised behind you. **2.** Extend your right leg straight out to the side, resting it on the inner length of the foot. **3.** Straighten your left leg, lifting your knee from the floor. **4.** Hold this pose for thirty seconds before releasing and performing with the other leg.

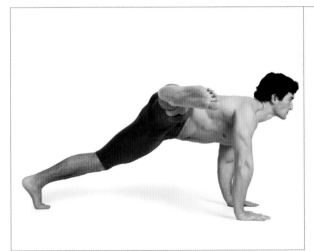

Extended Four-Limbs Staff Pose, Leg to Side 3

Target: Abductors.

Benefits: Opens the hips and stretches the outer length of the legs and hips.

Steps: 1. Begin on all fours, with your palms flat on the floor and your toes raised behind you. **2.** Extend your right leg straight out to the side, resting it on the inner length of the foot. **3.** Straighten your left leg, lifting your knee from the floor. **4.** Raise your right leg straight out to your side at hip height. **5.** Hold this pose for twenty seconds before releasing and performing with the other leg.

Four-Corner Stretch 1

Target: Abductors.

Benefits: Lengthens the hip abductors and increases alignment in the hips and spine.

Steps: 1. Begin seated on the floor, cross-legged with your right leg on top. **2.** Raise your right knee and hook your right arm beneath your calf. **3.** Lift your calf, so it is parallel to the floor. **4.** Hold this pose for thirty seconds before switching legs.

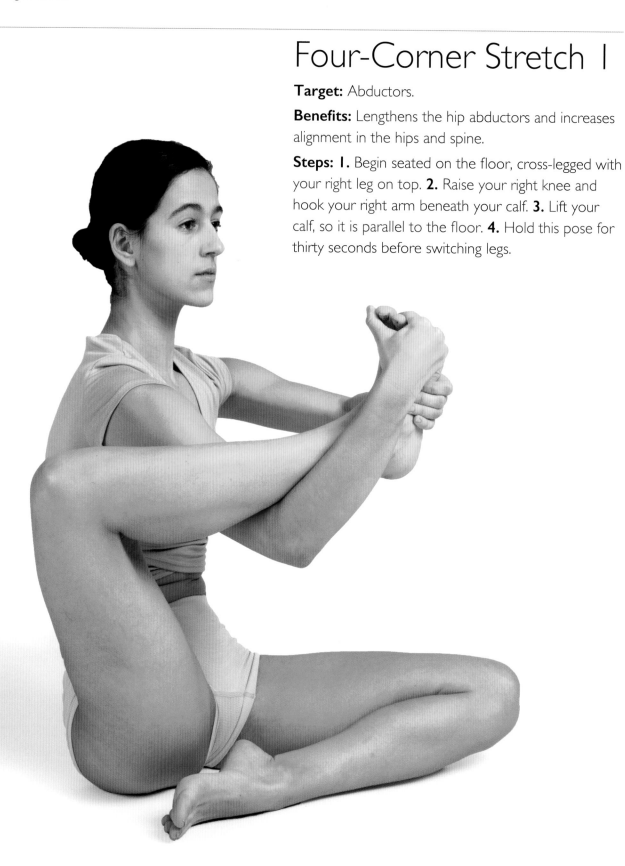

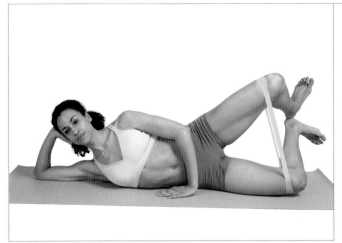

Frog Leg, Ankles Raised with Band

Target: Abductors.

Benefits: Increases the range of motion within the hip abductors.

Steps: 1. Lie on your right side and attach a resistance band around both legs above the knee. **2.** Keeping your right knee on the floor and heels touching, raise your left knee and both feet. **3.** Hold for ten seconds and return both legs to the floor. **4.** Repeat on the opposite side.

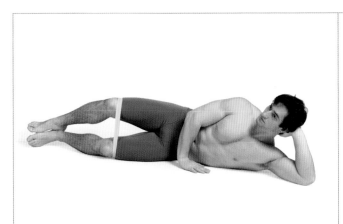

Frog Leg with Band

Target: Abductors.

Benefits: Increases the range of motion within the hip abductors.

Steps: 1. Lie on your right side and attach a resistance band around both legs above the knee. **2.** Keeping the right knee on the ground, raise your left knee against the resistance of the band. **3.** Hold for ten seconds and return both legs to the floor. **4.** Repeat on the opposite side.

Leg Cradle

Target: Abductors.

Benefits: Lengthens the hip abductors and improves alignment in the hips and spine.

Steps: 1. Begin seated on the floor with both legs extended. **2.** Bend your left knee and bring your foot to rest on top of your right thigh. **3.** Lean forward and bend your left elbow around your left knee, so your forearm rests along your shin. **4.** Reach your right hand around your left foot and join your hands in front of your left shin. **5.** Pull your left leg up to shoulder height. **6.** Hold this position for ten seconds before releasing. Lower and repeat on the opposite leg.

Four-Corner Stretch 2

Target: Abductors.

Benefits: Lengthens the hip abductors and increases alignment in the hips and spine.

Steps: 1. Begin seated on the floor, cross-legged with your right leg on top. **2.** Raise your right knee and hook your right arm beneath your calf. **3.** Lift your calf so it is parallel to the floor and bring your hands together on top of your head. **4.** Hold this pose for thirty seconds before switching legs.

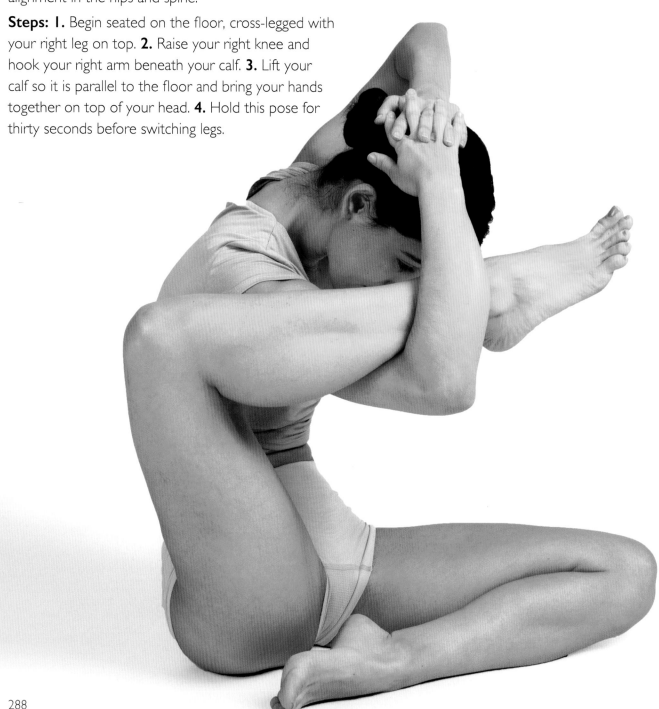

Hip Abductor, Supported

Target: Abductors.

Benefits: Targets the hip abductors.

Steps: 1. Rest your right hand against a wall. **2.** Raise your left knee and turn it toward the wall. **3.** Lower your leg to the floor and repeat twenty times on either side.

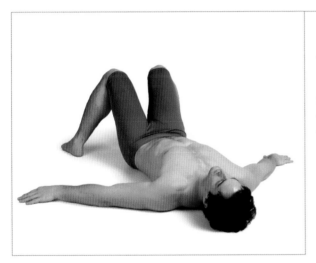

Hip Internal Rotation

Target: Abductors.

Benefits: Increases the range of motion within the hip abductors.

Steps: 1. Begin by lying on your back, with both knees bent and feet apart. **2.** Keeping your feet on the floor, bring your knees together. **3.** Return to the starting position and repeat twenty times.

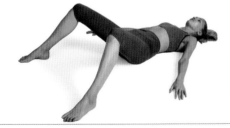
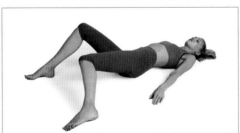

Hip Internal Rotator, Alternating Legs

Target: Abductors.

Benefits: Stretches the hip abductors.

Steps: 1. Begin by lying on your back, with knees bent and feet apart. **2.** Keeping your feet on the floor, turn your left knee inward and return it to the starting position. **3.** Next bring your right knee inward and return it to the starting position. **4.** Repeat this motion twenty times.

Hip Rotation

Target: Abductors.

Benefits: Lengthens the hip abductors and improves alignment in the hips and spine.

Steps: 1. Stand with your legs apart and hands on hips. **2.** Keeping your feet planted and back straight, stretch the torso to one side then the other. **3.** Repeat twenty times to both sides.

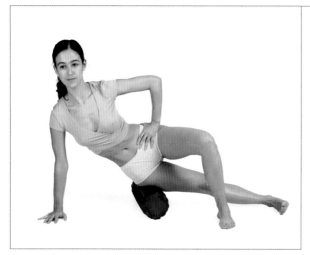

IT Band Stretch on Roller

Target: Abductors.

Benefits: Loosens the IT band, relieving tightness and swelling in the hips and knees.

Steps: 1. Lie on your right side and place a foam roller beneath your upper right thigh, perpendicular to your leg. **2.** Using your arms and left foot for support, roll up and down from your hips down your thigh. **3.** Continue this stretch for thirty seconds, targeting any troubled muscles, and repeat on the opposite leg.

Kick-to-Side with Body Bar

Target: Abductors.

Benefits: Strengthens the hip abductors while improving balance.

Steps: 1. Begin by standing with your right hand on your hip and your left hand holding a body bar at your side. **2.** Extend your right leg out to the side and point your toes. **3.** Raise your right leg, keeping your toes pointed. **4.** Slowly lower your leg to the floor and repeat twenty times on either side.

Note: For increased balance, perform this stretch without assistance.

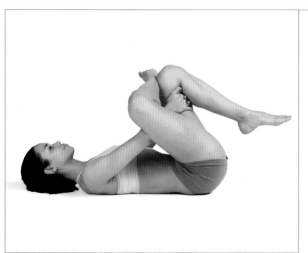

Knee Tuck, Lying 2

Target: Abductors.

Benefits: Opens the muscles in the inner and outer hips, increasing mobility and reducing the risk of injury.

Steps: 1. Begin on your back with your knees bent. **2.** Bring your left knee in toward your chest. **3.** Lift your right foot up and place it across your left knee. **4.** Use both hands to pull your left thigh in toward your chest. **5.** Maintain this stretch for thirty seconds before alternating legs.

Lateral Walk with Band

Target: Abductors.

Benefits: Aids flexibility in the abductors.

Steps: 1. Begin by attaching a resistance band around your thighs. **2.** Standing with feet apart, extend both arms out to your sides, palms facing forward. **3.** Extend your right leg out to the side with toes pointed. **4.** Return to the starting position. Repeat twenty times and alternate legs.

Leg Lift Side

Target: Abductors.

Benefits: Strengthens the muscles in the hips and obliques.

Steps: 1. Lie on your left side with your left arm bent and your hand supporting your head. **2.** Point your toes and try to keep your legs straight as you raise and lower your heels from the floor. **3.** Repeat this exercise for thirty seconds before attempting on the opposite side.

Lying-Down Figure 4

Target: Abductors.

Benefits: Targets hard-to-reach muscles in the hip abductors, improving mobility and balance in the hips.

Steps: 1. Lie on your back with both legs extended. Bend your left knee in and rest your ankle across your right thigh. **2.** Maintain this pose for thirty seconds, gently pulling your bent knee down toward the floor to increase pressure on the hips. **3.** Release and repeat on the opposite leg.

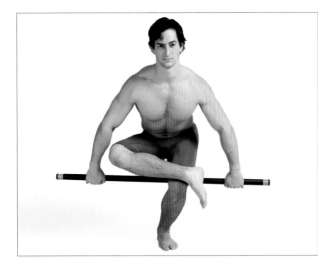

Piriformis Stretch

Target: Abductors.

Benefits: Aids flexibility and increased range of motion in the abductors.

Steps: 1. Stand straight, holding a body bar in front of you with both hands. **2.** Lift your right foot off the floor and place it across the front of your left knee. **3.** Lean forward and tuck the bar beneath your raised foot. **4.** Find your balance and gently pull your foot farther up with the bar. **5.** Hold your balance for as long as you are able and perform on the opposite leg.

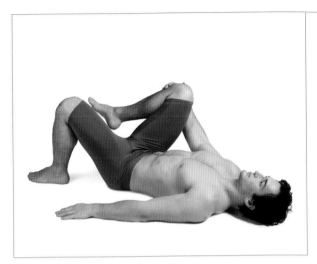

Prone Hip, External Rotation

Target: Abductors.

Benefits: Lengthens the hip abductors.

Steps: 1. Begin by lying flat on your back, with your knees bent and hands at your sides. **2.** Lift your right leg from the floor and press your knee into your chest with your right hand. **3.** Hold for twenty seconds and alternate legs.

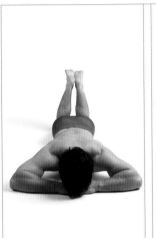 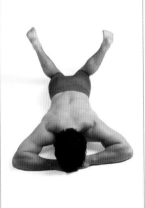

Prone Hip, Internal Rotation

Target: Abductors.

Benefits: Lengthens the hip abductors.

Steps: 1. Lie on your stomach, with both knees bent and feet flexed. **2.** Extend your ankles away from each other, keeping both knees planted. **3.** Bring your feet back together and repeat twenty times.

Revolved Paying-Homage Feet Spread

Target: Abductors.

Benefits: Extends the outer hips and hamstrings while lengthening the spine.

Steps: 1. Standing straight, step your left foot behind and across the other. **2.** Fold forward at the waist, bending down along the right leg. **3.** With both hands, reach around your leg to hold the back of your heel. **4.** Maintain this position for twenty seconds before repeating with the opposite leg.

Revolved Staff Pose, One Leg Upward

Target: Abductors.

Benefits: Twists the spine and opens the chest while strengthening the hip abductors.

Steps: 1. Begin seated on the floor with both legs straight ahead of you. **2.** Twist your torso to your right side and place both hands on the floor to your right. **3.** Raise your right leg straight up and grab the outside of your right ankle with your left hand. **4.** Gently pull your leg up higher while turning your torso to the right. **5.** Hold this position for twenty seconds before performing to the opposite side.

Rotational Thighs

Target: Abductors.

Benefits: Opens the hips and lengthens the abductors, increasing flexibility and mobility.

Steps: 1. Begin seated on the floor. **2.** Bend your right leg so your foot curls behind you and fold your left leg into your hips. **3.** Place both hands flat on the floor behind you and lean your shoulders and torso back to open your chest. **4.** Hold this pose for thirty seconds. Release and repeat on the opposite side.

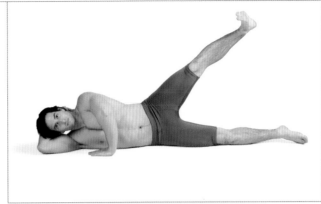

Side Kick, Lying

Target: Abductors.

Benefits: Strengthens the muscles in the hips, increasing mobility and reducing the risk of injury.

Steps: 1. Lie on your right side, with your legs straight and your right arm bent, supporting your head.
2. Keeping your legs straight, slowly lift your left leg up into the air. Hold and lower it back down to the starting pose. **3.** Repeat this exercise for twenty seconds on either side.

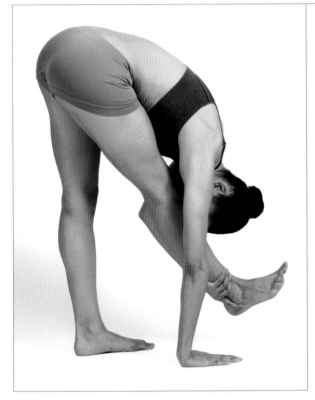

Standing Foot-Raise Stretch, Modification 1

Target: Abductors.

Benefits: Opens the hips and extends the muscles along the back of the leg.

Steps: 1. Stand straight with good upright posture. **2.** Fold your torso forward at the waist into a complete forward bend so your hands are flat on the floor. **3.** Twisting your torso to the right, touch your head to your right shin, and reach your left hand under your right ankle. **4.** Keeping your leg straight, pull your right leg up from the floor. **5.** Hold this position for fifteen seconds, release, and repeat on the other side.

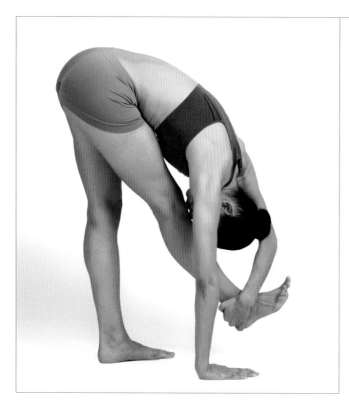

Standing Foot-Raise Stretch, Modification 2

Target: Abductors.

Benefits: Opens the hips and extends the muscles along the back of the leg.

Steps: 1. Stand straight with good upright posture.
2. Fold your torso forward at the waist into a complete forward bend so your hands are flat on the floor.
3. Twisting your torso to the right, touch your head to your right shin, and reach your left hand in front of your right ankle. **4.** Keeping your leg straight, pull your right leg up from the floor. **5.** Hold this position for fifteen seconds. Release and repeat to the other side.

Standing Hip Abduction with Band at Calves

Target: Abductors.

Benefits: Strengthens the hip abductors and increases balance.

Steps: 1. Start by standing with legs apart and place a resistance band around both legs above the ankles.
2. Keeping the band taut, raise your right foot off the floor.
3. Maintaining your balance, raise and lower the outstretched leg against the resistance of the band. **4.** Repeat on the opposite leg.

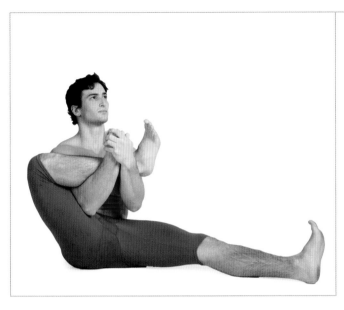

Thigh Stretch, Knee to Chest Extended

Target: Abductors.

Benefits: Lengthens the hip abductors and improves alignment in the hips and spine.

Steps: 1. Begin seated on the floor, with both legs extended. **2.** Bend your right knee and bring your foot to rest on top of your left thigh. **3.** Hook both arms under your right calf and pull your right leg toward your chest. **4.** Hold this position for ten seconds before releasing. **5.** Lower and repeat on the opposite leg.

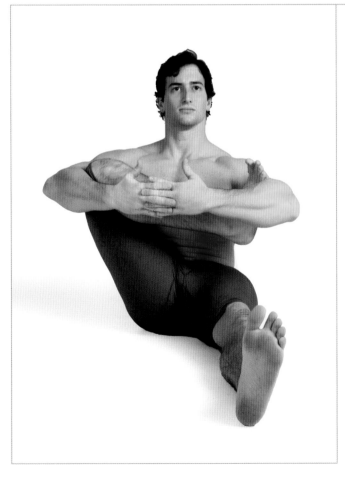

Thigh Stretch, Unilateral Leg Raise

Target: Abductors.

Benefits: Lengthens the hip abductors and improves alignment in the hips and spine.

Steps: 1. Begin seated on the floor, with both legs extended. **2.** Bend your right knee and bring your foot to rest on top of your left thigh. **3.** Bend your right elbow around your right knee, so your forearm rests along your shin. **4.** Reach your left hand around your right foot and join your hands in front of your right shin. **5.** Pull your leg into your chest and hold for ten seconds. Release and repeat on the opposite leg.

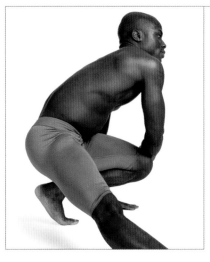

Adduction Deep Side Squat, Advanced

Target: Adductors.

Benefits: Targets the adductors of the extended leg and improves core balance.

Steps: 1. Begin by crouching on tiptoes, resting your weight on the balls of your feet. **2.** Place your left hand on the floor for balance and extend your right leg out to the side, resting the length of your flexed foot on the floor. **3.** Leaning forward, extend your right hand across your body and place it on the floor at your left. **4.** Hold for fifteen seconds and alternate sides.

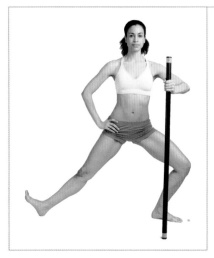

Adductor and Achilles Stretch with Body Bar

Target: Adductors.

Benefits: Lengthens the muscles down the inner thigh to the Achilles tendons.

Steps: 1. With your left hand, hold a body bar upright in front of you. **2.** Extend your right leg straight out to the side, resting your foot on its heel. **3.** Using the bar for support, lower your hips to the floor to deepen the stretch. **4.** Hold for twenty seconds and alternate sides.

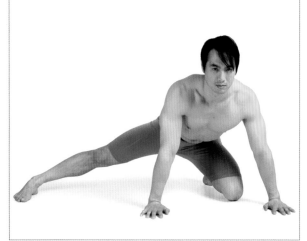

Adductor Deep Side Squat

Target: Adductors.

Benefits: Targets the abductors and opens the pelvis.

Steps: 1. Start by kneeling on all fours, palms flat on the floor and fingers pointing forward. **2.** Extend your right leg straight out to the side, toes pointed forward. **3.** Lower your pelvis to the floor to deepen this stretch. **4.** Hold for twenty seconds and alternate sides.

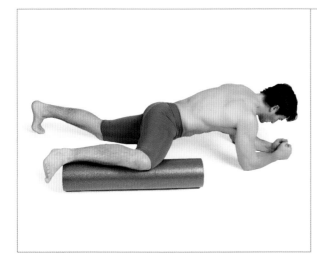

Adductor Stretch on Foam Roller

Target: Adductors.

Benefits: Relieves tightness and tension in the adductor and inner thigh.

Steps: 1. Lie on the floor supporting your upper body on your forearms. **2.** Place a foam roller beneath your right inner thigh. **3.** Resting the weight of your thigh on the roller, extend your left leg out to the side on tiptoes. **4.** From this position, roll your thigh along the roller for thirty seconds and alternate sides.

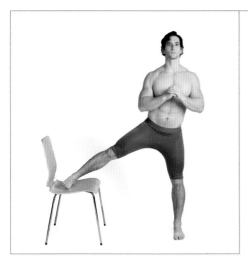

Adductor Stretch, One Foot off Floor

Target: Adductors.

Benefits: Increases flexibility and range of motion within the groin.

Steps: 1. Stand straight, with the seat of the chair to your right side. **2.** Lift your right foot and rest it on the seat, keeping your leg straight. **3.** With your hands clasped in front of you, push your pelvis downward to intensify the pressure on the targeted muscles. **4.** Hold for thirty seconds and alternate sides.

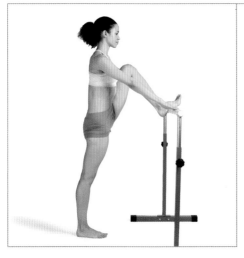

Adductor Stretch, One Leg Raised at Ballet Bar

Target: Adductors.

Benefits: Provides increased flexibility and range of motion within the groin and pelvis.

Steps: 1. Stand facing a ballet bar, set to waist height. **2.** Raise your left leg from the floor and rest the arch of your foot on the bar. **3.** Holding onto the bar for support, lean in toward the bar to deepen the stretch. **4.** Hold for twenty seconds and alternate sides.

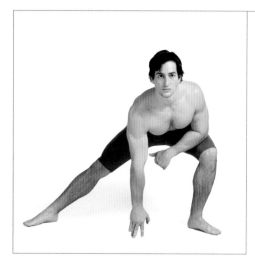

Adductor-Stretch Side Squat

Target: Adductors.

Benefits: Remedies tight or fatigued muscles in the adductors and inner thigh.

Steps: 1. Begin by standing with knees bent. **2.** Extend your right leg straight to the side, and rest your right hand on the floor for support, if necessary. **3.** Lean forward and rest your left forearm on your left thigh. **4.** Hold for twenty seconds and alternate sides.

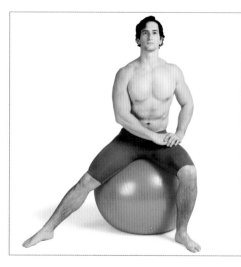

Adductor-Stretch Side Squat, Ball Variation

Target: Adductors.

Benefits: Reduces tightness in the adductors.

Steps: 1. Start seated on an exercise ball, knees bent. **2.** Extend your right leg straight to the side and lean on the left knee for balance and support. **3.** Roll in toward the bent knee to deepen the stretch. **4.** Hold for twenty seconds and alternate sides.

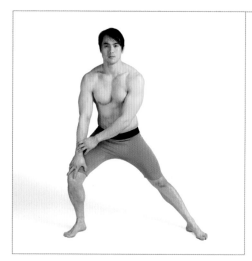

Adductor-Stretch Side Squat, Easiest

Target: Adductors.

Benefits: Reduces tightness in the adductors.

Steps: 1. Begin by standing with your feet apart. **2.** Extend your left leg straight to the side, leaning on your right knee for balance and support. **3.** Keeping your torso above the bent knee, push your pelvis toward the floor to deepen the stretch. **4.** Hold for twenty seconds and alternate sides.

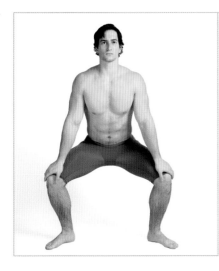

Adductor-Stretch Wide Squat

Target: Adductors.

Benefits: Lengthens and strengthens the adductors.

Steps: **1.** Stand straight, with your legs about three feet apart. **2.** Resting your hands on your knees for balance and support, lower your pelvis to the floor as deeply as you can. **3.** Hold for twenty seconds.

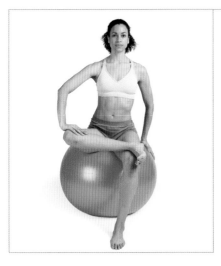

Ball-Assisted Hip Opener

Target: Adductors.

Benefits: Lengthens and strengthens the adductors while engaging the core.

Steps: **1.** Begin seated on an exercise ball, with your knees bent. **2.** Raise your right leg from the floor, resting your foot on the left knee. **3.** Maintain this pose for twenty seconds and repeat on the opposite side.

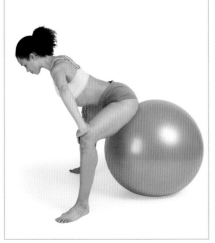

Ball-Assisted Wide Squat

Target: Adductors.

Benefits: Increases flexibility and mobility in the hip adductors.

Steps: **1.** Begin in a seated position on an exercise ball. **2.** Spread your legs apart, so both feet are pointed outward. **3.** Pressing against your knees, lean forward until you are facing the floor. **4.** Hold for twenty seconds.

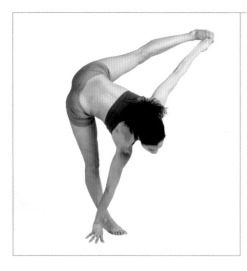

Bowing with Respect, Extended

Target: Adductors.

Benefits: Extends the spine and hamstrings and opens the groin and chest.

Steps: 1. Stand straight and fold forward at the waist in a full forward bend. **2.** Holding your left foot, raise your left leg off the floor and straight up to the side. **3.** Hold this pose for fifteen seconds before releasing and attempting to repeat with the other leg.

Butterfly-Knees Groin Stretch

Target: Adductors.

Benefits: Reduces tightness in the adductors.

Steps: 1. Sit with your back against a wall, knees raised. **2.** Slowly lower your knees to either side, keeping your heels together. **3.** Use your hands to press against your knees, to intensify the stretch. **4.** Hold this pose for fifteen seconds.

Butterfly Knees, Heels to Groin

Target: Adductors.

Benefits: Reduces tightness in the adductors and groin.

Steps: 1. Begin seated on the floor with the soles of your feet together in butterfly position. **2.** Holding your feet, pull them in toward your torso. **3.** Hold this pose for fifteen seconds.

Butterfly Knees with Chest Opener

Target: Adductors.

Benefits: Lengthens the muscles in the groin while opening the chest.

Steps: 1. Seated on the floor, bend both knees and drop them to your sides so your feet are flat together in front of you. **2.** Planting your right hand on the floor behind you, twist open your spine toward the left. **3.** Hold this pose for twenty seconds.

Butterfly Stretch, Feet to Forehead

Target: Adductors.

Benefits: Lengthens the muscles in the groin and hamstrings.

Steps: 1. Sitting on the floor, bend both legs at your sides and bring your feet flat together in front of you. **2.** Grab the outsides of your feet and raise your feet up from the floor. **3.** Keep your heels and toes pressed together and attempt to touch your feet to your forehead.

Complete Side Leg Stretch

Target: Adductors.

Benefits: Twists open the chest and shoulders while deeply extending the groin and increasing balance.

Steps: 1. Standing straight, raise your right knee into your chest. **2.** With your right hand on your right foot, extend your leg straight up your side in a standing split. **3.** Once you are balanced, wrap your left arm behind your back, holding onto your right hip in a half-bound position. **4.** Extend your gaze upward to complete the stretch and hold for ten seconds before switching sides.

Feet-Spread, Upward Hands

Target: Adductors.

Benefits: Increases strength and mobility in the groin and inner thighs while lengthening the spine.

Steps: 1. Stand straight, with your legs spread wide apart and toes pointed outward. **2.** Placing your palms together, raise your hands to the ceiling and tilt your head upward. **3.** Hold this pose for twenty seconds.

Fierce Pose 3 Tiptoe

Target: Adductors.

Benefits: Remedies tight or fatigued muscles along the inner thighs.

Steps: 1. Crouch low to the floor. **2.** Place your hands on the floor in front of you and extend your right leg straight out to the side into a deep side squat. **3.** Lean your torso to your left and find your balance before lifting both hands from the floor and extending your right arm straight up toward the ceiling. **4.** Hold this pose for twenty seconds before switching sides.

Frog Leg, Inverted Straddle

Target: Adductors.

Benefits: Lengthens the muscles in the groin and hips.

Steps: 1. Lie on your back, with your knees bent to your sides and feet pressed together. **2.** Gently press down on your inner thighs to increase the effect of the stretch. **3.** Hold this pose for twenty seconds.

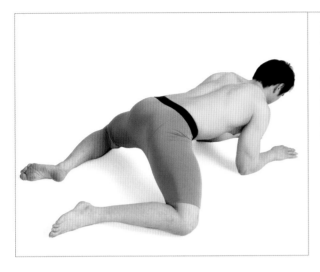

Frog Split Prep

Target: Adductors.

Benefits: Increases flexibility in the groin and hips.

Steps: 1. Start on all fours, resting on your forearms rather than your palms. **2.** Slowly lower your pelvis and hips to the floor, spreading your knees apart. **3.** Hold for twenty seconds.

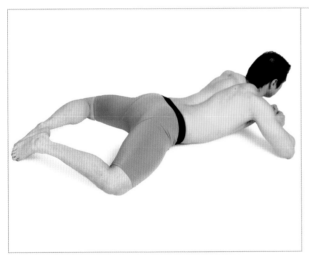

Frog Splits

Target: Adductors.

Benefits: Increases flexibility in the groin and hips.

Steps: 1. Start on all fours, resting on your forearms rather than your palms. **2.** Slowly lower your pelvis and hips to the floor, spreading your knees apart. **3.** Bring the soles of your feet together and hold for twenty seconds.

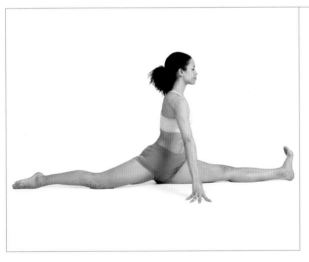

Front Split

Target: Adductors.

Benefits: Greatly increases flexibility in the legs and hips.

Steps: 1. Begin in a kneeling position and extend your left leg straight forward. **2.** Gently lower your hips into a split, allowing your body weight to pull you slowly down to the floor. As you sink down, your legs will straighten out further. **3.** Go down as far as you comfortably can before pushing yourself back up to the starting position. **4.** Repeat the stretch on the other side.

Caution: Carefully work your way up to a forward split by first increasing flexibility with simpler stretches for the hip flexors, quads, and hamstrings.

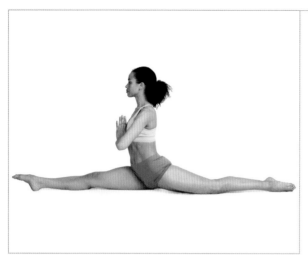

Front-Split Prayer Hands

Target: Adductors.

Benefits: Greatly increases flexibility in the legs and hips.

Steps: 1. Begin in a kneeling position and extend your right leg straight forward. **2.** Gently lower your hips into a split, allowing your body weight to pull you slowly down to the floor. As you sink down, your legs will straighten out further. **3.** Once both legs are flat on the floor, point your toes and raise your hands into the prayer position at your chest. **4.** Repeat the stretch on the other leg.

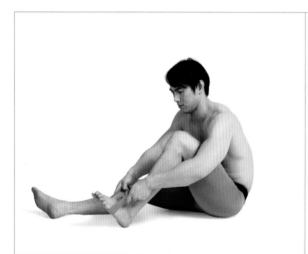

Groin Stretch, Band Assisted

Target: Adductors.

Benefits: Extends the muscles in the groin while lengthening the Achilles tendons and calves.

Steps: 1. Attach a resistance band around your left foot, and lie down flat on your back. **2.** Using the band, swing the bound leg away from your right leg in a wide split. **3.** Hold for twenty seconds and repeat on the other side.

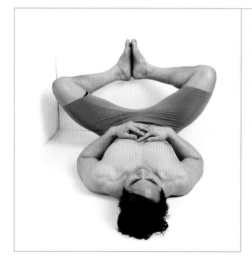

Groin Stretch, Supported

Target: Adductors.

Benefits: Extends the muscles in the groin and inner thighs.

Steps: 1. Begin by lying on your back, with your feet propped against a wall. **2.** Bend your knees to either side and lower your feet toward the floor. **3.** Use your hands to pull your thighs into a deeper stretch. **4.** Hold for twenty seconds.

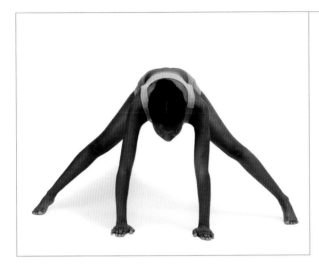

Half Feet-Spread-Out Intense-Stretch Pose

Target: Adductors.

Benefits: Increases strength and mobility in the groin and inner thighs while lengthening the spine.

Steps: 1. Standing straight, step your feet wide apart and keep your toes pointed ahead. **2.** Bend forward at the waist and lower your hands down to the floor between your legs. **3.** Drop your head and hold this pose for twenty seconds.

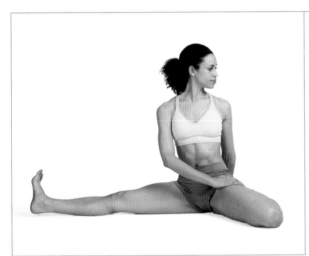

Half-Split

Target: Adductors.

Benefits: Opens the hips and lengthens the abductors, increasing flexibility and mobility.

Steps: 1. Begin seated on the floor. **2.** Extend your right leg straight to the side and bend your left leg behind you. **3.** Twist your torso to the left and reach your left hand behind you. **4.** Hold this position for thirty seconds before releasing and repeating on the opposite side.

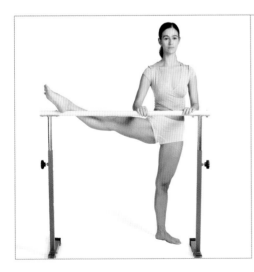

Half-Split at Ballet Bar

Target: Adductors.

Benefits: Increases flexibility and mobility in the adductors and hamstrings.

Steps: 1. Stand facing a ballet bar, holding it with both hands for support. **2.** Raise your right leg from the floor, resting your ankle on the bar and straightening your knees. **3.** Hold this position for thirty seconds and alternate legs.

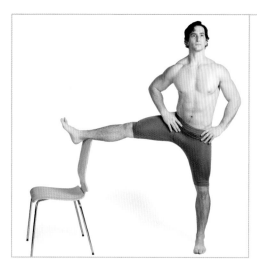

Half-Split, Standing

Target: Adductors.

Benefits: Lengthens the muscles in the hips.

Steps: 1. Stand with the back of a sturdy chair at your right side. **2.** Raise your right leg and rest your ankle on the back of the chair. **3.** Hold this position for ten seconds or more and repeat with the opposite leg.

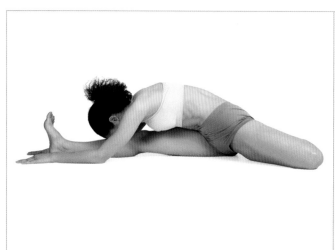

Half-Split with Forward Bend

Target: Adductors.

Benefits: Opens the hips and lengthens the abductors, increasing flexibility and mobility.

Steps: 1. Begin seated on the floor. **2.** Extend your right leg straight to the side and bend the other leg behind you. **3.** Twist your torso toward your right leg and bend forward at the waist, lowering your head to your knee. **4.** Hold this position for thirty seconds before releasing and repeating with the opposite leg.

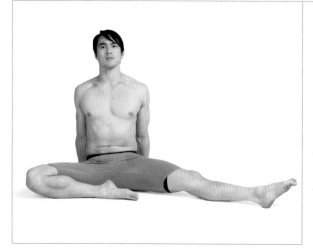

Half-Straddle

Target: Adductors.

Benefits: Improves flexibility in the hips and adductors.

Steps: 1. Beginning seated on the floor and stretch your left leg straight out to the side. **2.** Bend your right leg inward, so your foot is tucked in toward the groin, and place your hands behind your back. **3.** Hold this position for thirty seconds and repeat on the opposite side.

Note: For an amplified version of this stretch, lean your torso toward the outstretched leg in a side bend.

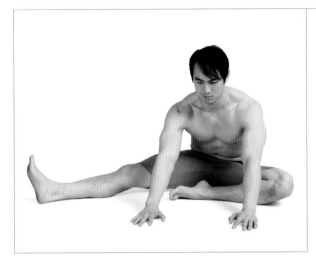

Hip-Extensor Stretch, Seated

Target: Adductors.

Benefits: Assists increased flexibility and range of motion within the groin and pelvis.

Steps: 1. Sit on the floor with legs stretched out far apart from each other. **2.** Bend your left leg inward, so your foot is tucked in toward the groin. **3.** Place your hands on the floor in front of you and slowly lean forward to deepen the stretch. **4.** Hold for twenty seconds and alternate sides.

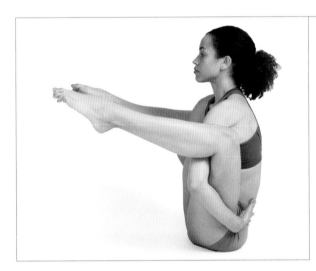

Vertical Split 1

Target: Adductors.

Benefits: Increases flexibility in the inner thighs, groin, and hips.

Steps: 1. Begin seated on the floor and bend both knees into your chest. **2.** Lift your left foot off the floor and reach with your left hand under the back of your left knee to touch your left hip. **3.** Find your balance and reach with your right hand under the back of your right knee to touch your right hip. **4.** Keep your back straight and hold for ten seconds.

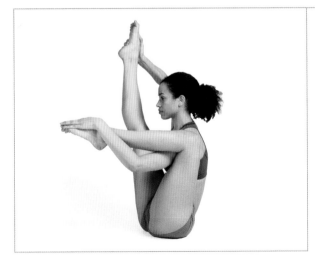

Vertical Split 2

Target: Adductors.

Benefits: Increases flexibility in the inner thighs, groin, and hips.

Steps: 1. Begin seated on the floor and bend both knees into your chest, raising your feet off the floor. **2.** Reach your left hand under your left knee to grab your left ankle. Pull your foot up until your shin is parallel to the floor. **3.** With your right hand, grab your right ankle and extend your foot up toward the ceiling. **4.** Resting on your hip bones, hold this pose for twenty seconds. **5.** Release and repeat, alternating legs.

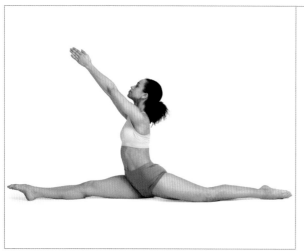

Horizontal Split, Arms Extended

Target: Adductors.

Benefits: Greatly increases flexibility in the legs and hips.

Steps: 1. Begin in a kneeling position and extend your right leg straight forward. **2.** Gently lower your hips into a split, allowing your body weight to pull you deeper into the front split. **3.** Once both legs are flat on the floor, point your toes and raise your hands into the prayer position at your chest. **4.** Straighten your arms and extend your hands upward. **5.** Release and repeat the stretch to the other side.

Horizontal Split, Band-Assisted Flexed Foot

Target: Adductors.

Benefits: Opens the hips while lengthening the calves and hamstrings.

Steps: 1. Seated on the floor, attach a resistance band around your left foot. **2.** Spread your legs far apart and pull the band in toward your torso to increase the flex on your left leg. **3.** Hold for twenty seconds and alternate sides.

Horizontal Split, Band Modification with Side Stretch

Target: Adductors.

Benefits: Increases flexibility in the inner thighs, groin, and hips.

Steps: 1. Squat low to the floor and place both hands on the floor in front of you. **2.** Slowly slide your feet outward as far apart as you can manage. Your legs should be completely straight as you lower yourself down, keeping your back straight and your hips in line with your legs. **3.** Once you are able, lower your groin to the floor. **4.** Try to roll your hips until you are sitting in an upright position. **5.** Attach a resistance band around one foot, and pull it toward you, flexing your foot.

Horizontal Split, Reclined Side Angle

Target: Adductors.

Benefits: Opens the hips and lengthens the hamstrings, improving flexibility and mobility.

Steps: 1. Lie on your back with your legs extended straight up from your hips. **2.** Reach your hands upward to grab hold of either foot and spread your legs wide apart. **3.** Gently pull down on your feet and hold for thirty seconds.

Horizontal Split, Wrapped

Target: Adductors.

Benefits: Increases flexibility in the inner thighs, groin, and hips.

Steps: 1. Begin seated on the floor and bend both knees into your chest. **2.** Lift your left foot off the floor and reach with your left hand under the back of your left knee to touch your left hip. **3.** Find your balance and reach with your right hand under the back of your right knee to touch your right hip. **4.** Keep your back straight and hold for ten seconds.

Vertical Split, Single-Leg Extension

Target: Adductors.

Benefits: Increases flexibility in the inner thighs, the groin and the hips.

1. Begin seated on the floor and bend both knees into your chest, raising your feet off the floor. **2.** Reach your left hand under your left knee to grab your left ankle. Pull your foot up until your shin is parallel to the floor. **3.** With your right hand, grab your right ankle and extend your foot up toward the ceiling. **4.** Resting on your hip bones, hold this pose for twenty seconds. **5.** Release and repeat, alternating legs.

Single-Leg Prone Split

Target: Adductors.

Benefits: Deeply opens the hips and groin while lengthening the hamstrings.

Steps: 1. Lie on your back with your legs straight. **2.** Keeping your right leg straight, extend it up to your side, reaching hold of your ankle with your right hand. Continue to pull your leg higher up to your right side, into a half-split pose. **3.** Hold this position for thirty seconds before releasing and attempting with the opposite leg.

Intense Ankle Stretch, Extended Leg to Side 1

Target: Adductors.

Benefits: Increases flexibility in the inner thighs, groin, and hips while stretching the calf muscles and Achilles tendons.

Steps: 1. Extend your right leg straight out to the side and bend your left knee, lowering your body into a side squat. **2.** Lean forward and place both hands flat on the floor ahead of you, with both hands pointed to the right. **3.** Hold this position for twenty seconds before alternating sides.

Intense Ankle Stretch, Extended Leg to Side 2

Target: Adductors.

Benefits: Increases flexibility in the inner thighs, groin, and hips while stretching the calf muscles and Achilles tendons.

Steps: 1. Extend your right leg straight out to the side and bend your left knee, lowering your body into a side squat. **2.** Lean forward and place both hands flat on the floor ahead of you, with both hands pointed to the right. **3.** Drop your head and shoulders down toward the floor. **4.** Hold this position for twenty seconds before alternating sides.

Intense Ankle Stretch, Extended Leg to Side 3

Target: Adductors.

Benefits Increases flexibility in the inner thighs, groin, and hips while stretching the calf muscles and Achilles tendons.

Steps: 1. Extend your right leg straight out to the side and bend your left knee, lowering your body into a side squat. **2.** Lean forward and place both hands flat on the floor ahead of you, with your left hand crossed behind your right. **3.** Turn your head to the right and drop your head and shoulders down toward the floor. **4.** Hold this position for twenty seconds before alternating sides.

Kali Squat, Extended Side Revolved Hands

Target: Adductors.

Benefits: Opens the hips and groin while lengthening the spine and improving balance.

Steps: 1. Step your feet wide apart and bend both knees, lowering your torso into a wide squat. **2.** Fold your arms behind your back and slowly bend forward at the waist, dropping your head down toward the floor between your legs.

Intense Ankle Stretch, Extended Leg to Side Tiptoe, Arms Overhead

Target: Adductors.

Benefits: Increases flexibility in the inner thighs, groin, and hips while stretching the calf muscles, obliques, and Achilles tendons.

Steps: 1. Extend your right leg straight out to the side and bend your left knee, lowering your body into a side squat. **2.** Find your balance and raise both hands from the floor, into prayer position in front of your chest, then extend your hands up above your head. **3.** Bend your arms and torso down to your left side and hold this position for twenty seconds before alternating sides.

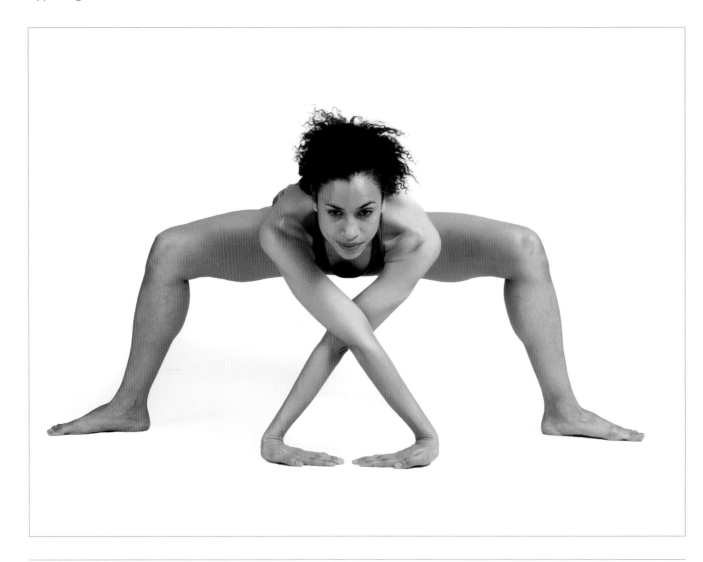

Kali Squat, Feet Flat Extended

Target: Adductors.

Benefits: Opens the hips and groin while lengthening the spine and improving balance.

Steps: 1. Step your feet wide apart and bend both knees, lowering your torso into a wide squat. **2.** Drop your palms down to the floor, crossing your arms at the elbows and placing your palms so that your hands are pointed toward each other. **3.** Hold this pose for fifteen seconds.

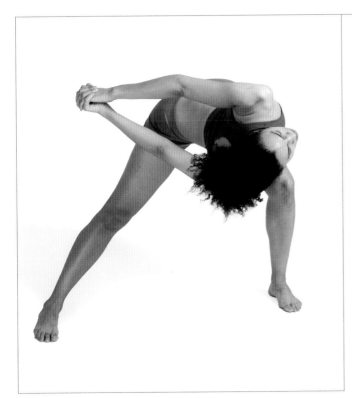

Kali Squat, Feet Flat

Target: Adductors.

Benefits: Opens the hips and groin while lengthening the spine and improving balance.

Steps: 1. Step your feet wide apart and bend both knees, lowering your torso into a wide squat. **2.** Clasp your hands behind your back and slowly bend at the waist, twisting your torso to the left side. **3.** Raise your gaze up to the ceiling and hold this pose for twenty seconds before alternating sides.

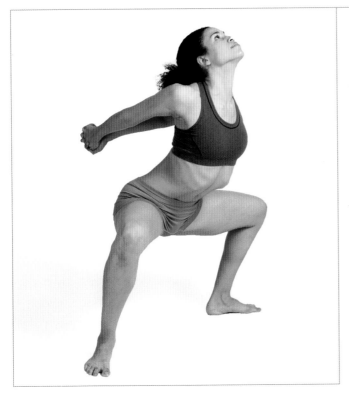

Kali Squat, Hands Bound Behind

Target: Adductors.

Benefits: Opens the hips and groin while lengthening the spine and improving balance.

Steps: 1. Step your feet wide apart and bend both knees, lowering your torso into a wide squat. **2.** Clasp your hands behind your back. Drop your head and shoulders back and pull your arms down toward the ground. **3.** Raise your gaze up to the ceiling and hold this pose for thirty seconds.

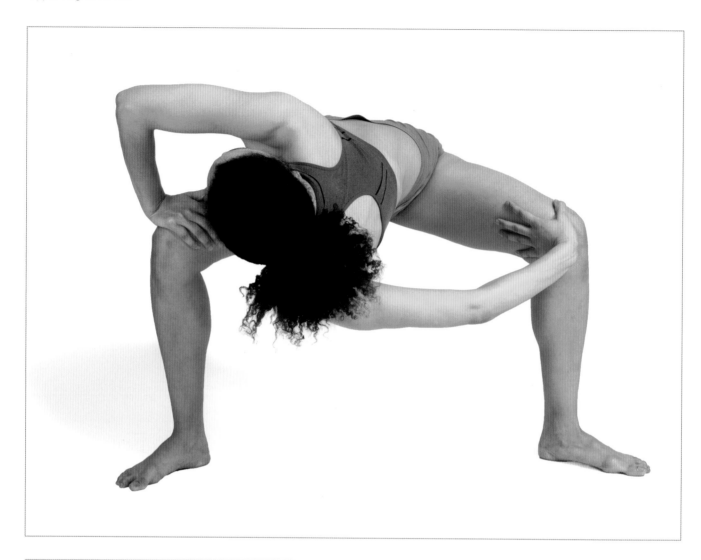

Kali Squat, Revolved

Target: Adductors.

Benefits: Opens the hips and groin while lengthening the spine and improving balance.

Steps: 1. Step your feet wide apart and bend both knees, lowering your torso into a wide squat. **2.** Fold forward at the waist, so your back is parallel to the ground. Place your hands on your knees. **3.** Twist your torso to the right side. **4.** Hold this pose for thirty seconds, before twisting the other way.

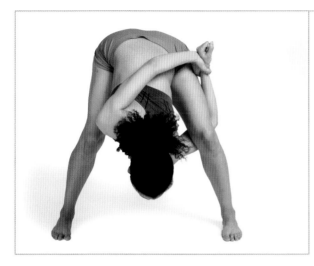

Kali Squat, Hands Bound to Leg

Target: Adductors.

Benefits: Opens the hips and groin while lengthening the spine and improving balance.

Steps: 1. Step your feet wide apart and bend both knees, lowering your torso into a wide squat. **2.** Slowly bend forward at the waist, dropping your head down toward the floor between your legs. **3.** Reach your left arm under your left knee and up toward your back. Reach your left arm behind your back, and clasp your hands together in a bound position. **4.** Hold for twenty seconds and repeat on the other side.

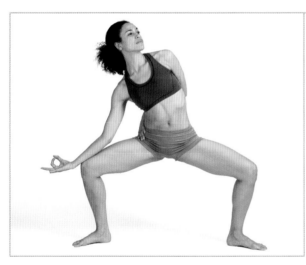

Kali Squat, Sideways Half-Bound 1

Target: Adductors.

Benefits: Opens the hips and groin while lengthening the spine and improving balance.

Steps: 1. Step your feet wide apart and bend both knees, lowering your torso into a wide squat. **2.** Reach your left arm around your back and hold your right hip in a half bound position. Place your right forearm on your right knee. **3.** Raise your gaze to the left and hold this pose for thirty seconds.

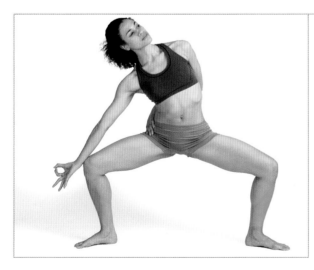

Kali Squat, Sideways Half-Bound 2

Target: Adductors.

Benefits: Opens the hips and groin while lengthening the spine and improving balance.

Steps: 1. Step your feet wide apart and bend both knees, lowering your torso into a wide squat. **2.** Reach your left arm around your back and hold your right hip in a half bound position. Place your right wrist on your right knee. **3.** Raise your gaze upward and hold this pose for thirty seconds.

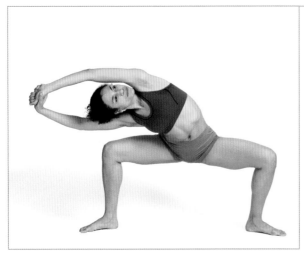

Kali Squat, Sideways Hands Bound

Target: Adductors.

Benefits: Opens the hips and groin while lengthening the spine and improving balance.

Steps: 1. Step your feet wide apart and bend both knees, lowering your torso into a wide squat. **2.** Clasp your hands over your head and slowly bend at the waist, twisting your torso to the right. **3.** Raise your gaze up to the ceiling and hold this pose for twenty seconds before alternating sides.

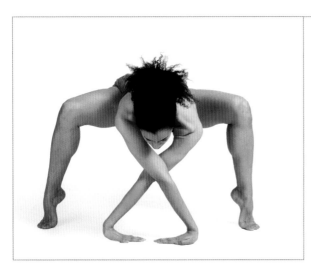

Kali Squat, Tiptoe

Target: Adductors.

Benefits: Opens the hips and groin while lengthening the spine and improving balance.

Steps: 1. Step your feet wide apart and rise up onto tiptoes. **2.** Bend both knees, lowering your torso into a wide squat. **3.** Drop your palms down to the floor, crossing your arms at the elbows and placing your palms so that both hands are pointed toward each other. **4.** Hold this pose for fifteen seconds.

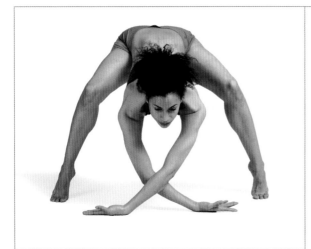

Kali Squat, Tiptoe Extended

Target: Adductors.

Benefits: Opens the hips and groin while lengthening the spine and improving balance.

Steps: 1. Step your feet wide apart and rise up onto tiptoes. **2.** Bend both knees, lowering your torso into a wide squat. **3.** Drop your arms down to the floor, crossing your arms at the elbows and placing your forearms on the floor with your palms facing up. **4.** Hold this pose for fifteen seconds.

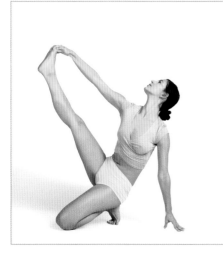

Kneeling Half-Split

Target: Adductors.

Benefits: Opens the groin and hips while lengthening the calves, Achilles tendons, and hamstrings.

Steps: 1. Begin by kneeling on the floor. **2.** Extend your right leg in front of you and grab your toes with your right hand. **3.** Raise your leg above your head and gaze upward. **4.** Hold for twenty seconds and repeat on the opposite side.

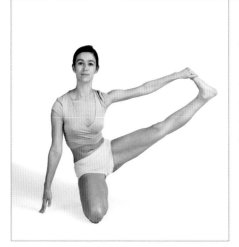

Kneeling Half-Split to the Side

Target: Adductors.

Benefits: Opens the groin and hips while lengthening the calves, Achilles tendons, and hamstrings.

Steps: 1. Begin by kneeling on the floor. **2.** Extend your left leg out to the side and grab your toes with your left hand. **3.** Raise your leg above your head and gaze upward. **4.** Hold for twenty seconds and repeat on the opposite side.

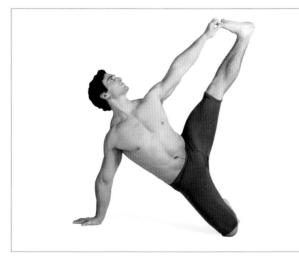

Kneeling Half-Split to Side, Plank Modification

Target: Adductors.

Benefits: Opens the groin and hips, lengthens the calves, Achilles tendons, and hamstrings, and strengthens the arms and lats.

Steps: 1. Begin by kneeling on the floor. **2.** Place your right hand on the floor at your right side and lean into a kneeling side plank. **3.** Grab your left toes with your left hand and raise and your leg straight out to the side. **4.** Hold for twenty seconds and repeat on the opposite side.

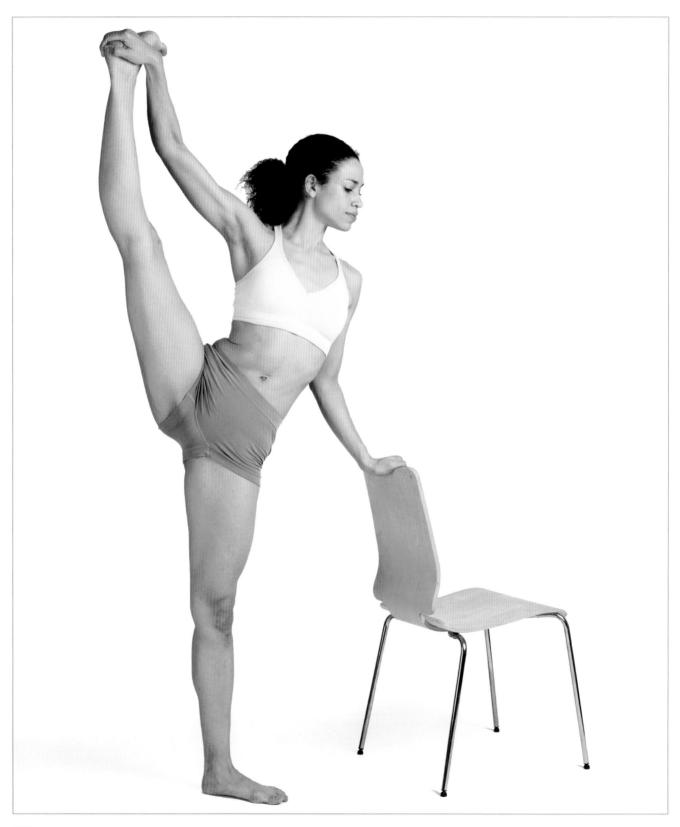

Leg-Extension Elevation with Chair I

Target: Adductors.

Benefits: Deeply opens the hips and lengthens the adductors while improving balance.

Steps: 1. Stand straight, holding the back of a chair at your left side. **2.** Lift your right knee into your chest, and grab hold of your foot with your right hand. **3.** Slowly straighten your leg up along your side, into a standing split. **4.** Keep your hand on your foot and lean your torso to the left. **5.** Hold this pose for thirty seconds before alternating sides.

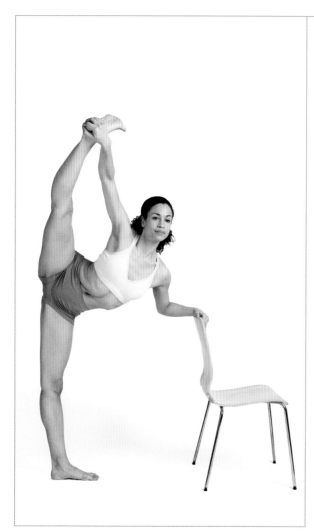

Leg-Extension Elevation with Chair 2

Target: Adductors.

Benefits: Deeply opens the hips and lengthens the adductors while improving balance.

Steps: 1. Stand straight, holding the back of the chair at your left side. **2.** Lift your right knee into your chest, and grab hold of your foot with your right hand. **3.** Slowly straighten your leg up along your side, into a standing split. **4.** Keep your hand on your foot and lean your torso to the left, bending at your elbow for a deep stretch. **5.** Hold this pose for thirty seconds before alternating sides.

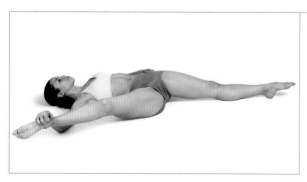

Leg-Abductor Stretch

Target: Adductors.

Benefits: Deeply opens the hips and groin while lengthening the hamstrings.

Steps: 1. Lie on your back with your legs straight. **2.** Extend your right leg up to your side, reaching hold of your ankle with your right hand. **3.** Continue to pull your leg up higher at your right side, into a half split pose. **4.** Hold for thirty seconds and repeat on the opposite leg.

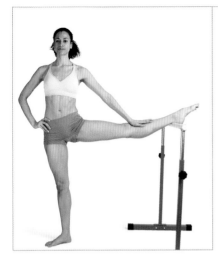

Leg Raise at Ballet Bar 1

Target: Adductors.

Benefits: Opens the hips and extends the muscles along the raised leg.

Steps: 1. Stand beside a ballet bar, two or three feet away on your left side. **2.** Raise your left knee into your chest and extend it out to the side, resting your left ankle on the bar. **3.** Place your left palm on your shin and press your leg down gently, to increase the pressure on your hips. **4.** Hold this pose for thirty seconds before performing on the opposite leg.

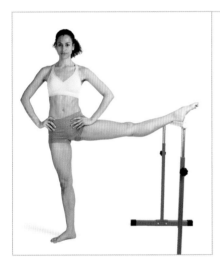

Leg Raise at Ballet Bar 2

Target: Adductors.

Benefits: Opens the hips and extends the muscles along the raised leg.

Steps: 1. Stand beside a ballet bar, two or three feet away on your left side. **2.** Raise your left knee into your chest and extend it out to the side, resting your left ankle on the bar. **3.** Place your hands on your hips and push your torso down, to increase pressure on the hips. **4.** Hold this pose for thirty seconds before performing on the opposite leg.

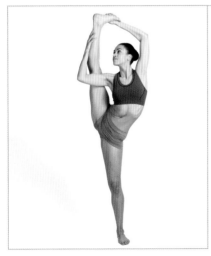

Leg-Raise Pose to Trivikrama 1

Target: Adductors.

Benefits: Deeply extends the hips and groin, increasing balance and core strength.

Steps: 1. Stand straight, and bend your right knee up into your chest. **2.** Holding your right foot with your right hand, extend your leg up along your side. **3.** Attempt to fully straighten your leg toward the ceiling. **4.** Hold your calf with your right hand, and reach over your head to grab hold of your toes with your left hand. **5.** Hold this position for as long as you are able, then release and repeat with the opposite leg raised.

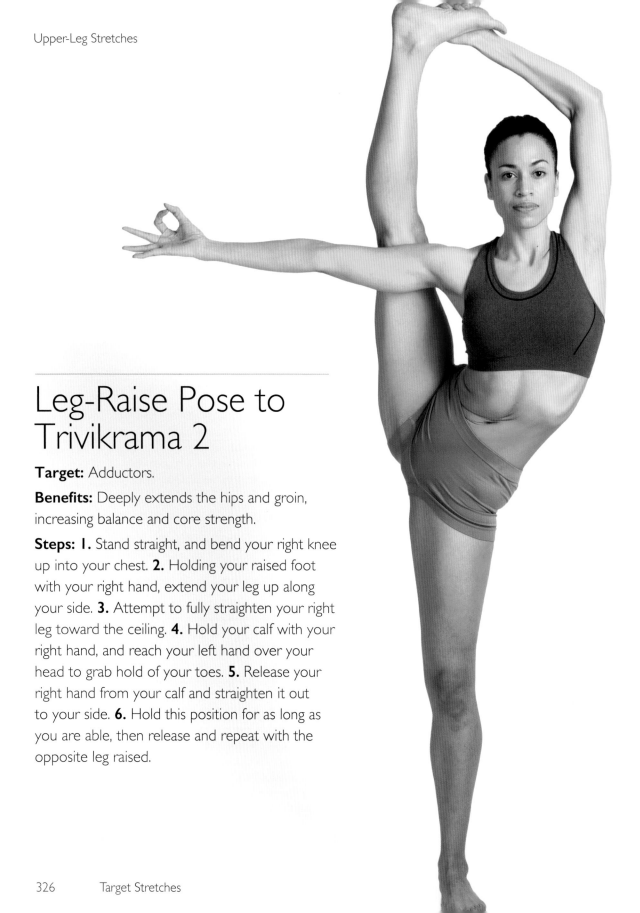

Leg-Raise Pose to Trivikrama 2

Target: Adductors.

Benefits: Deeply extends the hips and groin, increasing balance and core strength.

Steps: 1. Stand straight, and bend your right knee up into your chest. **2.** Holding your raised foot with your right hand, extend your leg up along your side. **3.** Attempt to fully straighten your right leg toward the ceiling. **4.** Hold your calf with your right hand, and reach your left hand over your head to grab hold of your toes. **5.** Release your right hand from your calf and straighten it out to your side. **6.** Hold this position for as long as you are able, then release and repeat with the opposite leg raised.

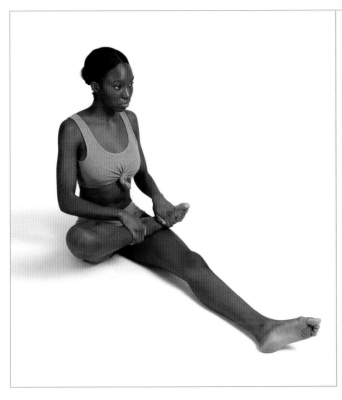

One-Legged Butterfly

Target: Adductors.

Benefits: Extends the groin muscles while lengthening the bridge of the foot.

Steps: 1. Begin seated, legs straight ahead. **2.** Bring your right foot toward the groin, placing your ankle on your left thigh. **3.** Using your hands, pull your right leg toward your torso to intensify the stretch.

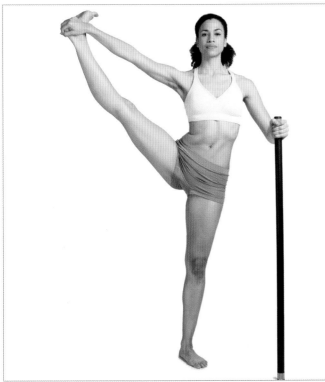

One-Legged Side Split Using the Body Bar

Target: Adductors.

Benefits: Lengthens and strengthens the adductors and hamstrings of the extended leg while increasing balance and engaging the core.

Steps: 1. Begin by standing straight, holding a body bar upright at your left side to provide balance. **2.** Lift your right leg up from the floor. **3.** From waist height, grab hold of your right foot with your right hand. **4.** Straighten the outstretched leg up from the hip and hold for thirty seconds before repeating on the opposite side.

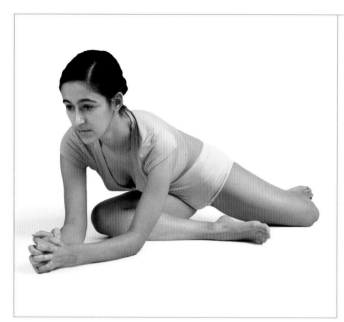

Pigeon Pose

Target: Adductors.

Benefits: Increases mobility in your hips.

Steps: 1. Begin by kneeling on all fours, with your hands shoulder-width apart and slightly farther forward than your shoulders. **2.** Clasp your hands together and bring your right knee forward, placing it on the floor just behind your elbows. **3.** Bend your left leg behind you and look forward. **4.** Hold this pose for thirty seconds and repeat on the opposite side.

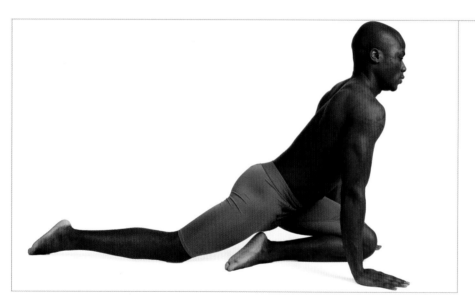

Pigeon Stretch

Target: Adductors.

Benefits: Opens the hips and lengthens the quad muscles, increasing strength and flexibility in the upper legs and hips.

Steps: 1. Begin by kneeling upright. **2.** Straighten your right leg out behind you, keeping your knee on the floor. **3.** Push your hips lower toward the floor, so your groin approaches your left foot. **4.** Hold this pose for thirty seconds before repeating on the opposite side.

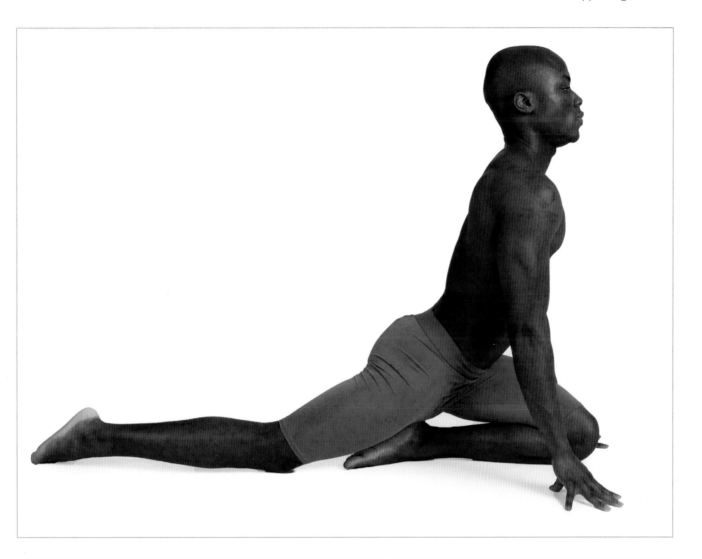

Pigeon Stretch, Fingertips Modification

Target: Adductors.

Benefits: Opens the hips and lengthens the quad muscles, increasing strength and flexibility in the upper legs and hips.

Steps: 1. Begin by kneeling upright. **2.** Straighten your right leg out behind you, keeping your knee on the floor. **3.** Place your fingertips on the floor on either side of your knees and push your hips lower toward the floor, so your groin approaches your left foot. **4.** Hold this pose for thirty seconds before repeating on the opposite side.

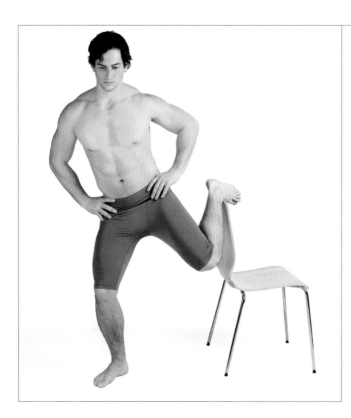

Rotational Hip Opener, Foot Raised

Target: Adductors.

Benefits: Strengthens the hip adductors and increases balance.

Steps: 1. Stand upright, with the back of a sturdy chair at your left side. **2.** Raise your left foot behind you and rest it on the back of the chair. **3.** From this position, slowly lower your pelvis to the floor, deepening the stretch. **4.** Hold this pose for fifteen seconds before repeating on the opposite side.

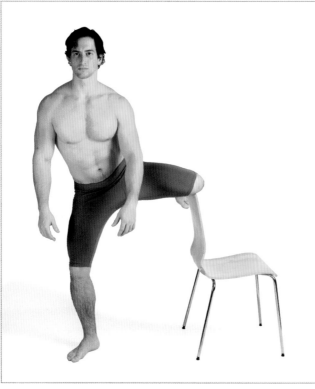

Rotational Hip Opener, Leg Raised

Target: Adductors.

Benefits: Increases flexibility and mobility in the hip adductors.

Steps: 1. Stand upright, with the back of a sturdy chair at your left side. **2.** Raise your left knee behind you and rest it on the back of the chair. **3.** From this position, slowly lower your pelvis to the floor to deepen the stretch. **4.** Hold this pose for fifteen seconds before repeating on the opposite side.

Russian Split, Arms to Floor

Target: Adductors.

Benefits: Increases flexibility in the inner thighs, groin, and hips while lengthening the spine.

Steps: 1. Squat down low and place both hands on the floor in front of you. **2.** Slowly begin to walk or slide both feet outward, as far apart as you can manage. **3.** Your legs should be completely straight and in line with each other as you lower your groin all the way to the floor. **4.** Lower your torso onto the floor and extend your arms straight out to your sides, parallel to your legs. **5.** Hold for five seconds or longer.

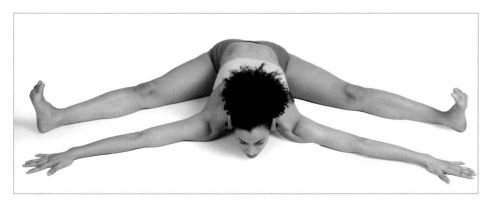

Russian Split, Flex

Target: Adductors.

Benefits: Increases flexibility in the inner thighs, groin, and hips.

Steps: 1. Squat down low and place both hands on the floor in front of you. **2.** Slowly begin to walk or slide both feet outward, as far apart as you can manage. **3.** Your legs should be completely straight and in line with each other as you lower your groin all the way to the floor. **4.** Try to roll your hips until you are sitting in an upright position and flex your toes up toward the ceiling. **5.** Place your hands onto your knees and hold this pose for five seconds or longer.

Russian Split, Hands to Floor

Target: Adductors.

Benefits: Increases flexibility in the inner thighs, groin, and hips.

Steps: 1. Squat down low and place both hands on the floor in front of you. **2.** Slowly begin to walk or slide both feet outward, as far apart as you can manage. **3.** Your legs should be completely straight and in line with each other as you lower your groin all the way to the floor. **4.** Try to roll your hips until you are sitting in an upright position and flex your toes up toward the ceiling. **5.** Place your hands flat on the floor in front of you and hold this pose for five seconds or longer.

Russian Split, Hands to Floor, Bent Arms

Target: Adductors.

Benefits: Increases flexibility in the inner thighs, groin, and hips while lengthening the spine.

Steps: 1. Squat down low and place both hands on the floor in front of you. **2.** Slowly begin to walk or slide both feet outward, as far apart as you can manage. **3.** Your legs should be completely straight and in line with each other as you lower your groin all the way to the floor. **4.** Lower your torso forward and place your palms flat on the floor by your knees, with your elbows bent and fingers pointing toward your toes. **5.** Hold this pose for five seconds or longer.

Russian Split, Point

Target: Adductors.

Benefits: Increases flexibility in the inner thighs, groin, and hips.

Steps: 1. Squat down low and place both hands on the floor in front of you. **2.** Slowly begin to walk or slide both feet outward, as far apart as you can manage. **3.** Your legs should be completely straight and in line with each other as you lower your groin all the way to the floor. **4.** Try to roll your hips until you are sitting in an upright position. **5.** Place your hands flat on the floor in front of you, point your toes, and hold for five seconds or longer.

Russian Split, Prayer Hands

Target: Adductors.

Benefits: Increases flexibility in the inner thighs, groin, and hips.

Steps: 1. Squat down low and place both hands on the floor in front of you. **2.** Slowly begin to walk or slide both feet outward, as far apart as you can manage. **3.** Your legs should be completely straight and in line with each other as you lower your groin all the way to the floor. **4.** Try to roll your hips until you are sitting in an upright position and flex your toes up toward the ceiling. **5.** Join your hands together in prayer position at your chest and hold this pose for five seconds or longer.

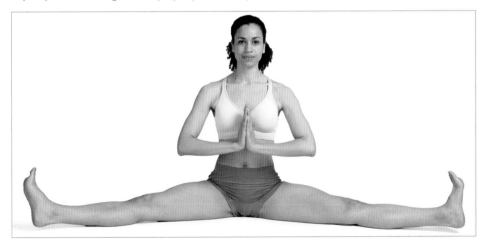

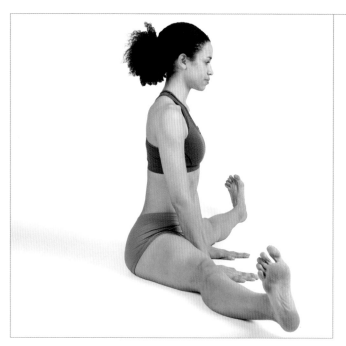
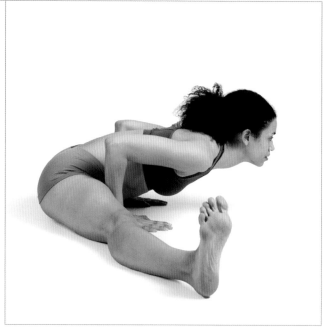

Russian Split, Roll Through

Target: Adductors.

Benefits: Increases flexibility in the inner thighs, groin, and hips.

1. Squat down low and place both hands flat on the floor in front of you. **2.** Slowly begin to walk or slide both feet outward, as far apart as you can manage. **3.** Your legs should be completely straight and in line with each other as you lower your groin all the way to the floor. **4.** Keeping your hands flat on the floor near your thighs, roll your hips forward as you lower your torso toward the floor. The length of your inner legs should be touching the floor. **5.** Hold for five seconds or longer.

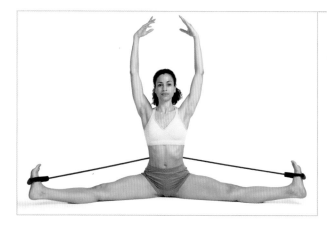

Russian Split with Band

Target: Adductors.

Benefits: Opens the hips and lengthens the calves and hamstrings.

Steps: 1. Seated on the floor, attach one handle of a resistance band around your left foot and spread your legs into a wide straddle. **2.** Stretch the band behind your back and place the other handle on your right foot, so both feet are attached and the band is pulling your legs into a wide straddle split with both feet flexed. **3.** Hold for ten seconds before carefully removing the band.

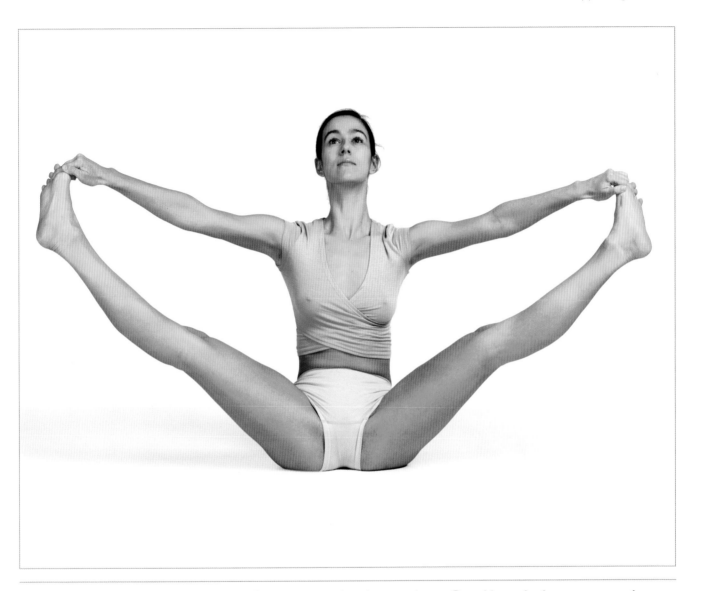

Seated Angle Split, Upward

Target: Adductors.

Benefits: Opens the hips and groin while lengthening the hamstrings and improving balance.

Steps: 1. Begin seated, with both legs bent and knees apart. **2.** Grab hold of either foot, and straighten your arms and legs up in the air to either side. **3.** Hold this position for fifteen seconds before releasing.

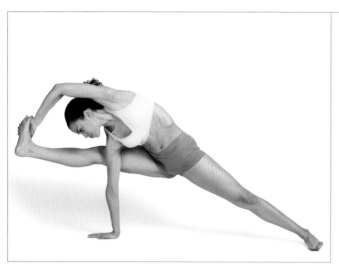

Side-Angle Leg Raise, Advanced 1

Target: Adductors.

Benefits: Lengthens the muscles along the side of the body while opening the hips.

Steps: 1. Stand with your feet shoulder-width apart. **2.** Extend your left leg straight out to the side and lower your body into a deep side squat. **3.** Lower your hands to the floor in front of your right foot. **4.** Keeping your right arm straight, extend your left arm over and grab the outside of your right foot. **5.** Pull your right foot up from the floor and attempt to straighten your leg out to the side. **6.** Hold this position for ten seconds before alternating sides.

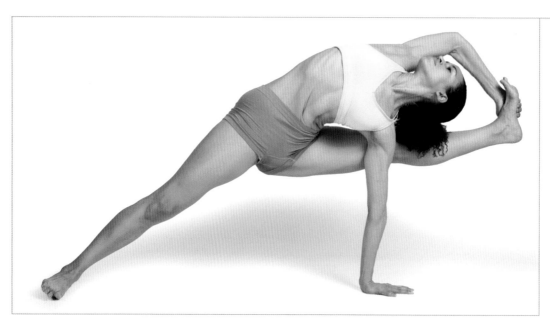

Side-Angle Leg Raise, Advanced 2

Target: Adductors.

Benefits: Lengthens the muscles along one side of the body while opening the hips and chest.

Steps: 1. Stand with your feet shoulder-width apart. **2.** Extend your left leg straight out to the side and lower your body into a deep side squat. **3.** Lower both hands to the floor in front of your left foot. **4.** Keeping your left arm straight, extend your right arm over and grab the outside of your left foot. **5.** Pull your left foot up from the floor and attempt to straighten your leg out to the side. **6.** Drop your shoulders back and turn your gaze up to the ceiling to open your chest. **7.** Hold this position for ten seconds before alternating sides.

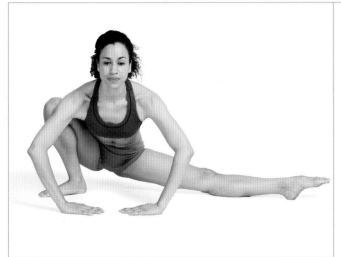

Side Squat, Extended 1

Target: Adductors.

Benefits: Lengthens the muscles in the hips and groin while strengthening the upper legs.

Steps: 1. Begin in a low squat and extend your left leg out to the side. **2.** Place your palms flat on the floor for support with your hands pointed toward each other. **3.** Lower your pelvis as far down to the floor as you are able. **4.** Hold this pose for fifteen seconds before releasing and performing on the opposite leg.

Side Squat, Extended 2

Target: Adductors.

Benefits: Lengthens the muscles in the hips and groin while strengthening the upper legs.

Steps: 1. Begin in a low squat and extend your left leg out to the side. **2.** Lower your pelvis as far down to the floor as you are able. **3.** Extend your arms straight in front of you with your palms facing down, and drop your chest toward the floor. **4.** Hold this pose for fifteen seconds before releasing and performing on the opposite leg.

Side Squat, Knee to Shoulder, Extended Leg to Side

Target: Adductors.

Benefits: Lengthens the muscles in the hips and groin, while strengthening the upper legs and opening the chest and shoulders.

Steps: 1. Begin in a low squat and lower your hips to the floor so you are sitting with knees close to your chest. **2.** Extend your right leg and reach your left hand around your left knee. **3.** Reach your right arm behind your back to join hands behind you in a bound position. **4.** Raise your gaze upward and hold this position for twenty seconds before alternating sides.

Side Squat, Overhead Reach

Target: Adductors.

Benefits: Opens the hips and groin while lengthening the spine and improving balance.

Steps: 1. Begin by standing with both legs slightly bent and extend your left leg straight out to the side. **2.** Bend your right arm and reach over your right shoulder toward your back, while reaching your left hand up your back to clasp your hands along your spine. **3.** Bend forward at the waist, bringing the top of your head down toward the floor between your legs. **4.** Hold this position for ten seconds before repeating on the opposite side.

Side Squat, Lotus Hand Extended, Leg to Side 1

Target: Adductors.

Benefits: Remedies tight or fatigued muscles in the inner thighs.

Steps: 1. Begin in a low squat, resting the fingertips of both hands on the floor. **2.** Extend your right leg straight out to the side with your toes pointed up toward the ceiling. **3.** Lower your pelvis as far down to the floor as you are able. **4.** Hold this pose for fifteen seconds before performing on the opposite side.

Side Squat, Lotus Hand Extended, Leg to Side 2

Target: Adductors.

Benefits: Remedies tight or fatigued muscles along the inner thighs.

Steps: 1. Begin in a low squat. **2.** Extend your left leg straight out to the side with your toes pointed. **3.** Lean your torso forward and extend your arms straight in front of you, placing your hands on the floor and flaring your fingers in the lotus gesture. **4.** Lower your pelvis as far down to the floor as you are able. **5.** Hold this pose for fifteen seconds before performing on the opposite side.

Side-Squat Stretch, Extended Leg

Target: Adductors.

Benefits: Opens the hips and groin, while strengthening the core and improving balance.

Steps: 1. Begin by standing with both legs slightly bent. **2.** Extend your left leg out to the side and place your foot flat on the floor. **3.** Join your hands together in prayer position and fold your torso down at the waist, resting your right elbow on your right knee. **4.** Hold this position for ten seconds before repeating on the opposite side.

Side Squat, Tiptoe, Extended Leg to Side

Target: Adductors.

Benefits: Opens the hips and groin while strengthening the core and improving balance.

Steps: 1. Begin by standing with both legs slightly bent and extend your right leg out to the side.
2. Raise your left foot onto tiptoes and extend both arms straight out to your sides.
3. Twisting your torso toward the left, place your right palm to the floor with fingers pointing out and reach your left hand overhead.
4. Hold this position for fifteen seconds before repeating on the opposite side.

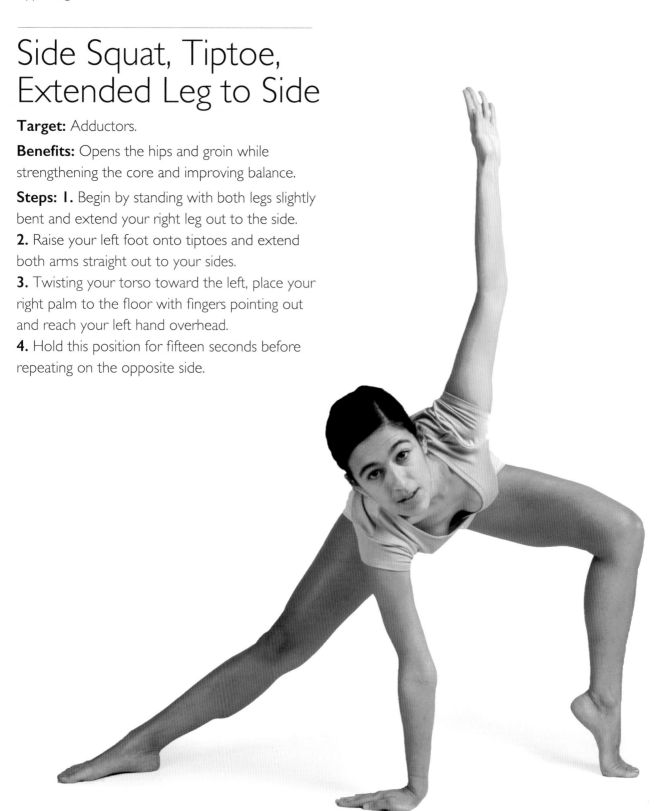

Side-Squat Stretch, Extended Leg, Advanced

Target: Adductors.

Benefits: Opens the hips and groin while strengthening the core and improving balance.

Steps: 1. Begin by standing with both legs slightly bent and extend your left leg straight out to the side. **2.** Join your hands together in prayer position in front of your chest and lean slightly forward. **3.** Gently press your hips down lower to the floor, keeping your spine straight. **4.** Hold this position for ten seconds before repeating with the opposite leg.

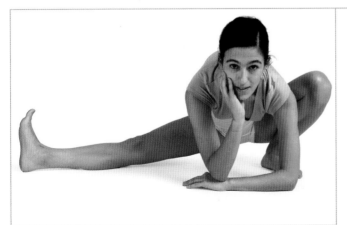

Side Squat, Uneven Arms, Extended Leg to Side

Target: Adductors.

Benefits: Remedies tight or fatigued adductors.

Steps: 1. Begin in a low squat. **2.** Extend your right leg straight to the side with your toes pointed up toward the ceiling. **3.** Lower your pelvis as far down to the floor as you are able. **4.** Drop your chest down toward the floor and rest both elbows on the floor. **5.** Hold this pose for fifteen seconds before releasing and performing on the opposite side.

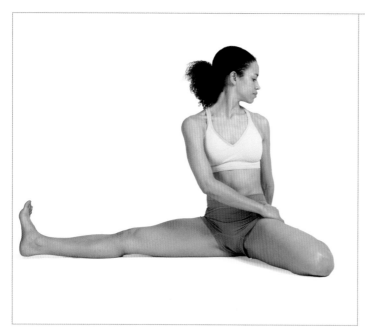

Half-Split, Modification

Target: Adductors.

Benefits: Increases flexibility in the inner thighs, groin, and hips.

Steps: 1. Begin in a low squat and extend your right leg straight out to the side. **2.** Lower your hips down toward the floor, so you are in a sitting position with your left knee bent to your side and with your foot pointed behind your hips. **3.** Keep your right leg extended straight out beside you with your toes flexed upward. **4.** Twist your torso to the left. **5.** Hold this position for thirty seconds before repeating on the opposite side.

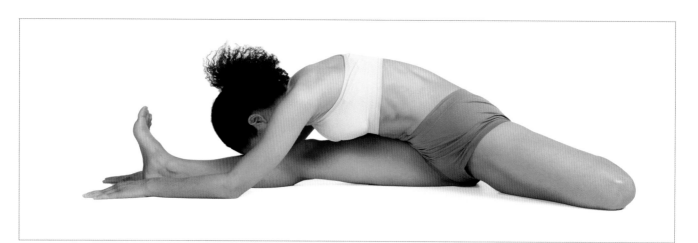

Split-Half with Forward Bend

Target: Adductors.

Benefits: Increases flexibility in the inner thighs, groin, and hips.

Steps: 1. Begin in a low squat and extend your right leg straight out to the side with your toes flexed upward. **2.** Lower your hips down toward the floor, so you are in a sitting position with your left knee bent to your side with your foot pointed behind your hips. **3.** Twisting your torso down to the right, drop your forehead to your shin and place your forearms on the floor on either side of your right leg. **4.** Hold this position for thirty seconds before repeating on the opposite side.

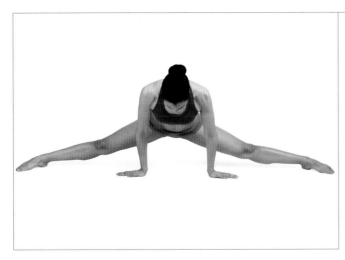

Split Prep

Target: Adductors.

Benefits: Increases flexibility in the inner thighs, groin, and hips.

Steps: 1. Squat low to the floor and place both palms flat on the floor in front of you, fingers pointing out. **2.** Slowly begin to walk or slide your feet outward, as far apart as you can manage. **3.** Your legs should be completely straight and in line with each other as you lower yourself into the split. **4.** Keep your back straight and lean your torso forward on straight arms. **5.** Hold for ten seconds.

Squat, Extended Leg to Side, Tiptoe 1

Target: Adductors.

Benefits: Opens the hips and groin while strengthening the core and improving balance.

Steps: 1. Begin in a low squat and extend your right leg straight out to the side. **2.** Raise your left foot onto tiptoes and find your balance. **3.** Bend your right arm so your fingers are pointing upward, and bend your left arm so your forearm is balancing across your chest. Form the wisdom gesture by touching your thumb to your index finger. **4.** Hold this position for fifteen seconds before repeating on the opposite side.

Squat, Extended Leg to Side 1

Target: Adductors.

Benefits: Opens the hips and groin while strengthening the core and improving balance.

Steps: 1. Begin in a low squat and extend your right leg straight out to the side. **2.** Raise your left foot up onto tiptoes and find your balance. **3.** Form the wisdom gesture with your fingers as you extend your right arm up overhead and bend your left arm up at your left side. **4.** Hold for fifteen seconds before repeating on the opposite side.

Squat, Extended Leg to Side 2

Target: Adductors.

Benefits: Opens the hips and groin while strengthening the core and improving balance.

Steps: 1. Begin in a low squat and extend your left leg straight out to the side. **2.** Place your hands on the floor in front of you and raise your right foot up onto tiptoes. **3.** Place your right hand on your knee and hold this position for fifteen seconds before repeating on the opposite side.

Squat, Extended Leg to Side 3

Target: Adductors.

Benefits: Opens the hips and groin while strengthening the core and improving balance.

Steps: 1. Begin in a low squat and extend your left leg straight to the side. **2.** Place your hands on the floor in front of you and raise your right foot onto tiptoes. **3.** Place your right hand on your knee and turn your head far to the left to increase the stretch. **4.** Hold this position for fifteen seconds before repeating on the opposite side.

Squat, Extended Leg to Side, Tiptoe 2

Target: Adductors.

Benefits: Opens the hips and groin while strengthening the core and improving balance.

Steps: 1. Begin in a low squat and extend your right leg straight out to the side. **2.** Raise your left foot up onto tiptoes and find your balance. **3.** Form the wisdom gesture with your fingers as you extend your left arm up and point your right arm down, so your arms are in a straight line. **4.** Hold this position for fifteen seconds before repeating on the opposite side.

Squat, Extended Leg to Side, Tiptoe 3

Target: Adductors.

Benefits: Opens the hips and groin while strengthening the core and improving balance.

Steps: 1. Begin in a low squat and extend your left leg straight out to the side. **2.** Place your hands on the floor in front of you and raise your right foot up onto tiptoes. **3.** Raise your left hand from the floor and point your arm out and parallel to your left leg. **4.** Keep your right palm flat on the floor, with your fingers pointing out. **5.** Hold this position for fifteen seconds before repeating on the opposite side.

Squat, Revolved Half-Bound Extended Leg to Side

Target: Adductors.

Benefits: Twists the spine and targets the outer hips.

Steps: 1. Begin in a low squat and extend your left leg straight out to the side. **2.** Twist your torso to the right, hooking your left arm around your raised knee. **3.** Reach your right arm across your back and hold your left hip in a half-bound position. **4.** Shift your gaze to the right and hold this position for thirty seconds before alternating sides.

Star Pose

Target: Adductors.

Benefits: Increases flexibility and mobility in the adductors while lengthening the spine.

Steps: 1. Begin seated, with your knees bent and the soles of your feet together, in the butterfly position. **2.** Hold your toes and bend forward until your forearms are flat on the floor in front of your shins and your forehead is resting on your feet. **3.** Hold for thirty seconds.

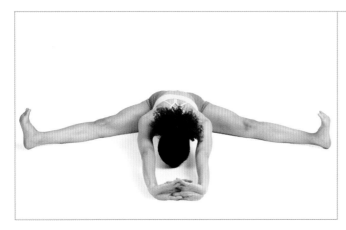

Straddle Stretch, Forward Fingers

Target: Adductors.

Benefits: Deeply opens the hips and lengthens the hamstrings.

Steps: 1. Begin by sitting on the floor, legs far apart and toes flexed upward. **2.** Clasp your hands together, palms facing outward, and extend your arms overhead. **3.** Lower your torso forward and rest your forehead and hands on the floor. **4.** Hold this pose for fifteen seconds.

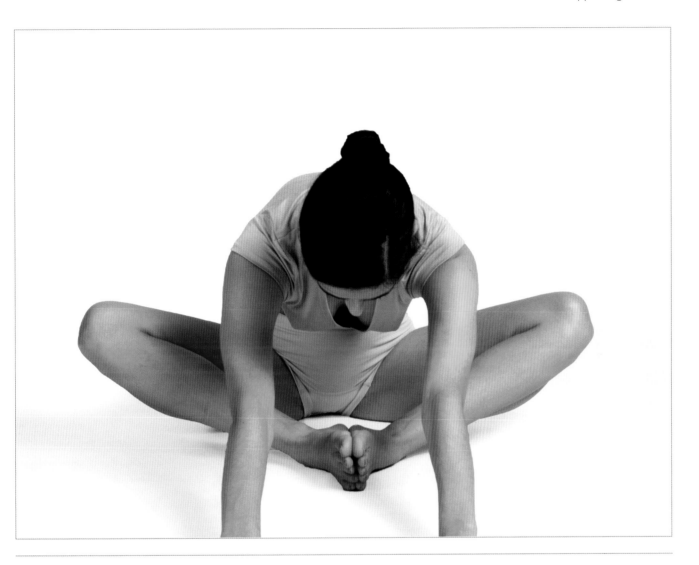

Star Pose, Arms Ahead

Target: Adductors.

Benefits: Lengthens the muscles in the groin, upper back, and shoulders.

Steps: 1. Begin seated, with your knees bent and the soles of your feet together, in the butterfly position. **2.** Bend forward and place your palms flat on the floor in front of you, reaching as far forward as you are able. **3.** Hold for thirty seconds.

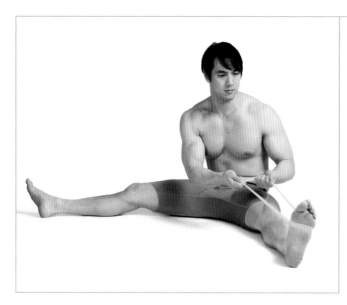

Straddle Stretch with Band

Target: Adductors.

Benefits: Improves flexibility in the hips and hamstrings.

Steps: 1. Begin seated on the floor and attach a resistance band around your left foot. **2.** Swing your right leg wide apart from your left, into a straddle position. **3.** Pull gently against the band, to increase the stretch on the calf and hamstring. **4.** Continue this stretch for thirty seconds before alternating sides.

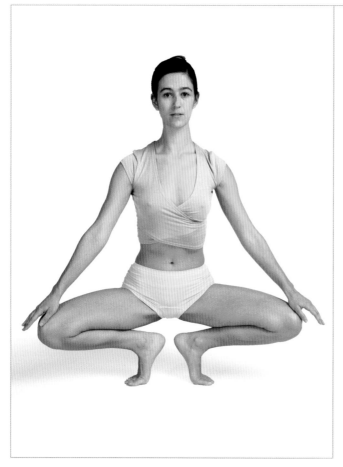

Tiptoe Stretch

Target: Adductors.

Benefits: Loosens the groin and hips while strengthening the feet and Achilles tendons.

Steps: 1. Begin by crouching on your tips toes, resting your hands on your knees for support. **2.** Slowly extend your knees wide apart so they are pointing out to your sides. **3.** Hold this position for thirty seconds or longer.

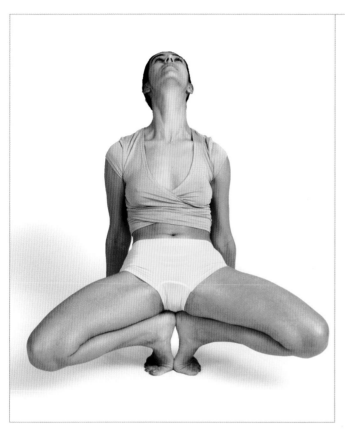

Tiptoe Stretch, Supported

Target: Adductors.

Benefits: Increases the range of motion in the groin and Achilles tendons while extending the chest and shoulders.

Steps: 1. Begin by crouching on your tiptoes, with your hips resting on your heels. **2.** Spread your knees wide apart, so your knees are pointing outward. **3.** Rest your hands flat on the floor behind you for support and turn your gaze upward. **4.** Hold this position for twenty seconds.

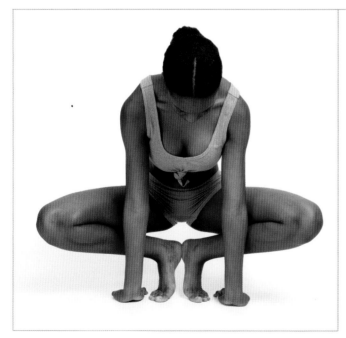

Tiptoe Balance, Intense Wrist Stretch

Target: Adductors.

Benefits: Strengthens the calves and ankles and core while opening the hips and wrists.

Steps: 1. Begin by crouching on your tiptoes, with your hips resting on your heels. **2.** Spread your knees wide apart so your knees are pointing outward. **3.** Place your palms flat on the floor in front of you, fingers facing backward, and hold for twenty seconds.

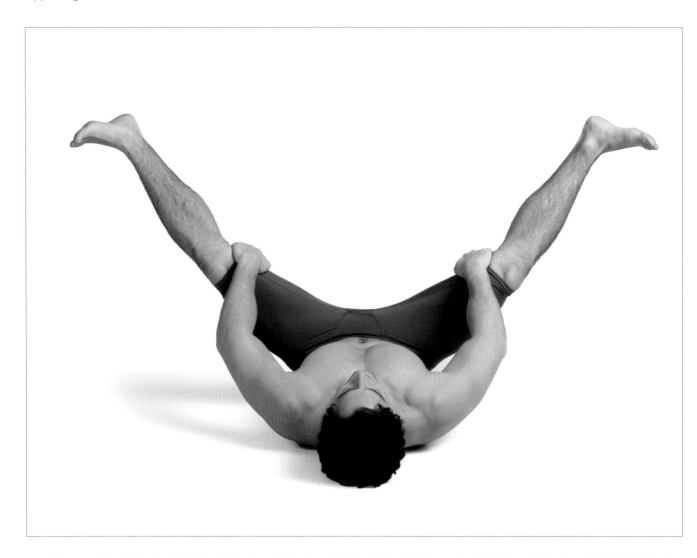

V Stretch

Target: Adductors.

Benefits: Reduces tightness in the adductors and groin.

Steps: 1. Lie flat on your back with your legs straight in the air with your feet flexed.

2. Slowly spread your legs apart from one another, keeping your knees straight.

3. Use your hands to pull against your inner thighs to create a deeper stretch.

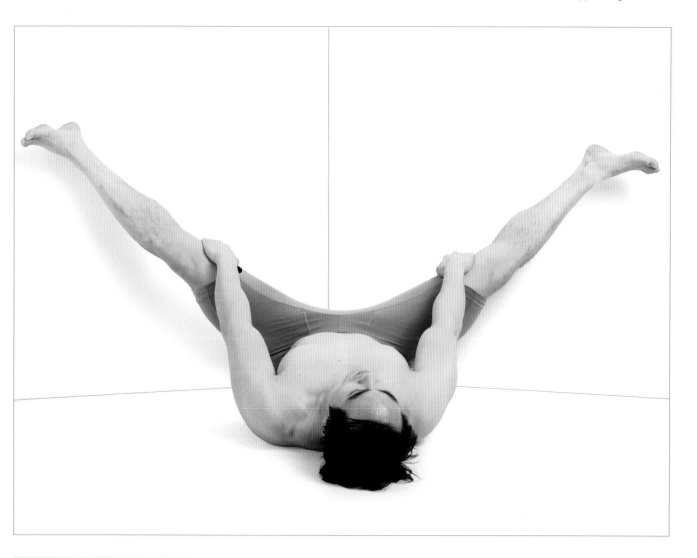

V Stretch, Supported

Target: Adductors.

Benefits: Reduces tightness in the adductors and groin.

Steps: 1. Lie flat on your back in the corner of a room and rest your feet on either wall.

2. With your legs straight and feet flexed, spread your legs far apart.

3. Making sure to keep your knees straight, use your hands to pull against your inner thighs to deepen the stretch.

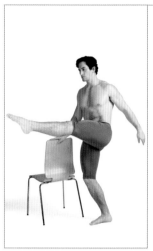 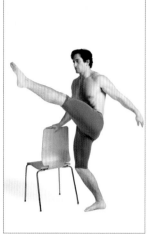

Chair Kicks

Target: Glutes.

Benefits: Provides a full range of motion in the glutes while increasing strength, balance, and flexibility.

Steps: 1. Stand upright, holding the back of a chair at your right side, and shift your weight onto your right foot. **2.** Using the chair for support, swing your left leg above your hips and back down and behind you, without touching the floor. **3.** Move quickly between motions and continue for thirty seconds on either leg.

 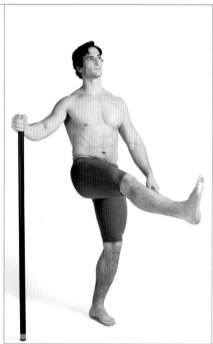 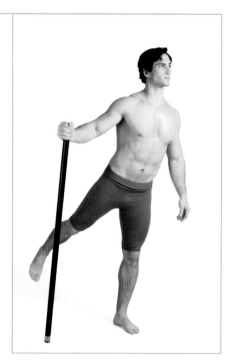

Supported Leg Swing

Target: Glutes.

Benefits: Provides a full range of motion in the glutes while increasing strength, balance, and flexibility.

Steps: 1. Stand straight, holding a body bar upright with your right hand, and shift your weight onto your left foot. **2.** Using the bar for support, swing your right leg up in front of you and back down and behind you, without touching the floor. **3.** Move quickly between motions and continue for thirty seconds on either leg.

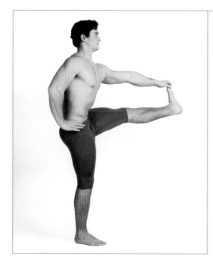

Extended Hand to Big Toe Pose

Target: Glutes.

Benefits: Strengthens the glutes while increasing balance and flexibility.

Steps: 1. Stand straight with your hands resting on your hips. **2.** Swing your left leg straight out in front of you and grab your big toe with your left hand. **3.** Raise your leg as high as you can, hold for five seconds, and lower your foot back down. **4.** Repeat this motion ten times on each leg.

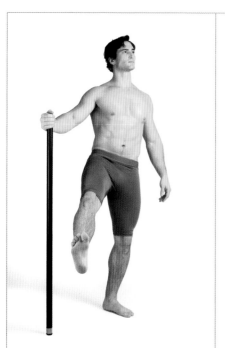
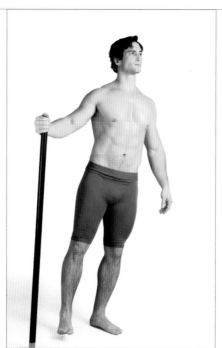

Supported Toe Turnout

Target: Glutes.

Benefits: Provides a full range of motion in the glutes while increasing strength, balance, and flexibility.

Steps: 1. Stand straight, holding a body bar upright with your right hand, and shift your weight onto your left foot. **2.** Using the bar for support, swing your right forward and backward, without touching the floor. **3.** Move quickly between motions and continue for thirty seconds on either leg.

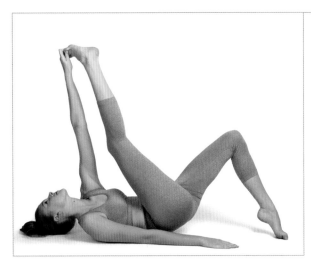

Extended Hand to Big Toe Pose, Intense Ankle Stretch

Target: Glutes.

Benefits: Increases strength and mobility in the hips and glutes while engaging the core.

Steps: 1. Lie flat on your back with both knees bent and your feet raised onto tiptoes. **2.** Extend your right leg straight up and grab your big toe with your left hand. **3.** Hold this position for fifteen seconds before switching legs.

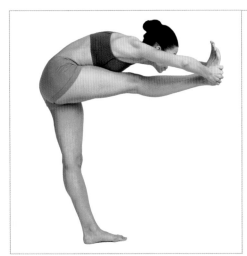

Extended One-Foot Pose

Target: Glutes.

Benefits: Extends the glutes and hamstrings while improving balance.

Steps: 1. Stand straight and raise your right leg up from the floor. **2.** Placing your hands under your right foot, gently straighten your leg and raise it so it is parallel to the floor. **3.** Find your balance, fold your torso forward, and bring your forehead down to your right shin. **4.** Hold this pose for ten seconds, before releasing and repeating on the opposite leg.

Front Kick at Ballet Bar

Target: Glutes.

Benefits: Strengthens the glutes and increases flexibility.

Steps: 1. Stand upright, holding a ballet bar at your right side, and shift your weight onto your left foot. **2.** Using the bar for support, swing your left leg up until it is parallel to the floor. **3.** Hold for five seconds, lower your foot back to the floor, and repeat this motion for thirty seconds on either side.

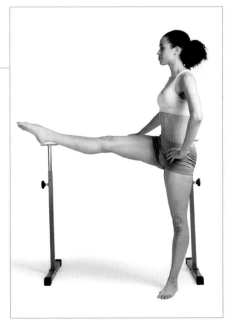

Chair Swings

Target: Glutes.

Benefits: Provides a full range of motion in the glutes while increasing strength, balance, and flexibility.

Steps: 1. Stand upright, holding the back of a chair at your right side, and shift your weight onto your right foot. **2.** Using the chair for support, swing your left leg up above your hips and swing it back down and behind you, without touching the floor. **3.** Move quickly between motions and continue for thirty seconds on either leg.

Glute Stretch on Roller

Target: Glutes.

Benefits: Relieves tight and fatigued glutes.

Steps: 1. Sit on top of a foam roller, knees bent. **2.** Roll up and down on the roller, targeting any troubled muscles, for thirty seconds.

Half One Leg Stretched Upward

Target: Glutes.

Benefits: Strengthens the glutes and abdominals while increasing flexibility in the hamstrings and wrists.

Steps: 1. Standing upright, bend your torso down at the waist and place both hands flat on the floor ahead of you with your fingers pointing forward. **2.** Shifting your weight onto your hands, raise your left leg straight up in the air and point your toes. **3.** Hold this position for thirty seconds, before releasing and repeating with the opposite leg.

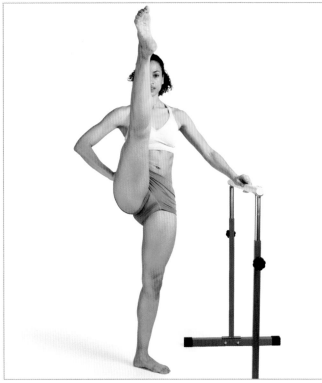

High Front Kick at Ballet Bar

Target: Glutes.

Benefits: Strengthens the glutes and increases flexibility and coordination.

Steps: 1. Stand upright, holding a ballet bar at your left side, and shift your weight onto your left foot. **2.** Using the bar for support, swing your right leg up and raise your toes as high as you are able. **3.** Lower your leg back down and repeat this motion for thirty seconds on each leg.

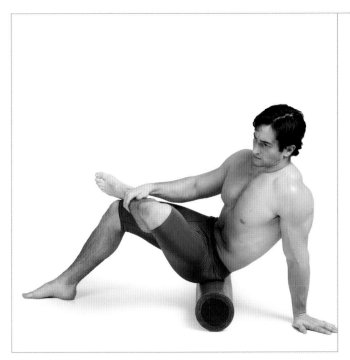 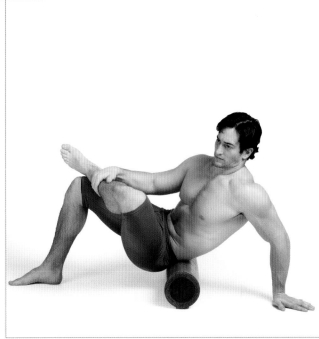

Glute Stretch on Roller, One-Sided Target

Target: Glutes.

Benefits: Relieves tight and fatigued glutes and hip abductors.

Steps: 1. Sit on top of a foam roller, knees bent. **2.** Lift your left leg from the floor and rest your foot on the right knee. **3.** Roll up and down on the roller, targeting any troubled muscles, for thirty seconds.

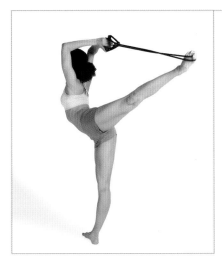

Kick Back with Band

Target: Glutes.

Benefits: Strengthens the glutes while lengthening the spine.

Steps: 1. Stand straight and tuck your left leg behind you. **2.** Loop a handled resistance band around your left foot. **3.** Extend your bound foot away from your torso and straighten your leg. **4.** Repeat this motion ten times on each leg.

357

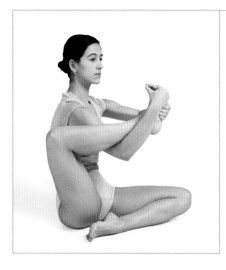

Iliopsoas Self-Stretch

Target: Glutes.

Benefits: Targets tightness or tension in the iliopsoas and lower back.

Steps: 1. Begin seated, with your knees bent, in the butterfly position. **2.** Raise your right leg and wrap your right arm under your shin to grab hold of your toes. **3.** Gently pull your foot in toward your chest with both hands. **4.** Hold for thirty seconds.

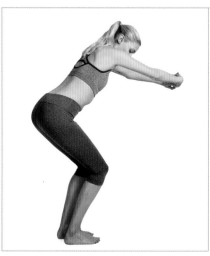

Kali Squat, Bound

Target: Glutes.

Benefits: Strengthens the glutes and quads, increasing mobility and alignment.

Steps: 1. Stand with your feet shoulder-width apart. **2.** Clasp your hands together and extend your arms straight out in front of you. **3.** Bend your legs into a low squat and hold for ten seconds. **4.** Rise back up to the starting position and repeat the exercise for thirty seconds.

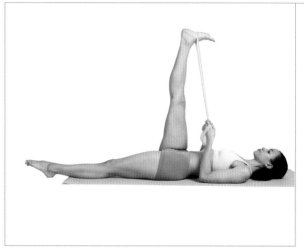

Kick Forward with Band

Target: Glutes.

Benefits: Strengthens the glutes while lengthening the spine.

Steps: 1. Lie flat on your back, with your right knee bent into your chest and the other leg straight. **2.** Loop a resistance band around your right foot. **3.** Kick your bound foot away from your torso so it extends straight above the floor. **4.** Bring your foot back into your chest and repeat this motion twenty times on each leg.

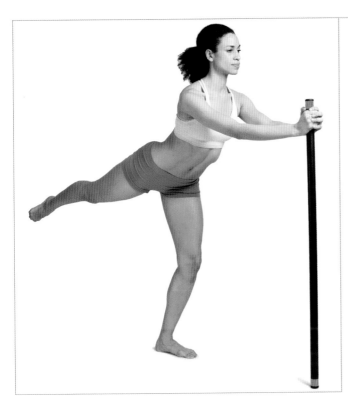

Kick to Back with Body Bar

Target: Glutes.

Benefits: Strengthens the glutes and hamstrings while increasing balance.

Steps: 1. Stand straight, holding a body bar upright in front of you with both hands. **2.** Lift your right leg straight out behind you to hip height. **3.** Lower your foot back to the floor and repeat this motion twenty times on each leg.

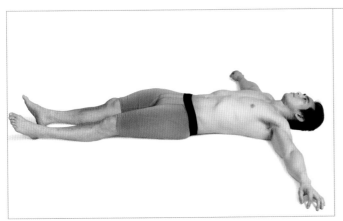

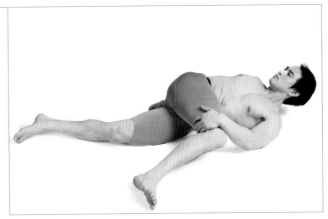

Knee Across Body

Target: Glutes.

Benefits: Increases flexibility and range of motion in the iliopsoas.

Steps: 1. Lie flat on your back with legs straight and arms out to your sides. **2.** Bend your right knee directly above your hips and drop it toward your left side. **3.** Use your left hand to pull your knee across your body until it is resting on the floor. **4.** Hold for thirty seconds and alternate sides.

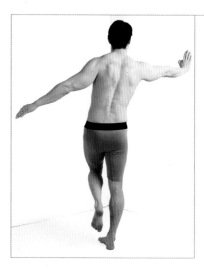

Knee Lifts at the Wall

Target: Glutes.

Benefits: Lengthens the glutes while strengthening the quadriceps.

Steps: 1. Begin by standing beside a wall at your right. **2.** Using the wall for support, raise your left knee to waist height. **3.** Straighten your leg and hold for ten seconds on each leg.

Lateral Leg Raise 1

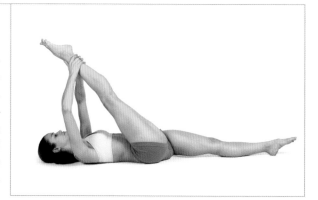

Target: Glutes.

Benefits: Extends the glutes and hamstrings, providing flexibility and reducing muscle imbalance.

Steps: 1. Lie flat on your back with both legs straight and your toes pointed. **2.** Bring your right knee into your chest and place both hands under your right calf. **3.** Gently straighten your leg and pull it in toward your torso. **4.** Hold this pose for fifteen seconds before repeating on the opposite leg.

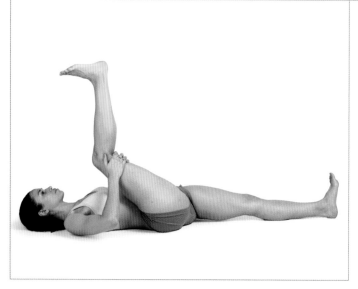

Lateral Leg Raise 2

Target: Glutes.

Benefits: Extends the glutes and hamstrings, providing flexibility and reducing muscle imbalance.

Steps: 1. Lie flat on your back with both legs straight and your toes pointed. **2.** Bring your right knee into your chest and place both hands under your right thigh. **3.** Gently pull your leg in toward your torso. **4.** Hold this pose for fifteen seconds before repeating on the opposite leg.

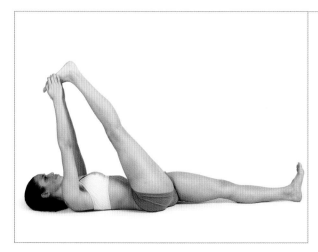

Lateral Leg Raise 3

Target: Glutes.

Benefits: Extends the glutes and hamstrings, providing flexibility and reducing muscle imbalance.

Steps: 1. Lie flat on your back with both legs straight and your toes pointed. **2.** Bring your right knee into your chest and place both hands on your right foot. **3.** Gently straighten your leg and pull it in toward your torso. **4.** Hold this pose for fifteen seconds before repeating on the opposite leg.

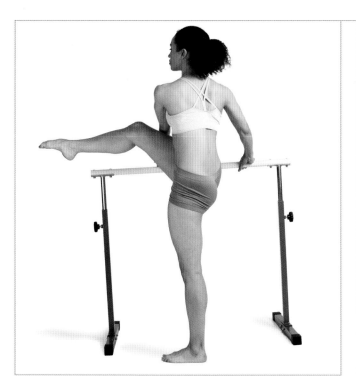

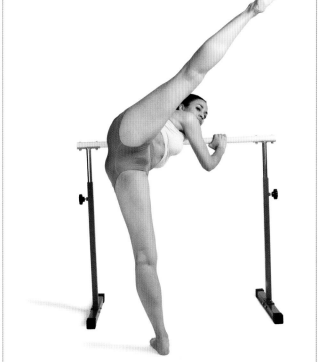

Lateral Leg Swing at Ballet Bar

Target: Glutes.

Benefits: Provides a wide range of motion in the glutes, increasing strength and flexibility in the legs and core.

Steps: 1. Stand facing the bar, holding it with both hands. **2.** Shift your weight onto your left foot and raise your right foot, bending your leg in front of you so your calf is parallel to the floor. **3.** Swing your right leg down and kick it straight out behind you, dropping your torso down at the waist as you are kicking. **4.** Return your right leg to the front and repeat this exercise for thirty seconds before switching legs.

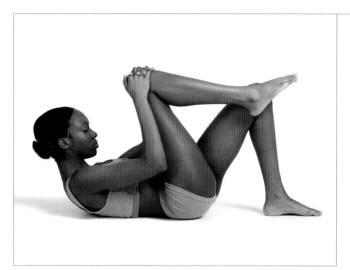
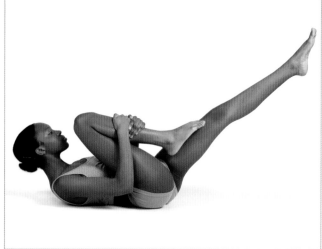

Leg Extension and Ab Stretch, Side-Lying

Target: Glutes.

Benefits: Extends the glutes and hamstrings, providing flexibility and reducing muscle imbalance.

Steps: 1. Begin by lying on your back, with both knees bent, and bring your right knee into your chest. **2.** Grab your right knee with both hands and lift your head and shoulders from the floor to engage the abdomen. **3.** Gently pull your knee into your chest as you extend your left leg straight out. **4.** Hold this stretch for twenty seconds before repeating on the opposite side.

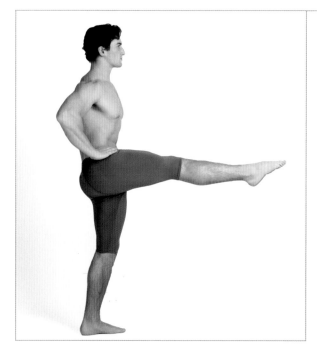

Leg Raise, Point

Target: Glutes.

Benefits: Strengthens the glutes while increasing balance and flexibility.

Steps: 1. Stand straight with both hands resting on your hips. **2.** Keeping your legs straight, swing your right leg out in front of you until it is parallel to the floor. **3.** Hold for five seconds and lower your foot. **4.** Repeat this motion ten times on either leg.

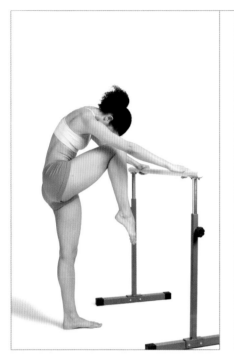
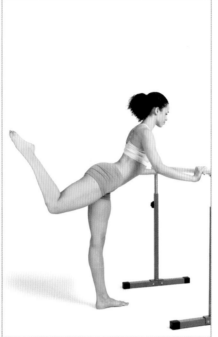
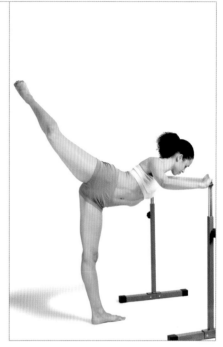

Leg Extensions at Ballet Bar

Target: Glutes.

Benefits: Strengthens the glutes while extending the muscles along the leg

Steps: 1. Begin by facing a ballet bar, set to waist height. **2.** Using the bar for support, raise your right knee into the chest and swing your leg out behind you. **3.** Drop your chest, extending the raised leg above your head. **4.** Curl your right leg back into your chest and repeat this motion twenty times on each leg.

Leg Raise, Rear

Target: Glutes.

Benefits: Strengthens the glutes.

Steps: 1. Start by lying flat on your stomach, toes pointed and arms crossed under your forehead. **2.** Lift both legs off the floor, keeping them straight. **3.** Hold this pose for five or more seconds.

Leg Raise, Advanced Point

Target: Glutes.

Benefits: Strengthens the glutes while increasing balance and flexibility.

Steps: 1. Stand with both hands resting against your lower back. **2.** Keeping your legs straight, swing your right leg straight out in front of you just above your hips. **3.** Hold for five seconds and lower your foot back down to the floor. **4.** Repeat this motion ten times on either leg.

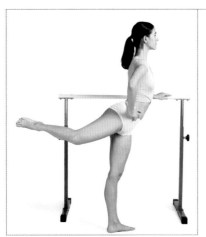
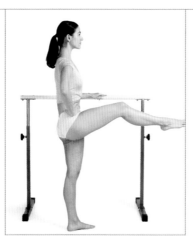

Leg Swings at Ballet Bar, Pointed

Target: Glutes.

Benefits: Lengthens and strengthens the glutes and hamstrings, targeting hard-to-reach muscles.

Steps: 1. Stand straight and hold a ballet bar at your left side. **2.** Shift your weight onto your left foot and raise your right foot in front of you to hip level, with your right knee slightly bent. **3.** Swing your leg around you until it is at hip level behind you. **4.** Continue this movement for thirty seconds, moving quickly. **5.** Lower your leg to the floor and repeat on the opposite side.

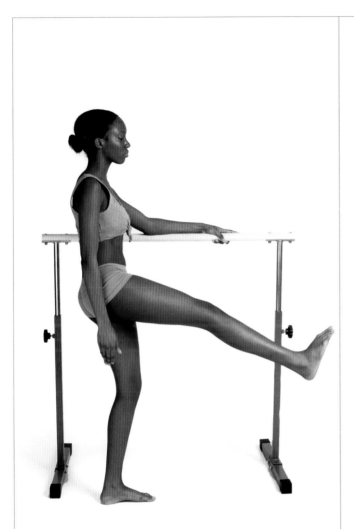
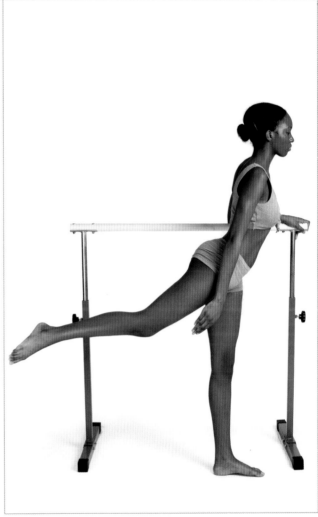

Leg Swings at Ballet Bar, Kick

Target: Glutes.

Benefits: Lengthens and strengthens the glutes and hamstrings, targeting hard-to-reach muscles.

Steps: 1. Stand straight and hold a ballet bar at your left side. **2.** Shift your weight onto your left foot and swing your right leg in front of you. **3.** Lower your foot back down and swing your leg out behind you. **4.** Continue this movement for thirty seconds, moving quickly. **5.** Lower your leg to the floor and repeat on the opposite side.

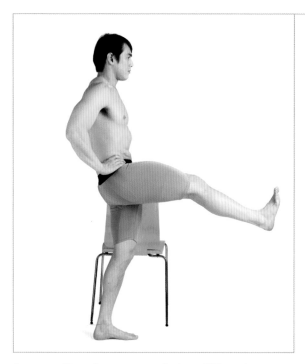
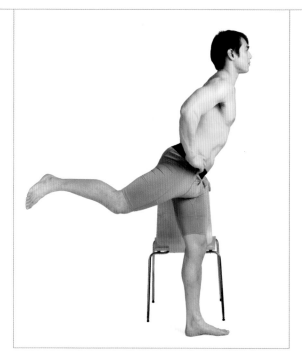

Leg Swings with Chair

Target: Glutes.

Benefits: Lengthens and strengthens the glutes and hamstrings, targeting hard-to-reach muscles.

Steps: **1.** Stand straight beside a chair, holding the back of the chair with your left hand. **2.** Shift your weight onto your left foot and raise your right foot in front of you to hip level, with your right knee slightly bent. **3.** Swing your leg around you until it is at hip level behind you. **4.** Continue this movement for thirty seconds, moving quickly. **5.** Lower your leg to the floor and repeat on the opposite side.

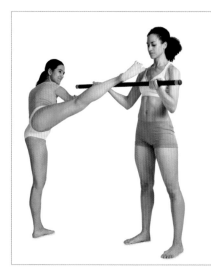

Measured Kick, High

Target: Glutes.

Benefits: Stretches the hips flexors while strengthening the glutes, quads, and abdominals.

Steps: **1.** Stand straight, with your target at your right side. **2.** Raise your right knee directly in front of you up to chest level and fold your knee in tightly. (The higher your target, the higher you should raise your knee.) **3.** Point your right foot and toes downward as you rotate your right hip over by pointing your toes away from the target. (Do not allow the knee to dip or point downward.) **4.** Deliver the kick by quickly unfolding your right leg at the knee, rotating toward the target, and snapping the hips over at the moment of impact. **5.** Lower your leg to the floor and repeat on the opposite side.

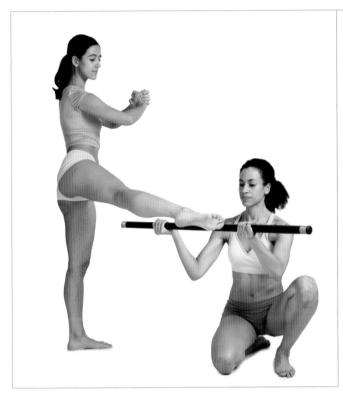

Measured Kick, Low

Target: Glutes.

Benefits: Stretches the hips flexors while strengthening the glutes, quads, and abdominals.

Steps: 1. Stand straight, with your target at your right side. **2.** Raise your right knee directly in front of you up to hip level and fold your knee in tightly. **3.** Point your right foot and toes downward as you rotate your right hip over by pointing your toes away from the target. (Do not allow the knee to dip or point downward.) **4.** Deliver the kick by quickly unfolding the leg at the knee, rotating toward the target, and snapping the hips over at the moment of impact.

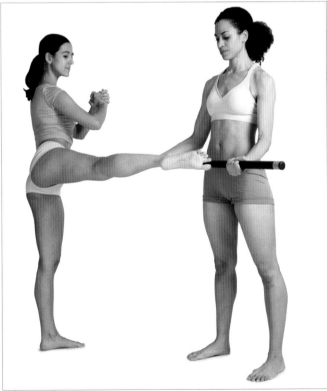

Measured Kick, Medium

Target: Glutes.

Benefits: Stretches the hips flexors of the kicking leg, while strengthening the glutes, quads and abdomen.

Steps: 1. Stand straight, with your target at your right side. **2.** Raise your right knee directly in front of you up to waist level and fold your knee in tightly. **3.** Point your right foot and toes downward as you rotate your right hip over by pointing your toes away from the target. (Do not allow the knee to dip or point downward.) **4.** Deliver the kick by quickly unfolding the leg at the knee, rotating toward the target, and snapping the hips over at the moment of impact.

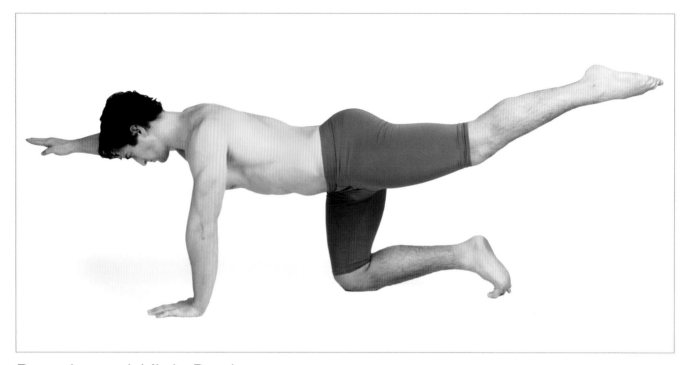

Reach and Kick Back

Target: Glutes.

Benefits: Tones the glutes while lengthening and strengthening the arms, legs, and core.

Steps: 1. Begin on all fours with your palms flat on the floor below your shoulders. **2.** Lift your left knee from the floor and kick your leg straight out behind you at hip level. At the same time, raise your right hand from the floor and extend your arm at shoulder height. **3.** Return to the starting position and continue this exercise for thirty seconds, alternating arms and legs.

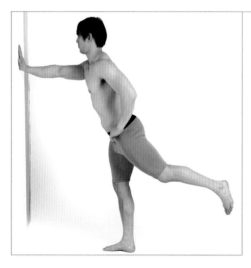

Rear Leg Raise

Target: Glutes.

Benefits: Strengthens the glutes and hamstrings.

Steps: 1. Begin by standing at arm's length from a wall. Place your right hand against the wall for support. **2.** Raise your left leg behind you and hold for fifteen seconds. **3.** Return your leg to the floor and repeat on the opposite side.

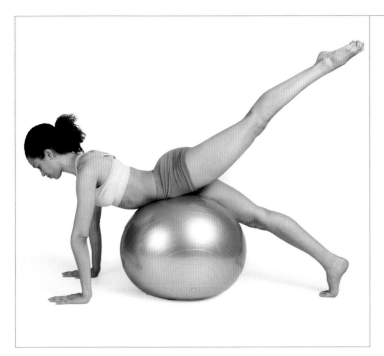

Rear Leg Raise, Lying on Ball

Target: Glutes.

Benefits: Strengthens the muscles in the glutes while increasing balance.

Steps: 1. Begin by lying on an exercise ball beneath your stomach, using your hands and feet for support. **2.** Extend your left leg straight out behind you and lower it to hip level. **3.** Repeat this motion five times before returning your foot to the floor and alternating legs.

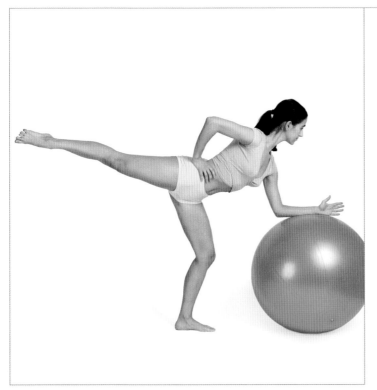

Rear Leg Raise with Ball

Target: Glutes.

Benefits: Strengthens the glutes while increasing balance.

Steps: 1. Bend forward, resting your left forearm on an exercise ball for balance. **2.** Extend your right leg straight behind you to waist height and hold the position for five seconds before returning your foot to the floor. **3.** Repeat on the opposite side.

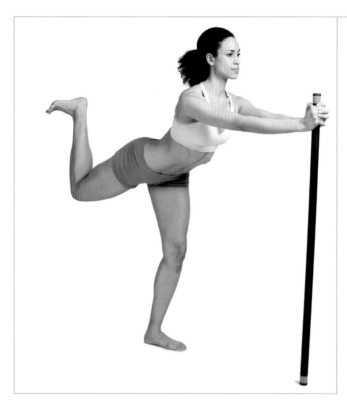

Rear Leg Raise with Body Bar

Target: Glutes.

Benefits: Strengthens the glutes and hamstrings, improves balance, and engages the core.

Steps: 1. Stand straight, holding a body bar upright in front of you. **2.** Raise your right leg from the floor, keeping your knee bent, until your foot is at shoulder level. **3.** Lower your right foot without touching the floor and repeat this motion ten times on each leg.

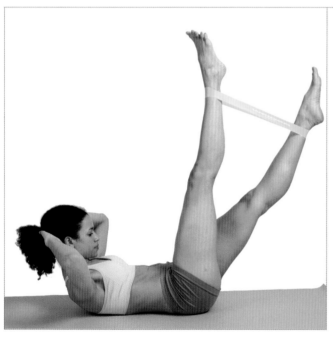

Scissor Legs, Band Assisted

Target: Glutes.

Benefits: Lengthens the muscles in the glutes and hamstrings, while strengthening the abdominals.

Steps: 1. Lie on your back and attach a resistance band around both ankles. **2.** Raise your legs from the floor, straight toward the ceiling. **3.** Bring your head to your chest in a crunch position, supporting your neck with your hands. **4.** From this position, scissor kick your legs, alternating them forward and backward against the resistance of the band, for thirty seconds.

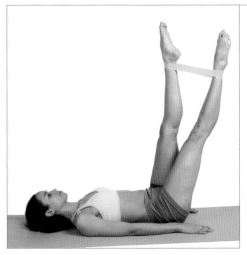

Scissor Legs, Lying with Band

Target: Glutes.

Benefits: Strengthens hard-to-target muscles in the glutes and upper legs.

Steps: 1. Attach a resistance band around both ankles and lie flat on your back. **2.** Extend both legs straight above you with your toes pointing upward. **3.** Scissor kick your legs, alternating them forward and backward against the resistance of the band, moving quickly between motions for thirty seconds.

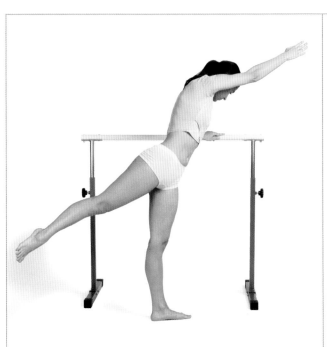

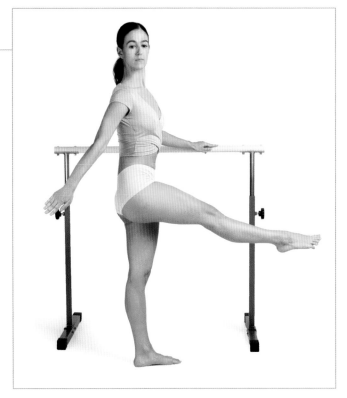

Scissor Swings at Ballet Bar

Target: Glutes.

Benefits: Lengthens and strengthens the glutes and hamstrings, targeting hard-to-reach muscles.

Steps: 1. Stand beside a ballet bar, holding it with your left hand, and shift your weight onto your left foot. **2.** Swing your right leg up in front of you while swinging your right arm behind you, keeping both straight. **3.** Next, swing your right leg around and behind you while swinging your right arm forward. **4.** Continue this motion for thirty seconds, lower your leg to the floor, and switch to the other side of the bar.

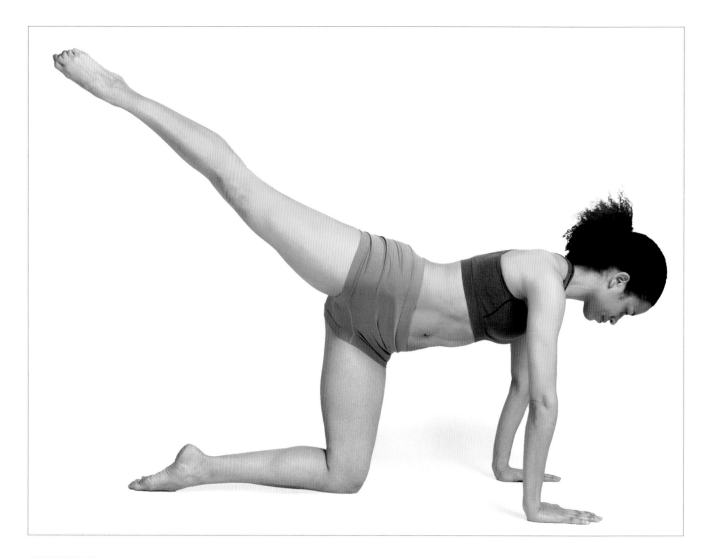

Tiger Pose

Target: Glutes.

Benefits: Increases strength in the glutes, creating greater tone and flexibility.

Steps: 1. Start by kneeling on all fours, with your palms flat on the floor below your shoulders. **2.** Raise your right knee and straighten your leg up above your hips. Hold this pose for twenty seconds, making sure not to let your foot drop or your knee bend. **3.** Lower your knee to the floor and repeat the exercise on the opposite leg.

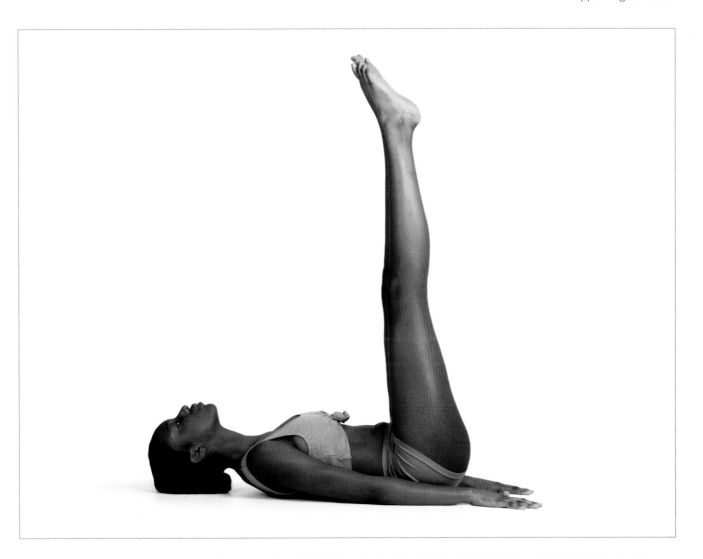

Upward Extended-Legs Pose

Target: Glutes.

Benefits: Strengthens and tones hard-to-target glutes and upper legs.

Steps: 1. Lie flat on your back and bring your knees into your chest. **2.** Straighten both legs directly above you and point your toes upward. **3.** Hold this pose for thirty seconds, making sure not to let your knees bend or your legs lower to the ground.

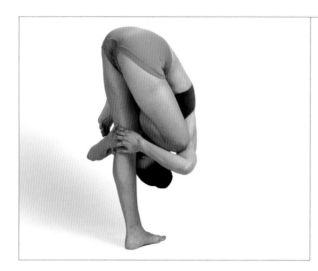

Baby-Cradle Intense Stretch

Target: Hamstrings.

Benefits: Increases core strength and balance, while lengthening the muscles in the hips and Hamstrings.

Steps: 1. Standing straight, raise your right foot to rest just above your left knee. **2.** Bend forward at the waist, dropping your forehead to your left shin. **3.** Reach both arms around to join together behind your left leg. **4.** Hold this position for as long as you can before releasing and repeating on the opposite leg.

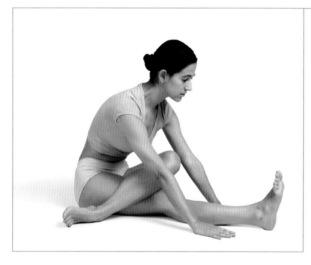

Forward Bend, One Leg Bent Over

Target: Hamstrings.

Benefits: Lengthens the hamstrings and the spine.

Steps: 1. Begin seated on the floor and cross your left leg over your right, so your foot is resting by your right hip. **2.** Place both palms flat on the floor on either side of your right calf and slowly pull your torso down toward the floor. **3.** Hold this position for twenty seconds before releasing and switching legs.

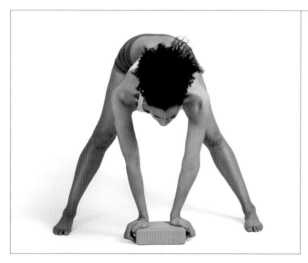

Forward Bend, Assisted

Target: Hamstrings.

Benefits: Extends the muscles in the calves and hamstrings, while lengthening the spinal cord.

Steps: 1. Stand straight with your legs wide apart. **2.** Drop your hands down to the floor, or onto a yoga block, between your legs. **3.** Hold this position for twenty seconds.

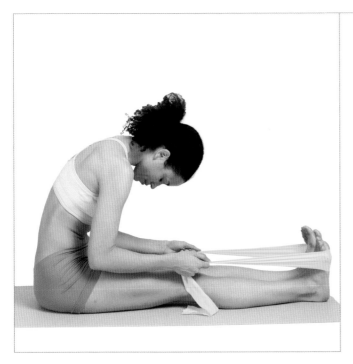

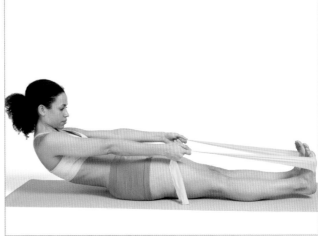

Both-Feet Hamstring Stretch, Leaning Back

Target: Hamstrings.

Benefits: Lengthens the muscles along the back of the legs, increasing flexibility and decreasing risk of injury.

Steps: 1. Begin seated on the floor. Attach a resistance band around the bottoms of both feet and straighten your legs in front of you. **2.** Pull back against the band, dropping your head and shoulders down toward the floor. **3.** Hold this position for thirty seconds before releasing and repeating on the opposite side.

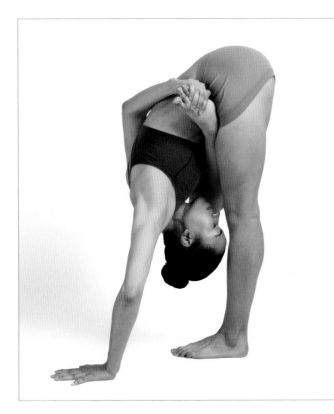

Forward Bend, Bound Hand to Foot

Target: Hamstrings.

Benefits: Increases core strength and balance while lengthening the muscles in the hips and hamstrings.

Steps: 1. Standing straight, raise your right foot up to your left hip. **2.** Reach your right arm behind your back to grab hold of your right foot. **3.** Bend forward at the waist, dropping your head to your left shin. **4.** Place your left hand flat on the floor for support. **5.** Hold this position for as long as you can before releasing and repeating on the opposite side.

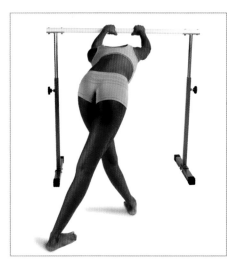

Forward Bend, Cross-Legged at Ballet Bar

Target: Hamstrings.

Benefits: Lengthens the hamstrings, spine, and upper back.

Steps: 1. Stand facing a ballet bar about two or three feet away. Step your right leg behind and across your left, keeping both feet pointed toward the bar. **2.** Bend your torso forward at the waist and reach to grab hold of the bar with both hands. **3.** Gently pull your head and shoulders down lower to the floor. Hold this position for thirty seconds and repeat on the opposite side.

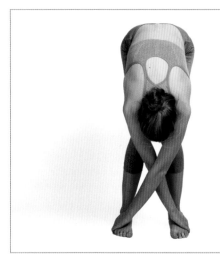

Forward Bend, Crossed Arms

Target: Hamstrings.

Benefits: Pulls along the length of the hamstrings while extending the spine.

Steps: 1. Stand straight with your feet shoulder-width apart. **2.** Bend forward at the waist, dropping the top of your head down toward the floor. **3.** Cross your arms at the elbows and extend them so you are able to tuck your fingers under the opposite foot. **4.** Hold this position for fifteen seconds for returning upright.

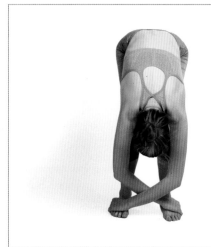

Forward Bend, Crossed Arms Advanced

Target: Hamstrings.

Benefits: Pulls along the length of the hamstrings while extending the spine.

Steps: 1. Stand straight with your feet shoulder-width apart. **2.** Bend forward at the waist, dropping the top of your head down toward the floor. **3.** Cross your arms at the elbows and extend them so you are able to tuck your fingers under the opposite feet. **4.** Deepen the forward bend by bending your elbows down toward the floor and hold for fifteen seconds.

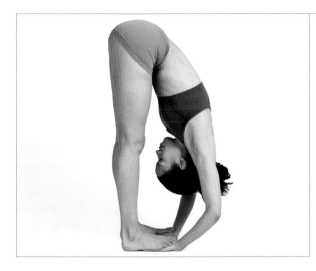

Forward Bend, Full

Target: Hamstrings.

Benefits: Deeply lengthens the spine and hamstrings, increasing flexibility and mobility.

Steps: 1. Stand straight with your feet shoulder-width apart. **2.** Bend forward at the waist, dropping the top of your head down toward the floor. Meanwhile, extend your arms down and tuck your fingers beneath your toes. **3.** Gently pull your torso further down toward the floor, bending your elbows as much as you are able. **4.** Hold this pose for twenty seconds before releasing.

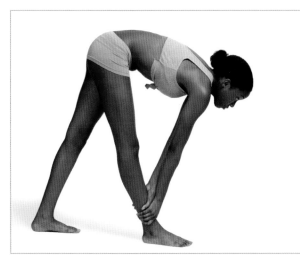

Forward Bend, Legs Apart 1

Target: Hamstrings.

Benefits: Lengthens the hamstrings and increases alignment in the hips and spine.

Steps: 1. Standing straight, step your right foot forward, keeping both feet pointed ahead. **2.** Bend forward at the waist, reaching your hands down to hold your right ankle. **3.** Gently pull your torso lower toward the floor. **4.** Hold this position for twenty seconds before releasing and switching legs.

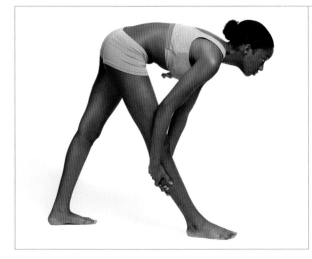

Forward Bend, Legs Apart 2

Target: Hamstrings.

Benefits: Lengthens the hamstrings and increases alignment in the hips and spine.

Steps: 1. Standing straight, step your right foot forward, keeping both feet pointed ahead. **2.** Bend forward at the waist, reaching your hands down to hold your right calf. **3.** Gently pull your torso lower toward the floor. **4.** Hold this position for twenty seconds before releasing and switching legs.

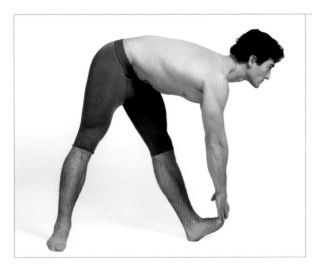

Forward Bend, Legs Apart, Hand to Toe

Target: Hamstrings.

Benefits: Lengthens the hamstrings and improves alignment in the hips and spine.

Steps: 1. Standing straight, step your left foot forward, keeping both feet pointed ahead. **2.** Bend forward at the waist, reaching your hands down to hold your left toes. **3.** Gently pull your torso lower toward the floor. **4.** Hold this position for twenty seconds before releasing and switching legs.

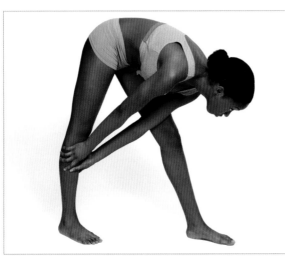

Forward Bend, Legs Apart, Hands to Knee

Target: Hamstrings.

Benefits: Lengthens the hamstrings and improves alignment in the hips and spine.

Steps: 1. Standing straight, step your left foot forward, keeping both feet pointed ahead. **2.** Bend forward at the waist, reaching your hands down to hold your right knee. **3.** Gently pull your torso lower toward the floor. **4.** Hold this position for twenty seconds before releasing and switching legs.

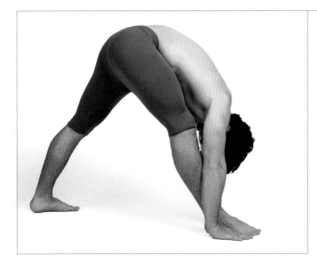

Forward Bend, Legs Apart, Head to Shin

Target: Hamstrings.

Benefits: Lengthens the hamstrings and improves alignment in the hips and spine.

Steps: 1. Standing straight, step your right foot forward, keeping both feet pointed ahead. **2.** Bend forward at the waist, reaching your hands down to the floor on either side of your right foot. **3.** Gently pull your torso lower toward the floor. **4.** Hold this position for twenty seconds before releasing and switching legs.

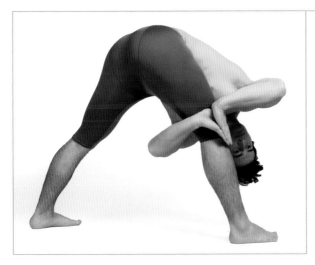

Forward Bend, Legs Apart, Revolved Prayer

Target: Hamstrings.

Benefits: Lengthens the hamstrings and improves alignment in the hips and spine.

Steps: 1. Standing straight, step your right foot forward, keeping both feet pointed ahead. **2.** Bend forward at the waist, reaching your hands around your right leg and joining your palms in prayer position behind your knee. **3.** Gently pull your torso lower along your right leg and twist your torso to the right. **4.** Hold this position for twenty seconds before releasing and switching legs.

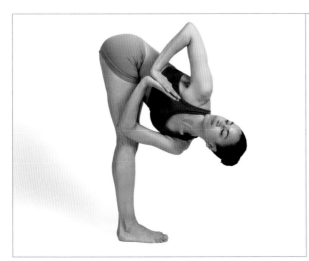

Forward Bend, Revolved Prayer

Target: Hamstrings.

Benefits: Twists the spine and extends the chest and shoulders, while lengthening the hamstrings.

Steps: 1. Stand straight with your feet together and join your palms in prayer position in front of your chest. **2.** Bend your torso at the waist, twisting deeply to the right, and attempt to hook your left forearm against your right thigh. **3.** Shift your gaze upward and hold this position for twenty seconds before releasing and repeating on the opposite side.

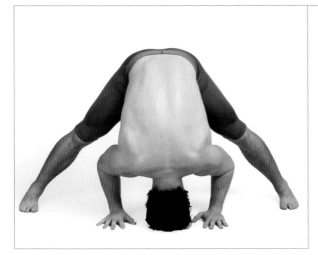

Half Intense Stretch, Feet Apart, Head to Floor

Target: Hamstrings.

Benefits: Reduces stress in the spine and hamstrings and helps find balance.

Steps: 1. Stand straight with your legs wide apart. **2.** Bend your torso forward at the waist, dropping the top of your head toward the floor. **3.** Place your hands on the floor on either side of your head for support and hold this position for twenty seconds.

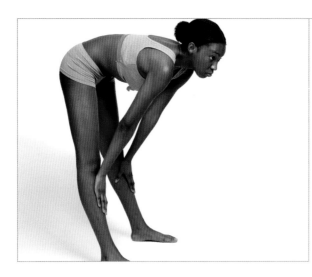

Half Intense-Stretch Pose, Feet Spread Out

Target: Hamstrings.

Benefits: Targets the calves and hamstrings and opens the pelvis.

Steps: 1. Stand straight with your legs apart. **2.** Bend forward at the waist, placing your hands just below your knees. **3.** Gently pull your torso down lower and hold this position for twenty seconds.

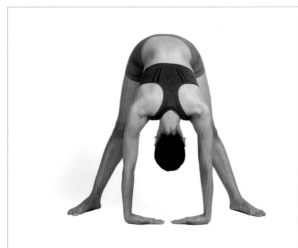

Half Intense-Stretch Pose, Feet Spread Out, Intense Wrist

Target: Hamstrings.

Benefits: Targets the hamstrings and extends the spine and wrists.

Steps: 1. Stand straight with your legs wide apart. **2.** Bend your torso forward at the waist, bringing the top of your head down toward the floor. **3.** Reach your hands down flat on the floor between your legs, with your fingers pointing toward each other. **4.** Hold this position for thirty seconds.

Half Intense-Stretch Pose, Feet Spread Out, Tiptoe

Target: Hamstrings.

Benefits: Targets the hamstrings and extends the spine and wrists.

Steps: 1. Stand straight with your legs wide apart. **2.** Bend your torso forward at the waist, bringing the top of your head down toward the floor. **3.** Reach your hands down flat on the floor between your legs, fingers apart. **4.** Raise both feet up onto your toes and hold for fifteen seconds.

Half Intense-Stretch Pose, Hand to Floor, Hand Extended

Target: Hamstrings.

Benefits: Targets the hamstrings while extending the spine and wrists.

Steps: 1. Stand straight with your legs wide apart and extend both arms straight out to your sides. **2.** Bend forward at the waist while twisting your torso to the left. **3.** Drop your right hand to the floor, with your fingers pointing to the right, and extend your left arm straight up toward the ceiling. **4.** Hold this pose for twenty seconds and repeat on the opposite side.

Half Intense-Stretch Pose, Reverse Prayer, Uneven Legs

Target: Hamstrings.

Benefits: Lengthens the hamstrings and shoulder muscles, increasing flexibility and improving posture.

Steps: 1. Stand straight and join your palms together behind your back, in reverse prayer position. **2.** Prop your right foot up onto your toes and bend forward at the waist. **3.** Hold this position for twenty seconds before repeating with opposite leg.

Half Intense-Stretch Pose, Revolved, Uneven Legs

Target: Hamstrings.

Benefits: Lengthens the hamstrings and shoulders, increasing flexibility and improving posture.

Steps: 1. Stand straight and extend your arms straight out to your sides. **2.** Prop your left foot up onto your toes and bend forward at the waist while twisting your torso to the right. **3.** Continue until your left hand is touching the floor and your right is extended straight up toward the ceiling. **4.** Hold this position for twenty seconds before repeating on the opposite side.

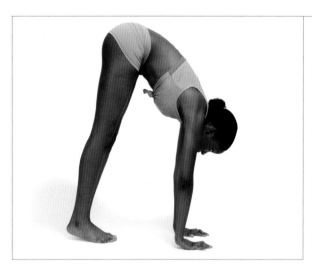

Half Intense-Stretch Pose, Heels Raised

Target: Hamstrings.

Benefits: Stretches and strengthens the hamstrings and upper arms, while engaging the core.

Steps: 1. Stand straight with your feet shoulder-width apart. **2.** Bend forward at the waist, and extend your hands down to the floor. **3.** Once your palms are flat on the floor, lift your feet up onto your toes. **4.** Hold this position for fifteen seconds.

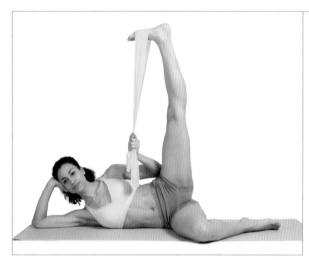

Hamstring Above, Side-Lying Stretch with Band

Target: Hamstrings.

Benefits: Pulls along the length of the calves and hamstrings, increasing flexibility and range of motion.

Steps: 1. Begin by lying on your right side, using your right hand to support your head. **2.** Attach a resistance band around your left foot and hold it with your left hand. **3.** Raise your left leg straight up above your hips and gently pull down on the band to increase pressure on the hamstrings. **4.** Continue this stretch for thirty seconds before releasing and switching sides.

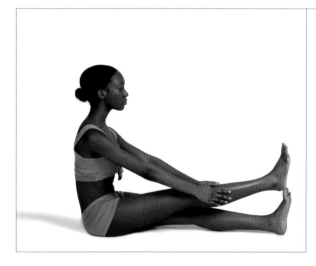

Hamstring and Calf-Stacked Stretch

Target: Hamstrings.

Benefits: Elongates the muscles in the calves and hamstrings, releasing tightness in the legs.

Steps: 1. Begin by sitting on the floor with your legs out straight ahead. **2.** Lift your right foot from the floor and rest the heel of your foot on top of your left toes. **3.** Slowly bend forward at the waist, reaching down to your right knee, making sure not to bend your knees. **4.** Hold this pose for twenty seconds before releasing and switching legs.

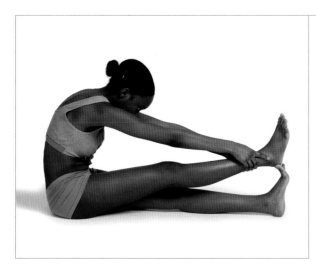

Hamstring and Calf-Stacked Stretch and Reach

Target: Hamstrings.

Benefits: Elongates the muscles in the calves and hamstrings, releasing tightness in the legs.

Steps: 1. Begin by sitting on the floor with your legs straight in front of you. **2.** Lift your right foot and rest the heel on your left toes. **3.** Slowly bend forward at the waist, reaching down to your right ankle, making sure not to bend your knees. **4.** Hold this pose for twenty seconds before releasing and switching legs.

Hamstring Inverted

Target: Hamstrings.

Benefits: Greatly increases flexibility and balance in the legs.

Steps: 1. Begin by standing straight with your arms at your sides and shift your weight onto your left foot. **2.** Bend forward at the waist while raising your right leg up and behind you until your right leg and torso create a straight line parallel to the floor. **3.** Hold this pose for ten seconds before releasing and repeating on the opposite side.

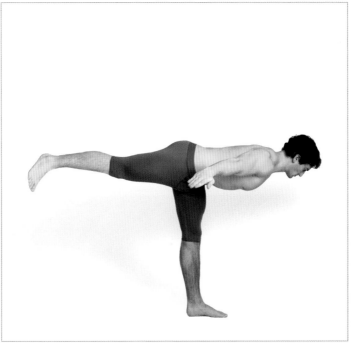

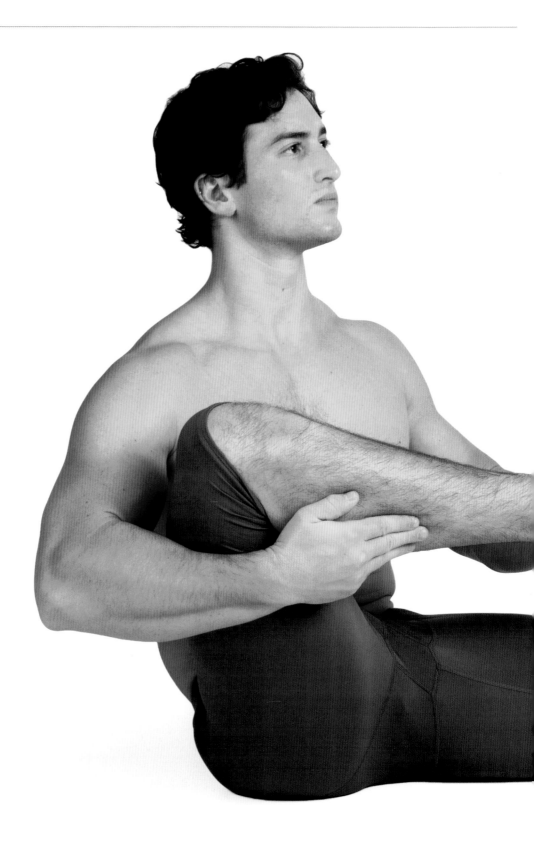

Hamstring Stretch, Knee to Chest

Target: Hamstrings.

Benefits: Lengthens the hip abductors and hamstrings while increasing alignment in the hips and spine.

Steps: 1. Begin seated on the floor with both legs extended. **2.** Bend your right knee and bring your foot to rest on top of your left thigh. **3.** Hook both hands under your right calf and pull your right leg in toward your chest. **4.** Hold this position for ten seconds before repeating on the opposite leg.

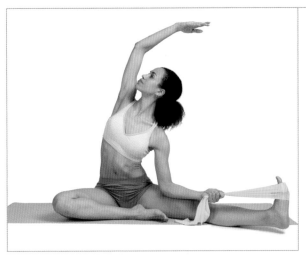

Hamstring Seated Side Bend with Band

Target: Hamstrings.

Benefits: Lengthens the abdominals while opening the hips and stretching the hamstrings.

Steps: 1. Begin seated and attach a resistance band around your left foot. **2.** Extend your left leg straight out to the side and tuck your right foot into your groin. **3.** Gently pull the band in toward your chest, increasing the stretch. **4.** Extend your right arm over your head to the left and slowly drop your shoulders to the left into a side bend. **5.** Hold for twenty seconds and repeat on the opposite side.

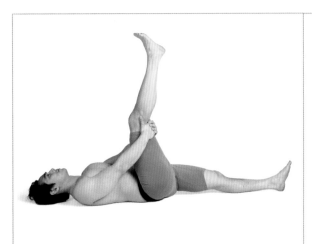

Hamstring Stretch 90/90

Target: Hamstrings.

Benefits: Provides mild relief from tight or strained hamstrings.

Steps: 1. Lie flat on your back with your legs straight. **2.** Bring your right knee into your chest and place both hands around your right thigh. **3.** Pull your right leg gently in toward your chest and hold for twenty seconds before repeating on the opposite leg.

Hamstring Stretch at Ballet Bar

Target: Hamstrings.

Benefits: Relieves tension and tightness in the hamstrings and calves.

Steps: 1. Stand facing a ballet bar. **2.** Raise your right leg and rest your ankle on the ballet bar. **3.** Hold your foot with both hands and lean toward the bar, pulling against your foot. **4.** Hold for twenty seconds.

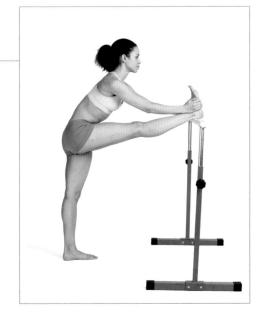

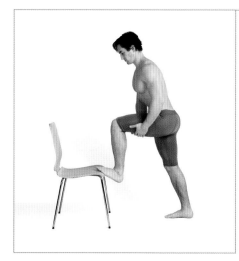

Hamstring Stretch, Bent Knee, Leg Up, Standing

Target: Hamstrings.

Benefits: Relieves tension and tightness in the hamstrings, calves, and Achilles tendons.

Steps: 1. Stand facing the chair. **2.** Raise your right foot from the floor and place your toes onto the seat of the chair. **3.** Gently press down against your raised toes. **4.** Maintain this stretch for twenty seconds before releasing and repeating to the left leg.

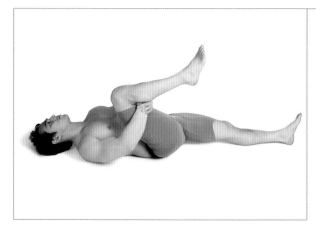

Prone Hamstring and Glute Pull

Target: Hamstrings.

Benefits: Lengthens the hip abductors and hamstrings while improving alignment in the hips and spine.

Steps: 1. Begin by lying flat on the floor with both legs extended. **2.** Bend your right knee and hook your hands under your right thigh. **3.** Pull your right knee in closer to your chest and hold for ten seconds before repeating on the opposite leg.

Hamstring Stretch, Lying Down with Band

Target: Hamstrings.

Benefits: Lengthens the hamstrings, increasing flexibility and decreasing risk of injury.

Steps: 1. Begin seated on the floor and attach a resistance band around both feet. **2.** Straighten your legs and pull back against the band, dropping your head and shoulders down to the floor. **3.** Hold this position for thirty seconds.

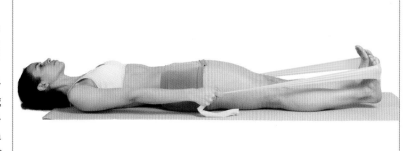

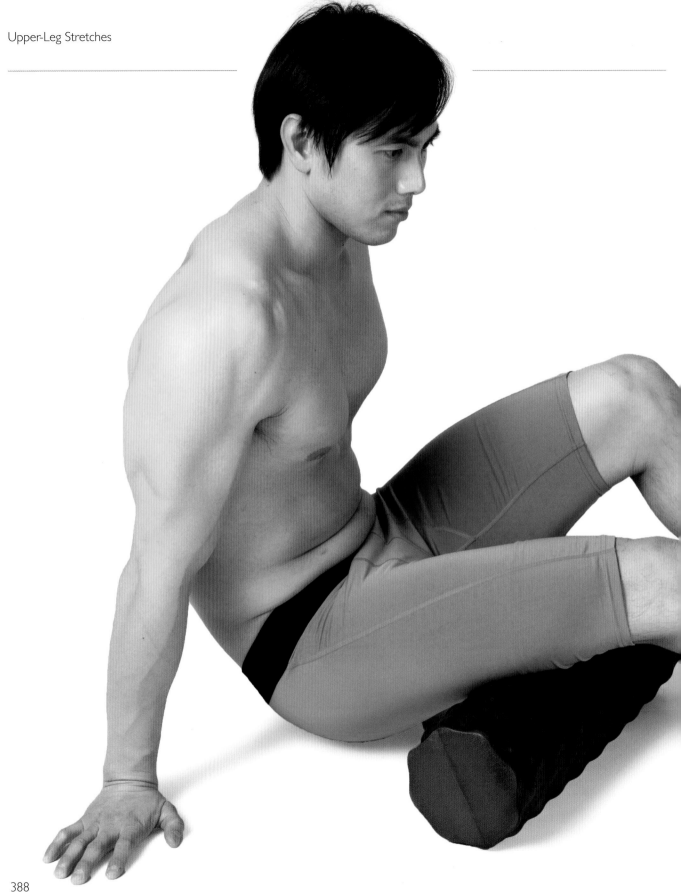

Hamstring Stretch on Roller

Target: Hamstrings.

Benefits: Relieves pain and tightness in the hamstrings.

Steps: 1. Lower yourself into a seated position with the foam roller beneath your right hamstrings. Place both hands flat on the floor behind you for support. **2.** Roll along the length of the hamstrings, targeting any troubled muscles. **3.** Release and repeat on the opposite leg.

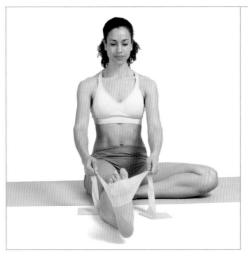

Hamstring Stretch, Seated with Band 1

Target: Hamstrings.

Benefits: Opens the hips and lengthens the hamstrings.

Steps: 1. Begin seated and attach a resistance band around your right foot. **2.** Extend your right leg straight out in front of you and tuck your left foot into your groin. **3.** Gently pull the band in toward your chest with both hands, increasing the stretch on the calf and hamstrings. **4.** Hold this pose for twenty seconds before repeating on the opposite leg.

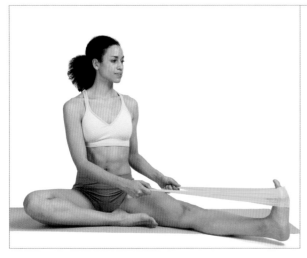

Hamstring Stretch, Seated with Band 2

Target: Hamstrings.

Benefits: Opens the hips and lengthens the hamstrings.

Steps: 1. Begin seated and attach a resistance band around your left foot. **2.** Extend your left leg out to your left and tuck your right foot against your left knee. **3.** Gently pull the band in toward your chest with both hands, increasing the stretch on the calf and hamstrings. **4.** Hold for twenty seconds before repeating on the opposite leg.

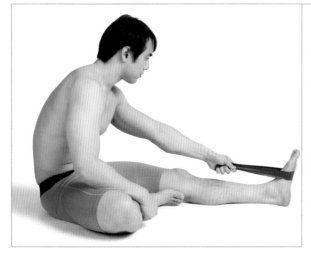

Hamstring Stretch, Seated with Band 3

Target: Hamstrings.

Benefits: Opens the hips and lengthens the hamstrings.

Steps: 1. Begin seated and attach a resistance band around your left foot. **2.** Extend your left leg straight out in front of you and tuck your right foot against your right knee. **3.** Gently pull the band in toward your chest with your left hand, increasing the stretch on the calf and hamstrings. Keep your heel on the floor. **4.** Hold for twenty seconds before repeating on the opposite leg.

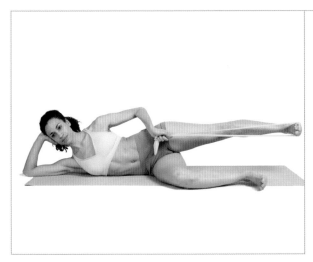

Hamstring Stretch, Side-Lying with Band

Target: Hamstrings.

Benefits: Pulls along the length of the calves and hamstrings, increasing flexibility and range of motion.

Steps: 1. Begin by lying on your right side, using your right hand to support your head. **2.** Attach a resistance band around your left foot and hold it with your left hand. **3.** Raise your left leg and straighten it so it is parallel to the floor. **4.** Gently pull on the band to increase the pressure on the hamstrings. **5.** Continue this stretch for thirty seconds before switching sides.

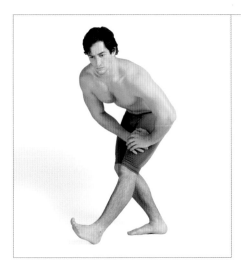

Hamstring Stretch, Toe Pointed

Target: Hamstrings.

Benefits: Provides mild relief from tight or strained hamstring muscles.

Steps: 1. Begin by standing straight. **2.** Step your left foot slightly forward and onto its heel, flexing your toes upward. **3.** Place both hands on your left thigh and begin to bend your right knee, keeping your left leg straight. **4.** Gently press down on your thigh as you lower into a crouching position. **5.** Maintain this position for twenty seconds before alternating sides.

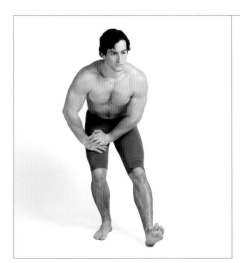

Hamstring, Alternate Foot Raised

Target: Hamstrings.

Benefits: Provides mild relief from tight or strained hamstring muscles.

Steps: 1. Begin by standing straight. **2.** Step your left foot slightly forward and onto its heel, flexing your toes upward. **3.** Place both hands on your right thigh and begin to bend your right knee, keeping your left leg straight. **4.** Gently press down on your thigh as you lower into a crouching position. **5.** Maintain this position for twenty seconds before alternating sides.

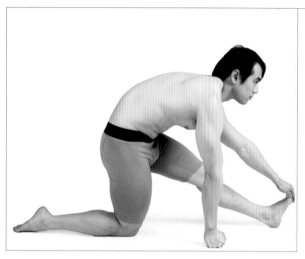

Hamstring Stretch, Toe-Raised, Kneeling

Target: Hamstrings.

Benefits: Opens the hips and groin while lengthening the hamstrings and improving balance.

Steps: 1. Begin by kneeling upright on the floor. **2.** Raise your left knee and extend your leg straight ahead so it is resting on its heel and your foot is flexed. **3.** Reach forward with your left hand to grab hold of your toes and place your right hand on the floor for support. **4.** Gently pull your left foot back, deepening the stretch on the hamstrings. **5.** Hold for twenty seconds before repeating on the opposite leg.

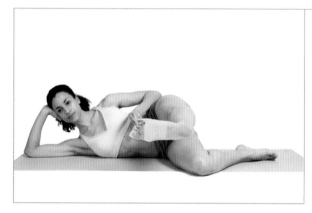

Hamstring to Front, Side-Lying with Band

Target: Hamstrings.

Benefits: Pulls along the length of the calves and hamstrings, increasing flexibility and range of motion.

Steps: 1. Begin by lying on your right side, using your right hand to support your head. **2.** Attach a resistance band around your left foot and hold it with your left hand. **3.** Raise your left leg straight out in front of you, parallel to the floor, and gently pull in on the band to increase pressure on the hamstrings. **4.** Continue this stretch for thirty seconds before switching sides.

Hamstring to Chest with Body Bar

Target: Hamstrings.

Benefits: Opens the hips and lengthens the hamstrings while increasing strength and balance in the core.

Steps: 1. Stand straight, holding a body bar upright with your left hand. **2.** Shift your weight onto your left foot and bend your right knee up toward your chest. **3.** Reach for your right heel with your right hand and gently pull your foot further up to increase the stretch on the hip and hamstrings. **4.** Hold for twenty seconds before alternating sides.

Hand Position of the Pose Dedicated to Garuda in Half-Intense Stretch

Target: Hamstrings.

Benefits: Lengthens the calves and hamstrings while extending the spinal cord and improving posture.

Steps: 1. Stand with your feet crossed at the ankles and your arms crossed at the wrists. **2.** Join your palms in a twisted prayer position and bend forward at the waist. **3.** Twist your torso to the right and touch your fingertips to the floor. **4.** Hold for ten seconds before repeating on the opposite side.

Hand to Foot, One-Legged, Half Intense-Stretch Pose

Target: Hamstrings.

Benefits: Lengthens the hamstrings while extending the spinal cord and improving balance.

Steps: 1. Stand straight and raise your left foot up behind you. **2.** Reach around with your left hand and press your foot into your hips. **3.** Bend forward at the waist and place your right hand flat on the floor. **4.** Hold for fifteen seconds and alternate sides.

Hands-Bound Forward Stretch, Modification

Target: Hamstrings.

Benefits: Lengthens the hamstrings while extending the spinal cord and improving balance.

Steps: 1. Stand straight with your feet together and clasp your hands behind your back. **2.** Bend your knees and begin to fold forward at the waist. **3.** As you bend forward, extend your arms out straight and away from your torso. **4.** Rest your torso against your thighs and hold for twenty seconds.

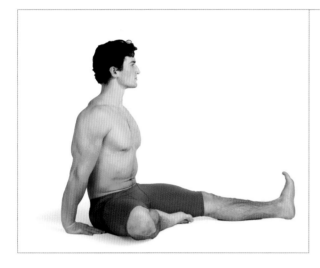

Head-to-Knee Pose Prep

Target: Hamstrings.

Benefits: Opens the hips and lengthens the hamstrings.

Steps: 1. Begin seated. **2.** Extend your left leg out to your side, flexing your foot, and tuck your right foot against your left thigh. **3.** Place your hands behind you, with your palms flat and fingers pointing forward. **4.** Hold for twenty second.

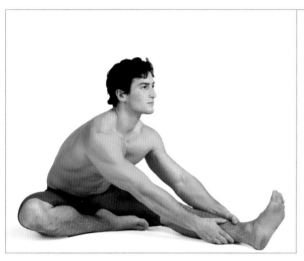

Head-to-Knee Pose, Both Hands to Ankle

Target: Hamstrings.

Benefits: Opens the hips and lengthens the hamstrings.

Steps: 1. Begin seated. Extend your left leg straight out in front of you and tuck your right foot against your left thigh. **2.** Bend forward at the waist, reaching your hands forward to your outstretched calf. **3.** Gently pull your torso farther down toward your left leg. **4.** Hold for twenty seconds before alternating legs.

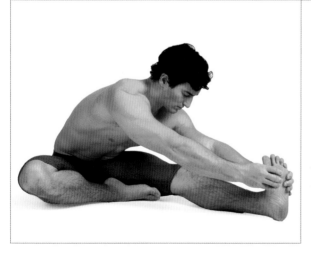

Head-to-Knee Pose, Both Hands to Foot

Target: Hamstring.

Benefits: Opens the hips and lengthens the hamstrings.

Steps: 1. Begin seated. Extend your left leg straight out in front of you and tuck your right foot against your left thigh. **2.** Bend forward at the waist, reaching your hands forward to your outstretched toes. **3.** Gently pull your torso farther down toward your left leg. **4.** Hold this pose for twenty seconds before alternating legs.

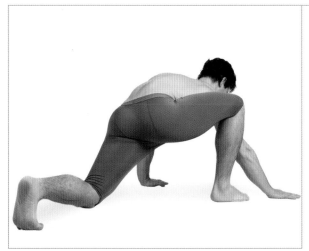

Forward Lunge, Arms Spread Out

Target: Hamstrings.

Benefits: Opens the hips and lengthens the hamstrings.

Steps: 1. Begin in a low squat with your hands flat on the floor in front of you. **2.** Extend your left leg behind you, with your foot propped up on your toes. **3.** Lean your torso forward and push your left thigh toward the ground. **4.** Hold for twenty seconds before repeating on the opposite side.

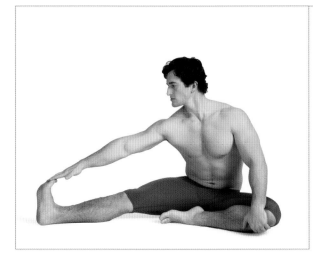

Head-to-Knee Pose Revolved

Target: Hamstrings.

Benefits: Opens the hips and lengthens the hamstrings.

Steps: 1. Begin seated. Extend your right leg out to the side and tuck your left foot into your groin. **2.** Bend forward at the waist, reaching your right hand to your toes. **3.** Gently pull your torso farther down toward your right leg and hold for twenty seconds before alternating legs.

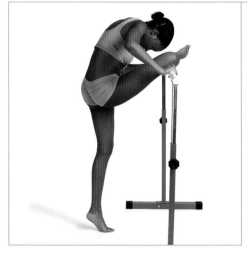

Hip External Rotator with Bar

Target: Hamstrings.

Benefits: Lengthens the hamstrings while opening the hips and spine.

Steps: 1. Stand facing a ballet bar, holding it with both hands. **2.** Lift your right leg and rest your calf along the bar. **3.** Raise your left foot onto tiptoes, if necessary. **4.** Gently press down against your right knee to increase the stretch on your hips and hold for twenty seconds before alternating legs.

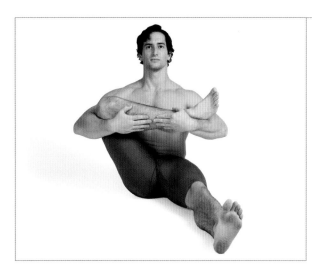

Hip Flexor and Internal Rotator

Target: Hamstrings.

Benefits: Lengthens the hip abductors and hamstrings while increasing alignment in the hips and spine.

Steps: 1. Begin seated on the floor with both legs extended. **2.** Bend your right knee in and bring your foot to rest on your left thigh. **3.** Hook both hands under your right calf and pull your leg up toward your chest. **4.** Hold this position for ten seconds and repeat on the opposite leg.

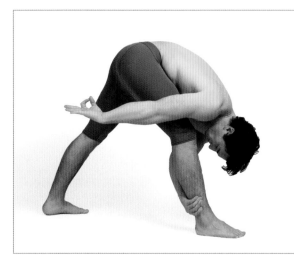

Intense Side-Stretch Pose Prep

Target: Hamstrings.

Benefits: Lengthens the calves, hamstrings, spine, and upper back.

Steps: 1. Stand straight and step your right foot forward, making sure to keep both legs straight throughout. **2.** Bend your torso forward, folding at the waist, and slide your hands down your right leg for support. **3.** Reach your left hand behind your right ankle and extend your right arm straight behind you, making the wisdom gesture with your fingers. **4.** Bring your torso to rest along your right leg and hold for fifteen seconds before alternating sides.

Intense-Stretch Pose 1

Target: Hamstrings.

Benefits: Deeply extends the spine and hamstrings, increasing flexibility and posture.

Steps: 1. Stand straight with your feet together. **2.** Bend forward at the waist, dropping the top of your head down toward the floor. **3.** Reach your hands to the floor behind your feet and straighten your arms. **4.** Bring your forehead to your shins and hold this pose for fifteen seconds.

Intense-Stretch Pose 2

Target: Hamstrings.

Benefits: Deeply extends the spine and hamstrings, increasing flexibility and posture.

Steps: 1. Stand straight with your feet apart. **2.** Bend forward at the waist, dropping the top of your head down toward the floor. **3.** Reach your hands to your ankles and bring your head down between your knees. **4.** Hold this pose for fifteen seconds.

Intense-Stretch Pose 3

Target: Hamstrings.

Benefits: Deeply extends the spine and hamstrings, increasing flexibility and posture.

Steps: 1. Stand straight with your feet together. **2.** Bend forward at the waist, dropping the top of your head down toward the floor. **3.** Reach your arms behind your legs, hugging them around your calves. **4.** Bring your forehead to your shins and hold for fifteen seconds.

Intense-Stretch Pose, Baby Cradle

Target: Hamstrings.

Benefits: Increases core strength and balance while lengthening the muscles in the hips and hamstrings.

Steps: 1. Standing straight, raise your left foot to your right knee. **2.** Cradle your left foot in your left hand and begin to bend your torso forward. **3.** Wrap your right hand behind your right ankle as you lower your head down toward your right shin. **4.** Hold this position for as long as you can before returning upright. **5.** Repeat on the opposite side.

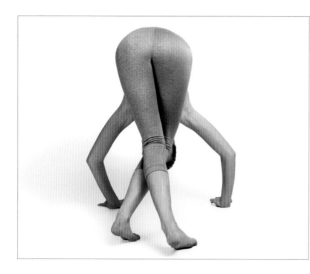

Intense-Stretch Pose, Cross-Legged

Target: Hamstrings.

Benefits: Lengthens the hamstrings, spine, and upper back.

Steps: 1. Stand straight. Cross your left foot behind your right, keeping both feet pointed forward. **2.** Bend your torso forward at the waist and reach down to the floor with both hands. **3.** Gently pull your head and shoulders down lower. **4.** Hold this position for thirty seconds before alternating sides.

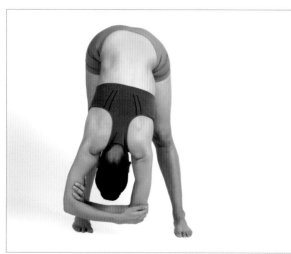

Intense-Stretch Pose, Overhead to One Side

Target: Hamstrings.

Benefits: Lengthens the hamstrings, spine, and shoulders, reducing tightness and increasing range of motion.

Steps: 1. Stand straight with your legs apart and bend both arms above your head, holding the opposite elbow. **2.** Bend forward at the waist, leaning your torso to your right side. **3.** Hold this position for fifteen seconds before alternating sides.

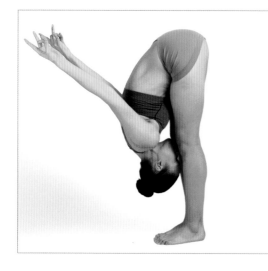

Intense-Stretch Pose with Shoulder Stretch

Target: Hamstrings.

Benefits: Deeply lengthens the hamstrings and spine, while opening the shoulders.

Steps: 1. Stand straight with your feet together. **2.** Bend forward at the waist so your forehead touches your shins. **3.** Straighten your arms up toward the ceiling and gently extend them farther away from your torso. **4.** Hold this position for twenty seconds.

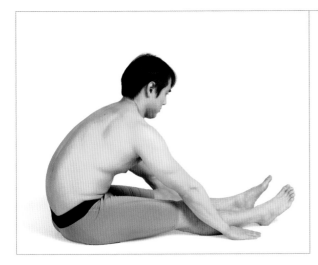

Knee Flexor, Seated Advanced

Target: Hamstrings.

Benefits: Provides mild relief from tight hamstrings.

Steps: 1. Begin seated with your legs outstretched. **2.** Bend forward at the waist, reaching your palms down to the floor beside either calf. **3.** Gently pull your torso further down toward your legs. **4.** Maintain this stretch for twenty seconds.

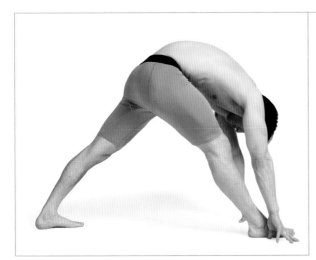

Knee Flexor, Standing

Target: Hamstrings.

Benefits: Opens the groin while deeply extending the spine and hamstrings.

Steps: 1. Begin by standing and step your right foot far forward. **2.** Bend forward at the waist, bringing your torso to rest down along your right leg. **3.** Reach both hands down to the floor for support. **4.** Hold this pose for fifteen seconds before repeating with your left foot forward.

Knee to Chest, Standing

Target: Hamstrings.

Benefits: Helps relax and relieve pain in your lower back, hamstrings, and glutes.

Steps: 1. Begin by standing straight. **2.** Raise your right foot and bend your knee up toward your waist. **3.** Reach both hands around your right knee and gently pull your knee into your chest. **4.** Hold for twenty seconds before switching legs.

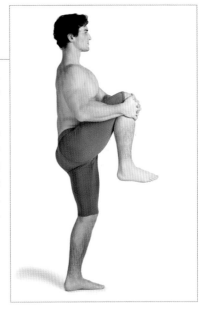

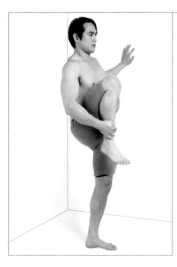

Knee to Chest, Supported Stretch

Target: Hamstrings.

Benefits: Helps relax and relieve pain in your lower back, hamstrings, and glutes.

Steps: 1. Begin by standing straight, resting your left hand against a wall for support. **2.** Raise your right foot and bend your knee up toward your waist. **3.** Reach your right hand to your right ankle and gently pull your leg into your chest. **4.** Hold this position for twenty seconds before switching legs.

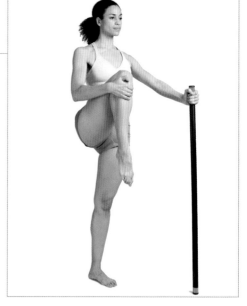

Knee to Chest with Body Bar

Target: Hamstrings.

Benefits: Helps relax and relieve pain in your lower back, hamstrings, and glutes.

Steps: 1. Stand straight, holding a body bar upright on the floor with your left hand. **2.** Shift your weight to your left foot and raise your right foot from the floor, bending your knee up toward your waist. **3.** Reach your right hand to your right knee and gently pull your leg into your chest. **4.** Hold this position for twenty seconds before switching legs.

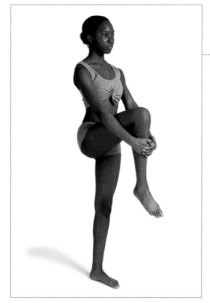

Knee to Chest, Simplified

Target: Hamstrings.

Benefits: Helps relax and relieve pain in your lower back, hamstrings, and glutes.

Steps: 1. Begin by standing straight. **2.** Shift your weight to your left foot and raise your right knee up toward your waist. **3.** Reach both hands around your right shin and gently pull your knee into your chest. **4.** Hold this position for twenty seconds before switching legs.

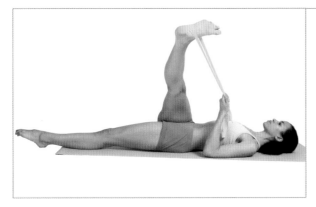

Leg Across Body with Band

Target: Hamstrings.

Benefits: Pulls along the length of the calves and hamstrings, increasing flexibility and range of motion.

Steps: 1. Begin by lying on your back with your legs out straight. **2.** Wrap a resistance band behind your right foot and hold the band with both hands. **3.** Swing your right leg straight above and across your body. Gently pull on the band to increase the pressure on the hamstrings. **4.** Continue this stretch for thirty seconds before switching legs.

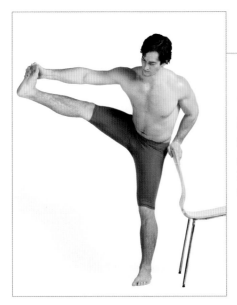

Leg Extension, Standing

Target: Hamstrings.

Benefits: Opens the hips and extends the glutes and hamstrings.

Steps: 1. Begin by standing straight, resting your left hand on the back of a sturdy chair. **2.** Raise your right foot and bend your knee up toward your waist. **3.** Reach your right hand to hold your toes and extend your right leg straight out to your side. **4.** Hold for twenty seconds before switching sides.

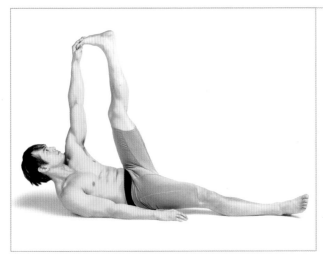

Leg Extensions

Target: Hamstrings.

Benefits: Opens the hips and extends the glutes and hamstrings.

Steps: 1. Begin by lying on your back with your legs straight. **2.** Raise your left foot from the floor and bend your knee up toward your waist. **3.** Reach your left hand to hold your toes and extend your left leg straight up above you. **4.** Hold this position for twenty seconds before switching legs.

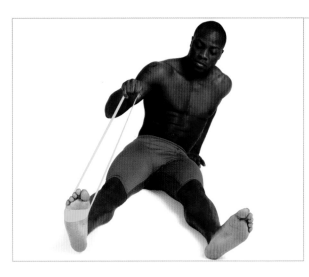

Leg-Raise Extension with Band

Target: Hamstrings.

Benefits: Opens the hips and lengthens the hamstrings.

Steps: 1. Begin seated and wrap a resistance band under your right foot. **2.** Extend both legs straight out in front of you. **3.** Gently pull the band in toward your chest, increasing the stretch on the calf and hamstrings. **4.** Hold for twenty seconds before releasing and repeating on the opposite leg.

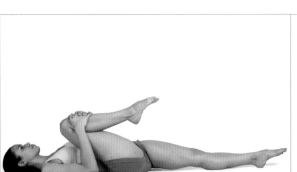

Knee Tuck, Lying I

Target: Hamstrings.

Benefits: Extends hard-to-target muscles in the glutes and upper legs.

Steps: 1. Lying flat on your back, bring your right knee in toward your chest. **2.** Reach both hands around your knee to pull your leg farther into your chest. **3.** Maintain for twenty seconds before alternating legs.

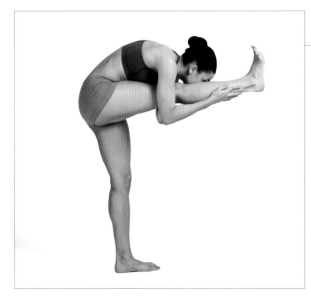

Leg Raise, Hand to Foot, Head to Knee, Head Tucked

Target: Hamstrings.

Benefits: Opens the hips and extends the calves and hamstrings while improving balance.

Steps: 1. Begin by standing straight. **2.** Shift your weight onto your left foot and raise your right knee up toward your chest. **3.** Reach both hands under your right calf and slowly extend your right leg straight out and parallel to the floor. **4.** Bend your torso at the waist, bringing your forehead down to your shin. **5.** Hold this position for ten seconds before releasing and switching legs.

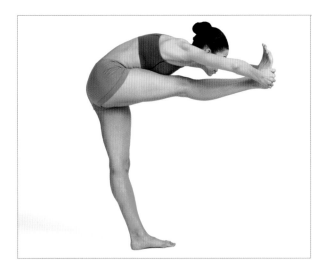

Leg Raise, Hand to Foot, Head to Knee

Target: Hamstrings.

Benefits: Opens the hips and extends the calves and hamstrings while improving balance.

Steps: 1. Begin by standing straight. **2.** Shift your weight onto your left foot and raise your right knee up toward your chest. **3.** Reach both hands under your right foot and slowly extend your right leg straight out and parallel to the floor. **4.** Bend your torso at the waist, bringing your chin down to your shin. **5.** Hold this position for ten seconds before releasing and switching legs.

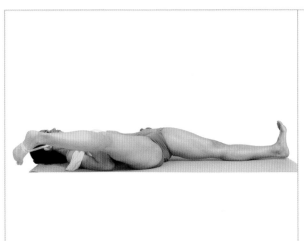

Leg Raise, Lying with Band

Target: Hamstrings.

Benefits: Deeply opens the hips and lengthens the hamstrings, increasing muscle alignment and flexibility in the legs and hips.

Steps: 1. Start by lying flat on your back with your legs outstretched and a resistance band attached to your right foot. **2.** Keeping your right leg straight, raise it slightly from the floor and swing it out to the side. **3.** Pull gently against the band, bringing your foot as far up toward your head as you are able. **4.** Hold this position for fifteen seconds before attempting on the opposite leg.

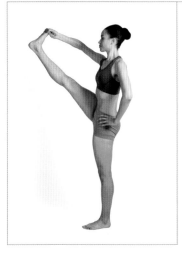

Leg-Raise Stretch

Target: Hamstrings.

Benefits: Opens the hips and extends the calves and hamstrings while improving balance.

Steps: 1. Begin by standing straight. **2.** Shift your weight onto your left foot and raise your right knee up toward your chest. **3.** Reach your right hand to hold your toes and extend your right leg straight out ahead of you. **4.** Gently pull your leg as far up toward your head as you are able. **5.** Hold this position for twenty seconds before switching legs.

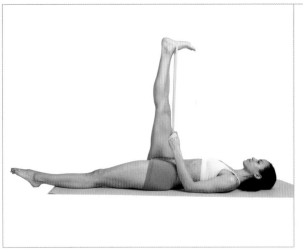

Leg-Straight Stretch with Band 1

Target: Hamstrings.

Benefits: Pulls along the length of the calves and hamstrings, increasing flexibility and range of motion.

Steps: 1. Begin by lying on your back with your legs out straight. **2.** Attach a resistance band around your right foot and hold it with both hands. **3.** Swing your right leg straight up above your hips and gently pull on the band, bringing your elbows down to the floor to increase pressure on the hamstrings. **4.** Continue this stretch for thirty seconds before releasing and switching legs.

Leg-Raise Stretch, Extended

Target: Hamstrings.

Benefits: Deeply extends the hips and groin while lengthening the hamstrings and increasing balance.

Steps: 1. Begin by standing straight. **2.** Shift your weight onto your left foot and raise your right knee up toward your chest. **3.** Reach both hands around your right heel and slowly extend your right leg straight up. **4.** Pull your leg as far up toward your head as you are able, attempting to touch your shin to your forehead. **5.** Hold this position for ten seconds before switching legs.

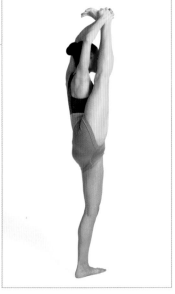

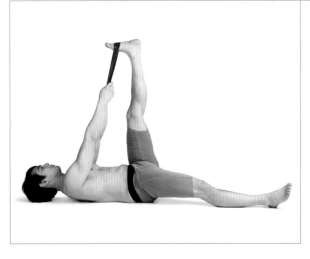

Leg-Straight Stretch with Band 2

Target: Hamstrings.

Benefits: Pulls along the length of the calves and hamstrings, increasing flexibility and range of motion.

Steps: 1. Begin by lying on your back with your legs out straight. **2.** Attach a resistance band around your right foot and hold it with both hands. **3.** Swing your right leg straight up above your hips. **4.** Continue this stretch for thirty seconds before releasing and switching legs.

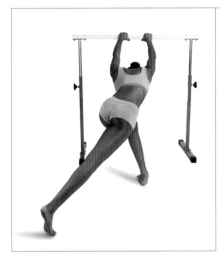

Leg Stretch, Cross-Legged at the Ballet Bar

Target: Hamstrings.

Benefits: Lengthens the spine and upper back while stretching the hamstrings.

Steps: 1. Stand facing a ballet bar, several paces away from it. **2.** Cross your right leg far behind the left, resting your right foot on tiptoes. **3.** Bend your left knee and lean forward, bending at the waist, until you are able to hold the bar with both hands. **4.** Let your head and shoulders drop toward the floor to amplify the stretch.

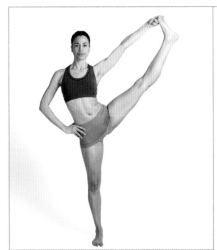

Leg Stretch, Hand to Big Toe 1

Target: Hamstrings.

Benefits: Deeply extends the hips and groin while lengthening the hamstrings and increasing balance.

Steps: 1. Begin by standing straight, hands on your hips. **2.** Shift your weight onto your right foot and raise your left knee up toward your chest. **3.** Reach your left hand to hold your left big toe and slowly extend your leg straight out to the side. **4.** Gently pull your leg as far up as you are able and hold for ten seconds before switching sides.

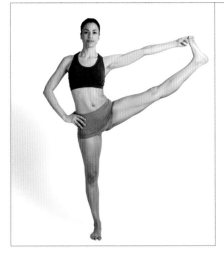

Leg Stretch, Hand to Big Toe 2

Target: Hamstrings.

Benefits: Deeply extends the hips and groin, while lengthening the hamstrings and increasing balance.

Steps: 1. Begin by standing straight, hands on your hips. **2.** Shift your weight onto your right foot and raise your left knee up toward your chest. **3.** Reach your left hand to hold your left big toe and slowly extend your leg straight out to the side. **4.** Hold for ten seconds before switching sides.

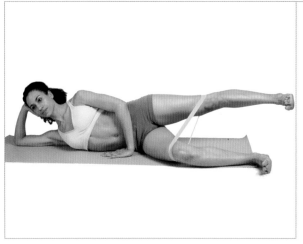

Leg Stretch, Outer, Side-Lying with Band

Target: Hamstrings.

Benefits: Extends the muscles in the hips and hamstrings, increasing mobility and muscle alignment.

Steps: 1. Begin by lying on your right side, using your right hand to support your head, and attach a resistance band around both legs just above the knee. **2.** Bend your right knee slightly, keeping your leg on the floor. **3.** Raise your left leg up from the floor and extend it straight out from your hips. **4.** Hold for twenty seconds and alternate sides.

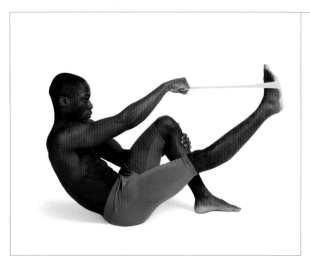

Lifted Leg with Band

Target: Hamstrings.

Benefits: Lengthens the hamstrings, while increasing stretch and balance in the core.

Steps: 1. Begin by sitting on the ground with both legs bent and attach a resistance band under your right foot. **2.** Place your left hand on your left shin and lift your right leg straight up from the floor. **3.** Gently pull against the band to increase pressure on the hamstrings. **4.** Lean your body back, so you are balancing on your hip bones and hold for fifteen seconds before alternating sides.

One-Legged Forward Bend, Hands Bound Behind

Target: Hamstrings.

Benefits: Lengthens the hamstrings and increases balance in the legs and core.

Steps: 1. From a standing position, lean over at the waist and place both hands flat on the floor in front of you. **2.** Bend your right leg up to your hips and extend your leg straight up toward the ceiling. **3.** Find your balance and slowly lift your right hand from the floor and reach it across your back into a half-bound position. **4.** Next, carefully lift your left hand from the floor and reach around your left leg. **5.** Clasp your hands together behind your lower back in a bound position and hold this position for ten seconds before switching sides.

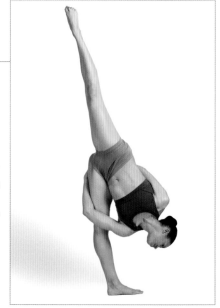

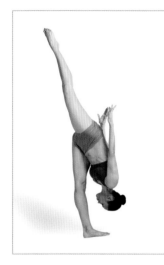

One-Legged Forward Bend, Hands-Free

Target: Hamstrings.

Benefits: Lengthens the hamstrings and increases balance in the legs and core.

Steps: 1. From a standing position, lean over at the waist and place both hands flat on the floor in front of you. **2.** Bend your right leg up to your hips and extend your leg straight up toward the ceiling. **3.** Find your balance and slowly lift both hands from the floor and extend your arms straight to your sides. **4.** Hold this position for ten seconds before switching sides.

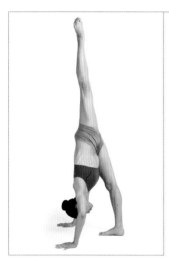

One-Legged Stretch, Upward 1

Target: Hamstrings.

Benefits: Lengthens the hamstrings and increases balance in the legs and core.

Steps: 1. From a standing position, lean over at the waist and place both hands flat on the floor in front of you. **2.** Bend your left leg up to your hips and extend your leg straight up toward the ceiling. **3.** Find your balance and hold this position for ten seconds before switching sides.

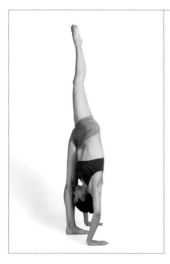

One-Legged Stretch, Upward 2

Target: Hamstrings.

Benefits: Lengthens the hamstrings and increases balance in the legs and core.

Steps: 1. From a standing position, lean over at the waist and place both hands flat on the floor in front of you. **2.** Bend your right leg up to your hips and extend your leg straight up toward the ceiling. **3.** One at a time, step your hands in toward your left leg and bring your forehead to your left shin. **4.** Find your balance and hold this position for ten seconds before switching sides.

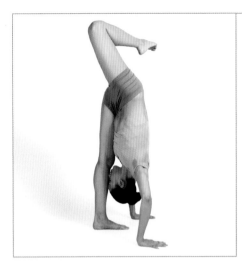

One-Legged Stretch, Upward Pose Prep

Target: Hamstrings.

Benefits: Lengthens the hamstrings and increases balance in the legs and core.

Steps: 1. From a standing position, lean over at the waist and place both hands flat on the floor in front of you. **2.** Bend your right leg and bring your foot up so your shin is parallel to the floor. **3.** One at a time, step your hands in toward your left leg and bring your forehead to your shin. **4.** Find your balance and hold for ten seconds before switching sides.

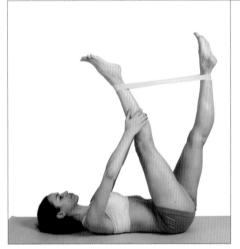
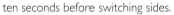

Scissor Legs, Lying with Band

Target: Hamstrings.

Benefits: Strengthens the glutes and abdominals while engaging the hamstrings.

Steps: 1. Attach a resistance band around both ankles and lie on your back with your legs straight up above you. **2.** Hold your right calf with both hands and swing your left leg away from your body and back next to your right leg. **3.** Continue this exercise for thirty seconds, moving quickly, and repeat on the opposite side.

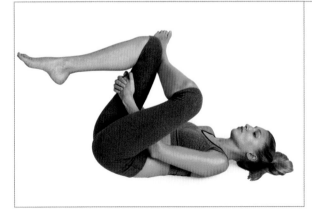

Self Knee Stretch

Target: Hamstrings.

Benefits: Increases flexibility and range of motion in the hamstrings and iliopsoas.

Steps: 1. Lie flat on your back with both legs bent and your feet flat on the floor. **2.** Lift your left leg up and rest your ankle on top of your right knee. **3.** Reach both hands behind your right thigh and gently pull your legs into your chest. **4.** Continue this stretch for fifteen seconds before alternating sides.

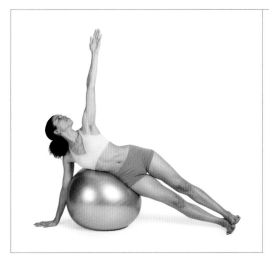

Side Plank on Ball

Target: Hamstrings.

Benefits: Strengthens your legs, obliques, and abdominals while engaging the core.

Steps: 1. Kneel on the floor with the exercise ball at your right side. **2.** Lean your upper body to the right so you are draped over the top of the ball, and are supported on your right knee. **3.** Step both feet away and lift your hips from the floor, so you body forms a straight line from your feet to your shoulders. **4.** Extend your right arm to the floor and reach your left arm straight above you. **5.** Hold this position for ten seconds before switching sides.

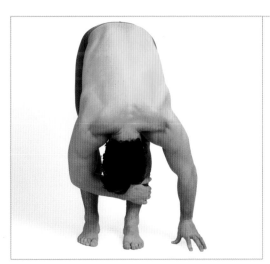

Sideways Intense-Stretch Pose

Target: Hamstrings.

Benefits: Extends the hamstrings and spinal cord, increasing mobility and improving posture.

Steps: 1. Stand straight with your feet shoulder-width apart. **2.** Bend forward at the waist, bringing the top of your head toward the floor, and extend both hands down to the floor for support. **3.** Lift your right hand and grab hold of your left shin. **4.** Maintain this position for fifteen seconds before repeating on the opposite side.

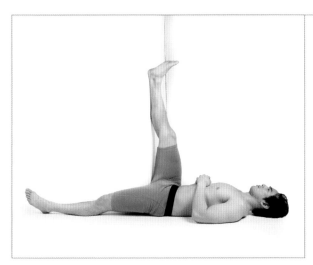

Split Prone, Supported

Target: Hamstrings.

Benefits: Extends the hamstrings and opens the hips.

Steps: 1. Lie flat on your back in a doorway. **2.** Bend your right knee into your chest and extend your right leg straight up against the door frame, leaving your left leg straight on the floor. **3.** Hold this pose for thirty seconds and repeat with the opposite leg.

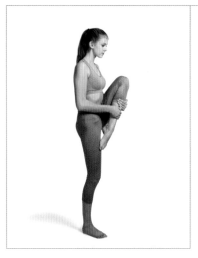

Standing, Riding One-Legged Chin-to-Knee Pose Prep

Target: Hamstrings.

Benefits: Opens the hips and extends the calves and hamstrings while improving balance.

Steps: 1. Stand straight and shift your weight onto your right foot. **2.** Raise your left knee up toward your chest and reach both hands around your left shin. **3.** Gently pull your left leg into your chest. **4.** Hold this position for twenty seconds before switching legs.

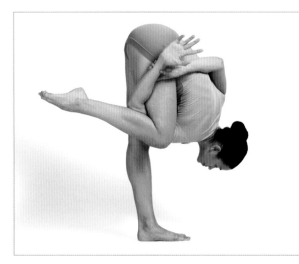

Standing Wind-Relieving, Intense-Stretch Pose 1

Target: Hamstrings.

Benefits: Opens the hips and extends the calves and hamstrings while improving balance.

Steps: 1. Stand straight and shift your weight onto your left foot. **2.** Raise your right knee into your chest. **3.** Reach your left hand behind your back and reach your right hand under your right knee to join your hands together behind your back, so your knee is bound to your side. **4.** Slowly bend forward at the waist, bringing your head down toward the floor. **5.** Hold this pose for ten seconds before releasing and alternating sides.

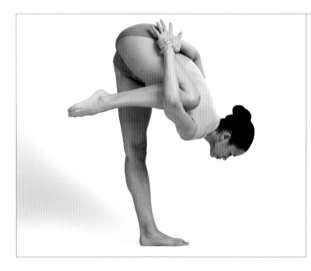

Standing Wind-Relieving, Intense-Stretch Pose 2

Target: Hamstrings.

Benefits: Opens the hips and extends the calves and hamstrings while improving balance.

Steps: 1. Stand straight and shift your weight onto your left foot. **2.** Raise your right knee into your chest. **3.** Reach your left hand behind your back and reach your right hand around your right knee to join your hands together behind your back, so your knee is bound to your side. **4.** Slowly bend forward at the waist, bringing your head down toward the floor. **5.** Hold this pose for ten seconds before releasing and alternating legs.

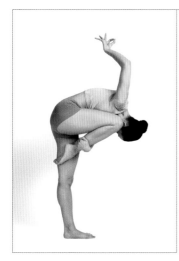

Standing Wind-Relieving, Intense-Stretch Pose, Hand to Ankle

Target: Hamstrings.

Benefits: Opens the hips, extends the calves and hamstrings, and improves balance.

Steps: 1. Stand straight and shift your weight onto your left foot. **2.** Raise your right knee into your chest. **3.** Reach your left arm to your right ankle, holding your leg into your chest. **4.** Raise your right arm up behind you, making the wisdom gesture with your fingers. **5.** Slowly bend forward at the waist, bringing your head down toward the floor. **6.** Hold this pose for ten seconds before releasing and alternating sides.

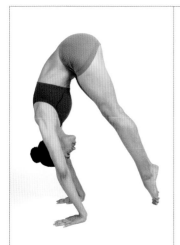

Tiptoe Ankle-Stretch Forward Bend 1

Target: Hamstrings.

Benefits: Targets the muscles in the hamstrings while extending the spine and wrists.

Steps: 1. Stand straight with your legs apart. **2.** Bend your torso forward at the waist, bringing the top of your head down toward the floor. **3.** Reach your hands down flat on the floor in front of your feet. **4.** Raise both feet up onto your toes and hold this position for fifteen seconds before releasing.

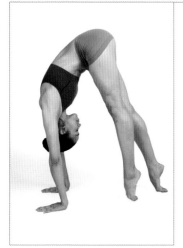

Tiptoe Ankle-Stretch Forward Bend 2

Target: Hamstrings.

Benefits: Targets the muscles in the hamstrings while extending the spine and wrists.

Steps: 1. Stand straight with your legs apart. **2.** Bend your torso forward at the waist, bringing the top of your head down toward the floor. **3.** Reach your hands down flat on the floor in front of your feet. **4.** Raise both feet up onto your toes and curl onto the tops of your toes, stepping one foot forward if necessary. **5.** Hold this position for fifteen seconds before releasing.

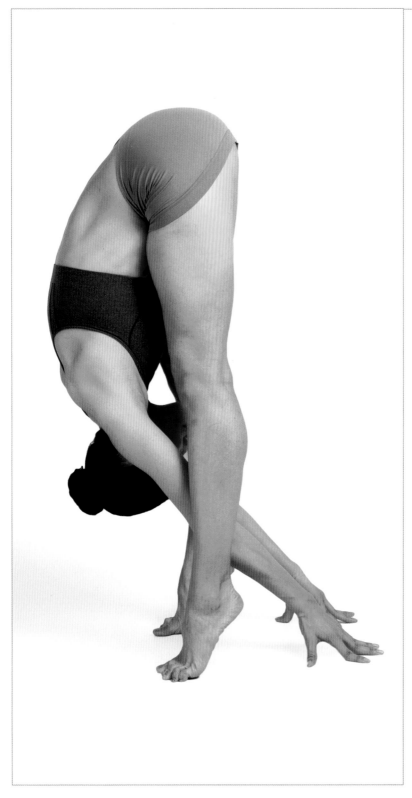

Tiptoe Intense-Stretch Pose, Modification 1

Target: Hamstrings.

Benefits: Targets the hamstrings while extending the spine and wrists.

Steps: 1. Stand straight with your legs apart. **2**. Bend your torso forward at the waist, bringing the top of your head down toward the floor. **3.** Reach your hands down flat on the floor between your legs. **4.** Raise both feet up onto tiptoes and, one at a time, walk your hands behind your legs, so your arms are straight and your fingers are resting on the floor behind you. Your forehead should be against your knees. **5.** Hold this position for fifteen seconds.

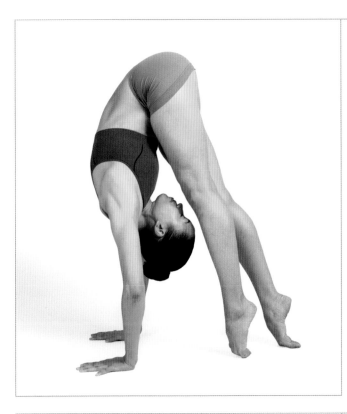

Tiptoe Ankle-Stretch Forward Bend 3

Target: Hamstrings.

Benefits: Targets the muscles in the hamstrings while extending the spine and wrists.

Steps: 1. Stand straight with your legs apart. **2.** Bend your torso forward at the waist, bringing the top of your head down toward the floor. Reach your hands down flat to the floor between your legs. **3.** Raise both feet up onto your toes. Then curl onto the tops of your toes, stepping one foot forward if necessary. **4.** One at a time, step your hands in so your forehead is touching your shin. **5.** Hold this position for fifteen seconds before releasing.

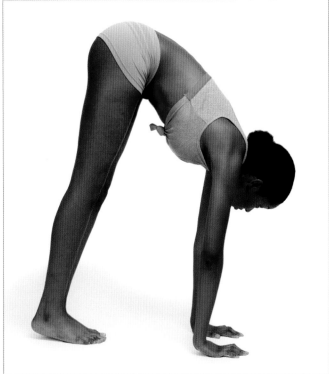

Half Intense-Stretch Pose, Head Up

Target: Hamstrings.

Benefits: Stretches and strengthens the hamstrings and upper arms while engaging the core.

Steps: 1. Stand straight with your feet shoulder-width apart. **2.** Bend forward at the waist and extend your hands down to the floor ahead of you. **3.** Once your palms are flat to the floor, lift your feet onto your toes. **4.** Hold this position for fifteens seconds.

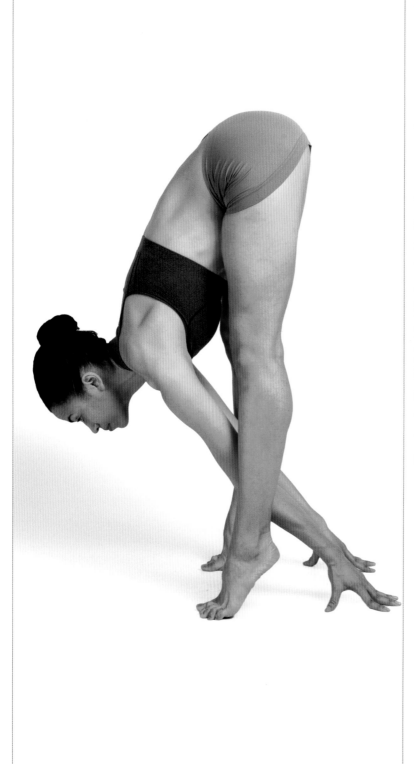

Tiptoe Intense-Stretch Pose, Modification 2

Target: Hamstrings.

Benefits: Targets the muscles in the hamstrings while extending the spine and wrists.

Steps: 1. Stand straight with your legs apart. **2.** Bend your torso forward at the waist, bringing the top of your head down toward the floor. **3.** Reach your hands down flat on the floor between your legs and raise both feet up onto your tiptoes. **4.** One at a time, walk your hands behind your legs, so your arms are straight and your fingers are resting on the floor behind you. **5.** Turn your gaze to the floor and hold this position for fifteen seconds before releasing.

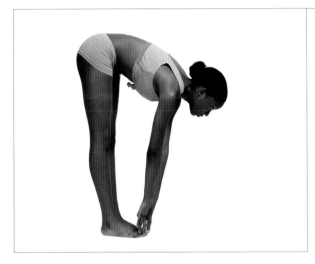

Toe Touch

Target: Hamstrings.

Benefits: Extends the hamstrings and lengthens the spine.

Steps: 1. Stand straight, with your feet shoulder-width apart.
2. Bend your torso forward at the waist, bringing the top of your head down toward the floor. **3.** Extend your arms so your fingers are touching your toes. **4.** Hold this pose for ten seconds before slowly rolling back upright.

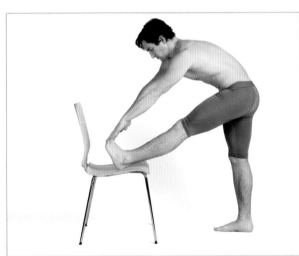

Toe Touch Standing, Leg Up

Target: Hamstrings.

Benefits: Provides mild relief from tight or strained hamstrings.

Steps: 1. Stand straight, facing a chair. **2.** Raise your left leg and rest your heel on the seat of the chair. **3.** Straighten your leg and fold your torso forward at the waist, touching your fingers to your toes. **4.** Hold this pose for fifteen seconds before alternating legs.

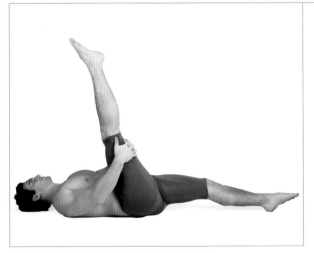

Unilateral Hamstring Stretch, Toe Pointed

Target: Hamstrings.

Benefits: Lengthens the hamstrings while engaging the lower back and glutes.

Steps: 1. Lie flat on your back, with your legs flat on the floor.
2. Bend your right knee into your chest and extend your leg straight up above your hips. **3.** Reach both hands around your right thigh and, keeping your leg straight, gently pull it in toward your torso. **4.** Maintain for fifteen seconds before switching legs.

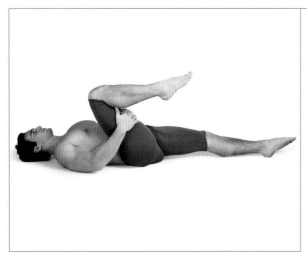

Unilateral Knee to Chest, Toe Pointed

Target: Hamstrings.

Benefits: Lengthens the hamstrings while engaging the lower back and glutes.

Steps: 1. Lie flat on your back, with your legs flat on the floor. **2.** Bend your right knee into your chest and extend your leg straight up above your hips. **3.** Reach both hands around your right thigh and, keeping your leg straight, gently pull it in toward your torso. **4.** Maintain this stretch for fifteen seconds before releasing and switching legs.

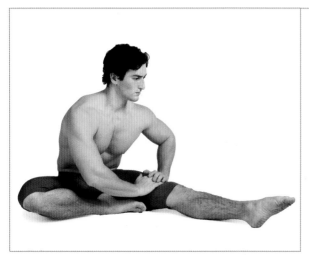

Unilateral Seated Forward Bend

Target: Hamstrings.

Benefits: Opens the hips and lengthens the hamstrings.

Steps: 1. Begin seated on the floor and extend your left leg straight out in front of you. **2.** Tuck your left foot against your right knee and place both palms on your left thigh. **3.** Bend forward at the waist and gently pull your torso farther down toward your left leg. **4.** Hold this pose for twenty seconds before releasing and alternating legs.

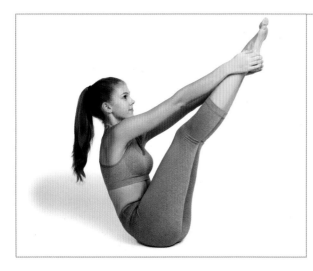

Upward-Facing Western Intense Stretch

Target: Hamstrings.

Benefits: Deeply extends the hamstrings while strengthening the lower back and abdomen.

Steps: 1. Sit down, with your legs bent, and grab your heels with both hands. **2.** Without letting go of your feet, straighten your legs up off the floor. **3.** Keep your back straight and try to bring your legs as close to your torso as you can. **4.** Balance on your pelvic bones and hold for ten seconds before releasing.

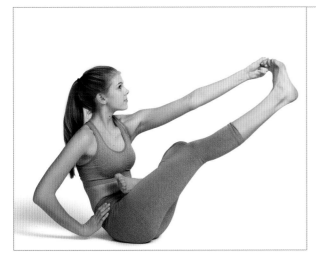

Upward One-Legged, Half-Lotus Western Intense-Stretch Pose

Target: Hamstrings.

Benefits: Deeply extends the hamstrings while strengthening the lower back and abdomen.

Steps: 1. Sit down, with your knees bent, and tuck your left foot into your right hip. **2.** Grab your right big toe with your left hand and straighten your right leg up from the floor. **3.** Balance on your pelvic bones and hold this pose for ten seconds before switching sides.

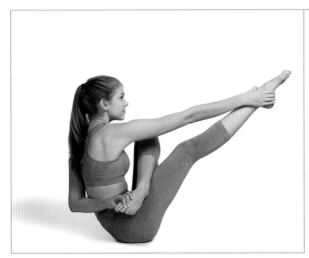

Upward One-Legged, Half-Bound Lotus Western Intense-Stretch Pose

Target: Hamstrings.

Benefits: Deeply extends the hamstrings while strengthening the lower back and abdomen.

Steps: 1. Sit down, with your knees bent, and tuck your left foot into your right hip. **2.** Reach your left hand across your back to hold your left foot. **3.** Grab your right foot with your right hand and straighten your leg up from the floor. **4.** Balance on your pelvic bones and hold this pose for ten seconds before switching legs.

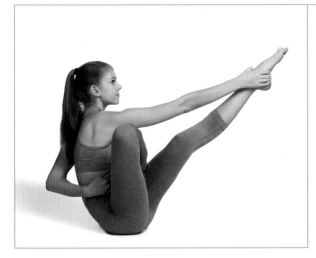

Upward One-Legged, Half-Bound Lotus Western Intense-Stretch Pose

Target: Hamstrings.

Benefits: Deeply extends the hamstrings while strengthening the lower back and abdomen.

Steps: 1. Sit down, with your knees bent, and tuck your right foot into your left hip. **2.** Reach your left arm across your back and hold onto your waist. **3.** Grab hold of your left foot with your right hand and straighten your right leg up from the floor. **4.** Balance on your pelvic bones and hold this pose for ten seconds before switching legs.

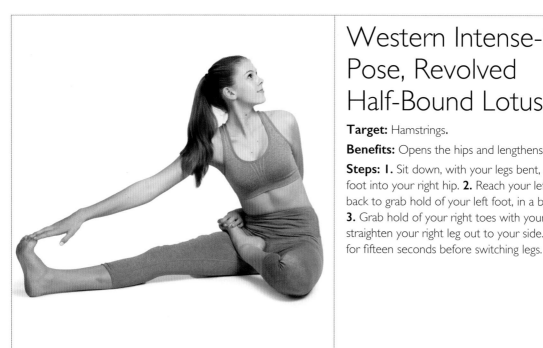

Western Intense-Stretch Pose, Revolved Half-Bound Lotus

Target: Hamstrings.

Benefits: Opens the hips and lengthens the hamstrings.

Steps: 1. Sit down, with your legs bent, and tuck your left foot into your right hip. **2.** Reach your left hand across your back to grab hold of your left foot, in a bound position. **3.** Grab hold of your right toes with your right hand and straighten your right leg out to your side. **4.** Hold this pose for fifteen seconds before switching legs.

Western Intense-Stretch Pose, Upward Half Cow Face 1

Target: Hamstrings.

Benefits: Deeply extends the hamstrings while strengthening the lower back and abdomen.

Steps: 1. Sit down, with your legs bent, and cross your right leg over your left thigh. **2.** Grab hold of your left toes with both hands and extend your left leg straight up from the floor. **3.** Lean back so your are balanced on your pelvic bones. **4.** Hold this pose for fifteen seconds before switching legs.

Western Intense-Stretch Pose, Upward Half Cow Face 2

Target: Hamstrings.

Benefits: Deeply extends the hamstrings while strengthening the lower back and abdomen.

Steps: 1. Sit down, with your legs bent, and cross your right leg over your left. **2.** Grab hold of your left foot with your right hand and reach for your right foot with your left hand. **3.** Without letting go of your right foot, straighten your right leg up and to the left. **4.** Lean back so you are balanced on your pelvic bones and hold this pose for fifteen seconds before switching legs.

Western Intense Stretch to Infinity, Hand to Big Toe

Target: Hamstrings.

Benefits: Deeply extends the hamstrings while strengthening the lower back and abdomen.

Steps: 1. Sit down, with your legs bent, and cross your left leg over your right. **2.** Place your right forearm flat on the floor at your side and grab hold of your right big toe with your left hand. **3.** Without letting go of your foot, extend your right leg straight up and to the left. **4.** Lean back, balancing on your pelvic bones and your right arm, and hold for fifteen seconds before switching sides.

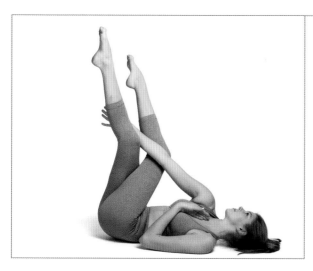

Western Intense Stretch, Upward Facing

Target: Hamstrings.

Benefits: Deeply extends the hamstrings while strengthening the lower back and abdomen.

Steps: 1. Lie down, with your legs raised, and cross your left leg over your right. **2.** Place your left hand at your chest and extend your right hand between your knees. **3.** Gaze up to the ceiling and hold for fifteen seconds before switching sides.

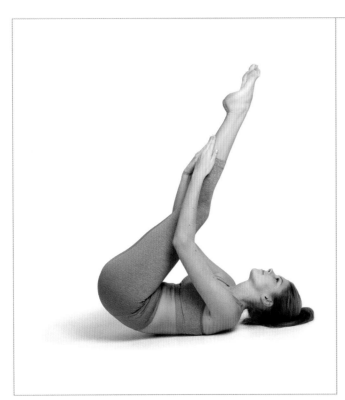

Half Upward-Facing Western Intense-Stretch Pose

Target: Hamstrings.

Benefits: Lengthens the muscles along the hamstrings while improving balance.

Steps: 1. Lie on your back, with your legs bent into your chest, and grab your calves from behind. **2.** Keeping hold of your calves, straighten your legs above you. **3.** Bring your forearms along your calves and try to bring your legs as close to your body as you can. **4.** Hold for twenty seconds.

Leg Raises

Target: Hamstrings.

Benefits: Opens the hips and strengthens the muscles in the upper legs and lower back.

Steps: 1. Stand holding the back of a chair at your left side. **2.** Using the chair for support, raise your right knee and extend your leg, bending it slightly so that your calf is parallel to the floor. **3.** Hold this pose for twenty seconds, without letting your foot drop lower. **4** Release and repeat on the opposite side.

Leg-to-Side Stretch, Revolved Extended

Target: Hamstrings.

Benefits: Opens the hips and lengthens the muscles in the hamstrings and upper back.

Steps: 1. Begin seated on the floor, with both knees bent. **2.** Reach your right hand between your knees and grab the outside of your right ankle. **3.** Hold the toes of your left foot with your left hand and extend your left leg straight out to the side. **4.** Hold this pose for twenty seconds before releasing and alternating legs.

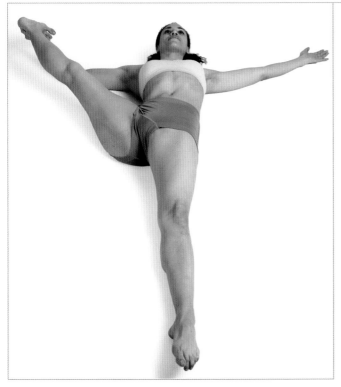

Single-Leg Pull

Target: Hamstrings.

Benefits: Opens the hips and extends the spine while deeply stretching the length of the hamstrings.

Steps: 1. Lie flat on your back with your arms and legs extended. **2.** Bring your right knee up into your chest and grab hold of your right toes with your right hand. **3.** Without letting go of your foot, extend your right leg straight up to your side. **4.** Hold this pose for ten seconds before releasing and repeating on the opposite leg.

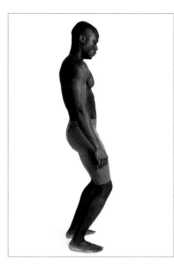

Bent Knee PNF

Target: Quadriceps.

Benefits: Strengthens the quadriceps and glutes.

Steps: 1. Stand straight with your feet together. **2.** Bend both knees slightly, keeping your back straight and your knees above your toes. **3.** Hold this position for ten seconds at a time, before returning upright and repeating.

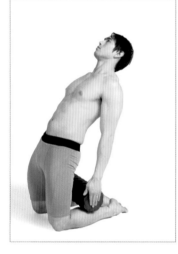

Calf and Hamstring Stretch

Target: Hamstrings.

Benefits: Lengthens the quadriceps and chest, increasing flexibility and reducing strain.

Steps: 1. Kneel upright and place a foam roller across your calves. **2.** Place both hands on the sides of the roller and gently lean back against it, making sure to bend at the knees and not the waist. **3.** Hold this position for twenty seconds.

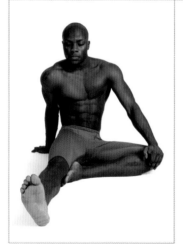

Con una Rodilla Extendida, Modification

Target: Quadriceps.

Benefits: Targets the quadriceps and hamstrings while opening the hips.

Steps: 1. Sit on the floor, with your right leg extended straight ahead of you and your left foot tucked into your hips. **2.** Holding your left knee with your left hand, slowly lean your torso forward at the waist, making sure keep your right leg straight. **3.** Continue this stretch for twenty seconds before repeating on the opposite leg.

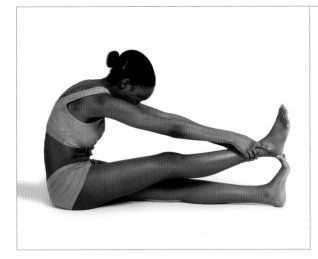

Cross Under Leg

Target: Quadriceps.

Benefits: Elongates the quadriceps and hamstrings, releasing tightness in the legs.

Steps: 1. Begin by sitting on the floor, with your legs out straight ahead. **2.** Lift your right foot from the floor and rest the heel of your foot on top of your left toes. **3.** Slowly bend forward at the waist, reaching down to your right ankle. Gently pull your torso forward, making sure not to bend your knees. **4.** Hold this pose for twenty seconds before releasing and switching legs.

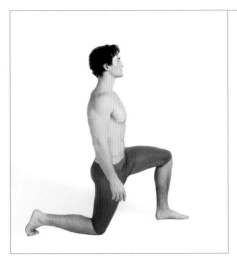

Forward Lunge Prep

Target: Quadriceps.

Benefits: Lengthens the leg muscles while opening the hips.

Steps: 1. Kneel on the floor and step your left leg far forward, bending at the knee and raising your right foot onto tiptoes. **2.** Place both palms flat on the floor beside your left foot for support and lower your hips into a deep lunge. **3.** Hold this pose for fifteen seconds before releasing and alternating legs.

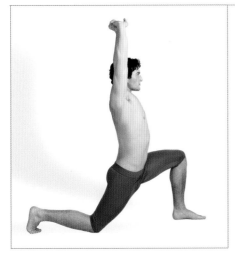

Hip-to-Thigh Lunge, Arms Up

Target: Quadriceps.

Benefits: Strengthens and extends the quads and calves, increasing mobility and reducing the risk of injury.

Steps: 1. Kneel on the floor and step your left leg far forward, bending at the knee and raising your right foot onto tiptoes. **2.** Clasp your hands and extend your arms straight overhead, palms facing up. **3.** Push your pelvis downward and lower your hips into a deep lunge. **4.** Hold for thirty seconds and alternate sides.

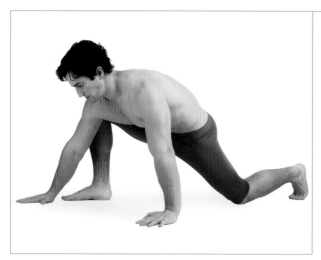

Hip Twist 3

Target: Quadriceps.

Benefits: Deeply lengthens the leg muscles while opening the hips and increasing balance.

Steps: 1. Kneel on the floor and step your right foot far forward, bending at the knee. **2.** Raise your left foot onto tiptoes and lower your hips into a deep lunge. **3.** Lean forward with extend both palms flat on the floor in front of you. **4.** Hold this pose for fifteen seconds before releasing and alternating legs.

Knee Bend, Crouching

Target: Quadriceps.

Benefits: Strengthens the quadriceps and glutes.

Steps: 1. Stand straight with your feet together and place both hands on the tops of your knees. **2.** Bend both knees slightly, keeping your back straight and your knees above your toes. **3.** Hold this position for ten seconds at a time, before returning upright and repeating.

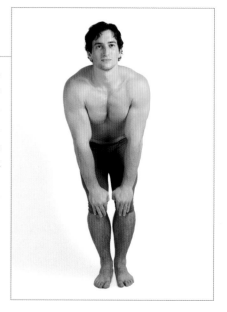

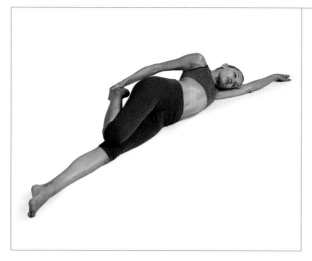

Knee Bend, Side-Lying

Target: Quadriceps.

Benefits: Lengthens the quads, providing relief from tight or strained muscles.

Steps: 1. Lie on your left side, with your left arm extended straight above you, and rest your head on your arm. **2.** Bend your right leg, bringing your foot in to rest against your hips. **3.** Grab hold of your foot with your right hand and gently pull your foot, bending your right elbow. **4.** Continue this stretch for twenty seconds before releasing and switching sides.

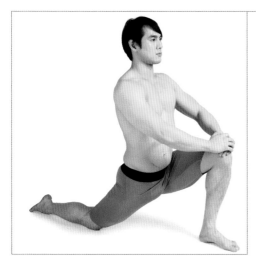

Knee Extensor, Kneeling Advanced

Target: Quadriceps.

Benefits: Deeply lengthens the leg muscles while opening the hips and increasing balance.

Steps: 1. Begin kneeling upright. Bring your right knee up from the floor, and place your foot flat on the floor ahead of you, so your leg forms a 90-degree angle. **2.** Place both hands on your right knee and gently pull your hips forward, straightening your left leg. **3.** Hold this position for twenty seconds before releasing and switching legs.

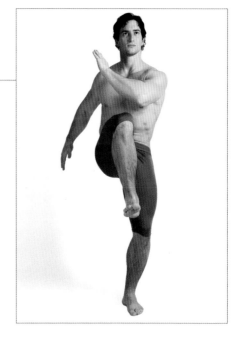

Knee Raise, Modification 1

Target: Quadriceps.

Benefits: Strengthens the quadriceps and hamstrings while increasing mobility and restoring balance.

Steps: 1. Stand straight with your feet slightly apart and shift your weight onto your left foot. **2.** Bending your left knee slightly, quickly thrust your right knee up as high as you are able and swing your arms to the right for balance. **3.** Lower your right foot to the floor and repeat with the opposite leg. **4.** Return to the starting position, and continue this repetition for thirty seconds, moving quickly between motions.

Knee Raise, Modification 2

Target: Quadriceps.

Benefits: Strengthens the muscles in the quads and hamstrings while increasing mobility and restoring balance.

Steps: 1. Stand straight with your feet slightly apart and shift your weight onto your left foot. **2.** Bending your left knee slightly, quickly thrust your right knee up from the floor in front of your left knee. At the same time, bend your elbows and swing them to the left for balance. **3.** Lower your right foot back to the floor and repeat with the opposite leg. **4.** Return to the starting position, and continue this repetition for thirty seconds, moving quickly between motions.

Knee Raises

Target: Quadriceps.

Benefits: Strengthens the quadriceps and hamstrings while increasing mobility and restoring balance.

Steps: 1. Stand straight with your feet slightly apart and shift your weight onto your right foot. **2.** Bending your right knee slightly, quickly thrust your left knee up to your chest. At the same time, bend your elbows and swing them to the left, touching your right elbow to your left knee. **3.** Lower your left foot to the floor and repeat on the opposite side. **4.** Return to the starting position and continue this repetition for thirty seconds, moving quickly between motions.

Lateral Duck Under

Target: Quadriceps.

Benefits: Increases strength and flexibility in the quadriceps and glutes while engaging the core.

Steps: 1. Stand to the right of a ballet bar with your hands on your hips. **2.** Step your left foot under the bar and bend both knees, lowering your body into a low squat beneath the bar. **3.** Step your left foot out to the left again and step out from under the bar, so you are now standing to the left of the bar. **4.** Repeat the exercise, this time squatting back to the right of the bar. **5.** Run through this exercise ten times.

Leg Bent Behind with Body Bar

Target: Quadriceps.

Benefits: Elongates the muscles in the quads and hamstrings, releasing tightness in the legs.

Steps: 1. Stand holding the body bar upright with your left hand and shift your weight onto your left foot. **2.** Bend your right knee behind you and grab hold of your right foot with your right hand. **3.** Gently pull your foot up from the floor, bending your right elbow. **4.** Hold this pose for fifteen seconds before releasing and switching legs.

Lunge

Target: Quadriceps.

Benefits: Deeply lengthens the leg muscles while opening the hips and increasing balance.

Steps: 1. Begin kneeling upright and bring your left knee up from the floor. **2.** Place your foot flat on the floor ahead of you, so your left leg forms a 90-degree angle. **3.** Place both hands on your left knee and gently push your hips down farther toward the ground. **4.** Hold this position for twenty seconds before releasing and switching legs.

Lunge, Kneeling

Target: Quadriceps.

Benefits: Deeply lengthens the leg muscles while opening the hips and increasing balance.

Steps: 1. Begin kneeling upright with your hands clasped behind your back. **2.** Bring your right knee up from the floor and place your foot flat on the floor ahead of you, so your right leg forms a 90-degree angle. **3.** Gently push your hips forward and straighten your left leg behind you. **4.** Pull your head and shoulders back and drop your clasped hands down toward the floor to extend your chest. **5.** Hold this position for twenty seconds before releasing and switching sides.

Lunge, Front of Hip, Arms Extended on Ball

Target: Quadriceps.

Benefits: Deeply lengthens the muscles in the legs while opening the hips and increasing balance.

Steps: 1. Stand with your left hand resting on an exercise ball at your side. **2.** Step your left leg far forward, bending at the knee and raising your right foot onto tiptoes behind you. **3.** Lower your hips into a deep lunge and extend your right arm straight above you. **4.** Drop your shoulders back and shift your gaze up to the ceiling to open your chest fully. **5.** Hold this pose for fifteen seconds before releasing and alternating legs.

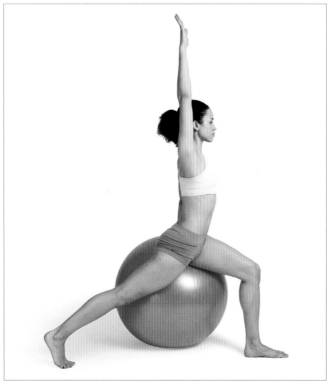

Lunge, Front of Hip on Ball

Target: Quadriceps.

Benefits: Deeply lengthens the muscles in the legs while opening the hips and increasing balance.

Steps: 1. Stand with your left hand resting on an exercise ball at your side. **2.** Step your left leg far forward, bending at the knee and raising your right foot onto tiptoes behind you. **3.** Lower your hips into a deep lunge and extend your right arm straight above you. **4.** Hold this pose for fifteen seconds before releasing and alternating legs.

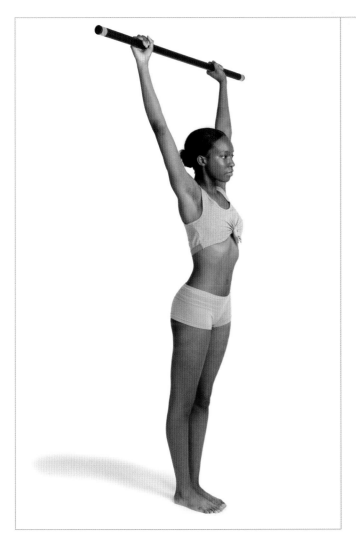 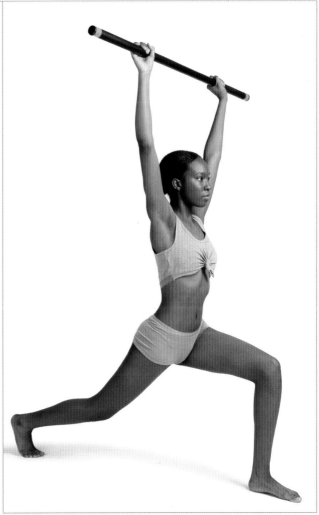

Lunge, Overhead with Rotation

Target: Quadriceps.

Benefits: Extends and strengthens the quadriceps, glutes, hamstrings, and upper arms.

Steps: 1. Stand straight, holding the body bar overhead with both hands. **2.** Step your left foot far forward and raise your right foot onto tiptoes. **3.** Bend your left knee, lowering your torso down into a deep lunge. **4.** Keep the bar high above your shoulders and step back to the starting position. **5.** Repeat, stepping your right foot forward, and continue alternating legs for thirty seconds.

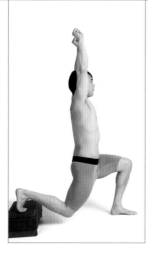

Lunge with Block

Target: Quadriceps.

Benefits: Strengthens the glutes, increasing flexibility and coordination.

Steps: 1. Stand with the toes of your right foot on a block behind you and ball your hands into fists at your chest. **2.** Extend your arms straight into the air as you bend your left knee, until it forms a 90-degree angle and your right knee approaches the floor. **3.** Straighten back up to the starting position and repeat this exercise ten times before switching legs.

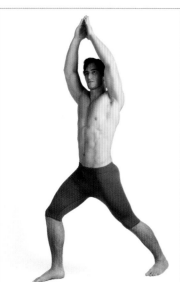

Lunging-Forward Stretch

Target: Quadriceps.

Benefits: Extends and strengthens the quadriceps, glutes, hamstrings, and upper arms.

Steps: 1. Stand straight with your palms together in prayer position above your head. **2.** Step your right foot far forward and raise your left foot onto tiptoes. **3.** Bend your right knee, lowering your torso down into a deep lunge. **4.** Keep your arms extended above you and step back to the starting position. **5.** Repeat, stepping your left foot forward, and continue alternating legs for thirty seconds.

One-Legged Squat

Target: Quadriceps.

Benefits: Increases strength and flexibility in the quadriceps and glutes while engaging the core.

Steps: 1. Stand straight on an exercise block and shift your weight onto your right foot. **2.** Extend your left leg out straight in front of you, with your foot flexed. **3.** Bend your right knee, slowly lowering your left foot down toward the floor. Rest your hands on your hips for balance. **4.** Straighten your leg, lifting your body back up to the standing position. **5.** Repeat this exercise ten times before switching legs.

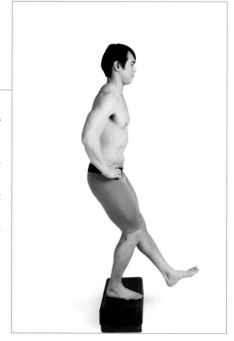

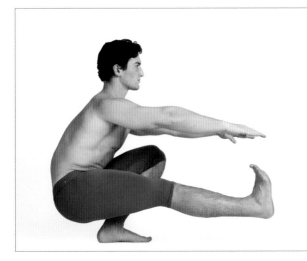

Intense One-Legged Squat

Target: Quadriceps.

Benefits: Engages the core, requiring a significant amount of strength, flexibility, and balance.

Steps: 1. Stand straight with your arms extended in front of you. **2.** Raise your right foot from the floor and bring your knee into your chest. **3.** Grab hold of your toes with both hands and attempt to lift and straighten your right leg forward. **4.** Meanwhile, bend your left leg, bringing your hips as low to the floor as you are able. **5.** Hold this balancing pose for twenty seconds before switching sides.

One-Legged Squat, Down

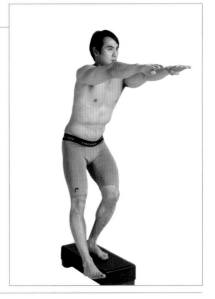

Target: Quadriceps.

Benefits: Increases strength and flexibility in the quadriceps and glutes while engaging the core.

Steps: 1. Stand with your left foot on the edge of an exercise block and your right foot dangling beside it. **2.** Balance your weight on your left foot and extend both arms in front of you. **3.** Lift your right foot slightly forward, keeping your leg straight and foot flexed. **4.** Bend your left knee, slowly lowering your right heel toward the floor. **5.** Straighten your leg, lifting your body back up to a standing position. **6.** Repeat this exercise ten times before switching sides.

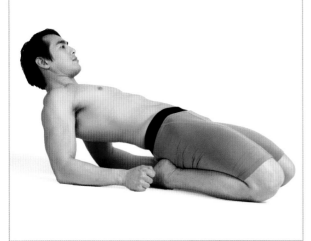

Quad Stretch, Leaning Back

Target: Quadriceps.

Benefits: Provides intense relief from tight quads and lower back muscles.

Steps: 1. Begin by kneeling on the floor, with your hips resting on your heels. **2.** Lean far back and lower your elbows, one at a time, down to the floor so your forearms are flat on the floor at your sides. **3.** Hold this pose for thirty seconds before releasing.

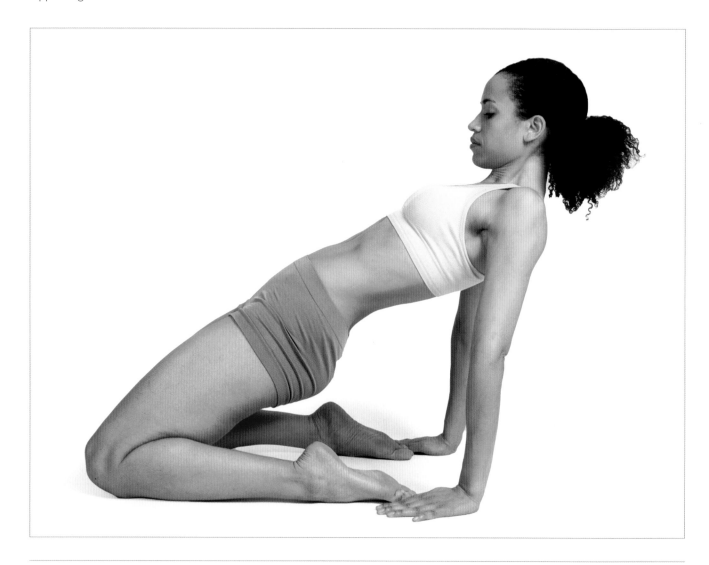

Quad Stretch, Bilateral

Target: Quadriceps.

Benefits: Provides mild relief from tight quads and lower back muscles.

Steps: 1. Begin by kneeling on the floor, with your hips resting on your heels. Place your hands flat on the floor behind you, pointing toward your toes.

2. Straighten your arms and push your hips up from the floor. Continue until your torso forms a straight line between your knees and shoulders.

3. Hold this pose for thirty seconds before releasing.

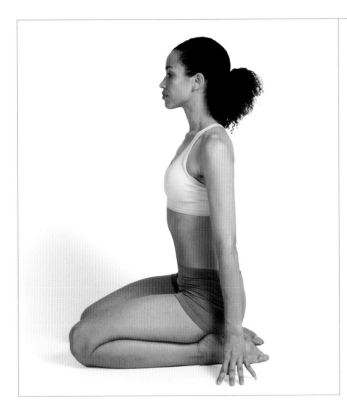

Quad Stretch, Bilateral Prep

Target: Quadriceps.

Benefits: Provides mild relief from tight quads and lower back muscles.

Steps: 1. Begin by kneeling on the floor, with your hips resting on your heels. **2.** Place your hands on the floor at your sides and gaze forward. **3.** Hold for thirty seconds.

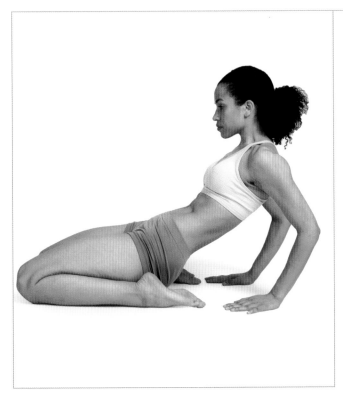

Quad Stretch, Bilateral Modification

Target: Quadriceps.

Benefits: Provides mild relief from tight quads and lower back muscles.

Steps: 1. Begin by kneeling on the floor, with your hips resting on your heels. **2.** Place your hands flat on the floor behind you, pointing toward your toes. **3.** Lean far back, bending at your elbows, and hold for thirty seconds.

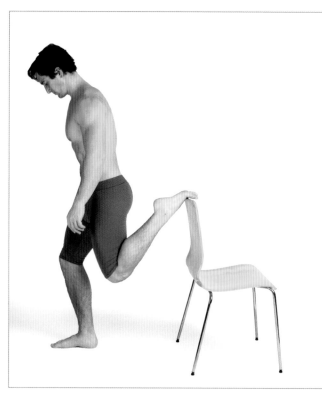

Quad Stretch, Chair Assisted

Target: Quadriceps.

Benefits: Lengthens the quadriceps while strengthening the glutes and hamstrings.

Steps: 1. Stand facing away from the back of a chair. **2.** Bend your left leg, raising your foot up toward your hips, and rest your toes on the back of the chair. **3.** Keeping your left foot on the chair, bend your right knee and lower your hips down toward the floor. **4.** Hold this pose for fifteen seconds before releasing and alternating sides.

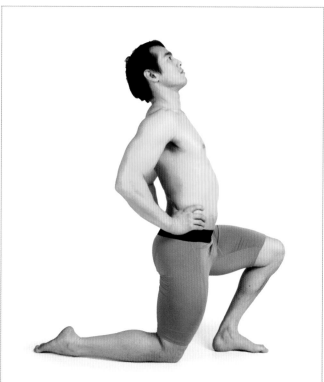

Quad Stretch, Kneeling

Target: Quadriceps.

Benefits: Deeply lengthens the muscles in the legs while opening the hips and lower back and increasing balance.

Steps: 1. Begin by kneeling upright with your hands on your hips. **2.** Bring your left knee up from the floor and place your foot flat on the floor ahead of you, so your left leg forms a 90-degree angle. **3.** Gently push your hips forward and pull your head and shoulders back to extend your chest. **4.** Hold this position for twenty seconds before releasing and switching legs.

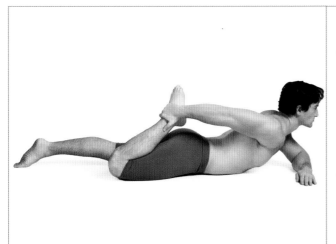

Quad Stretch, Lying

Target: Quadriceps.

Benefits: Pulls along the quads while opening the chest and shoulders.

Steps: 1. Begin by lying on your stomach, with your legs extended. **2.** Bend your right leg, bringing your foot up to rest against your hips. Reach around and grab hold of your raised foot with your right hand. **3.** Gently pull up against your foot, bending your right elbow. **4.** Hold this pose for twenty seconds before releasing and repeating to the opposite leg.

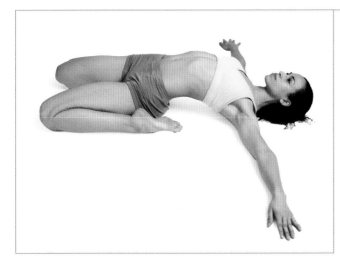

Quad Stretch, Lying Back

Target: Quadriceps.

Benefits: Provides intense relief from tight quads and lower back muscles.

Steps: 1. Begin kneeling on the floor, with your hips resting on your heels. **2.** Place your hands flat on the floor, pointing toward your toes. **3.** Lean your torso backward and lower your elbows to the floor, one at a time, until your forearms are flat on the floor at your sides. **4.** Then, carefully lower yourself all the way down onto your shoulders and extend your arms straight out to your sides. **5.** Hold this pose for thirty seconds before releasing.

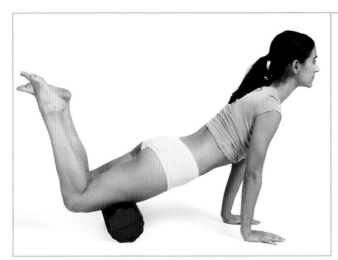

Quad Stretch on Roller

Target: Quadriceps.

Benefits: Provides relief from tight or strained quadriceps.

Steps:1. Lie facedown on the floor with your weight supported by your hands or forearms. **2.** Place a foam roller underneath your quads. **3.** Bend your knees and raise your feet off the floor, making sure to relax the legs as much as possible. **4.** Roll your quads along the foam roller, stopping at areas of tension, for ten to thirty seconds.

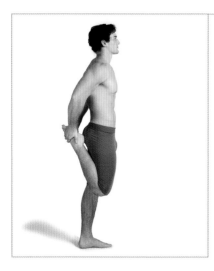

Quad Stretch, Standing

Target: Quadriceps.

Benefits: Deeply lengthens the quadriceps while opening the hips and increasing balance.

Steps: 1. Stand straight and shift your weight onto your left foot. **2.** Bend your right knee, raising your right foot up to your hips. **3.** Reach around behind you and grab hold of your raised foot with both hands. **4.** Gently pull up against your foot, bending both elbows. **5.** Hold for twenty seconds before releasing and alternating legs.

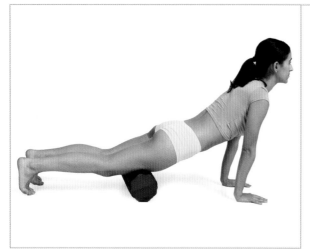

Quad Stretch, Tiptoe on Roller

Target: Quadriceps.

Benefits: Provides relief from tight or strained muscles in the quadriceps.

Steps: 1. Lay facedown on the floor with your weight supported by your hands or forearms. **2.** Place a foam roller underneath your quads. **3.** Raise your feet up onto your tiptoes and roll along the upper legs, pausing at points of tension, for ten to thirty seconds.

Quad-Glute Stretch 1

Target: Quadriceps.

Benefits: Lengthens the quadriceps and hips flexors, increasing flexibility and range of motion.

Steps: 1. Begin seated on the floor. **2.** Bend both legs into a cross-legged position, pulling the right foot into your left hip and into a half-lotus pose. **3.** Hold this position for fifteen seconds before releasing and switching sides.

Quad-Glute Stretch 2

Target: Quadriceps.

Benefits: Lengthens the quadriceps and hips flexors while extending the spine and wrists.

Steps: 1. Begin seated on the floor. **2.** Bend both legs into a cross-legged position, pulling the right foot into your left hip and into a half-lotus pose. **3.** Place both palms flat on the floor under your hips and gently lean your torso forward from the waist. **4.** Hold this position for fifteen seconds before releasing and switching legs.

Single-Leg Stretch, Behind

Target: Quadriceps.

Benefits: Deeply lengthens the quadriceps while opening the hips and increasing balance.

Steps: 1. Stand straight with your feet apart and shift your weight onto your right foot. **2.** Bend your left knee, raising your left foot up to your hips, and reach behind you to grab hold of your raised foot with your left hand. **3.** Gently pull up against your foot, bending your elbow. Meanwhile, lean your torso forward, bending at the waist, and extend your right arm out ahead of you for balance. **4.** Continue the forward bend until your torso and right leg form a straight line parallel to the floor. **5.** Hold this pose for ten seconds before releasing and alternating legs.

Squat at Ballet Bar

Target: Quadriceps.

Benefits: Strengthens the quadriceps, increasing flexibility and balance.

Steps: 1. Squat facing a ballet bar, holding it with both hands. **2.** Step your left foot several feet behind you and to the right, and raise your foot onto tiptoes. **3.** Bend your left knee, holding it just above the floor for ten seconds. **4.** Return to the starting position and repeat ten times before switching legs.

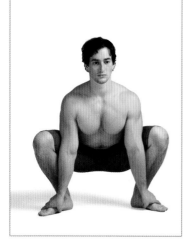

Squat, Hands to Ankles

Target: Quadriceps.

Benefits: Opens the hips and strengthens the quadriceps.

Steps: 1. Stand with your feet apart, just beyond shoulder width. **2.** Bend both knees, lowering your hips down low toward the floor, and reach to hold your ankles with both hands. **3.** Hold this pose for fifteen seconds before returning to the starting position. **4.** Repeat this exercise five times.

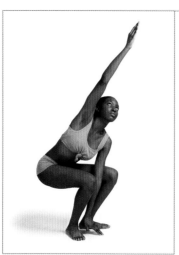

Squat, One Arm Reaching Up

Target: Quadriceps.

Benefits: Opens the hips and strengthens the quadriceps.

Steps: 1. Stand with your feet apart, just beyond shoulder width. **2.** Bend both knees, lowering your hips down until your upper legs are parallel to the floor. **3.** Reach down to touch your toes with your left hand and extend your right arm overhead. **4.** Hold this pose for fifteen seconds before returning to the starting position and repeat five times.

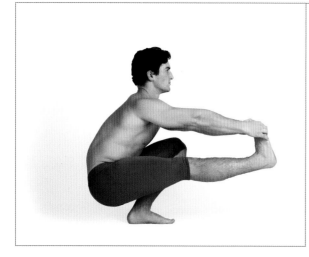

Squat Pose, Hands to Foot

Target: Quadriceps.

Benefits: Engages the core, requiring a significant amount of strength, flexibility, and balance.

Steps: 1. Stand straight with your arms extended in front of you. **2.** Raise your right foot from the floor and bring your knee into your chest. **3.** Grab hold of your toes with both hands and attempt to lift and straighten your right leg forward. Meanwhile, bend your left knee, bringing your hips as low to the floor as you are able. Lean your left hand down to the floor for support. **4.** Hold this balancing pose for twenty seconds before switching legs.

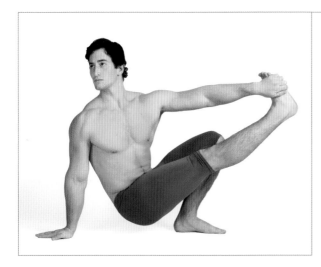

Squat Revolved, Supported Hand to Foot

Target: Quadriceps.

Benefits: Extends the quads and hip flexors, requiring a significant amount of strength, flexibility, and balance.

Steps: 1. Begin crouching low to the floor and reach your left hand to grab hold of your right foot. **2.** Plant your right hand on the floor behind you for support. **3.** Attempt to raise and straighten your right leg, keeping your hand on your foot. **4.** Drop your shoulders back and twist your torso to the right. **5.** Hold this pose for fifteen seconds before releasing and switching sides.

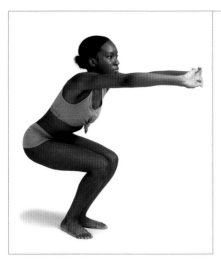

Squat with Arms Clasped

Target: Quadriceps.

Benefits: Strengthens the quads and hamstrings while extending the shoulders.

Steps: 1. Stand with your hands clasped and extended straight out ahead of your shoulders. **2.** Bend both knees and drop your hips down until your upper legs are parallel to the floor. **3.** Hold this pose for ten seconds and repeat five times.

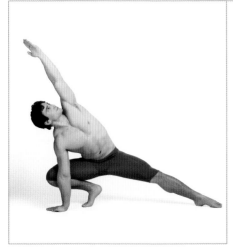

Squat with Arms Overhead

Target: Quadriceps.

Benefits: Lengthens the muscles along the side of the body while opening the hips and targeting the quadriceps.

Steps: 1. Stand with your feet shoulder-width apart. **2.** Extend your left leg straight out to the side and lower your body into a deep side squat, with your right foot raised onto tiptoes **3.** Drop your right hand flat on the floor in front of your right foot. **4.** Extend your left arm over your head, leaning your torso deeply to the side. **5.** Raise your gaze up to the ceiling and hold this position for fifteen seconds before alternating sides.

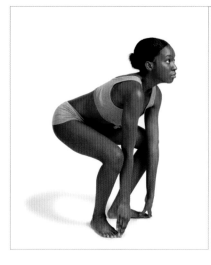

Squat, Straight-Arm Toe Touch

Target: Quadriceps.

Benefits: Opens the hips and strengthens the quadriceps.

Steps: 1. Stand with your feet apart, just beyond shoulder width. **2.** Bend both knees, lowering your hips down until your upper legs are parallel to the floor. **3.** Reach down to touch your toes with either hand. **4.** Gaze forward and hold for twenty seconds.

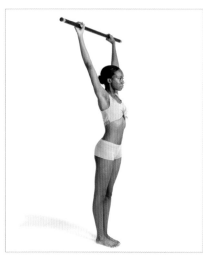

Overhead Straight Stretch with Bar

Target: Quadriceps.

Benefits: Extends and strengthens the quads, glutes, hamstrings, and upper arms.

Steps: 1. Stand straight, holding a body bar in front of you at your hips. **2.** Slowly raise the bar up over your head, keeping your elbows straight. **3.** Hold for twenty seconds.

Sumo Squat

Target: Quadriceps.

Benefits: Strengthens the quadriceps and glutes, and opens the hips.

Steps: 1. Stand with your feet wide apart and your toes pointing outward. **2.** Place your hands on your knees and lower your torso down toward the floor. Continue until your upper legs are parallel to the floor. **3.** Hold this pose for ten seconds at a time before returning upright and repeating.

Sumo Squat with Body Bar

Target: Quadriceps.

Benefits: Strengthens the quadriceps and glutes, and opens the hips.

Steps: 1. Stand with your feet wide apart and your toes pointing outward. **2.** Hold a body bar upright in front of you with both hands. **3.** Bend both knees and lower your torso down toward the floor. Continue until your upper legs are parallel to the floor. **4.** Hold this pose for ten seconds at a time before returning upright and repeating.

Thigh-Quad Interior Stretch

Target: Quadriceps.

Benefits: Twists the spine and shoulders and strengthens the quads and hamstrings.

Steps: 1. Stand upright with your arms straight out to your sides and step your left foot far forward. **2.** Raise your right foot up onto tiptoes and bend both knees until your right knee is just above the floor. Meanwhile, twist your torso to the left. **3.** Rise back up to the starting position and repeat this exercise, alternating sides, for thirty seconds.

Tiptoe One-Legged King Pigeon Pose Prep

Target: Quadriceps.

Benefits: Lengthens the quadriceps and shin muscles while opening the hips.

Steps: 1. Kneel upright and place your right foot flat on the floor in front of you, so your leg forms a 90-degree angle. **2.** Lift your left foot toward your hips and reach behind you to grab your foot with both hands. Gently pull your foot farther in toward your hips. **3.** Raise your right foot onto tiptoes and lean your torso forward. Hold this position for twenty seconds before releasing and switching legs.

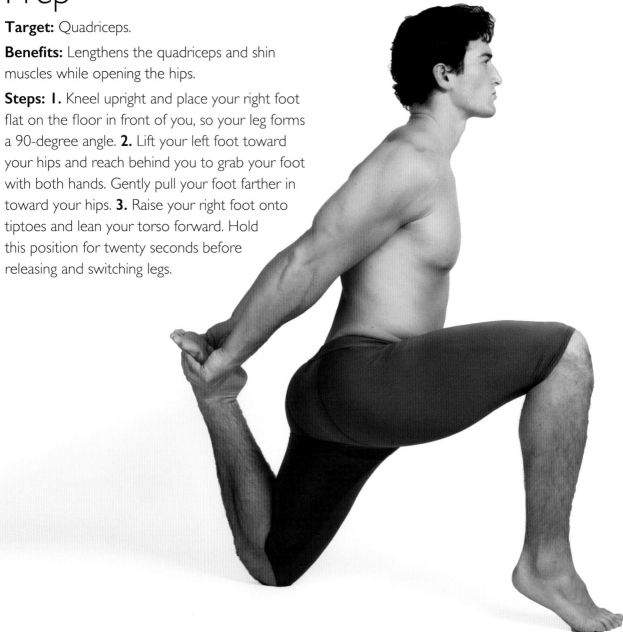

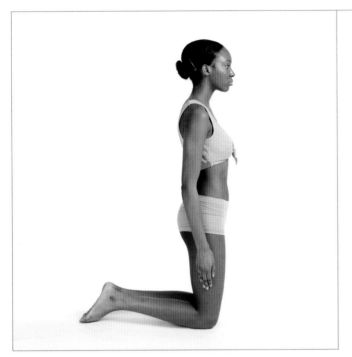
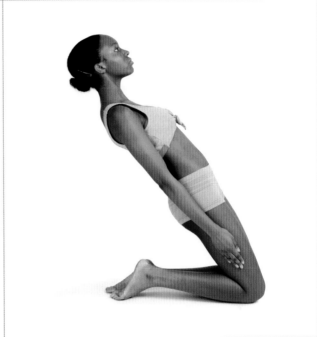

Thigh Rock-Back Dynamic

Target: Quadriceps.

Benefits: Extends the quadriceps and strengthens the abdominals.

Steps: 1. Kneel upright with your arms down at your sides. **2.** Keeping your spine and shoulders straight, lean your torso as far backward as your are able. **3.** Hold this position for twenty seconds before returning upright.

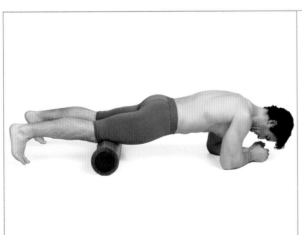

Thigh SMR

Target: Quadriceps.

Benefits: Relieves tightness and tension in the thighs while engaging the glutes and core.

Steps: 1. Lay facedown on the floor with your weight supported by your hands or forearms. **2.** Place a foam roller underneath your quadriceps and raise your feet up onto your tiptoes. **3.** Roll along the upper legs, stopping at areas of tension, for ten to thirty seconds.

Lower-Leg Stretches

Achilles Step-Up on Block

Target: Achilles.

Benefits: Lengthens the calf muscles and Achilles tendons.

Steps: 1. Start by standing straight, toes against a block. **2.** Step your left foot onto the edge of block, balancing on your toes. **3.** Step back down to the floor and repeat this motion, alternating feet.

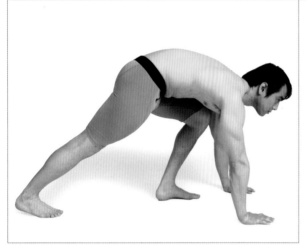

Achilles Stretch, Crouching

Target: Achilles.

Benefits: Lengthens the Achilles tendons and calf muscles.

Steps: 1. Beginning on all fours, raise your left knee toward your left elbow. **2.** Outstretch your right leg behind you. **3.** Press the heel of your right foot into the floor to heighten the effect of the stretch.

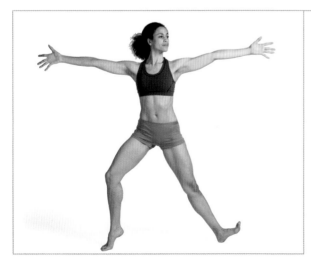

Achilles Stretch, Four-Limbs Spread

Target: Achilles.

Benefits: Targets the Achilles tendons while lengthening the limbs and opening the chest and groin.

Steps: 1. Begin by standing straight with your left leg extended to the side. **2.** Flex your leg foot, bending the right knee for support. **3.** Raise your right foot onto your toes and extend your arms out to the sides. **4.** Hold for twenty seconds.

Achilles Stretch, Heels off Floor

Target: Achilles.

Benefits: Lengthens the Achilles tendons and calf muscles.

Steps: 1. Stand with your toes balancing on the edge of a block.
2. Raise and lower your heels for thirty seconds.

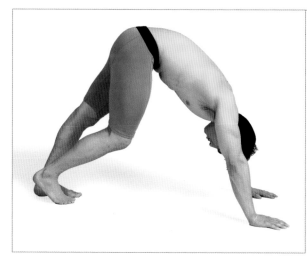

Achilles Stretch in Downward Dog

Target: Achilles.

Benefits: Lengthens the Achilles tendons.

Steps: 1. Start on all fours, in the downward dog position, keeping your palms flat on the floor and fingers pointed ahead. **2.** Raise your hips up to the ceiling, straightening your legs and relaxing your neck. **3.** Keeping your left heel flat on the floor, lift your right heel and bend your right leg. **4.** Press against the right toes to intensify the stretch. Hold for twenty seconds and alternate sides.

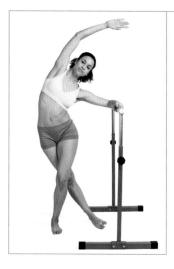

Achilles Stretch, Leg Extended at Ballet Bar

Target: Achilles.

Benefits: Relieves tension and tightness in the Achilles tendons and calf muscles.

Steps: 1. Stand next to a ballet bar and rest your left forearm on the bar.
2. Cross your right leg behind you and rest your leg on the outside of your right foot. **3.** Bend your left knee and lean toward the bar, pulling against your right foot. **4.** Reach your right arm overhead and hold for thirty seconds before alternating sides.

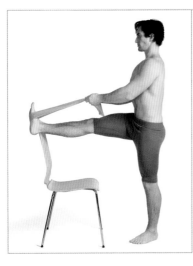

Achilles Stretch, Leg Raised with Band

Target: Achilles.

Benefits: Relieves tightness and tension in the ankle and calf.

Steps: 1. Standing facing the seat of a chair. **2.** Lift your right leg from the floor, resting your ankle on the back of the chair. **3.** Attach a resistance band to the raised foot, pulling back against the resistance of the band. **4.** Hold for twenty seconds and alternate sides.

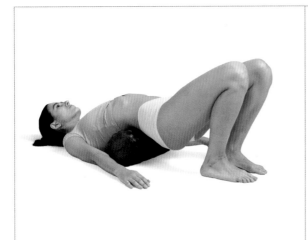

Achilles Stretch on Roller

Target: Achilles.

Benefits: Stretches the Achilles tendons.

Steps: 1. Place a foam roller under your back and rest your shoulders and arms on the floor, knees bent and hips raised. **2.** Roll downward on the roller, so the knees extend over the toes, making sure to keep your heels to the floor.

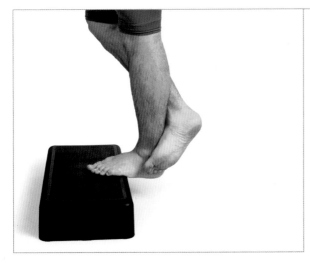

Achilles Stretch, One-Legged

Target: Achilles.

Benefits: Lengthens the Achilles tendons while improving balance.

Steps: 1. Stand at the edge of a block, balancing on your toes. **2.** Shifting your weight onto your left foot, lift the right foot and tuck it behind your left ankle. **3.** Raise and lower your heels above and below the edge of the block for thirty seconds. **4.** Repeat on the opposite side.

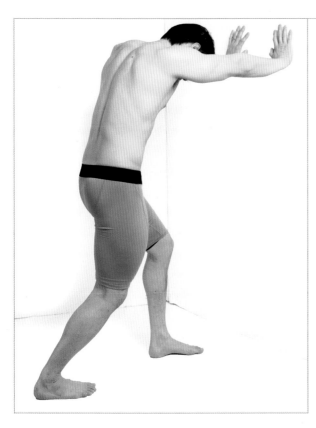

Achilles Stretch, Wall Supported 1

Target: Achilles.

Benefits: Anchors the body and targets the Achilles tendon of the extended leg.

Steps: 1. Stand facing a wall about a foot away. **2.** Lean your palms against the wall, at shoulder height. **3.** Step your right foot away from the wall, keeping your heels flat on the floor. **4.** Lean into the right leg to heighten the stretch. **5.** Hold for twenty seconds and switch sides.

Achilles Stretch Wall Supported 2

Target: Achilles.

Benefits: Anchors the body and targets the Achilles tendon of the extended leg.

Steps: 1. Stand facing a wall about six inches away. **2.** Shifting your balance to your right foot, extend the left foot away from the wall, leaning your forearms against the wall for support. **3.** Hold for twenty seconds and switch sides.

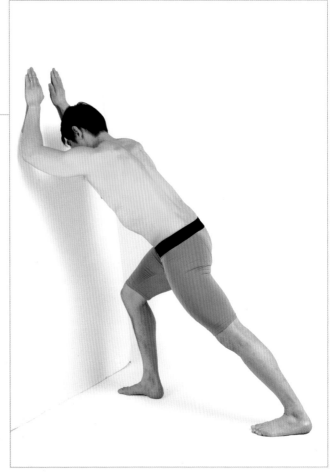

Achilles Stretch to Side

Target: Achilles.

Benefits: Lengthens the calf muscles and the Achilles tendons, and opens the groin and chest.

Steps: 1. Sit with your left leg extended to the side and your right foot tucked into the groin. **2.** Lean to the left and grab your left toes with your left hand. **3.** Reach your right arm across your back and grab your left hip to open the chest and shoulders. **4.** Gaze upward and hold for twenty seconds before alternating sides.

Note: If you are unable to reach your toes, try attaching a resistance band to the outstretched foot for an easier modification.

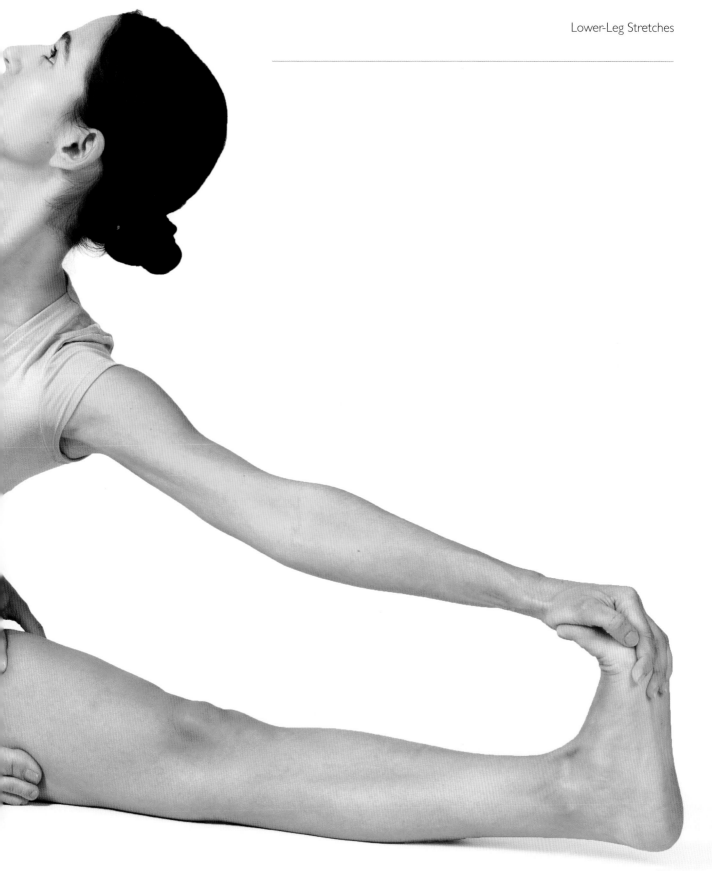

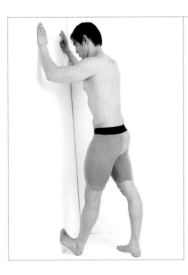

Ankle Flexion, Wall Supported

Target: Achilles.

Benefits: Anchors the body and targets the Achilles tendon of the extended leg.

Steps: 1. Stand facing a wall, at least a foot away. **2.** Lean your palms against the wall at shoulder height. **3.** Press your left toes into the wall, keeping your right heel flat on the floor. **4.** Lean your upper body toward the wall to heighten the stretch. **5.** Hold for thirty seconds on either foot.

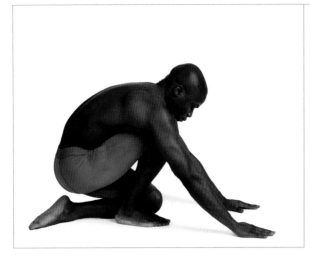

Ankle Stretch

Target: Achilles.

Benefits: Improves flexibility in the Achilles tendons and calf muscles.

Steps: 1. Begin by kneeling on the floor, palms flat on the floor in front of you. **2.** Raise your right knee and place your heel flat on the floor beneath your chest. **3.** Lean forward to increase pressure on the targeted muscles. **4.** Hold for twenty seconds and alternate sides.

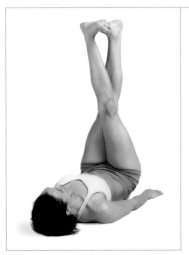

Heels-Apart Stretch

Target: Achilles.

Benefits: Targets the Achilles tendons and calf muscles while engaging the core.

Steps: 1. Lie flat on your back, feet extended straight upward. **2.** Cross your right leg in front of the other and bring the toes of both feet together. **3.** Making sure the toes remain touching, push the heels of your feet apart to heighten the effect of the stretch.

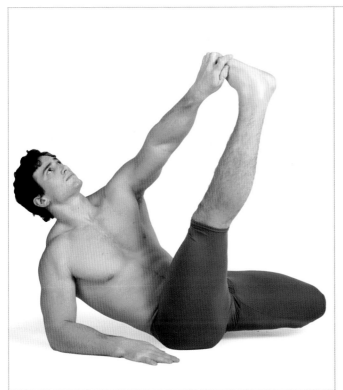

Reclined Achilles Stretch, Hand to Opposite Foot

Target: Achilles.

Benefits: Lengthens the calves and hamstrings while engaging the core.

Steps: 1. Start by kneeling, with your hips resting on your heels. **2.** Bring your right leg forward so your foot is flat on the floor and wrap your left leg behind you. **3.** Lean backward and rest on your right forearm. **4.** With your left hand, grab your right foot and extend your leg upward. **5.** Pull the extended leg toward your torso to intensify the stretch. Hold for twenty seconds and alternate sides.

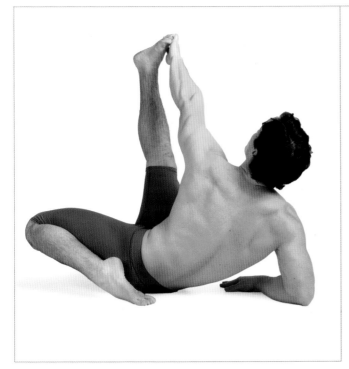

Reclined Achilles Stretch, Hand to Opposite Foot, Modification

Target: Achilles.

Benefits: Lengthens the Achilles tendons and calf muscles while putting pressure on the hamstring and groin.

Steps: 1. Start by kneeling, with your hips resting on your heels. **2.** Extend your right leg out to the side and tuck your left leg behind you. **3.** Grab your right foot with your left hand and pull the foot as you lean backward. **4.** Rest your right forearm flat on the floor for balance and hold for twenty seconds before alternating sides.

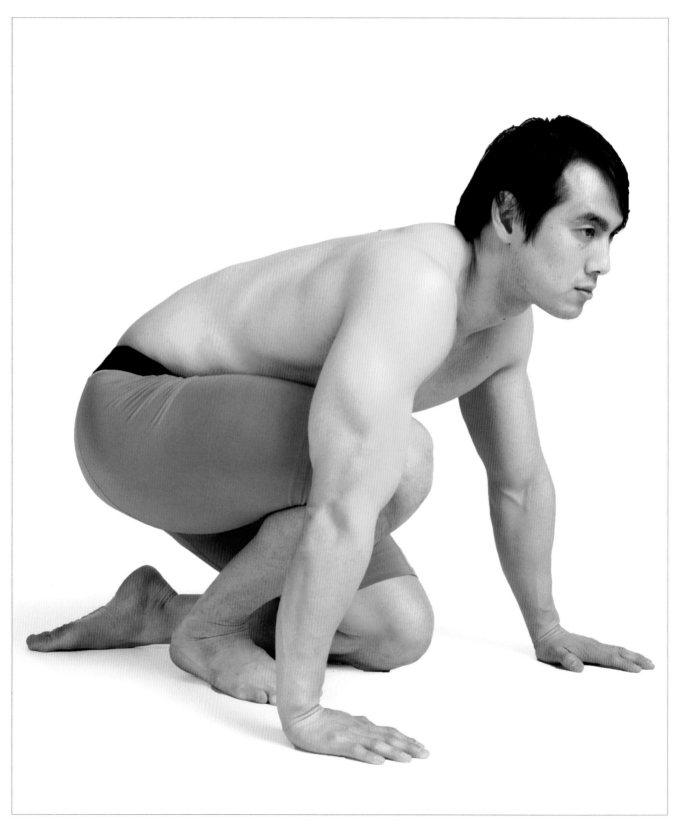

Sprinter Stretch

Target: Achilles.

Benefits: Lengthens and strengthens the ankle muscles.

Steps: 1. Begin in a kneeling position. **2.** Raise your right leg and place your foot flat on the floor in front of you, supporting your weight with both hands. **3.** Keeping your heel flat to the floor, lean forward to target the Achilles tendon. **4.** Hold for twenty seconds and alternate sides.

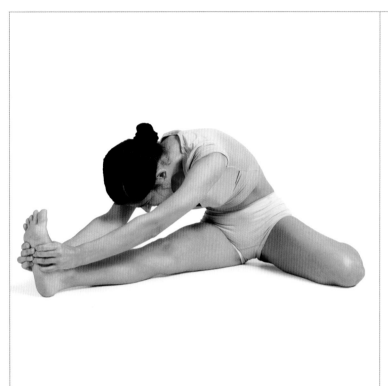

Seated Achilles Stretch, Hands to Foot, Advanced Modification

Target: Achilles.

Benefits: Lengthens the Achilles tendons and calf muscles while putting pressure on the hamstrings and groin.

Steps: 1. Start by kneeling, with your hips resting on your heels. **2.** Extend your right leg out to the side and tuck your left leg behind you. **3.** Grab your right foot with your hands and lean forward **4.** Pull back against the foot and hold for twenty seconds on each side.

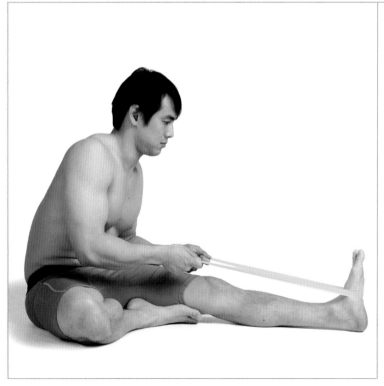

Seated Achilles Tendon Stretch, Modification with Resistance Band

Target: Achilles.

Benefits: Remedies tight or fatigued Achilles tendons and calf muscles.

Steps: 1. Begin seated with your left leg outstretched and the other bent inward. **2.** Attach a resistance band around your left foot and pull the resistance band toward you to intensify the stretch. **3.** Hold for twenty seconds on either side.

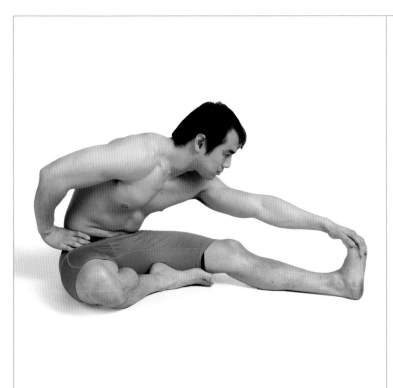

Seated Achilles Tendon Stretch

Target: Achilles.

Benefits: Remedies tight or fatigued muscles in the Achilles tendons and calf muscles.

Steps: 1. Begin seated with your left leg outstretched and the other bent inward. **2.** Lean forward, grabbing the toes of your outstretched leg with your left hand. **3.** Pull back on the toes to intensify the stretch and hold for twenty seconds before repeating on the other leg.

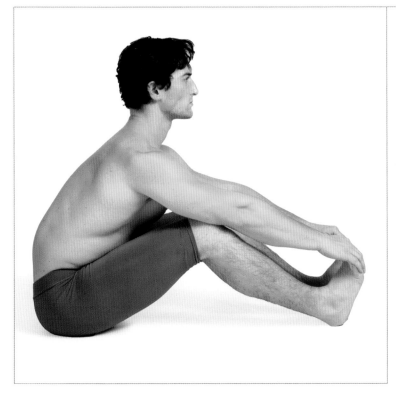

Toe-Pull Achilles Stretch

Target: Achilles.

Benefits: Targets the Achilles tendons and calf muscles.

Steps: 1. Start seated with both knees bent, your feet flat in front of you. **2.** Grab hold of your toes with both hands and attempt to straighten both legs.

Ankle Circles, Unsupported Variation

Target: Ankles.

Benefits: Increases range of motion in the ankle and improves balance.

Steps: 1. Begin standing upright, with your left leg raised from the floor, knee bent. **2.** Maintaining your balance on your right leg, slowly rotate your left toes clockwise, then counterclockwise, for thirty seconds with either foot.

Ankle Flexion, Lying

Target: Ankles.

Benefits: Lengthens the muscles in the ankles and shins.

Steps: 1. Lie flat on your back, with your arms at your sides. **2.** Point your toes as deeply toward the floor as you are able. **3.** Hold this position for fifteen seconds at a time.

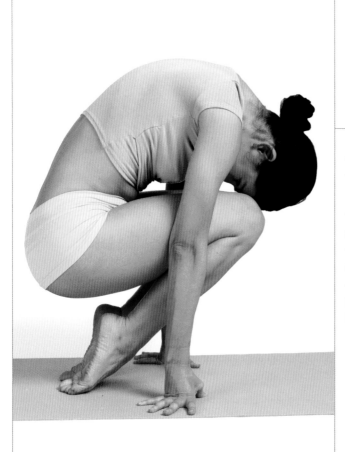

Ankle Stretch, Supported

Target: Ankles.

Benefits: Lengthens and strengthens muscles in the upper foot and ankle

Steps: 1. Begin in a crouching position, with your palms on the floor at your sides. **2.** Supporting your weight on your arms, reposition your feet so they are pointing behind you. **3.** Tuck your head into your knees and hold for thirty seconds.

Note: If this position proves difficult, try placing yoga blocks beneath either hand for an easier modification.

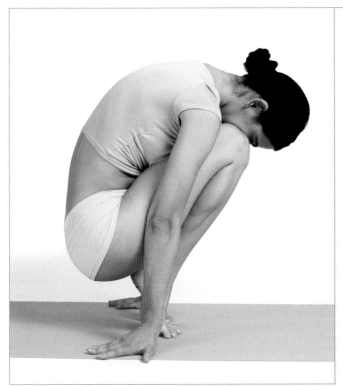

Ankle Stretch, Supported on Tiptoe

Target: Ankles.

Benefits: Lengthens and strengthens ankle muscles.

Steps: 1. Begin in a crouching position, palms on the floor at your sides. **2.** Turn your hands around so your fingers are pointed behind you and rise up onto tiptoes. **3.** From this position, lean forward to deepen the stretch for thirty seconds.

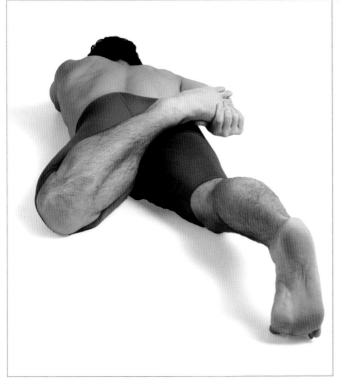

Prone Reverse Ankle Stretch

Target: Ankles.

Benefits: Relieves tightness and tension in the ankles.

Steps: 1. Start by lying flat on your stomach. **2.** Bend your left knee, so your foot approaches your back. **3.** Reach your right hand behind you and grab your left foot. **4.** Gently pull against the foot to increase pressure on the targeted muscles and hold for twenty seconds on either side.

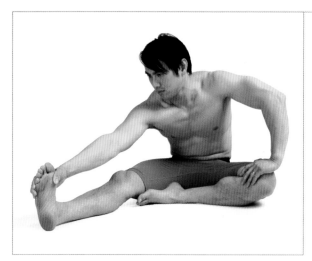

Anterior and Lower Leg

Target: Calves.

Benefits: Opens the groin and lengthens the muscles along the calves and hamstrings.

Steps: 1. Seated on the floor, bring your left foot into your groin and extend the other leg straight out. **2.** Lean your torso toward your right leg, reaching to grab hold of your toes. **3.** Gently pull back on your toes. **4.** Maintain this stretch for thirty seconds before switching sides.

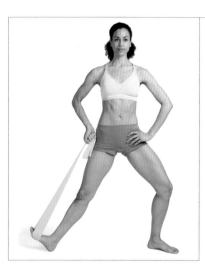

Band-Assisted Calf Stretch

Target: Calves.

Benefits: Lengthens the muscles along the leg.

Steps: 1. Begin by standing straight, attaching a resistance band around your right foot. **2.** Straighten the bound foot out to the side, heel to the floor. **3.** Pull the band up toward the body while bending the left knee to maximize the effect of the stretch. **4.** Hold for twenty seconds on each side.

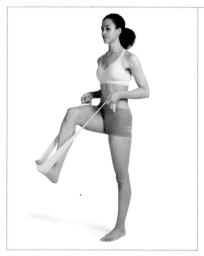

Band-Assisted Calf Stretch, Elevated

Target: Calves.

Benefits: Lengthens the calves and Achilles tendons while improving balance.

Steps: 1. Begin by standing straight. Attach a resistance band around your right foot. **2.** Lift the bound foot from the floor, until the knee reaches hip height. **3.** Pull the band up toward your body to deepen the effect of the stretch. **4.** Hold for twenty seconds on each side.

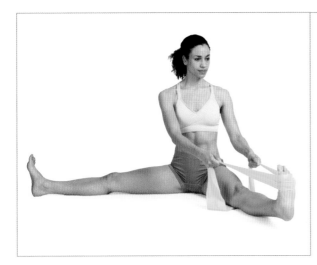

Band-Assisted Calf Stretch with Wide Pelvis Opener

Target: Calves.

Benefits: Targets the Achilles tendons and calf muscles while stretching open the pelvis.

Steps: 1. Begin seated, legs far apart. **2.** Attach a resistance band around your left foot and spread your legs farther apart. **3.** Using both hands, pull against the resistance of the band, bringing the bound toes toward your body. **4.** Maintain this stretch for thirty seconds before switching sides.

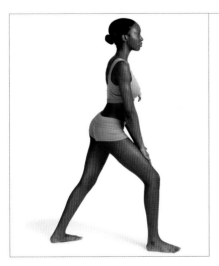

Basic Calf Stretch

Target: Calves.

Benefits: Increases flexibility in the calf and ankle muscles.

Steps: 1. Standing straight, step your right foot forward and bend the knee slightly.
2. Keeping both feet pointed forward, lean into the right knee to target the rear calf.
3. Hold this stretch for thirty seconds before switching sides.

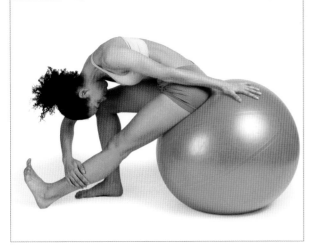

Calf and Upper-Back Stretch on Ball

Target: Calves.

Benefits: Lengthens the Achilles tendons and calves while relieving tightness in the upper back.

Steps: 1. Begin in a seated position on an exercise ball. **2.** Straighten your left leg forward, resting it on its heel. **3.** Lean forward, grabbing hold of your outstretched calf with your right hand.

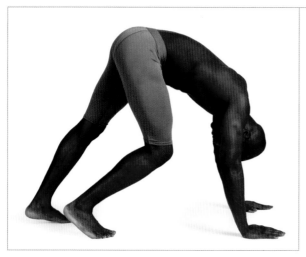

Calf Stretch, Alternating

Target: Calves.

Benefits: Increases strength and mobility in the calves and Achilles tendons.

Steps: 1. Start by kneeling on all fours, in the downward dog position, with your palms flat on the floor and fingers pointed ahead. **2.** Raise your hips up to the ceiling, straightening your legs and relaxing your neck. **3.** From this position, step your right foot forward, heel off the floor. **4.** Press against your right toes in order to intensify the targeted muscles. **5.** Step your foot back and repeat, alternating legs.

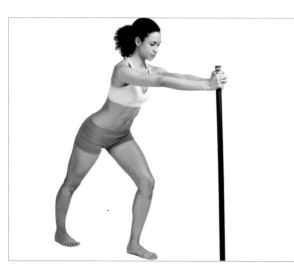

Calf Stretch, Body Bar, Supported

Target: Calves.

Benefits: Increases balance and engages the core.

Steps: 1. Begin by standing straight, holding the body bar upright in front of you with both hands. **2.** Using the bar for support, step your right foot away from the bar into a lunge. **3.** Keeping the back leg straight, bend the front leg into a deeper lunge to intensify the effect of the stretch. **4.** Hold for twenty seconds and alternate sides.

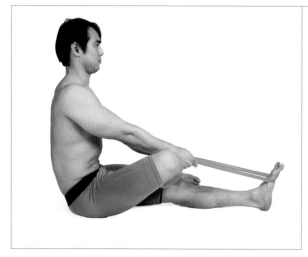

Calf Stretch, Cross-Legged

Target: Calves.

Benefits: Relieves tightness and tension in the calves.

Steps: 1. Begin seated, with your legs outstretched. **2.** Bend your right leg over the other, so your toes are flat on the floor beside the left knee. **3.** Attach a resistance band to your left foot, pulling back against the resistance of the band. **4.** Hold for twenty seconds and alternate sides.

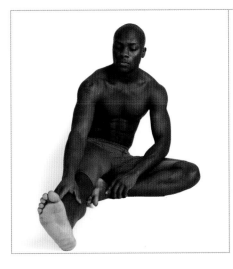

Calf Stretch, Seated

Target: Calves.

Benefits: Targets the calves and hamstrings and opens the pelvis.

Steps: 1. Seated on the floor, bring your left foot into your groin and extend the other leg straight out. **2.** Grab hold of your right ankle, leaning your torso forward to intensify the stretch. **3.** Hold for twenty seconds and alternate sides.

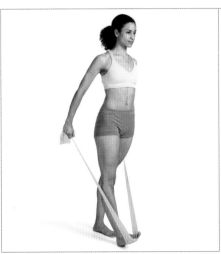

Calf Stretch, Standing with Band

Target: Calves.

Benefits: Lengthens the Achilles tendons and calves.

Steps: 1. Start by standing straight and attach a resistance band around your right foot. **2.** Keeping the heel of the bound foot on the floor, pull your right toes up toward the ceiling. **3.** Hold for twenty seconds and alternate sides.

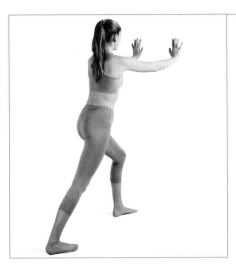

Calf Stretch, Wall Supported

Target: Calves.

Benefits: Targets the calf muscles and Achilles tendons.

Steps: 1. Begin facing a wall, feet shoulder-width apart. **2.** Resting your palms on the wall for support, step your right foot away from the wall into a lunge. **3.** Keeping the right leg straight, bend the front leg into a deeper lunge to intensify the stretch. **4.** Hold for twenty seconds and alternate sides.

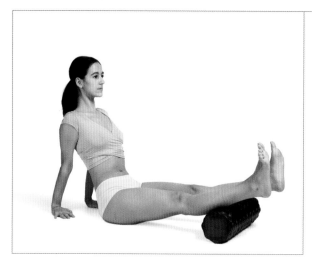

Double-Calf Stretch on Roller

Target: Calves.

Benefits: Relieves tight and fatigued calf muscles.

Steps: 1. Begin seated and place a foam roller beneath your calves. **2.** Pressing your palms to the floor for support, roll up and down across the length of the calves.

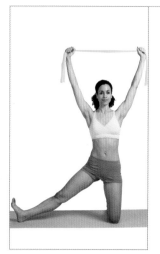
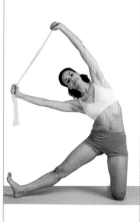

Extended Hamstring-Calf Stretch with Arm Stretch Overhead

Target: Calves.

Benefits: Relieves tightness in the calves and hamstrings while strengthening the triceps and engaging the core.

Steps: 1. Kneel on the floor and hold a resistance band in both hands. **2.** Extend your right leg out to the side, resting it on its heel. **3.** Raise the band overhead and stretch your arms apart. **4.** Lean to the right and hold for twenty seconds.

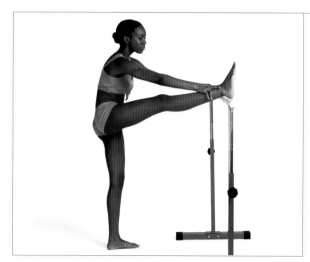

Forward-Bend Calf Stretch at Ballet Bar

Target: Calves.

Benefits: Lengthens the muscles in the calves and hamstrings.

Steps: 1. Begin by facing a ballet bar, set just above waist height. **2.** Lift your right leg from the floor, resting your ankle on the bar. **3.** Holding onto your ankle, lean in toward the bar in order to intensify the stretch. **4.** Hold for twenty seconds on either leg.

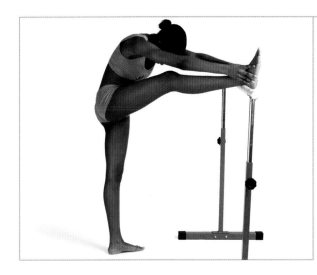

Forward Bend, Head to Knee at Ballet Bar

Target: Calves.

Benefits: Lengthens the muscles in the calves and hamstrings.

Steps: 1. Begin by facing a ballet bar that is set at waist height.
2. Lift your right leg from the floor, resting your ankle on the bar.
3. Place your hands on your ankle and lean your head to your knee.
4. Hold for twenty seconds on either leg.

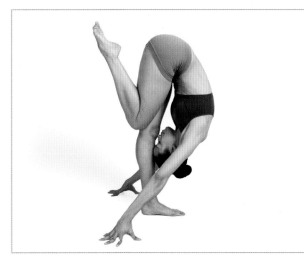

One-Legged Intense-Stretch Pose 1

Target: Calves.

Benefits: Extends the muscles along the calves, spine, neck, and shoulders while improving balance.

Steps: 1. Stand straight and bend your right knee, so your foot rests near the back of your hips. **2.** Bend forward from the waist into a forward bend. Place both hands on the floor and bring your head to your left shin. **3.** Extend your arms, so they are straight and your fingers are resting on the floor behind your left foot. **4.** Hold this position for thirty seconds, before attempting on the opposite side.

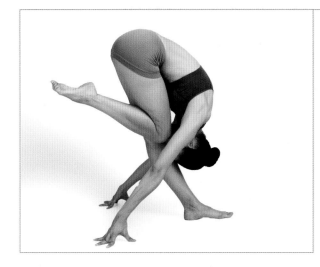

One-Legged Intense-Stretch Pose 2

Target: Calves.

Benefits: Extend the muscles along the calves, spine, neck, and shoulders while improving balance.

Steps: 1. Stand straight and bend your right knee, so your foot rests near the back of your hips. **2.** Fold your torso into a forward bend. Place both hands on the floor and bring your head to your shin. **3.** Extend your arms down, resting your fingers on the floor behind your foot. **4.** Lean your body backward, away from your left foot. Bend your elbows, if necessary. **5.** Hold this position for fifteen seconds, before attempting on the opposite side.

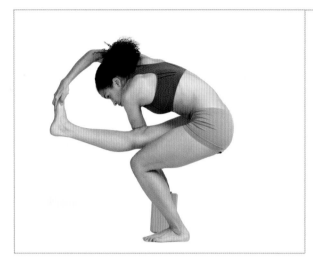

One-Legged Squat, Revolved Twist Reverse

Target: Calves.

Benefits: Stabilizes the muscles in the hips and pelvis while lengthening the calves and hamstrings and improving balance.

Steps: 1. Stand with arms extended out in front. **2.** Raise your right foot from the floor and grab hold of your toes with your right hand. **3.** Attempt to lift and straighten your right leg while squatting down low on your left leg. **4.** Lean your right hand on a yoga block for support, if necessary. **5.** Hold this balancing pose for twenty seconds before switching sides.

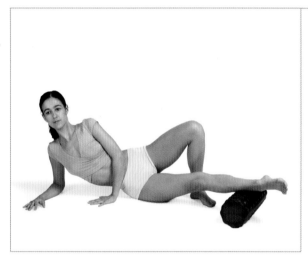

Peroneal Stretch on Roller

Target: Calves.

Benefits: Relieves tight and fatigued muscles in the side of the calves.

Steps: 1. Lie down on your right side and place a foam roller beneath the right calf. **2.** Using your arms and upper leg for support, lift your hips and roll across the length of the calf to target any troubled muscles. **3.** Repeat on the opposite side.

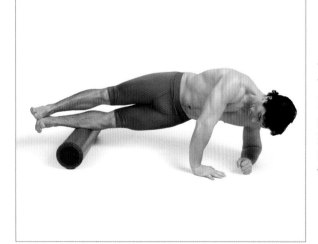

Peroneal Stretch on Roller, Advanced

Target: Calves.

Benefits: Requires increased core and arm strength.

Steps: 1. Lie down on your left side and place a foam roller beneath your left calf. **2.** Using your arms for support, lift your hips and roll across the length of your left calf to target any troubled muscles. **3.** Repeat on the opposite side.

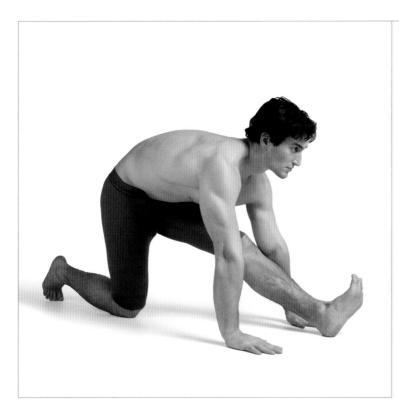

Side Split, Modification

Target: Calves.

Benefits: Opens the hips and lengthens the muscles along the calves.

Steps: 1. Begin by kneeling upright. Lift your left knee from the floor and extend your leg straight out. **2.** Lean your torso forward and place your hands on the floor. **3.** Press down against your left leg to increase pressure on the calf. **4.** Hold this position for thirty seconds before switching legs.

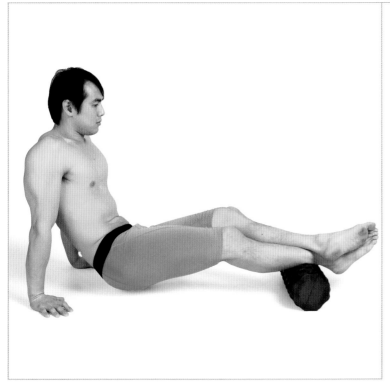

Single-Calf Stretch on Roller

Target: Calves.

Benefits: Relieves tight and fatigued calf muscles.

Steps: 1. Begin seated and place a foam roller beneath your calves. **2.** Cross your left leg over the other at the ankles. **3.** Pressing your palms to the floor for support, roll up and down along the length of the lower calf.

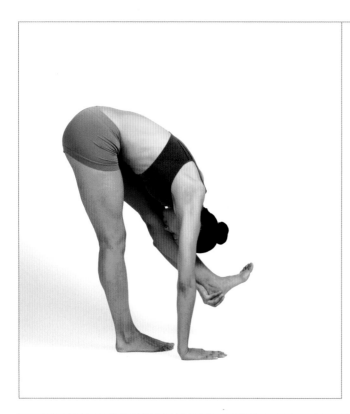

Standing Foot-Raise Stretch

Target: Calves.

Benefits: Lengthens the muscles in the calves and hamstrings, reducing tightness and increasing mobility.

Steps: 1. Stand with your arms shoulder-width apart. **2.** Fold forward at the waist into a forward bend. Place both palms on the floor in front of your toes. **3.** Reach your left hand around your leg and grab hold of your left heel. **4.** Keeping your left leg straight, pull it up from the floor by the heel. Place your head on your raised left shin. **5.** Hold this pose for fifteen seconds before attempting to repeat on opposite leg.

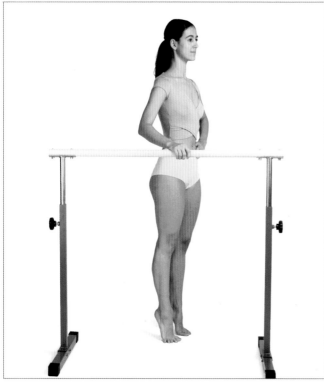

Toe Raise

Target: Calves.

Benefits: Strengthens the muscles in the calves.

Steps: 1. Stand to the right side of a ballet bar, legs together. **2.** Using the bar for support, rise up onto tiptoes. **3.** Hold this position for twenty seconds to strengthen the muscles in the calves.

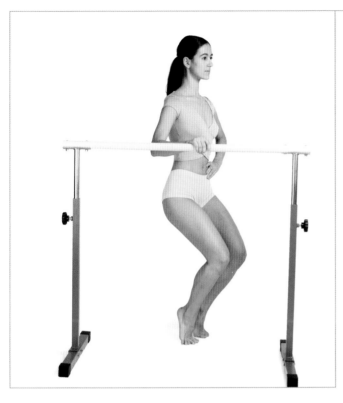

Toe Raise and Squat

Target: Calves.

Benefits: Strengthens the muscles in the calves and quadriceps.

Steps: 1. Stand to the side of the ballet bar, legs together. **2.** Using the bar for support, rise onto tiptoes. **3.** Remaining on tiptoes, bend the knees to a squat pose. **4.** Hold this position for twenty seconds to strengthen the muscles in the calves and quadriceps.

Western Intense Half-Bound Lotus-Stretch Pose

Target: Calves.

Benefits: Opens the hips and lengthens the muscles in the calves, hamstrings, and spine.

Steps: 1. Sit on the floor with both legs straight out ahead of you. Bend your left leg in and tuck your foot into your groin. **2.** Reach your left hand around your back and grab hold of your right hip a half-bound position. **3.** Lean your torso forward at the waist and grab hold of your right toes with your right hand. **4.** Gently pull back on the toes of your right foot to intensity the calf stretch. **5.** Continue this exercise for thirty seconds before switching legs.

Anterior Foot-and-Toe Stretch

Target: Feet.

Benefits: Relieves tightness and tension in the upper foot and toes.

Steps: 1. Standing straight, curl your left foot forward, resting on the tops of the toes. **2.** Press against the toes to intensify the effect of the stretch and alternate feet.

Anterior-Foot Stretch

Target: Feet.

Benefits: Lengthens the muscles in the shins and feet.

Steps: 1. Standing straight, curl your left foot out so you are resting on the outer length of the foot. **2.** Press against the foot to deepen the stretch and alternate feet.

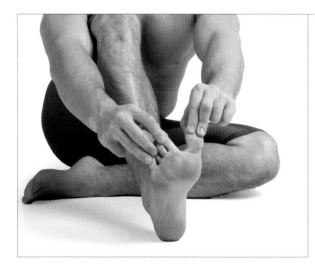

Big Toe Stretch

Target: Feet.

Benefits: Lengthens the muscles of the big toe.

Steps: 1. Sit with your right leg bent in front of you, toes raised from the floor. **2.** Holding the big toe with your left hand and the rest of the toes with your right hand, pull the big toe away from the others. **3.** Repeat on the other foot.

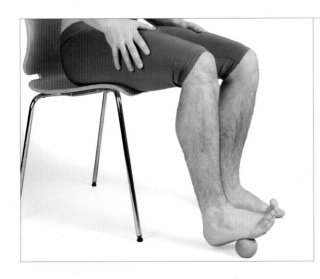

Foot Reliever

Target: Feet.

Benefits: Relieves pain and tension in the muscles of the foot.

Steps: 1. Sit on a chair and place a tennis ball beneath your right foot. **2.** Roll the ball, putting pressure on any troubled areas of the foot. **3.** Repeat on the other foot.

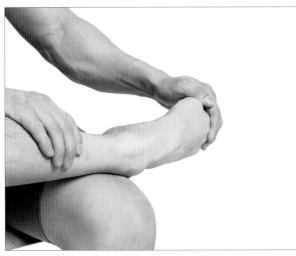

Sickle-Foot Stretch

Target: Feet.

Benefits: Lengthens the muscles in the shins and bridge of the feet.

Steps: 1. Sit on a chair and cross your legs, raising your right foot to rest on the left knee. **2.** Supporting the ankle, pull the toes of the raised foot inward toward the body. **3.** Repeat on the other foot.

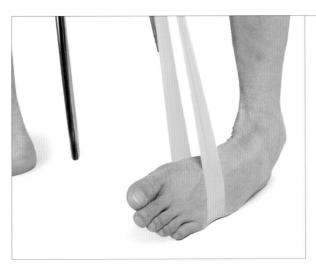

Sickle-Foot Stretch, Band Assisted

Target: Feet.

Benefits: Lengthens the muscles in the shins and bridge of the feet.

Steps: 1. Seated on a chair, attach a resistance band around one foot. **2.** Curl the bound foot inward, so the outer length of the foot is against the floor. **3.** Pull the band up away from the foot to increase the effect of the stretch. **4.** Repeat on the other foot.

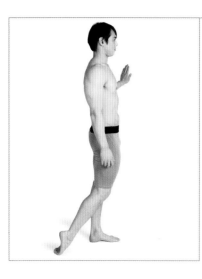

Sickle Stretch Standing, Wall Supported

Target: Feet.

Benefits: Relieves tightness in the shins and feet.

Steps: 1. Stand next to a wall at your left side. **2.** Rest your left palm against the wall for support and curl your right foot in until you are resting on the outer toes. **3.** Press against the curled toes to deepen the stretch and alternate sides.

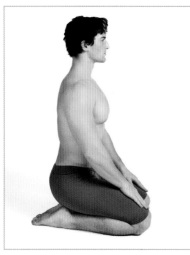

Tibialis Self-Stretch, Modification

Target: Feet.

Benefits: Relieves tightness in the shins and feet.

Steps: 1. Begin on your knees, feet pointed behind you. **2.** Lower your torso so your hips are resting on your heels. **3.** Hold for thirty seconds.

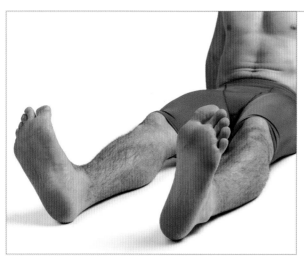

Toe and Calf Flex

Target: Feet.

Benefits: Flexes the muscles in the feet and calves.

Steps: 1. Begin seated with legs straight ahead. **2.** Flex your feet, pulling your toes in toward your body. **3.** Hold the stretch for thirty seconds.

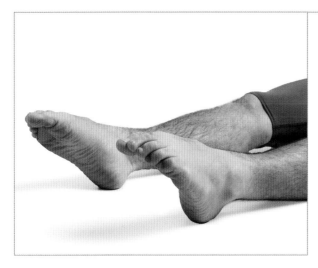

Toe and Calf Point

Target: Feet.

Benefits: Elongate the muscles in the shins and upper feet.

Steps: 1. Begin seated with your legs straight ahead. **2.** Point your feet, pressing your toes to the floor. **3.** Hold for thirty seconds.

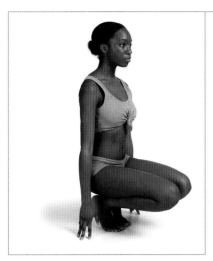

Toe Flexor, Knees-off-Floor Balance

Target: Feet.

Benefits: Strengthens the muscles of the feet, calves, and quads while engaging the core.

Steps: 1. Lower your body into a crouching position, raised on tiptoes. **2.** Keep your arms at your sides and back straight to increase the stretch. **3.** Hold for thirty seconds.

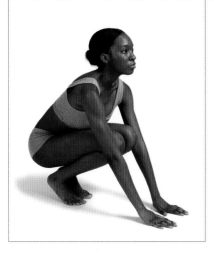

Toe-Flexor Stretch, Knees off Floor

Target: Feet.

Benefits: Lengthens the Achilles tendons and the muscles in the feet.

Steps: 1. Lower your body into a crouching position, raised on tiptoes. **2.** Placing your palms flat on the floor ahead, lower your heels toward the floor to increase the effect of the stretch. **3.** Hold for thirty seconds.

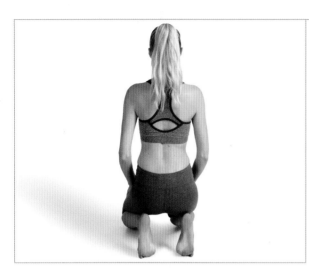

Toe-Flexor Stretch, Knees on Floor

Target: Feet.

Benefits: Lengthens the Achilles tendons and the muscles in the feet.

Steps: 1. Start on your knees, your toes pointed behind you.
2. Lean forward, raising your feet out so you are resting on tiptoes.
3. Lean you weight back to increase pressure on the toes and feet.
4. Hold for thirty seconds.

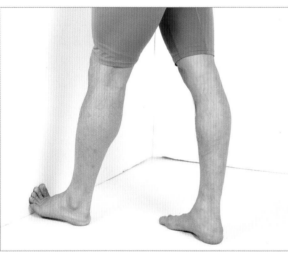

Toe Flexor to Wall

Target: Feet.

Benefits: Lengthens the Achilles tendons and the muscles in the feet.

Steps: 1. Begin facing a wall, feet shoulder-width apart. **2.** Step your left foot in, raising your toes against the wall. **3.** Keeping your leg straight, lean in toward the wall to deepen the stretch. **4.** Hold for thirty seconds.

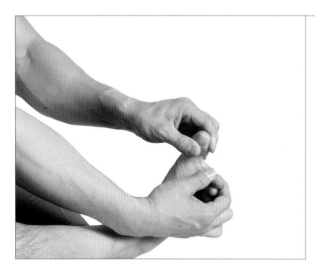

Toe Stretch, Seated

Target: Feet.

Benefits: Stimulates the muscles between the toes.

Steps: 1. Seated on a chair, cross your legs raising one foot to rest on the opposite knee. **2.** Pull the toes of the raised foot in opposite directions. **3.** Repeat on the opposite foot.

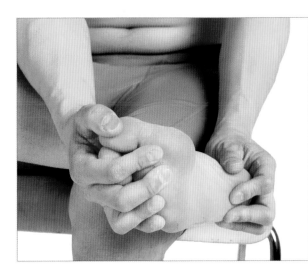

Wing-Foot Stretch

Target: Feet.

Benefits: Lengthens the Achilles tendons and the muscles in the feet.

Steps: 1. Seated on a chair, cross your legs, resting your right foot on the opposite knee. **2.** Supporting the ankle, pull the toes of the foot up away from the heel. **3.** Repeat on the other foot.

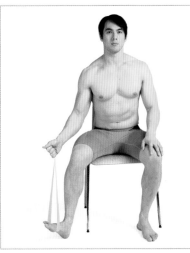

Wing-Foot Stretch with Band

Target: Feet.

Benefits: Lengthens the Achilles tendons and the muscles in the feet.

Steps: 1. Seated on a chair, attach a resistance band to your right foot. **2.** Pull the foot down against the resistance of the band. **3.** Hold for twenty seconds on either foot.

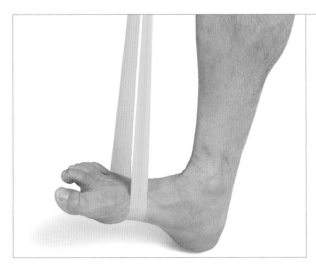

Wing-Foot Stretch with Band, Zoomed

Target: Feet.

Benefits: Lengthens the Achilles tendons and the muscles in the feet.

Steps: 1. Seated on a chair, attach a resistance band to your right foot. **2.** Pull the foot down against the resistance of the band. **3.** Hold for twenty seconds on either foot.

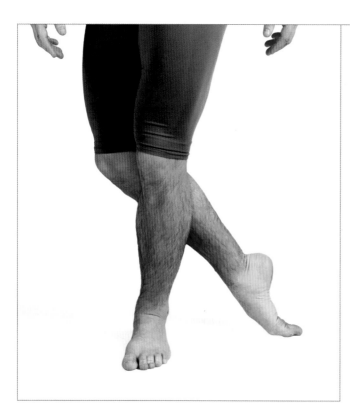

Foot-Raised Shin Stretch

Target: Shins.

Benefits: Lengthens the muscles along the shins to improve the flexibility of your lower legs, ankles, and feet.

Steps: 1. Standing straight, step your right foot behind your left. **2.** Roll onto the top of your right foot, so the sole of your foot is facing upward. **3.** Slowly bend your left knee to increase the targeted stretch. **4.** Hold for twenty seconds before alternating legs.

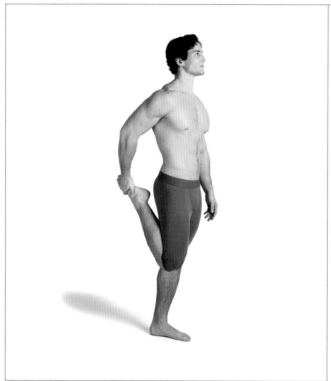

Heel-to-Glute Walking Stretch

Target: Shins.

Benefits: Stretches the muscles along the shin, improving flexibility and reducing tightness in the lower leg.

Steps: 1. Stand straight with good posture in the back and shoulders. **2.** Bend your right leg, raising your foot up to the back of your hips. Grab hold of your raised foot with your right hand. **3.** Gently pull your foot up away from your knee. **4.** Maintain this position for twenty seconds before switching legs.

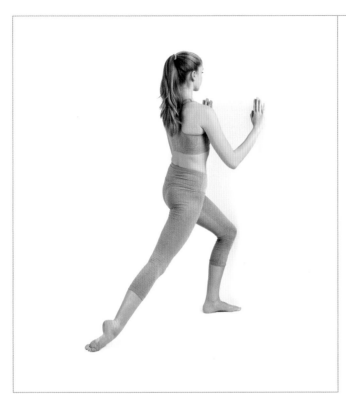

Instep Stretch at Wall

Target: Shins.

Benefits: Lengthens the muscles along the shins and improves the flexibility of your lower legs, ankles, and feet.

Steps: 1. Standing straight, step your right foot out behind you. **2.** Roll onto the top of your right foot, so the sole of your foot is facing upward. **3.** Slowly bend your left knee to increase the targeted stretch. Place your hands against the wall for support. **4.** Hold for twenty seconds before alternating legs.

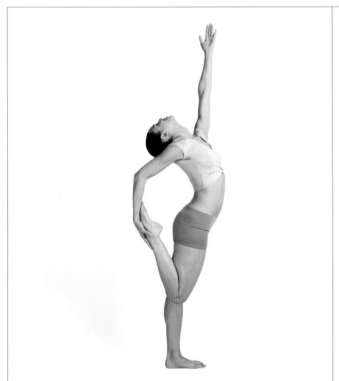

Lord of the Dance Pose

Target: Shins.

Benefits: Improves flexibility in the lower legs while improving balance and opening the neck and chest.

Steps: 1. Stand straight with good posture in the back and shoulders. **2.** Bend your right leg, raising your foot up to the back of your hips. Grab hold of your raised foot with your right hand. **3.** Gently pull your foot up away from your knee, bending your elbow and dropping your shoulders back to open your chest. **4.** Extend your left arm straight up toward the ceiling and drop your head back to your shoulders to complete the stretch. **5.** Maintain this position for twenty seconds before switching sides.

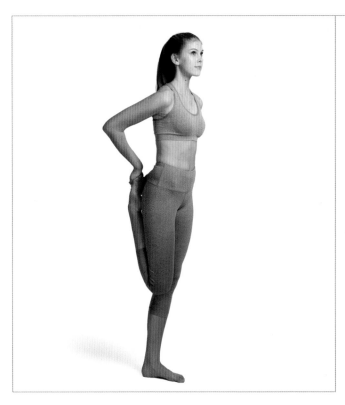

Lord of the Dance Pose Prep

Target: Shins.

Benefits: Improves flexibility in the lower legs while improving balance and opening the neck and chest.

Steps: 1. Stand straight with good posture in the back and shoulders. **2.** Bend your right leg, raising your foot up to the back of your hips. Grab hold of your raised foot with your hands. **3.** Gently pull your foot up away from your knee, bending your elbow and opening your chest. **4.** Hold for twenty seconds and repeat on the opposite leg.

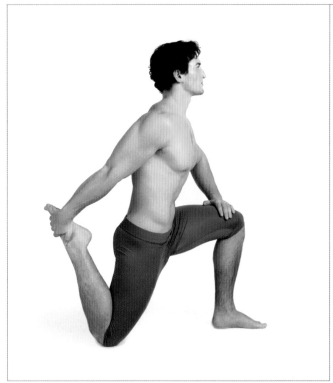

Lunge with Raised Rear Foot

Target: Shins.

Benefits: Opens the hips and lengthens the muscles along the shin.

Steps: 1. Begin by kneeling upright. Step your left leg forward so your knee is bent and your foot is flat on the floor ahead of you. **2.** Raise your right foot up behind you and reach your right hand back to grab hold of your right foot. Gently pull your foot into your hips to increase the shin stretch. **3.** Hold this pose for thirty seconds before switching sides.

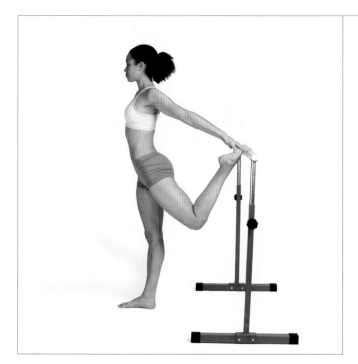
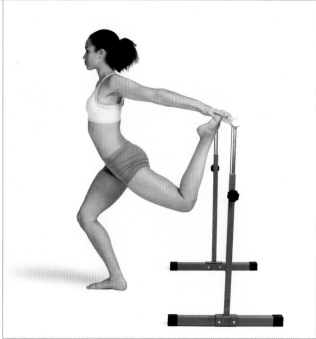

Shin Stretch at Ballet Bar

Target: Shins.

Benefits: Improves flexibility in the lower legs while improving balance and opening the neck and chest.

Steps: 1. Stand straight with good posture, facing away from a ballet bar. **2.** Bend your left leg back, raising your foot up onto the ballet bar. Reach behind you to hold the bar with both hands. **3.** Bend your right knee to intensify the stretch on your raised shin and open the chest. **4.** Hold this pose for thirty seconds before switching legs.

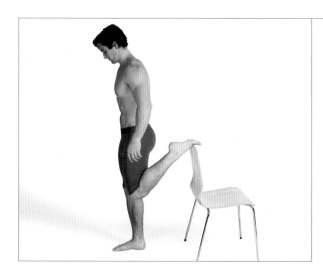

Shin Stretch, Chair Assisted

Target: Shins.

Benefits: Improves flexibility in the lower legs while improving balance and opening the neck and chest.

Steps: 1. Stand straight, facing away from the back of a chair. **2.** Bend your left leg behind you, raising your foot so your toes rest on the back of the chair. **3.** Bend your right knee to intensify the stretch on your raised shin. **4.** Hold this pose for thirty seconds before switching legs.

Shin Stretch, Kneeling

Target: Shins.

Benefits: Lengthens the muscles in the shins and quadriceps.

Steps: 1. Begin by kneeling upright. Place your hands on the floor at your sides. **2.** Lower your hips down onto your heels, so the tops of your feet are flat on the floor. **3.** Lean your shoulders back, away from your knees, to deepen the stretch. **4.** Hold this pose for thirty seconds.

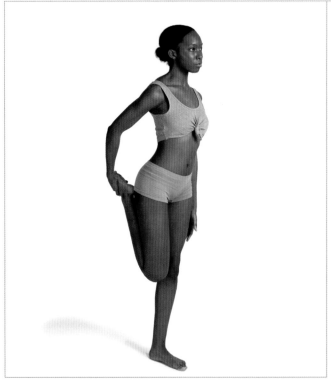

Thigh Stretch, Foot Behind, One-Legged

Target: Shins.

Benefits: Stretches the muscles in the shins, improving flexibility and reducing tightness in the lower leg.

Steps: 1. Stand straight with good posture in the back and shoulders. **2.** Bend your right leg, raising your foot up to the back of your hips. Grab hold of your raised foot with your right hand. **3.** Gently pull your foot up away from your knee. **4.** Maintain this position for twenty seconds before switching legs.

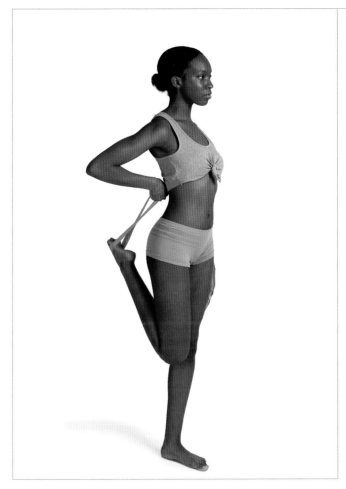

Thigh Stretch, Foot Behind, One-Legged with Band

Target: Shins.

Benefits: Stretches the muscles in the shins, improving flexibility and reducing tightness in the lower leg.

Steps: 1. Stand straight with good posture in the back and shoulders. **2.** Bend your right leg, raising your foot up to the back of your hips. Attach a resistance band around your raised foot and hold the other end of the band behind you with your right hand. **3.** Gently pull the band upward, bending your right elbow. **4.** Maintain this position for twenty seconds before switching legs.

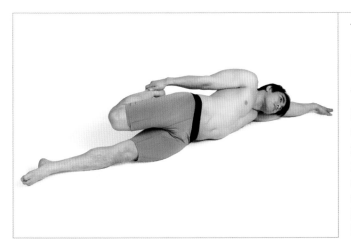

Thigh Stretch, Hand-to-Foot Reverse, Lying

Target: Shins.

Benefits: Stretches the muscles in the shins, improving flexibility and reducing tightness in the lower legs.

Steps: 1. Lie on your left side with your legs straight and your left arm up straight above your head. **2.** Bend your right leg, raising your foot up to the back of your hips. Grab hold of your raised foot with your right hand. **3.** Gently pull your foot up away from your knee. **4.** Maintain this position for twenty seconds before switching sides.

Specialist Stretches

Dance Stretches

Dynamic Stretches

Partner Stretches

Yoga Stretches

Pregnancy Stretches

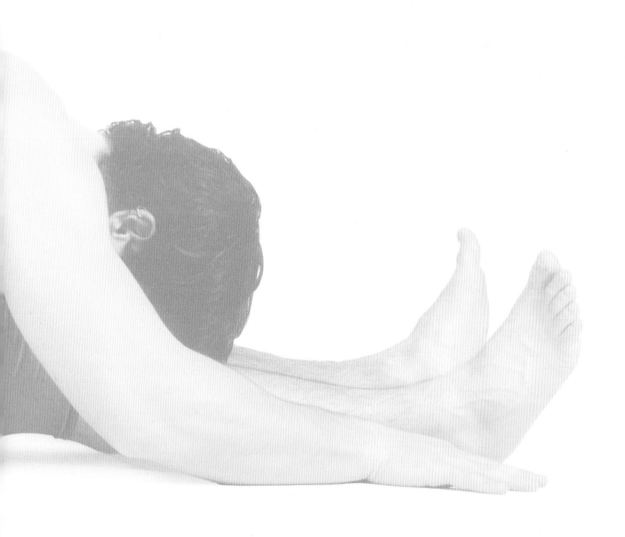

Dance Stretches

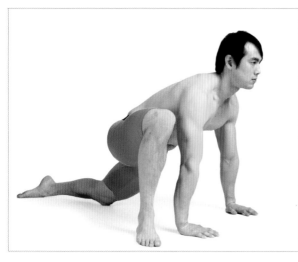

Advanced Dancer's Lunge

Target: Adductors.

Benefits: Deeply opens the hips and lengthens the leg muscles.

Steps: 1. Begin on all fours, with your palms flat on the floor.
2. Bring your right knee off the floor up to your right shoulder.
3. Step your left foot behind you and rest your left shin flat
on the floor. **4.** Hold this position for fifteen seconds before
alternating sides.

Plié Stretch

Target: Adductors.

Benefits: Lengthens the muscles in the lower legs while strengthening the upper legs.

Steps: 1. Stand with your heels apart and your toes pointed out. Hold your hands just below
either hip, with your elbows slightly bent. **2.** Raise your arms straight out to your sides and bend
your knees, lowering your hips toward the floor in a squat position. **3.** Return your hips and
arms back to the starting position and repeat this motion thirty times.

Ballet Stretch with Band 1

Target: Adductors.

Benefits: Opens the chest and shoulders while strengthening the upper legs and improving balance.

Steps: 1. From a standing position, attach a resistance band around your left foot and hold the ends of the band with your left hand.
2. Raise your left hand behind you as you lift your leg from the floor and lean your torso forward. **3.** Continue to bend your body forward into this balancing pose, until your left foot is pointing toward the ceiling. **4.** Extend your right arm toward the floor and hold this pose for twenty seconds before switching legs.

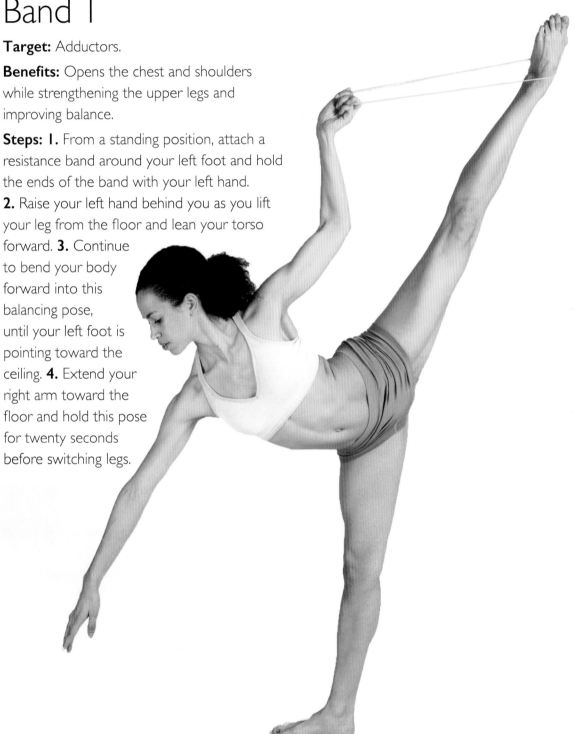

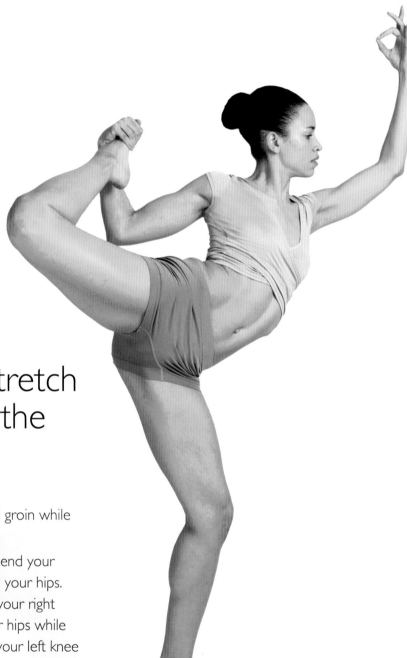

Intense Ankle Stretch Tiptoe, Lord of the Dance Pose

Target: Adductors.

Benefits: Deeply opens the hips and groin while improving balance and leg strength.

Steps: 1. From a standing position, bend your right knee and raise your foot behind your hips. **2.** Grab hold of your right foot with your right hand and pull your leg up above your hips while leaning your torso forward. **3.** Bend your left knee slightly and lift up onto your toes as you raise your left arm overhead to find your balance in this pose. **4.** Hold this pose for fifteen seconds before attempting to switch legs.

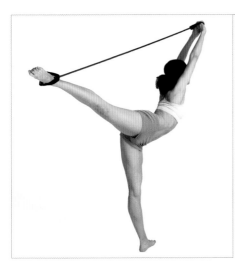

Ballet Stretch with Band 2

Target: Balance.

Benefits: Opens the chest and shoulders while strengthening the upper legs and improving balance.

Steps: 1. Attach a handled resistance band around your right foot and hold the other end of the band with both hands. **2.** Raise your hands straight above your head as you extend your right leg out behind you. **3.** Keeping your arms and legs straight, lean your torso forward and raise your right foot up to shoulder height. **4.** Hold this balancing pose for twenty seconds before switching legs.

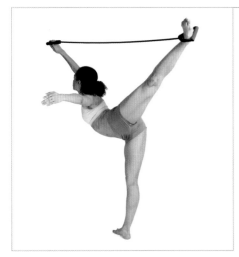

Ballet Stretch with Band 3

Target: Balance.

Benefits: Opens the chest and shoulders while strengthening the upper legs and improving balance.

Steps: 1. Attach a handled resistance band around your left foot and hold the other end of the band with your right hand. **2.** Raise your right hand straight above your head as you extend your left leg out behind you. **3.** Keeping your arms and legs straight, lean your torso forward and raise your left foot above shoulder height. **4.** Hold this balancing pose for twenty seconds before switching legs.

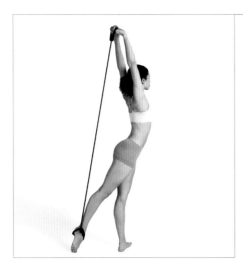

Ballet Stretch with Band 4

Target: Chest opener.

Benefits: Opens the chest and shoulders while strengthening the upper legs.

Steps: 1. Attach a handled resistance band around your right foot and hold the other end of the band with both hands. **2.** Raise your hands straight above your head as you extend your right leg out behind you. **3.** Keeping your arms and legs straight, raise and lower your foot behind you. **4.** Perform twenty repetitions before switching legs.

Pose Inspired by Shiva's Vigorous Cycle of Life Dance

Target: Chest opener.

Benefits: Opens the chest and shoulders while lengthening the abductor muscles.

Steps: 1. Stand straight, with your hands clasped above your head. Cross your right leg behind your left leg, keeping both feet flat on the floor.
2. Lean your torso back and to the left, and shift your gaze behind you.
3. Hold this pose for fifteen seconds.

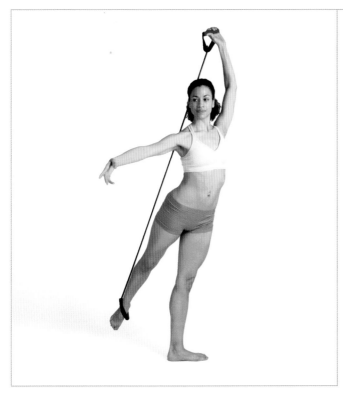

Ballet Stretch with Band 5

Target: Chest opener.

Benefits: Opens the chest and shoulders while strengthening the upper legs.

Steps: 1. Attach a handled resistance band around your right foot and hold the other end of the band with your left hand. **2.** Raise your left hand straight above your head and extend your right leg out behind you. **3.** Keeping your arms and legs straight, lift and lower your foot behind you. **4.** Perform twenty repetitions before switching legs.

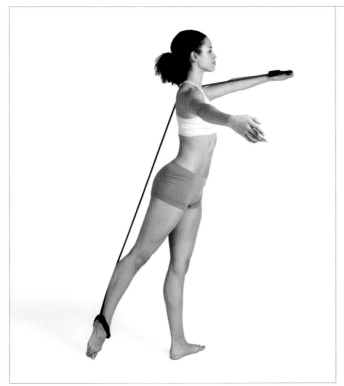

Ballet Stretch with Band 6

Target: Glutes.

Benefits: Opens the chest and shoulders while strengthening the upper legs.

Steps: 1. Attach a handled resistance band around your right foot and hold the other end of the band with your left hand. **2.** Raise your hands straight out to your sides at shoulder height and extend your right leg out behind you. **3.** Keeping your arms and legs straight, raise and lower your foot behind you. **4.** Perform twenty repetitions before switching legs.

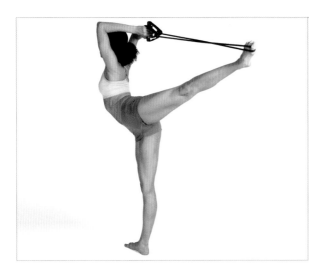

Ballet Stretch with Band 7

Target: Glutes.

Benefits: Opens the hips and groin while strengthening the glutes and quadriceps.

Steps: 1. Standing up straight, bend your left knee and bring your foot up behind your hips. **2.** Attach a resistance band around your raised foot and hold the ends of the band with both hands. **3.** Raise your arms up and over your head as you straighten your bound leg out behind you. **4.** Attempt to pull your leg down toward the floor against the resistance of the band. **5.** Perform this exercise for fifteen seconds before alternating legs.

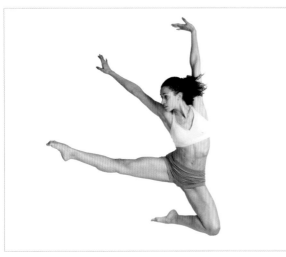

Jump Center-Split, Left Leg Bent

Target: Hamstrings and upper back.

Benefits: Increases leg strength and upper-back flexibility.

Steps: Swing your right leg straight up to your side while you deeply bend the left knee and swing your arms up to the sky with an upward thrust of energy. For a higher jump, take a few quick jog-runs in preparation for swinging up your right leg.

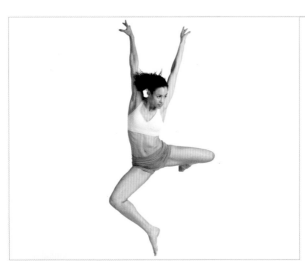

Jump Double Bison

Target: Quadriceps, calves, and lower back.

Benefits: Facilitates quadricep and calf strength while developing lower-back flexibility.

Steps: Stand in place and plié, or bend, your knees deeply with the heels of your feet together. Jump up high and swing your front and back legs away from each other into 90-degree splits. To aid in the height of the jump, simultaneously extend the arms up from the sides of your body.

Jump First Position

Target: Core and quadriceps, and hamstrings.

Benefits: Strengthens abdominals and aides with lightness in the body.

Steps: Stand with feet together and, in one explosive movement, push off both feet and spring directly up into the air, squeezing your core muscles in toward your spine.

Dart Jump

Target: Core, quadriceps, and hamstrings.

Benefits: Strengthens the core and leg muscles, and helps increase hamstring flexibility.

Steps: Take a few brisk runs and leap into the air as if jumping over a hurdle while bending your front leg forward and kicking the back leg straight behind you. This jump is a half-split in the air.

Jump Parallel Passé

Target: Core, calves, and quadriceps.

Benefits: Strengthens the legs and calves, and develops a strong core.

Steps: With both feet together, jump straight up into the air and quickly pull up your right leg and bend into a passé at the knee, all while keeping the opposite leg straight. Swing arms up from the sides while doing this jump to aid with the height of the jump.

Jump Second Position

Target: All core muscles and leg muscles.

Benefits: Develops a solid core and assists with other explosive-quick exercise moves.

Steps: Stand with your feet together and arms at your sides. In one big movement, jump up into the air and swing your arms and legs straight open simultaneously, and return your legs and arms back together into the starting position.

Pose Inspired by Parvati's Vigorous Cycle of Life Dance 1

Target: Obliques.

Benefits: Deeply lengthens the muscles along the obliques and abductors while opening the chest and shoulders.

Steps: 1. Begin by standing up straight. **2.** Cross your left leg behind your right, straighten it far out to the side, and bend your right knee slightly. **3.** Place your right hand on your right hip for support and cross your left arm overhead. **4.** Lean your shoulders back and to the right. **5.** Maintain this stretch for thirty seconds before alternating sides.

Side-Stretch Plié

Target: Obliques.

Benefits: Opens the hips while strengthening the upper legs and extending the obliques.

Steps: 1. Stand with your heels apart and your toes pointed out. Hold your hands just below either hip with your elbows slightly bent. **2.** Bend your knees, lowering your hips toward the floor. **3.** Drop your left hand to your left knee and extend your right arm up and over your head. **4.** Straighten your right leg out to the side, keeping your toes pointed outward. **5.** Pull along the length of your right side and hold this stretch for thirty seconds before switching sides.

Sideways Lunge, Knee off Floor

Target: Obliques.

Benefits: Lengthens the obliques and abductors while extending the spine.

Steps: 1. Extend your right leg straight out behind you, pointing it toward your left. **2.** Bend your left knee, lowering your hips. **3.** Drop your left hand down to the back of your right thigh, and reach your right arm up above your head and to the left. **4.** Pull along the length of your right side and hold this position for thirty seconds before alternating sides.

Ballet Stretch with Band 8

Target: Quadriceps.

Benefits: Lengthens the quadriceps while strengthening the triceps, biceps, and glutes.

Steps: 1. Attach a resistance band around the big toe of your right foot and hold the other end of the band with your left hand. **2.** Extend your right leg out behind you and hold the band up by your waist, bending your left elbow. **3.** Keeping your left leg straight, raise and lower your foot behind you. **4.** Repeat this exercise twenty times before switching legs.

Dancer's Lunge

Target: Quadriceps.

Benefits: Deeply lengthens the quadriceps while opening the hips.

Steps: 1. Begin on all fours with your palms flat on the floor. **2.** Bend your right leg forward and drape your knee over your right shoulder. **3.** Lower your hips down toward the floor, straightening your left knee. **4.** Continue putting pressure against your hips and back leg for fifteen seconds, before releasing and performing on the opposite leg.

Lord of the Dance Pose 2

Target: Quadriceps.

Benefits: Opens the chest and shoulders while strengthening the upper legs and improving balance.

Steps: 1. Stand up straight and bend your right leg up, bringing your right foot behind your hips. **2.** Grab hold of your foot with your right hand and lean your torso forward. **3.** Pull your right foot away from your hips, straightening your right arm, and extend your left arm forward. **4.** Hold this pose for fifteen seconds before attempting it on the opposite side.

Pose Inspired by Shiva's Vigorous Cycle of Life Dance Tiptoe

Target: Glutes and quadriceps.

Benefits: Strengthens the muscles in the legs and abdomen while improving balance.

Steps: 1. Standing upright, raise your right foot from the floor to rest on top of your left thigh. Rise up onto the toes of your left foot. **2.** Extend your right arm straight out to your side. Bend your left arm, bringing your elbow to your raised right knee. **3.** Hold this balancing pose for twenty seconds, before attempting this stretch on the opposite side.

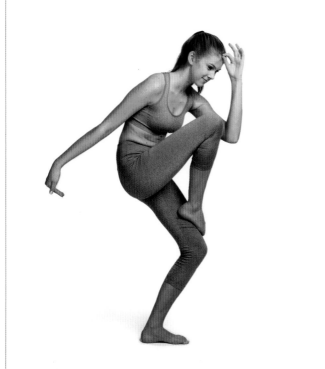

Pose Inspired by Parvati's Vigorous Cycle of Life Dance 2

Target: Glutes and quadriceps.

Benefits: Strengthens the muscles in the legs and abdomen while improving balance.

Steps: 1. Standing upright, raise your right foot from the floor to rest on top of your left thigh. Bend your right knee, slightly. **2.** Extend your right arm straight out to your side. Bend your left arm, bringing your elbow to your raised right knee. **3.** Hold this balancing pose for twenty seconds, before attempting this stretch on the opposite side.

Dynamic Stretches

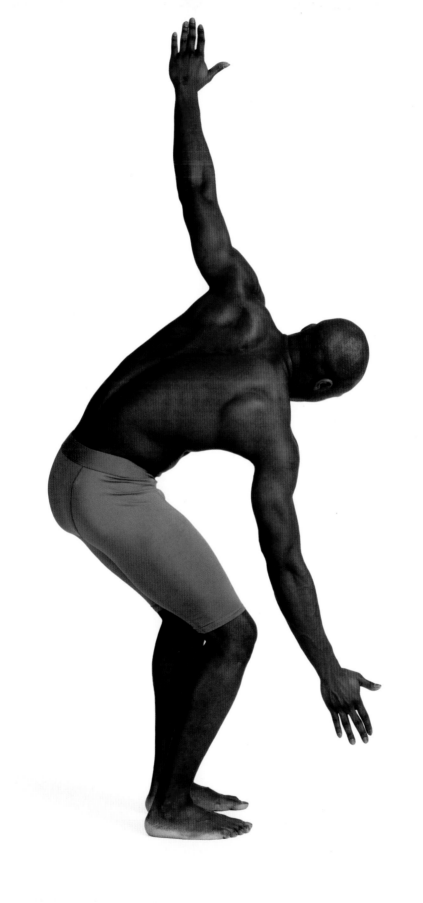

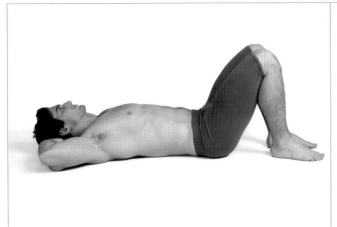

Abdominal Crunch

Target: Abdominals.

Benefits: Strengthens the abdominals and glutes while engaging the shoulders.

Steps: 1. Lie on your back with both knees bent. Place your hands under your head, holding the back of your head and extending your elbows out to the sides. **2.** Slowly raise your shoulders from the floor and swing your elbows together on either side of your head. **3.** Pull your elbows as close to your knees as you are able. Then, slowly drop your shoulders back down to the floor. **4.** Repeat this exercise thirty times.

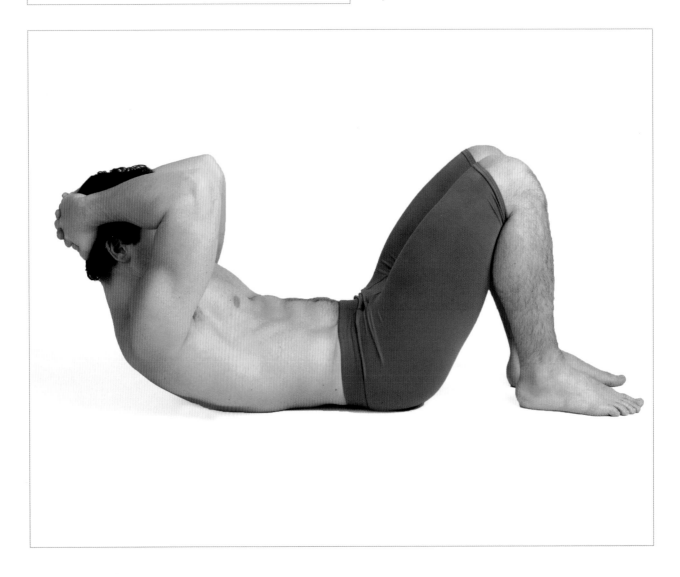

Core and Side Stretch with Medicine Ball

Target: Abdominals.

Benefits: Strengthens the abdominals and obliques.

Steps: 1. Sit on the floor with your knees bent upward and hold a medicine ball with both hands. **2.** Bring the ball down to one side, then up over your chest and down to the other side. **3.** Repeat this motion back and forth for twenty seconds.

Medicine Ball Rotation

Target: Abdominals.

Benefits: Strengthens the abdominals and obliques.

Steps: 1. Stand with your feet shoulder-width apart and hold a medicine ball with both hands. **2.** Bring the ball to your right side, then across your chest and to the other side. **3.** Repeat this exercise back and forth for thirty seconds, moving quickly from motion to motion.

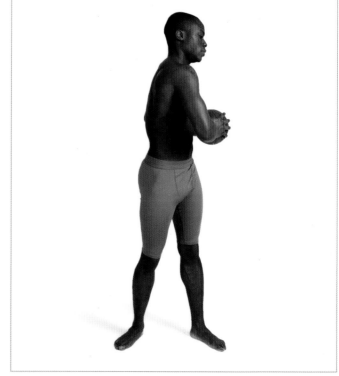

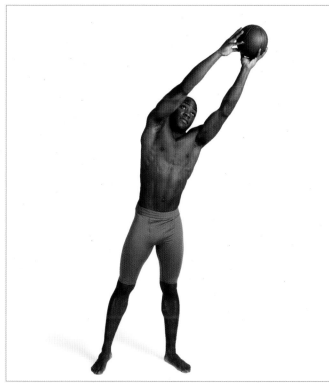

Medicine Ball Stretch, Overhead

Target: Abdominals.

Benefits: Strengthens the muscles in the abdomen, arms, and obliques.

Steps: 1. Raise the medicine ball up above your head with straight arms. **2.** Stretch the ball as far as your can to your left side, then the right. **3.** Repeat this motion for twenty seconds.

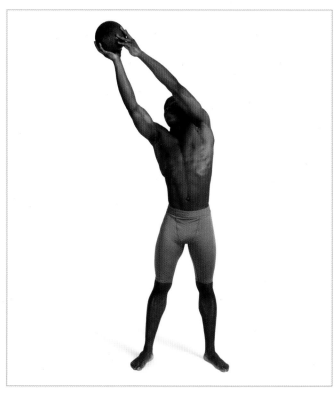

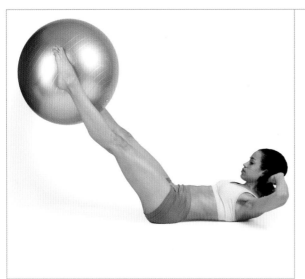

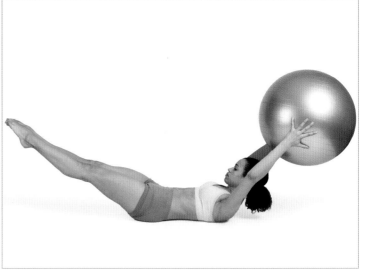

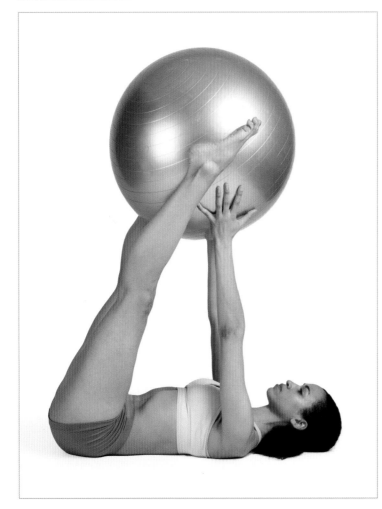

Stability Ball Pass

Target: Abdominals.

Benefits: Targets the upper and lower abdominals and glutes.

Steps: 1. Start by lying flat on your back, holding an exercise ball between your feet and placing your hands behind your head. **2.** Raise your shoulders from the floor into an abdominal crunch and lower the ball close to the floor but not touching it. **3.** Use your lower abs to bring the ball back up above your torso and pass the ball to your hands in a high crunch position. **4.** Lower your legs and arms toward the floor, hovering as low as you are able. **5.** Crunch back up to pass the ball back to your feet to complete one repetition. **6.** Perform five to ten repetitions.

Leg-Cradle Hip Abductor

Target: Abductors.

Benefits: Lengthens the muscles along the outer hips and thighs.

Steps: 1. Standing straight, raise your right knee up. Grab hold of your knee with your right hand and grab your ankle with the left hand. **2.** Pull your shin upward until it is parallel to the floor and at hip height. **3.** Hold this position for fifteen seconds before repeating on the opposite leg.

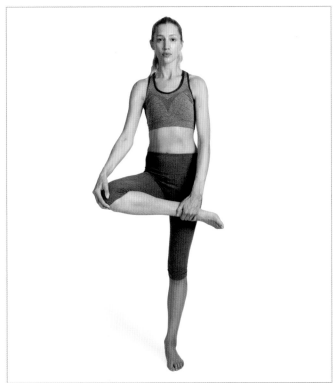

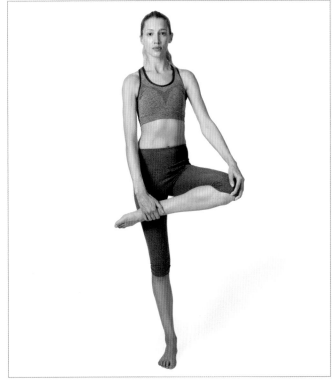

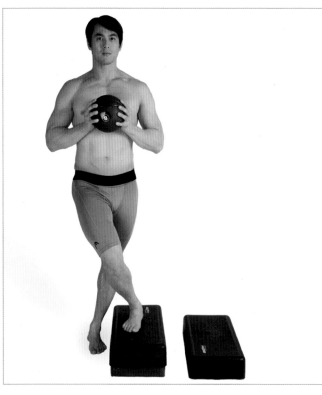

Lateral Step Across with Medicine Ball

Target: Quadriceps and glutes.

Benefits: Tightens the glutes and thighs and improves balance.

Steps: 1. Hold a weight at your chest with both hands and stand beside two exercise blocks on your left. **2.** Step your right foot across and in front of you onto the first block. **3.** Step your left foot across and behind you onto the second block. **4.** Again cross your right foot in front of you and down to the floor, and step your left foot behind you, so you are now standing with the blocks at your right side. **5.** Reverse direction and repeat twenty times.

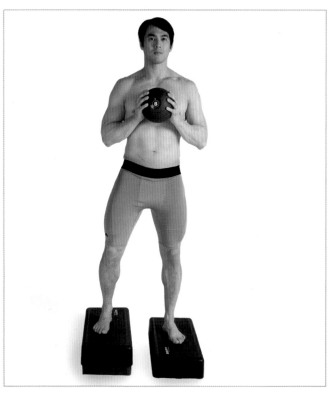

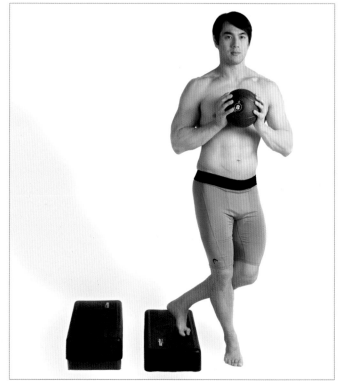

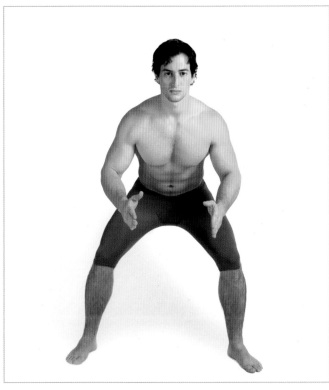

Lateral Slide

Target: Adductors.

Benefits: Lengthens the muscles in the hips and groin while strengthening the upper legs.

Steps: 1. Stand with your feet apart and your hands in front of your chest. **2.** Step your left leg out to the side and bend your right knee into a side squat, then return to the starting position. **3.** Extend your right leg out to the side and bend your left knee, then return to the starting position. **4.** Repeat this movement for thirty seconds.

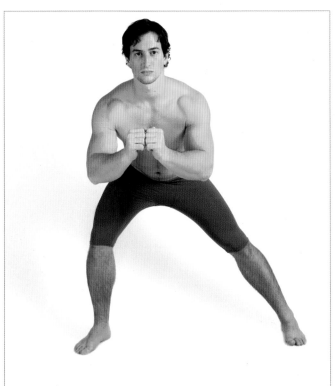

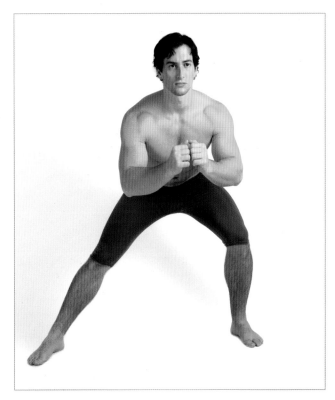

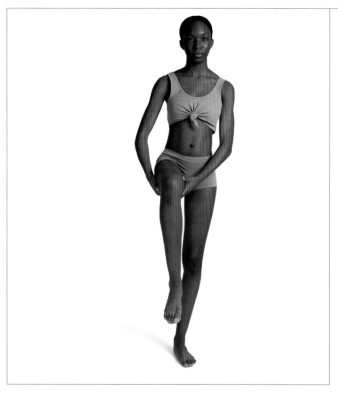

Ankle Circles

Target: Ankles.

Benefits: Increases the range of motion in the ankles.

Steps: 1. Begin by standing upright, with your right leg raised from the floor and the knee bent. **2.** Hold your raised thigh with both hands and slowly rotate your toes in clockwise circles, then counterclockwise. **3.** Continue for thirty seconds and alternate legs.

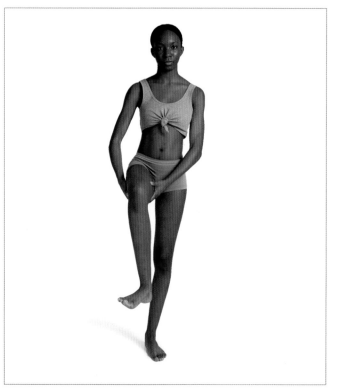

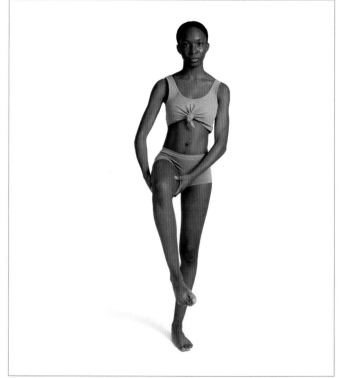

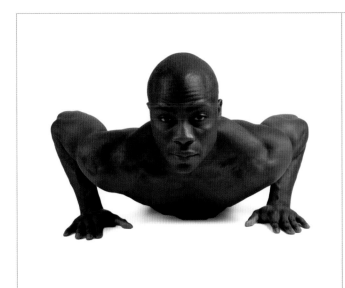

Chest Lift

Target: Arm strengthener.

Benefits: Strengthens the upper arms and abdominals while stretching the spine.

Steps: 1. Lie on your stomach with your palms flat on the floor beneath your shoulders. **2.** Push your shoulders up from the floor, until your elbows form right angles. **3.** Return to the starting position and repeat fifteen or more times.

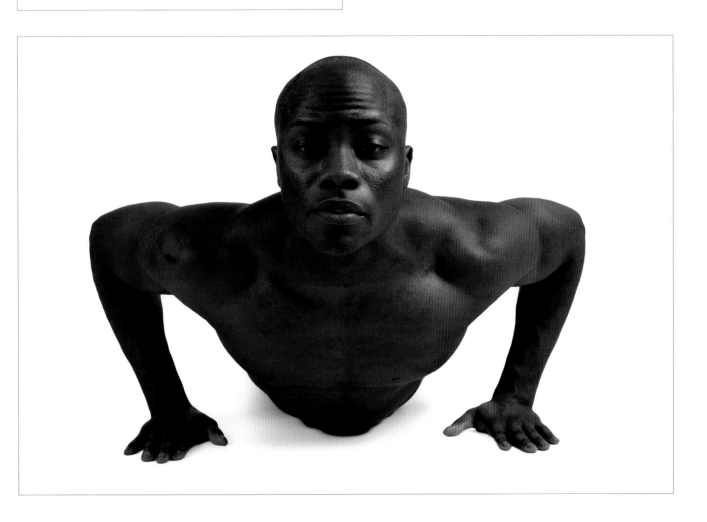

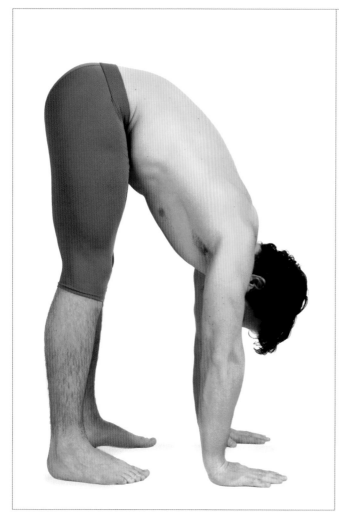

Inchworm

Target: Arm strengthener.

Benefits: Strengthens the arms, chest, back, and abdomen.

Steps: 1. Stand with your feet shoulder-width apart. Hinge forward at the waist and touch the floor with your palms. Bend your knees, if necessary. **2.** Walk your hands forward until you are supporting all your weight on your hands and toes. Your body should create a straight line from heels to shoulders. **3.** Now walk your feet forward to meet your hands, keeping your palms on the floor and bending your knees, if necessary. **4.** Repeat the inchworm exercise five or more times.

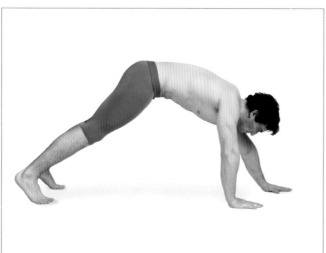

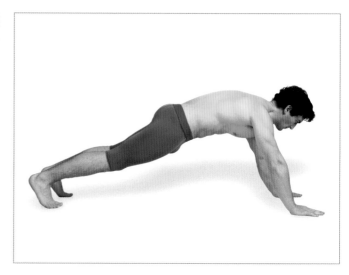

One-Arm Pushup

Target: Arm strengthener.

Benefits: Strengthens the triceps, biceps, chest, and core.

Steps: 1. Start in a plank position, with your right hand resting on a medicine ball and your left hand flat on the floor. **2.** Raise your left hand from the floor, resting it on your back, and step your feet away from each other. **3.** Lower your chest into a pushup, bringing your body as low to the floor as you are able. **4.** Raise your body back up into a one-arm plank on the ball. **5.** Perform ten pushups on each side.

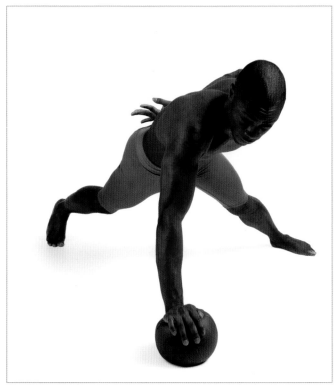

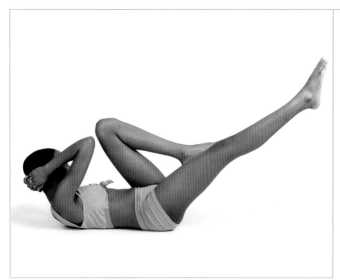

Leg Extensions, Oblique

Target: Core.

Benefits: Extends the muscles in the obliques while engaging the core.

Steps: 1. Lie on your back with legs off the floor and your knees bent at a 90-degree angle. Place your hands on the back of your head and extend your elbows out to the sides. **2.** Lift your chest so your shoulders are just barely touching the floor. **3.** Extend your right leg straight out and twist your torso to the left, touching your left elbow to your right knee. **4.** Bring your right leg back in and extend your left leg out, while twisting your torso to the opposite side. **5.** Repeat twenty times.

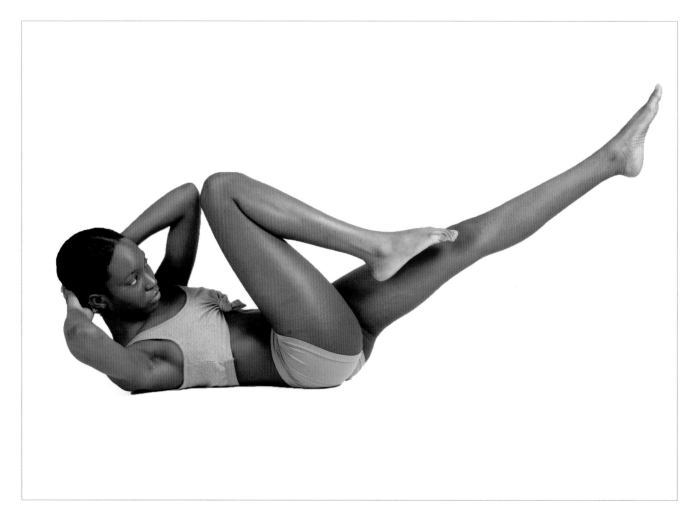

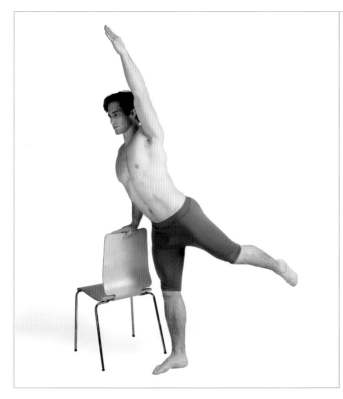

Chair Extended-Limbs Stretch

Target: Glutes.

Benefits: Increases strength and mobility in the hips and glutes.

Steps: 1. Stand straight, holding the back of a chair with your right hand, and extend your left arm overhead. **2.** Swing your left leg as far forward as you can and then swing your leg far behind you. **3.** Repeat this motion for thirty seconds, before alternating legs.

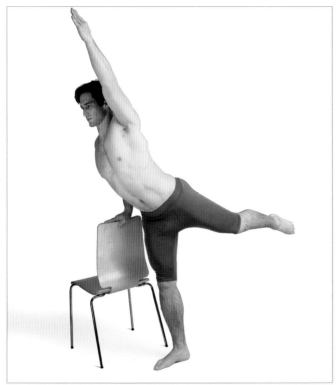

Heel Beats

Target: Glutes.

Benefits: Strengthens the muscles in the glutes and abdomen.

Steps: 1. Lie on your stomach and rest your forehead on crossed arms. Point your toes out away from you. **2.** Try to keep your legs straight as you raise your heels up, lifting your legs off the floor, and lower your legs back down. **3.** Repeat this exercise for thirty seconds.

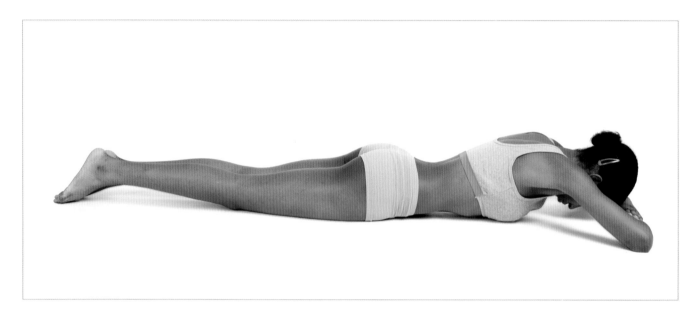

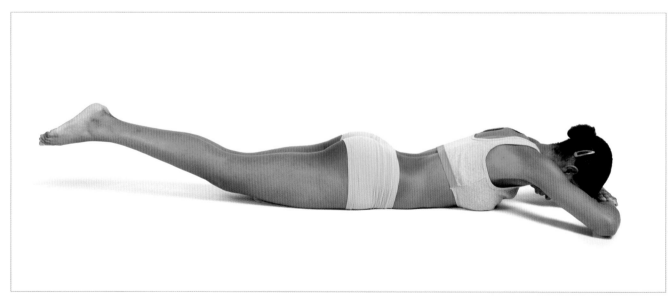

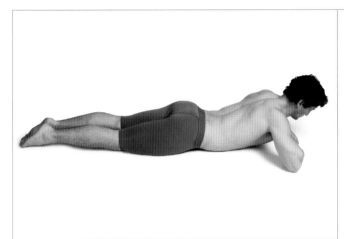

Prone Leg Beats

Target: Glutes.

Benefits: Strengthens the glutes and abdominals.

Steps: 1. Lie on your stomach with your forearms crossed beneath your chest. Point your toes out away from you. **2.** Try to keep your legs straight as you raise your heels from the floor. **3.** Spread your legs apart, bring them back together, and lower to the floor. **4.** Repeat this exercise for thirty seconds.

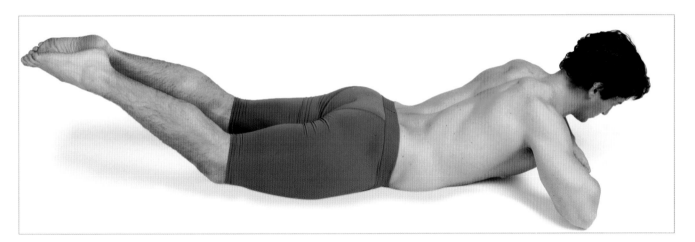

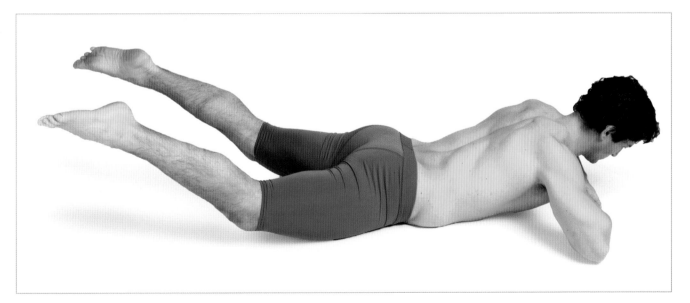

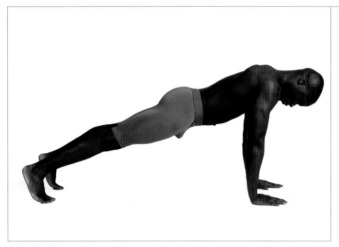

Alternating-Legs Staff Pose

Target: Glutes.

Benefits: Strengthens the muscles in the upper arms and abdomen while engaging the glutes.

Steps: 1. Begin on all fours, with your palms flat on the floor. **2.** Step both feet back and rise onto your toes into a plank position. **3.** Balancing on your right toes, bring your left knee into your chest. **4.** Extend your left leg back into the plank, then bring your right knee into your chest. **5.** Continue this exercise, alternating legs, for thirty seconds.

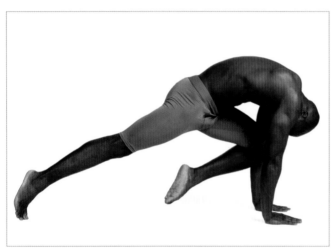

Knee Highs, Walking

Target: Glutes.

Benefits: Strengthens the muscles in the glutes and upper legs, and engages the abdomen.

Steps: 1. Stand with your feet shoulder-with apart and your hands on your hips. **2.** Raise your right knee to hip height, hold for five seconds, and lower your foot back to the floor. **3.** Raise your other knee up, hold, and lower. **4.** Repeat this exercise for sixty seconds.

Knee Hugs, Walking

Target: Glutes.

Benefits: Strengthens the muscles in the glutes and upper legs, and engages the abdomen.

Steps: 1. Stand with your feet shoulder-with apart and your hands at your sides. **2.** Raise your right knee to hip height, pull it into your chest with both hands, and lower your foot back to the floor. **3.** Raise your left knee up, hold, and lower. **4.** Repeat this exercise for sixty seconds.

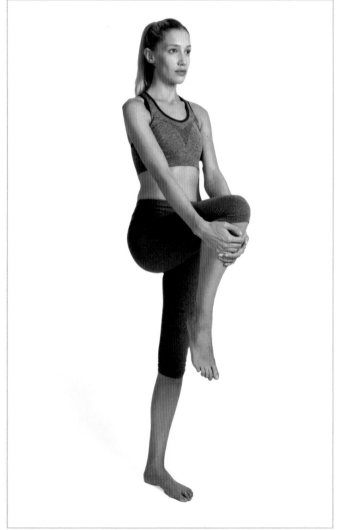

Raised Leg Beats

Target: Hamstrings.

Benefits: Works the hamstrings, glutes, inner thighs, lower back, and abdominals.

Steps: 1. Lie on your stomach and lean on your cross arms. **2.** Raise your legs several inches from the floor, making sure your abdomen is engaged. **3.** Hold your legs, return to the floor, and repeat this motion for thirty seconds.

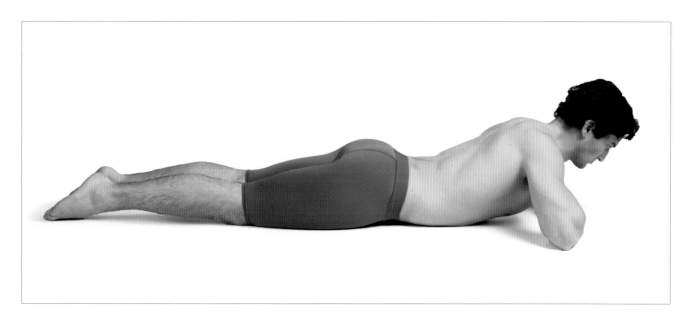

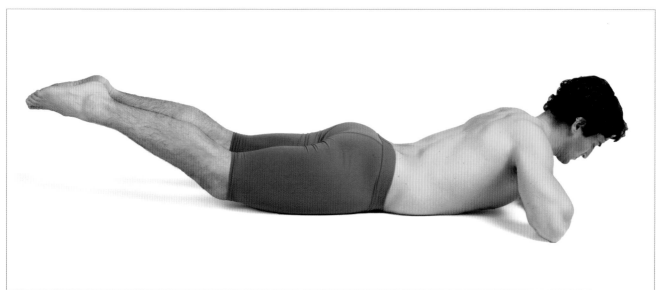

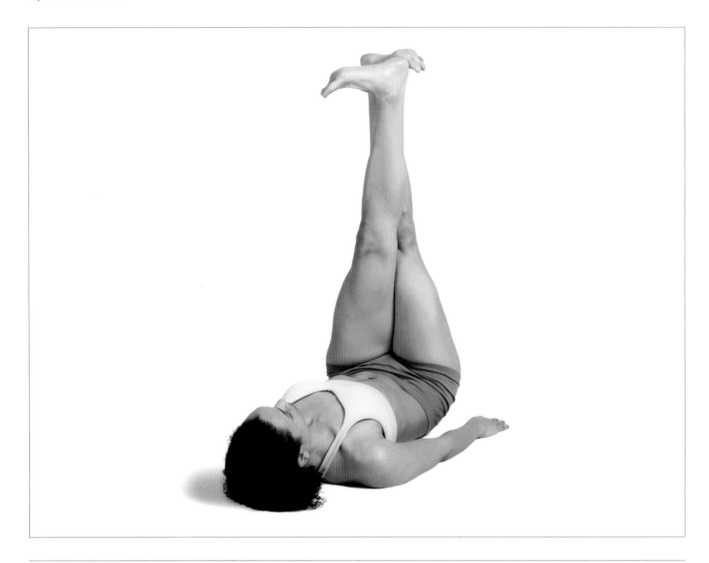

Scissor Beats Flex

Target: Hips.

Benefits: Strengthens the glutes and abdominals while lengthening the calves and Achilles tendons.

Steps: 1. Lie on your back with your legs straight up above you. **2.** Cross your left ankle in front of your right, touching your left heel to your right toes, with feet flexed. **3.** Now cross your right ankle in front of your left, touching your right heel to your left toes. **4.** Alternate feet for thirty seconds, moving quickly from motion to motion.

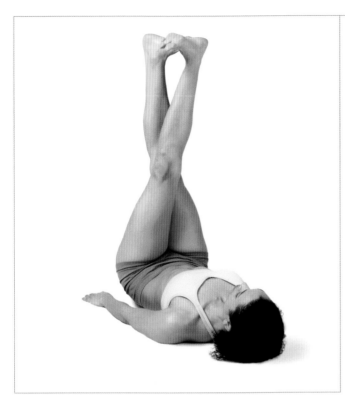

Scissor Beats Point

Target: Hips.

Benefits: Strengthens the glutes and abdominals.

Steps: 1. Lie on your back, with your legs straight up above you. Cross your left ankle in front of your right, flexing your feet. **2.** Swing your feet away from each other, keeping your toes pointed down. **3.** Swing your feet back together, crossing your right ankle in front of your left. **4.** Swing your legs apart and back together to the starting position. **5.** Continue thirty seconds, moving quickly from motion to motion.

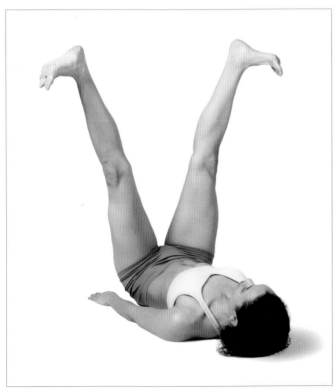

Reach, Roll, and Lift

Target: Latissimus dorsi.

Benefits: Improves mobility in the shoulders and lats.

Steps: 1. From a kneeling position, lower your hips so you are sitting on your heels. Rest your forearms on the floor in front of your knees. **2.** Reach your right arm forward, keeping your palm on the floor. **3.** Roll your palm faceup and raise your right arm to shoulder height. **4.** Lower your arm to the floor and turn your palm facedown. **5.** Bring your arm back toward your knees and repeat this exercise fifteen times on each arm.

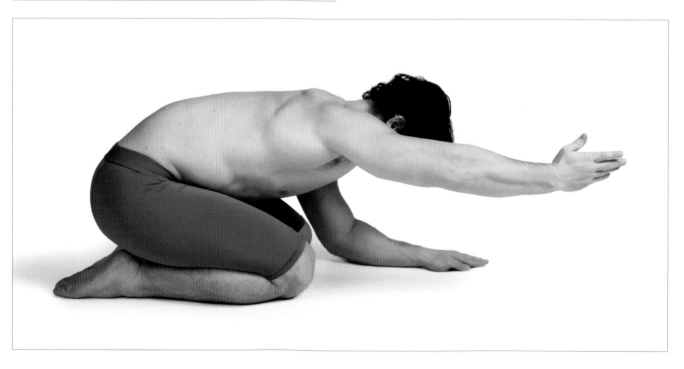

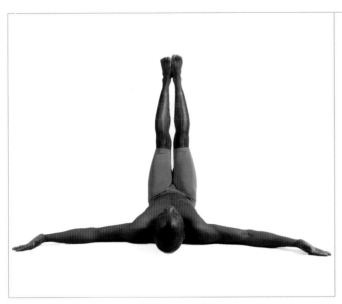

Double-Leg Extensions

Target: Lower back.

Benefits: Extends the muscles in the spine and lower back while strengthening the glutes.

Steps: 1. Lie on your back with your legs straight above you and your arms extended out to your sides. **2.** Making sure to keep your shoulders on the floor, drop both legs down to your right side. **3.** Hold this position for ten seconds before raising your legs back above you. **4.** Drop your legs down to the left side, hold for ten seconds, and return to the starting position.

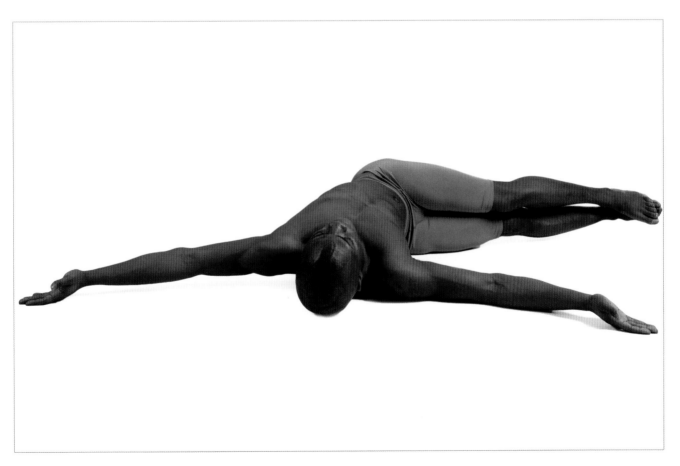

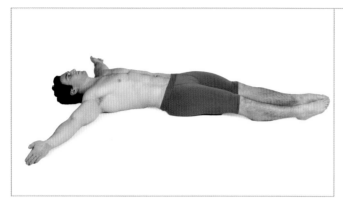

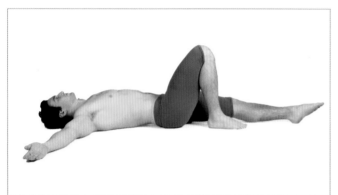

Knee-Over-Hip Twist, Lying

Target: Lower back.

Benefits: Increases flexibility and range of motion in the hip extensors, glutes, and hamstrings.

Steps: 1. Lie flat on your back with arms extended out to your sides. **2.** Bend your right knee, cross it over your left leg, and drop your foot on the floor to your left. **3.** Twist your lower body to the left and keep your right shoulder on the floor. **4.** Alternate sides for thirty seconds.

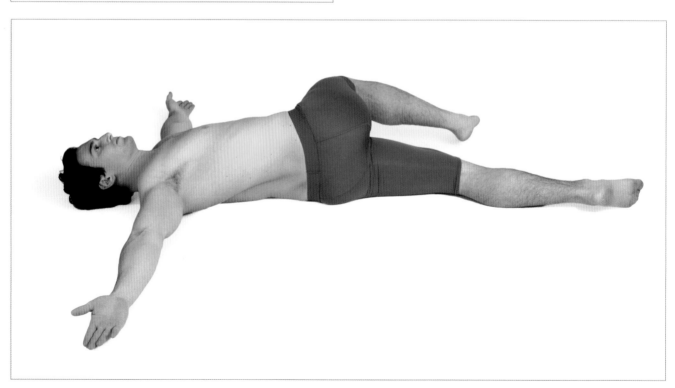

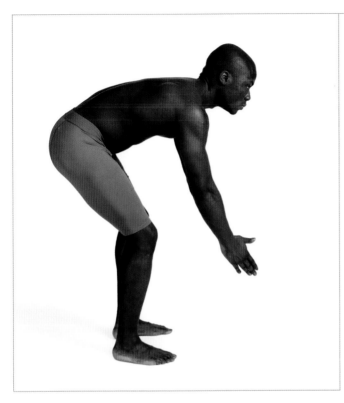

Reach to Sky, Bent Over

Target: Lower back.

Benefits: Increases mobility in the lower back and abdomen.

Steps: 1. Begin by standing upright. Bend your knees and lower your chest forward, while extending both arms out to your sides. **2.** Twist your torso to the right, so your left hand is pointing down toward the floor and your right hand is pointing toward the ceiling. **3.** Swing your torso to the left, keeping your arms outstretched and your abdomen engaged. **4.** Continue this side-to-side movement for thirty seconds.

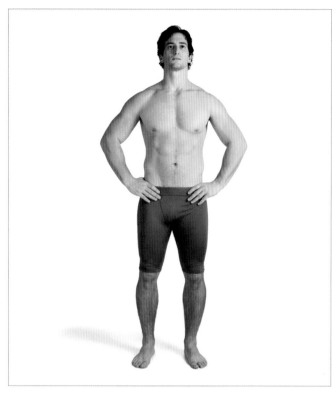

Twist Standing

Target: Lower back.

Benefits: Twists the spine and stretches the muscles across the lower back.

Steps: 1. Stand with your feet shoulder-width apart and your hands on your hips. **2.** Keeping both feet flat on the floor, twist your torso to the left and then to the right. **3.** Repeat this motion ten times on each side.

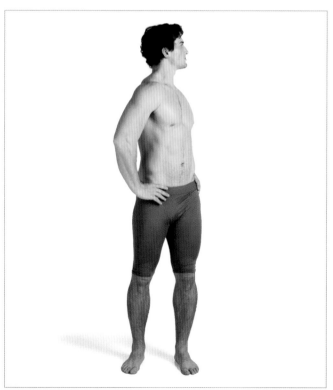

Side Bend Sliding

Target: Lower back.

Benefits: Stretches the obliques, upper arms, and shoulders.

Steps: 1. Stand with your feet shoulder-width apart. Raise your right arm straight up and rest your left hand on the side of your left leg. **2.** Bend your right elbow and bring your hand to your armpit as you lean your torso down to the left. Slide your left hand down to your knee in a side bend. **3.** Raise your torso back upright, this time stretching your left arm straight above and dropping your right hand to the side. Bend your left elbow and lean to your right side. **4.** Return upright and continue this exercise, alternating sides, for thirty seconds.

Lateral Trunk Flexion

Target: Obliques.

Benefits: Stretches the inner and outer obliques while lengthening the spine.

Steps: 1. Stand up straight with your feet should-width apart. **2.** Without letting your shoulders hunch forward, bend your torso to the right. Slide your right hand as far down your outer thigh as you are able. **3.** Rise back up to the starting position, then repeat the motion to the left. **4.** Continue this exercise for thirty seconds.

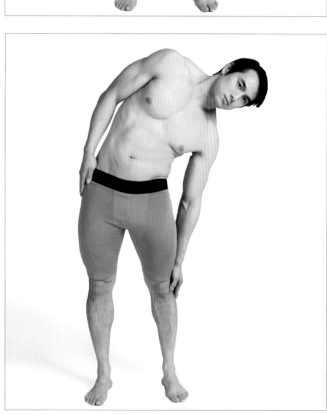

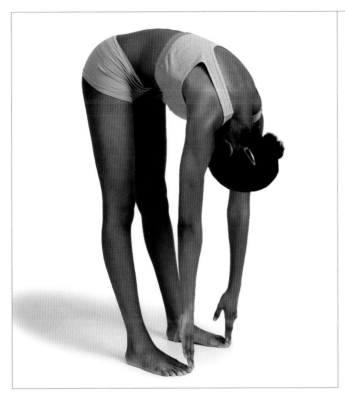

Sumo Squat to Stand

Target: Quadriceps.

Benefits: Strengthens the quadriceps and core while lengthening the lats and shoulders.

Steps: 1. Bend forward and touch your toes **2.** Squat low to the floor, keeping your fingers on our toes. **3.** Extend your arms overhead and rise from the squat into a standing position. **4.** Repeat this exercise ten times.

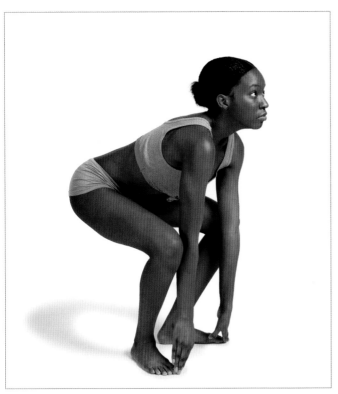

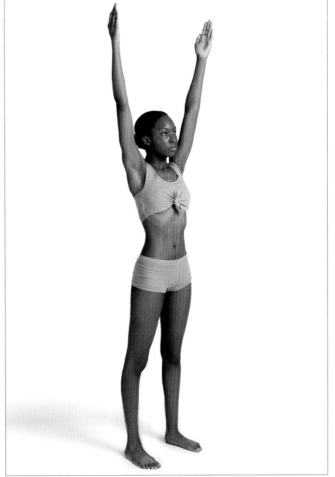

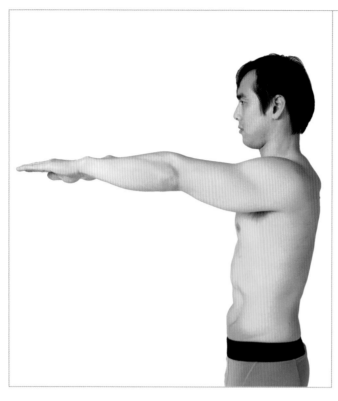

Arm Swings

Target: Shoulders.

Benefits: Improves mobility and alleviates tightness in the shoulders and upper back.

Steps: 1. Stand with your feet shoulder-width apart and your arms at your sides. **2.** Keeping your arms straight, swing them forward and backward quickly for thirty seconds.

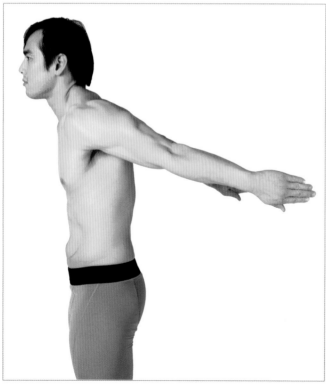

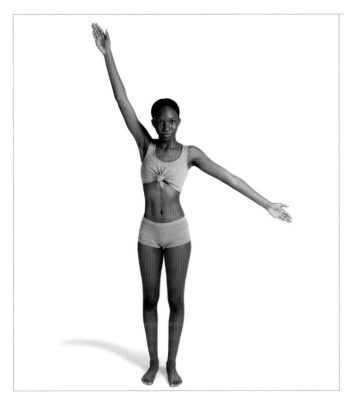

Hand Crossover 2

Target: Shoulders.

Benefits: Increases flexibility and range of motion in the shoulders while engaging the core.

Steps: 1. Extend your right hand up to your right and extend your left hand out to your hip, so that your arms create a straight line across your body. **2.** Swing both arms across the front of your body, then back out. **3.** Alternate arm positions and repeat for thirty seconds.

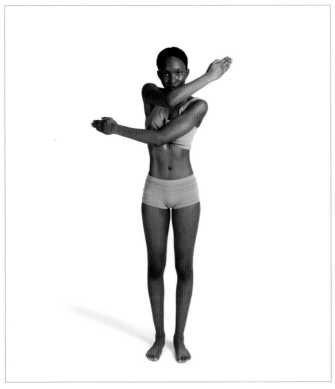

Shoulder Circles

Target: Shoulders.

Benefits: Improves mobility and alleviates tightness in the shoulders and upper back.

Steps: 1. Stand with your feet shoulder-width apart and your arms at your sides. **2.** Gently roll your shoulders forward, down, backward, and up. **3.** Continue this motion for fifteen seconds before reversing the direction.

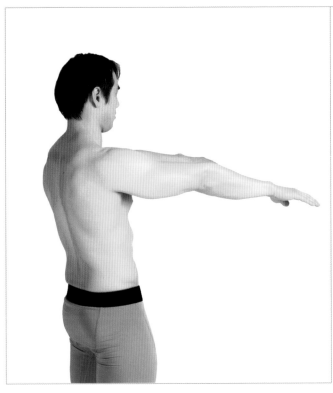

Shoulder-Girdle Modified Stretch

Target: Shoulders.

Benefits: Improves mobility and alleviates tightness in the shoulders and upper back.

Steps: 1. Stand with your feet shoulder-width apart and your arms raised in front of you at shoulder height.
2. Swing both arms out and behind you, then swing them back in front. **3.** Repeat this exercise for thirty seconds, moving quickly from motion to motion.

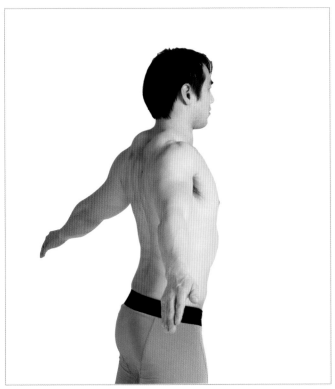

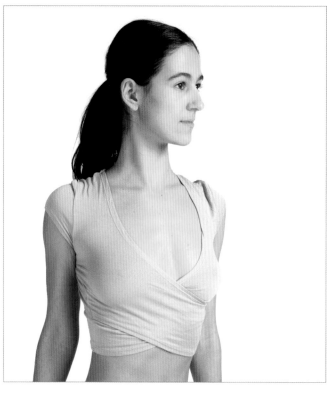

Shoulder Roll

Target: Shoulders.

Benefits: Improves mobility and alleviates tightness in the shoulders and upper back.

Steps: 1. Stand with your feet shoulder-width apart and your arms at your sides. **2.** Bending at the waist, roll your right shoulder forward, down, backward, and up. **3.** Continue this motion for thirty seconds before alternating shoulders.

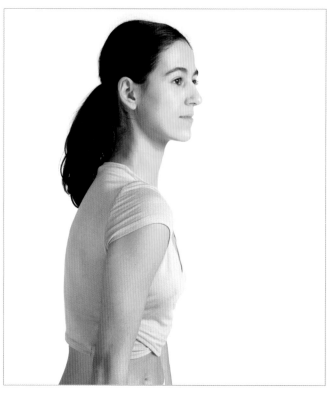

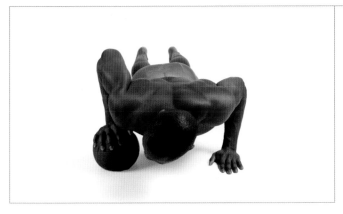

Pushup and Roll

Target: Core.

Benefits: Strengthens the muscles in the shoulders, arms, chest, core, back, and hips.

Steps: 1. Start in a plank position, with your right hand resting on a medicine ball and your left hand flat on the floor. **2.** Lower your body into a pushup, bringing your chest as close to the floor as you are able, and raise your chest back up to the starting position. **3.** Shift your weight onto your left hand and roll the medicine ball toward your left hand. **4.** Drop your right hand to the floor and raise your left hand onto the medicine ball in a plank position. **5.** Perform another pushup and pass the ball back to the right. **6.** Repeat ten times on both sides, moving quickly from motion to motion.

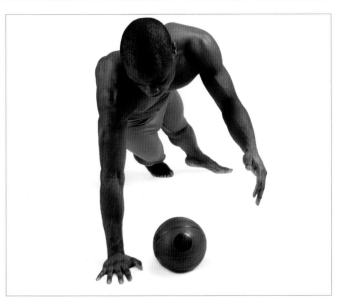

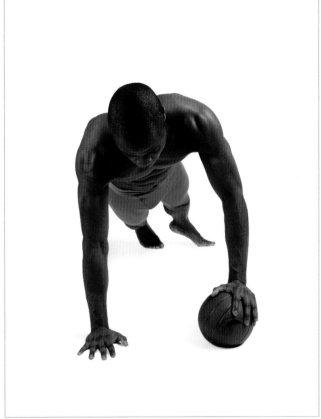

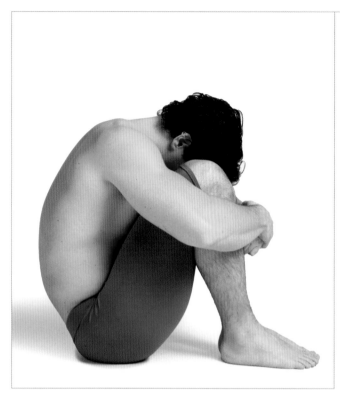

Spinal Roll

Target: Spine.

Benefits: Puts pressure on the spinal cord, releasing tightness and pain in the back.

Steps: 1. Sit with your knees tucked into your chest. **2.** Hug your knees and rock backward, along the length of your spine. **3.** Rock back into a seated position. **4.** Repeat this movement ten times.

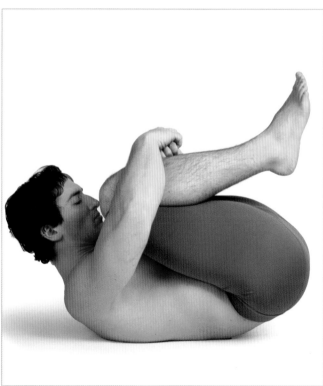

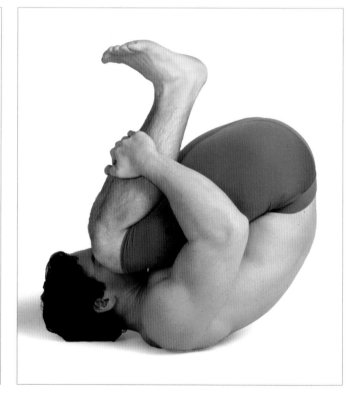

Tendon Stretch

Target: Glutes.

Benefits: Relieves tightness and tension along the spine while lengthening the abductor muscles.

Steps: 1. Begin by standing upright, hands extended straight ahead of you. **2.** Keeping your feet flat on the floor, bend into a squat and return to the starting position. **3.** Repeat this motion ten times.

Partner Stretches

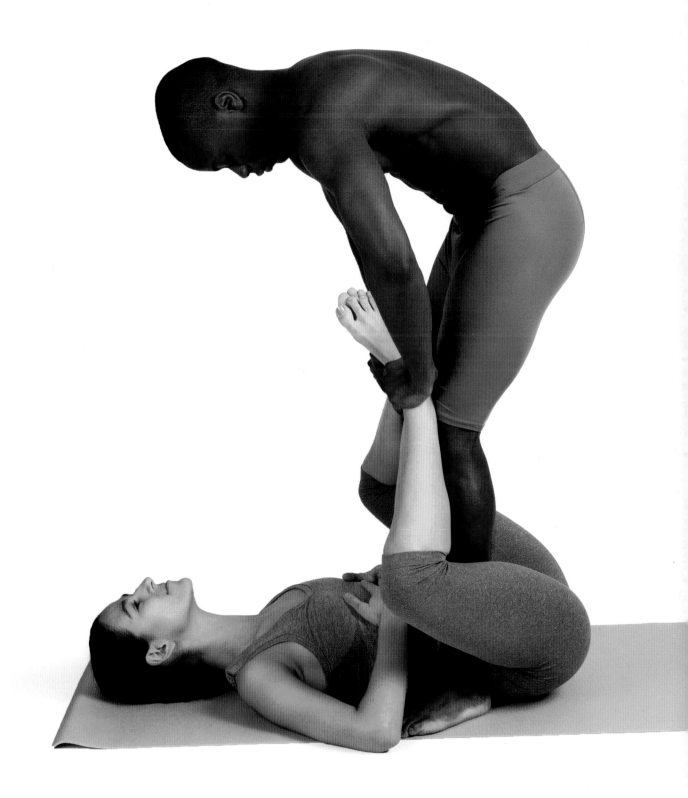

Parter Straddle Side Stretch

Target: Obliques.

Benefits: Opens the hips and lengthens the spinal column and obliques.

Steps: Begin seated, facing each other with your legs in the straddle position. The person with longer legs is the supporting Stretcher. The Partner with shorter legs should sit with their feet against the Stretcher's inner ankles. **Both Stretchers:** Twist your torso to the left and drop your head toward your left knee. Extend your arms out at your sides, and place your fingertips on the floor on the outside of your left leg and outside your partner's right leg. Hold for thirty seconds, pulling along the length of your spine throughout. Raise back to the starting position and repeat in the opposite direction.

Parter Wrist Flexor

Target: Wrist.

Benefits: Extends the muscles in the wrists, reducing tightness and immobility.

Steps: Stretcher: Lie down and extend your arm out to your side, so your palm is facing out and your fingers are pointed down. **Partner:** Kneel next to the Stretcher's left arm and place your right hand under the Stretcher's forearm for support. Press your left palm against the Stretcher's outstretched fingers and push gently against them. Repeat on the opposite arm.

Partner Abductor Stretch, Supine

Target: Abductors.

Benefits: Lengthens the hip abductors, reducing tightness and increasing range of motion.

Steps: Stretcher: Lie flat on your back with your arms and legs flat at your sides. Cross your left leg over your right leg, so your left foot is flat on the floor by your right thigh. **Partner:** Kneel to the right of the Stretcher. Place your left hand on their left hip for support, and grab hold of their left knee with your other hand. Gently pull the knee toward you and repeat on the opposite leg.

Partner Achilles and Calf Stretch

Target: Achilles.

Benefits: Relieves tension and tightness in the Achilles tendons and calf muscles.

Steps: Stretcher: Lie flat on your stomach and bend your left knee, raising your foot straight up. **Partner:** Place your right hand on the Stretcher's calf for support and rest your left palm on the Stretcher's foot. Press down gently against the ball of the foot, targeting the Achilles tendon.

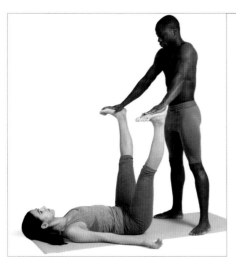

Partner Achilles and Hip Stretch

Target: Hips.

Benefits: Opens the hips and extends the calves, hamstrings, adductors, and Achilles tendons.

Steps: Stretcher: Lie flat on your back with your legs raised straight above your hips. Spread your feet wide apart, keeping your legs straight and the soles of your feet facing up. **Partner:** Stand above the Stretcher. Place one hand on each of the Stretcher's heels and gently press down against the Stretcher's feet, increasing pressure on the calves and Achilles tendons. Meanwhile, gently pull the Stretcher's feet wider apart, increasing pressure on the hips.

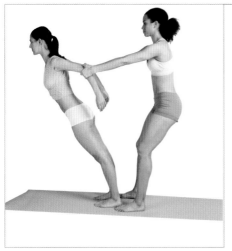

Partner Achilles Lean and Elbow Pull

Target: Achilles.

Benefits: Puts pressure on the Achilles tendons and calves, and extends the shoulders.

Steps: Stretcher: Stand straight with your arms at your sides. **Partner:** Stand directly behind the Stretcher with your feet slightly wider apart than the Stretcher's feet. Grab hold of the Stretcher's arms just above the elbows. **Stretcher:** Lean your body forward, keeping your heels flat on the floor and your body straight. **Partner:** Keep hold of the Stretcher's arms as they lean forward. Bend your knees slightly for support. **Stretcher:** Continue to lean forward until you feel pressure on your calves and Achilles tendons.

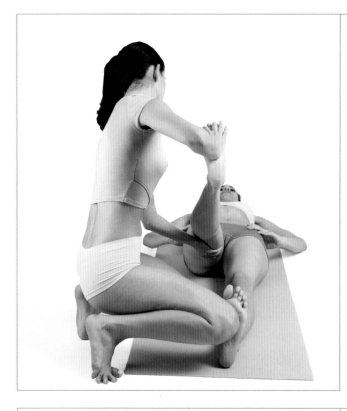

Partner Achilles Stretch

Target: Calves.

Benefits: Extends the calves, hamstrings, and Achilles tendons.

Steps: Stretcher: Lie flat on your back and flex your feet, toes pointing upward. **Partner:** Kneel beside the Stretcher's right leg. Tuck your left hand beneath the Stretcher's right thigh for support. Press your right hand against the sole of the Stretcher's right foot. Lift the Stretcher's leg from the floor, so their foot is at your chest level. Press gently into the Stretcher's foot. **Stretcher:** Keep your leg straight as your Partner applies pressure on the calf and Achilles tendon. Repeat on the opposite leg.

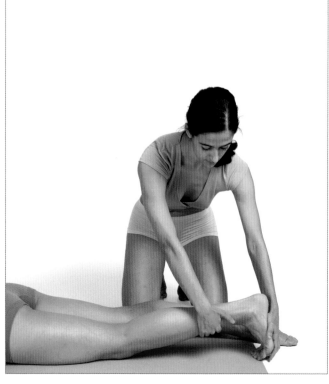

Partner Achilles Stretch, Lying

Target: Achilles.

Benefits: Extends the calves, hamstrings, and Achilles tendons.

Steps: Stretcher: Lie down on your stomach, with your legs flat on the floor. Prop your left foot up onto its toes, so your heel is raised. **Partner:** Kneel beside the Stretcher's right leg. Place your right hand under the Stretcher's shin for support and gently press your left hand against the sole of the Stretcher's left foot to increase pressure on the calf and Achilles tendon.

Partner Acroyoga Hip Stretch and Chest Opener

Target: Core.

Benefits: Strengthens the abdominals, hip flexors, hamstrings, obliques, and arms.

Steps: Stretcher: Kneel down, facing your Partner and push yourself up into a handstand. **Partner:** As Stretcher rises up into the handstand, tuck both arms under the Stretcher's calves and place their ankles on your shoulders, bending your knees for support.

Partner Adductor Stretch

Target: Adductors.

Benefits: Extends the hip flexors and abductors.

Steps: Stretcher: Lie down on your left side on a bench or similar raised surface. Extend your right leg straight, and slightly behind you so your foot hangs down below the side of the bench. **Partner:** Stand or kneel behind the Stretcher. Place one hand on the Stretcher's hip for support. Place the other hand on top of the Stretcher's left calf. Gently press down against the Stretcher's leg, increasing pressure on the outer hip.

Partner Adductor and Groin

Target: Adductors.

Benefits: Opens the hips and extends the calves, hamstrings, adductors, and Achilles tendons.

Steps: Stretcher: Lie flat on your back with your legs raised and your feet wide apart. Keep your legs straight and the soles of your feet facing up. **Partner:** Stand facing the Stretcher's legs and place your hands on the Stretcher's heels. Gently press down against the Stretcher's feet, increasing pressure on the calves and Achilles tendons. Meanwhile, gently pull the Stretcher's legs wider apart, increasing pressure on the hips.

Partner Acroyoga Back Stretch and Full-Body Opener

Target: Core.

Benefits: Stretches the back, spine, and front of rib cage. This move is ideal for someone seeking better posture or spinal traction.

Steps: Partner: Lie flat on the ground with your legs raised just behind the Stretcher. Place your feet on the back of the Stretcher's knees and extend your arms up to cradle the Stretcher's upper back. **Stretcher:** Lean your upper back into your Partner's outstretched hands. Once you are fully supported, lie back onto your Partner's hands and feet. Breathe deep and make small adjustments to find the best release for you.

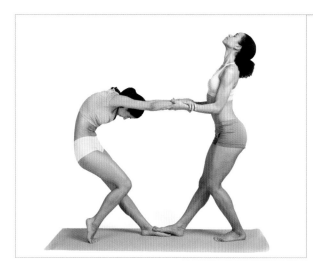

Partner Arch and Pull

Target: Spine.

Benefits: Stretches the length of the spinal column and the shoulders while extending the calves and hamstrings.

Steps: Partner: Stand facing your Partner and step your right foot on top of the Stretcher's left foot. Grab hold of the Stretcher's wrists and bend your left knee for support. **Stretcher:** Step your right foot back onto tiptoes, bending the right knee as you pull away from your Partner. Deeply curl your spine and drop your head between your shoulders. Focus on pulling from an imagined center point of your spine.

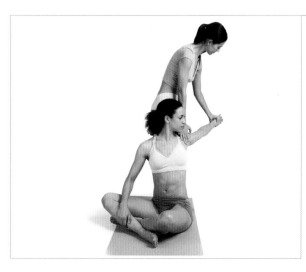

Partner Arm-Behind Stretch

Target: Shoulders.

Benefits: Opens the chest and extends the muscles in the shoulders, increasing flexibility and range of motion.

Steps: Stretcher: Begin seated or standing. Extend your left arm straight out and behind you. **Partner:** Stand behind the Stretcher. Place your right hand on the Stretcher's shoulder for support. Place your other palm against the Stretcher's left hand. Gently press against the Stretcher's hand, pulling their arm farther behind them. **Stretcher:** Attempt to keep your arm straight throughout the stretch. Repeat on the opposite arm.

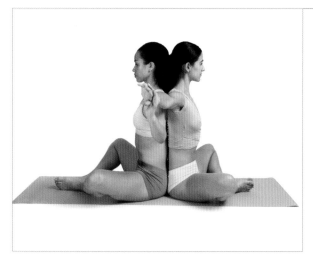

Partner Arm Stretch in Butterfly

Target: Shoulders.

Benefits: Opens the hips and extends the chest and shoulders.

Steps: Sit with your backs together. Bend your knees out to the sides and press the soles of your feet together in butterfly pose. **Stretcher:** Extend your arms straight out to your sides. **Partner:** Reach up to hold the Stretcher's arms by the wrists. Gently pull the Stretcher's arms toward you to increase the stretch on the Stretcher's shoulders.

Partner Arm Stretch in Folded Butterfly

Target: Shoulders.

Benefits: Opens the hips and extends the chest and shoulders.

Steps: Sit with your backs together. Bend your knees out to the sides and press the soles of your feet together in butterfly pose. **Stretcher:** Extend your arms out to your sides. **Partner:** Reach up to hold the Stretcher's arms just below the elbows. Bend your chest forward, bringing your shoulders down toward your knees. Gently pull the Stretcher's arms with you to increase the stretch on the Stretcher's shoulders. **Stretcher:** Let your head and shoulders drop back, as your Partner bends away from you.

Partner Arm Stretch on Ball

Target: Shoulders.

Benefits: Opens the chest and shoulders and engages the core.

Steps: Stretcher: Begin seated on top of an exercise ball with your feet shoulder-width apart. Raise your right arm up above your head. **Partner:** Stand directly behind the Stretcher and plant your feet at either side of the ball. Place your left hand under the Stretcher's raised wrist for support. With your other hand, grab hold of the Stretcher's right arm just above the elbow. Gently pull the Stretcher's arm up from their shoulder. Repeat on the opposite arm.

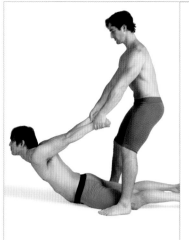

Partner Arm Traction

Target: Shoulders.

Benefits: Deeply extends the chest and shoulders.

Steps: Stretcher: Lie flat on your stomach with your arms at your sides. **Partner:** Stand above the Stretcher, with one foot on either side of their hips. Reach down and grab hold of both of the Stretcher's wrists. Gently pull the Stretcher's arms and chest up from the floor. **Stretcher:** Attempt to keep your arms straight and let your chest open.

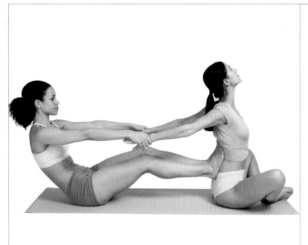

Partner Back and Arm Stretch

Target: Chest opener.

Benefits: Deeply extends the chest and shoulders while opening the hips.

Steps: Stretcher: Begin seated on the floor. Bend both knees out to the sides and press the soles of your feet together in butterfly pose. **Partner:** Begin seated directly behind the Stretcher, with your knees bent up to your chest. Place your feet on the Stretcher's lower back. Reach hold of the Stretcher's wrists and lean your torso back, pulling the Stretcher's arms straight behind them. Press your feet into the Stretcher's back. **Stretcher:** Let your head and shoulders drop back to open your chest.

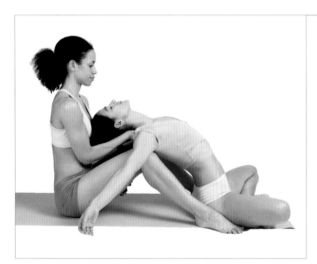

Partner Back and Neck Stretch

Target: Chest opener.

Benefits: Deeply extends the chest and shoulders while opening the hips.

Steps: Stretcher: Begin seated on the floor with your legs crossed. **Partner:** Sit directly behind the Stretcher, with your feet on either side of their hips. Rest your knees against the Stretcher's upper back and place your hands behind their shoulders for support. **Stretcher:** Lean your head and torso back to drape over the Partner's knees. Let your chest open completely **Partner:** Provide support under the Stretcher's upper back and shoulders as they bend back.

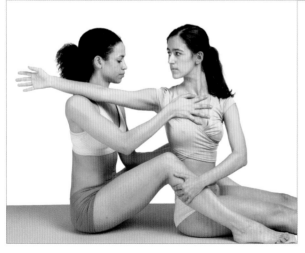

Partner Back and Shoulder Twist

Target: Spine.

Benefits: Twists the spine and opens the chest and shoulders.

Steps: Stretcher: Begin seated on the floor with your legs flat on the floor. **Partner:** Sit directly behind the Stretcher, with your feet on either side of their thighs and your knees raised from the floor. **Stretcher:** Twist your torso to the right and reach your left hand to grab hold of your Partner's right calf. Straighten your right arm behind you and rest it on your Partner's shoulder. **Partner:** Place your right palm flat against the Stretcher's chest and the other palm flat against their lower back for support as they twist.

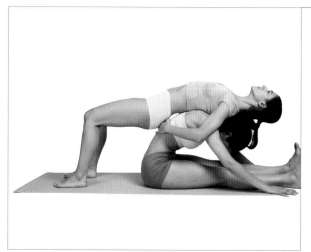

Partner Backbend and Front Bend

Target: Spine.

Benefits: Extends the spines of both the Partner and the Stretcher.

Steps: Partner: Sit on the floor with legs straight. Place your hands flat on the floor at your sides. **Stretcher:** Crouch directly behind your Partner and lean your hips and back against their upper back. Place your palms flat on your Partner's back for support. **Partner:** Slowly bend forward. Slide your hands toward your feet and bring your forehead toward your shins. **Stretcher:** Let your head and shoulders drop back to open your chest. Your feet should remain on the floor and your knees bent, so you do not release all your weight onto your Partner's back.

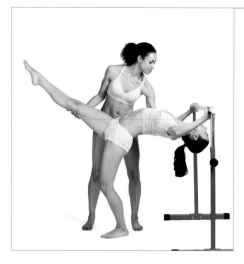

Partner Backbend at Ballet Bar

Target: Spine.

Benefits: Improves flexibility and balance.

Steps: Stretcher: Stand facing away from a ballet bar. Lift your right knee up into your chest and balance on your left foot. **Partner:** Place your left hand flat on the Stretcher's back for support. Reach your right hand under the Stretcher's raised leg, just above their knee. **Stretcher:** Begin to bend backward, dropping your head and shoulders. As you bend, stretch your hands out behind you and grab hold of the bar with both hands. Once your chest is fully open and you are balanced in the backbend, extend your right leg straight out and slightly upward. **Partner:** Support the Stretcher's back and leg as they engage in the backbend.

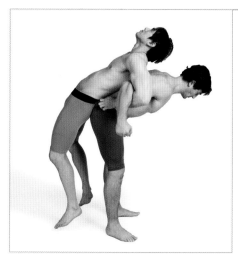

Partner Back Stretch

Target: Spine.

Benefits: Extends the spine of both the Partner and the Stretcher.

Steps: Stretcher: Stand straight with your arms at your sides and your feet apart. **Partner:** Stand directly behind the Stretcher, so your backs are touching. Hook your elbows under the Stretcher's elbows and bring your hands back to your sides. Bend your knees slightly and lean your torso forward, lifting the Stretcher from the floor. Continue the forward bend until your torso is parallel to the floor. Then attempt to straighten your legs. **Stretcher:** Let your head and shoulders drop back as your Partner lifts you up from the floor. Attempt to relax your shoulders and let your chest fully open. **Partner:** Hold this position for a few breaths, before bending your knees and slowly returning the Stretcher to the floor.

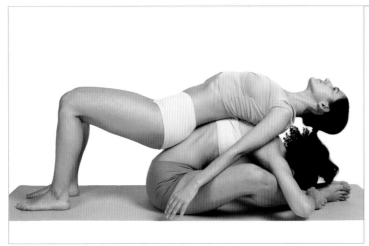

Partner Back Stretch

Target: Spine.

Benefits: Extends the spine of the Partner and the Stretcher.

Steps: Partner: Sit on the floor, with your knees out to the sides and the soles of your feet together. **Stretcher:** Crouch behind your Partner and press your hips and back against their upper back. Drop your arms to your sides. **Partner:** Slowly bend forward and reach your hands to your ankles and pull your forehead down toward your feet. **Stretcher:** Let your head and shoulders drop back to open your chest as your Partner bends forward. Your feet should remain on the floor and your knees bent so you do not release all your weight onto your Partner's back.

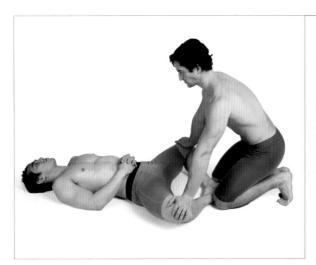

Partner Bent-Leg Groin

Target: Adductors.

Benefits: Deeply opens the hips and lengthens the adductors.

Steps: Stretcher: Lie flat on your back with both knees raised and your feet flat on the floor ahead of your hips. **Partner:** Kneel down with your knees on either side of the Stretcher's feet. Place your hands on the Stretcher's knees and slowly push their knees apart and down toward the floor. Continue pushing until their hips are fully open and their upper legs are flat on the floor.

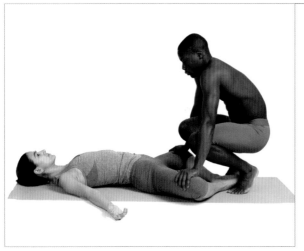

Partner Bicep, Seated

Target: Adductors.

Benefits: Deeply opens the hips and lengthens the adductors.

Steps: Stretcher: Lie flat on your back with your knees bent out to your sides and the soles of your feet pressed together. **Partner:** Crouch beside the Stretcher, with your feet on either side of their feet. Place your hands on the Stretcher's inner thighs and slowly push down against them. Continue pushing until their hips are fully open and their upper legs are flat on the floor.

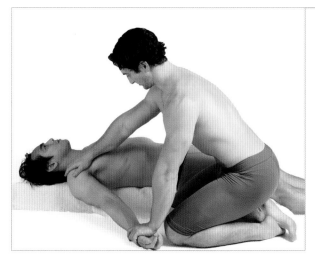

Partner Bicep Stretch

Target: Biceps.

Benefits: Reduces tightness and strain in the biceps and forearms.

Steps: Stretcher: Lie with your back on a cushion, slightly elevated from the floor. Extend your arm out to your sides.
Partner: Kneel at the Stretcher's right side, near their extended arm. Place your right hand on the Stretcher's shoulder for support. With your left hand, grab hold of the Stretcher's right wrist and gently pull their arm out away from their shoulder. Repeat on the opposite arm.

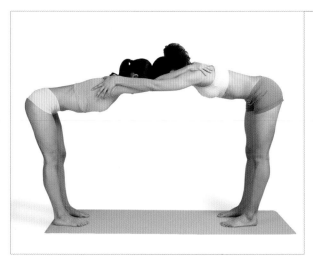

Partner Bridge

Target: Upper back.

Benefits: Extends the shoulders and spinal column while engaging the core.

Steps: Both Stretchers: Stand straight, facing each other several feet away. Bend forward at the waist, bringing your heads and shoulders down toward the floor. As you approach each other, reach your arms out and place your hands on the other Stretcher's shoulders. Your arms should be crossed at the elbows and the tops of your heads should be touching. Hold this pose for twenty seconds, keeping your legs and spines straight throughout.

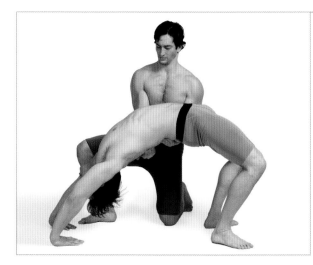

Partner Bridge Assistance

Target: Spine.

Benefits: Extends the spine and hips while strengthening the glutes and quadriceps.

Steps: Stretcher: Lie flat on your back with your knees bent. Bend your elbows and bring your palms flat on the floor beside your head, with your fingers pointed toward you. Using your arms and legs, lift your body off the floor. Round your back, so your bellybutton is your highest point. **Partner:** Kneel to one side of the Stretcher. As they lift from the floor, place both hands beneath their back for support. **Stretcher:** Let your head and shoulders drop. Hold this pose for as long as you feel confident.

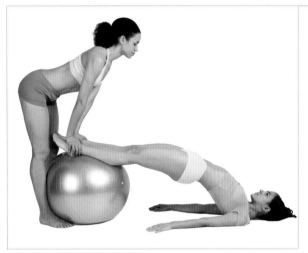

Partner Bridge on Ball

Target: Glutes, core, and thighs.

Benefits: Strengthens and tones the upper legs and core while creating stability in the hips and pelvis.

Steps: Stretcher: Lie on your back with your legs bent and feet propped up on an exercise ball. **Partner:** Stand at the Stretcher's feet and place your hands on their ankles to support your Partner's legs. **Stretcher:** Slowly lift your hips up into a straight body plank, hold for a minute, then lower back down and repeat.

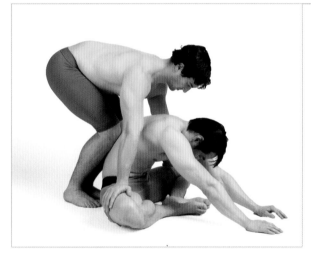

Partner Butterfly 1

Target: Adductors.

Benefits: Deeply opens the hips and lengthens the adductor muscles while extending the spine.

Steps: Stretcher: Begin seated on the floor with your knees bent to your sides and the soles of your feet together. **Partner:** Stand behind the Stretcher. Squat down, so your knees are pressed against the Stretcher's back and your hands are resting on the Stretcher's thighs, fingers pointing outward. **Stretcher:** Lean forward and place your hands flat on the floor in front of your feet. Slowly bend your torso forward, extending your hands in front of you and dropping your forehead toward the floor. **Partner:** Apply gentle pressure on the Stretcher's thighs and back as they stretch forward.

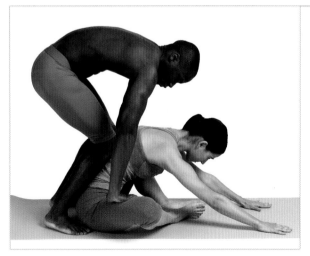

Partner Butterfly 2

Target: Upper back.

Benefits: Deeply opens the hips and lengthens the adductors while extending the spine.

Steps: Stretcher: Begin seated on the floor with your knees bent out to your sides and the soles of your feet pressed together. **Partner:** Stand behind the Stretcher. Squat down, so your knees are pressed against the Stretcher's back and your hands are resting on the Stretcher's thighs, fingers pointing inward. **Stretcher:** Lean forward and place your hands flat on the floor ahead of your feet. Slowly bend your torso forward, extending your hands out ahead of you and dropping your forehead toward the floor. **Partner:** Apply gentle pressure on the Stretcher's thighs and back as they stretch forward.

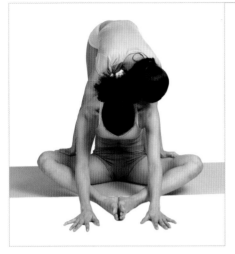

Partner Butterfly Knees

Target: Hamstrings.

Benefits: Deeply opens the hips and lengthens the adductor muscles while extending the spine

Steps: Stretcher: Begin seated on the floor with your knees bent out to your sides and the soles of your feet pressed together. **Partner:** Stand behind the Stretcher. Squat down, so your knees are pressed against the Stretcher's back and your hands are resting on the Stretcher's thighs. **Stretcher:** Lean forward and place your hands flat on the floor near your feet. Pull your head and shoulders down toward the floor and focus on keeping your hips wide open. **Partner:** Apply gentle pressure on the Stretcher's thighs and back as they stretch forward.

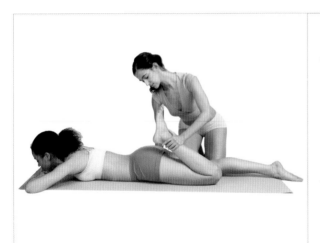

Partner Calf Stretch

Target: Calves.

Benefits: Contacts the muscles in the calves and hamstrings, relieving tightness and tension from overuse.

Steps: Stretcher: Lie flat on your stomach, with your legs extended. Bend your left leg and bring your foot to your hips. **Partner:** Kneel to the right side of the Stretcher. Hold the Stretcher's ankle with your left hand and gently press their leg in toward their hips.

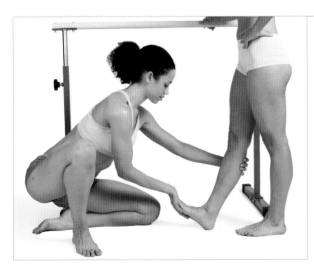

Partner Calf Stretch at Ballet Bar

Target: Calves.

Benefits: Lengthens the calf muscles, increasing flexibility and reducing tightness.

Steps: Stretcher: Stand to the left of a ballet bar and place your right hand on the bar for balance. Flex your foot and rest your heel on the floor. **Partner:** Kneel or sit in front of the Stretcher. Place your left hand behind the Stretcher's right calf for support. Reach your right hand beneath their flexed foot, and gently press it upward. **Stretcher:** Keep your heel on the floor throughout.

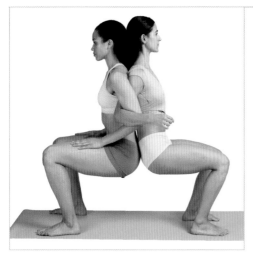

Partner Chair Squat

Target: Quadriceps.

Benefits: Strengthens the upper and lower legs, hips, and core.

Steps: Both Stretchers: Stand back to back, so the length of your backs are pressed against each other. Hook elbows and bring your hands back into your sides. One at a time, step both feet out and shoulder-width apart. Keep your backs pressed against each other for support. Slowly begin to bend your legs, in unison. Lower down into a chair squat, until your knees are perpendicular to the floor. Hold this pose for fifteen seconds.

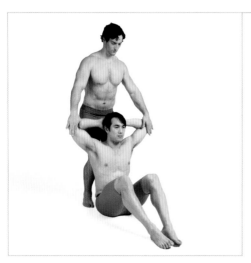

Partner Chest Opener

Target: Chest opener.

Benefits: Opens the chest and shoulders.

Steps: Stretcher: Begin seated on the floor, with your knees raised and your feet flat on the floor. Raise your hands to rest on the back of your head with your elbows out to the sides. **Partner:** Stand directly behind the Stretcher. Bend your knees slightly so your knees are pressed against the Stretcher's back for support. Press your palms against the Stretcher's inner elbows and gently pull their arms back.

Partner Chest Opener

Target: Chest opener.

Benefits: Opens the chest and shoulders.

Steps: Stretcher: Begin sitting cross-legged on the floor. Let your arms rest relaxed at your sides. **Partner:** Kneel directly behind the Stretcher. Place your hand son the Stretcher's shoulders and gently pull them back, opening the chest.

Partner Chest Opener Arm Raise

Target: Chest opener.

Benefits: Deeply extends the chest and shoulders.

Steps: Stretcher: Lie flat on your stomach with your arms at your sides. **Partner:** Stand above the Stretcher, with your feet at either side of their hips. Reach down and grab hold of the Stretcher's wrists. Gently pull the Stretcher's arms and chest up from the floor. **Stretcher:** Attempt to keep your arms straight and let your chest open.

Partner Chest Opener at Ballet Bar

Target: Chest opener.

Benefits: Extends the chest and shoulders, and twists the spine.

Steps: Stretcher: Stand facing away from a ballet bar, at an angle. Reach both hands back to hold the bar behind you. Twist your torso in the opposite direction from your feet. **Partner:** Place one hand on the Stretcher's back and your other hand on their chest. Press gently, helping the Stretcher into the twist.

Partner Chest Opener Backward-Arm Stretch

Target: Chest opener.

Benefits: Extends the shoulders and chest.

Steps: Stretcher: Stand straight with your arms at your sides. **Partner:** Stand directly behind the Stretcher, with your backs pressed together. Extend your arms to shoulder height, cross your arms at the wrists, and interlace your fingers. **Stretcher:** Reach behind you and hold the Partner's hips, opening your chest and shoulders. Continue to lengthen your spine in this pose.

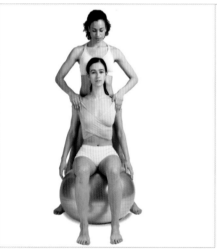

Partner Chest Opener on Ball

Target: Chest opener.

Benefits: Opens the chest and shoulders while engaging the core.

Steps: Stretcher: Begin seated on top of an exercise ball. Let your arms relax at your sides. **Partner:** Stand directly behind the Stretcher with your feet on either side of the ball. Place your hands on the Stretcher's shoulders and gently pull the Stretcher's shoulders back, opening the chest.

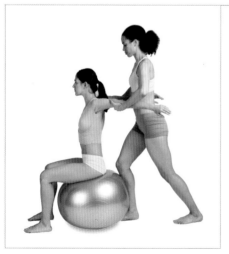

Partner Chest Opener on Ball

Target: Chest opener.

Benefits: Opens the chest and shoulders while engaging the core.

Steps: Stretcher: Begin seated on top of an exercise ball with your arms relaxed at your sides. **Partner:** Stand directly behind the Stretcher. Step your right leg into the ball and step the other away, bracing your body against the ball. Grab hold of the Stretcher's arms, just below the armpits. Gently pull the Stretcher's arms up behind them, targeting the shoulders and chest. **Stretcher:** Keep your spine long and your back straight as your Partner engages your arms.

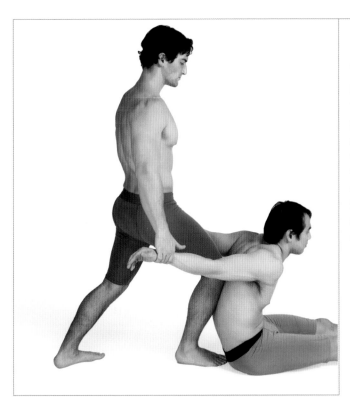

Partner Chest Pull

Target: Chest opener.

Benefits: Opens the chest and shoulders while engaging the upper arms.

Steps: Stretcher: Begin seated on the floor with your arms relaxed at your sides. **Partner:** Stand directly behind the Stretcher. Step your right knee into their back and step the other leg away, bracing your body against the Stretcher. Grab hold of the Stretcher's wrists and gently pull the Stretcher's arms up behind them, targeting the shoulders and chest. **Stretcher:** Keep your spine long and your back straight as your Partner engages your arms.

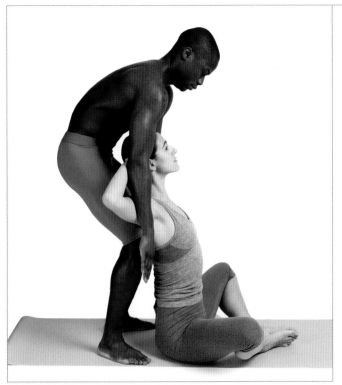

Partner Chest Stretch

Target: Chest opener.

Benefits: Opens the chest and shoulders while extending the hips.

Steps: Stretcher: Begin by sitting on the floor. Extend your knees out to your sides and press the soles of your feet together. Bring your hands to rest on the back of your head, so your elbows are extended out beside your head. **Partner:** Stand directly behind the Stretcher. Bend your knees slightly, so they are pressed against the Stretcher's back for support. Lean down and straighten your arms down against the Stretcher's bent arms. Gently push against the Stretcher's arms to open their chest and shoulders. **Stretcher:** Let your head and shoulders drop back against your Partner's thighs.

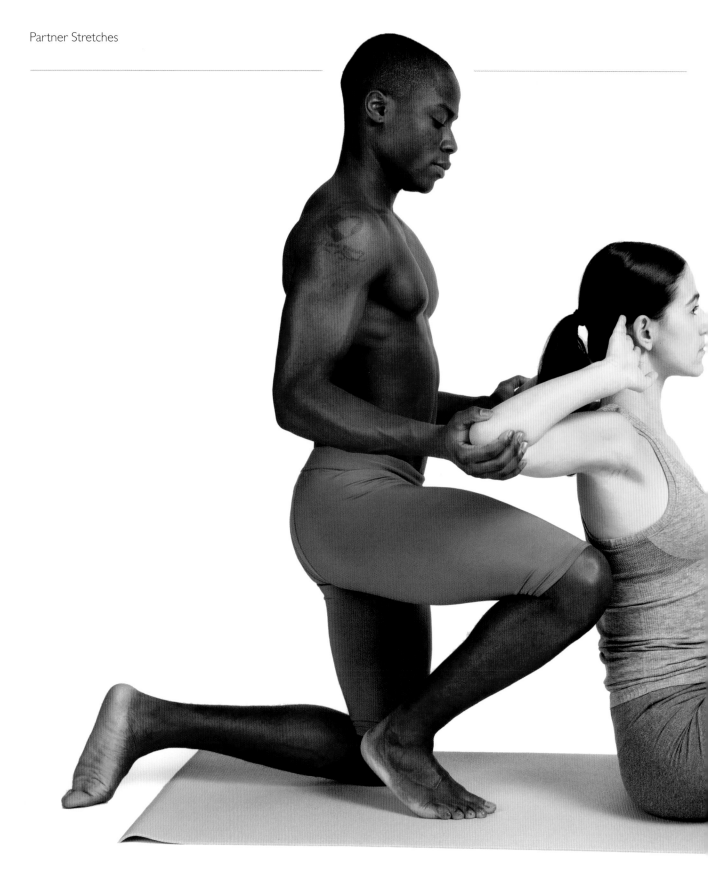

Partner Chest Stretch Behind Head

Target: Chest opener.

Benefits: Opens the chest and shoulders while engaging the upper arms.

Steps: Stretcher: Sit on the floor with your knees raised and your feet flat on the floor. Lift your hands to rest on the back of your head, with your elbows extended out to the side. **Partner:** Kneel directly behind the Stretcher. Bend one knee against their back for support. Reach and grab hold of the Stretcher's elbows. Gently pull their elbows back toward you and in toward each other. **Stretcher:** Keep your fingertips touching your head, as your partner pull your shoulders in behind your back.

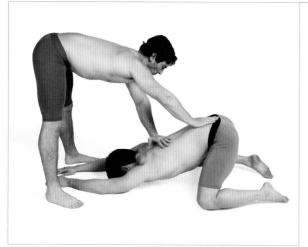

Partner Child Pose 1

Target: Upper back.

Benefits: Opens the chest, shoulders, and hips while extending the upper back.

Steps: Stretcher: Begin on all fours, with your palms flat on the floor directly below your shoulders and knees far apart. One at a time, extend your arms out straight ahead and lower your chest down toward the floor. **Partner:** Stand facing the Stretcher. As they lower down into Extended Child Pose, place one hand on their lower back and your other hand on their upper back. Gently press their back down into a deeper stretch.

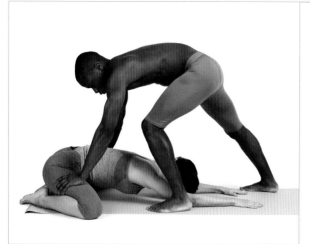

Partner Child Pose 2

Target: Adductors.

Benefits: Deeply opens the hips and lengthens the adductor muscles while extending the spine and shoulders.

Steps: Stretcher: Begin on all fours, with your palms flat on the floor directly below your shoulders. Lower your hips down toward the floor, and bend your knees out to your sides. One at a time, straighten your arms on the floor ahead of you and lower your forehead down to touch the floor. **Partner:** Stand directly above the Stretcher. As they lower their hips and chest down to the floor, lean down and place your hands on their upper thighs. Gently press down on their hips and thighs, into a deeper stretch.

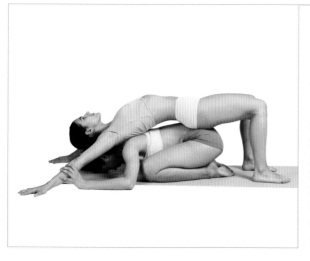

Partner Child Pose and Back Stretch

Target: Spine.

Benefits: Stretches the spine.

Steps: Partner: Begin on all fours and rest your hips on your heels. Lower your forehead down to the floor. **Stretcher:** Lower your hips into a sitting position on your Partner's upper hips. Your knees should be bent at a 90-degree angle and your feet flat on the floor. Drop your head and shoulders back, so your body is draped over your Partner's back. Extend your arms straight over your head and place your hands flat on the floor. **Partner:** Reach hold of the Stretcher's forearms and gently press them down, increasing the stretch on the chest and shoulders.

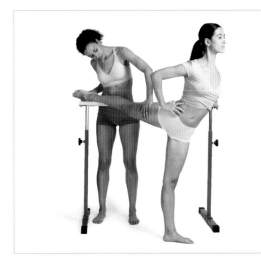

Partner Controlled Kick at Ballet Bar

Target: Adductors.

Benefits: Opens the hips and increases strength and balance in the legs.

Steps: Stretcher: Begin standing and facing away from a ballet bar at an angle. Shift your weight onto your left foot and raise the right foot up behind your hips. Place your hands on your hips and extend your right leg out straight behind you. **Partner:** Stand behind the Stretcher and behind the bar. As the Stretcher raises their leg up behind them, grab hold of their ankle. Place your left hand on the Stretcher's upper thigh for support. Carefully lift the outstretched leg up to rest on the ballet bar. Press in on the Stretcher's thigh, making sure the leg is straight.

Partner D1 Arm Supination

Target: Biceps and triceps.

Benefits: Relieves tension in the upper arms and shoulders.

Steps: Stretcher: Lie on your back, raised up off the floor on cushions. Let your left arm hang at your side, and extend your right arm across your chest and to the left. **Partner:** Kneel to the left of the Stretcher. Reach hold of their right wrist with your left hand and place your right hand on their shoulder for support. Gently pull the Stretcher's right arm toward you, raising it slightly up from their chest and lengthening the muscles in the upper arms. Repeat on the opposite arm.

Partner D1 Extension

Target: Biceps and triceps.

Benefits: Relieves tension in the upper arms and shoulders.

Steps: Stretcher: Lie on your back, raised up off the floor on cushions. Let your arms hang at your sides. **Partner:** Kneel to the right side of the Stretcher. Reach hold of their right wrist with your left hand and place your other hand on their shoulder for support. Gently pull their wrist down and away from the shoulder, to increase pressure on the upper arm. Repeat on the opposite arm.

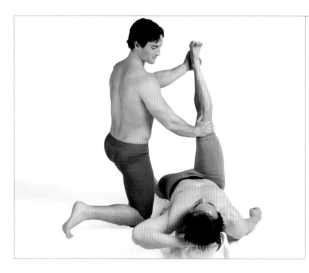

Partner D1 Leg

Target: Hamstrings.

Benefits: Lengthens the muscles in the calves and hamstrings while opening the hips.

Steps: Stretcher: Lie on your back, slightly raised up off the floor on cushions. Raise your right knee up, and attempt to straighten your leg from the hips. **Partner:** Kneel to the left side of the Stretcher. Place your right hand just above the right knee and place your other hand behind the Stretcher's ankle. Gently press in on their thigh and on their heel, straightening the targeted leg. Repeat on the opposite leg.

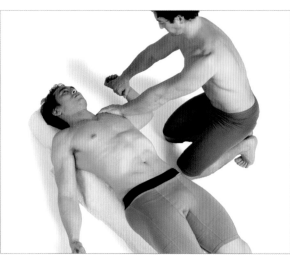

Partner D2 Elbow Extension

Target: Shoulders.

Benefits: Targets the muscles in the shoulders and upper arms.

Steps: Stretcher: Begin by lying flat on your back, slightly raised up off the floor on cushions. Bend your left arm up at your side at a 90-degree angle. **Partner:** Kneel at the Stretcher's left side. Place your left hand on their shoulder for support, and grab hold of their wrist with your other hand. Gently press down on the wrist toward the floor, twisting the Stretcher's arm out from the shoulder. Repeat on the opposite arm.

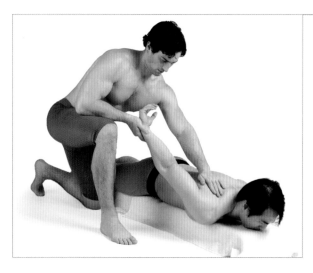

Partner D2 Elbow Supination

Target: Shoulders.

Benefits: Extends the muscles in the shoulders and upper arms.

Steps: Stretcher: Lie flat on your stomach, raised slightly off the floor on a cushion. Let your arms hang down at your sides. **Partner:** Kneel to the right side of the Stretcher. Place your left hand on their right shoulder blade for support. With your other hand, grab hold of their right wrist. Gently pull the Stretcher's arm up from the floor, twisting it out behind them. **Stretcher:** Attempt to keep your arm straight, as it is being raised up behind you. Repeat on the opposite arm.

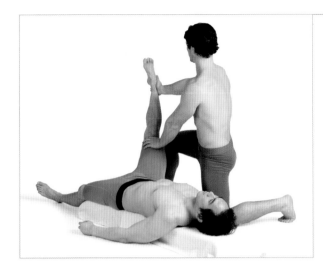

Partner D2 Leg Extension

Target: Adductors.

Benefits: Lengthens the muscles in the calves and hamstrings while opening the hips.

Steps: Stretcher: Begin by lying flat on your back, raised slightly from the floor on cushions. Raise your right knee up, and attempt to straighten your leg from your hips. **Partner:** Kneel to the right side of the Stretcher. Place your left hand just above their right knee and place your right hand behind the Stretcher's ankle. Gently press in on their thigh and heel, straightening the targeted leg. Repeat on the opposite leg.

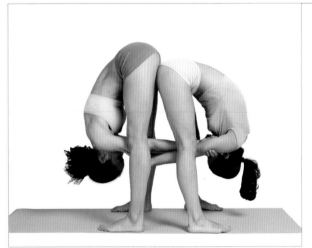

Partner Deep Backbend 1

Target: Spine.

Benefits: Engages both Partners in a deep spinal extension, targeting the upper back and shoulders.

Steps: Both Stretchers: Begin by standing back to back, with your hips touching. Begin to bend forward at the waist, bringing your heads down toward the floor. Once you are both in a complete forward bend, reach your hands in and grab hold of each other's upper arms. Pull gently each others arms, engaging your upper back and shoulder muscles.

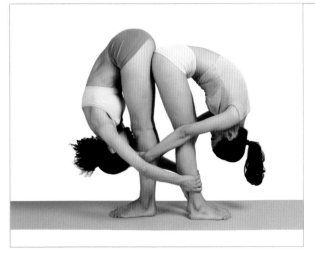

Partner Deep Backbend 2

Target: Spine.

Benefits: Engages both Partners in a deep spinal extension, targeting the upper back and shoulders.

Steps: Both Stretchers: Begin standing back to back, with your hips touching. Begin to bend forward at the waist, bringing your heads down toward the floor. Once you are both in a complete forward bend, reach your hands around each other's shins. Pull gently against each other's legs, bending your elbows and engaging the upper back and shoulder muscles.

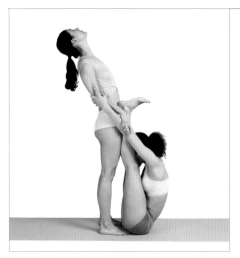

Partner Deep-Hamstring and Back Stretch

Target: Hamstrings and back

Benefits: This exercise will help in making the hamstrings more flexible and the spine more limber.

Steps: Stretcher: Lie down on your back with your arms and legs extended straight up. **Partner:** Stand facing the Stretcher's raised legs, with their heels on the front of your hips. Grab hold of the Partner's forearms and slowly pull the Partner's torso off the floor and toward their legs. Breathe deeply here. Slowly roll back down, supported by the Partner.

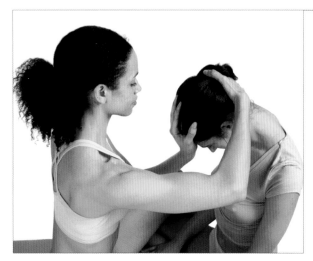

Partner Deep-Neck Bend

Target: Neck.

Benefits: Lengthens and extends the muscles in the back of the neck.

Steps: Stretcher: Begin seated with your legs crossed. Lengthen your back and sit with good upright posture. **Partner:** Place one hand on the back of Stretcher's head and the other hand on the Stretcher's forehead. Gently pull the Stretcher's head down into their chest and up out from their neck.

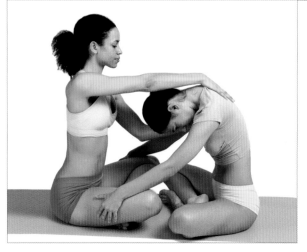

Partner Deep-Shoulder Curve

Target: Upper back.

Benefits: Lengthens and extends the muscles in the spine and upper back.

Steps: Stretcher: Begin seated with your legs crossed. Lengthen your back and sit with good upright posture. **Partner:** Place one hand on the Stretcher's upper back and the other on the Stretcher's chest. Gently pull the Stretcher's head down into their chest, deeply curving their upper back. Press down on the Stretcher's upper back to maximize the stretch. **Stretcher:** Place your hands on your Partner's thighs for support as you lengthen your spine.

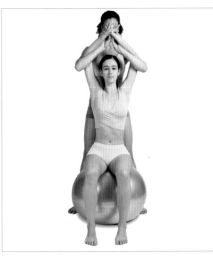

Partner Double-Arm Stretch on Ball

Target: Shoulders.

Benefits: Extends the spinal column and shoulder muscles while engaging the core.

Steps: Stretcher: Begin seated on top of an exercise ball. Lace your fingers together and raise your hands up above your head. **Partner:** Stand directly behind the Stretcher. Reach your hands around the Stretcher's elbows and back in between their hands. Hold the Stretcher's wrists, and pull their arms up gently from their shoulders.

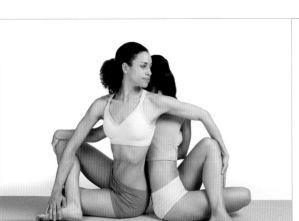

Partner Double-Back Twist

Target: Spine.

Benefits: Engages the body in a spinal twist while extending the hip abductors.

Steps: Stretcher: Begin seated back to back, legs crossed in front of you. Cross your right leg over your left leg so your foot is resting on the floor to the outside of your left thigh. Place your right hand on your right foot. **Partner:** Cross your left leg over your right leg so your foot is resting on the floor to the outside of your right thigh. Twist your torso to the left. **Both:** Twist your torso to the left and hook your left hand on other partner's raised knee. Gently pull into a deeper twist. Hold this pose for fifteen seconds and then repeat on the opposite side.

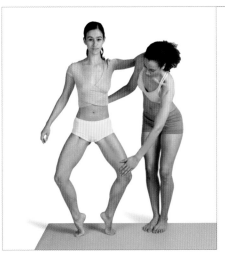

Partner Double-Toe Point

Target: Quadriceps and calves.

Benefits: Improves balance and strengthens legs.

Steps: Stretcher: Stand with your feet together and toes pointing out. Rise up onto tiptoes and bend your knees outward. Rest your left hand on your Partner's right shoulder for support. **Partner:** Stand on the Stretcher's left side and place your right hand on their back for support. Press your left hand just above the Stretcher's left knee and pull the leg back to help the Stretcher open their knees wider apart.

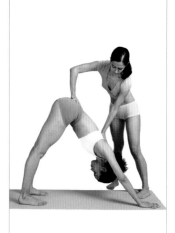

Partner Downward Dog

Target: Spine.

Benefits: Increases strength and flexibility the legs, spine, and arms.

Steps: Stretcher: Start on all fours, keeping your palms flat on the floor and fingers pointed ahead. Raise your hips up toward the ceiling, in a downward dog position, and straighten your legs. Relax your neck so your head is between your shoulders. **Partner:** Stand to the left of the Stretcher. Place your left hand against the Stretcher's upper back and the other hand against their lower back. Gently press in to the Stretcher's back, increasing pressure on the spine and shoulders.

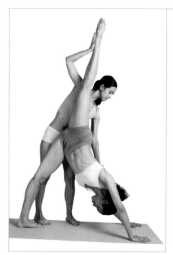

Partner Downward Dog, Extended

Target: Adductors.

Benefits: Increases strength, flexibility and balance in the legs, spine and arms while deeply opening the hips.

Steps: Stretcher: Start on all fours, keeping your palms flat on the floor and fingers pointed ahead. Raise your hips up toward the ceiling, in a downward dog position, and straighten your legs. Relax your neck so your head is between your shoulders. Lift your right foot from the floor and extend your leg straight up above you. **Partner:** Stand to the left of the Stretcher. Place your left hand against the Stretcher's upper back and reach hold of the Stretcher's raised ankle with your right hand. Gently press in on the Stretcher's back, increasing pressure on the spine and shoulders. Gently press the Stretcher's leg up, increasing the stretch on their hips.

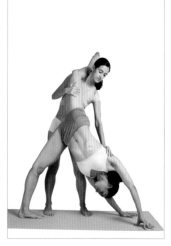

Partner Downward Dog, Hip Opener

Target: Adductors.

Benefits: Increases strength, flexibility, and balance in the legs, spine, and arms while deeply opening the hips.

Steps: Stretcher: Start on all fours, keeping your palms flat on the floor and fingers pointed ahead. Raise your hips up toward the ceiling, in a downward dog position, and straighten your legs. Relax your neck so your head is between your shoulders. Lift your right foot from the floor and extend your leg straight up above you. **Partner:** Stand to the left of the Stretcher. Place your left hand against the Stretcher's upper back and grab hold of the Stretcher's raised thigh with your right hand. Gently press in on the Stretcher's back, increasing pressure on the spine and shoulders. Gently pull the Stretcher's thigh into your chest. **Stretcher:** Let your raised knee rest over your Partner's shoulder, increasing pressure on your hips.

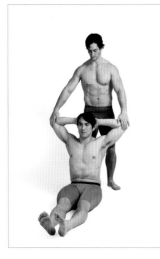

Chest Opener with Partner

Target: Chest opener.

Benefits: Opens the chest and shoulders, reducing tightness and tension.

Steps: Stretcher: Begin seated on the floor with your legs extended forward. Raise your hands to rest on the back of your head. **Partner:** Stand directly behind the Stretcher. Place your hands against the Stretcher's inner elbows. Gently press against the Stretcher's elbows, opening the chest and increasing pressure on the shoulders.

Partner Facing Palms

Target: Upper back.

Benefits: Opens the chest and shoulders, lengthening the spinal column and targeting the muscles across the upper back.

Steps: Both Stretchers: Stand facing each other about four feet apart. Raise your arms overhead and lean forward until you are able to press your palms together. Bend your torsos down toward the floor. Let your spines curve upward and attempt to lower down in unison, keeping your heads at the same level. Continue bending until your torsos are parallel to the floor.

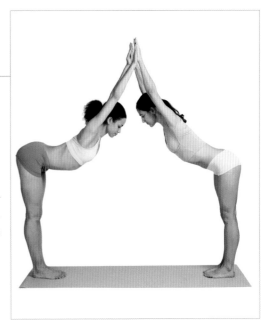

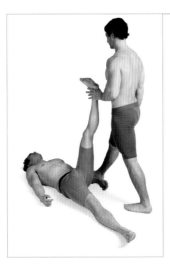

Partner Hip Flexion I

Target: Calves.

Benefits: Extends the muscles along the back of the leg while opening the hips.

Steps: Stretcher: Lie flat on your back with your arms at your sides. Raise your left leg up from the floor and extend it straight toward the ceiling. **Partner:** Stand at the Stretcher's left side. Grab hold of the Stretcher's left ankle and attempt to push their leg farther in toward their torso. **Stretcher:** Attempt to keep your leg straight as your Partner applies pressure.

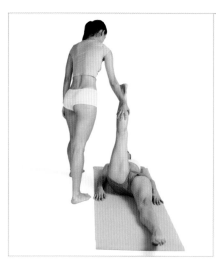

Partner Hip Flexion 2

Target: Hips.

Benefits: Extends the hamstrings while opening the hips.

Steps: Stretcher: Lie flat on your back with your arms at your sides. Raise your right leg up from the floor and attempt to straighten it toward the ceiling. **Partner:** Stand at the Stretcher's right side. Place your right hand against the Stretcher's raised calf and gently push their leg farther up above their hips. **Stretcher:** Attempt to keep your leg straight as your Partner applies pressure. Keep your foot flexed to increase pressure on the calves and Achilles tendon. Repeat on the opposite leg.

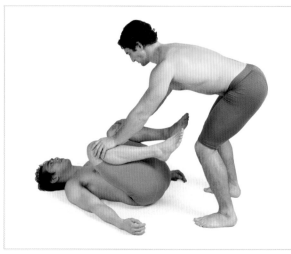

Partner Hip and Knee Flexion in Supine Position

Target: Hamstrings.

Benefits: Lengthens the muscles in the hamstrings and glutes while releasing the spine.

Steps: Stretcher: Lie flat on your back, with your arms resting on the floor at your sides. Tuck your knees into your chest. **Partner:** Stand facing the Stretcher. Place your hands on the Stretcher's knees and gently press the Stretcher's knees farther into their chest.

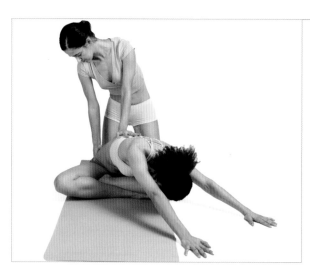

Partner Folded Side Stretch

Target: Obliques.

Benefits: Relieves tightness and increases mobility in the obliques.

Steps: Stretcher: Begin seated with your legs crossed. Fold forward at the waist, twisting slightly to your left, and extend both arms straight out ahead of you. Place your hands flat on the floor and lower your forehead just off the floor and in front of your left knee. **Partner:** Kneel directly behind the Stretcher and place on hand on the middle of the Stretcher's back and the other just above their hips. Gently press down on the Stretcher's back, increasing pressure on the spine and hips.

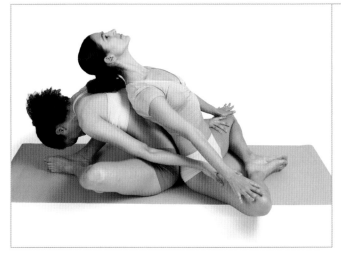

Partner Fold-Over Butterfly

Target: Spine.

Benefits: Engages the spine.

Steps: Begin seated back to back. Bend your knees out to the sides and press the soles of your feet together. **Partner:** Drop your forehead toward your feet, deeply bending your spine forward. **Stretcher:** As your Partner folds forward, allow your back and shoulders to fall open. Shift your gaze upward to open your neck.

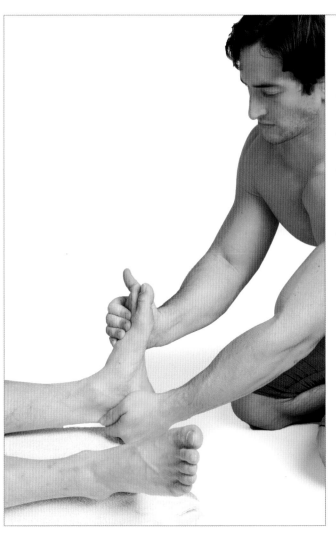

Partner Foot-Everted Supine

Target: Feet.

Benefits: Strengthens the muscles in the lower leg and foot while restoring balance in the ankle.

Steps: Stretcher: Sit or lie with your legs extended flat on the floor. **Partner:** Kneel at the Stretcher's feet. Place your left hand under the Stretcher's left heel. Wrap your right hand around the Stretcher's toes, with your palm pressed against the ball of their foot. Gently press the Stretcher's foot out to the left side. Repeat on the opposite foot.

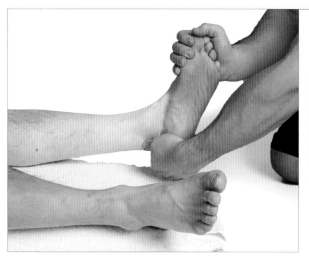

Partner Foot-Inverted Supine

Target: Feet.

Benefits: Strengthens the muscles in the lower legs and feet while restoring balance in the ankles.

Steps: Stretcher: Sit or lie with your legs extended flat on the floor. **Partner:** Kneel beside the Stretcher's feet. Place your left hand under the Stretcher's left heel. Place your right hand around the Stretcher's toes, with your palm on the top of the foot. Gently curl the Stretcher's foot inward. Repeat on the opposite foot.

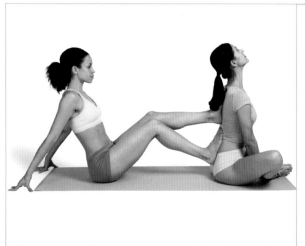

Partner Foot-to-Back Stretch

Target: Lower back.

Benefits: Lengthens the spine and targets the lower back while opening the hips.

Steps: Stretcher: Begin seated on the floor with your knees bent out to the sides and your feet pressed together. **Partner:** Sit directly behind the Stretcher. Place your hands on the floor behind you for support. Raise both feet flat against the Stretcher's back along their spine. Press gently against the Stretcher's spine with both feet. **Stretcher:** Allow your spine to lengthen and your chest to open, as your Partner presses against your back.

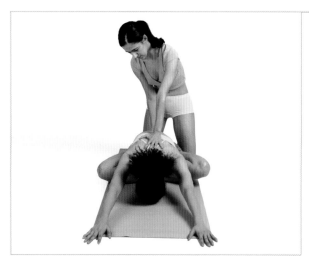

Partner Forward Bend 1

Target: Spine.

Benefits: Relieves tightness and increases mobility along the spine.

Steps: Stretcher: Begin seated with your legs crossed. Fold forward at the waist and extend both arms straight out ahead of you. Drop your forehead toward the floor. **Partner:** Kneel directly behind the Stretcher. As they bend over, place one hand on the Stretcher's upper back and the other just above their hips. Gently press down on the Stretcher's back, increasing pressure on the spine and hips.

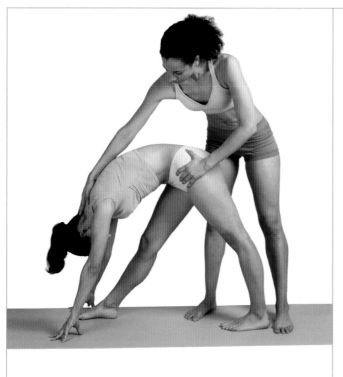

Partner Forward Bend 2

Target: Lower back.

Benefits: Increases flexibility and range of motion in the lower back.

Steps: Stretcher: Standing straight, step your right foot forward, keeping both feet pointed straight ahead. Bend forward at the waist, bringing your torso into a forward bend along your right leg. Extend both hands down to the floor on either side of your right foot. **Partner:** Stand directly behind the Stretcher. Place your right hand on the Stretcher's upper back and your other hand on their left hip for support. As the Stretcher bends forward, apply gentle pressure to the upper back, easing them down into the forward bend.

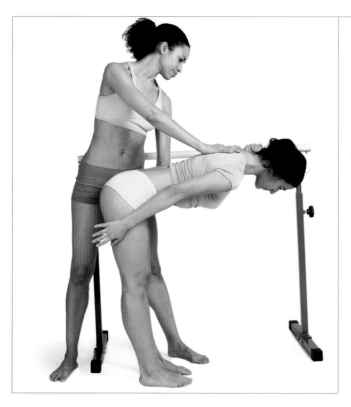

Partner Forward Bend at Ballet Bar

Target: Upper back.

Benefits: Lengthens the spine and broadens the muscles in the upper back.

Steps: Stretcher: Begin by standing to the left side of a ballet bar. Hold the bar with your left hand. Bend your torso forward at the waist, until it is parallel to the floor. **Partner:** Place your right hand flat on the Stretcher's upper back. Place your other hand on the Stretchers stomach. Gently press down on the Stretcher's upper back and up on their stomach, extending their upper back.

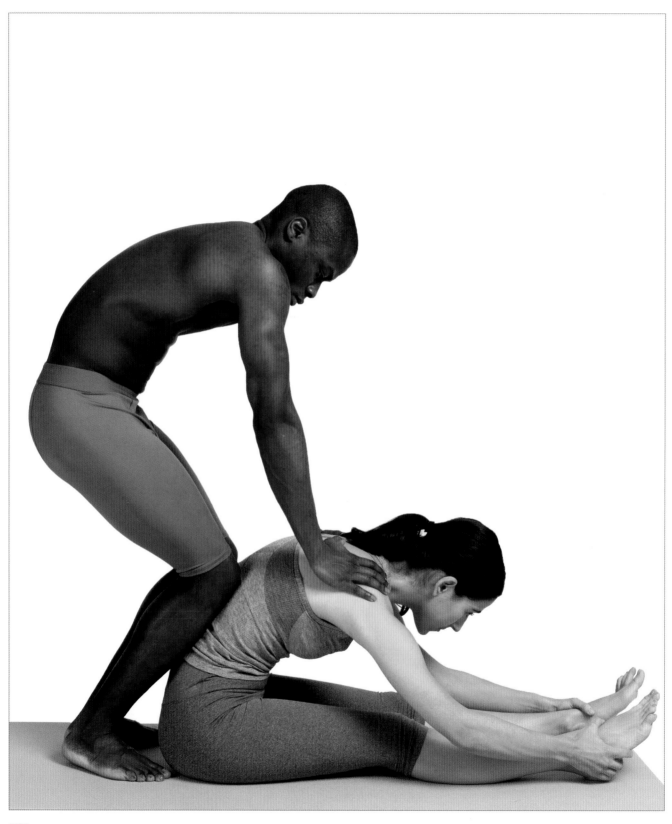

Partner Forward Bend, Seated

Target: Hamstrings.

Benefits: Extends the spinal column while lengthening the calves and hamstrings.

Steps: Stretcher: Begin seated on the floor with your legs extended straight ahead. Slowly bend forward from the waist and grab hold of your feet. Pull your head and torso down toward your legs. **Partner:** Stand directly begin the Stretcher. Bend your knees and press them against the Stretcher's back for support. Place both hands against the Stretcher's shoulders and press down gently, aiding in the forward bend.

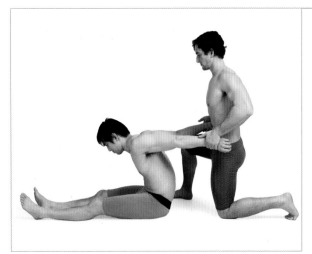

Partner Front Deltoid

Target: Shoulders.

Benefits: Opens the chest and shoulders while engaging the upper arms.

Steps: Stretcher: Begin seated on the floor with your arms relaxed at your sides and your legs straight out ahead. **Partner:** Kneel directly behind the Stretcher. Reach hold of the Stretcher's arms, just above the wrists. Gently pull the Stretcher's arms straight out behind them, targeting the shoulders and chest. Raise the Stretcher's arms so they are stretched out parallel to the floor. **Stretcher:** Keep your spine long and your back straight as your Partner engages your arms.

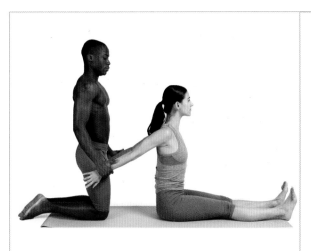

Partner Front Deltoid, Seated

Target: Chest opener.

Benefits: Opens the chest and shoulders and engages the upper arms.

Steps: Stretcher: Begin seated on the floor with your arms relaxed at your sides and your legs straight out ahead. **Partner:** Kneel directly behind the Stretcher. Reach hold of the Stretcher's arms, just above the wrists. Gently pull the Stretcher's arms straight out behind them, targeting the shoulders and chest. Place the Stretcher's hands beside your thighs. **Stretcher:** Keep your spine long and back straight as your Partner engages your arms.

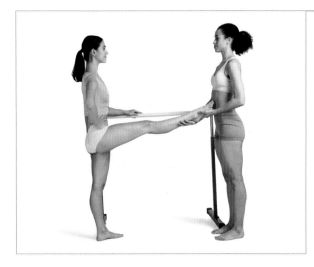

Partner Front-Leg Raise at Ballet Bar

Target: Adductors.

Benefits: Opens the hips and improves strength and balance in the legs.

Steps: Stretcher: Begin by standing to the left of a ballet bar. Grab hold of the bar with your left hand. Raise your right foot up and attempt to extend your leg straight out ahead. **Partner:** Stand in front of the Stretcher, several feet away. As the Stretcher raises their foot, grab hold of their ankle with both hands. Carefully pull the Stretcher's right leg farther up. **Stretcher:** Attempt to keep your leg straight and remain balanced as your Partner pulls your leg upward.

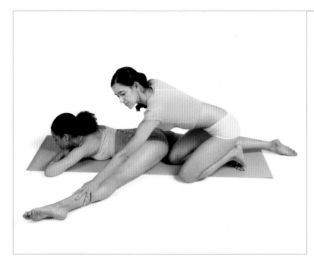

Partner Full-Leg Extension and Spinal Support

Target: Adductors.

Benefits: Deeply extends the hips and groin, targeting the adductors.

Steps: Stretcher: Begin lying on your stomach with your legs out straight. Bend your left knee and attempt to straighten your leg out to your left side. As you straighten your leg, roll your hips so the inner length of your leg is flat on the floor. **Partner:** Kneel behind the Stretcher near their hips. Place your right hand flat to the Stretcher's lower back for support. Reach your left hand to grab hold of their shin. Gently push the Stretcher's leg farther out to their side.

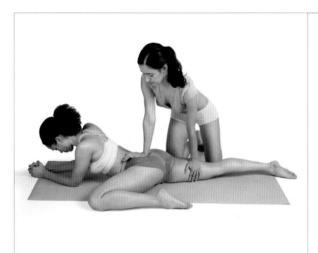

Partner Full-Quad Stretch

Target: Hips.

Benefits: Deeply extends the hips and groin, targeting the adductors as well as the lower back.

Steps: Stretcher: Begin by lying on your stomach with your legs out straight. Prop your chest up on your elbows. Bend your left knee deeply up into your side and roll your hips so your inner leg is flat on the floor. **Partner:** Kneel at the Stretcher's right side. Place your right hand flat on the Stretcher's lower back for support. Reach your left hand on the Stretcher's inner right thigh. Gently push down on the Stretcher's lower back. Meanwhile, gently pull their thigh toward you.

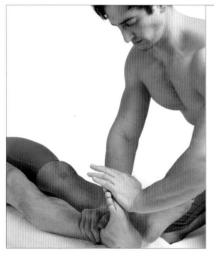

Partner Gastrocnemius Soleus

Target: Achilles.

Benefits: Provides relief from tight Achilles tendons and eases mobility in the ankles.

Steps: Stretcher: Sit or lie flat with your legs extended flat on the floor. Flex your right foot so your toes point up toward the ceiling. **Stretcher:** Kneel beside the Stretcher's feet. Place your right hand on the Stretcher's right shin for support. Press your other hand over their toes, so your palm is flat against the ball of the Stretcher's foot. Gently press the Stretcher's foot farther up, targeting their calf and Achilles tendon. Repeat on the opposite foot.

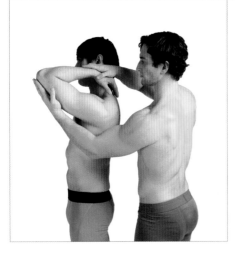

Partner Giro de Tronco 1

Target: Latissimus dorsi.

Benefits: Extends the shoulders and upper back, targeting the latissimus dorsi.

Steps: Stretcher: Stand straight and raise your left elbow up to eye level. Rest your hand on your upper back. **Partner:** Stand behind the Stretcher and rest your right hand on the Stretcher's hand. Reach your left hand under the Stretcher's elbow. Gently press up on the Stretcher's elbow, pulling their arm upward. Repeat on the opposite arm.

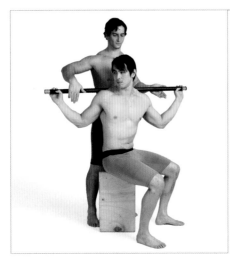

Partner Giro de Tronco 2

Target: Latissimus dorsi.

Benefits: Extends the shoulders and upper back, targeting the latissimus dorsi.

Steps: Stretcher: Begin seated on a bench or chair. Hold the exercise bar in both hands, so the bar rests across your upper back and shoulders. Gently twist your torso to the right side, using the bar to provide additional pressure. **Partner:** Stand directly behind the Stretcher. Place your hands on the bar beside the Stretcher's hands. Gently push against the bar to increase the twist.

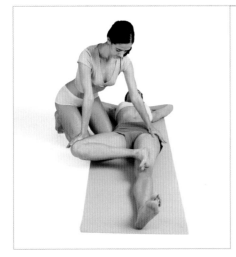

Partner Groin Extension

Target: Abductors.

Benefits: Opens the hips and engages the hip abductors.

Steps: Stretcher: Begin by lying on your back with your legs extended. Raise your right foot from the floor and place it on your left thigh, with your knee bent out to the side. **Partner:** Kneel on the Stretcher's right side. Place your left hand on the Stretcher's left hip. Place your right hand on the Stretcher's bent knee. Gently press the Stretcher's knee, increasing pressure on the hip abductors. Repeat on the opposite leg.

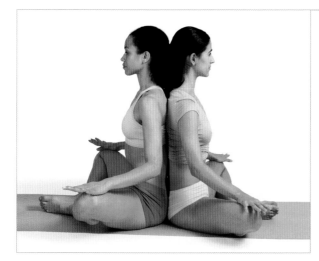

Partner Groin Stretch

Target: Adductors.

Benefits: Opens the hips and engages the hip adductors.

Steps: Both Stretchers: Sit with your backs pressed together. Bend your knees out to the sides and press the soles of your feet together. Place your hands on your knees and press them down gently to increase pressure on the hips.

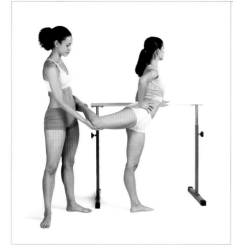

Partner Groin Stretch at Ballet Bar

Target: Adductors.

Benefits: Opens the hips and engages the hip adductors and abductors while increasing balance.

Steps: Stretcher: Stand to the right of a ballet bar. Hold the bar with your left hand. Shift your weight onto your left foot and raise your right foot out behind your hips. **Partner:** Stand behind the Stretcher. As they raise their leg, place your right hand beneath the Stretcher's right knee and the other hand beneath their ankle. Carefully pull the Stretcher's leg higher, making sure to keep their knee at a 90-degree angle throughout. Repeat on the opposite leg.

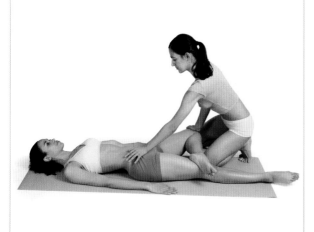

Partner Half-Lotus Stretch, Lying

Target: Adductors.

Benefits: Opens the hips and engages the hip adductors and hamstrings.

Steps: Stretcher: Begin by lying on your back with your legs extended. Raise your left foot and place it on your right thigh, so your knee is bent out to the side. **Partner:** Kneel on the Stretcher's left side. Place your left hand on the Stretcher's right hip. Place your right hand on the Stretcher's bent knee. Gently press down on the knee, increasing pressure on the hip abductors. Repeat on the opposite leg.

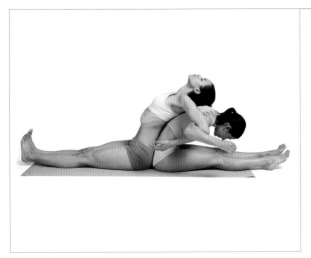

Partner Hamstring and Back Fold-Over

Target: Chest opener.

Benefits: Engages the spine.

Steps: Partner: Begin seated on the floor back to back with the Stretcher. Hook your elbows under the Stretcher's and bring your hands to your sides. Your legs should be flat on the floor. Slowly bend your torso forward, bringing your forehead down to your knees. Engage your arms and shoulders and pull the Stretcher with you as your bend forward. **Stretcher:** Allow your head and shoulders to drop back against your Partner. Relax your arms and shoulders, allowing your chest to open. Your legs should be straight and your feet flexed throughout.

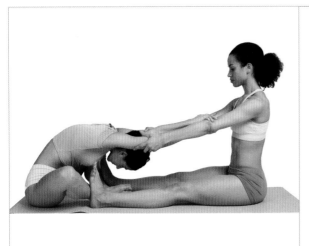

Partner Hamstring in Butterfly

Target: Spine.

Benefits: Deeply opens the hips and extends the spine and shoulders.

Steps: Stretcher: Begin by sitting on the floor with your knees bent out to your sides and the soles of your feet pressed together. Bend your torso forward from the waist, bringing your forehead down toward your feet. **Partner:** Sit facing the Stretcher with your feet pressed against their shins. Your legs should be flat on the floor. Reach forward and grab hold of the Stretcher's arms, just above the elbows. Gently pull the Stretcher's arms up toward you, lengthening their spinal column and shoulder muscles. **Stretcher:** Hold your Partner's upper arms and allow your spine to lengthen throughout the stretch.

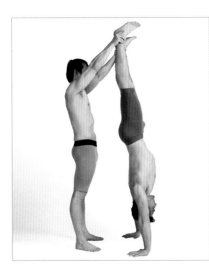

Partner Handstand

Target: Core.

Benefits: Strengthens the arms, legs, and spine while toning the abdominal muscles.

Steps: Stretcher: Kneel on the floor and set the crown of your head on the floor. Keep your hands flat on the floor shoulder-width apart. Inhale and lift your knees off the floor. Carefully walk your feet closer to your elbows, heels elevated. Try to keep your torso as straight as possible. Exhale and lift your feet off the floor. Take both feet up at the same time, even if it means bending your knees and hopping lightly off the floor. As the legs (or thighs, if your knees are bent) rise straight up, firm the tail bone against the back of the pelvis. **Partner:** Stand directly behind the Stretcher. As they propel their legs from the floor, carefully grab hold of the Stretcher's ankles. Slowly raise their legs up together, so that the Stretcher's feet are directly above their hips. Continue holding the Stretcher's ankles and help them find their balance.

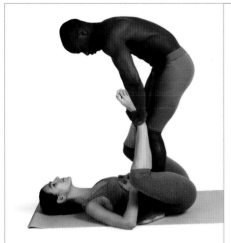

Partner Happy Baby I

Target: Adductors.

Benefits: Opens the hips and engages the hip abductors and lower back.

Steps: Stretcher: Begin by lying flat on your back with your legs out straight. **Partner:** Stand above the Stretcher, with your feet on either side of their waist. **Stretcher:** Bend both knees up into your sides, so they are tucked around your Partner's shins. Your feet should be raised directly above your knees. **Partner:** Reach down and grab hold of either of the Stretcher's ankles. Gently pull the Stretcher's feet in, so the soles of their feet are pressed together directly above their waist.

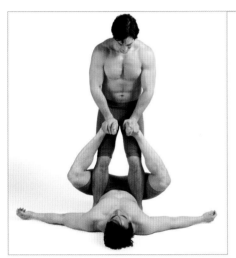

Partner Happy Baby 2

Target: Lower back.

Benefits: Opens the hips and engages the hip abductors and core muscles.

Steps: Stretcher: Begin by lying flat on your back with your legs out straight. **Partner:** Stand above the Stretcher, with your feet on either side of their waist. **Stretcher:** Bend both knees up into your sides, so they are tucked around your Partner's shins. Engage your core and raise your hips off the floor. Your feet should be raised directly above your knees. **Partner:** Reach down and grab hold of the Stretcher's ankles. Gently pull the Stretcher's feet in, so the soles of their feet are pressed together directly above their waist. **Stretcher:** Keep your abdomen engaged and your hips raised throughout.

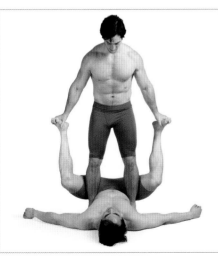

Partner Happy Baby, Modification

Target: Adductors.

Benefits: Opens the hips and engages the hip abductors and core muscles.

Steps: Stretcher: Begin by lying flat on your back with your legs out straight. **Partner:** Stand directly above the Stretcher, with your feet on either side of their waist. **Stretcher:** Bend both knees up into your sides, so they are tucked around your Partner's shins. Engage your core and raise your hips off the floor. Your feet should be raised directly above your knees. **Partner:** Reach down and grab hold of the Stretcher's feet and hold them out beside your thighs. Gently press their feet down, increasing pressure on the hips.

Partner Hip-Flex Lengthener

Target: Chest opener.

Benefits: Deeply opens the chest, neck, and shoulders while lengthening the spinal column.

Steps: Partner: Stand back to back with the Stretcher. Step your feet apart from each other and bend your knees slightly. Hook your elbows under theirs and bring your hands back into your sides. Begin to bend forward at the waist, dropping the top of your head down toward the floor. Keep your arms and shoulders engaged, in order to lift the Stretcher with you. **Stretcher:** Allow your head and shoulders to drop back as your Partner bends forward. Relax your arms and shoulders to open your chest. Your feet should lift up from the floor.

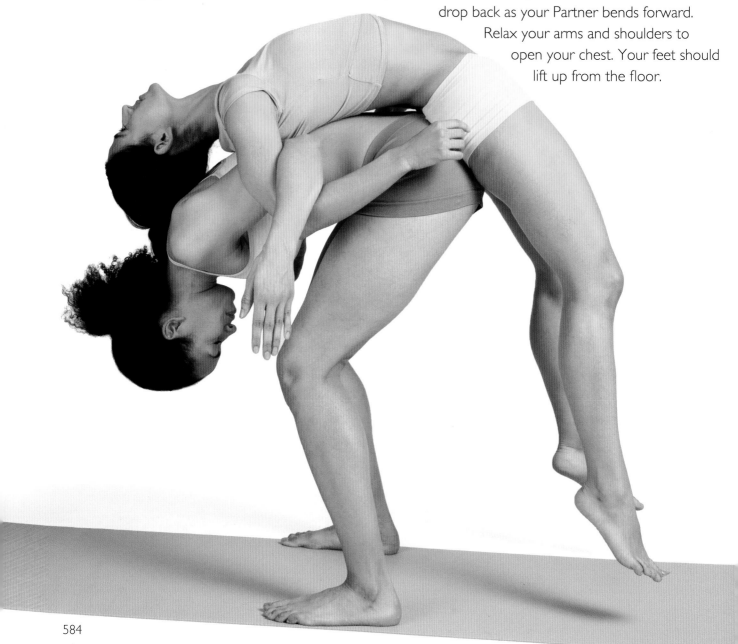

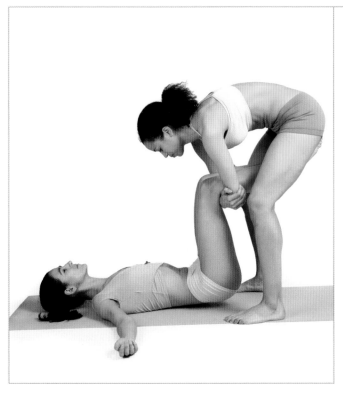

Partner Hip Traction

Target: Hips.

Benefits: Extends the hip flexors, glutes, and hamstrings while engaging the core.

Steps: Stretcher: Begin by lying flat on your back with your arms extended at your sides. Raise your knees up and keep your feet flat on the floor. **Partner:** Stand above the Stretcher, with your feet on the outside of the Stretcher's feet. Reach down and hook your forearms beneath the Stretcher's knees. Gently pull their legs up from the floor, until the Stretcher's calves are parallel to the floor and their knees are directly above their hips. The Stretcher's hips should rise slightly off the floor.

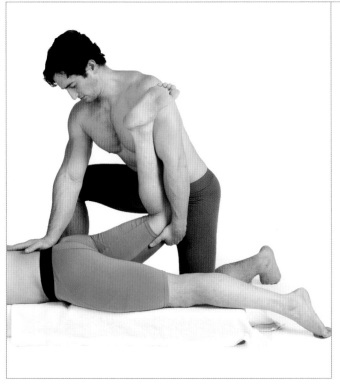

Partner Iliopsoas Prone

Target: Hips.

Benefits: Opens the hips and targets the iliopsoas and adductor muscles.

Steps: Stretcher: Lie flat on your stomach, raised slightly from the floor on a cushion. Spread your legs apart and raise your right foot onto tiptoes, so your heel is raised up toward the ceiling. **Partner:** Kneel at the Stretcher's right side. Place your right hand on the Stretcher's right hip for support. Reach your left hand to hold the Stretcher's thigh, just above the knee. Applying pressure to the Stretcher's hip, pull their leg gently out from the thigh. Repeat on the opposite leg.

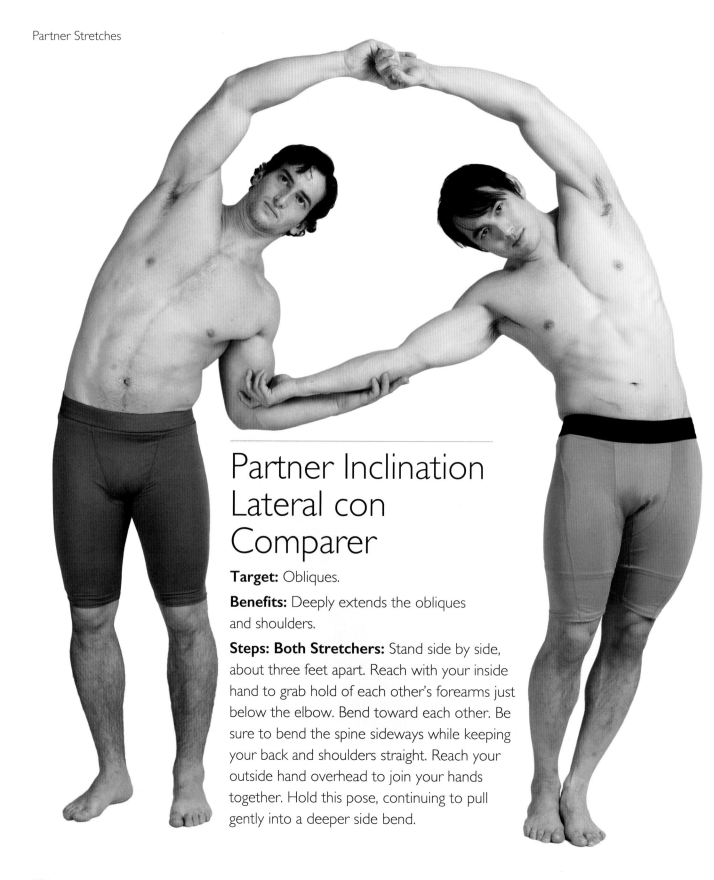

Partner Inclination Lateral con Comparer

Target: Obliques.

Benefits: Deeply extends the obliques and shoulders.

Steps: Both Stretchers: Stand side by side, about three feet apart. Reach with your inside hand to grab hold of each other's forearms just below the elbow. Bend toward each other. Be sure to bend the spine sideways while keeping your back and shoulders straight. Reach your outside hand overhead to join your hands together. Hold this pose, continuing to pull gently into a deeper side bend.

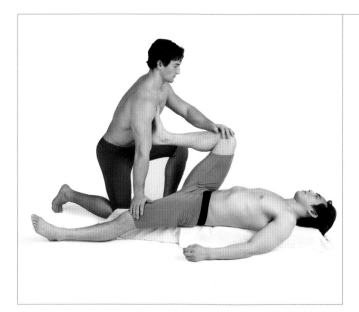

Partner Iliopsoas Supine

Target: Adductors.

Benefits: Opens the hips and targets the iliopsoas and adductor muscles.

Steps: Stretcher: Lie flat on your back with your torso raised slightly from the floor on a cushion. Let your legs and arms hang down below your torso. Raise your right knee toward your chest. **Partner:** Kneel on the Stretcher's right side. Place your left hand against the Stretcher's raised knee. Place your right hand on the Stretcher's left thigh for support. Gently press the Stretcher's knee farther up and into their chest.

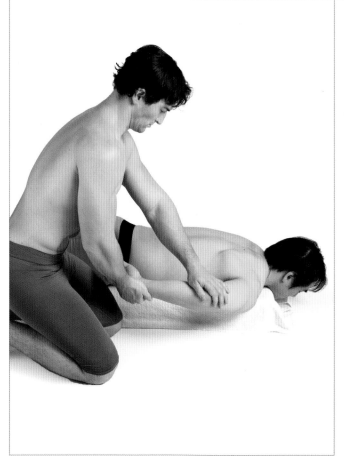

Partner Infraspinatus Stretch Prone

Target: Shoulders.

Benefits: Opens the chest and shoulders while engaging the lats.

Steps: Stretcher: Lie flat on your stomach, raised slightly from the floor on a cushion. Let your arms hang down below your torso. **Partner:** Kneel to the right of the Stretcher. Hold the Stretcher's wrist in your right hand. Place your left hand on the Stretcher's upper arm for support. Gently lift the Stretcher's arm up above their back. The Stretcher should feel the pressure of this stretch in the shoulder and latissimus dorsi.

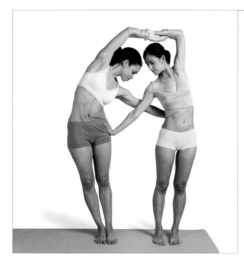

Partner Joined Side Stretch

Target: Obliques.

Benefits: Deeply extends the obliques and shoulders.

Steps: Both Stretchers: Stand side by side, about one foot apart. Reach your inside hand and place them against your partner's hip, either on the inside or the outside, depending on your arm length. Bend in toward each other. Make sure to bend the spine sideways while keeping your back and shoulders straight. Reach your outside arm overhead and grab hold of each other's forearms. Hold this pose, continuing to pull gently into a deeper side bend.

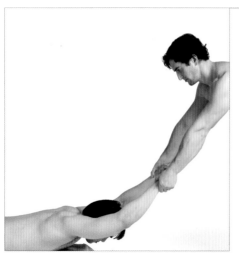

Partner Latissimus Dorsi

Target: Shoulders.

Benefits: Deeply opens the chest and shoulder while engaging the upper arms.

Steps: Stretcher: Lie flat on your stomach, raised slightly off the floor on a cushion. Extend your arms straight out above you. **Partner:** Kneel by the Stretcher's head and grab the Stretcher's wrists. Carefully pull the Stretcher's arms up from the floor. Keep the Stretcher's arms extended straight. The Stretcher's head and chest should lift slightly from the floor, so they feel the stretch in their shoulders.

Partner Latissimus Dorsi on Side

Target: Lats.

Benefits: Opens the shoulders and lengthens the lateral muscles.

Steps: Stretcher: Lie on your left side, slightly raised from the floor on a cushion. Extend your left arm up alongside your head, so your shoulder is fully open. **Partner:** Kneel behind the Stretcher's upper back. Place your right hand on the Stretcher's chest for support. Place your left hand on the Stretcher's arm, just above the elbow. Gently press down on the Stretcher's arm, increasing pressure on the lats.

Partner Leg Adductor Supine

Target: Adductors.

Benefits: Opens the hips and lengthens the adductor muscles.

Steps: Stretcher: Lie flat on your back, raised up slightly from the floor on a cushion. Extend your legs forward. **Partner:** Kneel at the Stretcher's feet. Hold the Stretcher's left ankle with your left hand. Place your right hand on their right knee. Pull the Stretcher's ankle up and outward, opening the Stretcher's hips and lengthening the leg muscles.

Partner Leg Extension

Target: Adductors.

Benefits: Opens the hips and lengthens the adductor muscles.

Steps: Stretcher: Lie flat on your back with your arms at your sides and your legs straight. Lift your right knee up into your chest and straighten your leg above your hips. **Partner:** Kneel at the Stretcher's right side and hold the Stretcher's right ankle. Pull the Stretcher's leg farther up from the hips and out to the side, opening the hips and lengthening the muscles along the leg.

Partner Leg Extension

Target: Hamstrings.

Benefits: Opens the hips and lengthens the glutes and hamstrings.

Steps: Stretcher: Lie flat on your back with your arms relaxed at your sides and your legs straight. Raise your right knee up into your chest and point your toes up toward the ceiling. **Partner:** Stand behind the Stretcher's right leg. Reach both hands to grab hold of the Stretcher's raised ankle. Gently press down on the leg, increasing pressure on the hips and hamstrings.

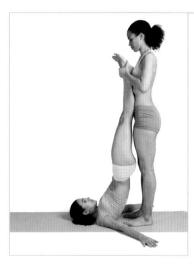

Partner Leg Lift

Target: Lower back.

Benefits: Lengthens the muscles in the legs and lower back, extending the spinal column.

Steps: Stretcher: Lie flat on your back with your arms out to your sides. Raise your knees up into your chest and attempt to extend both legs straight toward the ceiling. **Partner:** Stand facing the Stretcher's legs and grab the Stretcher's feet. Gently pull the Stretcher up from the floor by their feet until only their shoulders remain on the floor.

Partner Leg Lift at Ballet Bar

Target: Adductors.

Benefits: Deeply opens the hips and extends the muscles along the inner leg while increasing balance.

Steps: Stretcher: Stand facing away from the ballet bar at an angle. Grab the bar with your left hand. Lift your left knee up into your chest and find your balance on the right foot. **Partner:** Stand at the Stretcher's left side. Hold the Stretcher's left ankle with your left hand and pull their leg straight toward you. Place your right hand under the Stretcher's thigh for support. Continue to lift the Stretcher's leg from the ankle as high as they are able. Hold their leg in this position for at least ten seconds and repeat on the opposite leg.

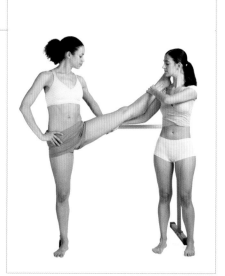

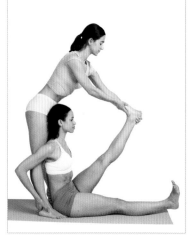

Partner Leg Lift, Behind

Target: Hamstrings.

Benefits: Deeply lengthens the muscles along the back of the leg, targeting the calves and Achilles tendons.

Steps: Stretcher: Begin seated on the floor, with both legs straight. Attempt to lift your left leg from the floor, keeping it straight. **Partner:** Stand directly behind the Stretcher with your feet against their hips. Reach over and grab hold of the Stretcher's raised foot. Gently pull the Stretcher's leg up farther from the floor. **Stretcher:** Reach behind you and hold onto your Partner's ankles for support. Attempt to keep your leg straight as it is being stretched.

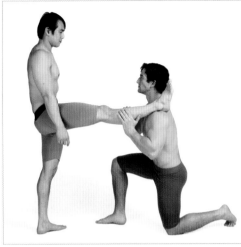

Partner Leg Raise 1

Target: Hamstrings.

Benefits: Opens the hips and deeply extends the muscles along the inner leg while increasing balance.

Steps: Stretcher: Stand straight with your arms at your sides. Shift your weight onto your left foot and raise your right knee up into your chest. **Partner:** Kneel directly in front of the Stretcher. Keep your back straight and place your right foot on the floor to provide a sturdy support. **Stretcher:** Extend your right leg and rest your ankle on your Partner's shoulder. Find your balance in this pose. **Partner:** Reach hold of the Stretcher's calf and pull down gently, straightening their outstretched leg.

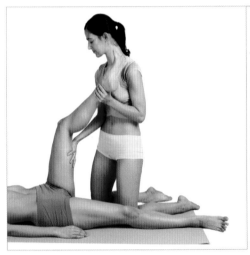

Partner Leg Raise 2

Target: Abductors.

Benefits: Opens and twists the hips, reducing tightness or immobility in the hip abductors.

Steps: Stretcher: Lie flat on your back with your arms and legs flat on the floor. Raise your left leg so your knee is directly above your hips. Rotate your leg inward, so the sole of your foot is facing inward. **Partner:** Kneel beside the Stretcher's raised leg. Place your right hand against the Stretcher's thigh and your other hand on their raised ankle. Gently press the Stretcher's leg farther in toward the torso.

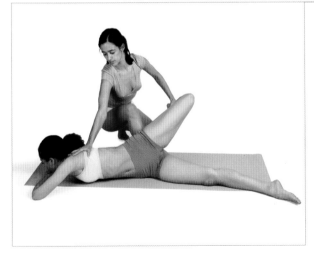

Partner Leg Stretch and Twist, Lying Backward

Target: Hips.

Benefits: Twists the lower back and extends the abductors and quadriceps.

Steps: Stretcher: Begin by lying on your stomach with your arms and legs flat on the floor. Bend your left leg and lift your foot to your hips. **Partner:** Kneel on the Stretcher's right side. Grab the Stretcher's raised foot around the front of the ankle with your left hand and place your right hand on the Stretcher's left shoulder. Carefully pull their left leg up toward you. The Stretcher's hip should lift up from the floor but their right leg should remain flat. Repeat on the opposite leg.

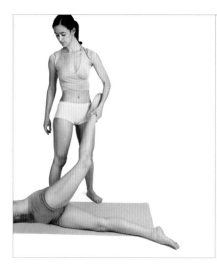

Partner Leg Stretch, Lying Backward

Target: Hips.

Benefits: Twists the lower back and extends the abductor and quad muscles.

Steps: Stretcher: Begin by lying on your stomach with your arms and legs flat on the floor. Bend your left leg up, lifting your foot to your hips. **Partner:** Stand at the Stretcher's right side. Hold the Stretcher's right foot around the front of the ankle. Carefully pull the leg up from the floor and toward you, so their foot crosses over their hips. The Stretcher's left hip should lift up from the floor but the right leg should remain flat. Repeat on the opposite leg.

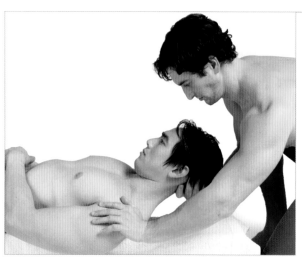

Partner Levator Scapula

Target: Neck.

Benefits: Targets hard-to-reach muscles in the upper back and neck.

Steps: Stretcher: Begin by lying flat on your back. **Partner:** Kneel directly behind the Stretcher. Place one hand on the Stretcher's shoulder for support. Place your other hand directly under the Stretcher's head and lift it up from the floor. Gently pull the Stretcher's head out and away from the shoulders.

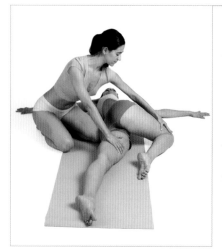

Partner Low Spinal Twist

Target: Lower back.

Benefits: Twists open the lower back and relieves tightness in the hips.

Steps: Stretcher: Lie on your back with your arms out to your sides. Raise your right knee and cross it over your left leg. Twist your lower body to the left, bringing your knee down to the floor to your left. Attempt to keep both your shoulders on the floor. **Partner:** Kneel on the Stretcher's right side. As they twist to the left, place one hand against their right knee and your other hand on their left thigh. Gently press the Stretcher's knee down to the floor, increasing pressure on the lower back and hips. Repeat on the opposite leg.

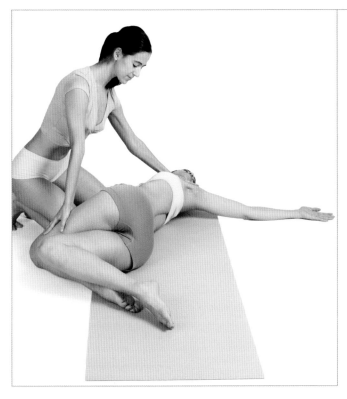

Partner Low Spinal Twist, Modification

Target: Lower back.

Benefits: Twists open the lower back and relieves tightness in the hips.

Steps: Stretcher: Lie flat on your back with your arms out to your sides and knees bent. Cross your left knee over your right. Twist your lower torso and drop both legs to the right, keeping them crossed. Attempt to keep your shoulders on the floor. **Partner:** Kneel on the Stretcher's right side. Place your left hand on their chest for support and the other hand on their left knee. Gently press the Stretcher's knee down toward the floor, increasing pressure on the lower back and hips. Repeat on the opposite leg.

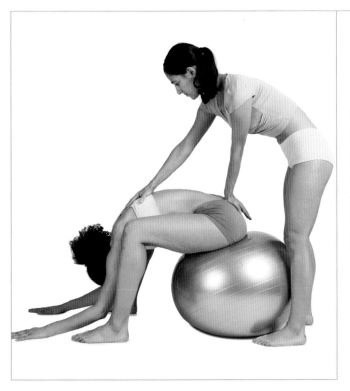

Partner Lower Back on Ball

Target: Lower back.

Benefits: Lengthens the spinal column, neck, and shoulders.

Steps: Stretcher: Begin seated on an exercise ball, with your knees apart. Bend forward at the waist, dropping your head and shoulders down between your knees. Place your hands flat on the floor ahead of your feet, and attempt to lengthen your spine, bringing your elbows down to the floor. **Partner:** Stand directly behind the Stretcher. Place one palm on the Stretcher's lower back and the other hand on their upper back. Press gently down on the Stretcher's upper back, increasing pressure on their spine.

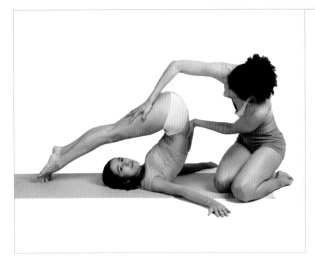

Partner Lower Torso

Target: Upper back.

Benefits: Lengthens the spinal column while extending the upper back and shoulders.

Steps: Stretcher: Lie flat on your back with your arms out to your sides. Lift your knees up toward your chest and extend your legs up over your head, raising your hips off the floor. **Partner:** Kneel directly behind the Stretcher. As they lift their hips from the floor, plant your hands on the Stretcher's lower back. Gently press their back farther up from the floor, targeting the muscles along the spine. Continue until the Stretcher's knees are directly above their head.

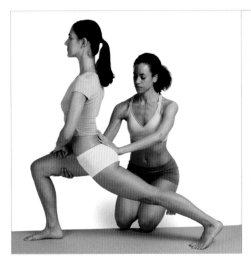

Partner Lunge

Target: Upper legs.

Benefits: Strengthens the glutes, hamstrings, and quadriceps while reinforcing stability in the calves and abdomen.

Steps: Stretcher: Step your right foot far forward, bending at the knee and raising your left foot onto tiptoes to lower into a deep lunge. Rest your hands on your front thigh for support. **Partner:** Kneel on the Stretcher's right side. Place your left hand flat against their lower back. Place your other hand under the Stretcher's right thigh. Press gently against the Stretcher's back, pushing them farther into the lunge. Repeat on the opposite leg.

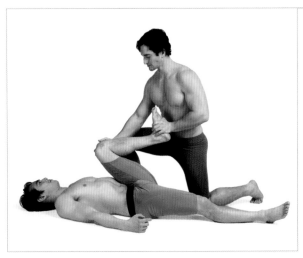

Partner Lying Glute

Target: Hips.

Benefits: Opens the hips and lengthens the glutes and hamstrings.

Steps: Stretcher: Lie flat on your back with your arms and legs straight. Bend your left knee into your chest. **Partner:** Kneel on the Stretcher's left side. Place your left hand against the Stretcher's foot and the other hand on their knee for support. Gently press in against the Stretcher's foot, bending their leg farther into their chest. Repeat on the opposite leg.

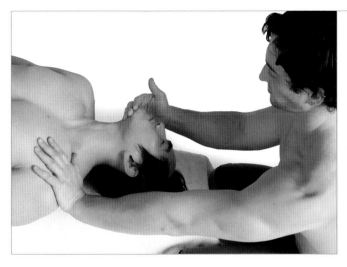

Partner Neck Stretch, Variation

Target: Neck.

Benefits: Extend the muscles along the front of the neck.

Steps: Stretcher: Lie flat on your back, raised up from the floor on a cushion. Pull your head back toward your shoulders, extending your neck. **Partner:** Kneel beside the Stretcher's head. Hold their chin with one hand and place your other hand against the Stretcher's shoulder for support. Gently pull their chin up toward you, increasing the stretch.

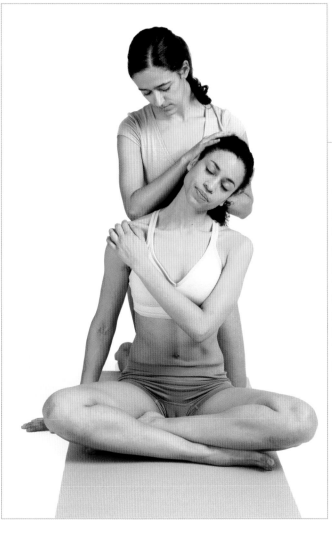

Partner Neck Stretch 1

Target: Neck.

Benefits: Targets hard-to-reach muscles in the neck, that may be tight or sore from poor posture or prolonged sitting.

Steps: Stretcher: Sit cross-legged on the floor, with good upright posture. **Partner:** Kneel directly behind the Stretcher. Place one hand on either side of the Stretcher's head. **Stretcher:** Reach one hand up to your shoulder. Drop your head down to the other side while pressing down on your shoulder. **Partner:** Gently press the Stretcher's head farther down to the side, increasing pressure on the neck.

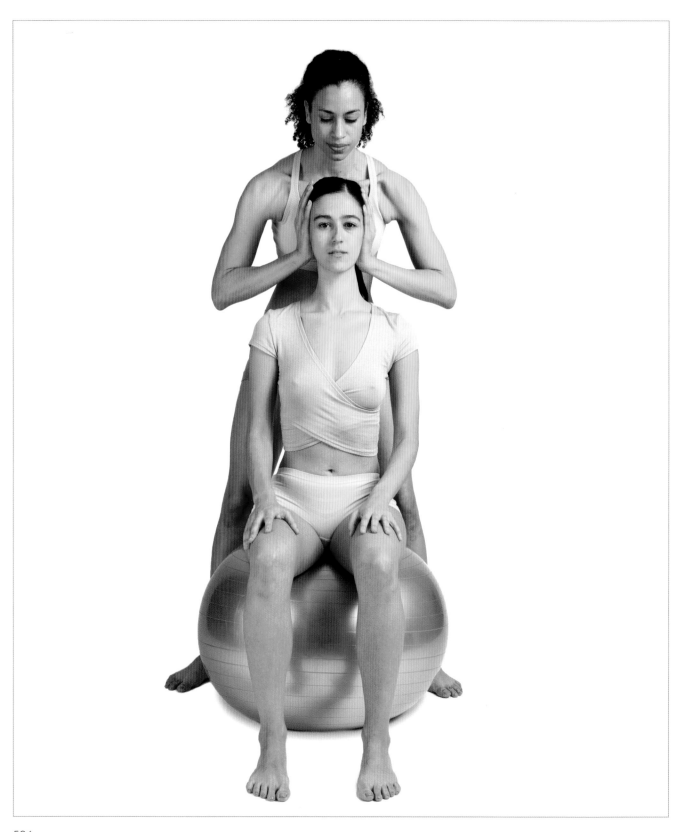

Partner Neck Pull on Ball

Target: Neck.

Benefits: Relieves tightness and tension in the neck while engaging the abdomen.

Steps: Stretcher: Begin seated on top of an exercise ball. Sit with good upright posture. **Partner:** Stand directly behind the Stretcher. Place one hand on either side of the Stretcher's head. Gently pull the Stretcher's head up from their shoulders.

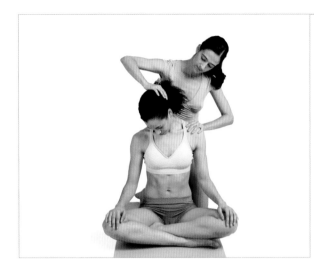

Partner Neck Stretch 2

Target: Neck.

Benefits: Targets hard-to-reach muscles in the neck, that may be tight or sore from poor posture or prolonged sitting.

Steps: Stretcher: Sit cross-legged on the floor with good upright posture. **Partner:** Kneel directly behind the Stretcher. Place your right hand on the back of the Stretcher's head and your left hand on their left shoulder for support. Gently press the Stretcher's head down into their chest and to the right. Press down simultaneously on the head and shoulder to lengthen the muscles in the neck and shoulder. Repeat on the opposite side.

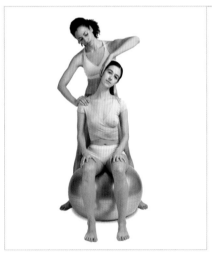

Partner Neck Stretch on Ball

Target: Neck.

Benefits: Relieves tightness and tension in the neck while engaging the abdomen.

Steps: Stretcher: Begin seated on top of an exercise ball. Sit with good upright posture. **Partner:** Stand directly behind the Stretcher. Place your left hand on the right side of the Stretcher's head. With your other hand, hold their right shoulder. Gently press the Stretcher's head down toward the left shoulder. Press down simultaneously on the head and shoulder to lengthen the muscles along the neck. Repeat on the opposite side.

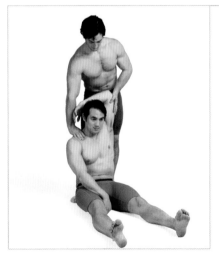

Partner Overhead Lat

Target: Latissimus dorsi.

Benefits: Opens the shoulders and lengthens the muscles along the lats.

Steps: Stretcher: Begin seated with your legs flat on the floor. Raise your left arm along your head, so your elbow is pointed straight up and your hand rests behind your neck. **Partner:** Stand behind the Stretcher. Place your left hand on the Stretcher's raised elbow and your other hand on the right shoulder. Gently press in against the Stretcher's elbow, opening the shoulders and targeting the latissimus dorsi muscles. Repeat on the opposite arm.

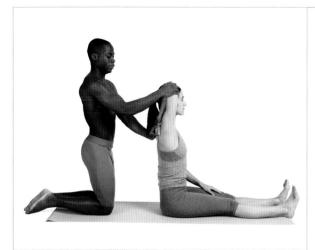

Partner Overhead Tricep 1

Target: Triceps.

Benefits: Opens the shoulders and lengthens the triceps muscles.

Steps: Stretcher: Begin seated with your legs flat on the floor. Raise your right arm, so your elbow is pointing straight up and your hand rests on your upper back. **Partner:** Kneel directly behind the Stretcher. Place one hand on the Stretcher's raised elbow and your other hand on the left shoulder. Gently press in against the Stretcher's elbow, opening the shoulders and lengthening the triceps muscles. Repeat on the opposite arm.

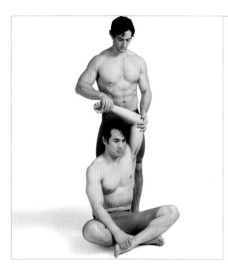

Partner Overhead Tricep 2

Target: Shoulders.

Benefits: Opens the shoulders and lengthens the triceps muscles.

Steps: Stretcher: Begin seated with your legs flat on the floor. Raise your left arm up along your head, so your elbow is pointing straight up and your hand rests on your upper back. **Partner:** Stand behind the Stretcher. Place your left hand on the Stretcher's raised elbow and your right hand on the wrist. Gently press in against the Stretcher's elbow, opening the shoulders and lengthening the triceps muscles. Repeat on the opposite arm.

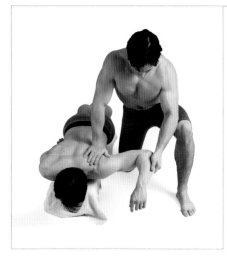

Partner Pectoral Major Prone

Target: Chest opener.

Benefits: Opens the muscles across the chest, extending the shoulders and triceps.

Steps: Stretcher: Lie flat on your stomach, raised slightly off the floor. Bend your left arm up to your side, so your elbow extends straight out from your shoulder. **Partner:** Kneel on the Stretcher's left side. Place your right hand on the Stretcher's left shoulder for support. Place your left hand under the Stretcher's left forearm, just below the elbow. Gently pull the Stretcher's arm farther upward, increasing the stretch on the chest and shoulder. Repeat on the opposite arm.

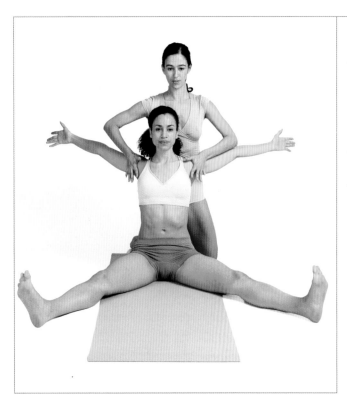

Partner Pectoral Stretch

Target: Chest opener.

Benefits: Deeply opens the chest and shoulders while engaging the core and hips.

Steps: Stretcher: Begin seated on the floor. Spread your legs wide apart and flex your feet so your toes point up toward the ceiling. Stretch your arms straight out to your sides. **Partner:** Kneel behind the Stretcher. As they spread their arms out to their sides, place one hand on each of the Stretcher's inner arms, just below the shoulders. Gently press the Stretcher's arms out farther behind them, increasing pressure on the chest.

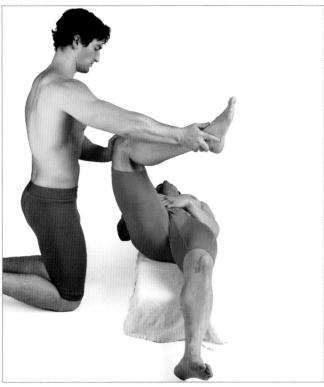

Partner Piriformis Supine

Target: Hamstrings.

Benefits: Opens and twists the hips, reducing tightness or immobility in the hip abductors.

Steps: Stretcher: Lie flat with your back raised on a cushion. Raise your right leg up from the floor, so your knee is directly above your hips. Rotate your leg inward, so the sole of your foot is facing left. **Partner:** Kneel on the Stretcher's right side. Place your left hand against the Stretcher's right thigh and your other hand on their raised ankle. Gently press the Stretcher's leg farther in toward their torso. Repeat on the opposite leg.

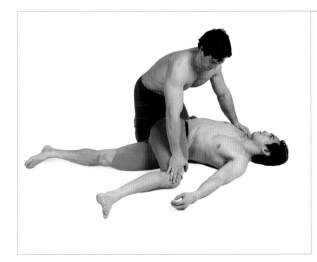

Partner Pretzel Stretch 1

Target: Hips.

Benefits: Twists open the lower back and relieves tightness in the hips.

Steps: Stretcher: Lie on your back with your arms out to the sides. Bend your right knee toward your chest and twist your lower body to your left, bringing your knee down to the floor on your left. Attempt to keep both your shoulders on the floor. **Partner:** Kneel on the Stretcher's right side. As they twist to the left side, place your right hand on their raised knee and your other hand on their right shoulder. Gently press the Stretcher's knee toward the floor, increasing pressure on the lower back and hips. Repeat on the opposite leg.

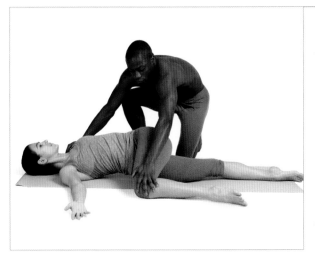

Partner Pretzel Stretch 2

Target: Hips.

Benefits: Twists open the lower back and relieves tightness in the hips.

Steps: Stretcher: Lie on your back with your arms out to the sides. Bend your left knee toward your chest and twist your lower body to your right, bringing your knee down to the floor on your right. Attempt to keep both your shoulders on the floor. **Partner:** Kneel on the Stretcher's left side. As they twist to the right, place your left hand on their raised knee and your other hand on their left shoulder. Gently press the Stretcher's knee toward the floor, increasing pressure on the lower back and hips. Repeat on the opposite leg.

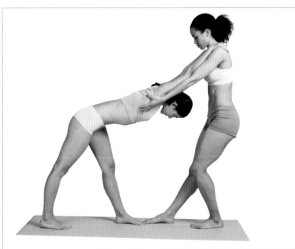

Partner Pull and Lean

Target: Upper back.

Benefits: Extends the muscles in the spine and shoulders while opening the hips.

Steps: Stretcher: Stand with good upright posture. Raise your arms straight overhead. Step your left foot forward and drop your torso, bending at the waist. **Partner:** Stand above the Stretcher. As they fold over, reach hold of the Stretcher's upper arms and shoulders. **Stretcher:** Hold onto the Partner's shoulders and pull your torso downward.

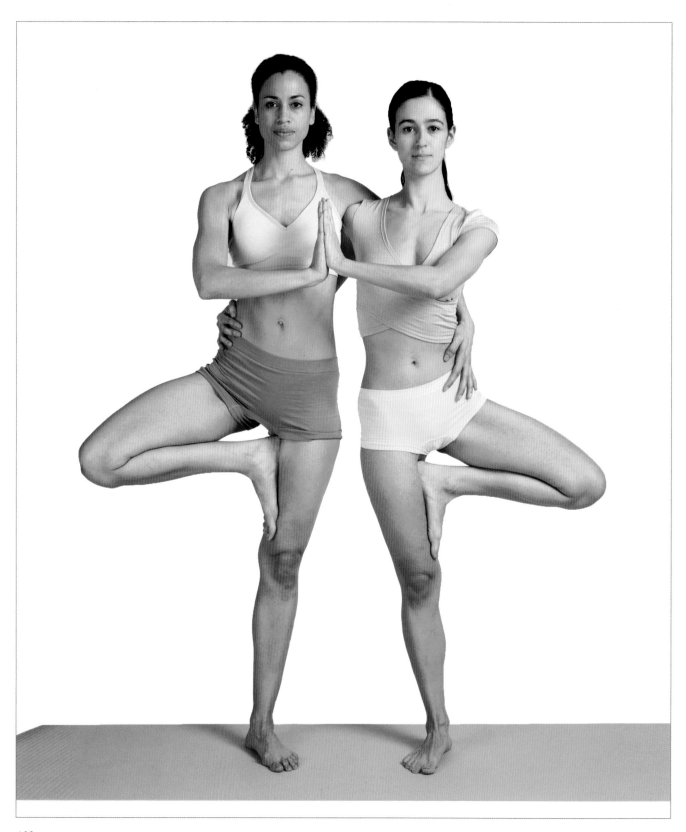

Partner Prayer-Hand Stretch

Target: Balance.

Benefits: Opens the hips and extends the adductor muscles while engaging core balance and strength.

Steps: Both Stretchers: Stand side by side, a couple of feet apart from each other. Shift your weight onto your inside foot. Raise your outside foot from the floor and use your hands to tuck your foot up into your hip, in a standing half-lotus pose. Once balanced, reach your inside hand behind the other Stretcher's back and place your hand on their outside hip for balance. Reach your outside hand in by your chest and press your palms together. Balance in this pose.

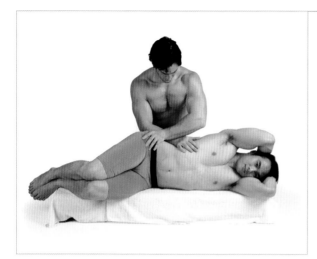

Partner Quad Side Stretch

Target: Obliques.

Benefits: Provides relief from tightness or strain in the lower oblique muscles.

Steps: 1. Stretcher: Lie on your left side with your hands tucked behind your head and your knees slightly bent. **Partner:** Kneel behind the Stretcher. Place both hands against the Stretcher's side and apply gentle pressure along the oblique muscles. Repeat on the opposite side.

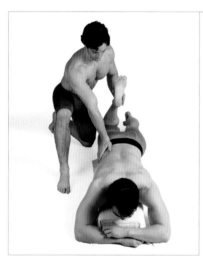

Partner Quad Stretch 1

Target: Quadriceps.

Benefits: Extends the muscles in the quadriceps and shins, relieving tightness and tension.

Steps: Stretcher: Lie flat on your stomach. Bend one knee, bringing your foot in toward your hips. **Partner:** Kneel beside the Stretcher, on the side of their targeted leg. Place one hand against the Stretcher's raised foot and the other on their lower back. Gently press the Stretcher's foot farther in toward their hips. Repeat on the opposite leg.

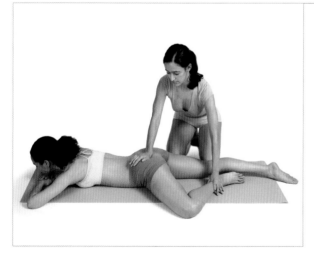

Partner Quad Stretch 2

Target: Quadriceps.

Benefits: Opens the hips and extends the quadriceps and adductors muscles.

Steps: Stretcher: Lie flat on your stomach, with your elbows bent your hands tucked beneath your chin. Bend your left knee out to your side, and rotate your hips so the sole of your foot is facing your right knee. **Partner:** Kneel on the Stretcher's right side. Place your right hand against the Stretcher's lower back. Reach your other hand to grab hold of the Stretcher's left ankle. Gently pull the Stretcher's foot farther up toward their hips. Repeat on the opposite leg.

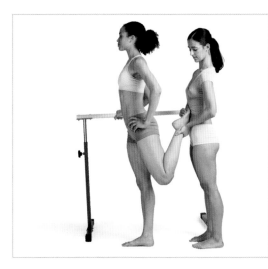

Partner Quad Stretch at Ballet Bar

Target: Quadriceps.

Benefits: Extends the muscles in the quadriceps and shin while improving balance in the core.

Steps: Stretcher: Stand with a ballet bar at your right and hold the bar with your right hand. Shift your weight onto your right foot and raise your left foot behind you. **Partner:** Stand behind the Stretcher. Grab hold of the Stretcher's raised foot with both hands. Gently pull the Stretcher's foot farther up and into their hips. Repeat on the opposite leg.

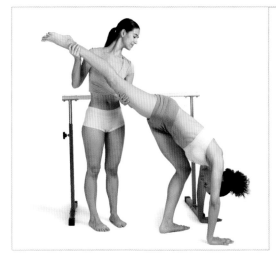

Partner Rear Leg Raise at Ballet Bar 1

Target: Quadriceps.

Benefits: Extends the quadriceps and shins while improving balance in the core.

Steps: Stretcher: Stand straight with a ballet bar to your left. Hold the bar with your left hand as you raise your right leg straight out behind you. Fold forward from the waist into a forward bend. **Partner:** Stand behind the Stretcher. As they bend forward, hold the Stretcher's raised leg and lift it higher. **Stretcher:** Carefully release your hand from the bar and place both hands on the floor. Bend your left knee for support. Repeat on the opposite side.

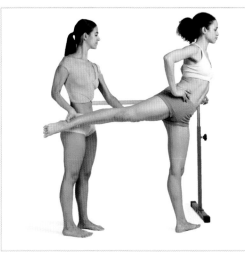

Partner Rear Leg Raise at Ballet Bar 2

Target: Quadriceps.

Benefits: Extends the quadriceps and adductors while improving strength and balance in the core.

Steps: Stretcher: Hold onto a ballet bar at your left side. Place your right hand on your hip. Shift your weight onto your left foot. Raise your right foot up from the floor and straighten your leg out behind you, leaning your torso forward for balance. **Partner:** Stand behind the Stretcher. Hold the Stretcher's raised ankle and inner thigh. Carefully straighten and lift the Stretcher's leg farther upward. Repeat on the opposite leg.

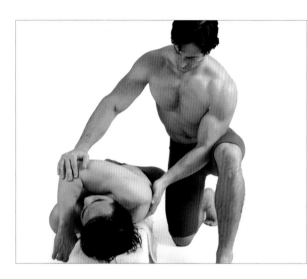

Partner Rhomboid Supine

Target: Shoulders.

Benefits: Extends the muscles in the shoulders and upper back, improving flexibility and alignment.

Steps: Stretcher: Lie flat on your back on a raised cushion. Bend your right elbow and cross it over your chest, dropping your hand down to your left side. **Partner:** Kneel on the Stretcher's right side. Place one hand against the Stretcher's raised elbow and your other hand under the their shoulder. Gently press down on the Stretcher's elbow, increasing pressure on the shoulder. Repeat on the opposite arm.

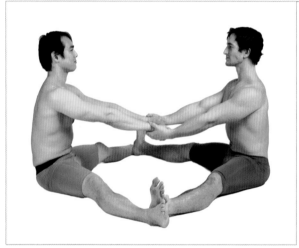

Partner Russian Split Switch

Target: Adductors.

Benefits: Opens the hips and lengthens the spinal column.

Steps: Both Stretchers: Begin seated, facing each other with your legs spread wide in a straddle position. The Stretcher with longer legs will be the supporting Partner. The Stretcher with shorter legs should sit with their legs spread so that their feet are pressed against the Partner's inner ankles. Hold each other's hands directly in front of you. Straighten your back and attempt to lengthen your spine.

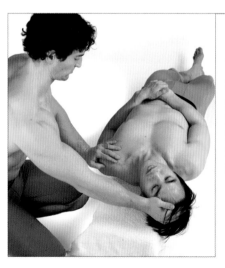

Partner Scalene I

Target: Neck.

Benefits: Lengthens the muscles along one side of the neck.

Steps: Stretcher: Lie flat on your back, with your arms and legs relaxed. **Partner:** Kneel at the Stretcher's left side. Place one hand on the side of the Stretcher's head. Rest your other hand against the Stretcher's shoulder. Press the Stretcher's head down to the right shoulder and gently pull down on their shoulder to lengthen the muscles along the neck. Repeat on the opposite side.

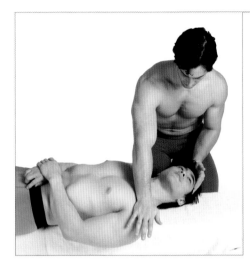

Partner Scalene 2

Target: Neck.

Benefits: Lengthens the muscles along one side of the neck.

Steps: Stretcher: Lie flat on your back, with your arms and legs relaxed. **Partner:** Kneel on the Stretcher's right side. Place your left hand on the left side of the Stretcher's head. Rest your other hand against the Stretcher's left shoulder. Pull the Stretcher's head down toward the right shoulder and gently press down on the shoulder to lengthen the muscles along the neck. Repeat on the opposite side.

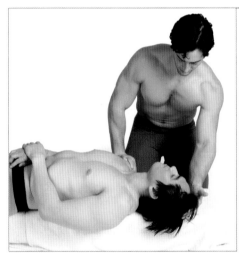

Partner Scalene 3

Target: Neck.

Benefits: Lengthens the muscles along one side of the neck.

Steps: Stretcher: Lie flat on your back, with your arms and legs relaxed. **Partner:** Kneel on the Stretcher's right side. Place your left hand on the top of the Stretcher's head. Rest your other hand against the Stretcher's right shoulder. Press the Stretcher's head back and to the left shoulder, so their chin twists upward. Gently pull down on the shoulder to lengthen the muscles along the neck. Repeat on the opposite side.

Partner Scalene 4

Target: Neck.

Benefits: Lengthens the muscles along one side of the neck.

Steps: Stretcher: Lie flat on your back, with your arms and legs relaxed. **Partner:** Kneel on the Stretcher's right side. Place your left hand on the top of the Stretcher's head. Rest your other hand against the Stretcher's right shoulder. Press the Stretcher's head down toward the left shoulder, so their chin rotates to the left. Gently pull down on their shoulder to lengthen the muscles along the neck. Repeat on the opposite side.

Partner Scalene 5

Target: Neck.

Benefits: Lengthens the muscles along the side of the neck.

Steps Stretcher: Lie flat on your back, with your arms and legs relaxed. **Partner:** Kneel on the Stretcher's left side. Place your right hand on the left side of the Stretcher's head. Rest your other hand against the Stretcher's left shoulder. Rotate the Stretcher's head toward the right shoulder, so their chin rotates to the right. Gently pull down on their shoulder, to lengthen the muscles along the neck.

Partner SCM Supine

Target: Neck.

Benefits: Lengthens the muscles along the front of the neck.

Steps: Stretcher: Lie flat on your back, with your arms and legs relaxed. **Partner:** Kneel on the Stretcher's left side. Place your right hand under the Stretcher's chin. Rest your other hand against the Stretcher's left shoulder. Pull the Stretcher's chin up gently from the neck. Gently press down on the shoulder to lengthen the muscles along the neck.

Partner Seated Bicep

Target: Chest opener.

Benefits: Extends the muscles across the chest and shoulders while lengthening the biceps.

Steps: Stretcher: Begin seated with your legs straight. Let your arms hang down at your sides. **Partner:** Kneel directly behind the **Stretcher.** Reach hold of the Stretcher's wrists. Gently pull the Stretcher's arms straight up behind them.

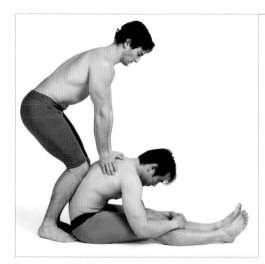

Partner Seated Forward Bend

Target: Spine.

Benefits: Extends the spinal column and hamstrings, increasing flexibility and range of motion.

Steps: Stretcher: Sit on the floor with your legs extended straight ahead. Reach your hands to your knees and curl your torso down toward your legs. **Partner:** Stand directly behind the Stretcher. Bend both knees in against the Stretcher's back for support. Place your hands flat across the Stretcher's upper back. Gently press down on the Stretcher's back, increasing pressure on the forward bend.

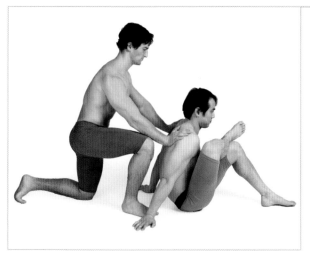

Partner Seated Glute

Target: Glutes.

Benefits: Reduces tightness and strain in the hips and glutes.

Steps: Stretcher: Begin seated on the floor with both knees bent. Rest your hands flat on the floor behind your hips. Raise your right foot up and rest your ankle across your left knee. Lean your chest in toward your knees to increase pressure on the hips and glutes. **Partner:** Kneel behind the Stretcher. Place your hands against the Stretcher's upper back. Gently press the Stretcher's back forward, increasing the stretch.

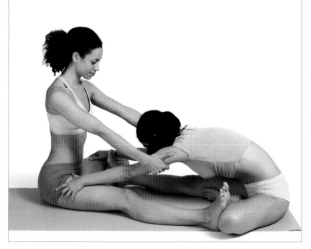

Partner Seated Hamstring Stretch

Target: Shoulders.

Benefits: Extends the muscles in the upper legs and shoulders.

Steps: Stretcher: Begin seated facing your Partner. Extend your right leg out and bend your left leg so your foot is tucked into your right thigh. **Partner:** Extend your right leg with your foot against the Stretcher's left knee. Bend your left knee out so it is pressed against the Stretcher's left foot. **Stretcher:** Bend forward at the waist. Drop your head toward the floor and hold your Partner's hips. Pull along the length of your spine. **Partner:** Reach hold of the Stretcher's upper arms, just below the armpits. Gently pull the Stretcher's arms away from the torso.

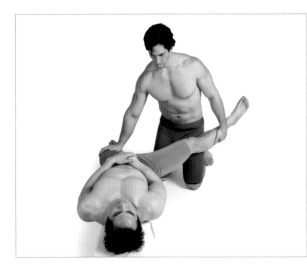

Partner Short Adductor Supine

Target: Adductors.

Benefits: Opens the hips and lengthens the hamstrings and adductor muscles.

Steps: Stretcher: Lie flat one your back with legs out straight and flat on the floor. Extend your right leg up from the floor and out to your side. **Partner:** Kneel between the Stretcher's legs. Grab hold of the Stretcher's raised ankle. Place you other hand on the Stretcher's left thigh. Gently pull the Stretcher's leg farther out to the side. Repeat on the opposite leg.

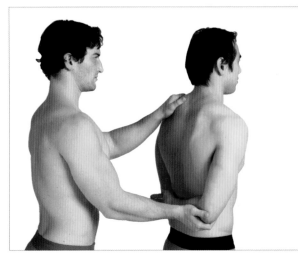

Partner Shoulder Abduction

Target: Shoulders.

Benefits: Targets hard-to-reach muscles in the shoulders, improving mobility and muscle alignment.

Steps: Stretcher: Sit with good upright posture. Bend your left arm behind your back, so your forearm is perpendicular to your spine. **Partner:** Stand directly behind the Stretcher. Place one hand on the Stretcher's bent elbow and your other hand on their left shoulder. Gently pull the Stretcher's shoulder in toward the spine, increasing pressure on the shoulder. Repeat on the opposite arm.

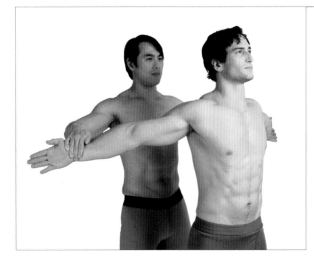

Partner Shoulder and Elbow Flexor

Target: Triceps and biceps.

Benefits: Opens the chest and shoulders while lengthening the muscles in the biceps and triceps.

Steps: Stretcher: Stand straight and extend your arms out at your sides, with your palms facing forward. **Partner:** Stand directly behind the Stretcher. Hold the Stretcher's wrists and gently pull the Stretcher's arms farther behind them. **Stretcher:** Attempt to keep your arms straight and parallel as your Partner engages your arms and shoulders.

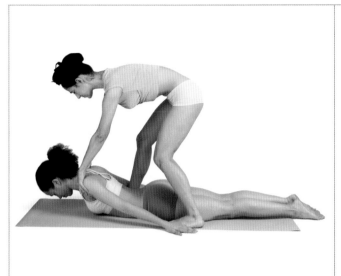

Partner Shoulder Pull

Target: Shoulders.

Benefits: Engages the chest and shoulders while extending the spine.

Steps: Stretcher: Lie on your stomach with your arms and legs flat on the floor. **Partner:** Stand above the Stretcher, with one foot on either side of the Stretcher's torso. Reach down and grab hold of the Stretcher's shoulders and gently pull them up from the floor, extending the spinal column.

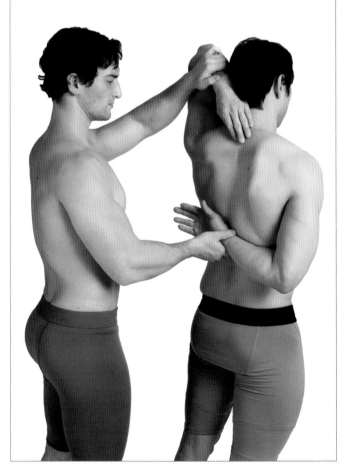

Partner Shoulder Stretch

Target: Shoulders.

Benefits: Targets hard-to-reach muscles in the shoulders, improving mobility and muscle alignment.

Steps: Stretcher: Stand with good posture. Raise your left elbow beside your head, so your hand rests on the back of your neck. Bend your right arm behind you, reaching your hand up your spine. **Partner:** Stand behind the Stretcher. Place your hands on the Stretcher's wrists and gently pull the Stretcher's hands toward each other, deepening the stretch.

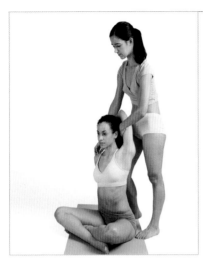

Partner Shoulder-Stretch Arm Bend

Target: Shoulders.

Benefits: Targets hard-to-reach muscles in the shoulders, improving mobility and muscle alignment.

Steps: Stretcher: Sit cross-legged with good posture. Raise your left elbow beside your head, so your hand rests on the back of your neck. **Partner:** Stand behind the Stretcher. Place your left hand on the Stretcher's left triceps. Gently push the Stretcher's arm down behind their head, deepening the stretch. Repeat on the opposite arm.

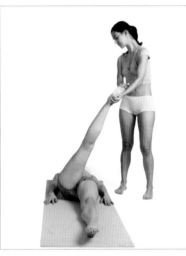

Partner Sickle-Foot Leg Extension

Target: Abductors.

Benefits: Targets hard-to-reach muscles in the hip abductors, improving mobility and muscle alignment.

Steps: Stretcher: Lie flat on your back with your arms and legs flat on the floor. Raise your right leg straight up. **Partner:** Stand at your Stretcher's left side. Reach hold of the Stretcher's raised ankle. Gently pull the Stretcher's leg across the hips toward you. Repeat on the opposite leg.

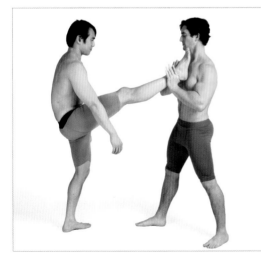

Partner Side Leg Raise

Target: Balance.

Benefits: Opens the hips and deeply extends the muscles along the inner leg while increasing balance.

Steps: Stretcher: Stand straight with your arms at your sides. Shift your weight onto your left foot and raise your right foot from the floor. Bring your right knee up into your chest. **Partner:** Stand directly ahead of the Stretcher. Keep your back straight and ground your body to provide a sturdy support. **Stretcher:** Extend your right leg out straight and rest your foot on your Partner's chest. Find your balance in this pose. **Partner:** Reach hold of the Stretcher's raised ankle and pull up gently, straightening the outstretched leg. Repeat on the opposite leg.

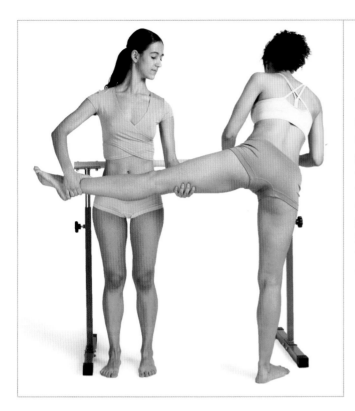

Partner Side Leg Raise at Ballet Bar

Target: Adductors.

Benefits: Opens the hips and increases balance and strength in the core.

Steps: Stretcher: Stand facing a ballet bar. Reach hold of the bar with both hands. Raise your left leg up from the floor and attempt to straighten it out to your side. Lean forward toward the bar for balance. **Partner:** Stand by the Stretcher's left leg. Place one hand under the Stretcher's left ankle and your other hand under the thigh. Gently lift the Stretcher's leg farther up and straight out to the side. Repeat on the opposite leg.

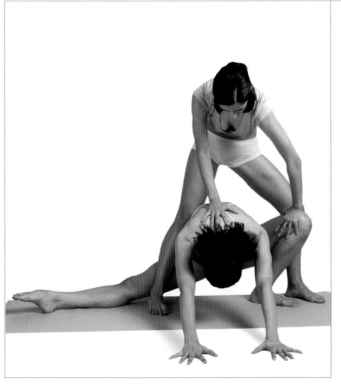

Partner Side Lunge

Target: Adductors.

Benefits: Deeply opens the hips and extends the spine, increasing balance and flexibility.

Steps: Stretcher: Step your legs wide apart and point your right foot out to the side. Bend your left knee and slide your right foot far out to the side, lowering your torso down into a deep side lunge. Extend your arms straight ahead of your torso, with your palms flat on the floor. Drop your forehead toward the floor. **Partner:** Stand behind the Stretcher. Place one hand on the Stretcher's bent left knee and your other hand on the upper back. Gently press down on the Stretcher's back, increasing the stretch. Repeat on the opposite side.

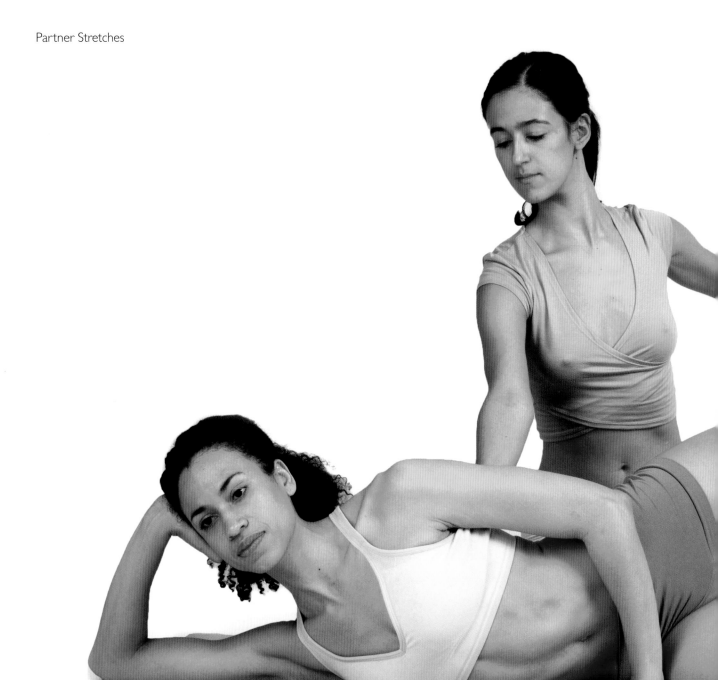

Partner Side-Lying Leg Lift

Target: Abductors.

Benefits: Open the hips and strengthens the muscles in the hip abductors and glutes.

Steps: Stretcher: Lie on your right side, with your right elbow bent and your hand supporting your head. Raise your right leg up and behind you. **Partner:** Kneel behind the Stretcher. Hold the Stretcher's extended ankle with one hand and place your other hand on the Stretcher's lower back for support. Gently pull the Stretcher's leg farther out behind them, to increase the stretch.

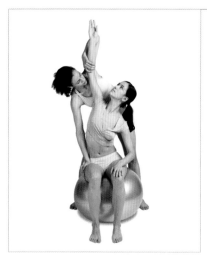

Partner Side Stretch on Ball

Target: Obliques.

Benefits: Lengthens the lats and obliques while engaging the spine and core.

Steps: Stretcher: Sit on top of an exercise ball with good posture. Raise your right arm straight up, with your palm facing inward. **Partner:** Stand behind the Stretcher. Grab hold of the Stretcher's raised wrist with one hand and place your other hand on their right hip for support. Gently pull the Stretcher's arm up from the torso to increase the stretch along the side. Repeat on the opposite side.

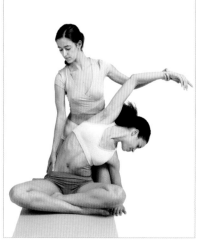

Partner Side Stretch 2

Target: Obliques.

Benefits: Lengthens the lats and obliques while engaging the spine and core.

Steps: Stretcher: Sit cross-legged on the floor with good posture. Raise your right arm straight up, with your palm facing inward. Lean your torso toward the left side, dropping your raised hand across your head. **Partner:** Kneel behind the Stretcher. Place one hand on the Stretcher's left forearm, and your other hand on the stretcher's hip for support. Gently press down on the Stretcher's forearm, increasing pressure along the side. Repeat on the opposite side.

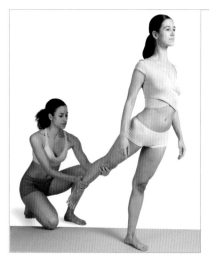

Partner SOAS Stretch

Target: Quadriceps.

Benefits: Increases balance and flexibility in the supporting leg while extending the muscles in the upper legs and hips.

Steps: Stretcher: Stand straight with good posture. Shift your weight onto your left foot. Lift your right foot from the floor and straighten your leg behind you. **Partner:** Kneel behind the Stretcher's right leg. Reach hold of the Stretcher's extended ankle. Lift the Stretcher's leg farther up and out behind them. Repeat on the opposite leg.

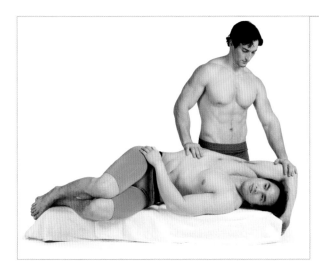

Partner Soleus Prone

Target: Latissimus dorsi.

Benefits: Provides relief from tight or strained muscles in the lats.

Steps: Stretcher: Lie on your left side. Extend your left arm up beside your head, with your elbow bent along the top of your head. **Partner:** Kneel beside the Stretcher. Place one hand on the Stretcher's bent elbow and your other hand on their side for support. Gently press down on the Stretcher's elbow. Repeat on the opposite arm.

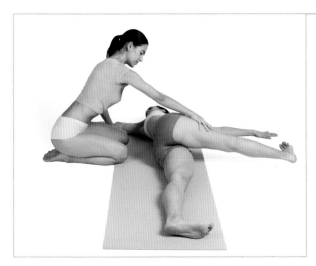

Partner Spinal Twist

Target: Lower back.

Benefits: Twists the spine and lower back while opening the shoulders and targeting the hip abductors.

Steps: Stretcher: Lie flat on your back with your arms straight out to your sides. Bend your right knee up to your chest. Twist your lower back to the left and extend your right foot to the floor on your left side. Attempt to keep both shoulders on the floor. **Partner:** Kneel on the Stretcher's right side. Place one hand on the Stretcher's right thigh and your other hand on the floor. Gently press down on the Stretcher's thigh, increasing pressure on the hips. Repeat on the opposite leg.

Partner Spine Stretch on Ball

Target: Spine.

Benefits: Twists the spine and extends the chest and shoulders while engaging the core.

Steps: Stretcher: Sit on top of an exercise ball. Place your right hand flat on the ball behind you. Twist your torso to the right, anchoring your left hand on your right knee to increase the stretch. **Partner:** Kneel behind the Stretcher. Place one hand on the Stretcher's right shoulder and your other hand on their left knee for support. Gently pull on the Stretcher's shoulder in order to increase the spinal twist. Repeat on the opposite side.

Partner Straddle Front Bend

Target: Spine.

Benefits: Opens the hips and lengthens the spinal column and oblique muscles.

Steps: Both Stretchers: Begin seated, facing each other with your legs spread wide in a straddle position. The Stretcher with shorter legs should sit with their feet pressed against the other Stretcher's inner ankles. Twist your torso to the left and drop your head down toward your left knee. Extend both arms straight out at your sides, so your left hand is on the floor to your left side and your right hand reaches over the other Stretcher's right leg. Hold this pose for thirty seconds and feel the pull along the length of your spine. Rise back to the starting position and repeat to the opposite side.

Partner Straddle Stretch

Target: Shoulders.

Benefits: Opens the hips and lengthens the spinal column and muscles along the arms.

Steps: Begin seated, facing each other with your legs spread wide in a straddle position. The person with longer legs will be the Stretcher. The Partner with shorter legs should sit with their feet pressed against the Stretcher's inner ankles. **Stretcher:** Extend your arms straight out to the sides. **Partner:** Reach hold of the Stretcher's wrists and gently pull the wrists out from the shoulders, lengthening the muscles along both arms.

Partner Stretching Flat-Hand Reference Picture

Target: Upper back.

Benefits: Releases tension and stress in the upper back and spinal column.

Steps: Stretcher: Begin seated with good posture. Place your left hand on the floor behind your hips and twist your torso gently to the left. **Partner:** Kneel behind the Stretcher. Place your left hand flat against the front of the Stretcher's left shoulder. Place you other hand against the back of the Stretcher's right shoulder. Gently assist the Stretcher in the twist by applying equal pressure against both shoulders.

Partner Subscapularis Supine

Target: Latissimus dorsi.

Benefits: Releases tension and stress in the chest while opening the shoulders and lengthening the muscles in the lats.

Steps: Stretcher: Lie flat on your back. Bend your right elbow out beside your head.
Partner: Kneel on the Stretcher's right side. Place one palm against the Stretcher's elbow. With your other hand, hold the Stretcher's wrist. Gently press the Stretcher's elbow farther up, increasing pressure on the shoulder and lats.

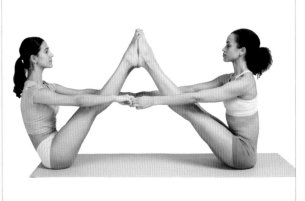

Partner T Stretch

Target: Core.

Benefits: Lengthens the spinal column and leg muscles, and improves balance.

Steps: Both Stretchers: Begin seated, about five feet apart, facing each other. Bend your knees bent and keep your feet together. Raise your feet up to meet the other Stretcher's feet. Reach across to hold each other's hands. Slowly straighten out your legs while keeping your backs straight.

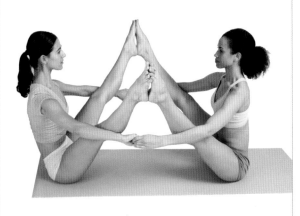

Partner T Stretch, Legs Apart

Target: Core.

Benefits: Lengthens the spinal column and leg muscles, and improves balance.

Steps: Both Stretchers: Begin seated, about five feet apart, facing each other. Bend your knees bent and keep your feet about shoulder-width apart. Raise your feet up to meet the other Stretcher's feet. Reach across to hold each other's hands. Slowly straighten out your legs while keeping your back straight.

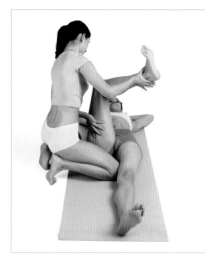

Partner Thigh Stretch 1

Target: Thighs.

Benefits: Opens the hips and extends the muscles along the outer thigh.

Steps: Stretcher: Lie flat on your back. Bend your right leg up, so your knee is directly above your hips, and your foot extends to the left side of your body. **Partner:** Kneel on the Stretcher's right side. Place your left hand against the Stretcher's upper thigh, and your right hand around the Stretcher's raised ankle. Gently press the Stretcher's leg farther in toward the torso, pressing on the thigh and ankle. Repeat on the opposite leg.

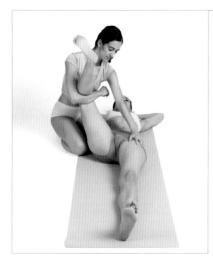

Partner Thigh Stretch 2

Target: Thighs.

Benefits: Opens the hips and extends the muscles along the outer thighs.

Steps: Stretcher: Lie flat on your back. Bend your right leg up, so your knee and foot are above your right hip. **Partner:** Kneel on the Stretcher's right side. Reach your right arm around the Stretcher's raised knee, and your other hand against the Stretcher's left thigh. Gently pull the Stretcher's raised leg farther up and toward you. Repeat on the opposite leg.

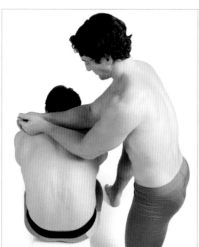

Partner Thoracic Lumbar

Target: Upper back.

Benefits: Extend the muscles across the upper back, increasing flexibility and reducing immobility.

Steps: Stretcher: Begin seated with good posture. Let your arms relax at your sides. Curl your shoulders forward, so your head drops toward your chest. **Partner:** Kneel on the Stretcher's right side. Rest both forearms across the Stretcher's upper back. As the Stretcher curls the shoulders and upper back, press down gently with your forearms, increasing the pressure of the stretch.

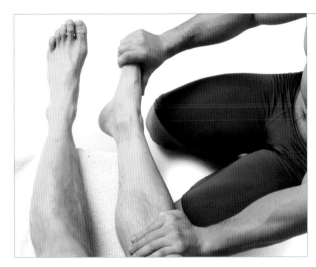

Partner Tibialis Interior

Target: Ankles.

Benefits: Lengthens the muscles along the shin while targeting the muscles in the ankle.

Steps: Stretcher: Begin seated on a cushion with both legs extended and feet hanging over the edge of the cushion.
Partner: Kneel on the Stretcher's right. Hold the Stretcher's right foot and twist it toward you so the heel of the foot faces inward. Repeat on the opposite foot.

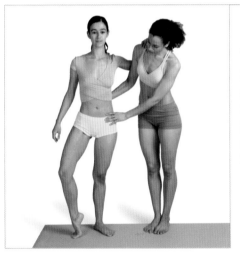

Partner Toe Point

Target: Calves.

Benefits: Strengthens the calves and upper leg muscles.

Steps: Stretcher: Stand with good posture. Raise your right foot onto tiptoes.
Partner: Stand at the Stretcher's left. Place your right hand on the Stretcher's lower back and your left hand on their left hip. **Stretcher:** Hold your Partner's right shoulder for support. Attempt to raise both feet onto tiptoes and balance in this position. Repeat on the opposite side.

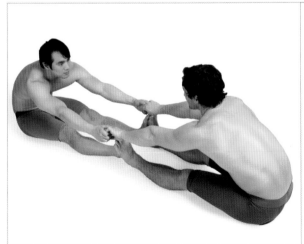

Partner Toe Touch

Target: Spine.

Benefits: Lengthens the muscles along the legs, arms, shoulders, and spine.

Steps: Both Stretchers: Begin seated with the soles of your feet pressed together and your legs flat on the floor. Bend forward from the waist and grab hold of each other's hands above your feet. Gently pull your joined hands, curling at the shoulders while keeping your legs flat on the floor.

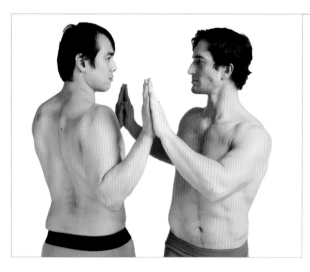

Partner Torso Twist

Target: Spine.

Benefits: Twists the spine and lower back while opening the shoulders and targeting the hip abductors.

Steps: Both Stretchers: Stand facing each other. Raise your hands up to chest level and press your palms against the other Stretcher's palms. Twist your torso toward the left and away from each.

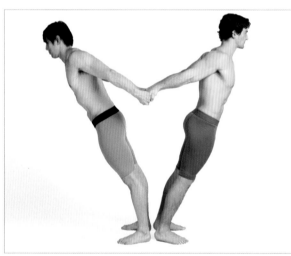

Partner Traction, Back to Back

Target: Shoulders.

Benefits: Targets the muscles in the upper back and shoulders while lengthening the calves and Achilles tendons.

Steps: Stretcher: Stand back to back, with your heels touching. Grab hold of each other's hands and carefully lean your bodies forward and away from each other. Let the other Stretcher support you as you fall forward. Keep your body straight.

Partner Unilateral Leg Raise

Target: Hips.

Benefits: Opens the hips and extends the muscles along the outer thighs and calves.

Steps: Stretcher: Lie flat on your back. Raise your left leg straight up so your heel is facing the ceiling. **Partner:** Stand behind the Stretcher's left leg. Lean over so the Stretcher's raised heel is resting against your right shoulder. Reach around the Stretcher's knee with both hands. Gently press the Stretcher's leg farther up from their hips. Repeat on the opposite leg.

Partner Unilateral Thigh Stretch

Target: Shin.

Benefits: Lengthens the muscles along the shin.

Steps: Stretcher: Lie flat on your stomach. Bend your left knee back, so your foot rests on your hip. **Partner:** Kneel behind the Stretcher's left leg and place your hand on the Stretcher's left ankle. Press down on the ankle, pushing the leg farther in toward the hips. Repeat on the opposite leg.

Partner Unilateral Thigh Stretch

Target: Thigh.

Benefits: Opens the hips and extends the muscles along the outer thighs and calves.

Steps: Stretcher: Lie flat on your back. Raise your right leg straight up so your heel is facing the ceiling. **Partner:** Stand behind the Stretcher's raised leg. Reach your right hand around the Stretcher's raised ankle and place your other hand on their right thigh. Gently press the Stretcher's leg farther up from their hips. Repeat on the opposite leg.

Partner Upper Spinal Twist

Target: Upper back.

Benefits: Opens the hips and extends the spinal column and upper back muscles.

Steps: Stretcher: Begin seated with the soles of your feet pressed together. Twist your torso to the right and reach your right hand to the floor behind you. Place your left hand on the Partner's left hip. **Partner:** Kneel on the Stretcher's right side. Place your left hand on the front of the Stretcher's right shoulder and place your right palm against the back of the Stretcher's left shoulder. Gently assist the Stretcher in the twist. Repeat on the opposite side.

Partner Upper Spinal Twist and Quad Stretch

Target: Upper back.

Benefits: Extends the hips abductors while lengthen the spinal column and targeting the lower back.

Steps: Stretcher: Sit straight with knees bent. Cross your right leg over your left thigh and tuck your left foot into your right hip. Place your left hand on the floor ahead of you and your right hand directly behind you. Twist your torso to the right. **Partner:** Kneel behind the Stretcher. Reach your right palm around the front of the Stretcher's right shoulder. Place your left palm on the back of the Stretcher's left shoulder. Gently assist the Stretcher in the twist.

Partner Upper Spine on Ball

Target: Spine.

Benefits: Twists the spine and engages the core.

Steps: Stretcher: Sit on an exercise ball. Extend your arms straight out to the sides and twist your torso to the left. **Partner:** Stand behind the Stretcher, with your right foot anchored against the ball. Reach your left hand to hold the front of the Stretcher's left arm and place your right palm against the back of the Stretcher's right shoulder. Gently assist the Stretcher in the twist.

Partner Upper Trapezius

Target: Neck.

Benefits: Pulls the muscles along one side of the neck.

Steps: Stretcher: Lie flat on your back, raised slightly from the floor on a cushion. Turn your head to your right, dropping your chin down to your shoulder. **Partner:** Kneel by the Stretcher's head. Place one hand on the side of the Stretcher's head and your other hand against the Stretcher's left shoulder. Gently press down on the Stretcher's shoulder, pulling along the length of the neck.

Partner Wrist Stretch on Ball

Target: Wrists.

Benefits: Targets the muscles in the wrists and along the bottom of the forearm.

Steps: Stretcher: Sit on an exercise ball. Extend your left arm out to the side with your palm facing outward, so your fingers are pointing up. **Partner:** Hold the Stretcher's forearm with your right hand for support. Place your left palm against the Stretcher's left palm and gently press the Stretcher's hand inward.

Partner Wrist Extensor

Target: Wrists.

Benefits: Targets the muscles in the wrists and forearms.

Steps: Stretcher: Lie flat and extend your left arm straight out to your side. Bend your wrist so your palm faces inward and your fingers are pointed down. **Partner:** Kneel on the Stretcher's left side. Hold the Stretcher's forearm with your right hand for support. Gently press your left hand against the Stretcher's down-turned hand.

Partner Wrist Bend on Ball

Target: Wrists.

Benefits: Targets the muscles in the wrists and forearms.

Steps: Stretcher: Begin seated on an exercise ball. Raise your left arm out to the side and turn your palm inward, so your fingers are pointing toward the floor. **Partner:** Hold the Stretcher's forearm for support. Gently press your left hand against the Stretcher's down-turned hand in toward their body.

Yoga Stretches

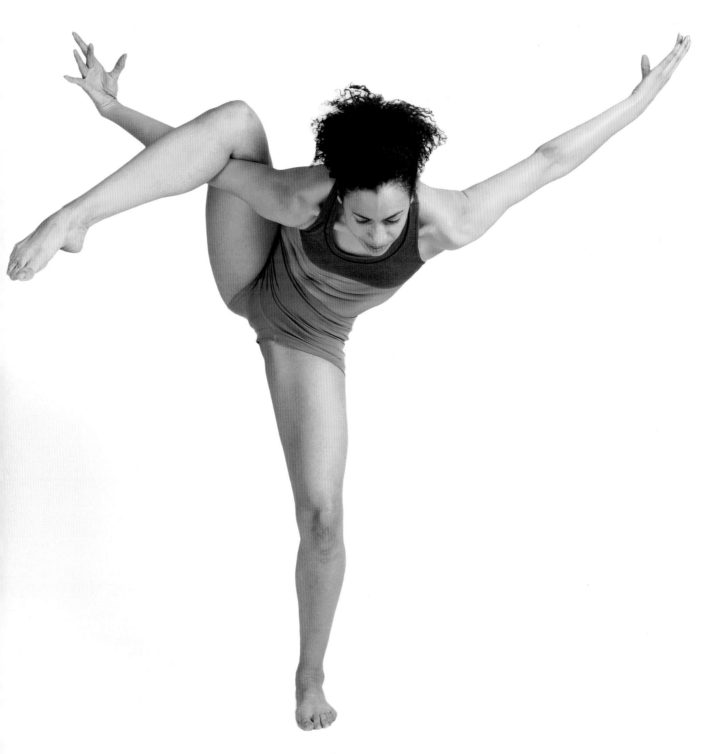

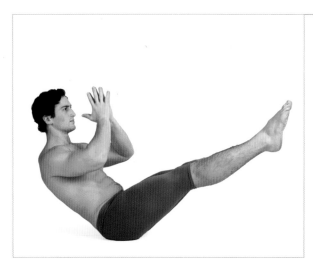

Boat Pose

Target: Abdominals.

Benefits: Deeply challenges the abdomen, spine, and hip flexors, building strength and steadiness at the body's core.

Steps: 1. Begin seated, with your knees bent and feet flat on the floor, hands resting by your hips. Keeping your spine straight, lean back and lift your feet, bringing your shins parallel to the floor. **2.** Draw in your lower back, lift your chest, and lengthen the front of your torso. Raise your hands and bring your palms together. **3.** Balance on your pelvic bones, keeping your spine straight. Extend your legs to a 45-degree angle, bringing your body into a V shape. **4.** Stay in the pose for five breaths, gradually working up to one minute. To release the pose, exhale as you lower your legs and hands to the floor.

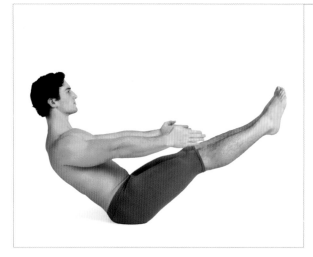

Boat Pose, Completed

Target: Abdominals.

Benefits: Deeply challenges the abdomen, spine, and hip flexors, building strength and stability in the core.

Steps: 1. Begin seated, with your knees bent and feet flat on the floor, hands resting by your hips. Keeping your spine straight, lean back and lift your feet, bringing your shins parallel to the floor. **2.** Draw in your lower back, lift your chest, and lengthen the front of your torso. Extend your arms forward, in line with your shoulders with your palms facing each other. **3.** Balance on your pelvic bones, keeping your spine straight. Extend your legs to a 45-degree angle, bringing your body into a V shape. **4.** Stay in the pose for five breaths, working up to one minute. To release the pose, exhale as you lower your legs and hands to the floor.

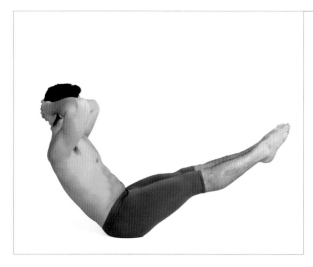

Boat Pose Half

Target: Abdominals.

Benefits: Deeply challenges the abdomen, spine, and hip flexors, building strength and steadiness at the body's core.

Steps: 1. Begin seated with your knees bent and feet flat on the floor, hands resting beside your hips. Keeping your spine straight, lean back and lift your feet, bringing your shins parallel to the floor. **2.** Draw in your lower back, lift your chest, and lengthen the front of your torso. Rest your hands against the back of your head. **3.** Balance on your pelvic bones, keeping your spine straight. Extend your legs to a 45-degree angle, bringing your body into a V shape. **4.** Stay in the pose for five breaths, gradually working up to one minute. To release the pose, exhale as you lower your legs and hands to the floor.

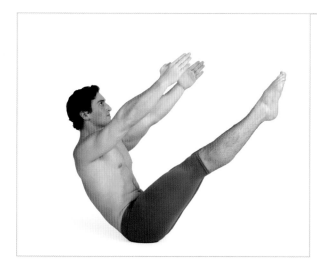

Boat Pose, Parallel

Target: Abdominals.

Benefits: Deeply challenges the abdomen, spine, and hip flexors, building strength and steadiness at the body's core.

Steps: 1. Begin seated, with your knees bent and feet flat on the floor, hands resting by your hips. Keeping your spine straight, lean back and lift your feet, bringing your shins parallel to the floor. **2.** Draw in your lower back, lift your chest, and lengthen the front of your torso. Extend your arms forward at a 45-degree angle. **3.** Balance on your pelvic bones, keeping your spine straight. Extend your legs parallel to your arms, bringing your body into a V shape. **4.** Stay in the pose for five breaths, gradually working up to one minute. To release the pose, exhale as you lower your legs and hands to the floor.

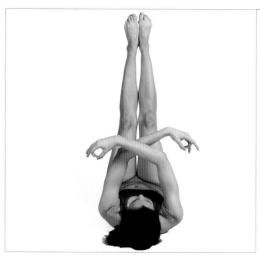

Cross Arms, Reclining

Target: Abdominals.

Benefits: Engages the core and abdominal muscles.

Steps: 1. Begin by lying flat on your back. Extend your legs straight up toward the ceiling, toes pointed. **2.** Cross your arms above your chest toward the opposite side, so your elbows are in line with each other. **3.** Hold for twenty seconds, making sure to keep your legs straight.

Half Eastern Intense-Stretch Pose, Hand to Ankle, Head Back

Target: Abdominals.

Benefits: Engages the abdominals, spine, and quadriceps.

Steps: 1. Begin seated, palms flat on the floor behind you. **2.** Support yourself on your hands and feet, and lift up your hips so your torso is parallel to the floor. **3.** Raise your right foot and extend your leg upward. Lift your left hand from the floor and reach for your right ankle. **4.** Draw your shoulders down and release your head and neck. Hold for twenty seconds before alternating sides.

Half Eastern Intense-Stretch Pose, Hand to Ankle

Target: Abdominals.

Benefits: Engages the abdominals, spine, and quadriceps, increasing core stretch and balance.

Steps: 1. Begin seated, palms flat on the floor behind you. **2.** Support yourself on your hands and feet, and lift up your hips so your torso is parallel to the floor. **3.** Raise your right foot and extend your leg upward. Lift your left hand from the floor and reach for your right ankle. Hold for twenty seconds before releasing and alternating sides.

Half Eastern Intense-Stretch Pose, Revolved

Target: Abdominals.

Benefits: Engages the abdominal, spine, and quadriceps, increasing core stretch and balance.

Steps: 1. Begin seated, palms flat on the floor behind you. **2.** Support yourself on your hands and feet, and lift up your hips so your torso is parallel to the floor. **3.** Raise your right foot and extend your leg upward. Lift your left hand from the floor rest it behind your head. **4.** Twist your body to the left, attempting to touch your left elbow to your right knee. Hold for twenty seconds before releasing and alternating sides.

Lizard Tail Lunge

Target: Abdominals.

Benefits: Deeply opens the hips and upper leg muscles while strengthening the core.

Steps: 1. Step your left foot far forward and raise your right foot up onto tiptoes. **2.** Slowly bend your left knee and lower your torso down into a deep forward lunge. Place your hands flat on the floor to the right of your left foot for support. **3.** One at a time, lower your hands onto your elbows and place your forearms flat on the floor. **4.** Hold this pose for twenty seconds before repeating with alternate legs.

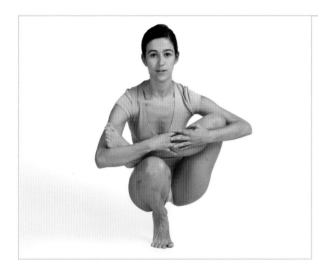

Baby Cradle Pose on One-Legged Tiptoe

Target: Abductors.

Benefits: Extends the muscles in the hips while improving core balance and strength.

Steps: 1. Begin by crouching low to the floor on tiptoes. **2.** Raise your left foot from the floor and pull up your leg to rest across your right thigh. **3.** Maintaining your balance, use both hands to pull your left leg farther into your chest to increase the stretch on the hip abductors. **4.** Hold this pose for as long as you are able before releasing and repeating on the opposite leg.

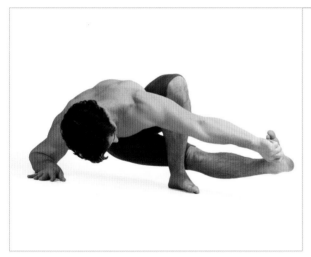

Baby Grasshopper

Target: Abductors.

Benefits: Targets the hip abductors while deeply challenging the abdomen and upper arms.

Steps: 1. Begin seated with your legs straight ahead of you. Place your right hand on the floor slightly behind your hip. **2.** Raise your left knee and cross your left foot over your right leg, placing your foot on the floor to your right. Roll your weight onto the outside of your right leg. **3.** Lower your right forearm to the floor and reach your left hand to grab your right foot. **4.** Shift your weight onto your left foot and right forearm and attempt to push your hips and torso off the floor. **5.** Drop your shoulders forward and raise your hips. Try to hold this pose for five seconds. Release and repeat to the opposite side.

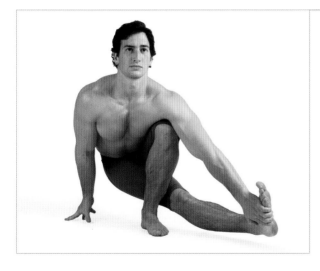

Baby Grasshopper Prep

Target: Abductors.

Benefits: Targets the hip abductors while deeply challenging the abdomen and upper arms.

Steps: 1. Begin seated with your legs straight ahead of you. Place your left hand on the floor slightly behind your hip. **2.** Raise your left knee and cross your left foot over your right leg, placing your foot on the floor to your right. Roll your weight onto the outside of your right leg. **3.** Reach your left hand to grab hold of your right ankle or foot, depending on your level of flexibility. **4.** Shift your weight onto your right foot and left hand and attempt to push your hips off the floor. **5.** Try to hold this pose for five seconds. Release and repeat to the opposite side.

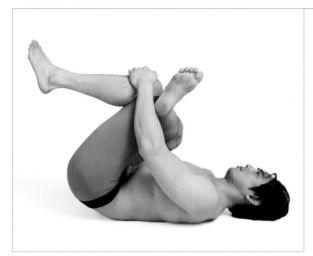

Eye of the Needle

Target: Abductors.

Benefits: Relieves stiffness in the outer hips and lower back due to the lack of use or prolonged sitting.

Steps: 1. Begin by lying on your back with legs bent and feet flat on the floor. **2.** Raise your right foot and cross it over the left leg, resting your right ankle on your right knee. Pull your left knee into your chest, so both feet are now off the floor. **3.** Hold this pose for fifteen seconds before switching legs.

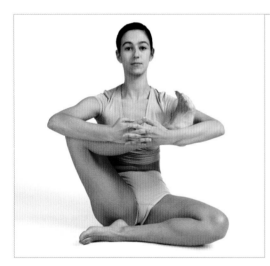

Four-Corner Stretch

Target: Abductors.

Benefits: Extends the muscles in the hips while improving core balance and strength.

Steps: 1. Begin seated on the floor, cross-legged **2.** Raise your right foot from the floor and place it on your left thigh. **3.** Reach both hands around your right calf and lace your fingers together against your shin. Gently pull your calf up from the floor, until it is parallel to the floor. **4.** Hold this pose for as long as you are able. Release and repeat, switching legs.

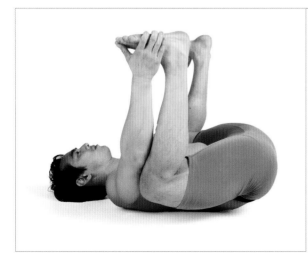

Happy Baby Stretch 1

Target: Abductors.

Benefits: Opens the hips and extends the muscles across the lower back.

Steps: 1. Lie flat on your back with legs bent and feet on the floor. **2.** Raise both feet from the floor and bring your knees into your chest. Reach up with both hands and grab hold of the outside of your feet. **3.** Gently pull down on your feet, bringing your knees down and into your sides. **4.** Hold this pose for thirty seconds before releasing.

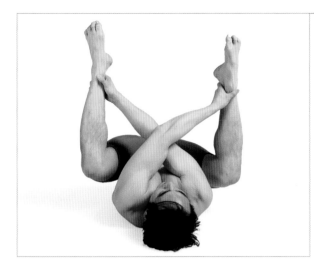

Happy Baby Stretch 2

Target: Abductors.

Benefits: Opens the hips and extends the muscles across the lower back.

Steps: 1. Lie flat on your back with legs bent and your feet on the floor. **2.** Raise both feet from the floor and bring your knees into your chest. Reach both hands across to grab hold of the opposite ankle. **3.** Gently pull down on your feet, bringing your knees down and into your sides. **4.** Hold this pose for thirty seconds before releasing.

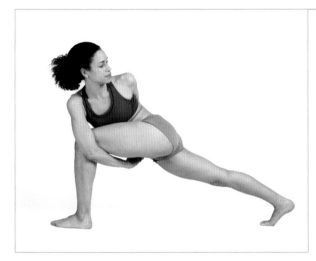

Lizard Tail Lunge, Bound Revolved

Target: Abductors.

Benefits: Deeply opens the hips and upper leg muscles while strengthening the core.

Steps: 1. Step your left foot far forward and raise your right foot up onto tiptoes. **2.** Bend your left knee and lower your torso down into a deep forward lunge. Place your hands flat on the floor beside your left foot for support. **3.** Reach your left hand behind your back and twist your torso to the left. Reach your right hand under your left thigh and attempt to clasp your hands. **4.** Hold for twenty seconds before repeating to the opposite side.

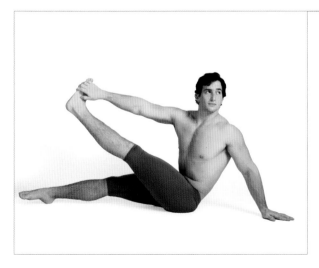

Staff Pose, One-Leg Upward Revolved

Target: Abductors.

Benefits: Twists the spine and opens the chest while strengthening the hip abductors.

Steps: 1. Begin seated on the floor with legs straight ahead of you. **2.** Twist your torso to your left and place both hands on the floor to your left. **3.** Keeping your left leg straight, raise it into the air. Grab your left ankle with your right hand and gently pull it up higher. **4.** Hold this position for twenty seconds before performing on the opposite side.

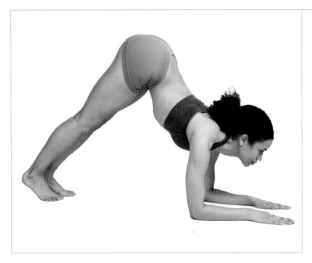

Dolphin Pose

Target: Achilles.

Benefits: Opens and strengthens the shoulders, hamstrings, and Achilles tendons.

Steps: 1. Begin by kneeling on all fours. Lower onto your forearms so your forearms and hands are flat on the floor and your shoulders are directly above your elbows. Spread your fingers comfortably. **2.** Curl your toes up from the floor so your feet are propped up. Press your hips up from the floor and straighten your legs. Drop your head so your ears are in line with your upper arms. **3.** Press your heels down toward the floor and lift your hips away from your shoulders to increase the stretch on the spine and sides. **4.** Hold this pose for twenty seconds before releasing.

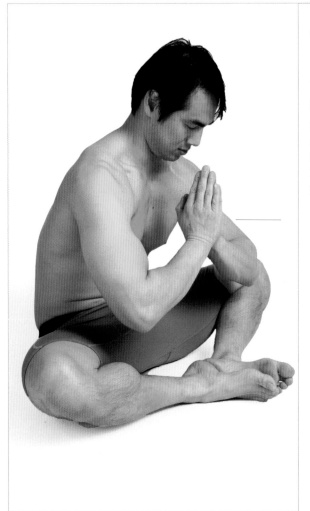

Angle Pose, Bound Prayer Hands

Target: Adductors.

Benefits: Opens the hips and lengthens the spine.

Steps: 1. Begin seated on the floor. Bend both knees out to your sides and press the soles of your feet together. **2.** Raise your hands in front of your chest and join your palms together in prayer position. **3.** Bend your shoulders forward and lower your hands toward your feet. **4.** Hold this position for thirty seconds before releasing.

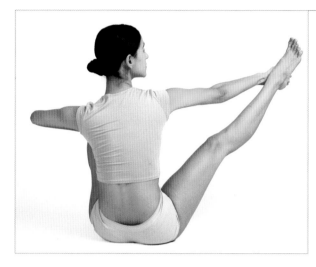

Angle Pose, One Leg Extended

Target: Adductors.

Benefits: Extends the muscles in the hips and hamstrings, increasing mobility and muscle alignment.

Steps: 1. Begin seated on the floor with both knees bent and your feet flat on the floor in front of you. **2.** Reach your right hand down and grab hold of your right ankle from the inside. **3.** Extend your right leg straight up from the floor. **4.** Hold this pose for thirty seconds before repeating on the opposite leg.

Bird of Paradise, Half-Bound Leg-Extension Pose, Modified

Target: Adductors.

Benefits: Twists open the chest and shoulders while deeply extending the groin and increasing balance.

Steps: 1. Standing straight, raise your right knee into your chest. Place your right hand on your foot and lift your leg straight up along your side in a standing split. **2.** Once you are balanced, wrap your left arm behind your back and hold onto your right hip in a half-bound position. **3.** Extend your gaze upward to complete the stretch. Hold this pose for ten seconds before switching sides.

Bird of Paradise Pose

Target: Adductors.

Benefits: Incorporates hip opening, core and back strengthening, and hamstring lengthening.

Steps: 1. Stand upright with your feet apart. Raise your right foot up from the floor and bring your knee to your chest. **2.** Reach your right arm under your right thigh and behind your hip. Reach your left arm across your back to join your hands in a bound pose. **3.** Find your balance and carefully extend your right leg straight up along your side. **4.** Attempt to stay in this pose for ten seconds at a time, before releasing and switching sides.

Bird of Paradise Pose, Revolved

Target: Adductors.

Benefits: Incorporates hip opening, core and back strengthening, and hamstring lengthening.

Steps: 1. Stand upright with your feet apart. Raise your right foot up from the floor and bring your knee up to your chest. **2.** Reach your left hand and grab hold of your right ankle. Keeping your hand and foot together, carefully extend your right leg straight up in front of you so your foot is at shoulder height. **3.** Twist your torso to the right and extend your right arm straight out behind you, in line with your shoulders. Attempt to stay in this pose for ten seconds at a time, before releasing and switching sides.

Bird of Paradise, Revolved Bound

Target: Adductors.

Benefits: Incorporates hip opening, core and back strengthening, and hamstring lengthening.

Steps: 1. Stand upright with your feet apart. Raise your right foot up from the floor and bring your knee up to your chest. **2.** Twist your torso to the right as you reach your left arm under your right thigh. Reach your right arm behind your back and clasp your hands in a bound pose. **3.** Find your balance and carefully extend your right leg straight out. **4.** Attempt to stay in this pose for ten seconds at a time, before releasing and switching sides.

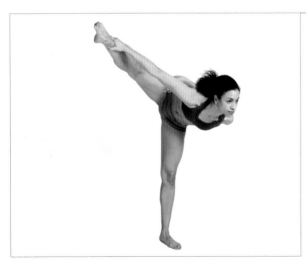

Bowing with Respect Forward Bend

Target: Adductors.

Benefits: Twists open the chest and shoulders while deeply extending the groin and increasing balance.

Steps: 1. Standing straight, raise your right knee into your chest. Using your right hand, lift your leg straight out to your side in a standing split. **2.** Once you are balanced, wrap your left arm behind your back, holding onto your opposite hip in a half-bound position. **3.** Slowly lean your torso forward, bending at the waist. Continue the forward bend until your torso is parallel to the floor. **4.** Perform this pose for ten seconds before alternating legs.

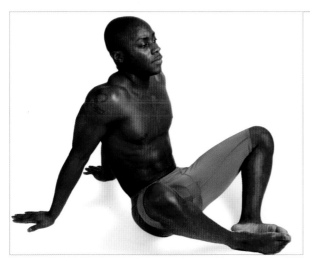

Butterfly Stretch

Target: Adductors.

Benefits: Opens the hips and groin, improving flexibility and muscle alignment.

Steps: 1. Begin seated on the floor. Place both hands flat on the floor behind your hips. **2.** Bend both knees out to your sides and press the soles of your feet together. **3.** Attempt to pull your knees lower toward the floor.

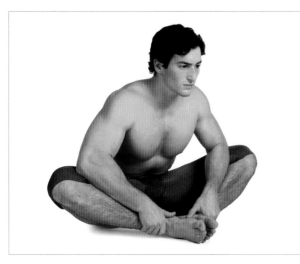

Butterfly Stretch, Folded

Target: Adductors.

Benefits: Opens the hips and groin, improving flexibility and muscle alignment.

Steps: 1. Begin seated on the floor. Bend both knees out to your sides and press the soles of your feet together. **2.** Reach both hands down to grab hold of your ankles. Attempt to pull your knees lower toward the floor. **3.** Bend your torso forward while keeping your back straight.

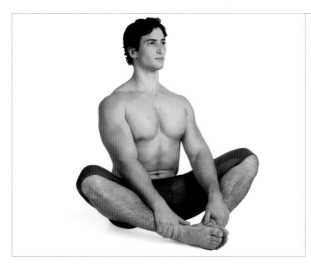

Butterfly Stretch, Seated

Target: Adductors.

Benefits: Opens the hips and groin, improving flexibility and muscle alignment.

Steps: 1. Begin seated on the floor. Place both hands flat on the floor behind your hips. **2.** Bend both knees out to your sides and press the soles of your feet together. **3.** Attempt to pull your knees lower toward the floor.

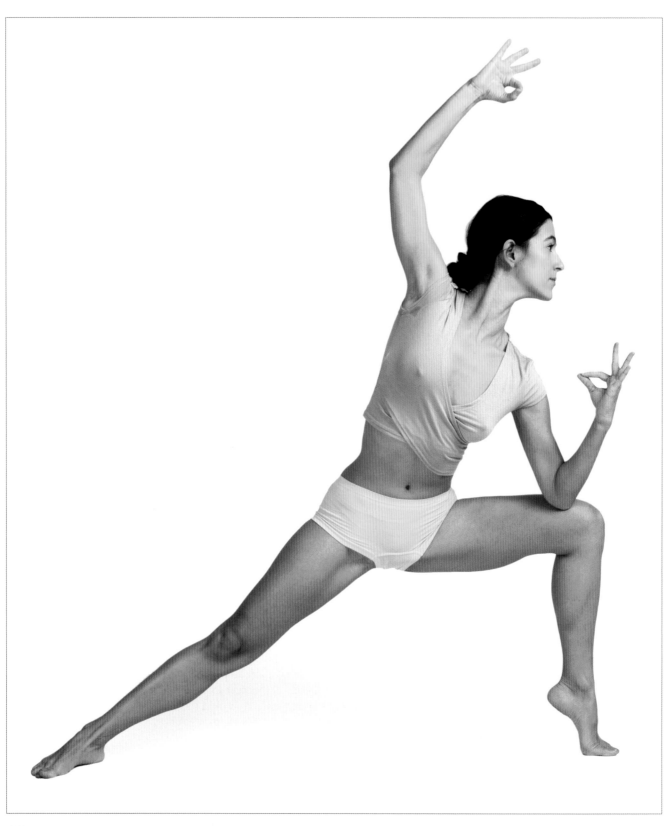

Extended Leg-to-Side Tiptoe Stretch

Target: Adductors.

Benefits: Incorporates hip opening, core and back strengthening, and hamstring lengthening.

Steps: 1. Step your legs wide apart and point your right foot out to the side. Raise your left foot onto tiptoes. **2.** Bend your left knee and lower your torso down into a deep side lunge. **3.** Drop your left elbow down to your left thigh. Extend your right arm overhead, and make the wisdom gesture with your fingers. **4.** Hold this pose for ten seconds at a time, before alternating sides.

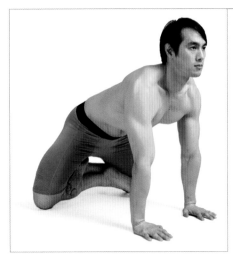

Lotus Cobra Pose

Target: Adductors.

Benefits: Opens the hips and groin, improving flexibility and muscle alignment.

Steps: 1. Sit on the floor with your legs extended, spine straight, and arms resting at your sides. **2.** Bring your left ankle to rest in the crease of your right hip, with the sole of your foot facing upward. **3.** Bend your right knee and place your right ankle onto your left thigh. The sole of your right foot should also face upward. **4.** Lengthen your spine and place your palms on the floor in front of you. **5.** Supporting yourself on your hands, lift your hips from the floor and roll up onto your knees. Walk your hands, one at a time, away from your knees. **6.** Attempt to stay in this position for five seconds or longer.

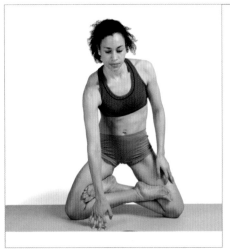

Kneeling Lotus Pose Prep 2

Target: Adductors.

Benefits: Addresses tightness in the spine and upper back while stretching the knees, groin, and ankles.

Steps: 1. Sit on the floor with your legs extended, spine straight, and arms resting at your sides. **2.** Bring your left ankle to rest in the crease of your right hip, with the sole of your foot facing upward. **3.** Bend your right knee and place your right ankle onto your left thigh. The sole of your right foot should also face upward. **4.** Lengthen your spine and place your fingertips on the floor in front of you. **5.** Supporting yourself on your fingers, carefully lift your hips from the floor and roll up onto your knees. **6.** Once your body is extended straight up from your knees, lift your hands from the floor one at a time. Attempt to stay in this position for five seconds or longer.

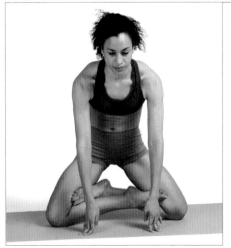

Kneeling Lotus Pose Prep 1

Target: Adductors.

Benefits: Addresses tightness in the spine and upper back while stretching the knees, groin, and ankles.

Steps: 1. Sit on the floor with your legs extended, spine straight, and arms resting at your sides. **2.** Bring your left ankle to rest in the crease of your right hip, with the sole of your foot facing upward. **3.** Bend your right knee and place your right ankle onto your left thigh. The sole of your right foot should also face upward. **4.** Lengthen your spine and place your fingertips on the floor in front of you. **5.** Supporting yourself on your fingers, carefully lift your hips from the floor and roll up onto your knees. **6.** Attempt to stay in this position for five seconds.

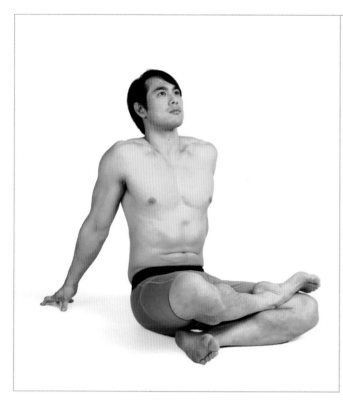

Fire-Log Pose

Target: Adductors.

Benefits: Extends the muscles in the hips while improving spinal balance and strength.

Steps: 1. Begin seated on the floor, cross-legged. Place your hands flat on the floor behind your hips. **2.** Raise your right foot from the floor and tuck it into your right thigh. **3.** Hold this pose for fifteen seconds. Release and repeat, switching legs.

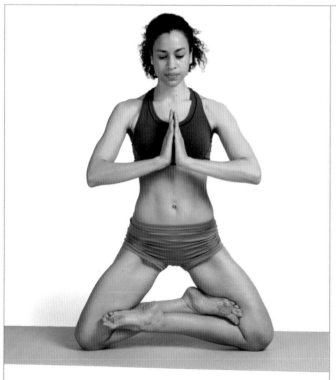

Kneeling-Lotus Pose

Target: Adductors.

Benefits: Addresses tightness in the spine and upper back while stretching the knees, groin, and ankles.

Steps: 1. Sit on the floor with your legs extended, spine straight, and arms resting at your sides. **2.** Bring your right ankle to rest in the crease of your left hip, with the sole of your foot facing upward. **3.** Bend your left knee and place your left ankle onto your right thigh. The sole of your left foot should also face upward. **4.** Lengthen your spine and place your fingertips on the floor in front of you. **5.** Supporting yourself on your fingers, carefully lift your hips from the floor and roll up onto your knees. **6.** Once your body is extended straight up from your knees, lift your hands from the floor and join your palms together in prayer position ahead of your chest. Attempt to stay in this position for five seconds or longer.

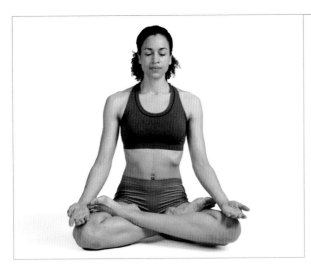

Lotus Pose

Target: Adductors.

Benefits: Opens the hips and groin, improving flexibility and muscle alignment.

Steps: 1. Sit on the floor with your legs extended, spine straight, and arms resting at your sides. **2.** Bring your right ankle to rest in the crease of your left hip, with the sole of your foot facing upward. **3.** Bend your left knee and place your left ankle onto your right thigh. The sole of your left foot should also face upward. **4.** Lengthen your spine and place your hands on your knees, with palms facing up. **5.** Attempt to stay in this position for ten seconds or longer.

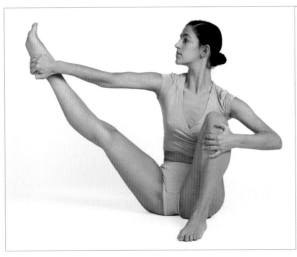

Seated Angle Pose

Target: Adductors.

Benefits: Extends the muscles in the hips and hamstrings, increasing mobility and muscle alignment.

Steps: 1. Begin seated on the floor, with both knees bent and your feet flat on the floor. **2.** Reach your right hand down to grab your right ankle from the inside. **3.** Keeping your right hand and foot together, lift your right leg straight up from the floor at a 45-degree angle. **4.** Hold this pose for thirty seconds before repeating on the opposite leg.

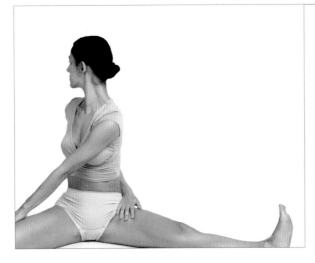

Seated Angle, Revolved Half-Bound Half-Hero

Target: Adductors.

Benefits: Opens the hips and twists the spine and lower back.

Steps: 1. Begin seated on the floor. **2.** Extend your left leg out to the side. Bend your right knee, so your foot is tucked behind your hip. **3.** Twist your torso to the right. Reach your left hand to your right knee. Extend your left arm across your back and hold your left hip. **4.** Hold this pose for thirty seconds before releasing and performing in the opposite direction.

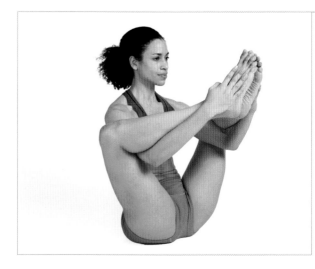

Star Pose

Target: Adductors.

Benefits: Opens the hips and increases core balance and strength.

Steps: 1. Sit on the floor, with your knees bent out to your sides and your feet flat on the floor. **2.** Reach both arms under your legs and hook your elbows under your calves. Lift your feet up from the floor and use your hands to press the soles of your feet against each other. **3.** Rock back onto your pelvic bones. Continue to lift your feet and hands until they reach shoulder height. **4.** Hold this pose for fifteen seconds.

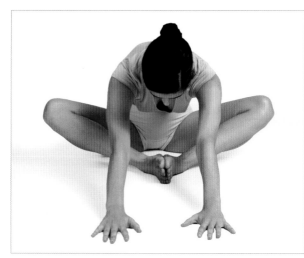

Star Pose, Arms Ahead

Target: Adductors.

Benefits: Lengthens the muscles in the groin, upper back, and shoulders.

Steps: 1. Begin seated with knees bent to the sides and the soles of your feet together in the butterfly position. **2.** Bend forward, reaching your hands to the floor as far in front of you as you can. Hold for thirty seconds.

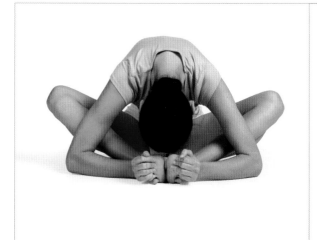

Star Pose, Elbows to Floor

Target: Adductors.

Benefits: Increases flexibility and mobility in the adductor muscles while lengthening the spine.

Steps: 1. Begin seated with knees bent to the sides and the soles of your feet together in the butterfly position. **2.** Bend forward until your forearms are flat on the floor in front of your shins and your forehead is resting on your feet. Hold for thirty seconds.

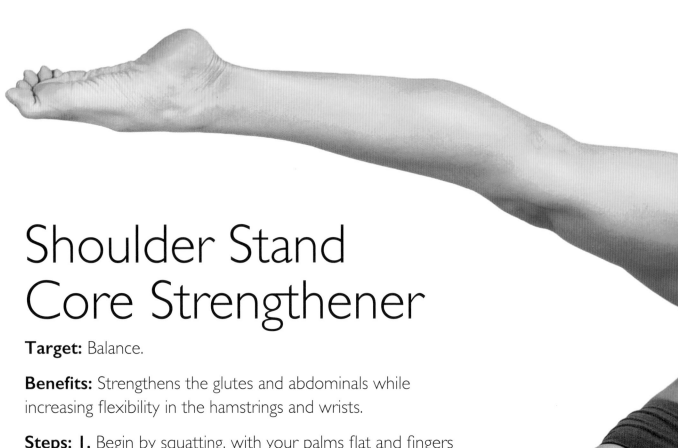

Shoulder Stand Core Strengthener

Target: Balance.

Benefits: Strengthens the glutes and abdominals while increasing flexibility in the hamstrings and wrists.

Steps: 1. Begin by squatting, with your palms flat and fingers pointing forward. **2.** Lean the right side of your head to the floor. Bend your elbows and shift your weight onto your hands and head. Twist your lower torso toward your left and attempt to anchor your right knee onto your left elbow. **3.** Slowly extend your left leg out to the side. **4.** Hold this position for thirty seconds, before releasing and repeating on the opposite side.

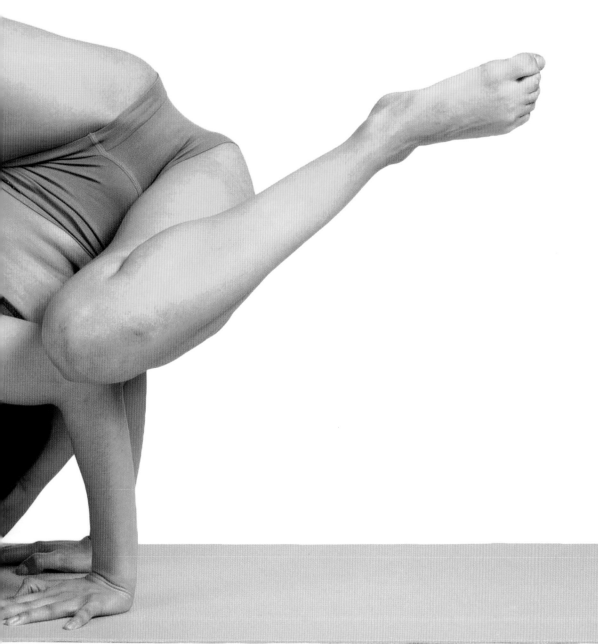

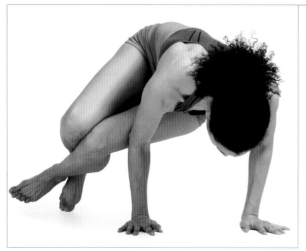

Arm Balance Prep

Target: Arms and core.

Benefits: Strengthens the muscles in the arms and the core.

Steps: 1. Begin sitting with both knees bent to your right. Plant both hands flat on the floor in front of your right hip. **2.** Bend both arms so your upper arms are parallel to the floor. **3.** Shift all your weight onto your hands and upper arms. Attempt to raise yourself up onto your toes and push yourself up from the floor.

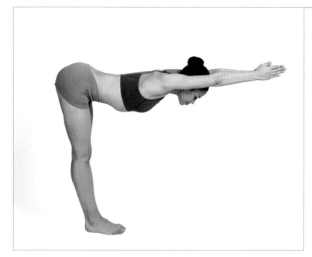

Arms-Extended Half Intense-Stretch Pose

Target: Arms and core.

Benefits: Lengthens the muscles in the legs and spine while engaging the arms and core.

Steps: 1. Stand straight with your feet shoulder-width apart. Extend your arms straight overhead with your palms together. **2.** Fold your torso forward, bending at the waist, until your arms and torso are parallel to the floor. **3.** Hold this pose for thirty seconds.

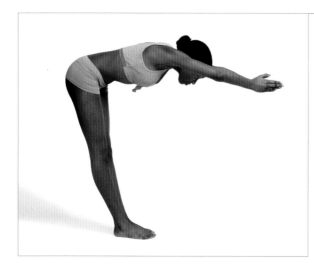

Arms-Extended Half-Stretch Pose

Target: Arms and core.

Benefits: Lengthens the muscles in the legs and spine while engaging the arms and core.

Steps: 1. Stand straight with your feet shoulder-width apart. Extend your arms straight overhead with your palms together. **2.** Fold your torso forward, bending at the waist, with your arms slightly lower than your shoulders. **3.** Hold for thirty seconds.

Crane Pose Prep

Target: Arms.

Benefits: Prepares your upper arms and core to accomplish the crane pose.

Steps: 1. Squat low to the floor, with your feet raised onto tiptoes. **2.** Place your hands flat on the floor for support, with your fingers pointing toward your feet. Spread your fingers wide and make sure your hands are shoulder-width apart. **3.** Push your hips up from the floor, so they are the highest point of your body.

Crane Pose

Target: Arms.

Benefits: Incorporates equal parts flexibility and strength in the upper arms and core.

Steps: 1. Begin by squatting low to the floor, with your feet raised onto tiptoes and your hands flat on the floor ahead for support. **2.** Spread your fingers wide and make sure your hands are shoulder-width apart. Push your hips up from the floor, so they are the highest point of your body. **3.** Gently press your knees into the backs of your triceps and begin to shift your weight onto your hands, raising one foot at a time off the floor. Bend your elbows if necessary for balance. **4.** Draw your navel in toward the spine to find the core balance that will eventually allow you to straighten your elbows and hold this pose.

Rooster Pose

Target: Arms.

Benefits: Deeply strengthens the upper arms while opening the hips and groin, improving flexibility and muscle alignment.

Steps: 1. Sit on the floor with your legs extended, spine straight, and arms resting at your sides. **2.** Bring your right ankle to rest in the crease of your left hip and the sole of your foot facing upward. **3.** Bend your left knee and rest your left ankle on your right hip. The sole of your left foot should also face upward. **4.** Lengthen your spine and reach your arms straight down between your legs. **5.** Roll your weight onto your pelvic bones and lift your hips and legs off the floor.

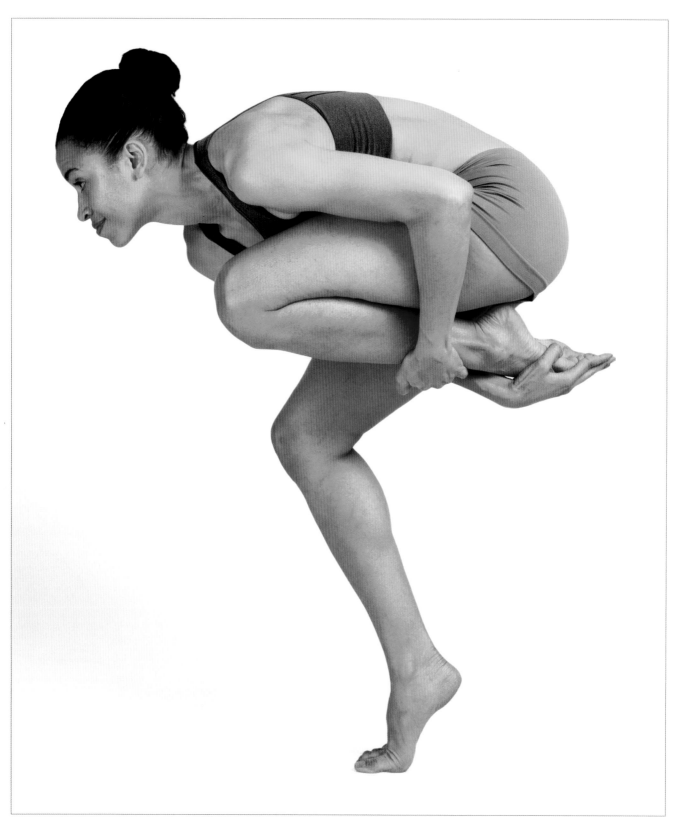

Both Hands to Foot, Tiptoe Half-Standing Wind-Relieving Intense-Stretch Pose 1

Target: Balance.

Benefits: Lengthens the muscles along the spine while improving balance and strength in the legs.

Steps: 1. Stand straight. Lift your left foot off the floor and bend your leg so your foot rests behind your hip. **2.** Reach your right hand behind you to grab hold of your left foot and pull it into your hips. **3.** Bend your torso forward at the waist, tucking your left knee into your chest. Place your left hand on the floor for support. **4.** Carefully bend your right knee and raise your right foot onto tiptoes. **5.** Keeping your right hand on your left foot, bend down until your torso is parallel to the floor. Once you are balanced, lift your left hand from the floor to hold your left foot as well. **6.** Hold this balancing position for twenty seconds before releasing and alternating legs.

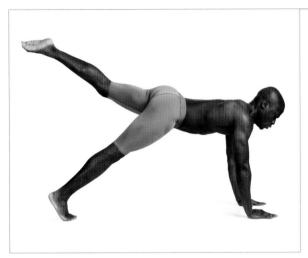

Extended Four-Limbs Staff Pose, One-Legged 4

Target: Arms.

Benefits: Strengthens the upper arms and core, improving balance.

Steps: 1. Begin on all fours with your palms flat on the floor directly beneath your shoulders. One at a time, step your feet out and onto your toes so you are in a plank position. **2.** Extend your left foot up from the floor and raise your leg up so it is parallel to the floor. **3.** Hold this pose for thirty seconds. Release and repeat, this time raising the opposite leg.

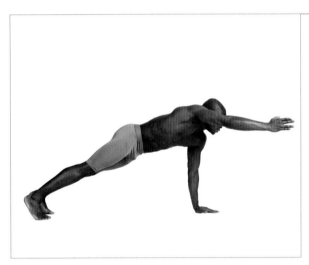

Extended Four-Limbs Staff Pose, One-Legged 5

Target: Arms.

Benefits: Strengthens the upper arms and core muscles, improving balance reducing muscle imbalance.

Steps: 1. Begin on all fours with your palms flat on the floor directly beneath your shoulders. One at a time, step your feet out and onto your toes so you are in a plank position. **2.** Extend your right hand up from the floor and raise your arm to shoulder height. **3.** Hold this pose for thirty seconds. Release and repeat, this time raising the opposite arm.

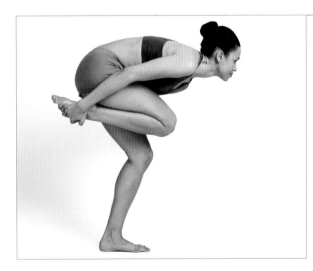

Both Hands to Foot, Half-Standing Wind-Relieving Intense-Stretch Pose 2

Target: Lower back.

Benefits: Lengthens the back muscles while improving balance.

Steps: 1. Stand straight. Lift your right foot behind your hip. **2.** With your right hand, grab your right foot and pull it into your hip. **3.** Slowly bend your left knee and lean your torso forward until it is parallel to the floor. Place your left hand on the floor for support. **4.** Once you are balanced, lift your left hand from the floor to hold your right foot as well. **5.** Hold for twenty seconds before alternating legs.

Hands to Foot, Tiptoe Half-Standing Wind-Relieving Intense-Stretch Pose Prep

Target: Lower back.

Benefits: Lengthens the muscles along the spine while improving balance and strength in the legs.

Steps: 1. Stand straight. Lift your right foot up from the floor and bend your knee so your foot rests behind your hip. **2.** Reach your right hand behind you to grab hold of your foot and pull it into your hip. **3.** Slowly bend your left knee and lean your torso forward, tucking your right knee into your chest. **4.** Place your left hand on the floor for support and raise your left foot onto tiptoes. **5.** Keeping your right hand and foot bound, bend forward until your torso is parallel to the floor.

Hand to Foot, One-Legged Intense-Stretch Pose

Target: Lower back.

Benefits: Lengthens the muscles along the spine while improving balance and strength in the legs.

Steps: 1. Stand straight. Lift your right foot up from the floor and bend your knee so your foot rests behind your hip. **2.** Reach both hands behind you to grab hold of your foot and pull it into your hips. **3.** Carefully bend your torso forward at the waist, keeping your hands and foot connected. Bring the top of your head toward the floor and press your forehead against your left shin. **4.** Hold this balancing position for twenty seconds before releasing and alternating legs.

One Hand to Foot Rising, Standing One-Legged Frog Pose

Target: Balance.

Benefits: Improves core balance and strength while engaging the leg muscles.

Steps: 1. Stand straight and shift your weight onto your right foot. Bend your left knee and lift your left foot behind you. **2.** Reach your right hand behind you to grab hold of your left foot and pull it into your hips. **3.** Then, reach your left hand around your chest to grab hold of your left foot. Once your right hand reaches your left foot, let go with your right hand and extend your right arm straight ahead. **4.** Hold this pose for fifteen seconds before releasing and switching sides.

One-Leg Standing, Balance

Target: Balance.

Benefits: Increases flexibility and range of motion along the spine while improving balance.

Steps: 1. Stand straight and shift your weight onto your right foot. Lift your right foot from the floor and bend your knee up to your side. **2.** Use your right hand to pull your knee higher up your side. Your right elbow should be hooked around your knee with your hand reaching behind your back. **3.** Reach your left arm behind your back to grab hold of your right hand, binding your leg up to your side. **4.** Lengthen your spine and hold this pose for twenty seconds. Release and repeat, switching legs.

One-Leg Standing, Balance Backbend

Target: Balance.

Benefits: Increases flexibility and range of motion along the spine while practicing balance.

Steps: 1. Standing up straight, bend your right leg up to your waist and grab your raised ankle with your right hand. Raise your left hand straight above you. **2.** Keeping your right hand and foot bound, slowly lean your torso backward at the waist. Bend as far back as you are able before alternating sides.

One-Leg Standing, Balance Backbend Intense

Target: Balance.

Benefits: Increases flexibility and range of motion along the spine while practicing balance.

Steps: 1. Standing up straight, bend your right leg up to your waist and grab your raised foot with your right hand. Raise your left hand straight above you. **2.** Keeping your right hand and foot bound, slowly lean your torso backward at the waist. **3.** Bend as far back as you are able before alternating sides.

One-Leg Standing, Balance Backbend Bound Foot

Target: Balance.

Benefits: Increases flexibility and range of motion along the spine while practicing balance.

Steps: 1. Stand up straight and shift your weight onto your left foot. **2.** Bend your right knee up to waist height and grab your raised foot with your right hand. Pull your foot up and into your hips. **3.** Raise your left hand straight above you and turn your head to the left. Lean back slightly and to the left. **4.** Hold this pose for thirty seconds before alternating sides.

One-Leg Standing, Balance Knee Bent to Side

Target: Balance.

Benefits: Increases flexibility and range of motion along the spine while practicing balance.

Steps: 1. Stand up straight and shift your weight onto your left foot. **2.** Bend your right knee up to waist height and grab your raised knee with your right hand. **3.** Keeping your hand and knee attached, swing your knee out to your right side and pull it gently up higher. Hold this pose for thirty seconds before alternating sides.

One-Leg Standing Pose, Leg Straight to Side

Target: Balance.

Benefits: Increases flexibility and range of motion along the spine while opening the hips and improving balance.

Steps: 1. Stand straight and shift your weight onto your left foot. **2.** Bend your right knee up to waist height at your side. Reach your right arm in front of your right thigh and under your knee to grab hold of your right ankle from the outside. **3.** Find your balance and, keeping your hand and ankle attached, straighten your right leg up to your side. **4.** Use your hand to gently pull your leg up and into your body. Hold this pose for ten seconds before alternating sides.

One-Legged Fierce Pose 1

Target: Balance.

Benefits: Increasing strength and balance in the legs and core.

Steps: 1. Stand straight and shift your weight onto your left foot. Raise your right foot up from the floor and tuck your ankle across your left thigh. **2.** Slowly bend your left knee, lowering your hips down toward the floor. Reach your hands down to your left ankle for support. **3.** Maintain this position for twenty seconds on either leg.

One-Legged Fierce Pose 2

Target: Balance.

Benefits: Increasing strength and balance in the legs and core.

Steps: 1. Stand straight and shift your weight onto your right foot. Raise your left foot up from the floor and tuck your ankle across your right thigh. **2.** Slowly bend your right knee, lowering your hips toward the floor. Reach your hands down to the floor for support. **3.** Find your balance in this position and raise your hands from the floor and extend them straight out behind you. Maintain this position for twenty seconds on either leg.

One-Legged Fierce Pose 3

Target: Balance.

Benefits: Increases strength and balance in the legs and core.

Steps: 1. Stand straight and shift your weight onto your left foot. Raise your right foot up from the floor and tuck your ankle across your left thigh. **2.** Slowly bend your left knee, lowering your hips toward the floor. Reach your hands down to the floor for support. **3.** Once you are balanced in this position, raise your hands from the floor and clasp them together behind your back. Extend your arms straight up. **4.** Maintain this position for twenty seconds on each leg.

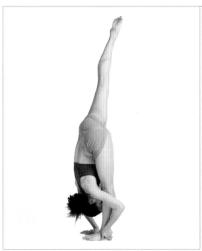

One-Legged Forward Bend, Holding Ankle

Target: Balance.

Benefits: Lengthens the muscles along the spine while improving balance and strength in the legs.

Steps: 1. Stand straight and shift your weight onto your left foot. Lift your right foot up behind your hip. **2.** Bend your torso forward at the waist. Reach your right hand down to the floor and your left hand behind your ankle. **3.** Continue the forward bend, bringing the top of your head toward the floor and pressing your forehead to your left shin. **4.** Once your have found your balance, straighten your right leg up toward the ceiling. Hold this position for fifteen seconds before releasing and alternating legs.

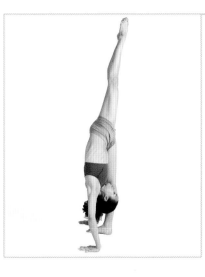

One-Legged Forward Bend, Legs Straight

Target: Balance.

Benefits: Lengthens the muscles along the spine while improving balance and strength in the legs.

Steps: 1. Stand straight and shift your weight onto your right foot. Lift your left foot up behind your hips. **2.** Carefully bend your torso forward at the waist. Reach both hands flat on the floor. **3.** Continue the forward bend, bringing the top of your head toward the floor and pressing your forehead to your left shin. **4.** Once your have found your balance, straighten your left leg up toward the ceiling. Hold this balancing position for fifteen seconds before releasing and alternating legs.

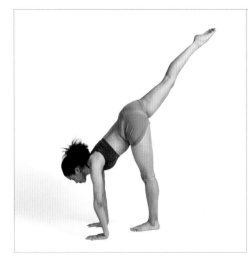

One-Legged Forward Bend Pose Prep 1

Target: Balance.

Benefits: Strengthens the glutes and abdominals while increasing flexibility in the hamstrings and wrists.

Steps: 1. Standing upright, bend your torso forward at the waist and place both hands flat on the floor ahead of you. Point your fingers forward. **2.** Shifting your weight onto your hands, raise your right leg straight up in the air above you. Point your toes. **3.** Hold this position for thirty seconds, before releasing and repeating with the opposite leg.

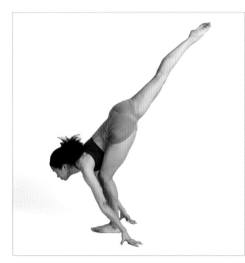

One-Legged Forward Bend Pose Prep 2

Target: Balance.

Benefits: Strengthens the glutes and abdominals while increasing flexibility in the hamstrings and wrists.

Steps: 1. Standing upright, bend your torso down at the waist and place both hands flat on the floor ahead of you. Point your fingers forward. **2.** Shifting your weight onto your hands, raise your right leg straight up behind you, pointing your toes. Bent your left knee slightly. **3.** One at a time, step your hands out behind your right foot. Your fingers should now be pointing behind you. **4.** Hold this position for thirty seconds, before releasing and repeating with the opposite leg.

One-Legged Forward Bend, Prayer Hands

Target: Balance.

Benefits: Lengthens the spine while improving balance.

Steps: 1. Stand straight and shift your weight onto your left foot. Lift your right foot up behind hips. **2.** Carefully bend your torso forward at the waist. Join your palms together in prayer position at your chest. **3.** Continue the forward bend, until your torso is parallel to the floor. Straighten your right leg up so it is in line with your torso. **4.** Once you have found your balance, rotate your torso out to the right, twisting from the left hip. **5.** Hold this balancing position for fifteen seconds before releasing and alternating legs.

One-Legged, Half-Bound Balance Pose

Target: Balance.

Benefits: Increases flexibility and range of motion along the spine while opening the hips and improving balance.

Steps: 1. Stand straight and shift your weight onto your left foot. Raise your right foot and use your left hand pull it up into your left hip. **2.** Lean your torso forward, bending at the waist. **3.** Reach your right arm around the inside of your right thigh, hooking your elbow under your knee. Your hand should be reaching behind to hold your right hip. Extend your left hand in front of you. **4.** Hold this pose for twenty seconds before releasing. Repeat on opposite leg.

One-Legged, Reverse-Squat Achilles Stretch, Hands-to-Foot

Target: Balance.

Benefits: Increases flexibility in the calves and hamstrings while improving balance and strength in the core.

Steps: 1. Stand straight and shift your weight onto your left foot. Raise your right knee up to your chest. **2.** Reach both hands to hold your raised foot. Keeping your hands and foot together, extend your right leg straight out ahead. **3.** Slowly bend your left knee, lowering your torso toward the floor. Meanwhile, pull your chest down toward your right leg so your forehead is touching your shin. **4.** Hold this pose for five seconds or longer.

One-Legged, Reverse-Squat Achilles Stretch Prep

Benefits: Increases flexibility in the calf and hamstrings while improving balance and strength in the core.

Steps: 1. Stand straight and shift your weight onto your left foot. **2.** Raise your right knee up to your chest and hold your right foot with your right hand. **3.** Slowly bend your left knee, lowering your torso toward the floor. Meanwhile, twist your torso to the right and extend your left hand to the floor. **4.** Hold this pose for five seconds or longer.

Yoga Stretch Prep

Target: Balance.

Benefits: Improves posture.

Steps: 1. Begin by stranding straight. Place your hands on your hips and keep your feet together. **2.** Focus on pulling in your torso and lengthening your spine. Take long and slow breaths.

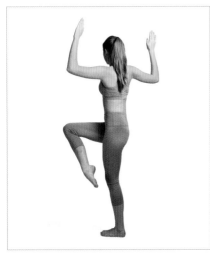

Pose Inspired by Shiva's Vigorous Cycle of Life Dance 2

Target: Balance.

Benefits: Provides strength and stamina in the balancing leg while twisting the spine and extending the shoulders.

Steps: 1. Begin by standing straight. Shift your weight onto your left foot. **2.** Lift your right foot from the floor and raise your knee to hip height. **3.** Raise and bend your arms so your elbows are at shoulder height and your forearms are parallel. Keeping your raised knee steady, twist your torso to the right. **4.** Hold this position for fifteen seconds before alternating sides.

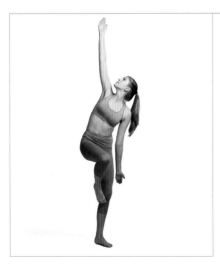

Pose Inspired by Shiva's Vigorous Cycle of Life Dance 3

Target: Balance.

Benefits: Provides strength and stamina in the balancing leg while twisting the spine and extending the shoulders.

Steps: 1. Begin by standing straight. Shift your weight onto your left foot. **2.** Lift your right foot from the floor and raise your knee to hip height. Tuck your right foot against your left thigh. **3.** Extend your right arm straight overhead and drop your left hand down to your side. Pull your shoulders down to the left side, extending your left hand lower to your side. **4.** Continue this stretch for fifteen seconds before alternating sides.

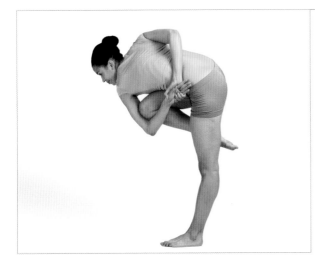

Revolved Half-Standing, Wind-Relieving Intense-Stretch Pose

Target: Balance.

Benefits: Provides strength and stamina in the balancing leg while twisting the spine and extending the shoulders.

Steps: 1. Begin by standing straight. Shift your weight onto your left foot. **2.** Lift your right foot from the floor and raise your knee to hip height. Tuck your right foot against your left thigh. **3.** Cross your left arm over your raised leg, hooking your elbow over your knee. Reach your left forearm back to your left side and reach your right arm across your back to join hands by your left hip. **4.** Bend your torso toward the floor. Maintain this stretch for fifteen seconds before alternating sides.

Revolved Half-Standing, Wind-Relieving Intense-Stretch Pose with Hands in Prayer

Target: Balance.

Benefits: Builds strength and balance while engaging the leg muscles.

Steps: 1. Stand straight, shifting your weight onto your left foot. Raise your right foot up from the floor, so your shin is parallel to the floor. **2.** Bend your left leg slightly and lean your torso forward. Twist slightly to your right to touch your left elbow to your raised right knee. Extend your right arm straight behind you. **3.** Hold this pose for fifteen seconds before releasing and repeating to the opposite side.

Revolved One Hand to Foot, Hand-Standing, Wind-Relieving Intense-Stretch Pose

Target: Balance.

Benefits: Builds strength and balance while engaging the leg muscles.

Steps: 1. Stand straight, shifting your weight onto your left foot. Bend your right knee, so your shin is parallel to the floor. **2.** Reach your right hand back to hold your right ankle, pulling it up gently. Bend your left leg slightly and drop your shoulders downward. Twist to the right to touch your left elbow to your right knee. **3.** Hold for fifteen seconds before releasing and repeating to the opposite side.

Standing Balance, One Leg

Target: Balance.

Benefits: Opens the chest and shoulders while improving strength and balance in the grounded leg.

Steps: 1. Begin by standing straight. Shift your weight onto your left foot. Raise your right foot up from the floor to rest behind your hip. **2.** Reach your right hand to grab hold of your right ankle from the inside. Keeping your hand and ankle together, extend your right leg out from your torso. Drop your shoulders down toward the floor for balance. **3.** Pull your head and shoulders up, in order to open your chest. Hold this pose for ten seconds or longer, before attempting on the opposite side.

Sundial Pose

Target: Balance.

Opens the chest and shoulders while improving strength and balance in the grounded leg.

Steps: 1. Begin by standing straight. Shift your weight onto your left foot. Raise your right knee up toward your chest. **2.** Reach your right hand to grab hold of your right ankle. Keeping your hand and ankle together, extend your right leg out to the side. **3.** Lean your torso toward the right. Extend your left hand overhead to grab your right toes. Hold this pose for ten seconds or longer, before attempting on the opposite side.

Tiptoe Core-Strengthening Pose

Target: Balance.

Benefits: Builds strength in the calves and hamstrings while improving core balance.

Steps: 1. Stand straight and raise both feet onto tiptoes. **2.** Remaining balanced on the balls of your feet, bend both knees slightly and lower your body down into a squat position. **3.** Extend your left arm in front of you, and your right arm behind you. Hold this pose for ten seconds at a time, before rising back up to the starting position and repeating.

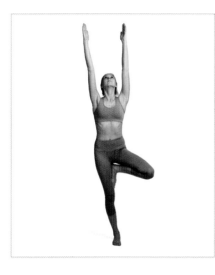

Tree Pose 1

Target: Balance.

Benefits: Stretches the thighs, groin, torso, and shoulders, building strength in the ankles and calves, and toning the abdominal muscles.

Steps: 1. Start by standing straight. Shift your weight onto your right foot. **2.** Bend your left knee, lifting your foot up off the floor. Reach down and clasp your left ankle and pull your foot alongside your inner right thigh. **3.** To find balance, adjust your position so the center of your pelvis is directly over your right foot. Adjust your hips so they are aligned. **4.** Once you have found your balance, raise both arms straight up toward the ceiling. Attempt to remain in this position for ten seconds or longer. **5.** Release and repeat, this time balancing on your left foot.

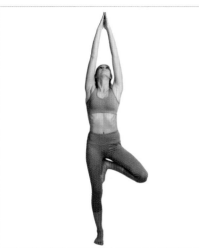

Tree Pose 2

Target: Balance.

Benefits: Stretches the thighs, groin, torso, and shoulders, building strength in the ankles and calves, and toning the abdominal muscles.

Steps: 1. Start by standing straight. Shift your weight onto your right foot. **2.** Bend your left knee, lifting your foot up off the floor. Reach down and clasp your left ankle and pull your foot alongside your inner right thigh. **3.** To find balance, adjust your position so the center of your pelvis is directly over your right foot. Adjust your hips so they are aligned. **4.** Once you have found your balance, raise both arms straight up toward the ceiling. Press your palms together in prayer position directly overhead. **5.** Attempt to remain in this position for ten seconds or longer. Release and repeat, this time balancing on your left foot.

Tree Pose Bound Forward Bend

Target: Balance.

Benefits: Opens the hips and groin, building strength and balance in the calves, hamstrings, and abdomen.

Steps: 1. Start by standing straight. Shift your weight onto your left foot and bend your right knee, lifting your leg behind you. **2.** Reach both hands to hold your right calf. Keeping your hands and leg together, extend your leg farther behind you. Meanwhile, bend your torso forward at the waist until your torso is parallel to the floor. **3.** Attempt to maintain this position for fifteen seconds before releasing and repeating on the opposite leg.

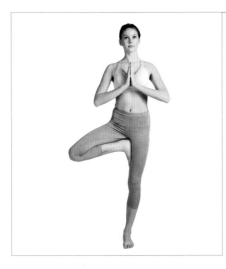

Tree Pose in Half-Lotus

Target: Balance.

Benefits: Opens the hips and groin, building strength and balance in the calves, hamstrings, and abdomen.

Steps: 1. Stand straight and shift your weight onto your left foot. **2.** Bend your right knee, lifting your foot off the floor. Reach down and clasp your right ankle and pull your foot into your inner left thigh. **3.** Bring your hands into prayer position at your chest. Attempt to remain in this balancing pose for fifteen seconds or more before releasing and repeating on the opposite leg.

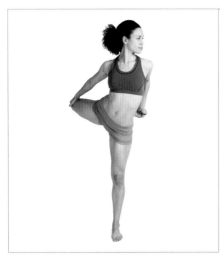

Tree Pose, Reverse Lotus I

Target: Balance.

Benefits: Stretches the thighs, groin, torso, and shoulders, building strength in the ankles and calves, and toning the abdominal muscles.

Steps: 1. Stand straight and shift your weight onto your left foot. Bend your right knee, raising your foot up behind you. **2.** With your right hand, reach behind you and grab hold of your right knee. Reach your left hand behind you and grab hold of your right foot. **3.** Gently pull your leg up with both hands. Drop your torso forward slightly for balance. **4.** Hold this pose for ten seconds before releasing. Repeat on the opposite leg.

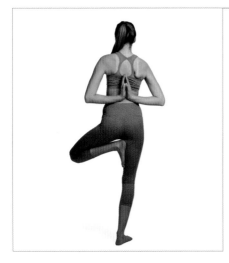

Tree Pose, Reverse Prayer

Target: Balance.

Benefits: Stretches the thighs, groin, torso, and shoulders, building strength in the ankles and calves, and toning the abdominal muscles.

Steps: 1. Stand straight and shift your weight onto your right foot. **2.** Bend your left knee, lifting your foot off the floor. Clasp your left ankle and pull your left foot into your inner right thigh. **3.** To find balance, adjust your position so the center of your pelvis is directly over your right foot. Adjust your hips so they are aligned. **4.** Once you have found your balance, raise both hands behind your back. Press your palms together with your fingers pointing upward, in reverse prayer position. **5.** Attempt to remain in this position for ten seconds or longer. Release and balance on the opposite leg.

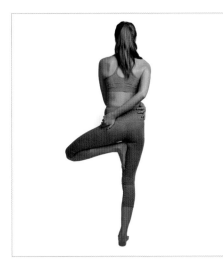

Tree Pose, Revolved Half-Bound

Target: Balance.

Benefits: Stretches the thighs, groin, torso, and shoulders, building strength in the ankles and calves, and toning the abdominal muscles.

Steps: 1. Stand straight and shift your weight onto your right foot. **2.** Bend your left knee, lifting your foot off the floor. Clasp your left ankle and pull your left foot into your inner right thigh. **3.** To find balance, adjust your position so the center of your pelvis is directly over your right foot. Adjust your hips so they are aligned. **4.** Once you have found your balance, reach your right hand across your back to your left hip. Reach your left hand in front of you to hold your opposite hip. **5.** Attempt to remain in this position for ten seconds or longer. Release and balance on the other leg.

Tree Pose, Revolved Lotus

Target: Balance.

Benefits: Opens the hips and groin, building strength and balance in the calves, hamstrings, and abdomen.

Steps: 1. Stand straight with good posture. Shift your weight onto your left foot. **2.** Bend your right knee up into your chest. Grab hold of your ankle with your left hand and pull your right foot up toward your left hip. **3.** Once balanced, twist your torso to the right and extend your right hand behind your back to hold your right toes. **4.** Release your left hand from your ankle and rest it on your knee. Attempt to hold this pose for ten seconds or longer. **5.** Release and balance on the opposite leg.

Tree Pose, Sideways

Target: Balance.

Benefits: Increases flexibility and range of motion along the spine while opening the hips and improving balance.

Steps: 1. Stand straight and shift your weight onto your left foot. **2.** Bend your right knee, lifting your foot off the floor. Clasp your inner ankle and pull your foot into your inner left thigh. **3.** Once balanced, extend your arms straight out to your sides. Lean your torso down to the right, so your left hand is extended up toward the ceiling. **4.** Hold this position for fifteen seconds. Release and balance on the opposite leg.

Tree Pose with Arms in Cow Pose

Target: Balance.

Benefits: Increases flexibility and range of motion along the spine while opening the hips and improving balance.

Steps: 1. Stand straight and shift your weight onto your right foot. **2.** Bend your left knee, lifting your foot off the floor. Clasp your left ankle and pull your left foot into your inner right thigh. **3.** Once balanced, extend your right elbow up above your head so your hand is resting on your upper back. Reach your left hand up your spine and join your hands together. **4.** Hold this position for fifteen seconds. Release and balance on the opposite leg.

Tree Pose with Garuda Arms

Target: Balance.

Benefits: Lengthens the muscles in the arms and wrists, builds strength in the calves and hamstrings, and improves core balance.

Steps: 1. Stand straight and shift your weight onto your left foot. **2.** Bend your right knee, lifting your foot off the floor. Clasp your right ankle and pull your right foot into your inner left thigh. **3.** Once balanced, bend your elbows in front of you, crossing your right elbow under the left and intertwining your hands. **4.** Hold this position for fifteen seconds. Release and balance on the opposite leg.

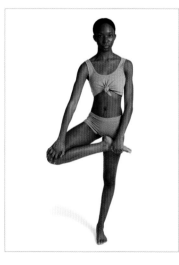

Tree Pose in Half-Lotus Variation

Target: Balance.

Benefits: Opens the hips and groin, building strength and balance in the calves, hamstrings, and abdomen.

Steps: 1. Stand straight and shift your weight onto your left foot. **2.** Raise your right knee out to your side. Reach down with your left hand and grab hold of your ankle. **3.** Gently pull up on your right leg, increasing the stretch on your hips. **4.** Attempt to remain in this balancing pose for fifteen seconds or more before releasing and repeating, this time balancing on your right foot.

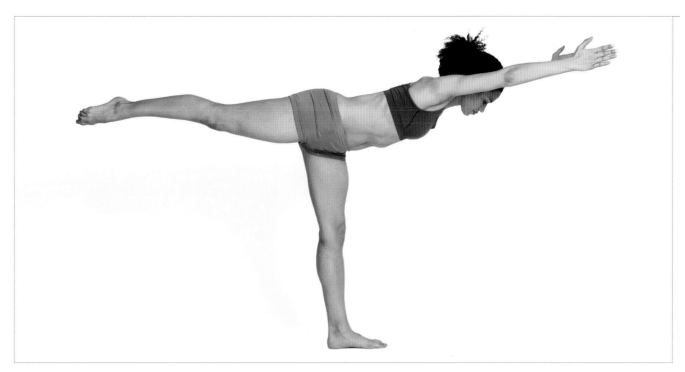

Warrior 3, Extended

Target: Balance.

Benefits: Lengthens the muscles along the spine while improving balance and strength in the legs.

Steps: 1. Stand straight and shift your weight onto your left foot. Bend your right knee and bring your right foot behind your hip. **2.** Carefully bend your torso forward at the waist. Extend your arms straight ahead of you. **3.** Continue the forward bend, until your arms and torso are parallel to the floor. Straighten your right leg in line with your torso. **4.** Hold this balancing position for fifteen seconds before releasing and alternating legs.

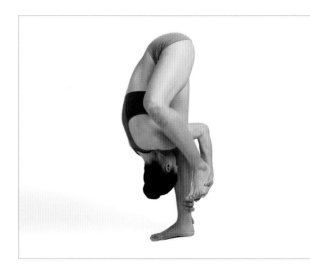

Yogic Staff Intense Stretch

Target: Balance.

Benefits: Deeply extends the hamstrings and spine, improving balance and muscle alignment.

Steps: 1. Stand straight with your hands on your hips. **2.** Exhale and bend forward from the hips, not from the waist. Focus on lengthening the front of the torso. **3.** With your knees straight, bring your palms to the backs of your ankles. Shift your balance onto your right foot. **4.** Carefully raise your left foot from the floor, sliding your left hand under the sole of your foot. **5.** Attempt to hold this position for five seconds or longer. Release and repeat, this time balancing on the opposite leg.

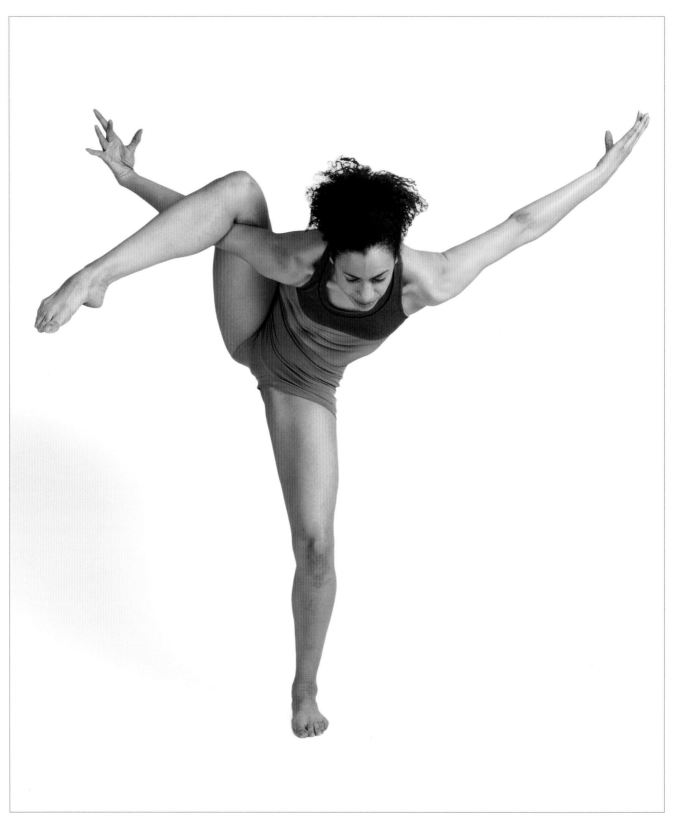

Bowing with Respect Bird of Paradise

Target: Balance.

Benefits: Incorporates hip opening, core and back strengthening, and hamstring lengthening.

Steps: 1. Stand upright with your feet apart. Raise your right knee up to your chest. **2.** Reach your right hand under your right thigh and behind your hips. Extend your left arm straight out to your side. **3.** Find your balance and carefully lift your arms and chest up toward the ceiling. **4.** Attempt to stay in this pose for ten seconds at a time, before releasing and switching legs.

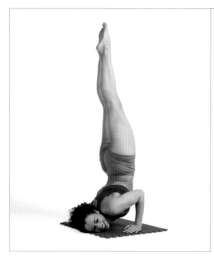

Chest on Floor

Target: Chest opener.

Benefits: An intense backbend and chest opener, which extends the back, chest, hips, and shoulders.

Steps: 1. Begin on all fours with your palms directly below your shoulders. Lower your chest and right side of your head onto the floor, keeping your hips raised. **2.** Put your palms flat on the floor. Arch your lower back and tuck your toes under you, so both feet are raised up from the floor. **3.** Lift your left foot up from the floor and straighten your leg up toward the ceiling. Pushing against your propped right toes, lift your knee off the floor and straighten your leg. **4.** Engage your core and shoulders and propel your right foot up from the floor, so both legs are extended up from your hips toward the ceiling. **5.** Attempt to hold this pose for five seconds or more before lowering one foot at a time back to the floor.

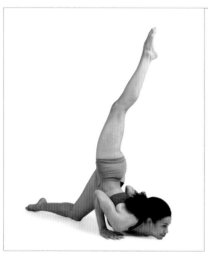

Chest on Floor, Chin on Floor

Target: Chest opener.

Benefits: An intense backbend and chest opener, which extends the back, chest, hips, and shoulders.

Steps: 1. Begin on all fours with your palms directly below your shoulders. Lower your chest and chin down onto the floor, keeping your hips raised. **2.** Your palms should be flat on the floor and your elbows raised at your sides. Arch your lower back and tuck your toes under you, so both feet are raised from the floor. **3.** Lift your right foot up from the floor and straighten your leg up toward the ceiling. **4.** Hold this pose for fifteen seconds at a time, before returning your foot to the floor and repeating with the opposite leg. **5.** Repeat this exercise to build strength and flexibility in preparation for a shoulder-stand stretch.

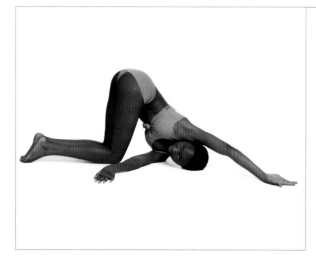

Child's Pose, Revolved Side

Target: Chest opener.

Benefits: Twists the spine and opens the muscles across the chest and shoulders.

Steps: 1. Begin on all fours with your palms flat on the floor directly below your shoulders. **2.** Lift your left hand from the floor and extend your arm beneath your chest toward your right side. Twist your torso to the right and drop your left shoulder to the floor. Straighten your right arm overhead, rolling it over so your palm is facing up. **3.** Hold this pose for fifteen seconds. Release and repeat on the opposite side.

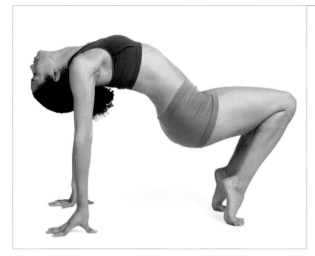

Eastern Intense-Stretch Pose, Leaning Back

Target: Chest opener.

Benefits: Strengthens the arms, legs, and core while extending the spine, chest, and neck.

Steps: 1. Begin seated with your knees bent and your feet flat on the floor. Place your hands on the floor behind your hips with your fingers pointing behind you. **2.** Drop your head back and press against your hands and feet to raise your hips up from the floor. **3.** Continue to lift your hips, raising your feet onto tiptoes and your hands onto your fingertips. Let your head drop farther back. **4.** Hold this pose for fifteen seconds before releasing.

Half Intense-Stretch Pose, Twist Revolved, Uneven Legs

Target: Chest opener.

Benefits: Strengthens the legs and core while extending the chest and shoulders.

Steps: 1. Stand straight with your fingertips against your lower back. Rise onto tiptoes. **2.** Bend both knees and lower your hips toward the floor. **3.** Extend your left arm across your chest toward the right side. Twist your torso to the right, resting your left shoulder against your left knee. **4.** Hold this pose for fifteen seconds. Rise back up to the starting position and repeat on the opposite side.

Half-Lotus Backbend, Hand to Foot

Target: Chest opener.

Benefits: Strengthens the upper arms and chest while extending the hips, shins, and quadriceps.

Steps: 1. Begin on all fours with your palms directly below your shoulders. Slide your left foot in front of your right knee. **2.** Reach your right hand behind to grab hold of your right foot, pulling it in gently toward your hip. Press your hips down toward the floor, keeping your hand on your foot. **3.** Remain in this stretching pose for twenty seconds before releasing and alternating sides.

Half-Lotus, Half Eastern-Intense Stretch

Target: Pelvis, hips, and upper back

Benefits: Deeply stretches and opens the hips and upper back.

Steps: 1. Sit with legs extended. Bend your left knee and place your left foot on your right inner thigh. **2.** Place your hands on the floor and lift your hips. **3.** Slide your right leg up, bend the knee, and rise up on tiptoe. **4.** Slowly lower your left elbow down to the floor under your left shoulder. Then place the right elbow on the floor under your right shoulder. **5.** Rest your hands on your lower back and drop your head backward. Press your hips upward. Hold for fifteen seconds and repeat on the opposite side.

Partridge Pose

Target: Chest opener.

Benefits: Deeply opens the chest and shoulders while engaging the core.

Steps: 1. Begin on all fours with your palms directly below your shoulders. **2.** Lift your right knee from the floor and raise it to hip level. Reach around with your right hand and grab hold of your right foot. **3.** Twist your torso out to the right. Keeping your hand and foot together, carefully push your foot out from your hips. **4.** Hold this pose for fifteen seconds. Release and repeat on the opposite side.

Partridge Pose, Advanced

Target: Chest opener.

Benefits: Deeply opens the chest and shoulders while engaging the core.

Steps: 1. Begin on all fours with your palms directly below your shoulders. One at a time, step your feet out so your legs are straight and you are raised up on your toes in a plank position. **2.** Lift your right foot from the floor and bring it to your hips. Reach around with your right hand and grab hold of your right foot. **3.** Twist your torso out to the right. Keeping your hand and foot together, carefully push your foot out from your hips. **4.** Hold this pose for fifteen seconds. Release and repeat to the opposite side.

Son of Anjani Front, Both Hands to Foot, Head Back

Target: Chest opener.

Benefits: Opens the chest and shoulders and lengthens the leg muscles.

Steps: 1. Start with your hands and feet on the floor and your hips pointed upward, in an downward dog position. **2.** Step your right foot forward between your palms. Lower your left knee to the floor, lifting your foot to rest on its top. **3.** Lift up your palms and press your hips lower to the floor. **4.** Drop your head back and pull your shoulders into a backbend. Arch your chest, and reach for your left ankle with both hands. **5.** Hold for ten seconds and repeat on the opposite side.

Unsupported Bound, One-Foot Intense Stretch

Target: Chest opener.

Benefits: Lengthens the muscles along the spine while improving balance and strength in the legs.

Steps: 1. Stand straight. Lift your left foot up from the floor and bring it up to your hips. **2.** Reach both hands behind you to grab hold of your foot and pull it into your hips. **3.** Carefully bend your torso forward at the waist, keeping your hands and foot together. Lower the top of your head down toward the floor and press your forehead to your left shin. **4.** Hold this balancing position for twenty seconds before releasing and alternating legs.

Upward-Facing Dog, One Leg

Target: Chest opener.

Benefits: Deeply opens the chest and shoulders while engaging the core.

Steps: 1. Begin on all fours, with your palms directly below your shoulders. **2.** One at a time, step out your feet so your legs are straight and you are raised on your toes in a plank position. **3.** Lift your right foot from the floor and rest it on your left shin. Pull your head and shoulders back to open your chest. **4.** Hold this pose for fifteen seconds. Release and repeat on the opposite foot.

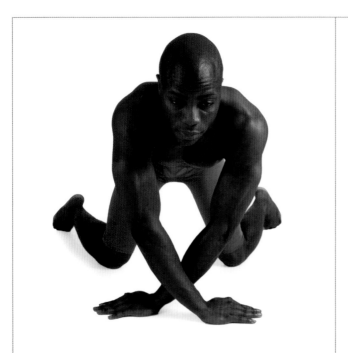
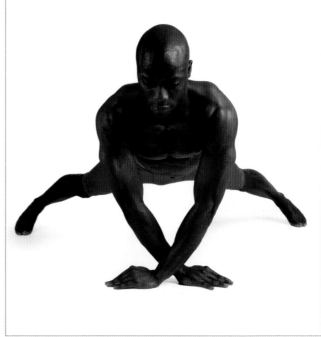

Extended Four-Limbs Staff Pose, Arms Crossed

Target: Core.

Benefits: Strengthens the muscles in the arms, hands, legs, and abdomen.

Steps: 1. Begin on all fours, with your arms crossed under your chest and your palms placed beneath alternate shoulders. **2.** Lift both feet onto their toes and step your feet apart. **3.** Using your hands and forearms, lift your knees from the floor. Make sure to create a straight line from your heels to your shoulders. **4.** Hold this pose for twenty seconds or longer.

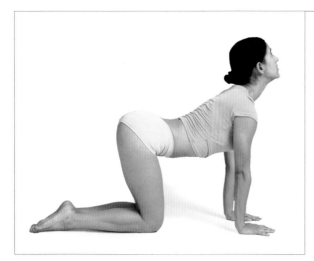

Upward-Facing Dog Pose

Target: Spine.

Benefits: Opens the chest and shoulders while extending the spinal core.

Steps: 1. Begin kneeling upright on the floor. Lower your hands to the floor so your palms are face-down and directly below your shoulders. **2.** Pull your head and shoulders up to open your chest. **3.** Hold this pose for ten seconds before releasing.

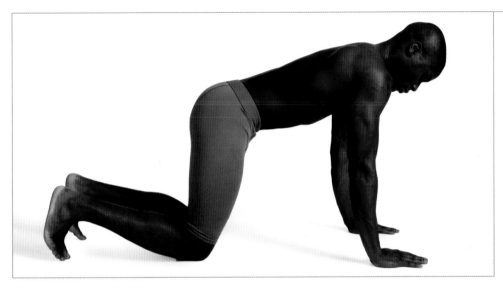

Extended Four-Limbs Staff Pose Prep

Target: Core.

Benefits: Strengthens the muscles in the arms, hands, legs, and abdomen.

Steps: 1. Begin on all fours with your palms placed beneath your shoulders. **2.** Lift both feet onto your toes and step your feet away from you. **3.** Using your hands and forearms, lift your knees from the floor. Make sure to create a straight line from your heels to your shoulders. **4.** Hold this pose for twenty seconds or longer.

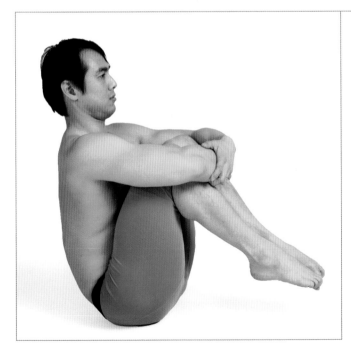

Easy Boat Pose

Target: Spine.

Benefits: Engages the muscles in the glutes and abdominals.

Steps: 1. Begin seated on the floor with your knees bent into your chest and your feet flat on the floor in front of your hips. **2.** Hug both arms around your knees, and pull them in gently to your chest. Roll backward onto your hip bones, lifting your feet up off the floor. **3.** Hold this pose for fifteen seconds.

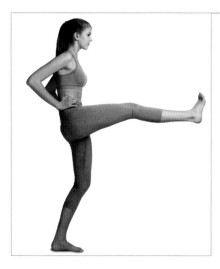

Extended One-Foot Pose

Target: Glutes.

Benefits: Strengthens and tones the glutes.

Steps: 1. Begin by standing straight, with your hands on your hips. **2.** Raise your right foot from the floor and lift your leg so it is parallel to the floor. Try to keep your leg straight during this stretch. **3.** Hold for ten seconds and return your foot to the floor. **4.** Repeat this exercise ten times on each leg.

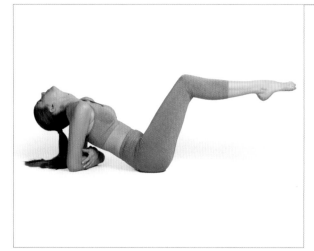

Hands-Bound, Easy Intense-Leg Stretch

Target: Glutes.

Benefits: Strengthens the glutes and upper legs while extending the neck and chest.

Steps: 1. Begin seated on the floor. Lean backward, slowly dropping both elbows onto the floor behind you. Reach your hands across to hold the opposite forearm. **2.** Lift both feet from the floor and raise them until your calves are parallel to the floor. Drop your head and shoulders back, opening your chest. **3.** Hold this pose for thirty seconds.

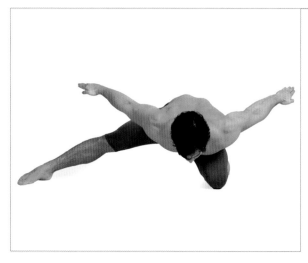

Half-Hero, Half-Extended, Hand-to-Foot Pose, Reclined Variation

Target: Hamstrings.

Benefits: Extends the hamstrings while opening the hips and spine.

Steps: 1. Begin by kneeling upright. Swing your right foot around and straighten your leg out to your side. Lower your hips down onto your left heel. **2.** Drop your chest down toward the floor, extending both arms straight out to the sides. Bring your forehead toward the floor. **3.** Hold this pose for fifteen seconds. Release and repeat with your left leg extended.

One Hand, Both Feet Behind Head

Target: Stretches the full body, especially the hamstrings, hips, and lower back.

Benefits: Gives intense range and flexibility to the back and legs.

Steps: 1. Lie on your back. Weave your right foot under your right shoulder and toward the back of your head. Deeply bend your right knee so that it rests on the floor. **2.** Use your arms and hands to slide your left leg up past your left shoulder. **3.** Wrap your left arm over your left leg and touch your right foot. **4.** Once both of your legs are in position, breathe deep for ten seconds and repeat on the opposite side.

One Hand, Both Feet Behind Head Prep

Target: Stretches the hamstrings, hips, and lower back.

Benefits: Gives intense range and flexibility to the back and legs.

Steps: 1. Lie on your back. Extend your right foot over your right shoulder and toward the floor. **2.** Use your arms and hands to slide your left leg up under your left shoulder and along your left side. **3.** Hold your left foot with your left hand and wrap your right hand around your right ankle. **4.** Once both of your legs are in position, breathe deep for ten seconds and repeat on the opposite side.

One Hand, Half-Bound, Half-Standing, Wind-Relieving Intense Stretch

Target: Hamstrings.

Benefits: Increases flexibility and range of motion along the spine.

Steps: 1. Stand straight and shift your weight onto your right foot. Raise your left foot up behind your left hip. **2.** Lean your torso forward, bending at the waist. Extend your right palm to floor and reach your left hand across your back to touch your right hip. **3.** Hold this pose for twenty seconds before releasing. Repeat the exercise, this time balancing on the opposite leg.

Western Intense Half-Bound Lotus-Stretch Pose Prep

Target: Hamstrings.

Benefits: Lengthens the muscles in the hips and hamstrings while extending the side.

Steps: 1. Begin seated with both legs extended straight. Bend your right knee, and raise your foot up into your left hip so the sole of your foot is facing upward. **2.** Reach your right hand across your back and try to touch your right toes. Extend your left arm straight up into the air. **3.** Keeping your left hand and foot bound, pull along the right side of your torso. **4.** Maintain this stretch for thirty seconds before releasing and alternating sides.

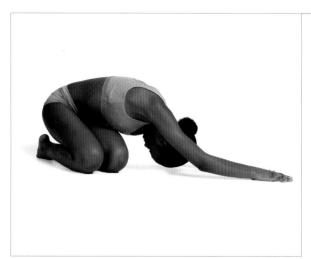

Child's Pose, Hands to Side

Target: Lats.

Benefits: Extends the spinal column and obliques, targeting the lats.

Steps: 1. Begin by kneeling with your hips on your heels. **2.** Twist your torso slightly to your left and lean forward. Extend your hands on the floor over your head. **3.** Lower your forehead to the floor. Hold this pose for fifteen seconds. **4.** Alternate sides and repeat the stretch.

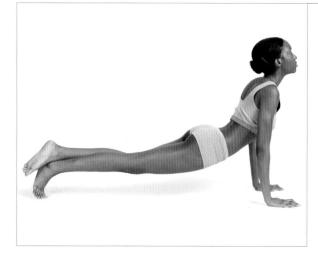

Upward-Facing Dog, One-Leg Variation

Target: Chest opener.

Benefits: Deeply opens the chest and shoulders while engaging the core.

Steps: 1. Begin on all fours with your palms directly below your shoulders. **2.** One at a time, step your feet out so your legs are straight and you are raised up on your toes in a plank position. **3.** Lift your left foot from the floor and rest it on your right ankle. Pull your head and shoulders back to open your chest fully. **4.** Hold this pose for fifteen seconds. Release and repeat on the opposite foot.

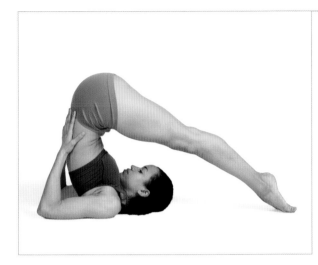

Plow Pose Prep

Target: Lower back.

Benefits: Stretches the shoulders, hamstrings, and lower back while improving flexibility along the spine.

Steps: 1. Begin by lying flat on your back. Inhale and activate your core. Raise your feet from the floor so your calves legs are parallel to the floor. **2.** Press your hands against your lower back for support and continue to lift your feet up, hinging at the hips. Swing your feet overhead and down onto the floor directly overhead. **3.** Once grounded, press your toes firmly into the floor beyond your head and press up your heels. Lift your thighs and tail bone toward the sky and create space between your chin and chest. Hold for thirty seconds.

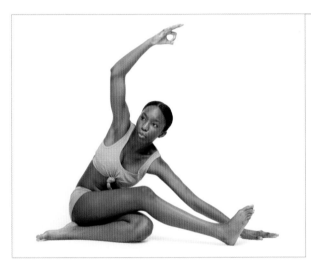

Western Intense-Stretch Pose, Sideways

Target: Obliques.

Benefits: Lengthens the hip flexors while extending the obliques and lats.

Steps: 1. Begin seated on the floor with both legs out straight. Raise your right knee slightly and tuck your left leg under your right thigh. **2.** Twist your torso to the right and extend your left hand out to your right foot. Extend your right arm over your head. Lean your torso down toward your left foot. **3.** Hold this position for fifteen seconds before releasing and switching sides.

Plow Pose

Target: Lower back.

Benefits: Stretches the shoulders, hamstrings, and lower back.

Steps: 1. Begin by lying flat on your back. Inhale and activate your core. Raise your feet from the floor so your calves legs are parallel to the floor. **2.** Press your hands against your lower back for support and continue to lift your feet up, hinging at the hips. Swing your feet overhead and down onto the floor directly overhead. **3.** Once grounded, press your toes firmly into the floor beyond your head and press up your heels. Lift your thighs and tail bone toward the sky and create space between your chin and chest. **4.** Lower your arms flat on the floor. Hold for thirty seconds.

Half-Bound Lotus Cow Pose on Head

Target: Upper back.

Benefits: Lengthens the muscles in the hip flexors and along the spinal column and neck.

Steps: 1. Begin on all fours with your palms directly below your shoulders. Raise your left knee from the floor, cross it over your right leg, and place it onto the floor on the outside of your right calf. **2.** Lower the top of your head to the floor. Lift both palms up from the floor and press them together pointing up your spine in a reverse prayer position. **3.** Hold this position for ten seconds. Release and repeat, alternating sides.

Easy Pose

Target: Spine.

Benefits: Increases focus and muscle awareness.

Steps: 1. Begin seated on the floor. Bend both knees up toward your chest, crossing your ankles. **2.** Reach both hands up and place them over your eyes. Lengthen your spine and become aware of your posture. **3.** Slowly bring your attention to the various muscles in your body, moving from head to toe. Attempt to release each muscle to a neutral state, one at a time.

Half-Lotus, Tiptoe-Pose Arm Twist

Target: Abductors.

Benefits: Opens the hips and engages the hip abductors and shoulder muscles.

Steps: 1. Begin by kneeling upright on the floor. Raise your feet up onto your toes. Lower your hips to rest on your raised heels. **2.** Raise your left foot from the floor and swing your leg in front of you. Use your hands to pull your left foot up into your right hip, so the sole of your left foot is facing up and your knee is resting on the floor. **3.** One balanced, raise your hands up in front of your chest. Wrap your forearms and press your palms together. **4.** Hold this pose for ten seconds or more. Release and alternate sides.

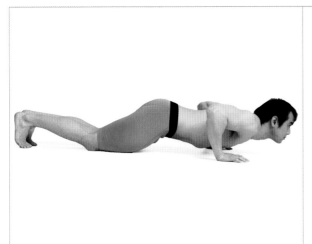

Staff Pose, Four-Limbed

Target: Core.

Benefits: Strengthens the muscles in the arms, hands, legs, and abdomen.

Steps: 1. Begin by lying on your stomach with your palms directly beneath your shoulders. Lift both feet onto your toes so your heels are raised. **2.** Pressing against your palms, slowly raise your chest and shoulders from the floor. Your hips and elbows should remain elevated. **3.** Hold this pose for twenty seconds or longer.

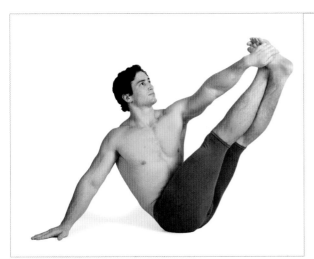

Boat Pose, Supported

Target: Obliques.

Benefits: Engages the core and abdominal muscles while extending the hamstrings and obliques.

Steps: 1. Begin seated on the floor. Extend both legs up straight, crossing the right foot over the left. **2.** Grab the inside of your left foot with your left hand and twist your torso to the right. Rest your right hand on the floor behind you for support. **3.** Extend your spine and find your balance. **4.** Attempt to hold this pose for ten seconds. Release and repeat to the opposite side.

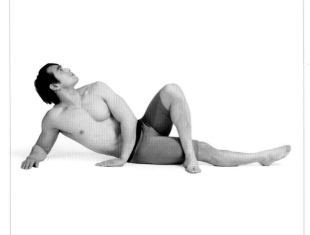

Infinity Pose

Target: Obliques.

Benefits: Provides mild relief from tight oblique and hip muscles.

Steps: 1. Begin by lying on your right side, with your torso propped up on your right forearm. **2.** Bend your left knee and bring your foot flat on the floor in front of your right thigh. **3.** Pull along the length of your spine. Remain in the pose for fifteen seconds before switching sides and repeating.

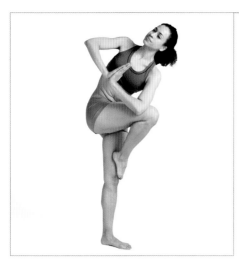

One-Leg Standing Balance, Variation

Target: Obliques.

Benefits: Increases flexibility and range of motion along the spine and in the obliques while opening the hips and improving balance.

Steps: 1. Begin by standing straight. Shift your weight onto your left foot. **2.** Lift your right foot from the floor and rest it against your left thigh. Find your balance and join your hands together in prayer position ahead of your chest. **3.** Twist your torso to the right and, at the same time, lean slightly downward to touch your left elbow to your right knee. **4.** Hold for ten seconds and release. Repeat on the opposite side.

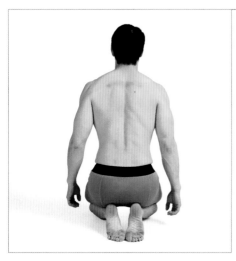

Hero Pose

Target: Quadriceps.

Benefits: 1. Begin by kneeling upright with your shins flat on the floor. **2.** Lower your hips down onto your heels. **3.** Slowly roll backward, raising your knees up slightly from the floor. You should feel the stretch in your shins. **4.** Hold this pose for twenty seconds.

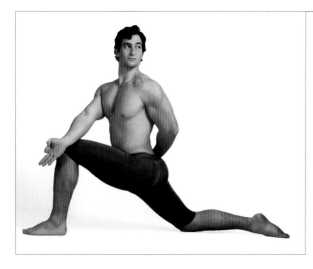

Tiptoe One-Legged King Pigeon Pose 2 Prep

Target: Quadriceps.

Benefits: Opens the hips and extends the quadriceps while twisting the spine.

Steps: 1. Begin by kneeling upright on the floor. Raise your left knee from the floor and place your left foot flat on the floor ahead of you, so your leg forms a 90-degree angle. **2.** Gently lean your hips forward, straightening your right leg slightly. Reach your left arm behind your back, and twist your torso to the left. **3.** Hook your right hand on the outside of your left knee. Feel the pull along the length of your spine. **4.** Hold for fifteen seconds and release. Repeat on the opposite side.

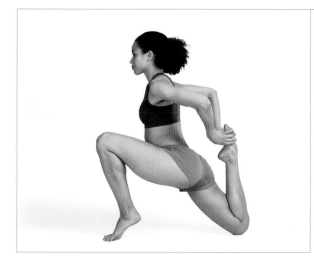

Tiptoe One-Legged Pigeon Pose

Target: Quadriceps.

Benefits: Lengthens the quad and shin muscles while opening the hips.

Steps: 1. Begin by kneeling upright. Bring your left knee up from the floor and place your foot flat on the floor ahead of you, so your left leg forms a 90-degree angle. **2.** Lift your right foot up from the floor toward your hips, and reach around to grab it with both hands. Gently pull your foot farther in toward you. **3.** Raise your left foot up onto tiptoes and lean your torso toward. Hold this position for twenty seconds before releasing and switching sides.

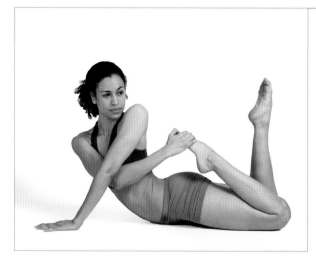

Sage Gheranda Pose

Target: Shins.

Benefits: Extends the spinal column and obliques while increasing flexibility in the lower legs.

Steps: 1. Begin by lying on your stomach with your palms flat on the floor beside your shoulders. **2.** Pressing against your palms, lift your chest up from the floor and straighten both arms. Bend both knees and bring your feet in toward your hips. **3.** Lift your right hand from the floor and reach under your left arm and behind to your left hip. Then, grab hold of your left foot with your right hand. **4.** Keeping your hand and foot together, pull along the length of your spine. Maintain this stretch for fifteen seconds. **5.** Release and repeat, this time twisting to the opposite side.

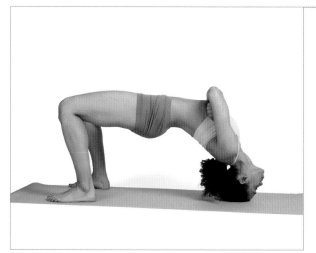

Sage Vameda Pose

Target: Legs and hips.

Benefits: Create a deeper stretch in the hamstrings, quadriceps, and more openness in the front of the hips.

Steps: 1. Lie on the floor with knees bent and fee flat on the floor hip-width apart. **2.** Cross your arms at your chest. Keeping your head on the floor, raise your hips and shoulders upward until your torso is parallel to the floor. **3.** Hold for twenty seconds.

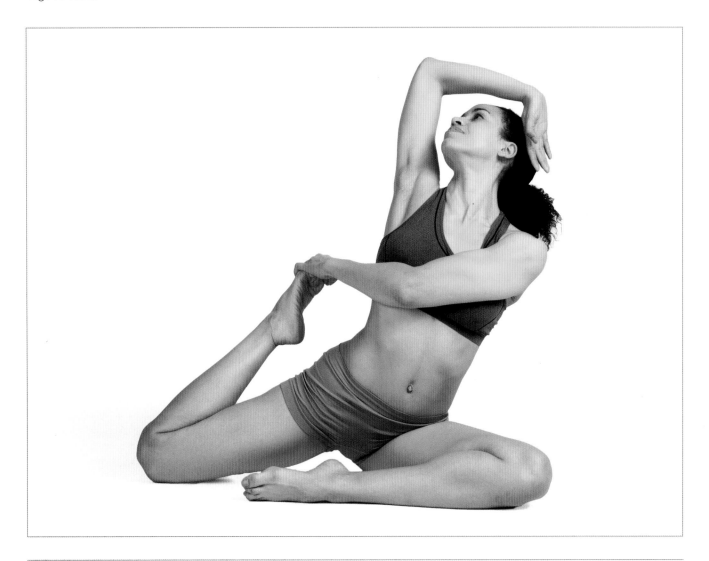

Sage Vameda Pose Bound

Target: Legs.

Benefits: Deeply stretches the hamstrings and opens the front of the hips.

Steps: 1. From the downward dog position, bring the left leg down to the floor, bending the knee in at a 90-degree angle. **2.** Extend the right leg along the floor behind you and bend your right foot into your right hip. **3.** Reach your left hand across your chest to rest on top of the right foot, gently pushing the right heel deeper into the hip. **4.** Look up and drape your right arm overhead, resting the forearm on top of your head. **5.** Hold for twenty seconds and repeat on the opposite side.

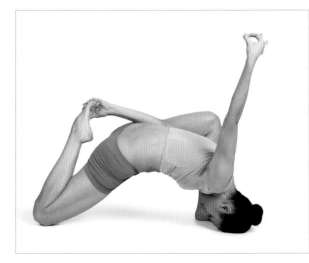

Triangle Pose, Reverse

Target: Upper back.

Benefits: Lengthens the muscles in the hip flexors and along the spinal column and neck.

Steps: 1. Begin on all fours with your palms directly below your shoulders. Step your left foot far forward. **2.** Lean your torso forward and rest the top of your head on the floor. **3.** Lift your right foot off the floor and bring it in toward the back of your hip. Reach your left hand behind you and grab your right toes, pulling your foot farther into your hip. **4.** Find your balance and raise your right hand off the floor and extend it toward the ceiling. Hold this position for ten seconds. Release and repeat, alternating sides.

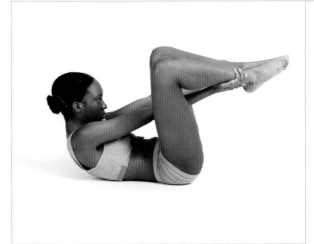

The Saw

Target: Shoulders.

Benefits: Strengthens and extends the muscles in the neck and shoulders while engaging the abdomen.

Steps: 1. Begin by lying on your back, with both knees bent. Raise your feet up from the floor so that your lower legs are parallel to the floor. **2.** Engage your abdomen and lift your head and shoulders up from the floor. Keeping your shoulders raised, reach both hands in between your thighs and grab hold of your ankles. **3.** Pull along the length of your spine. Remain in this pose for ten seconds at a time.

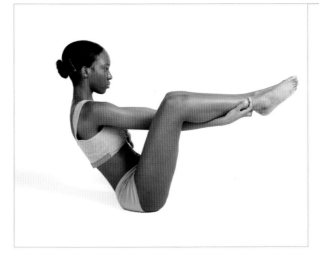

The Seal

Target: Shoulders.

Benefits: Strengthens and extends the muscles in the upper back and shoulders while engaging the abdomen.

Steps: 1. Begin by sitting, with both knees bent. Raise your feet up from the floor so that your lower legs are parallel to the floor. **2.** Engage your abdomen and lift your hands up from the floor. Reach both hands in between your thighs and grab hold of your ankles. **3.** Pull along the length of your spine and keep your shoulders from curling forward. Remain in this pose for ten seconds at a time.

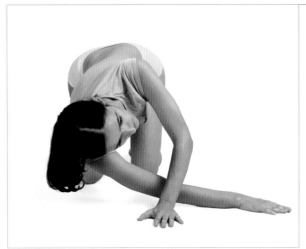

Thread the Needle Pose

Target: Shoulders.

Benefits: Twists the spine and extends the chest and shoulders.

Steps: 1. Begin kneeling on all fours with your palms directly below your shoulders. **2.** Slide your right arm behind your left arm and out to the left. Drop your right shoulder down toward the floor behind your left palm. **3.** Hold this pose for ten seconds before returning to the starting position. Repeat the exercise to the right.

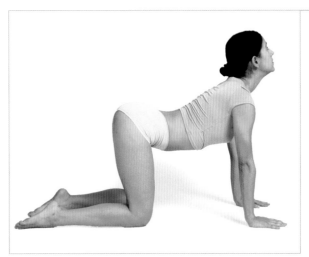

Cow Pose 1

Target: Spine.

Benefits: Extends the muscles along the spinal cord, opening the chest and shoulders.

Steps: 1. Begin on all fours with your palms flat on the floor directly below your shoulders. **2.** Pull your stomach down toward the floor, deeply arching your chest. Pull your head and shoulders up toward the ceiling. **3.** Hold this pose for fifteen seconds.

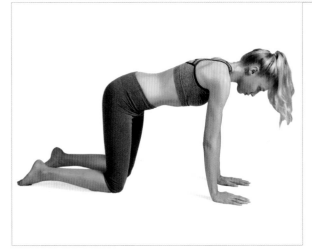

Cow Pose 2

Target: Spine.

Benefits: Extends the muscles along the spinal cord and shoulders.

Steps: 1. Begin on all fours with your palms flat on the floor directly below your shoulders. **2.** Pull your center-point of your spine up toward the ceiling, deeply arching your back. Drop your head and shoulders down toward the floor. **3.** Hold this pose for fifteen seconds.

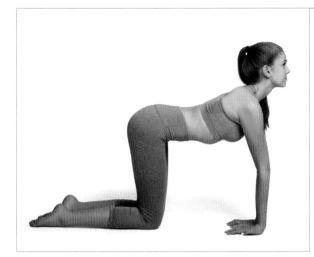

Cow Pose, Intense Wrist Stretch

Target: Spine.

Benefits: Extends the muscles along the spinal cord and in the wrists, opening the chest and shoulders.

Steps: 1. Begin on all fours with your palms flat on the floor directly below your shoulders. **2.** One at a time, rotate your hands so your fingers are pointing directly toward your knees. Your palms should still be flat on the floor and directly below your shoulders. Pull your head and shoulders up toward the ceiling. **3.** Hold this pose for fifteen seconds.

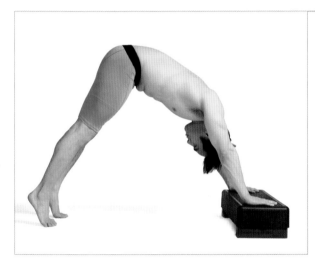

Downward Dog, Block Assisted

Target: Spine.

Benefits: Lengthens the neck, spine and hamstrings while strengthening the upper arms and shoulders.

Steps: 1. Begin on all fours with your palms resting on the block, directly below your shoulders. Step both feet up onto your toes so your heels are raised up from the floor. **2.** Brace your hands and shoulders to hold your weight, and push your hips up into the air in a downward dog pose. **3.** Step one foot out at a time, until both legs are straight and both feet are level. **4.** Hold this pose for thirty seconds before stepping one foot at a time back down to the floor.

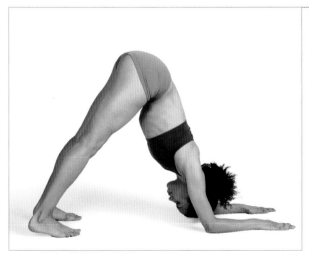

Downward Dog, Elbow

Target: Spine.

Benefits: Lengthens the neck, spine and hamstrings while strengthening the upper arms and shoulders.

Steps: 1. Begin on all fours with your palms resting on the block, directly below your shoulders. Step both feet up onto your toes so your heels are raised up from the floor. **2.** One at a time, lower from your palms onto your elbows so both forearms are flat on the floor ahead of you. Brace your upper arms to hold your weight, and push your hips up into the air in a downward dog pose. **3.** Step one foot out at a time, until both legs are straight and both feet are level with your heels touching the floor. **4.** Hold this pose for thirty seconds before stepping one foot at a time back down to the floor.

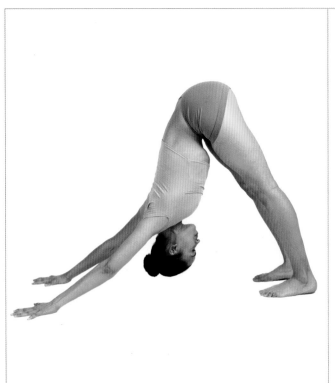

Downward Dog, Extended Variation

Target: Spine.

Benefits: Lengthens the neck, spine and hamstrings while strengthening the upper arms and shoulders.

Steps: 1. Begin on all fours with your palms directly below your shoulders. Step both feet up onto your toes so your heels are raised up from the floor. **2.** Brace your hands and shoulders to hold your weight, and push your hips up into the air in a downward dog pose. **3.** Step one foot out at a time away, until both legs are straight and both feet are level with your heels touching the floor. Then, drop your head and down and in toward your legs, targeting your shoulder muscles. **4.** Hold this pose for thirty seconds before stepping one foot at a time back down to the floor.

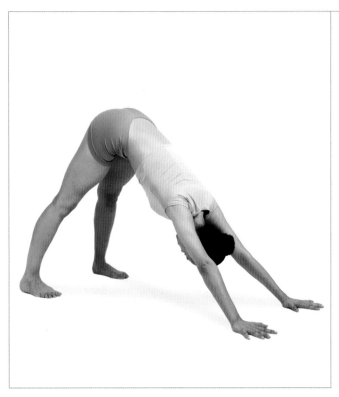

Downward Dog, Feet-Spread Variation

Target: Spine.

Benefits: Lengthens the neck, spine and hamstrings while strengthening the upper arms and shoulders.

Steps: 1. Begin on all fours with your palms directly below your shoulders. Step both feet up onto your toes so your heels are raised up from the floor. **2.** Brace your hands and shoulders to hold your weight, and push your hips up into the air in a downward dog pose. **3.** Step one foot out at a time, so both legs are straight and your feet are apart. Then, drop your head and shoulders down to complete the stretch. **4.** Hold this pose for thirty seconds before stepping one foot at a time back down to the floor.

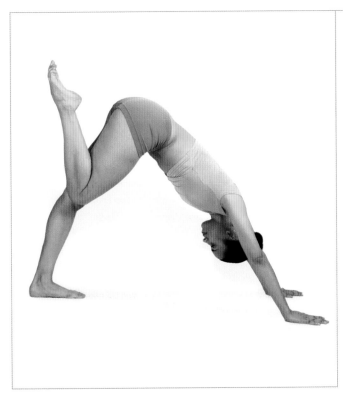

Downward Dog, One Leg Bent

Target: Spine.

Benefits: Lengthens the neck, spine and hamstrings while strengthening the upper arms and shoulders.

Steps: 1. Begin on all fours with your palms directly below your shoulders. Step both feet up onto your toes so your heels are raised up from the floor. **2.** Brace your hands and shoulders to hold your weight, and push your hips up into the air in a downward dog pose. **3.** Step one foot out at a time, so both legs are straight and your feet are even with your heels touching the floor. Then, drop your head and shoulders down. **4.** Raise your right foot up from the floor, keeping your upper leg parallel to your left but pointing your foot up toward the ceiling. Hold this pose for thirty seconds before stepping your foot down and repeating with your left foot raised.

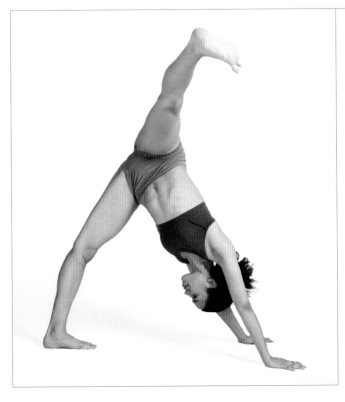

Downward Dog, One Leg Flex

Target: Spine.

Benefits: Lengthens the neck, spine and hamstrings while strengthening the upper arms and shoulders.

Steps: 1. Begin on all fours with your palms directly below your shoulders. Step both feet up onto your toes so your heels are raised up from the floor. **2.** Brace your hands and shoulders to hold your weight, and push your hips up into the air in a downward dog pose. **3.** Step one foot out at a time, so both legs are straight and your feet are even with your heels touching the floor. Then, drop your head and shoulders down. **4.** Raise your right foot up from the floor, and extend your leg straight out to your side. Hold this pose for ten seconds before stepping your foot down and repeating with your left leg raised.

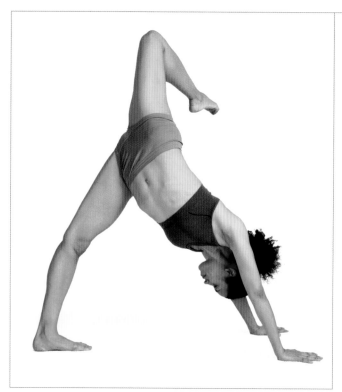

Downward Dog, One Leg to Side Stretched Over

Target: Spine.

Benefits: Lengthens the neck, spine, and hamstrings while strengthening the upper arms and shoulders.

Steps: 1. Begin on all fours, with your palms directly below your shoulders. Step both feet up onto your toes so your heels are raised up from the floor. **2.** Brace your hands and shoulders to hold your weight, and push your hips up into the air in a downward dog pose. **3.** Step one foot out at a time, so both legs are straight and your feet are even with your heels touching the floor Then, drop your head and shoulders down. **4.** Raise your right foot up from the floor, and extend your leg up above your hips. Your knee should be raised directly above your hips and your foot should extend down to your left side. **5.** Hold this pose for ten seconds before stepping your foot back down and repeating with your left foot raised.

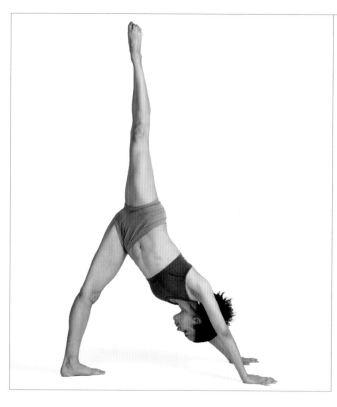

Downward Dog, One-Leg Variation

Target: Spine.

Benefits: Lengthens the neck, spine, and hamstrings while strengthening the upper arms and shoulders.

Steps: 1. Begin on all fours, with your palms directly below your shoulders. Step both feet up onto your toes so your heels are raised up from the floor. **2.** Brace your hands and shoulders to hold your weight, and push your hips up into the air in a downward dog pose. **3.** Step one foot out at a time, so both legs are straight and your feet are even with your heels touching the floor. Then, drop your head and shoulders down to complete the stretch. **4.** Raise your right foot up from the floor, and extend your leg straight toward the ceiling. Hold this pose for ten seconds before stepping your foot down and repeating with your left leg raised.

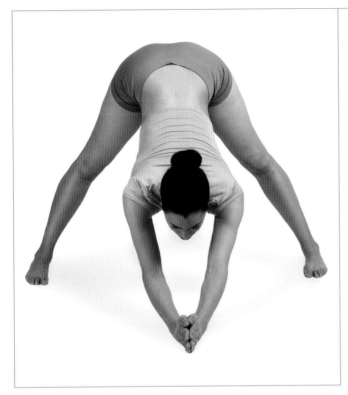

Downward Dog, Palm Variation

Target: Spine.

Benefits: Lengthens the neck, spine, and hamstrings while strengthening the upper arms and shoulders.

Steps: 1. Begin on all fours, with your palms directly below your shoulders. Step both feet up onto your toes so your heels are raised up from the floor. **2.** Brace your hands and shoulders to hold your weight, and push your hips up into the air in a downward dog pose. Once in this position, slide your hands in together, so your palms are joined in prayer position resting against the floor. **3.** Step one foot out at a time, so both legs are straight and your feet are apart with your heels touching the floor. Then, drop your head and shoulders down to complete the stretch. **4.** Hold this pose for thirty seconds before stepping one foot at a time back down to the floor.

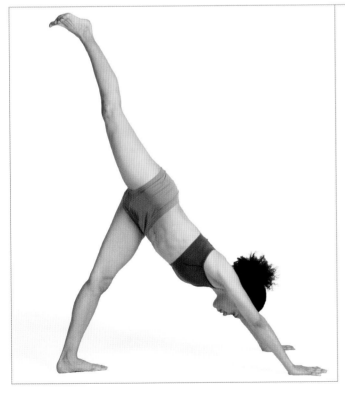

Downward Dog, Parallel

Target: Spine.

Benefits: Lengthens the neck, spine, and hamstrings while strengthening the upper arms and shoulders.

Steps: 1. Begin on all fours, with your palms directly below your shoulders. Step both feet up onto your toes so your heels are raised up from the floor. **2.** Brace your hands and shoulders to hold your weight, and push your hips up into the air in a downward dog pose. **3.** Step one foot out at a time, so both legs are straight and your feet are apart with your heels touching the floor. Then, drop your head and shoulders down to complete the stretch. **4.** Raise your right foot up from the floor, and extend your leg straight up parallel from your torso. Hold this pose for ten seconds before stepping your foot down and repeating with your left leg raised.

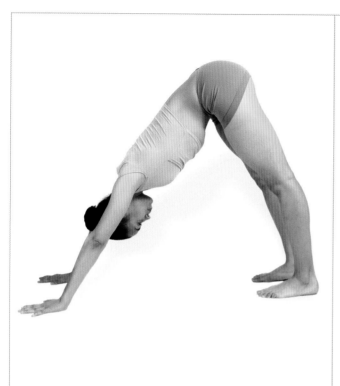

Downward-Facing Dog

Target: Spine.

Benefits: Lengthens the neck, spine and hamstrings while strengthening the upper arms and shoulders.

Steps: 1. Begin on all fours, with your palms directly below your shoulders. Step both feet up onto your toes so your heels are raised up from the floor. **2.** Brace your hands and shoulders to hold your weight, and push your hips up into the air in a downward dog pose. **3.** Step one foot out at a time, so both legs are straight and your feet are even with your heels touching the floor. Then, drop your head and shoulders down, targeting your shoulder muscles. **4.** Hold this pose for thirty seconds before stepping one foot at a time back down to the floor.

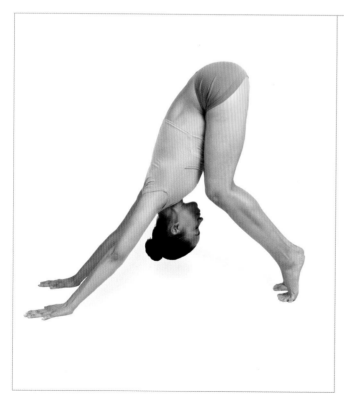

Downward-Facing Dog, Tiptoe

Target: Spine.

Benefits: Lengthens the neck, spine and hamstrings while strengthening the upper arms and shoulders.

Steps: 1. Begin on all fours, with your palms directly below your shoulders. Step both feet up onto your toes so your heels are raised up from the floor. **2.** Brace your hands and shoulders to hold your weight, and push your hips up into the air in a downward dog pose. **3.** Keep your feet raised on tiptoes and your knees slightly bent. Then, drop your head and shoulders down, targeting your shoulder muscles. **4.** Hold this pose for thirty seconds before stepping one foot at a time back down to the floor.

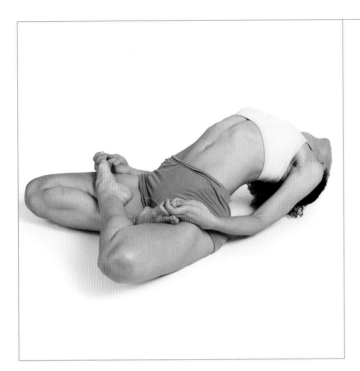

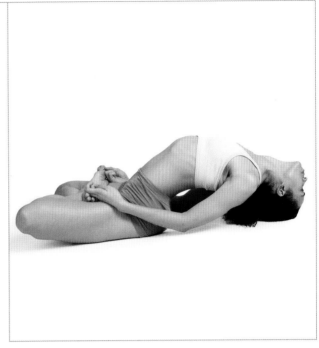

Fish Pose

Target: Spine.

Benefits: Opens the chest and extends the upper back while stretching the knees, groin and ankles.

Steps: 1. Sit on the floor with your legs extended, spine straight, and arms resting at your sides. **2.** Bring your right ankle to rest in the crease of your left hip and the sole of your foot is facing upward. **3.** Bend your left knee, crossing your left ankle over the top of your right shin and into your right hip. The sole of your left foot should also face upward. **4.** Place your palms flat on the floor behind you. Drop your head and shoulders back and lower yourself from your hands to your elbows. **5.** Then, lower yourself completely so the top of your head is resting against the floor. Raise your elbows up from the floor and bring your hands to your hips. **6.** Remain in this position for fifteen seconds.

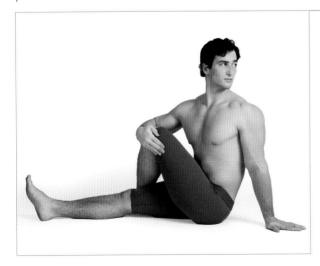

Easy Lord of the Fishes Pose Prep

Target: Spine.

Benefits: Lengthens the muscles in the hip flexors and along the spinal column and upper back.

Steps: 1. Begin seated with your legs straight ahead. Raise your right foot over your left leg and place is flat on the floor to the left of your left thigh. **2.** Reach your left arm out behind you and plant your palm flat on the floor. Twist your torso all the way to the left. **3.** Shift your gaze behind you to complete the stretch. Hold this position for twenty seconds. **4.** Release and repeat to the opposite side.

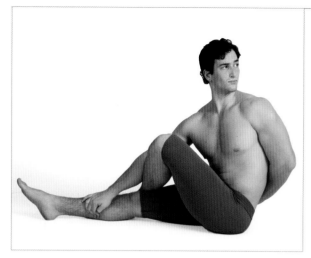

Easy Lord of the Fishes Pose

Target: Spine.

Benefits: Lengthens the muscles in the hip flexors and along the spinal column and upper back.

Steps: 1. Begin seated, with your legs straight ahead. Raise your right foot over your left leg and place it flat on the floor to the left of your left thigh. **2.** Reach your left arm behind and around your back and grab hold of your opposite hip. Twist your torso all the way to the left. **3.** Shift your gaze behind you to complete the stretch. Hold this position for twenty seconds. **4.** Release and repeat to the opposite side.

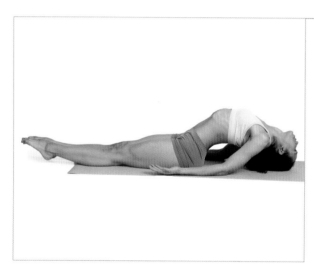

Fish Pose Pointed

Target: Spine.

Benefits: Opens the chest and extends the upper back while stretching the knees, groin and ankles.

Steps: 1. Sit on the floor, with your legs extended, spine straight, and arms resting at your sides. **2.** Place your palms flat on the floor behind you. Drop your head and shoulders back and lower yourself from your hands to your elbows, so your forearms are flat against the floor **3.** Then, lower yourself completely so the top of your head is resting against the floor. Raise your elbows up from the floor and straighten your arms by your sides. Keep your toes pointed throughout the stretch. **4.** Remain in this position for fifteen seconds.

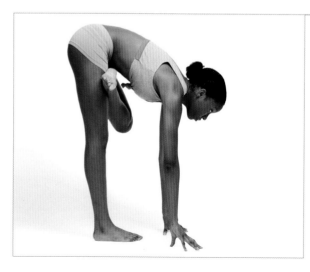

Half-Bound, Lotus Intense-Stretch Pose Prep 1

Target: Spine.

Benefits: Extends the hips while lengthening the spine and hamstrings.

Steps: 1. Begin by standing straight, with your arms resting at your sides. Shift your weight onto your right foot. **2.** Raise your left foot from the floor and bend it in front of you. Reach with both hands and tuck your foot against your right hip. **3.** Keeping your left foot in place, begin to fold forward from the waist, dropping your head and shoulders downward. Reach both hands to the floor. **4.** Hold this pose for fifteen seconds. Release and repeat on the opposite leg.

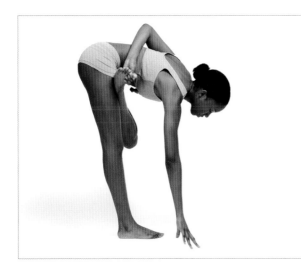

Half-Bound, Lotus Intense-Stretch Pose Prep 2

Target: Spine.

Benefits: Extends the hips and lengthens the spine and hamstrings.

Steps: 1. Stand straight with your arms resting at your sides. Shift your weight onto your right foot. **2.** Raise your left foot and, using both hands, tuck your left foot into your right hip. **3.** Keeping your left foot in place with your right hand, reach your left hand across your back and grab hold of your left foot. **4.** Release your right hand and bend forward, dropping your head and shoulders down toward the floor. Extend your right hand down to the floor. **5.** Hold this pose for fifteen seconds. Release and repeat on the opposite foot.

Half Intense-Stretch Pose, Arms Extended

Target: Spine.

Benefits: Strengthens the legs and core while extending the spine and shoulders.

Steps: 1. Begin by standing straight, with your arms extended above your head. **2.** Bend forward at the waist, leaning your head and shoulders toward the floor. Continue until your arms and torso are parallel to the floor. **3.** Hold this pose for fifteen seconds.

Reverse-Prayer Revolved, Uneven-Legs Stretch

Target: Spine.

Benefits: Lengthens the spine while engaging the core, shoulders, and hamstrings.

Steps: 1. Begin by standing straight with your arms relaxed at your sides. **2.** Bring your hands together behind your back in a reverse prayer position. **3.** Fold forward at the waist and bend your right knee up slightly, resting your right foot on the toes. **4.** Hook your right elbow on your right knees. **5.** Hold this pose for ten seconds. Release and repeat on the opposite side.

Intense Leg Stretch

Target: Spine.

Benefits: Provides relief from tight or strained muscles along the spine while engaging the abdomen.

Steps: 1. Begin by lying flat on your back with your arms at your sides. **2.** Arch your back and lift your shoulders up from the floor, resting the top of your head on the floor. **3.** From this position, extend your arms straight up above your torso at a 45-degree angle. Keep your toes pointed throughout. **4.** Hold this position for twenty seconds.

Intense Leg Stretch, Dedicated to Garuda

Target: Spine.

Benefits: Provides relief from tight or strained muscles along the spine.

Steps: 1. Lie flat on your back, arms at your sides. **2.** Arch your back and lift your shoulders from the floor, resting the top of your head on the floor. **3.** Raise your legs and bring your knees above your hips. Cross your left knee over your right and tuck your left foot under your right foot, so your legs are in a twined position. Keep your lower legs parallel to the floor. **4.** Extend both arms overhead, crossing them at the elbows, and rest your fingertips on the floor above your head so the back of your hands are pressed together. **5.** Hold this position for twenty seconds.

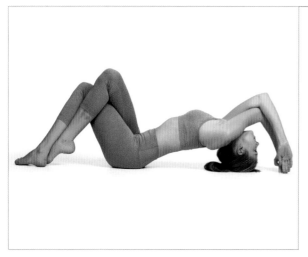

Intense Leg-Stretch Pose, Dedicated to Garuda

Target: Spine.

Benefits: Provides relief from tight or strained muscles along the spine.

Steps: 1. Lie flat on your back, arms at your sides. **2.** Arch your back and lift your shoulders from the floor, resting the top of your head on the floor. **3.** Raise your legs and bring your knees above your hips. Cross your right knee over your left and tuck your right foot under your left foot, so your legs are in a twined position. Keep your lower legs parallel to the floor. **4.** Extend both arms overhead, crossing them at the elbows, and rest your fingertips on the floor above your head so the back of your hands are pressed together. **5.** Hold this position for twenty seconds.

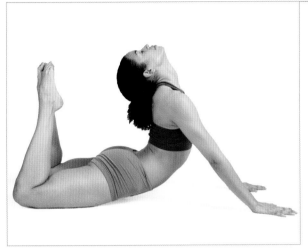

King Pigeon

Target: Spine.

Benefits: Deeply extends the spine while opening the chest and shoulders.

Steps: 1. Begin on all fours with your palms directly below your shoulders. **2.** Slowly lower your hips down toward the floor. Bend your legs, bringing your feet to rest above your hips. Your quadriceps should be flat against the floor. **3.** Drop your head back. Press against your hands, pushing your head and shoulders back toward your feet to increase the chest opener. **4.** Hold this position for fifteen seconds.

King Pigeon, One Leg

Target: Spine.

Benefits: Deeply extends the spine while opening the chest and shoulders.

Steps: 1. Begin by kneeling upright with your arms at your sides. Slide your left knee back slightly and raise your left foot up from the floor so it is pointing up behind your hips. **2.** Reach your arms straight out behind you, making the wisdom gesture with your fingers. Drop your head and shoulders back and pull them down toward your raised foot. Your chin should be pointed directly toward the ceiling. **3.** Hold this pose for fifteen seconds. Release and repeat on the opposite leg.

King Pigeon, One-Legged Revolved

Target: Spine.

Benefits: Pulls along the length of the spine while opening the hips and shoulders.

Steps: 1. Begin by kneeling upright. Raise your left knee from the floor and place your foot flat on the floor ahead of you so your leg forms a 90-degree angle. **2.** Place your right hand flat on the floor beside your left foot. Raise your right foot up toward your hips and grab hold of your foot with your left hand. **3.** Press your hips down toward the floor and gently pull your foot in toward you. **4.** Hold this pose for fifteen seconds. Release and repeat on the opposite side.

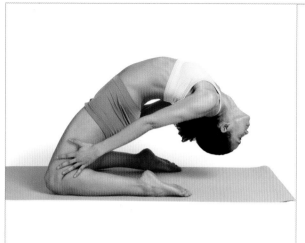

Little Thunderbolt Pose

Target: Spine.

Benefits: Deeply extends the spine and neck while opening the chest and shoulders.

Steps: 1. Begin by kneeling upright with your knees shoulder-width apart. **2.** Reach both hands down behind you and grab hold of your ankles. Drop your head and shoulders back so your chin is pointing up to the ceiling. **3.** Slide your hands up your legs until they are resting on your upper legs. Continue to pull the top of your head down toward the floor behind you. **4.** Hold this pose for five seconds or longer.

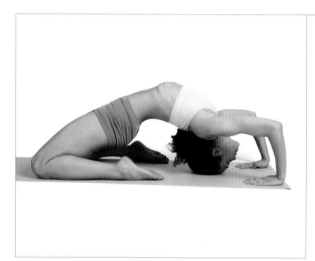

Little Thunderbolt Pose Prep

Target: Spine.

Benefits: Deeply extends the spine and neck while opening the chest and shoulders.

Steps: 1. Begin by kneeling upright, with your knees shoulder-width apart. **2.** Reach both hands down behind you and grab hold of your ankles. Drop your head and shoulders down so your chin is pointing up to the ceiling. **3.** Lift your hands from your ankles and bring them flat on the floor ahead of you, so your forearms are perpendicular to the floor and your fingers are pointed toward your feet. Slowly lower the top of your head down to the floor, bending at the elbows. **4.** Hold this pose for five seconds or longer.

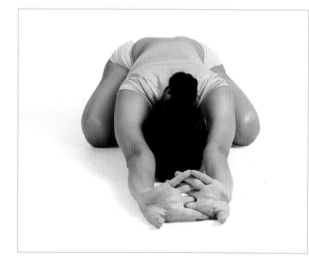

Lotus Forward Bend

Target: Spine.

Benefits: Addresses tightness in the spine and upper back while stretching the knees, groin, and ankles.

Steps: 1. Kneel with your hips resting on your heels, knees slightly apart. **2.** Clasp your arms overhead, palms pointing up, and bend your torso forward. **3.** Lengthen your spine and rest your forehead to the floor. Extend your clasped hands straight overhead onto the floor. **4.** Hold this pose for ten seconds.

Lotus Pose, Reclining

Target: Spine.

Benefits: Addresses tightness in the spine, shoulders, and groin.

Steps: 1. Sit on the floor with your legs extended, spine straight, and arms resting at your sides. **2.** Bring your right ankle to rest in the crease of your left hip and cross your left ankle to rest on your right hip. The soles of your feet should face upward. **3.** Lengthen your spine and place your hands flat on the floor behind you. One at a time, lower your hands onto your elbows and bring your forearms flat on the floor. **4.** Continue to lower your torso to the floor and extend your arms straight above you. Lie in this pose for thirty seconds.

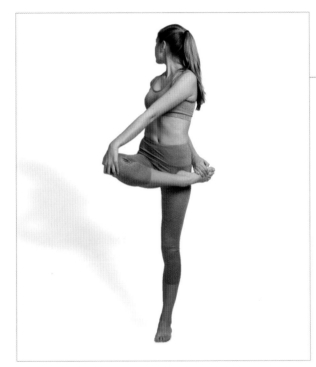

Lotus Tree Pose, Half-Bound Revolved

Target: Spine.

Benefits: Opens the hips and twists the spine and lower back.

Steps: 1. Begin by standing straight with your arms at your sides. Shift your weight onto your left foot. **2.** Bend your right knee and raise your foot up toward your hips. With your left hand, gently pull your right foot up to your left hip. **3.** Once you are balanced, reach your right arm across your back and grab hold of your right foot. Move your left hand over to your right knee. **4.** Pushing lightly against your right knee, twist your torso to the right. Shift your gaze behind you to complete the stretch. **5.** Hold this pose for ten seconds. Release and repeat on the opposite side.

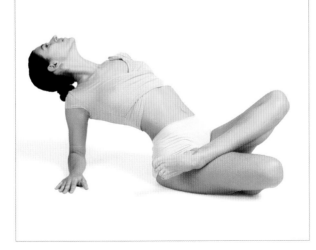

Lotus Spinal Twist

Target: Spine.

Benefits: Opens the chest and extends the length of the spine.

Steps: 1. Begin by sitting on the floor with your knees bent. **2.** Tuck your right foot under your left hip and place your left foot into your right hip with the sole of your foot facing up, in a half-lotus position. **3.** Place your hands flat on the floor behind your hips. Then, one at a time, lower your hands onto your elbows, so your forearms are flat on the floor. **4.** Drop your head and shoulders back to open your chest. Hold this position for twenty seconds. Release and repeat on the opposite side.

Mountain Pose

Target: Spine.

Benefits: Improves spinal posture, balance, and muscle alignment.

Steps: 1. Stand with your feet together and your arms at your sides. Press your weight evenly across the balls and arches of your feet. **2.** Bring your pelvis to its neutral position. Do not let your front hip bones point down or up; instead, point them straight forward. Draw your belly in slightly. **3.** Elongate through your torso. Exhale and release your shoulder blades away from your head, toward the back of your waist. **4.** Rotate your inner arms outward, bringing your hands out to your sides. Spread your fingers apart and hold your palms facing forward. **5.** Hold this pose for one minute, feeling your spine lengthen throughout.

Mountain Pose, Raised Bound Hands

Target: Spine.

Benefits: Improves spinal posture, balance, and muscle alignment.

Steps: 1. Stand with your feet together and your arms at your sides. Press your weight evenly across the balls and arches of your feet. **2.** Bring your pelvis to its neutral position. Do not let your front hip bones point down or up; instead, point them straight forward. Draw your belly in slightly. **3.** Elongate through your torso. Exhale and release your shoulder blades away from your head, toward the back of your waist. **4.** Clasp your hands together and raise your hands straight overhead. Your palms should be extended up toward the ceiling. **5.** Hold this pose for one minute, feeling your spine lengthen throughout.

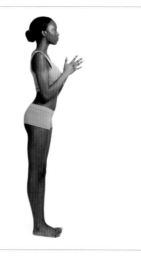

Mountain Pose with Prayer Hands

Target: Spine.

Benefits: Improves spinal posture, balance, and muscle alignment.

Steps: 1. Stand with your feet together and your arms at your sides. Press your weight evenly across the balls and arches of your feet. **2.** Bring your pelvis to its neutral position. Do not let your front hip bones point down or up; instead, point them straight forward. Draw your belly in slightly. **3.** Elongate through your torso. Exhale and release your shoulder blades away from your head, toward the back of your waist. **4.** Raise your hands in front of your chest and press your palms together in prayer position. Apply gentle, even pressure from each hand and shoulder. **5.** Hold this pose for one minute, feeling your spine lengthen throughout.

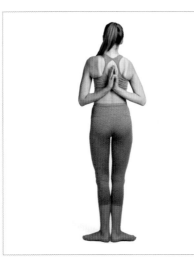

Mountain Pose with Reverse Prayer Hands

Target: Spine.

Benefits: Improves spinal posture, balance, and muscle alignment.

Steps: 1. Stand with your feet together and your arms at your sides. Press your weight evenly across the balls and arches of your feet. **2.** Bring your pelvis to its neutral position. Do not let your front hip bones point down or up; instead, point them straight forward. Draw your belly in slightly. **3.** Elongate through your torso. Exhale and release your shoulder blades away from your head, toward the back of your waist. **4.** Extend your hands behind your back and press your palms together in reverse prayer position. Attempt to lift your joined hands up farther along your spine. **5.** Hold this pose for one minute, feeling your spine lengthen throughout.

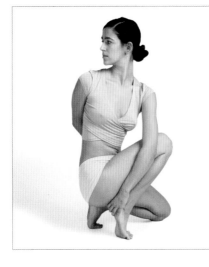

Noose Pose, Uneven Legs, Hands to Feet

Target: Spine.

Benefits: Twists the spine and lower back while stretching the hips and Achilles tendons.

Steps: 1. Begin by kneeling on the ground, with your shins flat on the floor. Raise both feet up onto tiptoes. **2.** Step your right foot forward and raise your knee up toward your chest. **3.** Swing your left elbow around to the right side of your right thigh. Reach your right arm across your back. **4.** Gently twist your spine to the right. Hold this pose for thirty seconds and repeat on the opposite side.

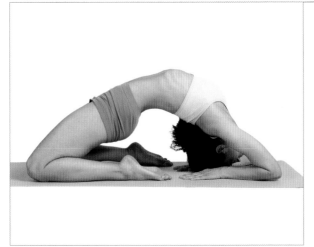

Pigeon Stretch

Target: Spine.

Benefits: Deeply extends the spine and neck while opening the chest and shoulders.

Steps: 1. Begin by kneeling upright with your knees shoulder-width apart. **2.** Reach both hands down behind you and grab hold of your ankles. Drop your head and shoulders down so your chin is pointing up to the ceiling. **3.** Lower your elbows down onto the floor. Your forearms should be flat against the floor and your fingertips pointing toward your toes. Continue to pull the top of your head down toward the floor between your palms. **4.** Hold this pose for five seconds or longer.

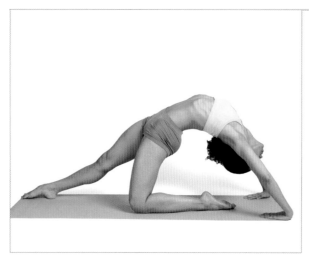

Pigeon Stretch, One-Legged Prep

Target: Spine.

Benefits: Deeply extends the spine and neck while opening the chest and shoulders.

Steps: 1. Kneel upright with your knees shoulder-width apart. **2.** Reach both hands down behind you and grab hold of your ankles. Drop your head and shoulders back so your chin is pointing to the ceiling. **3.** Lift your hands from your ankles and bring them flat on the floor ahead of you, fingers pointing toward your feet. Lift your right knee and extend your leg forward. **4.** Hold for fifteen seconds and repeat on the opposite side.

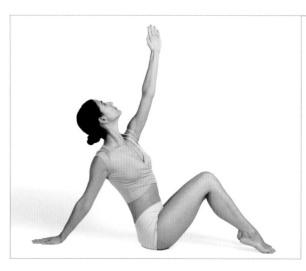

Seated Eastern Intense-Stretch Pose, One Hand

Target: Spine.

Benefits: Extend the spinal column and engages the abdomen.

Steps: 1. Begin seated on the floor with your knees bent and your feet flat on the floor straight ahead of you. **2.** Raise your heels from the floor, so both feet are resting on their toes. Reach your right hand flat to the floor behind your hips. Extend your left arm straight up from your shoulder. **3.** Hold this pose for thirty seconds, pulling along the length of your spine throughout. **4.** Release and repeat, alternating arms.

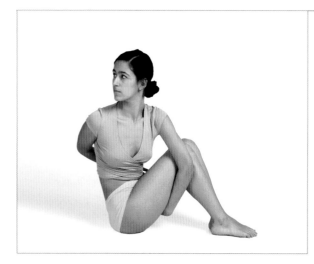

Seated Noose Pose

Target: Spine.

Benefits: Twists the spine and extends the upper arms and shoulders.

Steps: 1. Begin seated on the floor with your knees bent and your feet flat on the floor ahead of you. **2.** Reach your right hand across your back, toward your left hip, and twist your torso to the right. **3.** Reach your left hand under your knees and join your hands together beside your left hip. **4.** Once bound, pull your shoulders up and attempt to lengthen your spine. **5.** Hold this pose for twenty seconds. Release and repeat on the opposite side.

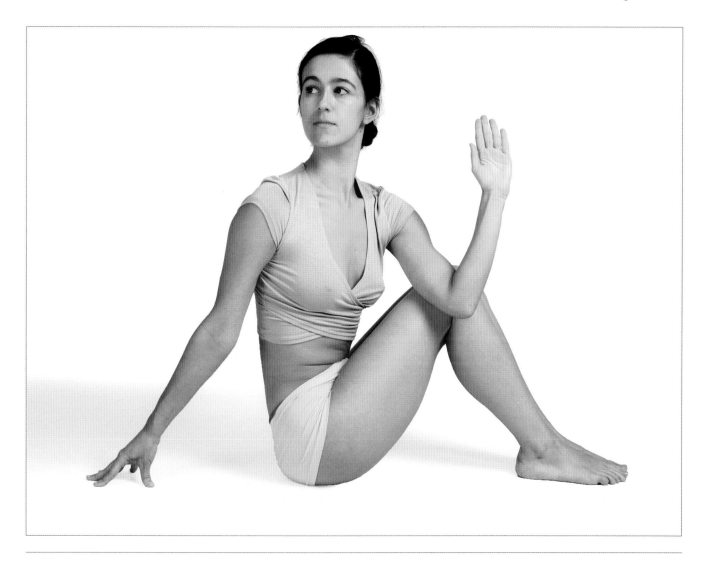

Seated Noose Pose Prep

Target: Spine.

Benefits: Twists the spine while extending the upper arms and shoulders.

Steps: 1. Begin seated on the floor with your knees bent and your feet flat on the floor ahead of you. **2.** Twist your torso to the right. Extend your right arm straight out behind you and plant your palm on the floor. **3.** Hook your left elbow to the outside of your left knee. Press gently against your elbow to increase the spinal twist. **4.** Release and repeat to the opposite side.

Side Stretch Spine Opener

Target: Spine.

Benefits: Lengthens the spine and extends the muscles across the upper back and shoulders.

Steps: 1. Begin seated with your legs extended in front of you. **2.** Place your right hand flat on the floor and roll onto your right hip so your left hip is raised off the floor. **3.** Raise your left hand up toward the ceiling. **4.** Attempt to pull along the length of your spine and neck.

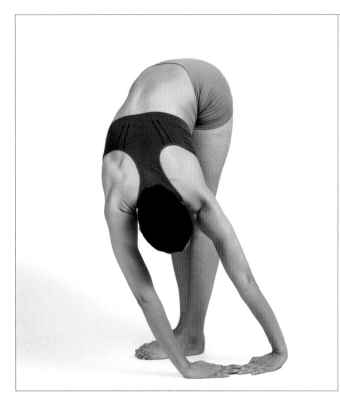

Sideways Half-Intense Stretch Pose

Target: Spine.

Benefits: Deeply lengthens the spine and hamstrings, extending the muscles across the lower back.

Steps: 1. Stand straight with good posture. Lace your fingers together in front of your waist. **2.** Bend forward, folding at the waist, and extend your head and shoulders down toward the floor. **3.** As you lean, twist your torso to the left. Drop your palms down flat on the floor to the left of your feet. Hold this position for ten seconds. **4.** Rise back to the starting position and repeat the stretch, this time twisting to the right.

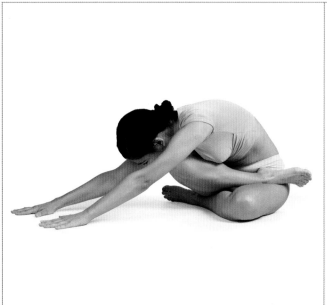

Spinal Twist in Lotus

Target: Spine.

Benefits: Opens the chest and extends the length of the spinal cord.

Steps: 1. Begin by sitting on the floor with your knees bent. **2.** Tuck your left foot under your right hip and place your right foot into your left hip, with the sole of your foot facing up. **3.** Twist your torso to the right and extend both hands flat on the floor to your right side. Slowly slide your hands away from you, dropping your chest toward the floor toward your right. **4.** Keep your hands flat on the floor throughout. Hold this position for twenty seconds. Release and repeat on the opposite side.

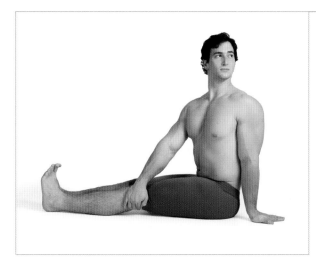

Staff Pose, Revolved

Target: Spine.

Benefits: Lengthens the spine and extends the muscles across the lower back.

Steps: 1. Begin seated on the floor with your legs straight and your feet flexed. **2.** Place your left hand flat on the floor behind your left hip. Your fingers should be pointing behind you. Twist your torso to the left. **3.** Place your right hand against your left thigh and gently press against it to increase the spinal twist. Shift your gaze behind you to complete the stretch. **4.** Hold this pose for thirty seconds, focusing on lengthening your spine throughout. Return to the starting position and repeat on the opposite side.

Sun Salutation, Kneeling

Target: Spine.

Benefits: Lengthens the spinal column and shoulders, improving circulation and muscle alignment.

Steps: 1. Begin kneeling upright with your knees shoulder-width apart. **2.** Extend your arms straight up toward the ceiling, with your palms facing forward. **3.** Bring your pelvis to its neutral position. Do not let your front hip bones point down or up; instead, point them straight forward. Draw your belly in slightly. **4.** Elongate through your torso. Exhale and release your shoulder blades away from your head, toward the back of your waist. **5.** Hold this pose for one minute, feeling your spine lengthen throughout.

Standing Sun Salutation

Target: Spine.

Benefits: Lengthens the spinal column and shoulders while improving circulation and muscle alignment.

Steps: 1. Begin by standing with your feet shoulder-width apart. **2.** Extend your arms straight up toward the ceiling, with your palms facing each other. **3.** Press your weight evenly across the balls and arches of your feet. Bring your pelvis to its neutral position. Do not let your front hip bones point down or up; instead, point them straight forward. Draw your belly in slightly. **4.** Elongate through your torso. Exhale and release your shoulder blades away from your head, toward the back of your waist. **5.** Hold this pose for one minute, feeling your spine lengthen throughout.

Upward Salute Pose 1

Target: Spine.

Benefits: Lengthens the spinal column and shoulders, improving circulation and muscle alignment.

Steps: 1. Begin standing with your feet together. **2.** Extend your arms straight up toward the ceiling, with your palms facing each other. **3.** Press your weight evenly across the balls and arches of your feet. Bring your pelvis to its neutral position. Do not let your front hip bones point down or up; instead, point them straight forward. Draw your belly in slightly. **4.** Elongate through your torso. Exhale and release your shoulder blades away from your head, toward the back of your waist. **5.** Shift your gaze up toward the ceiling. Hold this pose for one minute, feeling your spine lengthen throughout.

Upward Salute Pose 2

Target: Spine.

Benefits: Lengthens the spinal column and shoulders, improving circulation and muscle alignment.

Steps: 1. Begin standing with your feet together. **2.** Extend your arms straight up toward the ceiling, and press your palms together in prayer position. **3.** Press your weight evenly across the balls and arches of your feet. Bring your pelvis to its neutral position. Do not let your front hip bones point down or up; instead, point them straight forward. Draw your belly in slightly. **4.** Elongate through your torso. Exhale and release your shoulder blades away from your head, toward the back of your waist. **5.** Shift your gaze up toward the ceiling. Hold this pose for one minute, feeling your spine lengthen throughout.

Wild Thing Pose

Target: Spine.

Benefits: Stabilizes the muscles in the arms, legs, and core while lengthening the spine.

Steps: 1. Begin by lying on your left side. Come up into a side plank pose. Your weight should be resting on your left forearm and the outside of your left foot. Reach your right arm straight toward the ceiling. **2.** Keeping your left leg straight, extend your right foot down to the floor behind you. Push your hips up and away from the floor. **3.** Curl your head and shoulders back. Extend your right arm overhead and down behind you, arching your spine into a deep backbend. **4.** Hold this pose for five seconds or more. Release and repeat, switching sides.

Bed Pose 1

Target: Upper back.

Benefits: Opens the hips while extending the upper back and the shoulders.

Steps: 1. Begin by kneeling low to the floor, with your hips resting on your heels. **2.** Place your hands flat on the floor behind your hips. One at a time, lower your hands so that you are resting on your elbows and forearms. **3.** Slowly touch the top of your head to the floor. Lift your elbows from the floor and raise your hands onto your hips. **4.** Hold this pose for thirty seconds, feeling your spine lengthen throughout.

Bed Pose 2

Target: Upper back.

Benefits: Opens the hips while extending the upper back and the shoulders.

Steps: 1. Begin by kneeling low to the floor, with your hips resting on your heels. **2.** Place your hands flat on the floor behind your hips. One at a time, lower your hands so that you are resting on your elbows and forearms. **3.** Slowly lower the top of your head to touch the floor. Raise your elbows up over your head and back down to the floor. Reach both hand in to hold the opposite elbow. **4.** Hold this pose for thirty seconds, feeling your spine lengthen throughout.

Cat Pose

Target: Upper back.

Benefits: Extends the muscles along the spinal cord and shoulders.

Steps: 1. Begin on all fours with your palms flat on the floor directly below your shoulders. **2.** Pull your center point of your spine up toward the ceiling, deeply arching your back. Drop your head and shoulders down toward the floor. **3.** Hold this pose for fifteen seconds.

Child's Pose

Target: Upper back.

Benefits: Lengthens the spinal column and neck while opening the shoulders and upper back.

Steps: 1. Begin on all fours with your palms directly below your shoulders. Lower your hips down onto your heels. **2.** Raise your palms from the floor and extend your arms along the outside of your legs. The tops of your hands should be resting against the floor near your feet. **3.** Lower your forehead to the floor. Pull along the length of your spine and neck. **4.** Hold for fifteen seconds.

Child's Pose, Arms Extended

Target: Upper back.

Benefits: Lengthens the spinal column and neck while opening the shoulders and upper back.

Steps: 1. Begin on all fours with your palms directly below your shoulders. Lower your hips down onto your heels. **2.** From this position, extend your arms straight ahead, with your palms flat against the floor. **3.** Lower your forehead down toward the floor between your shoulders Pull along the length of your spine and arms. **4.** Hold this pose for fifteen seconds.

Child's Pose Bound

Target: Upper back.

Benefits: Lengthens the spinal column and neck while opening the shoulders, upper back, and hips.

Steps: 1. Begin on all fours with your palms directly below your shoulders. Slide your left knee in front of your right and raise your left foot up to your right side. **2.** Bend at the elbows and lower the top of your head to touch the floor. **3.** Lift your left hand from the floor and reach across your back to grab hold of your left foot. **4.** Hold this pose for ten seconds. Release and repeat on the opposite side.

Child's Pose, Bound Prep

Target: Upper back.

Benefits: Lengthens the spinal column and neck while opening the shoulders, upper back, and hips.

Steps: 1. Begin on all fours with your palms directly below your shoulders. Slide your left knee in front of your right and raise your left foot up to your right side. **2.** Bend at the elbows and lower the top of your head to touch the floor. **3.** Lift your left hand from the floor and reach across your back to grab hold of your left foot.

Child's Pose, Hand Position of Pose Dedicated to Garuda

Target: Upper back.

Benefits: Lengthens the spinal column while opening the shoulders.

Steps: 1. Begin on all fours with your palms directly below your shoulders. Lower your hips onto your heels. **2.** Lean onto your elbows and place your forearms flat on the floor. Cross your right elbow over your left and place it back on the floor. Reach the fingers of your left hand over your right wrist so your arms are double-twined. **3.** Drop the top of your head down toward the floor to complete the stretch. Hold this pose for thirty seconds, pulling along the length of the spine.

Child's Pose, Hands to Feet

Target: Upper back.

Benefits: Lengthens the spinal column and neck while opening the shoulders and upper back.

Steps: 1. Begin on all fours with your palms directly below your shoulders. **2.** Drop the top of your head down to the floor, just in front of your knees. **3.** Lift your palms from the floor and reach both arms down your sides to grab hold of your feet. **4.** Hold this pose for thirty seconds, pulling along the length of the spine.

Child's Pose, One Arm

Target: Upper back.

Benefits: Lengthens the spinal column and neck while opening the shoulders and upper back.

Steps: 1. Begin on all fours with your palms directly below your shoulders. Lower your hips down onto your heels. **2.** From this position, extend your right arm out straight ahead, with your palm flat against the floor. Fold your other arm in front of your knees. Lower your forehead down toward the floor between your shoulders **3.** Pull along the length of your spine and right arm. **4.** Hold this pose for fifteen seconds. Release and repeat on the opposite arm.

Child's Pose, Variation

Target: Upper back.

Benefits: Extends the spinal column and obliques, targeting the upper back.

Steps: 1. Begin on all fours with your palms directly below your elbows. Lower your hips down onto your heels. **2.** Twist your torso to the right and extend your arms straight ahead. Place your left palm on your right hand and lower your head and shoulders. **3.** Pull along the length of your spine and arms. Hold this pose for fifteen seconds and repeat on the opposite side.

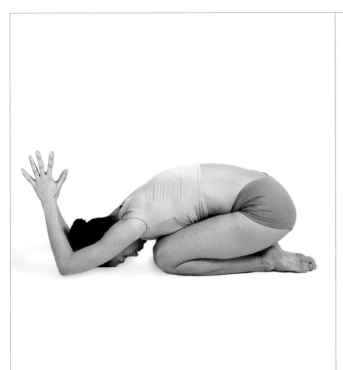

Child's Pose with Fingers Spread

Target: Upper back.

Benefits: Extends the spinal column and obliques, targeting the lats.

Steps: 1. Begin on all fours with your palms directly below your elbows. Lower your hips down onto your heels, and bring your forehead to touch the floor between your shoulders. **2.** Pull gently along the length of your spine. Lift your palms from the floor and instead rest both elbows down. Press your palms together above your head and spread your fingers wide. **3.** Hold this pose for thirty seconds, focusing on extending your neck and spine.

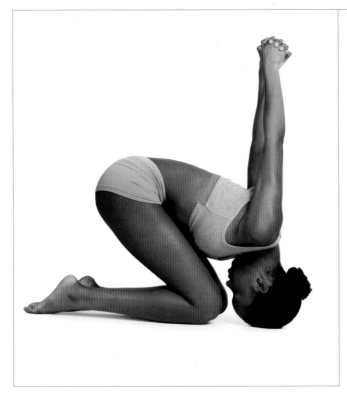

Child's Pose, Hands Clasped Above

Target: Upper back.

Benefits: Opens and strengthens your shoulders, improving alignment across the entire shoulder girdle and upper back.

Steps: 1. Start on all fours. Bend your torso forward and rest the top of your head on the floor by your knees. **2.** Raise your palms from the floor so you are balancing on the crown of your head. **3.** Clasp your hands behind your back and extend your hands as far up your back as you are able. **4.** Hold this position for twenty seconds before releasing.

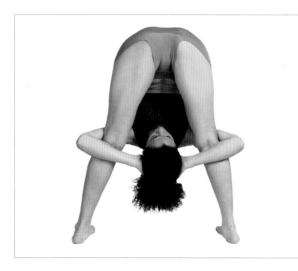

Firefly Pose, Variation

Target: Upper back.

Benefits: Deeply extends the hamstrings, spine, and neck, targeting the upper back.

Steps: 1. Stand straight with your feet wide apart. **2.** Bend forward at the waist, bringing your head and shoulders down toward the floor. Reach both hands flat on the floor between your legs, and continue the forward bend until your head is between your knees. **3.** Once balanced, raise your hands from the floor and hook both elbows around your legs. **4.** Reach your hands back and place your palms against the back of your head. **5.** Gently press against your head and shoulders. Attempt to remain in this position for five or more seconds.

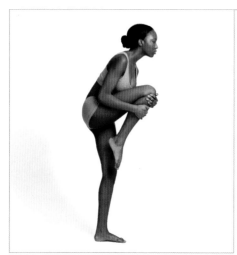

Half-Standing, Wind-Relieving Intense-Stretch Pose 1 & 2 Prep

Target: Upper back.

Benefits: Extends the hips and upper back while increasing balance.

Steps: 1. Begin standing straight with your arms at your sides. Shift your weight onto your left foot. **2.** Lift your right foot from the floor and raise it up to your knee. **3.** Bend forward at the waist, and hug both arms around your raised knee. Attempt to pull your torso down toward your knee. **4.** Hold this pose for ten seconds. Release and repeat on the opposite leg.

Hands-Bound, Forward-Stretch Side Stretch

Target: Upper back.

Benefits: Targets the shoulders and upper back muscles while lengthening the calves and hamstrings.

Steps: 1. Stand straight and press your palms together behind your back so your fingers are pointing up your spine. Step your left foot forward. **2.** Fold your torso forward, bending at the waist. Continue to drop your head and shoulders down toward the floor, until your forehead is resting against your left shin. **3.** Hold this position for ten seconds. Release and repeat on the opposite side.

Hands-Bound, Seated Tiptoe Stretch

Target: Upper back.

Benefits: Opens the shoulders and targets the upper back while strengthening the calves and hamstrings.

Steps: 1. Begin crouching low to the ground with your hips resting on your heels. Clasp your fingers together behind your hips. **2.** Raise your heels up from the ground, so you are raised up onto tiptoes. **3.** Attempt to straighten your arms and lift your clasped fingers up behind you. Hold for twenty seconds.

Intense Side-Stretch Pose 1

Target: Upper back.

Benefits: Targets the shoulder and upper back muscles while lengthening the calves and hamstrings.

Steps: 1. Stand straight and clasp your hands together behind you. Step your right foot forward. **2.** Fold your torso forward, bending at the waist. Continue to drop your head and shoulders down toward the floor, along your right leg. As you bend forward, extend your clasped hands up away from your torso, so your hands are raised up toward the ceiling. **3.** Hold this position for ten seconds. Release and repeat on the opposite side.

Intense Side-Stretch Pose 2

Target: Upper back.

Benefits: Targets the shoulders and upper back while lengthening the calves and hamstrings.

Steps: 1. Stand straight and clasp your hands together behind you. Step your right foot forward. **2.** Fold your torso forward, bending at the waist. As you drop your head and shoulders toward the floor, bend your left knee. **3.** Meanwhile, extend your clasped hands away from your torso, so your arms are raised toward the ceiling. **4.** Hold this position for ten seconds. Release and repeat on the opposite side.

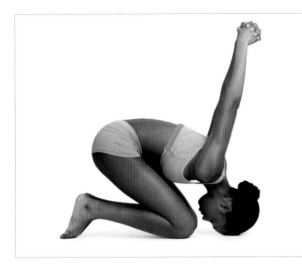

Rabbit Pose 2

Target: Upper back.

Benefits: Opens and strengthen your shoulders, improving alignment across the entire shoulder girdle and upper back.

Steps: 1. Start on all fours. Lower your head toward your knees and rest the top of your head on the floor. Flex your feet so your ankles are raised from the floor. **2.** Balance on the crown of the head and clasp your hands behind your back, raising your hands as far up your back as you are able. **3.** Hold this position for twenty seconds before releasing.

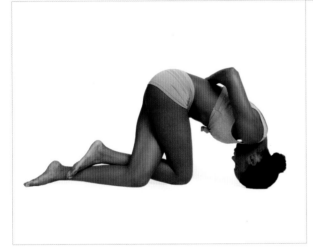

Reverse Prayer in Leg Position of Pose Dedicated to Garuda in Cow Pose on Head

Target: Upper back.

Benefits: Lengthens the spine and improves flexibility in the back.

Steps: 1. Begin on all fours with your palms flat on the floor below your shoulders. **2.** Cross your left knee over your right leg. Then raise your right foot across your left ankle, so your legs are double-twined. **3.** Lower your head to the floor, so your are resting on the top of your head. Once balanced, raise your hands up to your back. **4.** Hold for ten seconds. Release and repeat on the opposite side.

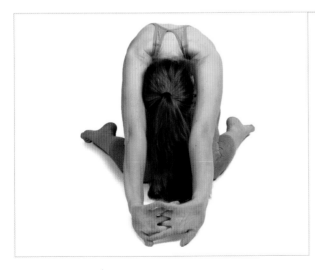

Cat Pose, Hands Clasped

Target: Upper back.

Benefits: Lengthens the spine and improves flexibility in the upper back.

Steps: 1. Begin on all fours with your palms flat on the floor below your shoulders. Keep your knees together while spreading your feet apart. **2.** Curl your spine upward and lift your hands from the floor. **3.** Clasp your hands together and extend them in front of your knees, palms facing out and thumbs touching the floor. **4.** Hold this pose for ten seconds.

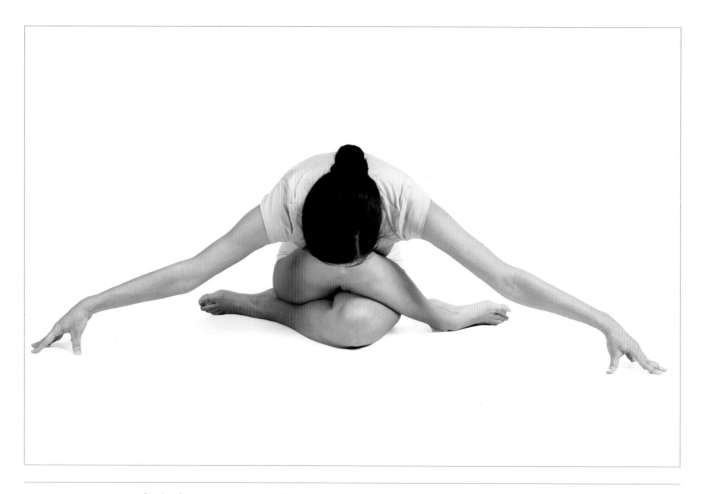

Western Intense Stretch in Leg Position of Half Cow Face Pose

Target: Upper back.

Benefits: Extends the hips and stretches the muscles across the upper back and shoulders.

Steps: 1. Begin seated with your knees bent and your feet flat on the floor. **2.** Slide your left foot under the right hip. Then cross your right leg over the left, stacking the right knee on top of the left, and bring the right foot to the outside of your left hip. Your legs are now in half-cow position. **3.** Bend your torso forward at the waist, dropping your forehead down toward the floor. Extend your arms straight out to the sides and balance your hands on your fingertips. **4.** Hold for fifteen seconds, feeling the muscles in your upper back extend.

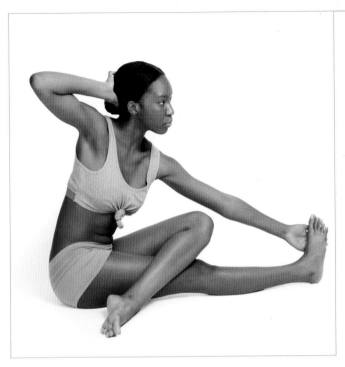

Western Intense-Stretch Pose, Hands to Foot Revolved

Target: Upper back.

Benefits: Extends the hips and stretches the muscles across the upper back and shoulders.

Steps: 1. Start seated on the floor, with your legs out straight. Bend your left leg in and over your right leg, so your foot is tucked beside your right thigh. **2.** Twist your torso to the right, and reach your left hand out to your right foot. Place your right palm against the back of your head. **3.** Maintain this pose for twenty seconds, continuing to press into the twist. **4.** Release and repeat on the opposite side.

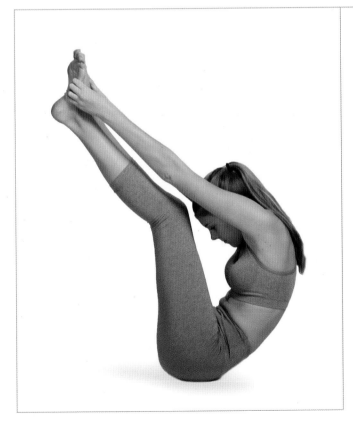

Western Intense Stretch, Upward Half-Log

Target: Upper back.

Benefits: Extends the muscles in the back, arms, and hamstrings while engaging the core.

Steps: 1. Sit on the floor with both knees bent into your chest. Reach both hands down and hook your fingers under your feet. **2.** Keeping your hands and feet together, straighten your legs up from the floor. Keep your back straight and roll your balance onto your pelvic bones. **3.** Pull your legs as close to your body as you are able. Attempt to keep your legs straight. **4.** Hold this pose for fifteen seconds.

Pregnancy Stretches

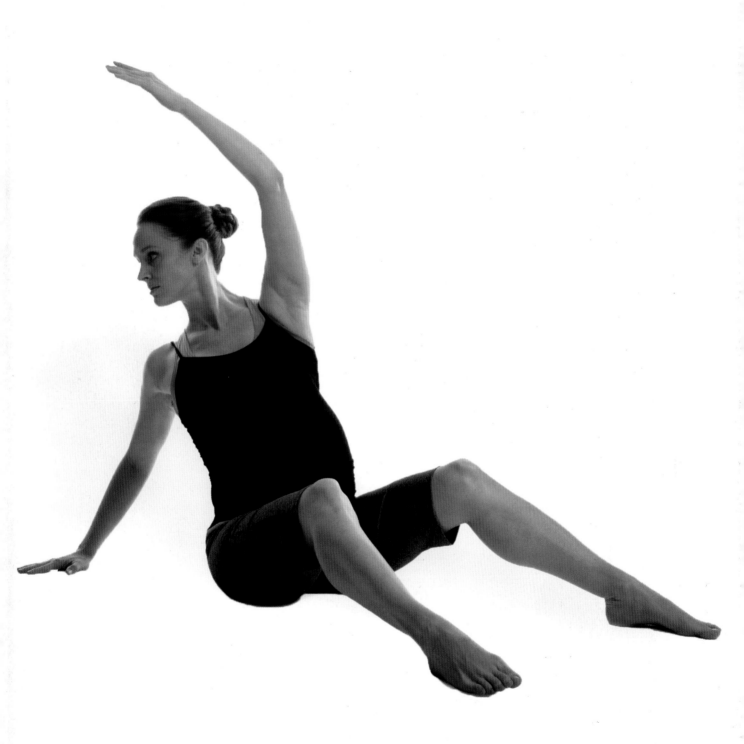

Torso Rotation

Target: Obliques.

Benefits: Reduces stiffness in the spine and obliques, associated with pregnancy.

Steps: 1. Sit with your feet flat on the floor, shoulder-width apart and your knees slightly bent. **2.** Place your right palm flat on the floor behind your hips. Extend your left arm over your head and twist your torso to the right. **3.** Return to the starting position and repeat, this time twisting to the left.

Hand-on-Knee Stretch

Target: Hamstrings.

Benefits: Reduces stiffness in the spine, hips, and hamstrings associated with pregnancy.

Steps: 1. Begin seated, with your left leg extended and your right knee bent, so your foot is tucked into your left knee. **2.** Place both hands on your extended knee. Fold your torso toward your outstretched leg.

Lying Pelvic Tilt

Target: Lower back.

Benefits: Reduces stiffness in the spine and lower back associated with pregnancy.

Steps: 1. Lie flat on your back, with a towel beneath your head for support. Your knees should be bent and your feet flat on the floor. **2.** Slowly arch your spine up off the floor. Hold this pose for five seconds then release and repeat.

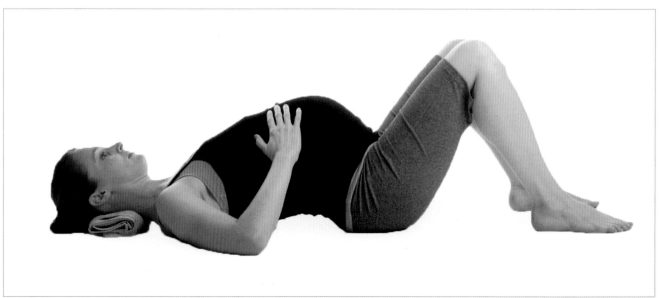

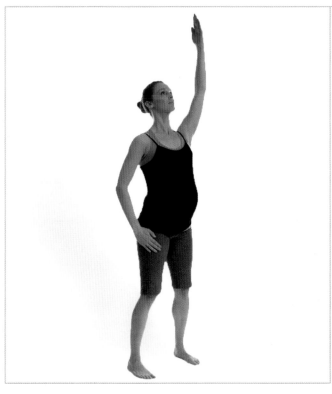

Unilateral Good Morning Stretch

Target: Spine.

Benefits: Reduces stiffness in the spine and obliques associated with pregnancy.

Steps: 1. Stand with your feet apart and your knees slightly bent. **2.** Extend your left arm over your head and lean your torso to the right. **3.** Return to the starting position and repeat on the opposite side.

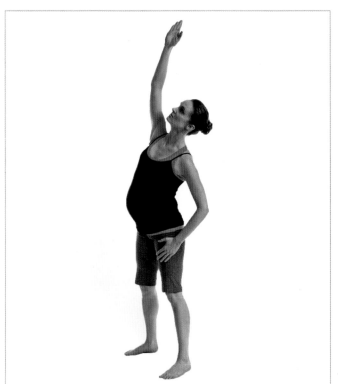

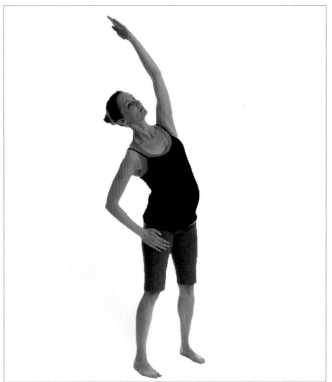

Cat Stretch

Target: Spine.

Benefits: Alleviates pain and stiffness associated with pregnancy along the spine, shoulders, and hips.

Steps: 1. Begin on all fours, with your palms directly below your shoulders and your knees hip-width apart. **2.** Pull the center of your spine down toward the floor and lift your gaze straight ahead. Hold this pose for ten seconds. **3.** Then, arch your back toward the ceiling and drop your head down between your shoulders. Hold for ten seconds.

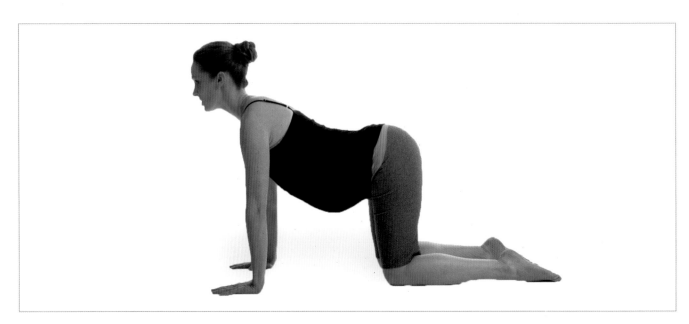

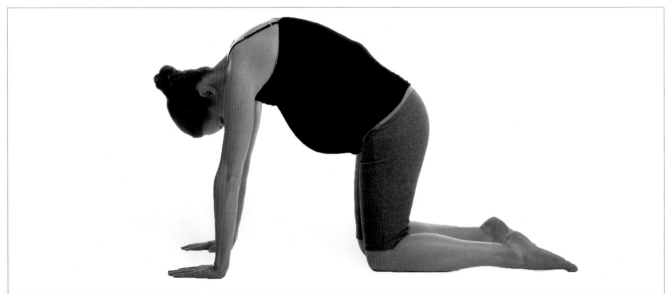

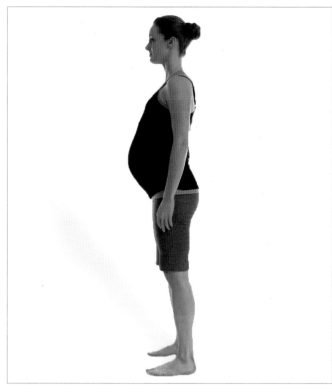

Downward-Facing Dog

Target: Hips.

Benefits: Alleviates pain and stiffness associated with pregnancy along the spine, shoulders, and hips.

Steps: 1. Stand straight, with your feet shoulder-width apart. **2.** Fold forward at the waist and carefully lower both hands to the floor. Walk your hands several steps away from your feet, until you are able to straighten your legs. **3.** Lower your head between your shoulders and pull your hips up toward the ceiling. Your body should form a triangle.

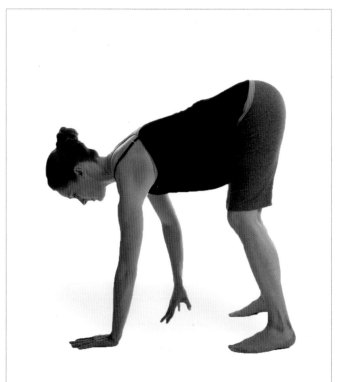

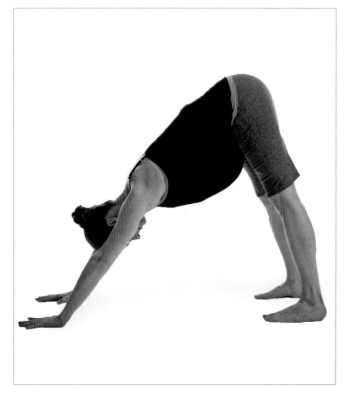

Index

Targeted Stretches

Chest Stretches

Core Stretches

Specialist Stretches

Dance Stretches

Pregnancy Stretches

Yoga Stretches